DJDodds
October 1997

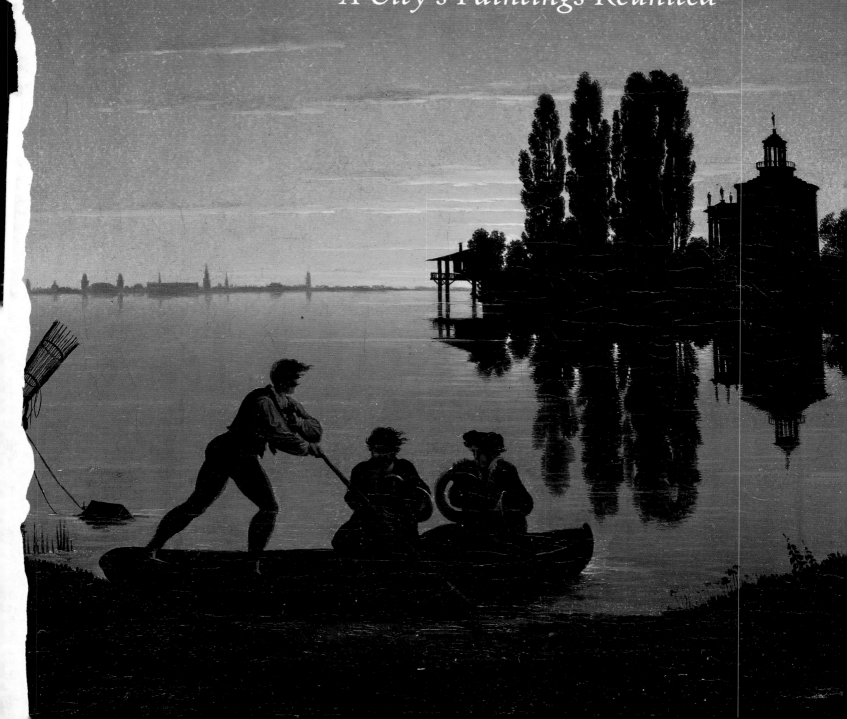

Masterworks in *BERLIN*

A City's Paintings Reunited

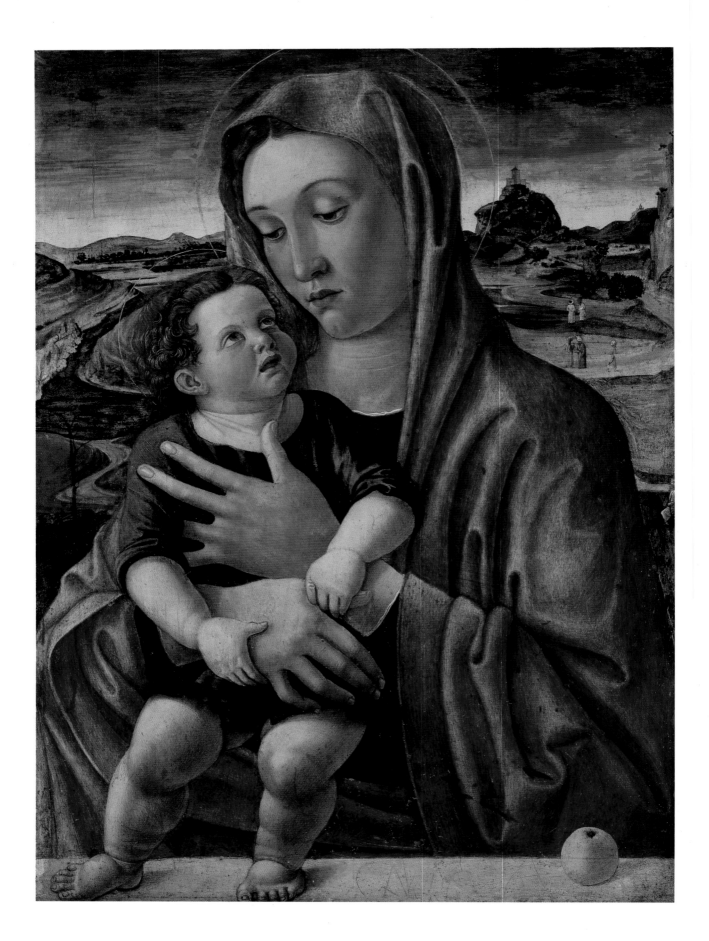

Masterworks in

BERLIN

A City's Paintings Reunited

Painting in the Western World, 1300–1914

Colin Eisler

Foreword by Prof. Dr. Wolf-Dieter Dube

A Bulfinch Press Book ≋ *Little, Brown and Company*

Boston ≋ *New York* ≋ *Toronto* ≋ *London*

FIRST EDITION

Photographs from the Gemäldegalerie, Kunstgewerbe-
museum, Museum für Spätantike und Byzantinische Kunst,
and Nationalgalerie Berlin have been provided by the
Bildarchiv Preussischer Kulturbesitz with permission of the
Staatliche Museen zu Berlin Preussischer Kulturbesitz.
Other photographs have been provided by and with the
permission of Berlinische Galerie, Brücke Museum, Stiftung
Preussischer Schlösser und Gärten Berlin Brandenburg
(Jagdschloss Grunewald, Neues Palais, Schloss Charlotten-
burg, Schloss Sanssouci), and Stiftung Stadtmuseum Berlin
(Berlin Museum and Märkisches Museum).

Library of Congress Cataloging-in-Publication Data

Eisler, Colin T.
 Masterworks in Berlin : a city's paintings reunited /
Colin Eisler; foreword by Wolf-Dieter Dube.
 p. cm.
 "A Bulfinch Press book."
 Includes index.
 ISBN 0-8212-1951-0
 1. Painting — Germany — Berlin. 2. Art
museums — Germany — Berlin.
 I. Title.
N2220.E38 1996
759.94'074'43155 — dc20 95-17511

Published simultaneously in Canada by
Little, Brown & Company (Canada) Limited

PRINTED IN ITALY

Endpapers:
EDUARD GÄRTNER
Berlin Diorama from Friedrichswerder Church Looking South,
1843 (detail)

Half title:
KARL FRIEDRICH SCHINKEL
The Banks of the Spree at Stralau, 1817 (detail)

Frontispiece:
GIOVANNI BELLINI
Madonna, with Child Standing on a Parapet

Colophon:
MASTER OF THE DEICHSLER ALTAR
Two panels from the *Deichsler Altar,* c. 1415–20:
Madonna and Child (left); *St. Peter Martyr* (right)

A Jew who fled Germany aged two, I write above all to honor Berlin's greatest lost treasures: those who opposed Nazism on the basis of conscience. So my book is dedicated to the memory of Berlin's true Christians and to her Jews active as fighters in the press, the law, and labor movements, on stage, in film and cabaret; to the city's early, idealistic Anarchists, Communists, and Socialists — those political groups who were Hitler's first and most effective enemies — and to her Gay men and women, soon as relentlessly persecuted as any political or religious group.

Ironically, many of the city's most principled residents to survive Hitler lived only to suffer once again under Russian Occupation or Western conservatism. Betrayed, exiled, murdered, imprisoned, or silenced between 1930 and 1991, countless numbers of Berlin's very best fell victim to successive oppression, sacrificed to their fellows' compliance, indifference, cowardice, opportunism, or dread. Of those who escaped, many lost their loved ones, their language, their eloquence, their faith, their respect, and their security in and for the past, cruel deprivations all.

Let not one of these treasured lost be forgotten.

COLIN EISLER

Contents

ACKNOWLEDGMENTS

Without the crucial, generous support of Professor Doctor Wolf-Dieter Dube, General Director of the Berlin Staatliche Museen, Preussischer Kulturbesitz, this project could never have been realized. The German Consul General in New York, Erhard Holtermann, and his Cultural Attaché, Thomas Meister, were also extremely supportive, true too for the most gracious, sympathetic, and ever effective Irene Kohlhaas, at the German Consulate in New York and now in Bonn.

In Berlin, my dear friends Wernher and Maria Schade provided their habitual warmth and hospitality, lending invaluable reference works and great learning. Director Irene Geismeier and her curatorial staff made it a pleasure to study paintings at the then Bode Museum. Helmet Börsch-Supan also made much information available.

Dr. Karl Heinz Pütz, Director of the Bildarchiv Preussischer Kulturbesitz, was very sympathetic to this daunting project, as was his assistant Heidrun Klein. They facilitated the taking and the delivery of the photographs, all of them new, prepared especially for this publication, a huge undertaking paid for by Bulfinch Press.

Pizzi-Hamilcar has done its habitually painstaking work in printing the reproductions.

This book reads and looks the way it does due to Brian Hotchkiss's editorial vision and Susan Marsh's authoritative design. If *Masterworks* satisfies the reader-viewer, that is very largely to their credit. Editor Karen Dane and copyeditor David Coen clarified the text.

My resourceful agent Robin Straus delivered what began as a deceptively simple project to term with her usual dispatch and diplomacy.

Few authors have been as fortunate as this one in having a publisher who allowed them absolute freedom in the organization of their material and the selection and quantity of illustrations, for which I am deeply indebted to Publisher Carol Judy Leslie. I also thank Brian Hotchkiss and the Press for granting this member of the unfair sex the "female prerogative" of mind-changing, permitting the adding and subtracting of material as my intricate project developed over the years. While these changes required additional labor, they have, I hope, contributed to the quality of this book.

At the Institute of Fine Arts I want to thank Egbert Haverkamp-Begemann, who lent several essential books now battered by my abuse, and his student Lisa Banner. As always, Sharon Chickanzeff, Director of Libraries, has been especially helpful, along with Clare Hills-Nova, our omniscient Reference Librarian, and Blythe Peelor Kingston, essential Demystifier of Computer Arts. Mark Trowbridge was a paragon of efficiency in setting up a picture file, and Karina Fryklund's brilliance caught many an error. Barbara Banks lent her helpful, generous assistance.

If the term "dream team" may be applied without an infinitely costly criminal context, I so wish to characterize all the men and women listed above. They sustained me through a surprisingly difficult and unexpectedly long campaign, facilitating the production of, and my final freedom from, this book!

COLIN EISLER
Robert Lehman Professor of Fine Arts,
New York University — Institute of Fine Arts

FOREWORD

THERE IS A SPECIAL pleasure in seeing united in one volume the masterworks of European painting that belong to the public trust in Berlin. Most viewers will be surprised by its abundance, because these pictures could not be seen in their entirety in museum collections during the past few decades — whether due to war damage to buildings not yet repaired, or because of the political division of Germany and of Berlin. The present volume, however, also gives those familiar with the collection's original magnitude cause for grief, because so many paintings that were once our proud possessions are missing. We are not speaking of the van Eycks' *Ghent Altar,* in Berlin since 1818, nor of the wings of the *Louvain Altar* by Dieric Bouts, acquired in 1834. Both of these were handed over to Belgium as a result of the Treaty of Versailles. More drastic were the losses to the Nationalgalerie from the "Aktion entartete Kunst," or campaign against "Degenerate Art," in 1938, during which the *Neue Abteilung* (New Wing) of the Nationalgalerie, at that time the most influential collection of modern art in the world and the model for the Museum of Modern Art in New York, was destroyed, and 164 paintings lost.

Far worse were the losses that occurred as a result of the Second World War. In all, 593 of the Gemäldegalerie's (Old Masters Paintings Gallery) works, 852 nineteenth-century paintings of the Nationalgalerie, about three thousand from the state-owned palaces, and 150 from the Märkisches Museum were lost. These disasters resulted not from wartime events, but following the surrender of Germany. One week after the end of the war on 8 May 1945 — the Red Army had taken Berlin on 2 May — the aboveground antiaircraft bunker in Friedrichshain, where the largest holdings of the Gemäldegalerie and the Nationalgalerie were placed to protect them from shelling and from bombs, was gutted by a fire whose cause remains obscure. Four hundred fifty paintings were lost, among them such irreplaceable works as Signorelli's *Pan,* three Caravaggios, monumental altarpieces by Fra Bartolommeo, Francesco Francia, Moretto da Brescia, Andrea del Sarto, eight works by Peter Paul Rubens, four by Anthony van Dyck, and all Berlin's paintings by Jacob Jordaens, Estéban Murillo, Francisco Zurbarán, Simon Vouet, and Charles Lebrun, to name but a few. At the same time the government of the Soviet Union appointed "Trophy Commissions" to select large quantities of the art that had fallen into its hands and have these transported to Russia. Whether some of the paintings from the Friedrichshain bunker were among them, as many still hope, remains unclear. In spite of the works returned between 1954 and 1958, Russia retains extensive holdings from many collections — not just German ones — as "prisoners of war." Her authorities have not yet provided information about the extent of these works nor made the secret warehouses accessible to outside inspection. Nevertheless we are acquainted with a list of close to two hundred paintings from the Schlösserverwaltung (Palace Administration) removed from Potsdam that are now in the storehouse of the Hermitage. So hope still remains that some of the masterworks believed to have been lost may reappear and return to Berlin.

Display of the constantly and rapidly growing collections had already become an urgent problem for the Gemäldegalerie in the third quarter of the nineteenth century. Construction of the Kaiser Friedrich Museum (renamed the Bodemuseum in 1956) on the northern tip of the Museumsinsel (Museum Island) in Berlin was supposed to remedy this situation. Conceived as a Renaissance museum, it was built in the Neo-Baroque style from 1898 through 1904 according to the plans of the architect

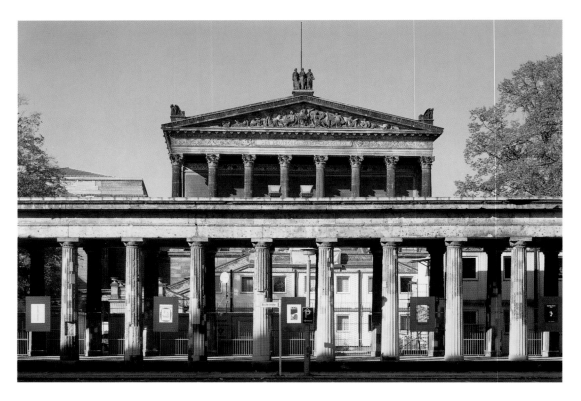

Alte Nationalgalerie

Ernst Eberhard von Ihne. The Gemäldegalerie moved into the upper floor. Wilhelm von Bode, who at that time was already Director of the Gemäldegalerie and of the Skulpturensammlung (Sculpture Collection), utilized this situation for an unusual form of interdisciplinary presentation of the arts. In order to create an environment that represented the historical period, not only were paintings and sculptures displayed together, but furnishings were added to the display, with decorative architectural pieces and antique frames. The result, however, did not remedy the desperate lack of space. Thus, as early as 1908 the planning of a further monumental building was begun with the Pergamon Museum. Plans were drawn up for the last building site on the Museum Island. A large three-wing complex was planned, with one wing for the *Pergamon Altar* and classical architecture, a second wing for ancient Near Eastern cultures, and the north wing for the Deutsches Museum, where the entire art of Northern Europe was to be brought together.

This heterogeneous juxtaposition of collections was clearly not the result of long-term planning, but rather of the need to satisfy urgent space requirements in any way possible. The First World War and the political and economic problems of the postwar era delayed construction, and the building, although opened in 1930, was never completely finished. In contrast to the Bodemuseum, the design of the galleries in the Pergamon Museum, which were determined by classical architecture, was anything but ideal for European painting and sculpture. Neither the combined exhibition with which the museum was opened, nor the separate presentation of painting and sculpture, carried out in 1936, managed to be effective.

The Nationalgalerie profited from the fall of the Prussian monarchy, receiving the Crown Prince's Palace on "Unter den Linden" as an additional exhibition building for its Modern Wing. The Decorative Arts Museum moved into the Berlin City Palace and was merged with the Palace Museum; all furnishings and fittings remained in place.

As of 1937 the New Wing of the Nationalgalerie, the center for "Degenerate Art," was no longer

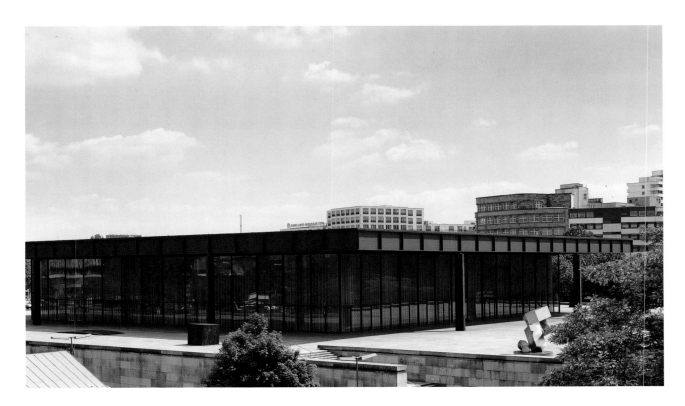

Neue Nationalgalerie

accessible to the public. With the outbreak of war in 1939 all museums were closed. The works of art were taken down and hidden in basements. Parts of the collections were finally placed in antiaircraft bunkers, which offered secure protection from the constantly increasing number of air raids. Unlike other German museums, Berlin's were not allowed to bring their collections to safety outside the city, because it was essential to Nazi leadership to keep these masterworks in the capital to symbolize its firm belief in Final Victory. Not until 8 March 1945, long after the Red Army had reached the Oder, was an order (probably forged) issued from the Führer that permitted the museums to remove the most valuable items from the city. Starting on 11 March, 1,225 pictures from the Gemäldegalerie and 342 paintings from the Nationalgalerie, among many other works of art, were brought to the Kaiseroda-Merkers salt mine in Thuringia. This was occupied by American troops on 4 April. A few days later the works of art were transported to Frankfurt am Main and then to the "Central Art Collecting Point" in Wiesbaden. From there 202 major works of the

Gemäldegalerie were transferred to Washington in November 1945 and deposited in the National Gallery despite protests from all of the American officers in charge of the art. Under pressure from the American public, President Truman agreed to their repatriation in 1948. After a tour of thirteen cities from Washington to Toledo, the paintings were returned to Wiesbaden in May 1949.

Thus, portions of the Berlin museum collections were stored in Wiesbaden in the American Occupation Zone, and another portion at Celle in the British Zone. But the overwhelming majority of the museum holdings remaining in Berlin was taken to the Soviet Union by the Trophy Commissions of the Red Army after the end of the war. All museum buildings were as much as 80 percent destroyed, so that one could well speak of the destruction of the Berlin museum world. Postwar reconstruction required firm resolve. This effort was particularly difficult in Berlin, due to the political threat posed by the Soviet Union, which manifested itself in the blockade and the Khrushchev ultimatum; time and again return of the holdings being stored in the

West was prevented. Not only the newly founded Federal Republic, but also some individual states, such as Hessen, claimed ownership of the former Prussian museums. This conflict was finally resolved through the founding of the *Stiftung Preussischer Kulturbesitz* (Foundation for Prussian Cultural Heritage), which was given the task, among others, of administering the museums and parts of the Palace Administration until the reunification of Germany. This foundation, in which the Federal Government and all of the states cooperate, provided the basis for the return of the collections, which was agreed upon in 1957.

On the Museum Island, then in East Berlin, where the heart of the museums lay, the former Prussian collections were put under the authority of the German Democratic Republic. The museums thus became an expression of the division of Germany into opposing enemy states. In view of this role and of the changed political situation, by 1958 the Soviet Union returned the major portions of the collections that it had removed, including most of the pictures of the Gemäldegalerie and the old Nationalgalerie. According to the political doctrine of the GDR, which assumed the permanent division of Germany, museum planning in East Berlin remained confined solely to the Museum Island, which is still not fully restored today and may well take another twenty to thirty years. Nevertheless, the picture galleries of the Nationalgalerie and the Gemäldegalerie were completed in 1963. The situation was entirely different in West Berlin. The Reunification Decree (*Wiedervereinigungsgebot*) of the Basic Law (*Grundgesetz*) of the Federal Republic of Germany provided that Berlin would again be the capital, not Bonn. In addition, the task of the *Stiftung Preussischer Kulturbesitz,* limited until reorganization could take place after reunification, directed all planning and reconstruction toward a reunited Berlin.

That policy was maintained long after belief in eventual reunification, not envisioned before the year 2100, had ceased. Consequences for the implementation of the plan were clear. Acquisition policy was relatively straightforward, as the existing holdings in East Berlin were always taken into consideration. Thus, for example, no classical sculpture was

acquired in West Berlin, nor numismatics, because there were already large collections on the Museum Island. The situation was different, however, with regard to new construction. To save costs, sources for funding insisted upon housing only the collections then present in the West. Seen from today's vantage point, many buildings turned out to be far too small, particularly the new Kunstgewerbemuseum (Decorative Arts Museum).

In 1962, a year after the Wall went up, planners agreed on a central concept for the long-term accommodation of the *Staatliche Museen* (State Museums) that took into consideration the reunification of the collections. Basic to this plan were considerations that had already been developed before the First World War. The archaeological collections were to be concentrated on the Museum Island, while nineteenth-century painting and sculpture would be housed in the old Nationalgallerie. The museum complex at Dahlem, where the most important holdings of the Gemäldegalerie were kept until recently, was planned for the non-European collections from the Museum for Ethnology, the Museum for East Asian Art, and the Museum for Indian Art. The European art collections were to be housed in new buildings at the center of the city right next to the Wall, within walking distance of the Museum Island. Even if the realization of this plan made slow progress, by the time the two Germanys were united in 1990, four of the six planned museums had been built: the New National Gallery for art of the twentieth century, the Museum for Decorative Arts, the Print Collection, and the Art Reference Library.

With the fall of the Wall everything had to be questioned anew, the reunification of the museums planned with the cooperation of colleagues from East and West. Politically, unification of the Germanys was not an issue for quite a while. In fact, just the opposite proved true. In the GDR in particular, until the middle of 1990, renovating the government, not abandoning it, was the first issue on the agenda. So we in the West worked without a political mandate, and those in the East worked against it. This is hardly the place to review these developments, which were truly exciting. Suffice it to say that a combination of twenty-eight museum

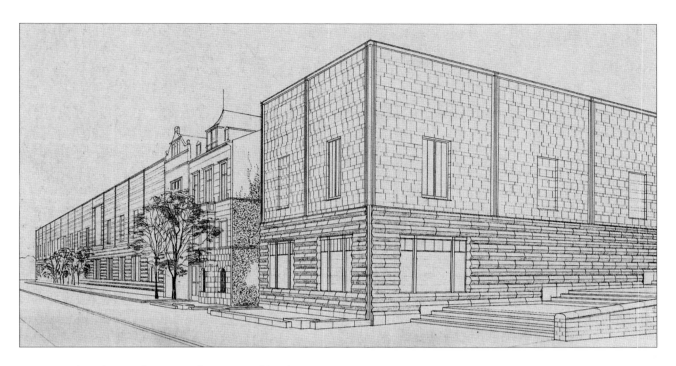

Perspectival rendering of exterior of new Gemäldegalerie

directors and two director generals succeeded in publishing in September 1990 the *"Denkschrift zu den künftigen Standorten und zur Struktur der Staatlichen Museen zu Berlin"* ("Memorandum on the Future Locations and Structure of the State Museums of Berlin"). This resulted in confirming the central concept planned in 1962, with the European art collections housed in new buildings at the center of the city close to the Museum Island. These proposals were accepted in February 1991 by the official committees responsible for the decision, so that their implementation could then begin. A construction plan was already at hand and needed to be changed only to accommodate a study gallery in the basement for the reunited collection. This planning of the new Picture Gallery (*Gemäldegalerie*) was the work of the Munich architects Heinz Hilmer and Christoph Sattler, who won the design competition in 1986.

Their design accommodates the need for overhead lighting, a clear layout, ready orientation, and variety in the appearance of the various galleries. A rotunda serves as the entry hall and also guides viewers toward the various collections. Three

choices present themselves. Visitors may be tempted to enter the long and airy hall of columns, around which the galleries are arranged, something that can be done by those who specifically want to see certain sections or paintings. Or one can turn immediately to the pictures, in which case one has two different options: the Multscher Gallery to the right or the Botticelli Gallery to the left. Here the visitor sees how the collection is exhibited according to school. There was no specific plan to put the Italian schools south of the rotunda and the hall of columns, and the Northern ones to the north. This arrangement was determined by the extent of the collections and by the need to incorporate pre-existing buildings. In the southwest corner of the Gemäldegalerie the schools meet and intermingle in eighteenth-century paintings. No matter which way one moves, after walking through about half of the collection, one reaches the art of the eighteenth century, which represents the chronological endpoint of the Gemäldegalerie's acquisition mandate. All later works belong within the realm of the Nationalgalerie.

A visitor who wants to make the Gemälde-

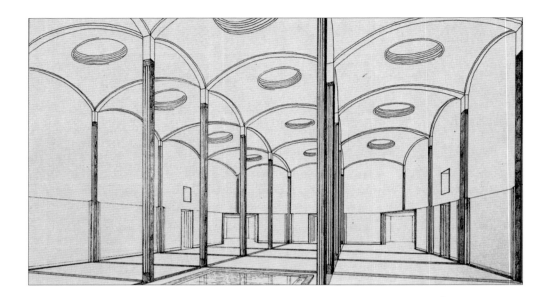

Perspectival rendering of atrium of new Gemäldegalerie

galerie's complete tour must ascend on one side from the fourteenth-century to the eighteenth-century galleries and then descend on the other side from the eighteenth century back to the fourteenth. Whoever sees any didactic disadvantage in this plan might prefer that everything be arranged in an "ascending" line according to period. We weighed the pros and cons very carefully, but finally confirmed our conviction that separation according to schools in the manner described above corresponds best to the special character of the Berlin Gemäldegalerie — one uniquely its own by virtue of the history and fate of its collection. This special character cannot change in the future because substantial acquisitions are becoming increasingly difficult and prohibitively expensive. The more significant a collection of historic art, the sooner it will have to abandon the nineteenth-century doctrine that constant acquisition is an indispensable premise for a "living museum."

Seven to eight hundred paintings will be exhibited in the Gemäldegalerie. As in every museum, more objects will be offered to viewers than they can possibly absorb in one visit. Christian Wolters's important insights influenced the Hilmer / Sattler project. The visitor can make a short tour through the sequence of large galleries laid out around the atrium and gain an impression of the highlights of the collection, culminating in the large Rembrandt-Saal with its octagonal format. At most three large galleries are linked by a single sight line. As a result, visitors should feel invited to linger in a section and at the same time to visit the smaller galleries that are laid out parallel to and around the perimeter of the main ones. Even the small galleries are lit from above. The even lighting emphasizes the equality of the large and small galleries seen during the average visit.

All these considerations proved the inherent qualities of the Hilmer / Sattler design, which accommodated the demands for variety in gallery size, as determined by the specific needs of the collection, without losing any clarity in its arrangement sacrificing any of the tension between symmetry and variation. The atrium presents this theme of varied symmetry from the very outset. Although symmetrically designed with columns, it tapers from east to west. All four corners are designed with individually distinctive openings.

All the doorways are laid out with sight relationships to enhance the full scale of the building and its surroundings. At one end of the building, a view extends into the rotunda and onto the central entrance hall that lies behind it. Another view leads through a bay window into the inner courtyard of the so-called Villa Parey. At the far end, the vista continues through sequences of octagons, diagonally through the rooms situated behind them, and

on to the corners of the building at the exterior. One may look out of the southeast room onto the Nationalgalerie. Three loggie along the building's axes toward the north, south, and west complete the outer orientation.

The inner sequence of the large galleries is only indirectly affected by this design feature. The sequence opens through six doors onto the atrium, which, because of the light entering directly through cupolas, maintains a relationship with the outside world that differs from that of the rooms with their diffuse light. These views guarantee the public the variety needed to counteract fatigue. All of this is irrelevant for the individual paintings, which are given the ambiance they require to manifest their vitality and radiant power. "Perplexity when confronted by art is not resolved by falsely ascribing a mediating character or a use to it, and thus trivializing it." So says the painter Georg Baselitz, continuing: "Art contains no information, at least no more than ever; the only way it can be used is by contemplation. For this it needs space, walls, and light. The best light comes from above; the best room for this purpose has closed high walls, few doors, no side windows, skylights, no partitions, no baseboards, no pedestals, no paneling, no reflective floorings, and finally even no colors."

We have deviated from this concept in some details, but in principle we agree with the artists: they reinforce us in the correctness of our efforts.

Due to financial constraints, the new gallery may not open before the beginning of 1998. Then the Berlin Gemäldegalerie will once again shine forth in all its glory and the Picture Gallery at Sanssouci Palace at Potsdam will also be accessible to the public. Parts of the Gemäldegalerie, together with masterworks of the Sculpture Collection, will be seen in the Bodemuseum. The Nationalgalerie will present its department of contemporary art in the rebuilt Hamburger Bahnhof. But it will take longer to restore the Alte Nationalgalerie, to provide additional space for masterworks of the nineteenth century. The Galerie der Romantik (Romantic Painting Gallery), now still exhibited in Schloss Charlottenburg, will then return to its original home, the Alte Nationalgalerie.

We confidently hope that in the near future the entire wealth of European painting, so strikingly preserved in Berlin and Potsdam, will be on permanent display.

PROF. DR. WOLF-DIETER DUBE
Director General of the State Museums of Berlin
Berlin, May 1995

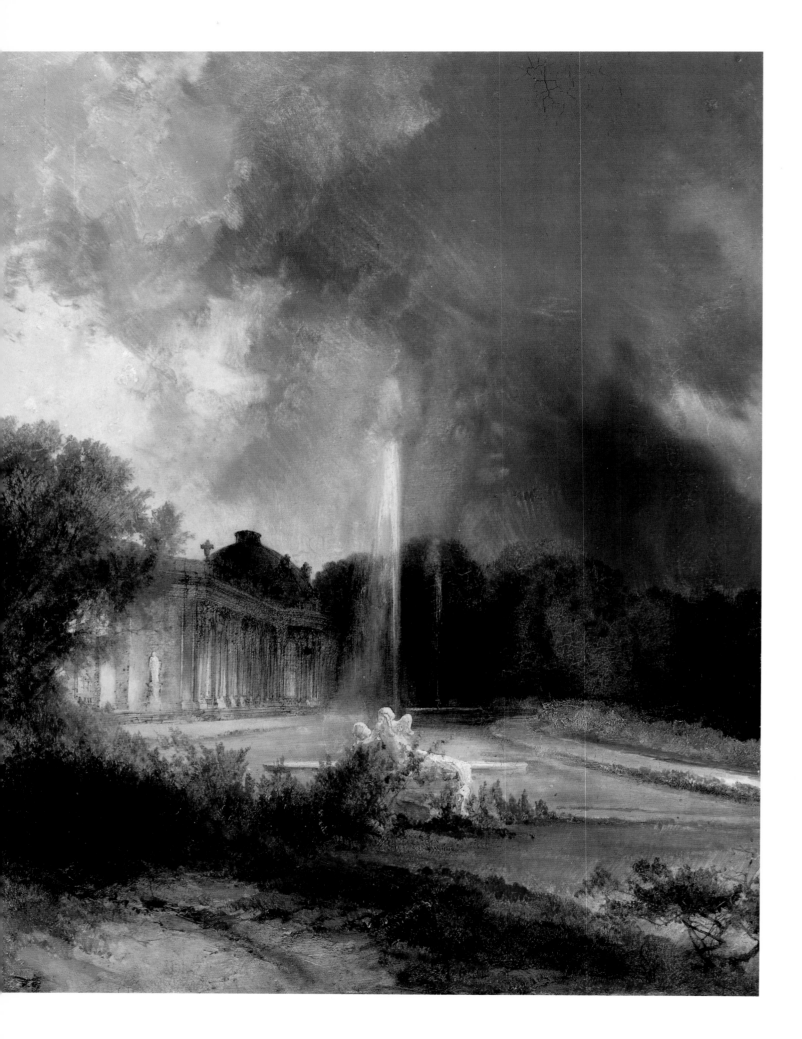

BERLIN'S PAINTINGS COLLECTED, HOUSED, REUNITED

ALONG with the rapacious, ravenous Prussian eagle, another bird — the legendary phoenix — might prove an apt emblem for the first united kingdom of Germany. Like the mythological bird, born again from the ashes of defeat, the nation is perpetually renewing, rediscovering, and redefining herself. First formed as an imperial confederacy in 1871, Germany has risen triumphantly from the flaming devastation of two world wars. Reunification after almost fifty years has created a new nation, the youngest of superpowers.

Ironically, of all the disasters visited upon art preserved in Berlin, the very worst took place in May 1945, just after the city's surrender. This destruction occurred in the Flakturm fire, when about four hundred sculptures and a similar number of paintings, including some of the world's finest, perished. Flames ripped through the closely packed works stored in a bunker near the Tiergarten, Berlin's zoo, at Friedrichshain. Had what may have been Hitler's last, and surely his only good, order been followed — the evacuation of all Berlin's major art works to the West — this cataclysm might have been prevented.

The capital's losses of art and architecture during the later years of World War II and its aftermath are incalculable. Among the destroyed paintings are such incomparable works as the vast early German *Quedlinburg Retable* of c. 1250, and the so-called *Education of Pan*, Luca Signorelli's greatest panel. Major Renaissance altarpieces by Ercole de' Roberti (his masterpiece), Alvise Vivarini, Fra Bartolommeo, Francesco Francia, Moretto da Brescia, and Andrea

Opposite:
KARL BLECHEN
Sanssouci Palace, 1830–32

del Sarto were burned. Three Caravaggios, including Berlin's best, *The Inspiration of St. Matthew*, perished in the Flakturm fire. Guido Reni's *SS. Anthony and Paul*, Anthony van Dyck's *Bacchanalia*, and three other of his works are gone, as are several of Berlin's paintings by Jacob Jordaens. Such French Baroque losses as Simon Vouet's early *Annunciation*, Charles LeBrun's *Jabach Family*, and Claude Lorrain's *Landscape with Diana and Hippolytus*, along with the loss of key Spanish Baroque canvases, are especially lamentable as the art of that period from these nations was relatively poorly represented in Berlin. Zurbarán's major *SS. Thomas Aquinas and Victorinus*, Murillo's *St. Anthony of Padua with the Infant Jesus*, and Berlin's best Goya (a monastic portrait) were all destroyed. Eight major Rubenses, his magnificent *Conversion of St. Paul* among them, went up in flames.

A major collection of period frames that had long been kept at the Kaiser Friedrich Museum also perished. Objects like these are now almost as hard to find as paintings of the quality that once went with them. Many of these moldings were first assembled by Wilhelm von Bode (1845–1927), the museum's best-known director. He appreciated the need for suitably individual frames appropriate to the paintings' period styles, a view that was preferable to the long-prevalent taste for placing all pictures in deadeningly uniform enclosures.

Between 1961 and 1989, Berlin was divided. Its western half was completely isolated — accessible only by air or sealed train — while the eastern sector was cruelly walled away. This division provided a stark contrast between subsidized opulence and punitive austerity. The renewed bringing together of Berlin's vast pictorial holdings confirms that they constitute one of the world's most impressive paintings collections. Under a reconstituted central administration for Prussian Cultural Properties, the

city's twenty-eight public museums will continue to function in several locales. But the capital's massive art collection calls for a major overhaul, often for reinstallation in new settings, some to be rebuilt, others to be erected afresh.

First and most important will be the complete restoration of the Museumsinsel (Museum Island), a cluster of sanctuaries that grew from the imperial dream of that leading architect of Romantic classicism, Karl Friedrich Schinkel. New buildings, along with the inspired reuse of old ones, are to supplement the Museumsinsel's now crowded spaces.

Following Paris's creative reuse of the Belle Epoque Gare d'Orsay as a museum, Berlin's collection of post-Modern, late-twentieth-century paintings will be installed in the Hamburger Bahnhof, a railway station dating from 1845–47 that was later adapted for use as a construction-history museum. Long the link between the Prussian capital and Germany's leading seaport, the Hamburg railway line symbolized the new nation's massive prosperity, first made possible after unification, in 1871. A world-class maritime power, the new state's equally novel industrial might was celebrated in paintings by Karl Blechen and Adolf Menzel.

Mies van der Rohe's chastely lavish Neue Nationalgalerie, by now a "good old Modern" building, was erected by the Bundesrepublik at the Potsdamerstrasse. In it are housed works that have achieved the status of classics and that reflect securely established Modernist values, from Impressionism to Abstract Expressionism. Originally designed by the German architect as Bacardi's Santiago de Cuba rum factory, this International Style project was of no use after Castro's takeover. Bought for Berlin, and built in 1968, its chilly grandeur suited the vast wealth of the burgeoning West German un-economy at the very peak of the *Wunderwerkschaft*.

The Neue Nationalgalerie is part of the capital's post–World War II cultural center, the construction of which began with Philharmonic Hall (1960–63) — Berliners call Hugh Hardy's structure "The Pregnant Oyster" — followed by the Kunstgewerbemuseum (Museum for Decorative Arts) of 1985, both built at the Potsdamer Platz. This is also the site of the new Gemäldegalerie for Old Masters,

designed by Heinz Hilmer and Christoph Sattler. It is discussed in the Foreword to this book, by Professor Dr. Wolf-Dieter Dube, General Director of the Staatliche Museums Preussischer Kulturbesitz, who has played such a prominent role in its establishment. This new gallery for Old Masters houses those paintings from the Kaiser Friedrich Museum that were later long divided between the museum at Dahlem and the Bodemuseum (the name for the Kaiser Friedrich Museum under Soviet occupation).

Pleasantly suburban, unpretentious, and well lit, the spacious museum at Dahlem was designed by Bruno Paul and built between 1914 and 1921 near the site of Berlin's university. Following Bode's plan, it housed the Asiatic Museum (and will continue to do so), along with the ethnological, non–Greco-Roman or Egyptian archaeological, and tribal arts collections. After the return of most of the Kaiser Friedrich Museum's paintings to the city's western zone, Dahlem's galleries afforded them most effective housing.

Collectively, the Potsdamer Platz institutions will form one of Berlin's two key urban museum poles; the other remains on the Museumsinsel, a scant one and a half miles away in the reunited capital. First developed in the early nineteenth century, and situated in the eastern zone for almost five decades, the Museumsinsel, including the grand Alte Nationalgalerie — built between 1861 and 1876 to house Consul Wagner's collection of contemporary German art, bequeathed to the Prussian state in 1861 — has long constituted Germany's Louvre. It will continue to house several separate buildings and their collections. Much German nineteenth-century painting is to stay in, or be returned to, the Alte Nationalgalerie.

On the Museumsinsel and across the waters, a series of separate buildings, many designed and built long after the death of Schinkel, but often anticipated by his concepts, presents a dramatic combination of individual shrines to various media and cultures. Quickly proving to be a cosmic sanctuary of art, the Museumsinsel provided Prussia, and then the unified Germany, with an art-historical "around the world in less than eight hours." This real visual fantasy was made uniquely possible by

JOHANN HEINRICH HINTZE, *Altes Museum*, 1832

cultural adventures afforded by explorations of the boat-shaped Museumsinsel dredged from the mud and sand of the River Spree.

The Museumsinsel's eclectic range of buildings rises from the waters like a Neoclassical Oz, all the more unlikely for the railroad and other bridges crossing the waters and traversing the museums. Its waterbound site is one of the many reasons why that water-girt Temple of the Muses remains such an incomparable success. Long devoted to providing a uniquely comprehensive journey through the space and time of almost all *Kunstgeschichte*, the Museumsinsel is a mighty fortress consecrated to the cultures whose histories so often lie close to Germany's ethos and to her cosmic ambition. Here many of the world's greatest works of art were long laid out in almost ritual fashion, placed within a series of festive *all' antica* pavilions. These, with their contents, recall the treasuries of the ancient

Greek city-states, which were usually built within the temple sanctuaries, on sacred ground, to guard and display votive goods, whether the booty and tribute of war or of Olympic victory.

A Berlin professor of architecture and city planning who taught in these fields from 1815 on, Schinkel first contributed to the design of Berlin's earliest major art museum, now known as the Altes Museum, which was built between 1825 and 1830, opposite the royal palace's *Lustgarten* (pleasure garden). Schinkel's many skills as architect, visionary artist of classical and Christian subjects, stage designer, and hydraulic engineer made this first great building possible and contributed to the concept of the Museumsinsel. As the science of hydraulics was within Schinkel's vast expertise, he was unusually sensitive to the relationship between building site and waterway. This made him a key figure in the planning and engineering of Berlin's

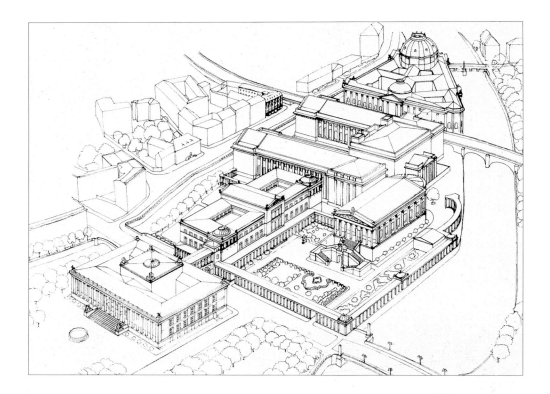

Diagram of
Museumsinsel

many canals, and he filled in a canal opposite the palace to provide space for the Altes Museum. His students and their successors went on to devise the design of the Museumsinsel, conceiving it as a wondrous entity.

At once classical and Romantic, this miraculously cultivated isle works so well because so many of its designer's skills sprang from stage design, an occupation to which young Schinkel was forced to turn when building commissions dried up during the Napoleonic Wars. Thinking in terms of illusion, of scenography, inviting that suspension of disbelief lying at the heart of much great art and architecture, the visionary builder made his exotic image take plausible shape in the midst of modern Berlin.

Follies — those picturesque eighteenth-century architectural caprices designed solely to surprise and amuse — come close to Schinkel's shrewd architectural fantasy. At first his Museumsinsel seems no more than a monument to itself, beyond utility, solely dedicated to visual sensation. Yet, from the start, it worked. More than a mere frisson of momentary theatrical effect, his building housed art for eternity.

A second museum, behind Schinkel's, was begun

in 1843. Finished in 1859 it is, inevitably, known as the Neues Museum, designed for prints, drawings, the Egyptian collection, and plaster casts. This, with much of the planning of the Museumsinsel, was the work of Friedrich Stüler (1800–1865).

Tucked into the northwest corner of the island, in its last remaining major space, is the final building to house Western art. This monument to Berlin's modern affluence as well as to the nation's ambition is the Kaiser Friedrich Museum. The neo-Baroque structure (1896/98–1904) was designed by Ernst Eberhard von Ihne, the court architect selected by Kaiser Wilhelm II.

This pompous building suggests a railroad station in a tight squeeze as it is built between river, railway tracks, and the Kupfergraben. With its almost triangular form and eclectic style, the museum is an implausible, bureaucratic reworking of Italian Baroque elements, suggesting design by committee or computer. But it functions surprisingly well, admirably adapted to an awkward site and equally well suited to the needs of what was then the world's fastest-growing collection of sculpture and painting. All its galleries were satisfactorily lit by natural illumination coming from five court-

yards. A splendid rotunda inspired by Schinkel's houses a great equestrian monument cast after Andreas Schlüter's 1703 tribute to the Great Elector, founder of Berlin's picture collections. Just outside the building, another such bronze — this one of the Emperor Friedrich Wilhelm IV as victorious general — seems about to ride within.

The city's post-classical, pre-twentieth-century Western sculpture will be shown in the Kaiser Friedrich Museum, where it was initially installed under Bode's direction. Those museums devoted to ancient arts, often of German excavation — most notably the Pergamon Museum, built to house a magnificent Hellenistic altar excavated by a German team at that Turkish site — and for ancient Near Eastern cultures, with another for Egypt's, will also remain on the museum island.

Seldom a major locus for extremely heavy manufacturing with its requisite *Lumpenproletariat*, Berlin could count on a sophisticated public, one unusually aware and appreciative of what its museums had to offer. Photojournalism and the graphic arts enriched the city's cultural perspectives and collecting concerns, adding to the already strong interest in photography, prints, and drawings used for students in art, design, manufacturing, and architecture. A building entitled the Germanisches Museum, designed by Alfred Messel (1853–1909), was connected to the Kaiser Friedrich Museum by a footbridge over the railroad tracks. Great nineteenth-century museums and railways often went hand in hand. Edinburgh's and Chicago's art museums exploited their railways' "airspaces," as now did the kaiser's new museum. Passengers on express trains en route to Paris or Warsaw still get a fleeting glimpse of its galleries.

So much major early Northern art had been acquired under Bode that a special building was planned for it as early as 1909. The new museum's national emphasis guaranteed a relatively free hand from the state treasury. By the time of its long-delayed construction two decades later, the by then antiquated design entailed vast expense that was made still greater by a marshy building site. Such costs were unwelcome in the depressed economy of post–World War I Germany. Completed in 1930, just in time for the centenary of the founding of the

Berlin museums, the new institution followed the more specialized goals of Nuremberg's Germanisches Museum, founded in 1852, and Munich's Bayerisches Nationalmuseum, established three years later.

Berlin's wise and witty Max J. Friedländer, the world's greatest scholar of early Netherlandish and German art, was this collection's first director. Aware that *Deutsch* was far from an entirely accurate characterization of his new museum's contents, he justified its title in a "racial," rather than geographical, or political, sense. Ironically, Friedländer soon fell victim to that same fallacious concept when he was exiled on racial grounds a scant eight years later. By then in his late sixties, the great man had devoted a lifetime in service of German culture.

With the Deutsches Museum's installation, two other major (and final) additions to the Museumsinsel were also completed, including the Pergamon Museum. Also designed by Messel, it displayed, in addition to the Hellenistic altar for which it was built, the almost equally impressive Babylonian Lion Gate from Ishtar. The island's classical and Egyptian collections were kept nearby.

Though shell-shocked, bullet-pocked, and wall-eyed after almost fifty major British and American Baedeker bombings between 1943 and 1945, Schinkel's magnificent, truly Utopian Altes Museum still survives with its magic intact. Years of neglect of all but the most basic repairs followed the war. The Museumsinsel was bravely patched together during the long, poverty-stricken years of the occupation, and will take many more years to restore.

The city's smaller, more individual museums hopefully will continue to maintain their welcome personal character. Often invitingly houselike, these include the attractive setting for a collection devoted to the Expressionist movement known as *Die Brücke* (The Bridge) in an effectively designed gallery by Werner Düttmann that opened in 1967. It was built to house the bequest of Erich Heckel (1883–1970), a founding member of *Die Brücke*. It is Berlin's major center for the display of Expressionist art, the school that was banned from the twenty-five German museums forced by the Nazis to surrender their modern holdings.

Other new art museums in Berlin include one

now dedicated to the oeuvre of Berlin's own great Käthe Kollwitz. A very modest house art museum was set up in memory of Otto Nagel, the forceful Communist painter, and to the anti-Nazi artists in his circle, but this may go with the city's reunification. The Bauhaus Archiv is installed in a newly minted International Style building after designs of Walter Gropius. These specialized collections add a needed intimate environment to that otherwise too often yawning void known as the museum experience.

The little-known Märkisches Museum (its name referring to Berlin and its environs) is a late-nineteenth-century historical grab bag, a varied, quirky collection of paintings with much other material of local interest, including fine Biedermeier city views, important portraits by Max Slevogt and Edvard Munch, and works by leading Berlin figures.

Happiest of the city's post–World War II museum institutions is the Berlinische Galerie, presenting Modernist movements developed there since about 1900. After World War II, innovative European achievements were seen through exclusively Parisian tinted glasses, ignoring or denying Germany's seminal importance to Modernism, so this museum plays an especially important role in rectifying that situation.

Unlike the largely platitudinous pictures gathered at the Neue Nationalgalerie, with its predictably expensive, somewhat passé French- and American-oriented works of the 1950s, 1960s, and 1970s, the Berlinische Galerie comes as an eye-opener, a dazzling tribute to the unique achievement of Germany's capital of culture as well as government for brief but splendid years from the late nineteenth century to the early 1930s.

Founded in West Berlin in 1975, its acquisition funds are largely provided by a percentage of profits from the state lottery, a common German practice that is also used for the Bauhaus and Brücke museums. Located in a massively Wilhelmine structure, designed largely by Martin Gropius, the uncle of Walter Gropius, in 1877, it was mostly destroyed in World War II. Part of the capacious building is used for temporary exhibitions. Dedicated primarily to the avant-garde, to vital developments before and after the First World War, to Dada and other movements of the 1920s and 1930s, this museum bears striking witness to Berlin's unique cultural vitality and innovation, so important to Parisian Modernism.

All in all, approximately DM 1.5 billion ($950 million) will have been spent when plans for the building, rebuilding, and reorganization of Berlin's many museums and their contents are fully realized. New wiring, lighting, heating, and air conditioning — along with extensive rebuilding from the ground up of the Museumsinsel's lost pavilions and arcades — are only a few of the basic needs that must be attended to before Schinkel's dream may once again become the next century's reality.

From Royal Heritage to State's Acquisitions: The Growth of a Capital's Collection

Alois Hirt (1759–1837), an archaeologist and professor of art theory at the Berlin Academy, was an early adviser and planner of a didactic royal gallery for the capital. Having spent much time in Italy, with its rich, recent network of public art collections, Hirt advocated a new, comprehensive Prussian museum plan in 1797, presenting his proposal to the academy in honor of the twenty-seventh birthday of Frederick William III, when that young king acceded to the throne. Knowing of the many major works of painting and sculpture scattered about the various royal palaces in and around Berlin, Hirt wanted to unite them under one roof to function as "a school of good taste for the entire nation" that would include pictures representative of as many different movements as possible. "Beauty" and "Education" were to be the new institution's twin goals.

In 1798, after Napoleon had stunned Europe by his systematic, encyclopaedic art plunder, and had bedazzled the Continent by his intelligent, accessible installation in the Louvre of that incomparable booty, Hirt was all for a similarly educational, if neccessarily far more modest, museum in Berlin. Frederick William III, like most monarchs, was awed by the propagandistic mileage the little Corsi-

can had extracted from his massive artistic rapine. So, after attending the Parisian peace negotiations in 1815 following Napoleon's fall, the Prussian king decided to have the Academy at Unter den Linden establish a royal museum — a Berlin picture gallery. Its first function was to exhibit Prussia's royal paintings, freshly returned from the Louvre.

These 123 pictures had been installed in the Hohenzollern's various palaces and included sixteen Cranachs and Correggio's *Leda and the Swan* (271). Their theft and return must have heightened the king's consciousness of his cultural heritage, causing him to make a major economic commitment to its care, including building the gallery that would be open to the public. Frederick William III's growing interest in such a royal urban picture gallery made 1816 the perfect year for Schinkel to come up with his grand plan. The museum finally opened in 1830, on the king's sixtieth birthday.

The Altes Museum has a great rotunda. This feature, inspired by the Vatican museums, was emulated by many other museums — most extravagantly and effectively by John Russell Pope's National Gallery in Washington, D.C., erected about a century later. No reused palace, Berlin's was the first major northern European building designed on such a grand scale to be precisely that. Picture galleries, their long passages consecrated to a similar purpose, such as Frederick the Great's at Potsdam, were well-known, but the capital's monumental urban "picture palace," open to all and planned from the very start to house art, not nobility, was a distinct novelty.

As would prove true too for Washington's National Gallery, freshly completed art museums such as Berlin's, though they might initially be relatively empty, abhor a pictorial vacuum. Their yawning voids are soon filled by contents worthy of such architectural grandeur. Before the end of the nineteenth century, Schinkel's building joined the roster of the world's greatest national galleries.

At first, under the early Electors of Brandenburg, members of the house of Hohenzollern who acquired that marquisate (which included Berlin) had relatively little to spend, and what they did, often went for hardware, military or otherwise, or for building. Their art collecting was slow to start.

Paintings executed by Lucas Cranach the Elder during his 1529 Berlin journey were ordered by the Kurfurst Joachim III for his castle and for the city's Protestant cathedral. The Thirty Years' War (1618–48) devastated the Prussian province of Brandenburg. Only with Prince Frederick William (reigning 1640–88) did things take a much needed, radical turn for the better. That wise young man went west to study at the University of Leiden, close to his very prosperous great-uncle William I of Orange.

The student prince soon married his rich cousin Louise Henriette of Orange in 1646. She brought Gerrit van Honthorst from Utrecht to Berlin as court artist. Much of her family's most distinguished collection soon followed, and a private royal picture gallery was built to house Louise's many works by Rubens, Rembrandt, and Titian. Frederick William was also interested in Italian painting as well as in coins, gems, bronzes, antiquities, Asian porcelains, and African arts. These filled the *Kunstkammer* in his Berlin castle with a cosmic variety of curios, symbolic of a vicarious dominion of several continents and their cultures.

Many more paintings came to Berlin in 1675 from Dutch palaces; they were bequeathed by the House of Orange to that of Brandenburg upon the death of Amalie von Solms, wife of the Statthalter Frederik Hendrik. More than forty works by Rubens, van Dyck, and Jan Brueghel the Elder joined Titian's *Bearded Young Man* (265), and all were exhibited in Berlin's small royal picture gallery. Another group arrived in 1702, upon the death of Amalie's grandson William III of England. Though mostly by lesser-known Dutch artists, this bequest included Rembrandt's *Rape of Prosperina* (356) and his *Minerva* (358).

Then came the rise of the Prussian kingdom under the rule of Frederick I (1657–1713), followed by that of his tightfisted, narrow-minded successor Frederick William I (r. 1713–40). Only with the ascendance of the latter's son, Frederick II (the Great), was there a radical change in outlook. New wealth — and extravagance — of Prussian kings in the early 1700s had already enabled Berlin to take on just a few of the conspicuous hallmarks of a major royal residence.

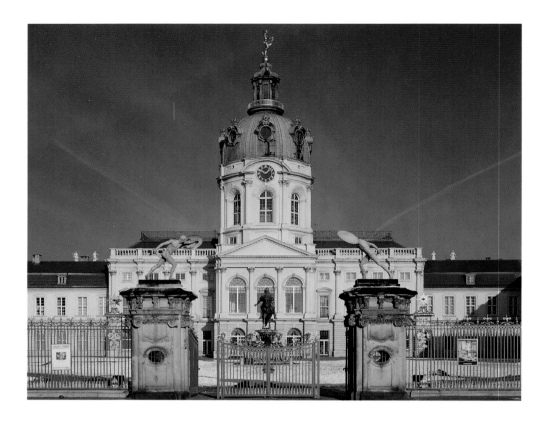

Schloss
Charlottenburg

Frederick the Great's taste for contemporary French culture, its thought, music, and painting, led to the formation of one of the Berlin collections' major strengths. His youthful passion for the Gallic was first evidenced in the decoration of his residence as crown prince at Rheinsberg, where the art of Jean-Antoine Watteau, Nicolas Lancret, and Jean-Baptiste-Joseph Pater was represented with singular brilliance. By 1739 Frederick had filled two galleries with paintings, mostly by these modern young Parisian artists.

Much of the massive construction campaign for Frederick's new or rebuilt personal apartments in the palaces outside Berlin at Potsdam or in Charlottenburg took place during a twenty-year period ended by the Seven Years' War (1756–63). Suitably, Charlottenburg has long since been made into Berlin's leading museum for eighteenth-century art. The dominant artists at court at this time were the painter Antoine Pesne, who came from Paris, and the architect and painter Georg Wenzeslaus von Knobelsdorff, director of the Berlin Academy. Frederick the Great's Versailles at nearby Potsdam on the Havel, with its *maison de plaisance* known as Sanssouci (Carefree), completed in 1747, and the awesome Neues Palais, along with other palaces

built in the city itself, all proclaimed Berlin's shift toward massively prosperous urban modernity. This new architecture manifested Hohenzollern-Brandenburg sovereignty, a Prussia of daunting authority.

Upon assuming the throne in 1740, Frederick the Great expanded both his collecting and his building activities. He corresponded with such foreign agents as the Venetian count (and probably spy) Algarotti, who had already purveyed so many great paintings to the court of Saxony. The French ambassador to the court of Prussia, Comte Rothenburg, Marquis d'Argens, was another major source, providing contemporary French art. Pesne, too, helped as a supplier, forming a collection of several hundred paintings, nineteen of which are given to Watteau, including two of his greatest works, the *Enseigne de Gersaint* (454–55), bought by 1745, and *The Embarcation for Cythera* (450–51), which was in Potsdam by 1765.

Sanssouci represents the end of Frederick's search for present laughter. It is more commemorative of past inclinations than a key to the future. By the 1750s the king sought to make his mark in the world as a serious collector in the conventionally Grand Manner. No longer associated with the fey

Jagdschloss
Grunewald

world of *fêtes galantes*, he now wanted a major, impressive picture gallery like that of Augustus the Strong at Dresden. Such imposing paintings and their special housing were understood to be a royal attribute rather than a personal one. In this lavish courtly setting it was made propagandistically clear that the art of Apelles and his pictorial heirs was in the service of Alexander and his imperial successors.

The monarch's new mood led him to leave behind the pursuit of modern Parisian gaiety as he became ever more willing to face the gravity of Baroque religious images or of history paintings. Frederick abandoned the happy-go-lucky world of the Rococo for the leading Dutch, Flemish, and French masters of the seventeenth century. In his own words, the middle-aged king shifted "from Ovid to Virgil." But he was not so severe in taste as to exclude a Correggio (*271*). Frederick added to Sanssouci a substantial picture gallery that was more of an *orangerie* than a conventional exhibition space, built between 1755 and 1764 by Johann Gottfried Büring.

The new gallery's scenes of martyrdom and triumph, relieved by a bacchanal or two, were viewed in an awesome display of double-hung images, a far cry from the intimacy and good times of the little

French pictures collected in Frederick's youth. An inspired frivolity was now eclipsed by the less libidinous perspectives of resigned middle age. No more than seven French paintings (none of them Rococo) appeared in the royal catalogue of 1770. Of the 168 Baroque pictures, 65 are Italian, 96 are Dutch or Flemish, and none came from the family's castles around Berlin, which had kept more than their share of significant seventeenth-century works.

Frederick was not known for his affection for the fair sex. Women complained that the picture gallery at Sanssouci allowed insufficient space for their voluminous crinolines. Only the Rococo, gently vaulted ceiling of Frederick's new picture gallery acted as a subtle reminder of his recently abandoned celebration of that lighthearted style. Any entertainment of so happy a mode ended when the viewer looked down from the festive ceiling to the often tragic subjects of the big Baroque canvases hanging below.

Two magnificent collections, purchased in their entirety, along with paintings from the electors of Brandenburg and those from the House of Hohenzollern, form the basis of Berlin's Old Master treasury. A spectacular purchase in 1821 predated the museum's official opening in 1830.

The astronomic growth of Berlin's picture gallery under royal patronage began when Parisian art dealer Féréol Bonnemaison offered King Frederick William III (1770–1840) a staggering group of 158 pictures. These had been owned in the seventeenth century by the Roman Giustiniani brothers — Vincenzo and Benedetto, a marquis and a cardinal, respectively. Ultimately the owners of five of Caravaggio's works, the brothers were quite literally in on the ground floor of that painter's major works as their palace was adjacent to the church whose Contarelli Chapel received Caravaggio's first key Roman commission. The Giustiniani also collected canvases by Northern European and Italian followers of that artist, along with fine paintings by Annibale Carracci and Domenichino, Bolognese masters active in Rome. The seventeenth-century German painter and art historian Joachim von Sandrart, a six-year resident with the Giustiniani, prepared an elaborately illustrated catalogue of their antiquities, which was published in 1635.

Frederick William had seen the Giustiniani collection in Paris during the peace negotiations of 1814 and must then have been interested in its purchase. That such a conspicuously Catholic, not-all-that-fashionable gathering of pictures should ever have been bought for a largely Protestant Prussian kingdom, for the very considerable sum of 500,000 francs, remains a major museological miracle.

Favorable lightning struck once again when, in one fell swoop, the Prussian museum was incaculably enriched by the purchase of another, far more important assemblage that was then the world's most comprehensive independent paintings collection in private hands. Bought for Berlin in 1821, it had been formed by Edward Solly (1776–1848), an English lumber dealer living in the Prussian capital. He was a junior partner of a London company whose timber came from the Baltic region. Since Solly's merchant fleet could be used for the defense of Prussia along with Danzig, he had become an important figure in Berlin.

The English connoisseur's splendid acquisitions reflected his role as political theorist; Solly's intellectual awareness and originality in writing on the European economy provided a valuable counterbalance to the cautious views of Prussia's Frederick William III. In 1815 the king had warned against buying early art works lest "we might move backwards instead of forwards," fearing that the authority of antiquity might inhibit progress.

Solly benefited immensely from the chaos of the post-Napoleonic era, when hard northern European currency went a long, long way toward buying innumerable masterpieces that had been taken from secularized institutions and impoverished owners throughout much of Europe.

Many of Solly's three thousand paintings were Italian, all somehow squeezed into his house on the Wilhelmstrasse, where they were displayed in chronological order. Before buying a major picture, the British businessman consulted agents who tracked down the academies, churches, or other owners from whom Napoleon had "liberated" it.

He also had the advice of specialists, including Germany's two greatest art scholars. The more senior was Karl Friedrich von Rumohr (1785–1843), the founder of academic art history, who became the new Berlin museum's major adviser, just as he had been Solly's. Equally important was Solly's second adviser and Rumohr's most distinguished student, Gustav Friedrich Waagen (1794–1868). A venturesome traveler, the scholar pursued missing masterpieces to the wildest shores of Britain and Russia, recording their new locations in his invaluable guides. He would soon play a major role at the museum.

Financial reverses forced Solly to part with his paintings. Long a staunch advocate of Prussia's purchasing the Solly collection, Alois Hirt was happy to hear that the Englishman was unable to sell his paintings at a good price and now had to act fast. Fortunately, both Rumohr and Waagen, key figures in the establishment of the expanded Prussian picture gallery, knew just what masterpieces came with Solly's collection. Berlin bought all the paintings, of which only 677 were exhibited at Schinkel's picture gallery, catalogued by Waagen for its opening in 1830. Another 538 Solly pictures were hung in the Prussian royal palaces, and the rest were stored.

Rich in Trecento works, Solly's collection included paintings by Taddeo (33) and Agnolo Gaddi and the Lorenzetti (36–37). Also of principal importance are Filippo Lippi's *Adoration with the Infant*

Baptist and St. Bernard (*191*) from the Medici Chapel, Botticelli's early *St. Sebastian* (*234*), Mantegna's *Presentation in the Temple* (*208*), and Carpaccio's *Ordination of St. Stephen as Deacon* (*229*), along with equally stellar later-Renaissance works such as the early Raphael Madonna named for Solly (*245*), the magnificent Titian self-portrait (*268*), and Lorenzo Lotto's spectacular *Christ Taking Leave of His Mother* (*257*).

To this day Solly's remains among the three greatest, most encyclopaedic, individually assembled paintings collections ever known, rivaled only by Napoleon's largely temporarily held Louvre loot and by the American Kress brothers' acquisitions made from the 1930s to the 1950s. In Solly's footsteps, the Kresses benefited from expert advice and from European disruption and economic depression.

In 1828, Schinkel had manifested a psychologically astute approach to his building's mission — "First please, then instruct." One year later, Prussian minister Wilhelm von Humboldt (1767–1835) established Berlin's vastly influential university and humanistic *Gymnasium* near its palace, cathedral, and picture gallery. A founder of modern linguistics, Humboldt was appointed to "chair the establishment of a museum of fine arts" a few months before the gallery was first opened to the public in 1830. Noting how most great state art collections "came together gradually," lacking any overall grand design or method, Humboldt stressed the way in which Berlin's would differ from such accidental, if wonderful, accumulations by kings, emperors, popes, or grand dukes. Under his supervision, a commission arranged for the selection of 1,198 paintings to be exhibited in forty small galleries on the upper level. This display was to provide a systematic survey of all periods of painting from art's most distant origins, so reflecting the perspective of the minister's brother, Alexander von Humboldt (1769–1859), which was profound, and profoundly reassuring, one dictated by Providence. That view would be promulgated by Humboldt's immensely popular (though five volumes in length) *Cosmos*, written between 1845 and 1862. But it was soon shattered by Darwin's evolutionary discoveries of 1859. Alexander von Humboldt was a man of universal knowledge and concerns, equally at home

in the domains of culture and science. Under his influence, along with that of others of his generation, Berlin's royal picture gallery and other museums broadened their horizons, expanding their collections, eventually including massive archaeological and ethnological assemblages from the New World and the ancient Near and Far East.

Like the gallery's later director Wilhelm von Bode, Karl Friedrich von Rumohr, the museum's first great adviser, was independently wealthy and vastly capable, a learned Prussian aristocrat. Breaking away from the then predominant picture gallery practice of installing paintings by subject, thus reducing such collections to tediously thematic ghettoes, von Rumohr advocated a livelier grouping, one designed to project art's history and context. Thus Antonello da Messina's portraits (*224–25*) were placed close to the gallery's section of Jan and Hubert van Eyck's *Ghent Altar* (which was returned to Belgium after World War I). This juxtaposition allowed viewers to experience the diffusion of oil technique from north to south, following Vasari's account of the Italian's Eyckian tutelage. Von Rumohr's dynamically pan-European perspective, with its welcome, surprising absence of nationalism, was also found in a gallery devoted to the installation of Arcadian landscapes, showing how they, too, reflect a current flowing throughout the Continent.

Prussia's hoard of visual achievements came to be catalogued with that exhaustive, incomparably German *Gründligkeit*, a daunting fusion of erudition and compulsion soon displayed in encyclopaedic fashion in splendid *catalogues raisonnés*.

As the first director of the Prussian Royal Picture Gallery, it was Waagen's happy fate to build up the world's greatest collection of early Netherlandish art, buying the wings of the van Eyck brothers' *Ghent Altar* from the sale of the king of Holland's collection in 1838. Waagen had written his 1823 dissertation on these artists and urged von Rumohr to acquire their greatest painting. He also bought the Petrus Christus *Young Lady* (*57*) and Holbein's portrait of the merchant George Gisze (*106*), the three triptychs by Rogier van der Weyden (*62–63, 66–69*), and several other of this master's works. Many of these pictures were also bought from the

king of Holland, one of Napoleon's many "instant monarchs."

Toward the mid-nineteenth century, Berlin benefited from an enlivening coexistence and intersection between Prussian values and Jewish enlightenment. The latter was evidenced by the influential salon of Rachel Varnhagen von Ense (1771–1833), as tellingly analyzed by Hannah Arendt. The city also acquired an increasing urbanity as it maintained its awareness of its ties to the East — to Russia — and developed its publications industry, among others.

In 1840, when Prussia's Frederick William IV (1795–1861) ascended the throne, he gave Waagen 100,000 thaler to spend on a leisurely journey to Italy that resulted in the acquisition of seventy paintings, many of them major. Eight years later, when Germany's Revolution was crushed, the extremely conservative king sent Waagen to Italy once again, where many further distinguished purchases were made. Most appropriately, these included frescoes by Titian and Giorgione that were removed from the facade of the Fondaco degli Tedeschi, the German trading company in Venice, along with works by Raphael. Though the mystical, unstable king clearly saw the royal picture gallery as a pearl in his crown, Frederick William IV was not eager or able to extend his rule to the rest of Germany, and he turned down the rule of a united Germany offered him by the Parliament of Frankfurt. His brother William became regent in 1858 and king of Prussia in 1861, after Frederick William's death.

By the mid-1850s, the picture gallery was well grounded in Dutch art — including ten Rembrandts — but it lacked works by Frans Hals until Waagen added four portraits by that master. Waagen also had close ties to England. His *Works of Art and Artists in England* (1838), expanded in 1854 into the three-volume *Treasures of Art in Great Britain*, had first made it surprisingly clear just how that little island was by then the world's major storehouse of privately owned masterpieces of all schools. His British guide was translated into English by Lady Eastlake, wife of the National Gallery's first director.

Using Waagen as their guide, dealers, agents, and institutions were to mine England, Scotland, and Ireland over the next 150 years to develop their holdings. Paradoxically, Waagen himself proved reluctant to exploit his own incomparable expertise, as if unwilling to poach upon his British hosts' preserves of great paintings. Such singular restraint may have won him affectionate respect in England; Waagen contributed to the formulation of the policies of Britain's National Gallery, testifying before a royal commission in 1853 concerning the museum's condition and future.

The Prussian Royal Picture Gallery benefited from direct purchases at British auctions, which brought many masterpieces to Berlin. Great sales such as those of Munro of Novar, the Duke of Marlborough, the Earl of Burlington, Lord Francis Pelham Clinton Hope, and Sir Robert Peel were among the Prussian gallery's key sources for major paintings, many of these from the Dutch and Flemish schools.

By 1860, for all the glories of its collections in Berlin and nearby Potsdam, its great university, and the splendors of its palaces, Berlin was still surprisingly much of a backwater. Henry Adams, who, admittedly, was all too ready to disapprove, characterized the city as "a poor, keen-witted provincial town, simple, dirty, uncivilized, and in most respects, disgusting." Renowned for their irreverence and savoir faire, Berliners could not have cared less about Adams's views. Their city was developing new parks and boulevards, such as Unter den Linden, and one of its major cultural investments continued to be the growing royal art collection.

The third major building to house Berlin's paintings was erected to accommodate recent art. The Nationalgalerie, planned by Frederick William IV and Friedrich August Stüler, was built on the Museumsinsel between 1861 and 1876. The large collection of contemporary German art bequeathed by Consul Wagner in 1861, the year of the Prince Regent's ascendance, provided the impetus to get this gallery built. Much of Berlin's nineteenth-century German art is preserved in this stylistically impractical, space-eating Victorian Parthenon-in-brownstone.

After 1871, with Germany's victory in the Franco-Prussian War, Berlin was selected to be the newly unified nation's capital, leading the country not only politically, but in many industrial, commercial,

and educational arenas. By this time it had become Europe's most modern capital, no longer the sleepy center scorned by Henry Adams. Berlin was hailed as a paragon of progressive urbanism by Mark Twain, who found it a new city — "the newest I have ever seen. Chicago would seem venerable beside it. . . . The next feature that strikes one is the spaciousness, the roominess. . . . There is no other city, in any country, whose streets are so generally wide. . . . Only parts of Chicago are stately and beautiful, whereas all of Berlin is stately and substantial, and. . . beautiful." All of Germany was now ruled by Kaiser Wilhelm I.

The old Prussian capital's population almost tripled in the forty-five years following national unification, to reach about three million inhabitants by 1910. Housing the central government, Berlin was now Germany's richest center in almost every sense, suitably the focal point for the collecting of paintings on a truly imperial scale. In its boom years before World War I the paintings gallery's acquisition funds far outstripped those of any other museum in the world. Only Britain's National Gallery may, in the later nineteenth century, have come close to the extraordinary and varied purchases made in so short a time as those of Berlin at its peak.

Key to that complex period was Otto von Bismarck, Kaiser Wilhelm's chief counsel. Conservative and imperialist, he was shrewdly determined to make popular Socialist policies his own, usurping their appeal to reinforce right-wing goals. Bismarck proved the beneficiary of financial counsel from Gerson Bleichröder, Berlin's Rothschild representative, at a time of triumphant capitalism.

Several of the city's leading bankers, merchants, manufacturers, and publishers were members of the capital's culturally prominent Jewish community. Shortly before the First World War, two such individuals, James Simon and Richard Kaufmann, donated lavishly to Berlin's museums and were duly rewarded by admission to the Prussian nobility. Presented with certificates in lavishly Gothic calligraphy to that effect, they could now prefix a "von" to their names.

Named for the art-loving emperor Frederick III (who only reigned from March to June 1888), the

Kaiser Friedrich Museum

Kaiser Friedrich Museum was opened by his son William II. As a liberal crown prince known as Frederick William, the future Frederick III had devoted himself to the advancement of the state museums and was greatly influenced in this by his wife, the Empress Victoria. She was the daughter of England's queen of the same name and her German-born consort, Prince Albert of Saxe-Coburg. The empress learned much from her father, who was a passionate advocate of art and education.

Empress Victoria took a lively interest in Berlin's burgeoning new museum, approving plans for a centrally placed basilica for Renaissance art. She noted in 1903 how that handsomely columned ecclesiastical space would avoid the "hospital ward-like," visually deadly exhibition areas so much the rule in most museums. Sadly, many of the great Italian altarpieces so long displayed in this gallery were destroyed in the Flakturm fire.

Wilhelm von Bode (1845–1929) was director of the museum from 1906 to 1920, having entered in 1872 just after completing studies in law and art history. His Leipzig doctorate was on Frans Hals. Long its resident genius, Bode's entire career

was spent in service of the Berlin museum, where he began as an assistant in the sculpture collection. Though the Prussian's expertise in Northern Baroque art was of the first water, his initial interest was to expand the holdings of early Italian sculpture and paintings. Bode achieved this goal with dazzling success, buying great works by Ugolino di Nerio (28), Simone Martini (29), Bernardo Daddi (30–31), Masaccio (179–81), Domenico Veneziano (223), Signorelli (238–41), Botticelli (233–37), Giovanni Bellini (226–27), Carpaccio (228–29), Bronzino (255), and Titian (263, 266–69). Bode's purchasing policy has been characterized as almost manic. If so, this mania was greatly to Berlin's advantage. Within a few decades Berlin's major museum had become one of the world's leading picture collections.

By 1880, the institution's fiftieth anniversary, Dürer's art was notable for its absence. This void was filled by Bode's purchase of seven key works by the Nuremburg artist, all bought between 1882 and 1899! He also made further acquisitions in the early Netherlandish field, including Jan van Eyck's portraits of Giovanni Arnolfini (55) and Baudoin de Lannoy (55) and the uniquely important Aelbert van Ouwater *Raising of Lazarus* (90), found in Genoa. Bode's passion for Flemish art must have been requited by the purchase of no less than fifteen major works by Rubens (290–307). Rembrandt (356–373) was also among his favorite painters, and Bode added thirteen by the Amsterdam master and his circle.

In the 1870s Berlin was invited to buy the Prado's entire matchless assemblage of paintings along with all the rest of its collections. That proposal, from the near-bankrupt Spanish state treasury, was properly turned down by Bismarck. Such virtue was rewarded in 1874, when the museum bought the splendid gathering of Northern paintings owned by the Aachen industrialist Bartholdt Suermondt. Then the nation's largest and finest art collection in private hands to be formed by a single individual, this was acquired for one million goldmarks. That sum, awarded by the state with Crown Prince Frederick's backing, made Berlin's museum not only a German national gallery of unparalleled scope, but the Getty of its day. So huge a figure came in stunning contrast to the acquisitions budget of Munich's analogous institution, the Alte Pinakothek, which could only count upon ten thousand marks per annum.

Strangely, the great Suermondt purchase was unwelcome to Bode despite its having been thoroughly catalogued by Waagen in 1859, leaving no doubt as to the splendor of the collector's paintings. Many great fifteenth- and seventeenth-century Northern pictures were included, such as Jan van Eyck's *Madonna in the Church* (53), along with superlative examples from sixteenth-century Germany. Five Hals paintings (322, 326–29), Vermeer's *Young Woman with a Pearl Necklace* (379), and many other major Dutch seventeenth-century pictures in Suermondt's collection rounded out what was already one of the world's outstanding gatherings of transalpine art.

Bode extended Waagen's staggering purchases in the area of early Netherlandish painting, buying Hugo van der Goes's *Adoration of the Shepherds* (80–81) from the Infanta Cristina de Borbón in 1903 and, ten years later, the same painter's *Adoration of the Magi* (82–83) from the monastery of Monforte. First displayed in Berlin on Christmas Day, the latter must have proved the most glorious imaginable present to the city's art-loving public. Germany had long cherished van der Goes's works. Dürer, on his Netherlandish journey, rightly grouped Hugo with Rogier van der Weyden and Jan van Eyck as among the Netherlands' three major painters. Holy Roman Emperor Maximilian, too, was an admirer and patron of van der Goes.

Bode was appointed director general of all Prussia's royal museums, a post he would keep until 1920. As a rich and independent bachelor, Bode could afford to present the museum with whatever he wanted on those rare occasions when bureaucracy prevented such purchases. Arrogant and hard driving, with a hawklike profile, his was a rare flair for showmanship, for the sensationalistic master coup. Karl Scheffler, a Berlin art critic and journalist, described Bode's boldness and flair for promotion and fund-raising as American, but an Americanism that was united with a rigorously Prussian sense of method.

By combining sculpture, painting, and furniture

of the same periods in his galleries, preserving the past from deadly isolation by media, Bode strove for reunion and synergy among all the visual arts, each reinforcing and echoing the other in lively fashion. This imaginative installation — close to that of a period room but without the fussy sense of "let's pretend" — remained in situ until 1936, when the Nazi passion for radical categorization and concentration extended even to art galleries and destroyed Bode's dynamic synthesis.

Bode was a cowboy of millionaires, lassoing Germany's leading captains of industry, enticing them to join a prestigious committee to beef up the Gemäldegalerie's reduced post–World War I acquisition budget. These "new men" included August von der Heydt, the great collector of contemporary German, French, and Belgian art, and Friedrich Alfred Krupp, the Catholic Ruhr industrialist and maker of military matériel. Several of those admitted to this elite group were Jewish, including the painter Max Liebermann, the newspaper publisher Rudolf Mosse, and the press lord Leopold Ullstein, whose company issued the lavishly illustrated art-historical encyclopaedia, the *Propylaen Kunstgeschichte*. Many of the city's major businessmen — among them Marcus Kappel, Oscar Huldschinsky, Arthur Hollitscher, Arnold Julius Carstanjen, Hermann Beckerath, Oscar Hainauer, and Max von Oppenheim — had Bode prepare suitably daunting catalogues of their collections. Such splendid publications supposedly guaranteed that the owners would pass the contents on to the museum. However, but for Richard von Kaufmann's and James von Simon's collections (the latter accorded its special Morgan Library–like gallery in 1904), these projected donations were not to be as the Depression led to their sale.

Of Germany's cities only Berlin approximated a metropolis. Only there could Fritz Lang's prophetic film of that title have been filmed in 1926. Where almost any major urban shift for the modern might have proved one for the worse in the nation's other cities, Berlin always had room for change. Centrally located, long connected by water, then by rail, to Hamburg, Dresden, and other major cities, the capital enjoyed an unusually active commercial and cultural urban existence. Traces of its Vermeer-like, seventeenth-century residential and mercantile quarter even survived World War II, only to fall victim to subsequent prosperity. With lots of *Lebensraum*, the capital has had space for its expansively enlightened, gargantuan eighteenth-century palaces and parks, for new parade grounds and plazas, for an Unter den Linden and Tiergarten alike. New urban demands of the nineteenth and twentieth centuries were as readily filled by the development of elevated and underground transportation.

The city's seemingly elastic borders allowed for ever more light and not-so-light manufacturing, for massive printing plants, and square miles of new housing for all classes. Of all Germany's urban residents, Berlin's alone proved to be uniquely prescient, anticipating or attuned to whatever the new might prove to be — or leave in its wake. Her irreverent cabarets, long stalwartly left-wing politics, the avant-garde theater of Max Reinhardt, Erwin Piscator, and Bertolt Brecht, a devil-may-care sexuality, the profound criticism by Walter Benjamin, and the satirical photomontages of John Heartfield were all tributes to a stubbornly, relentlessly, often deliciously independent, inventive urban culture. Utterly lacking in smarmy Austrian or Bavarian sentimentality, or snobbish Hamburgian restraint, Berlin was a place where wit, money, and smarts called the shots. More than merely tolerated, the irreverent, the satirical, and the "depraved" were often encouraged as both enjoyable and profitable.

Kurt Weill's *Dreigroschen Oper* (*Threepenny Opera*), suitably inspired by another fierce metropolis — John Gay's eighteenth-century London — is unthinkable without a Berlin of the Roaring Twenties as background and foreground alike. Long the nation's most (if not sole) sophisticated center, Berlin possessed Germany's largest Jewish population prior to flight and Final Solution. This community played a large role in the worlds of hard cash and lively arts, in banking, manufacturing, utilities, merchandising, publishing, journalism, film, theater, and fashion. Among its painters was Lesser Ury (609), whose portraits of Belle Epoque Berlin were lovingly unsentimental. Max Liebermann (578–79), scion of a rich, liberal, local Jewish family, was the key figure for cosmopolitan Berlin's taste in the late

nineteenth and early twentieth centuries. He broke with conventional circles to champion Edvard Munch (621–23) and Käthe Kollwitz. Liebermann's ability to communicate a new interest in Manet, Monet, Renoir, and Degas among his highly privileged, largely Jewish clientele led to the presentation of major canvases by these artists to the Berlin museum. Liebermann's fine collection of French art was bought from Paul Cassirer, Berlin's leading dealer, who, with Fritz Gurlitt, was the key source for most Impressionist art brought there for sale.

Patrons grouped together to purchase costlier canvases, such as Manet's *In the Wintergarden* (591). Installation of that painting in the Nationalgalerie aroused the Kaiser's ire. Not only did he hate Impressionism, he also found its inclusion improper in a museum consecrated to German art. The director, Hugo von Tschudi, was fired, taking his great talents to Munich, where he built up fine collections in the areas so abhorred by the Kaiser.

Forcefully independent painters soon made Berlin a center for a vital new approach. Edvard Munch's (621–23) many periods of Berlin residence were the major factor in making that city a center for turn-of-the-century Modernism. Lovis Corinth came there in 1901 and soon was followed by Max Slevogt (626); Max Beckmann (633) became their major Berlin follower. All these dynamic artists, vigorous forerunners of Expressionism (or themselves members of that movement) made the capital a dynamic arena for new approaches, contributing to Berlin's role as a center for counteracademic arts. They opposed the complacency of entrenched official painters, most of whom enjoyed court appointments. These new, young artists received help from Max Liebermann, a lifelong Socialist, who headed the Gruppe XI, a Berlin Sezession movement founded in 1899.

By 1911 Erich Heckel and Ernst Ludwig Kirchner had moved to Berlin, bringing with them aspects of *Die Brücke*. That Expressionist, primitivistic movement was first founded in Dresden in 1905 by four architecture students who had turned to painting (among them Heckel, Kirchner, and Karl Schmitt-Rottluff) and was dissolved in 1913. A new *Sezession* was established in Berlin in 1910–11, directed by Max Pechstein (628), who had been there since 1908. He

was expelled from *Die Brücke* because he also wanted to maintain his association with a Berlin group, *Der Sturm*.

The capital was also the focal point for Germany's modern art market, for dealers who acted as evangelists of Modernism, many of them publishing their artists' writings and issuing richly documented catalogues. Paul Cassirer and Fritz Gurlitt were now supplemented by Alfred Flechtheim, J. B. Neumann, and many others who dealt in tribal as well as contemporary arts.

Herwarth Walden, proprietor of the gallery entitled *Der Sturm*, headed the movement of the same name, which signified assault. He brought to Berlin a familiarity with *Der Blaue Reiter* (The Blue Rider), a group founded in Munich in 1911 by two Russians, Wassily Kandinsky and Alexis von Jawlensky. Their mystical, pan-European group was dissolved by the First World War. Oskar Kokoschka (635), first active in Vienna, followed Walden to Berlin, making the city more of an Expressionist center than ever.

Nazism's rise killed Berlin's cultural glory. Her Jewish, Communist, Socialist, or most uncompromisingly Christian residents went into exile, went underground, or were killed or otherwise silenced. Most public and private collections of Expressionist and other twentieth-century schools of art were auctioned in Switzerland. The *Entartete Kunst* (Degenerate Art) exhibitions held in Berlin and Munich bade such painting and sculpture a zealously well attended, profitable farewell. What could not be auctioned in Lucerne or otherwise sold abroad to enrich Nazi coffers was burned in Berlin in 1939. Marlene Dietrich and Peter Lorre, Berlin's greatest film stars, went to Hollywood, as did director Fritz Lang, who was largely neglected there. Erwin Piscator came to New York, where Kurt Weill was to flourish and old Leopold Ullstein lived in genteel discomfort. Max Beckmann went to St. Louis. Many art dealers, like Hanns and Kate Schaeffer, who were also important donors to the Berlin museum, and Curt Valentin, fled to New York, where they educated that New World community in modern art along with that of the past. Many of the German capital's art scholars also came to London, New York, or other American

cities and broadened the American understanding of *Kunstgeschichte*.

During the years of National Socialism, Nazi bigotry exploited all museums for the worst of propagandistic purposes: the subjugation and perversion of art toward evil. This regime proved unusually responsive to the power of images, calculating in its use of culture, shrewdly misled by a failed Austrian painter and architecture student, Adolf Hitler. Goering, for years second in command, proved to be more a passionate collector than a knowledgeable one. He rationalized the means and massive extent of his "acquisitions" by their putative entry into a new museum dedicated to the victory of National Socialism, a triumphal display close to Napoleon's goals.

Having expelled or stilled all meaningful independent art, along with most of its makers, in the 1930s, Hitler encouraged only the most narrowly conventional images that lauded fertile "Aryan" family life, the joys of the peasantry, or martial spirit, all celebrated by small blond minds in suitably large strong bodies.

For richer or poorer, in war and peace, Berlin's enduring marriage to her museums has lasted almost two hundred years, from the days of Schinkel and Bode to the present, and well over three hundred if the collections of the electors and those of the Prussian kings are included. Major historically oriented acquisitions, purchases designed to fill in the gaps of a great collection, came with increasing frequency as the West German economy improved after World War II. Since many of the major eighteenth-century French pictures were then locked in the city's eastern zone, this became an area of impressive investment for the picture collections displayed in Dahlem or Charlottenburg. Major works by Watteau (*444, 450–51*) and Boucher (*462*) were bought to balance the holdings, as was a fine Rubens, partly compensating for the terrible losses of 1945. A handsome series of English eighteenth- and early-nineteenth-century pictures (*500, 502–4*), never before one of Berlin's strengths, has also been acquired.

The city's most celebrated, distinctive purchases remain those dictated by individual, not academic and/or curatorial taste. These were the French and other acquisitions made by the gay, militaristic, Rococo emperor Frederick the Great, who sought their lightly Gallic touch, cherishing images multiplied in a never-never land's glittering chandeliers and mirrors.

Another fashion- and power-oriented campaign came with Germany's new wealth, beginning in the 1960s, when her tastes hinged upon those of her captors, turning her toward French and American Modernism, to the blandly decorative values that could never rock any imaginable boat, personal or political. Most recently a very large bequest of paintings by artists of the Cobra Movement — painters active in Copenhagen, Brussels, and Antwerp after the Second World War — has made the new Nationalgalerie the leading assemblage of such works.

With the losses of two world wars, and suffering many decades of dictatorship from within and without, Germany has lost a third of the twentieth century. Literature first recovered from such crippling isolation with books of Günther Grass, Heinrich Böll, and other writers who soon achieved international distinction. Only in the last thirty years have the visual arts been shaken from their all too political slumber. A major filmmaker like the late Rainer Maria Fassbinder created a one-man renaissance in a once-great German art form uniquely Berlin's. Challenging artists such as Josef Beuys and Anselm Kiefer have contributed to a new Teutonic mythology with their powerful, if morally dubious, declarations of alchemical yet personal evocations of suffering, survival, and transcendence. They re-create a neo-Wagnerian mystique, a triumphal pictorial declamation of *aprés le deluge*. Once again, the phoenix rises from the flames. Or is it an eagle instead?

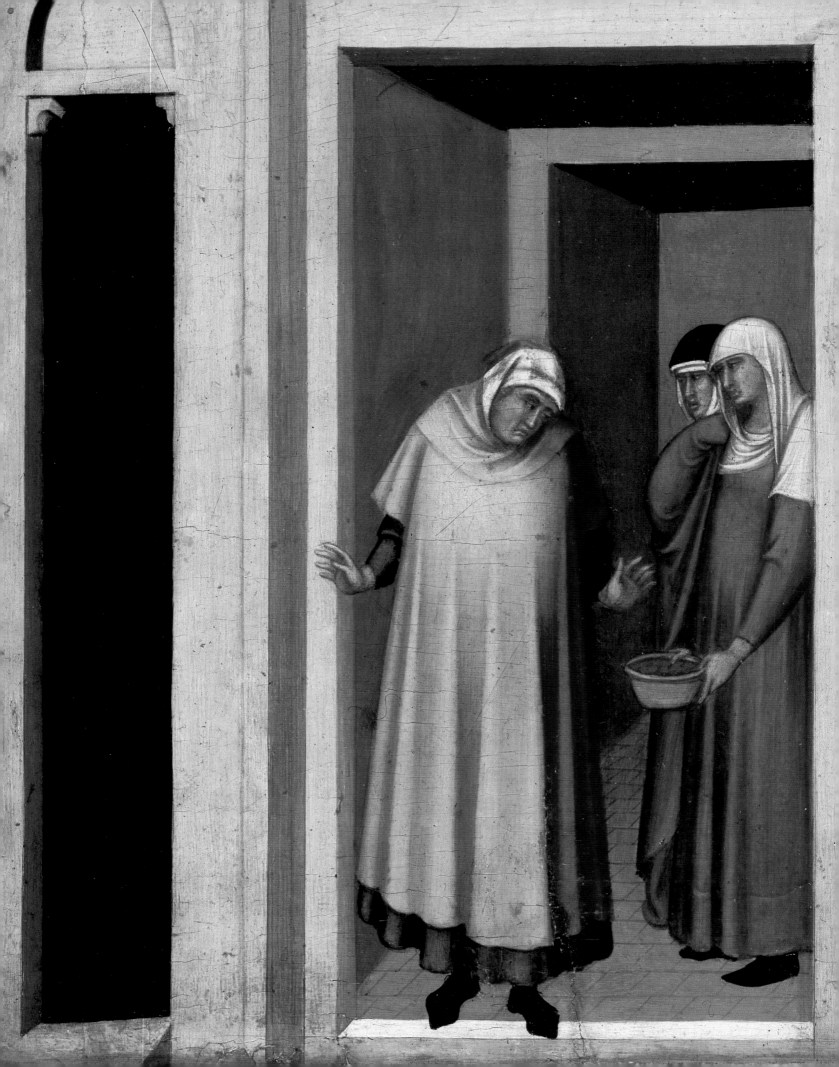

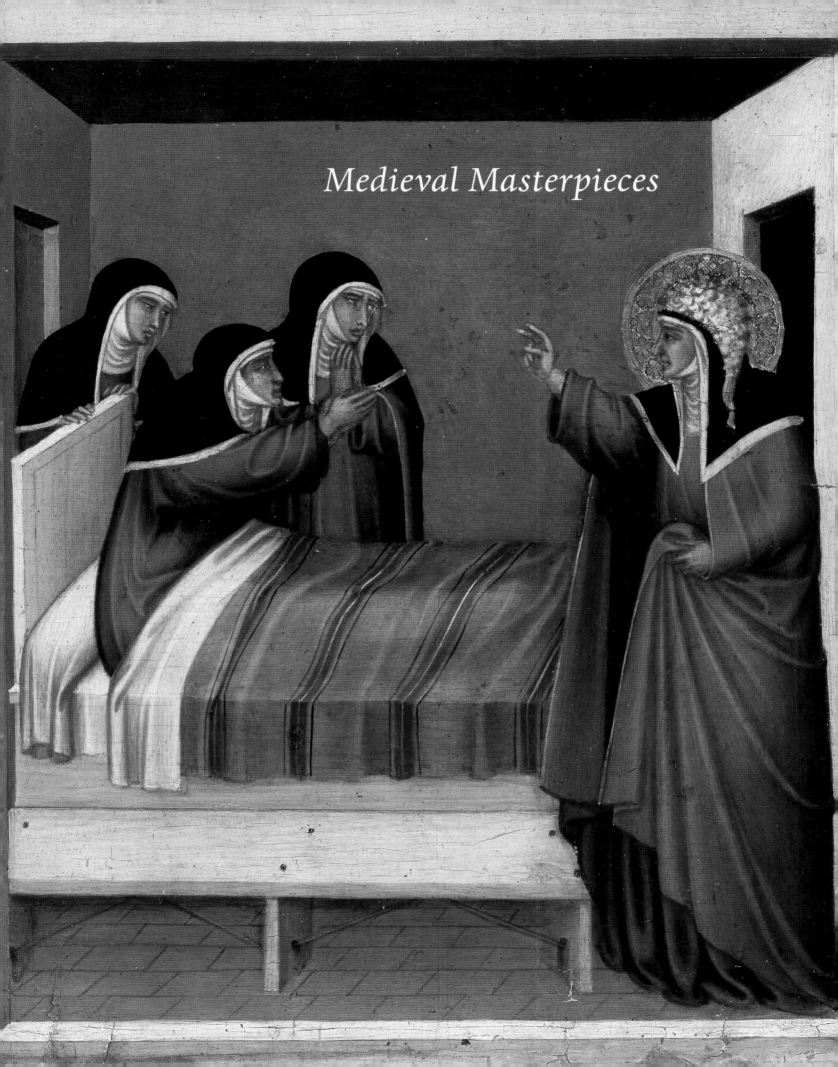

Medieval Masterpieces

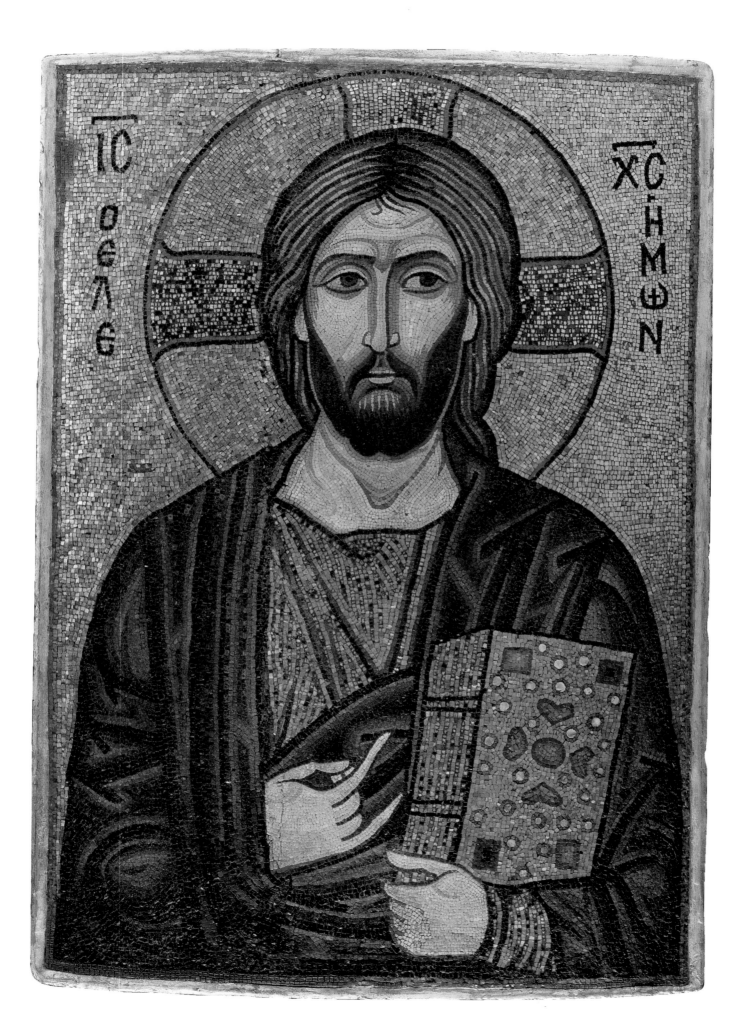

Beginning Again — In Italy

Mosaic — creating illusion with an assemblage of tesserae, little pieces of glittering color- or gold-backed glass — is among the most ancient forms of "painting," one that became highly evolved in classical antiquity. Berlin has an unusually splendid example of an early Medieval work in this medium, a Constantinopolitan *Salvator Mundi* (20) from the first half of the twelfth century. Itinerant artisans skilled in mosaic came from Byzantium to work all over Western Europe. Their forceful, colorful, effulgent images of religious and decorative subjects contributed a major visual vocabulary for Medieval and later artists to draw upon.

Varied and strong, Berlin's early Italian collection is not only most impressive in itself but provides an essential foundation for the museum's very large gathering of other European painting of the same period. Oldest of Berlin's Italian panels is a huge *Madonna and Child Enthroned with Two Angels* (25) from the 1260s or 1270s, by the Florentine known as the Magdalen Master, after the altar frontal in Florence (Accademia) with scenes from the life of St. Mary Magdalen. Still Byzantine in form, the nursing Madonna and Child follows the Hodegetria model. Drapery is indicated by a tracery of parallel gold lines that recall conventions found in precious metalwork of the period. The Infant's active pose, striding forward, arm raised in benediction, refers to future triumphs, those of the rescuing from Limbo, the Resurrection, and the Last Judgment. Here the enthroned group prefigures the Coronation of the Mother by the Son. Mary supports her baby's san-

daled foot as if to help him make the first step toward realizing the cycle of Christian redemption.

Pictorial traces of the passion plays, religious dramas filled with profound emotion and humanity as well as mysticism, may be found in the art of Giotto. Even the best panels ascribed to him are often open to critical controversy. Berlin's *Death of the Virgin* (26) is one of these, yet so powerful is the modeling, so assured the command of gesture and expression, that it seems arbitrary to take this magnificent painting away from Giotto's immediate authorship. Very close to his fresco cycle in Padua's Arena Chapel (1303–5), it also recalls the heroic sculptural tradition of Florence. Pedimental in format, the panel may have been the uppermost section of an altar, yet the subject — more often found in northern Italy than in Florence — would be a strange choice for such a location. As they mourn Mary's death, her body displayed on an elaborately inlaid bier or bed, the apostles remain unaware of the presence of Christ, who has come to earth to carry his Mother's soul — seen in infant form — to heaven.

Among the best documented of the works ascribed to Giotto, this panel was recorded by Ghiberti in his *Commentarii* as being by that earlier master. From 1445 to 1455 it was in the Florentine church of Ognissanti and listed as by Giotto. That Michelangelo singled out this stirring image for special admiration is reported in Vasari's *Vita*. Hard though it may be to believe, *The Death of the Virgin* was turned down for purchase by the Metropolitan Museum of Art in 1913, then snapped up by Berlin the following year.

Courtlier, Gothic in reference and preference, the Sienese artist Simone Martini preferred lyricism to monumentality. From time to time emotion surges to the fore, as in his very small *Entombment* (29), which packs in about twenty-six mourners, includ-

Opposite:
MOSAIC IKON
Constantinopolitan
Salvator Mundi, first half of twelfth century

ing several nuns, possibly relatives of the donor. Passion is falsely intensified by a blood-red sky added at a much later date to cover the original gold background. Long at Dijon's Chartreuse de Champmol, this was part of a little portable travel altar painted for Cardinal Napoleone Orsini and signed on the lost frame of this panel.

When closed, a two-part *Annunciation* was at the center (Antwerp, Koninklijk Museum voor Schone Kunsten), flanked by panels displaying the Orsini arms (those to the left are lost). Opened, four Passion scenes, reading from left to right, showed *Christ Carrying the Cross* (Louvre), *The Crucifixion* (inscribed "Pinxit" on the frame), and *The Deposition*, which is signed "Symon" on the frame, below the little portrait of the kneeling donor (Antwerp, Koninklijk Museum voor Schone Kunsten). Berlin's *Entombment*, at the far right, was also faced by the donor.

Another unusually well documented early Italian project is the High Altar for Santa Croce, the great Franciscan church of Florence (*28*). This was painted by the Sienese Ugolino di Nerio. With at least thirty-five sections in all, this massive altar was painted and erected c. 1325–30, according to Miklos Boskovits, author of the splendid catalogue of Berlin's early Italian paintings. Still close to Duccio's massive *Maestà* (Siena, Museo del Opera del Duomo), painted for Siena's cathedral and completed in 1310, the Santa Croce panels recall that master's sense of style and organization, as Ugolino was still working with Byzantine line and color.

The altar was dismantled shortly after 1566 and moved to the church's dormitory. By the 1830s, most of its panels had been sold to the major English collector of early Italian painting, William Young Ottley (the central *Madonna* seemingly was lost before his ownership). The persistent scholar Waagen, whose scouting activities were central to the formation of the Berlin gallery, traced the panels to Ottley's ownership. Now the surviving panels are scattered among museums and private collections in Europe and North America.

Berlin owns five, including *The Flagellation* and *The Entombment*, two of the seven original predella panels, with scenes from the Last Supper to the Resurrection. London's National Gallery had the signed

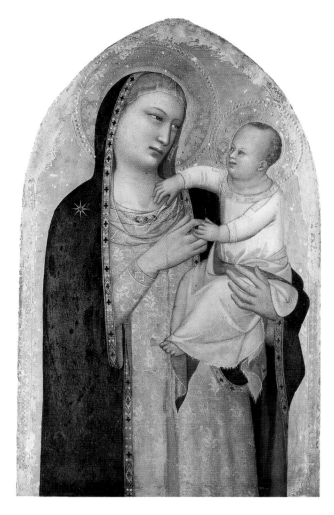

MASO DI BANCO
active Florence, second quarter of fourteenth century
Madonna and Child, c. 1335

central *Crucifixion*, but this is lost. Other panels in Berlin include *SS. James the Greater and Philip*, *SS. Matthias and Elizabeth of Hungary (?)*, and *SS. Matthew and James the Less*, each of which includes a portrait bust of a prophet.

Shifts in scale from the large, central, three-quarter-length apostles to the seated, monumental Madonna, to the much smaller narrative predelle and still smaller images in the pinnacles establish a complex hierarchy bespeaking its own values and messages from timely to timeless.

Maso di Banco, an unusually fine Giotto follower who was active in Florence in the second quarter of the fourteenth century, painted two panels now in

Berlin. His *Madonna and Child* (22) has the Infant reaching for Mary's neckline, preparatory to nursing. Mother and Son exchange glances in direct, intimate fashion. Boskovits has reconstructed the setting for this panel, with two half-length saints at each side. Of the four, three are lost; the sole surviving panel — of St. Anthony Abbot — is in New York (Metropolitan Museum of Art).

Another panel by Maso shows the subject of the Descent of Mary's Girdle to the Apostle Thomas (27), a striking combination of intensity and reticence. Art, like Mary's girdle, provides visual "evidence," documenting doctrine. Thomas's doubt as to the veracity of the Assumption of the Virgin, allayed by the dropping of her belt, is ever close to that basic human demand: "Show me." The setting for this panel has also been reconstructed by Boskovits, who placed it at the center of two scenes from the Life of the Virgin: *Her Death* (Chantilly, Musée Condé) at the left and *Her Coronation* (Budapest, Szépmüvészti Muzeum) at the right.

Another fine Florentine Giotto follower, Bernardo Daddi, painted a small altarpiece (30) in which the central *Coronation of the Virgin* is flanked by *The Nativity* (the nursing Virgin seated humbly on the ground) and *The Crucifixion*. The latter shows Mary's Co-Passio, when she swoons at the moment of Christ's death, sharing his fate. Boskovits dates this unusually well preserved triptych, still in its original frame, to c. 1338–40.

The same painter's little predella panel, *The Temptation of St. Thomas Aquinas* (31), part of an altar signed and dated 1338, shows the kneeling saint praying for strength in the face of temptation. He is quite literally backed up by angels as his temptress, the devil, stands uncertainly to the right. Boskovits reconstructed the original predella of which this panel formed the right-most section. Other scenes, from left to right, show *St. Peter Martyr Preaching* (Paris, Musée des Arts Décoratifs); *St. Dominic Rescuing a Storm-Tossed Ship at Senot* (Poznán, Muzeum Narodowe); and *The Vision of St. Dominic* (New Haven, Yale University Art Gallery).

A triptych (32), one of Taddeo Gaddi's two signed and dated works, is inscribed September 1333. Another of Giotto's major students, Taddeo was the son and father of painters — Agnolo being his tal-

ented heir. The triptych's wings have been split so both the outer and inner sides of each wing can be seen at the same time. If today the ornate columns and arches seem to get in the way of the story, their architectural vocabulary, providing a suitably ecclesiastical setting, was originally almost as important as the sacred drama within.

This little devotional triptych provides a rich contrast between the scenes of saints' lives shown on the exterior wings and those seen inside. The former include Margaret with her dragon above an image of Jesus entrusting John the Evangelist with looking after Mary — a marriage-like group — and Catherine of Alexandria with her wheel above Christopher bearing the Infant. Uppermost scenes when the wings are open show Nicholas freeing little Adeodatus from slavery as royal cup-bearer (left) and the same saint restoring the boy to his parents (right). The central panel presents Mother and Child enthroned, framed by an arch composed of the eleven apostles, two prophets at the top, and the Franciscan St. Louis of Toulouse at the lowermost right. Donors kneel to the sides of the throne. The *Nativity* and the *Crucifixion* are on the wings.

Taddeo Gaddi's *Pentecost* (33) and *St. Francis Restoring a Boy to Life* (33) are confined within quatrefoils. Their insistent Gothic frames highlight rather than negate the heroic narratives within, each scene Giottesque in its strength of vision. These panels are part of a series of twenty-six, twenty-two of which are in Munich, the rest in Florence (Accademia); originally, all were in the sacristy of Santa Croce, Florence.

Pictures' areas often suggest windows, apertures opening upon their subjects. As the quatrefoil formats employed to enclose these scenes were also used for light openings, they lack the cookie-cutter delimitation such a format suggests today. This insistent framing for Taddeo's cycle acts with a rhetorical insistence. The quality of calculated repetition increases the strength of each vignette, creating a dramatically serial synergy. This was felt when the series was installed on sacristy cupboards. As St. Francis's life parallels Christ's in so many ways, their pictorial biographies were probably juxtaposed when the cycle was seen in its original Franciscan setting.

Moving pictures predate film. Banners fluttered in religious observances and painted panels were attached to processional staffs. Like a miniature altarpiece, one pair of little panels for such a staff is in Berlin, both painted by the Sienese Francesco di Vannuccio (33). Images on the recto are scratched through a glass-backed golden ground, then covered by one or more colors, in a technique known as *verre églomisé*.

In Venice and Siena

Surprisingly, for such a basic subject, cycles devoted to St. Peter's life are seldom found. When they are, these are usually seen in a maritime center, such as Venice, or were ordered by those connected with export and import. Lorenzo Veneziano fulfilled countless commissions in Venice and its vicinity that display a handsome fusion of Byzantine and later pictorial currents, included among which are Berlin's predelle from the lives of SS. Peter and Paul. These came from an altarpiece whose central section is in the Museo Correr (Venice); its side panels were destroyed in Berlin in 1945. The predella survives (34), comprising *The Conversion of Paul, The Calling of the Apostles Peter and Andrew, Christ Rescuing Peter from Drowning, The Apostle Peter Preaching,* and *The Crucifixion of Peter.* Active near Padua, site of Giotto's Arena Chapel, Lorenzo turned to that Florentine's art for his central composition and for *The Apostle Peter Preaching.*

When Venetian artists began to break away from the grip of Byzantium, Antonio Veneziano was among the first to lead the way. Berlin's unusually fine *Apostle James the Greater* (35) shows Antonio at his best, exercising a bold, almost expressionistic force. This explains the artist's popularity in Siena, Florence, and Pisa; all gave him important commissions. The painting — part of a polyptych whose central image may possibly be a *Madonna* in Hannover (Landesmuseum) — is in its original frame, but cut at the bottom. An Annunciation group by the same master from the same altar is also in Berlin, as are three other panels.

The major Sienese artists to move from Byzantine conventions to pioneering realism were the Lorenzetti brothers, Ambrogio and Pietro. More than their Florentine contemporaries, the Lorenzetti tackled problems of space. They studied perspective and cartography and took on pictorial challenges presented by panoramic views and nature's subtle changes from season to season. Aware of Giotto's bold path, the Lorenzetti continued his vigorous reassessment and utilization of antiquity.

As popular in Florence as he was in Siena, Pietro Lorenzetti painted an altar inscribed 1341, devoted to Beata Humilitas of the Vallombrosan Order. Born in Faenza, this little-known holy woman was venerated at the convent of the Donne di Faenza attached to the Florentine church of San Giovanni Evangelista. Just outside the city's walls, this was her burial place and became a pilgrimage site.

Among Pietro's finest works, Berlin's two *Beata Humilitas Altar* predelle show a balance between the extremes of action and repose that was almost uniquely his. Gesturing perplexedly, the doctor at the far left has clearly given up hope for healing his patient of a nosebleed just as Humilitas, at the far right, is about to raise the nun from her sickbed (36). In *The Miracle of the Ice* (37), Humilitas is assailed by a raging fever in mid-August. She calls for ice, which is miraculously found in a well and brought to assuage her fever.

These panels are from an altar, reconstructed by Boskovits, in which they form the central and next-to-right panels of the lowermost of three registers, which, all told, comprised thirteen scenes from the life of Humilitas; all but the Berlin panels are in the Uffizi. Seven tondi formed the predella (Florence, Uffizi), a full-length figure of Humilitas (Uffizi) was at the altar's center, and the four evangelists formed pinnacles separated into pairs by a *Blessing Christ* (Rome, Art Market).

An early example of the Madonna of Humility is from the Circle of Lippo Memmi (37). Lippo, Simone Martini's brother-in-law and best associate, followed Simone to Avignon during the period of the papal residence there. This beautifully preserved painting has its original silvered frame and finely tooled silvered back.

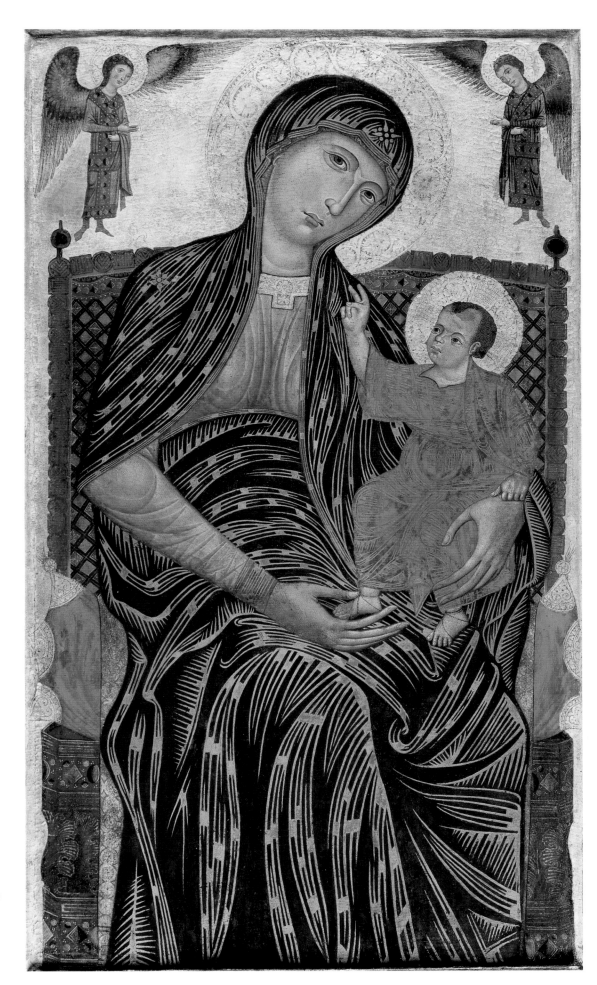

THE MAGDALEN MASTER
Florence, second half of
thirteenth century
*Madonna and Child Enthroned
with Two Angels*, 1260s or 1270s

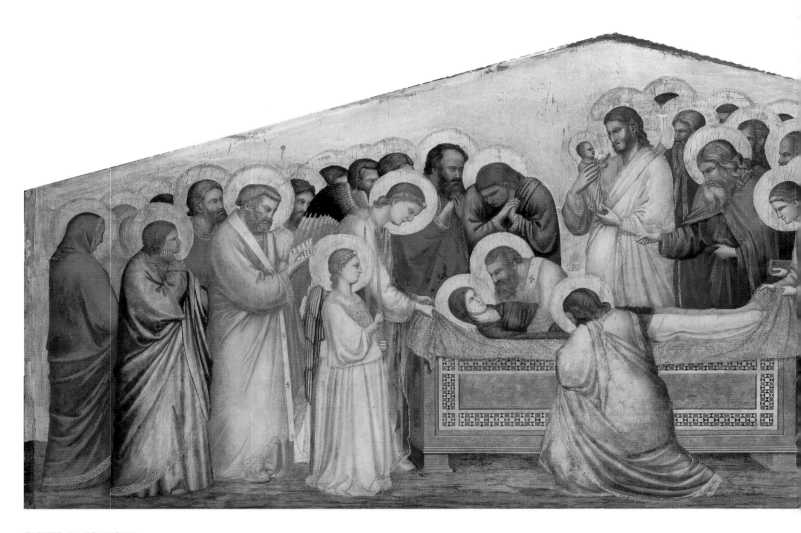

GIOTTO DI BONDONE
near Vicchio di Mugello, c. 1267–Florence, 1337
The Death of the Virgin, c. 1310

MASO DI BANCO
The Descent of Mary's Girdle to the Apostle Thomas,
late 1330s

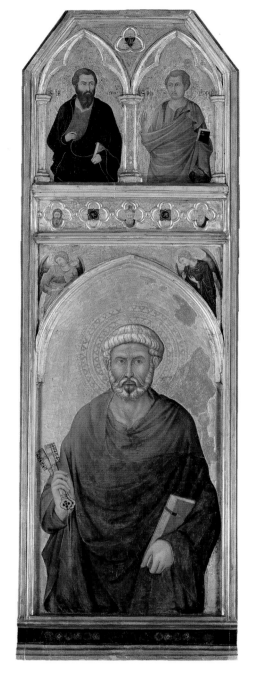

UGOLINO DI NERIO
traceable to Siena and Florence, 1317–27
Five panels from the *Santa Croce Altar*,
c. 1325–30:

St. John the Baptist; (above) *SS. Matthias and
Elizabeth of Hungary (?)* (above, left)
St. Paul; (above) *SS. Matthew and James
the Less* (above, center)
St. Peter; (above) *SS. James the Greater
and Philip* (above, right)

The Flagellation (right)
The Entombment (far right)

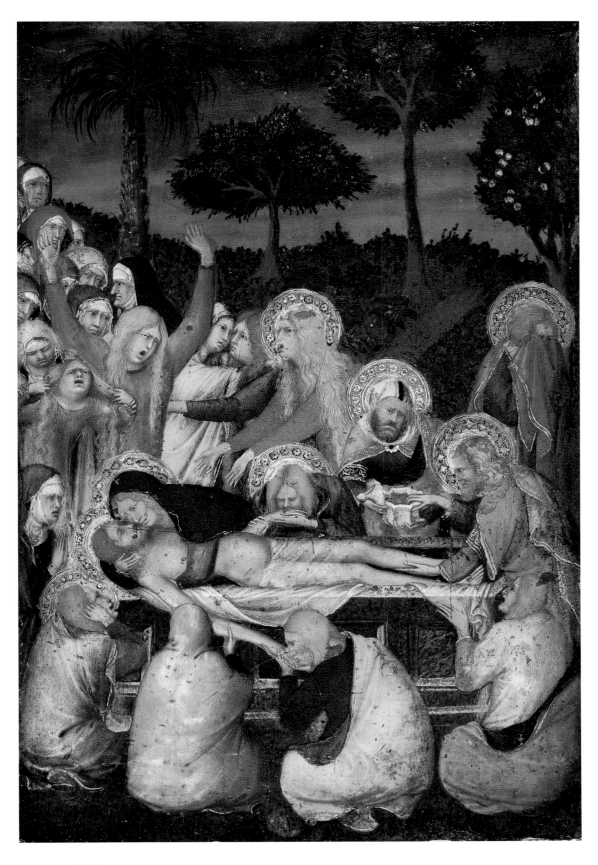

SIMONE MARTINI
Siena, c. 1285–Avignon, 1344
The Entombment, c. 1335–44

BERNARDO DADDI
Florence, late thirteenth century–1348
Triptych, c. 1338–40:

The Nativity (left wing)
The Coronation of the Virgin (middle)
The Crucifixion (right wing)

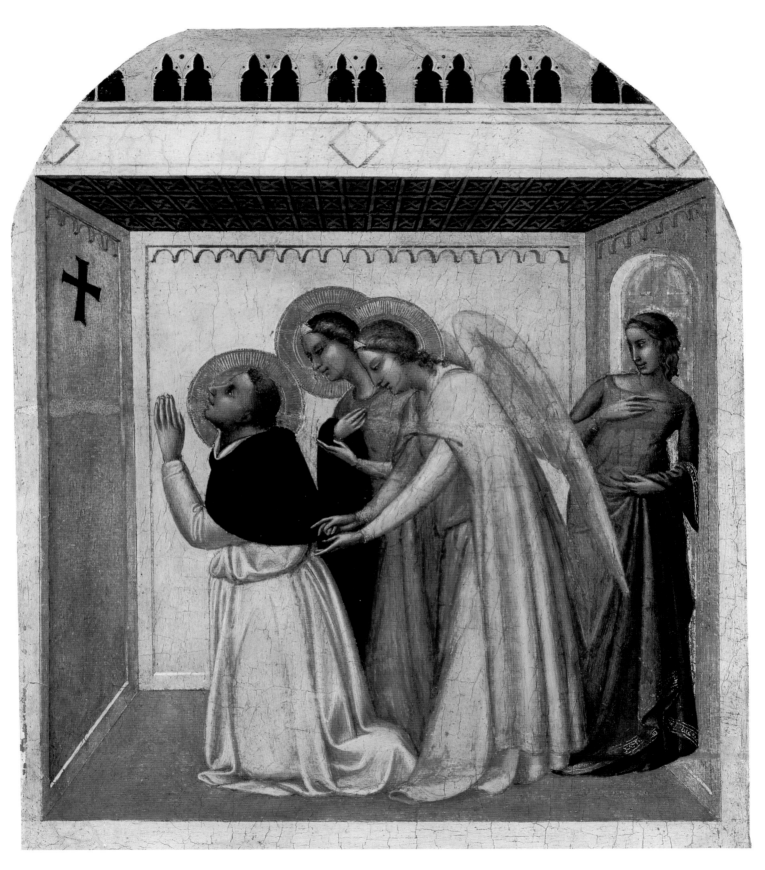

BERNARDO DADDI
The Temptation of St. Thomas Aquinas, 1338

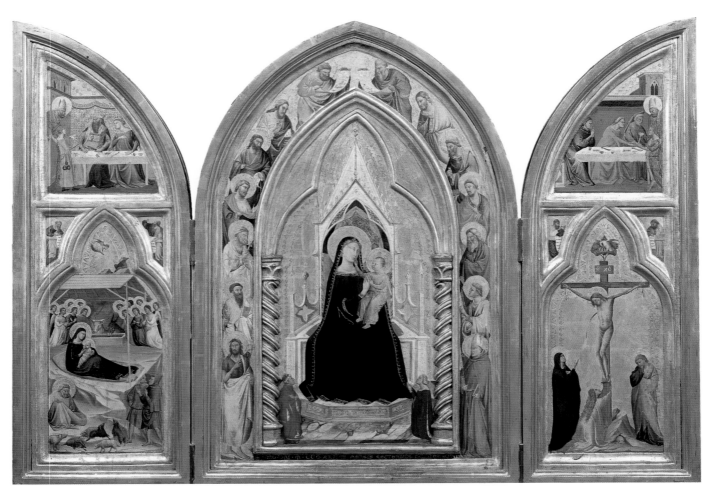

TADDEO GADDI
Florence, last decade of
thirteenth century–1366
Triptych, 1333:

Interior (above):
The Nativity; (above) *St.
Nicholas Freeing Adeodatus from
Slavery* (left)
*Madonna and Child Enthroned
with Apostles and Prophets*
(middle)
The Crucifixion; (above) *St.
Nicholas Restoring Adeodatus to
His Parents* (right)

Exterior of wings (right):
*Christ Entrusts the Care of Mary
to John*; (above) *St. Margaret*
(left)
St. Christopher; (above) *St.
Catherine of Alexandria* (right)

TADDEO GADDI
Pentecost, c. 1335–40

TADDEO GADDI
St. Francis Restoring a Boy to Life, c. 1335–40

FRANCESCO DI VANNUCCIO
active Siena 1361–68
Processional staff,
Crucifixion with Donor, 1380

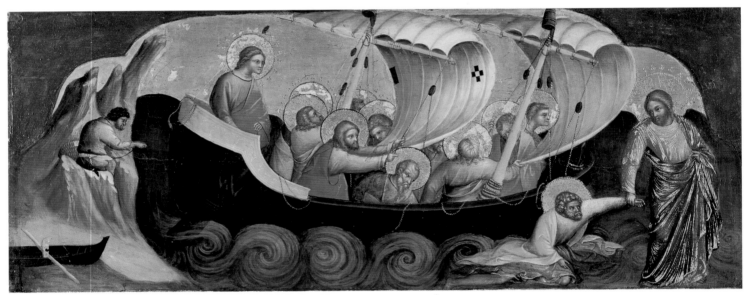

Opposite:

LORENZO VENEZIANO
active c. 1355–1372
Predella panels, c. 1370, with
scenes from the lives of
SS. Peter and Paul:

The Conversion of Paul (top, left)
*The Calling of the Apostles Peter
and Andrew* (top, right)
*Christ Rescuing Peter from
Drowning* (center)
The Apostle Peter Preaching
(bottom, left)
The Crucifixion of Peter
(bottom, right)

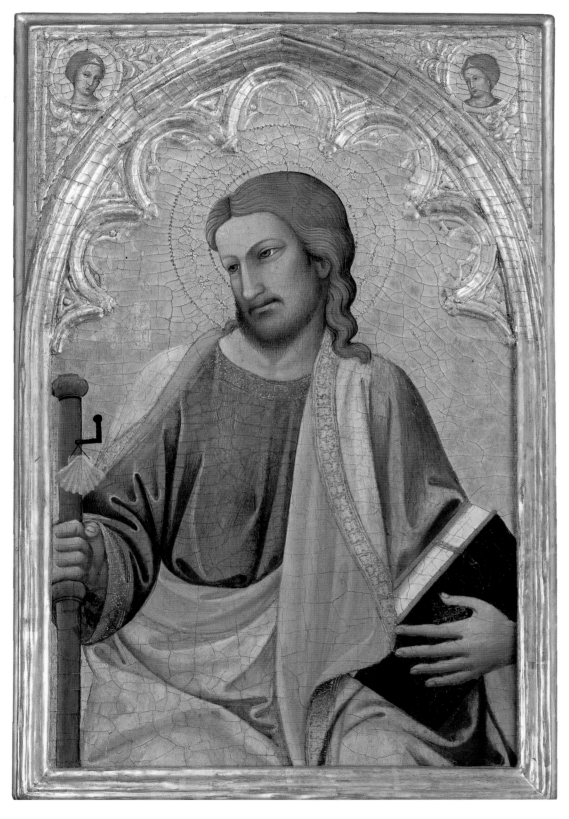

ANTONIO VENEZIANO
documented in Siena, 1369–70; in Florence, 1374; in Pisa, 1384–88
The Apostle James the Greater, c. 1384

PIETRO LORENZETTI
Siena, active after c. 1306–1348
Two panels from the *Beata Humilitas Altar*, c. 1341:

Blessed Humilitas Heals a Sick Nun (above)
The Miracle of the Ice (opposite)

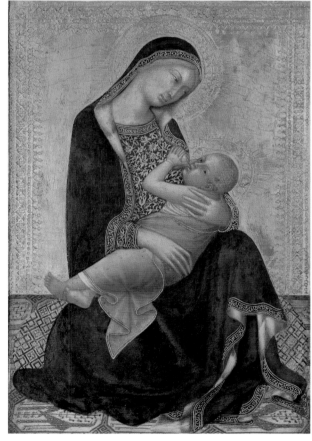

CIRCLE OF LIPPO MEMMI
Madonna and Child, c. 1340s

GERMANY'S MEDIEVAL RENAISSANCE

"Medieval renaissance" sounds foolish as well as confusing, but there were innumerable classical revivals, taking place whenever antiquity was seen in a freshly appreciative, concentrated light. These movements — rebirths — are all "renaissance" means. The earliest such art from German-speaking lands is closely allied to the imperial ambitions of the Carolingian, Ottonian, and later rulers, who saw themselves as new caesars, or *kaisers*. The many manuscripts and few paintings from their early reigns are often allied to Byzantine and Early Christian arts.

Italy abounds in major paintings from the thirteenth and early fourteenth centuries, but due to iconoclasm's toll, predominantly Protestant lands sadly have very few. Changes in taste also contributed to the neglect and loss of early devotional art, so massive numbers of Medieval images on wood or canvas were destroyed in the Lowlands, in France, and in German-speaking nations.

Five of the very best of early "German" devotional panels are in Berlin, some as small in size as they are monumental in effect and often made to rest upon or just above the altar table. Others, far larger, were for installation before it as altar frontals. Images could actually become part of the Mass, often reflecting the imperial, neoclassical ambitions of contemporary Holy Roman culture, theirs a visual authority seldom equaled in Northern painting. Awesome, hieratic, austere, and stoical, these thirteenth- and fourteenth-century pictures' subjects and treatment often bespeak a severity very different from the concern with nature and humanity that would come to the fore in the art of the later fourteenth and fifteenth centuries. The shape, convention, and format of works in precious metals — in relief, colored with enamel — often determined the appearance of early panel

paintings. These devotional images are close to the aristocratic, autocratic values of Byzantium.

Earliest, and among the most splendid of all Northern European paintings, are two large German panels discovered in 1858 in the Wiesenkirche at Soest (Westphalia) but dating back to a much earlier building. Both were bought for the Berlin Museum in 1862. The older of the two (*38–39*) dates c. 1230 and was designed for attachment to the back of an altar. Two great roundels flank a *Crucifixion*; all three scenes stress sacrifice for salvation. In the central panel, the defeated Synagogue, holding

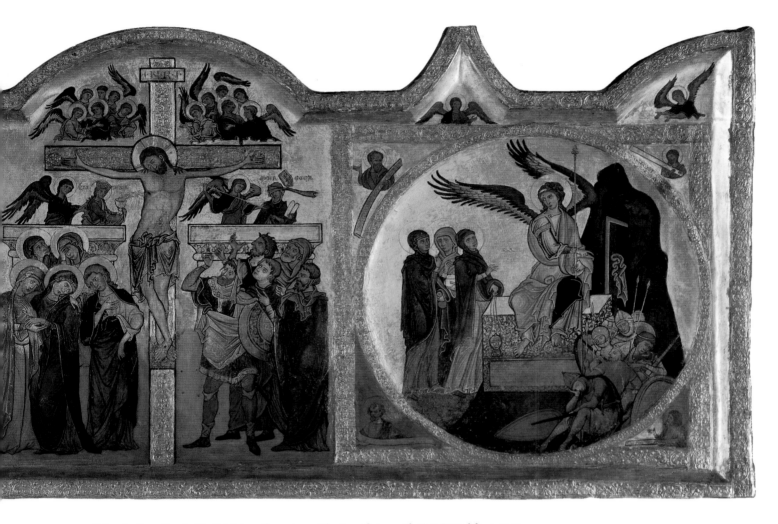

Westphalian, first half of thirteenth century, *The Crucifixion with Two Roundels*, c. 1230

Moses' tablets of the law and losing her crown, is seen at Christ's left. Ecclesia, on the good side (Christ's right), collects his blood in a chalice. The left-flanking roundel encloses the scene of Christ's trial before the High Priest Caiaphas. Those oddly conical hats were assigned to Jews in Northern Europe when this picture was painted. Eight prophets, four framing each circle, hold scrolls attesting to Christ's role as Messiah and to his sacrifice. The roundel at the right shows the *Three Marys at the Empty Tomb*. Sharply outlined in black, the scenes recall Byzantine enamels.

The basic geometry of this exquisite panel is almost as eloquent as its contents. The architectural elements, strips in relief, and areas of pattern are all worked out with such perfection that they sustain, rather than detract from, the tripartite altar's impact. The fact that the lateral circular scenes are recessed like Greek sacrificial dishes known as *patera* gives them a vital contrast to the vertical organization of the central section. The unknown author of this altar, active between the times of Cavallini and Cimabue, is certainly one of the founding fathers of German panel painting.

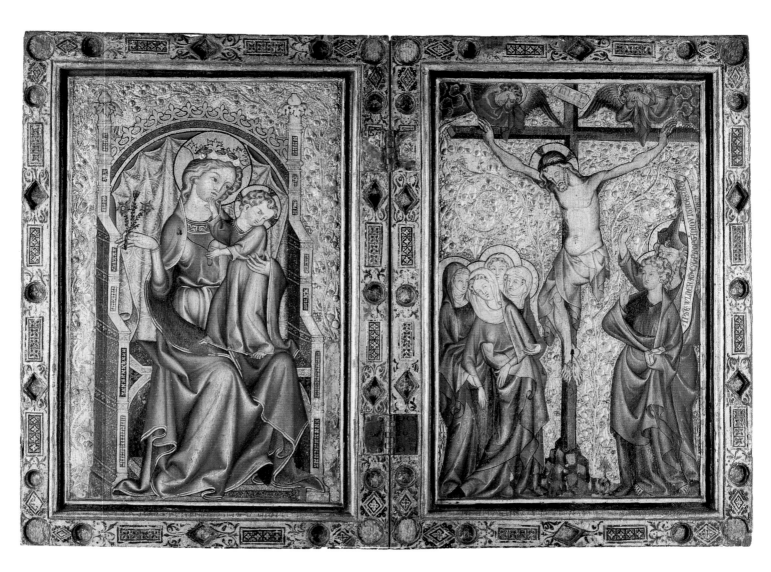

COLOGNE MASTER
Diptych, c. 1320–30

Much Christian art originated with the value and function of the reliquary, an object suggesting sacred enclosure, working as a touching, immediate souvenir of divinity. A little diptych (40), the Annunciation painted on its exterior, came to the museum in 1902 from Cologne's church of St. George. It is datable to 1320–30 on the basis of its stylistic proximity to illuminations of that decade and was possibly destined for domestic use. The frame alludes to reliquary features — some of its many crystal-covered recesses may have contained sacred remains. Both panels on the interior are elaborately gilded and tooled, as if made of gold rather than lowly wood. The poetic, lyrical left wing unites the regal and the intimate, Mary crowned and enthroned, Jesus standing in her lap. This lovely group recalls the amorous German poetry of the *Minnesänger*. Mother and Son's heads are inclined toward *The Crucifixion* to the right. Already crowned Queen of Heaven, Mary holds roses symbolizing that lofty realm. The Infant's cruciform halo points to the right scene's subject. Tooled vegetal motifs seem to spring from the base of the cross, as if sustained by Christ's blood. To the far right, next to St. John, stands Isaiah, holding a prophetic scroll, whose unorthodox Latin inscription reads, "He is willingly wounded for our transgressions" (Isaiah 53:5).

A Bohemian *Madonna and Child Enthroned* (43) dating from c. 1350 shows its subjects towering above the Lilliputian kneeling Ernst von Pardubitz, archbishop of Glatz. This panel comes from an Augustinian monastery he founded there in 1350; it was bought by the museum from that city's Gymnasium in 1904. Proudly yet modestly the donor lays all the attributes of his ecclesiastical rank — elegant episcopal gloves, miter, and crosier — on the throne's steps. Lions in little houses near the top suggest that this massive throne is that of wise king Solomon; its tie to learning is also enforced by the Infant's holding of a scroll. Elevated to heavenly furniture by Marian occupation, the throne and its sitter symbolize Ecclesia. The Virgin's future role as Queen of Heaven is anticipated by the angel who adds a crown to her investiture with regal orb and scepter. Conspicuously bare, the boards behind Mother and Son suggest the wood of the Cross, a theme echoed by the Infant's cruciform halo.

Originally this large panel formed the central section of a triptych with scenes, now lost, from the lives of Christ and Mary. Since the donor studied in Paris and Italy before becoming first bishop of Prague, the painting's sophisticated aspects may have been infuenced by its patron's previous exposure to the art of many leading centers, including Avignon.

This glorious image is executed in a suitably painstaking technique, its poplar support covered with fine linen prior to painting. That not unusual but elaborate preparation serves two different purposes — protecting the wooden panel and providing the delicately responsive surface of fine linen, which absorbs the preparatory gesso.

From the same Bohemian region, but executed about a decade later, is an unusually violent *Crucifixion* (42), possibly the central section of a triptych. It shows the moment when the fatal lance wound is made by the blind Roman centurion Longinus, who regains his sight with Christ's blood. This convinces his colleague (to the right with raised arm) of Christ's divinity. Caricatured, the soldiers gambling for Christ's robes are given the fierce visages often found in Northern personifications of evil. The agony of the Good and the Bad thief, both pretzeled about their crosses, is in hideous contrast to Christ's relative tranquility. This painting is partly derived from a Bolognese manuscript illumination (Rome, Archivio di S. Pietro).

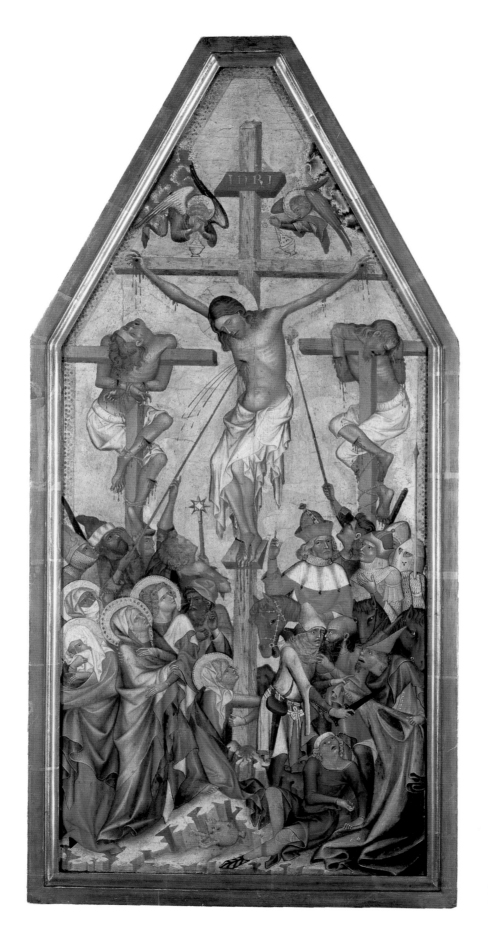

Bohemian
The Crucifixion, c. 1360

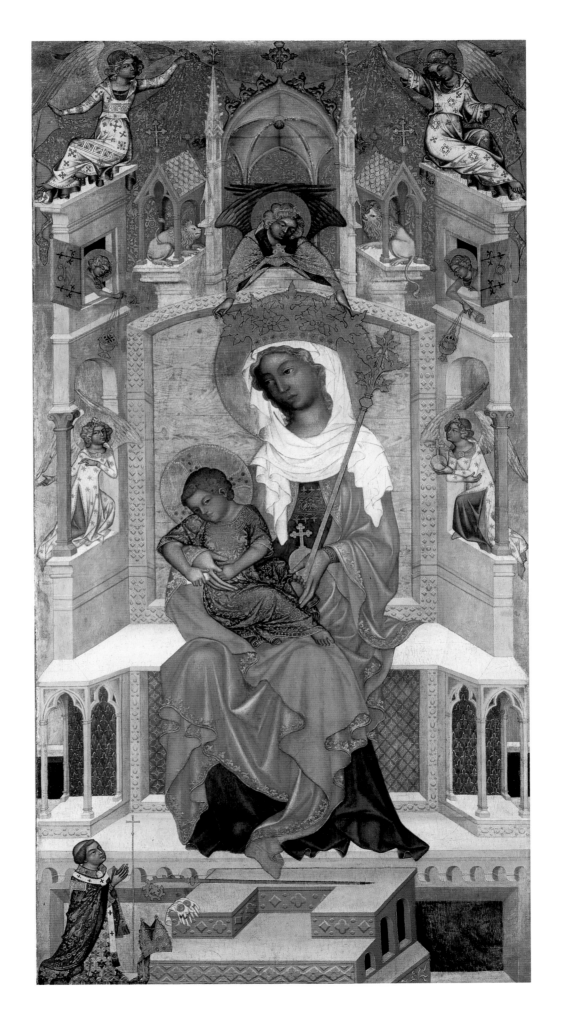

Bohemian
Madonna and Child Enthroned
("Madonna from Glatz"),
c. 1350

43

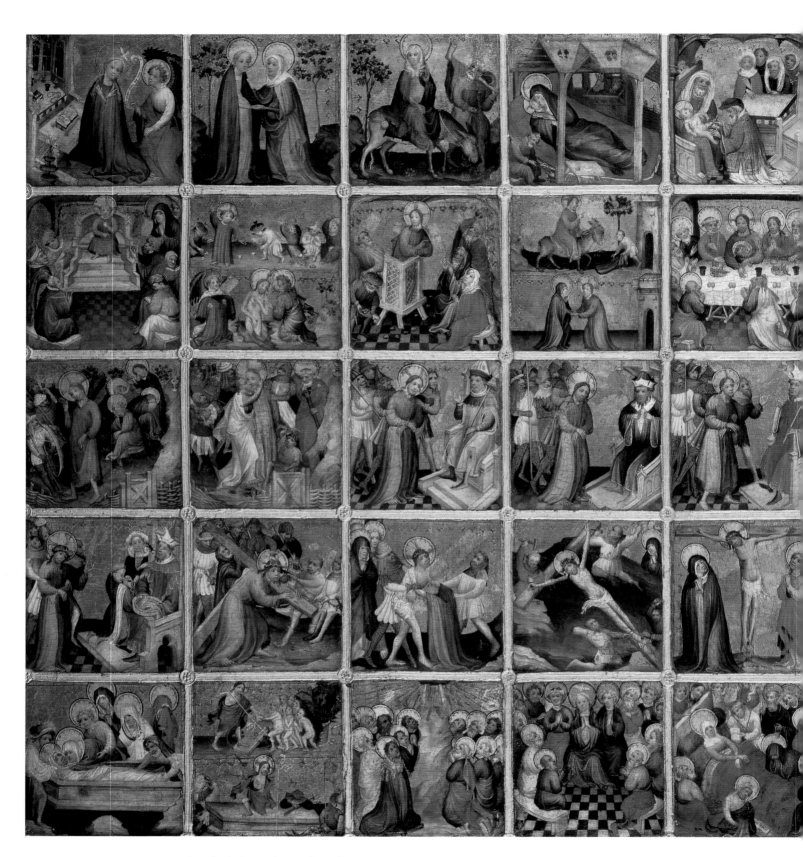

COLOGNE SCHOOL, *The Life of Christ* (altar in thirty-five scenes), c. 1410–20

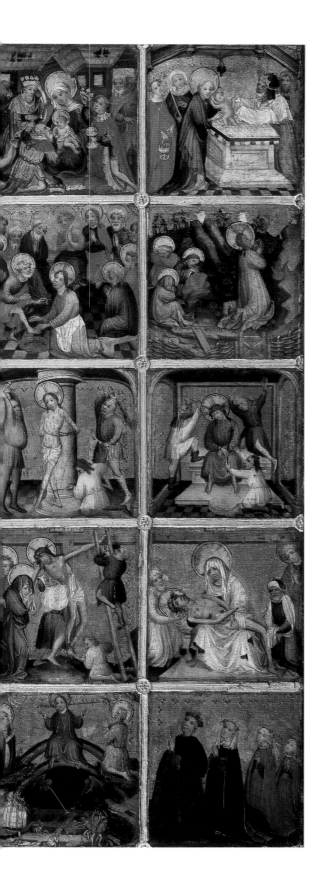

B Y THE LATER fourteenth century, Cologne had taken its place among the very largest of European cities. With its advantageous location on the Rhine, the city was a major center for shipping and other commerce and a member of the Hanseatic League. Already prominent in Roman times and wealthy once again in the Middle Ages, later-medieval Cologne was rapidly built up, flourishing in every way.

The unusual optimism of her burgeoning urban population, the city's splendid Romanesque churches, and her affluent society seem to determine the character of Cologne's lyrical painting, sculpture, and manuscript illumination. They share a quality of scarcely contained joy, a sense of quiet laughter felt in her singularly happy visual arts, all distinguished by clear, bright color, spiraling bodies, and smiling faces. That sweet archaism is far more accessible, if less refined, than France's far better known, far earlier archaic smile found in the statuary of Rheims Cathedral.

A sacred, if comic-striplike, Cologne altar (44–45) includes thirty-four images from the life of Christ and Mary with a thirty-fifth — at the lower-right-most corner — showing the donor family. Some of the little panels are divided to accommodate two different subjects, so that an unusually playful scene from Christ's infancy is placed above that of his Baptism. Similarly, the Entry into Jerusalem is seen like a vision, above the Visitation. Christ in Limbo is tucked in above the Resurrection.

A courtly, small, standing Madonna (46) is a Woman of the Apocalypse, as is indicated by the sun and moon at her feet. Mary is invested with a lavish bridal crown, typifying the Beautiful Madonna of the period, an aristocratic theme close

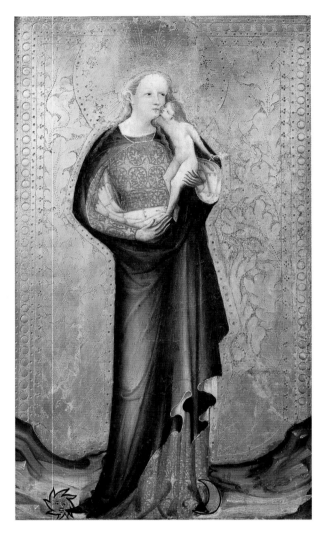

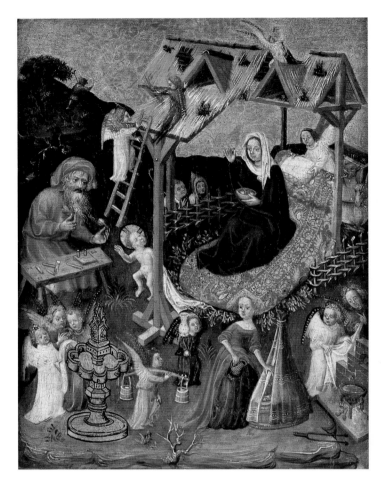

COLOGNE SCHOOL
Woman of the Apocalypse (Madonna and Child atop the Sun and Moon), c. 1390–1400

LOWER RHENISH SCHOOL
Holy Family with Angels, c. 1425

to the elegant ideals of the International Style. This aristocratic, conservative manner prevailed throughout Europe close to the year 1400, whether in Siena or Seligenstadt.

Cheek-to-cheek and mouth-to-mouth, Mother and Son's intimacy comes close to Byzantine ikons, but the Infant's nudity and his elegant gesture, embracing Mary with his right hand, is also typical of the pan-European manner of 1400, one that revived the courtliest aspects of High Gothic art.

A Lower Rhenish depiction of the *Holy Family with Angels* (46) is unique for its angelic bucket brigade bearing water for the Byzantine theme of Jesus' first bath. This will take place within an elegantly covered tub, a demure attendant alongside.

The naked Infant approaches Joseph at his carpenter's bench, in flight from unwelcome ablution. Other angels warm Christ's clothing near a fire that also heats his bathwater. Equally industrious angels bring Mary a snack while two more repair the stable's decrepit thatched roof. This scene is a touching fusion of the playful spirit of the early fifteenth century with the new matter-of-factness of the *Devotio Moderna*, whose mystical currents bring novel qualities of intimacy and conviction to Northern Christianity, creating a happy or tragic sense of "See it now," furthered by Bible translation into the vernacular.

Cologne's playful spirit is seen in a triptych by the Master of the Older Holy Kinship Altar (47).

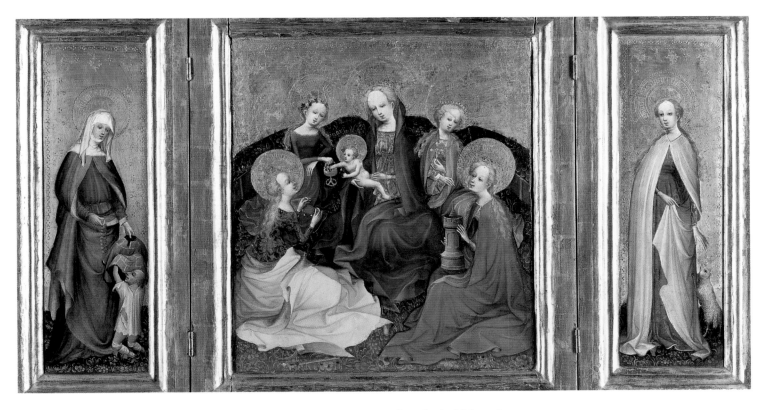

MASTER OF THE OLDER HOLY KINSHIP ALTAR, Cologne, active first third of fifteenth century
Triptych: *Madonna and Child with Saints*, c. 1410–20

Mary and her baby, with surrounding maiden saints, seem to be enjoying a picnic, all seated in a garden, Catherine to the lower left, Dorothy to the upper left, Margaret in the upper right, and Barbara in the foreground. SS. Elizabeth and Agnes stand in the wings. Another panel of the same theme from the Circle of the Cologne Master of the Life of the Virgin (49) shows Mother and Son with three saints — Mary Magdalen, Catherine, and Barbara — shaded by an exquisite arbor. A large donor family, segregated by sex, kneels in the corners. The burnished gold background sheds an ineffable light upon this heavenly scene where all the holy figures are seated directly upon the flowering garden to stress their accessibility and humility. Once again, gold almost

takes over in the same master's *Madonna and Child* (48). This panel has the fresh, direct approach so typical of the region. The Mother and Son are not far from the art of Rogier van der Weyden (58, 66–69) and Dieric Bouts, whose pupil the Master of the Life of the Virgin may have been.

An unusual image — a Woman of the Apocalypse combined with a Madonna of Humility — is shown seated in an enclosed garden (48), with male and female donors in suitably humble small scale to the lower left and right. This work by the Master of 1456 shows how conservative Cologne's art remained, still close to the style of Stephan Lochner, the center's leading painter, who had died by 1451.

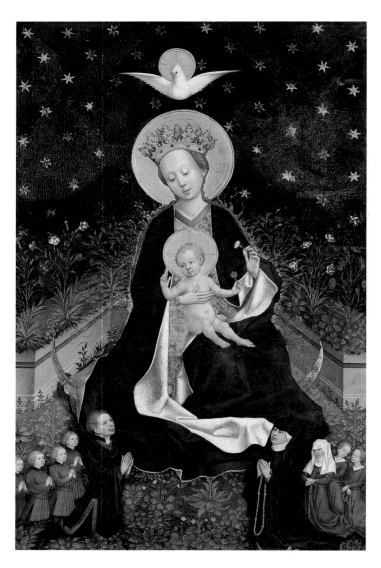

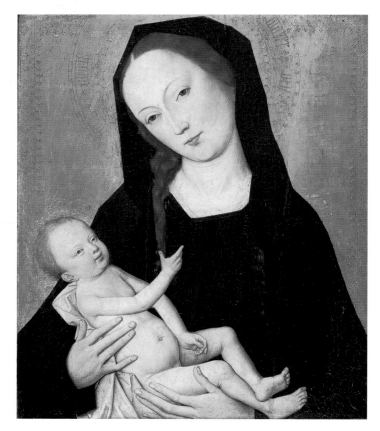

MASTER OF 1456
Cologne, active c. 1450–60
Madonna on a Crescent Moon in Hortus Conclusus

COLOGNE MASTER OF THE LIFE OF THE VIRGIN
active second half of fifteenth century
Madonna and Child, c. 1470

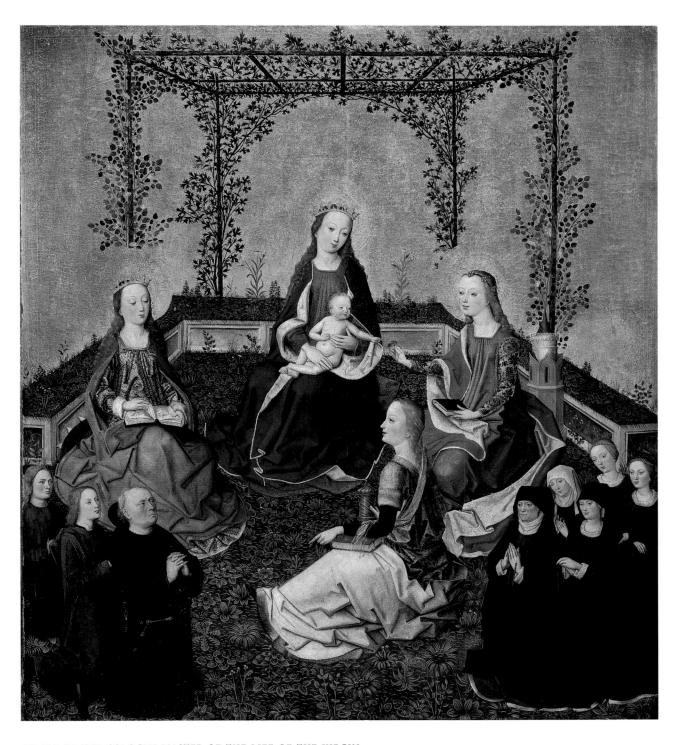

CIRCLE OF THE COLOGNE MASTER OF THE LIFE OF THE VIRGIN
Madonna and Child with Three Saints, c. 1470

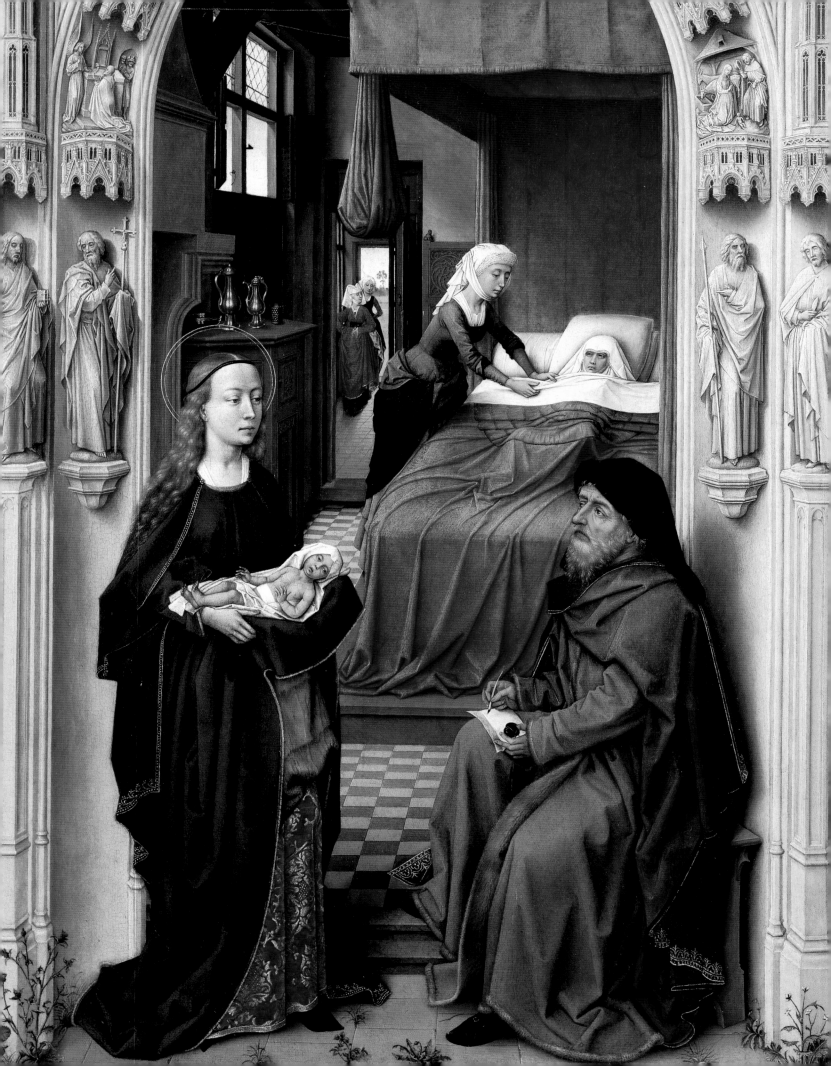

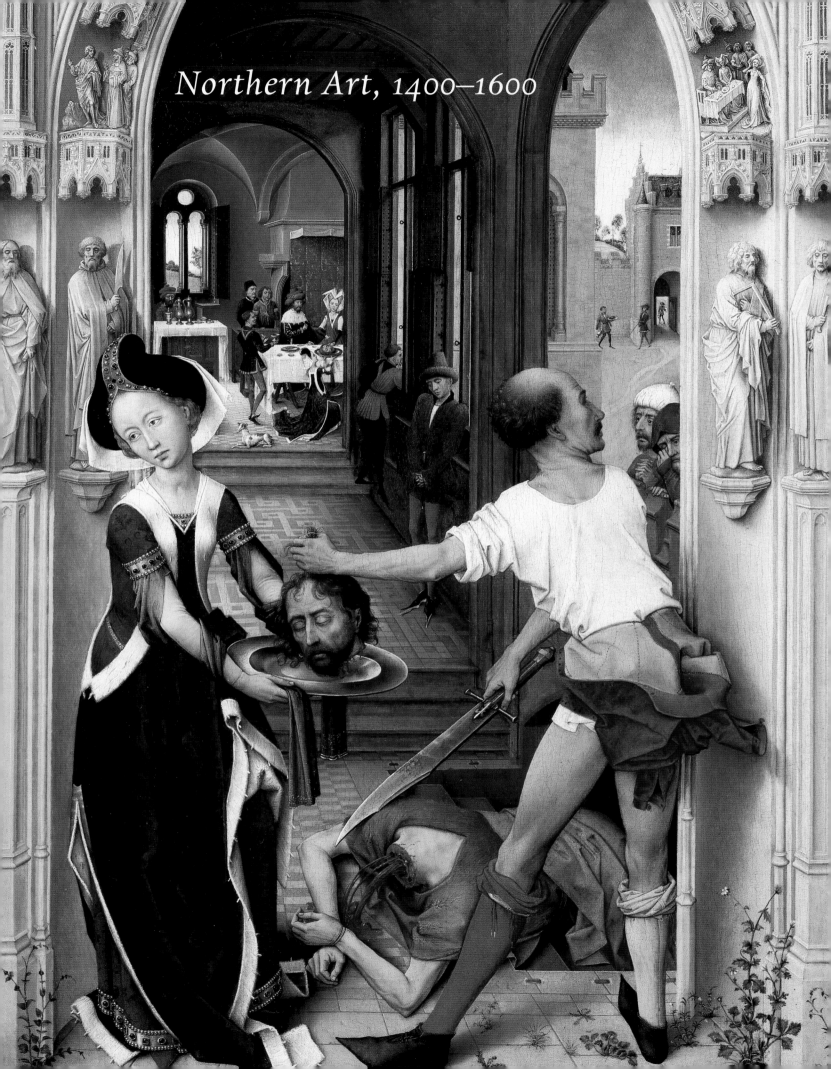

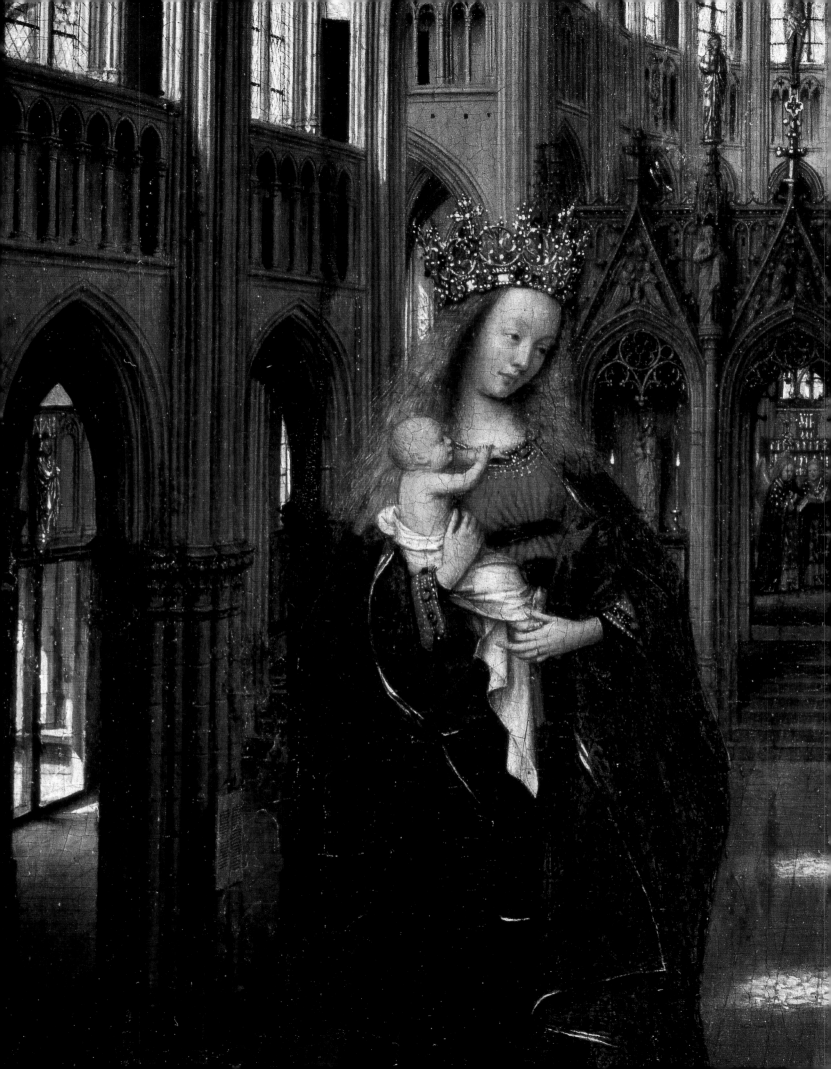

Jan van Eyck and Petrus Christus, Sorcerer and Apprentice

No painter was more famous in fifteenth-century Europe than Jan van Eyck. Far more highly prized than that of his contemporary, Masaccio, his art was sought after for every courtly collection in Italy as well as the North. Jan was renowned as alchemist and cartographer, famed for his mastery of portraiture, of spatial illusion, the nude, landscape, and botanical arts, as well as for the suasion of his devotional imagery. In Burgundian ducal employ, he was widely traveled, going to Portugal and probably to Italy to prepare complex maps toward a new crusade. Very possibly Jan also acted as a spy in addition to performing the countless other duties of court artist. Though he probably started out as a manuscript illuminator and possibly as a jeweler, van Eyck developed an oil technique that was never quite duplicated by anyone else, not even by his immediate follower in Bruges, Petrus Christus.

Among van Eyck's finest paintings is a small yet full-length image known as *The Madonna in the Church* (53). Holding her Son, Mary is seen in a miraculously large scale, dwarfing the interior of the great Gothic cathedral in which she stands while angels perform the Mass. Bathed in light, wearing the lavish bridal crown of the Beautiful Madonna and the garb of the Queen of Heaven, the pensive, girlish Virgin holds an unusually babylike Infant, who tugs at her neckline for nurture.

Other images within the church are of the Mother and Son in statuary form — on a little candlelit altar-niche behind the main subjects. They are seen once again on the lavish choir screen as mourning Virgin and dead Christ on the Cross. Their tragic presence makes it clear that this is not intended to be a historical image, but a timeless, mystical one, identifying the towering figure of the Mother as Ecclesia and the sacrificial Son as Redeemer. Mary may also be in her traditional role

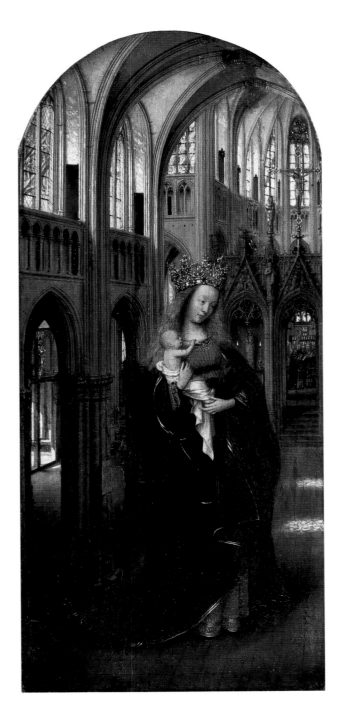

JAN VAN EYCK, Maastricht (?), c. 1390–Bruges, 1441
The Madonna in the Church, c. 1425–27
Opposite: (detail)

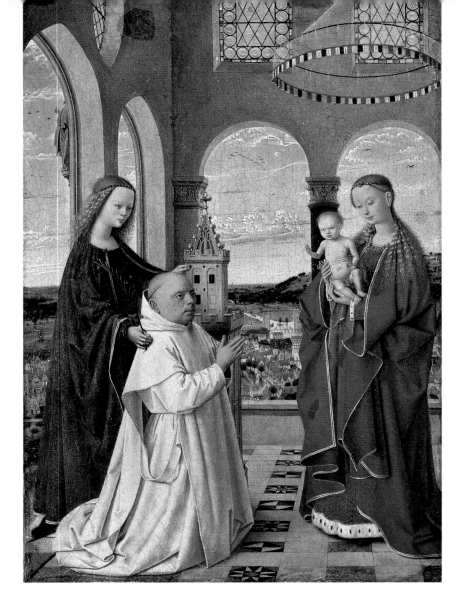

PETRUS CHRISTUS
Baerle, c. 1410–Bruges, 1472/73
*Madonna and Child with St. Barbara
and a Carthusian Monk
(Exeter Madonna)*, c. 1450

of Priest, an important early Christian doctrine. By holding up the Infant, she anticipates the elevation of the Host, as if performing part of the angelic Mass celebrated at the little altar in the background.

The Madonna in the Church has lost its original, inscribed, marbleized frame, also painted by Jan van Eyck, which was stolen in 1877. There may also have been a companion panel to the right, of a kneeling donor, if a diptych by Gossaert (Rome, Galleria Doria Pamphili) is an accurate indication of this work's original appearance.

Typical of Jan's finest art, this glossy, jewel-like little picture suggests a magical mirror or window, one not wrought by human hands, an "artless" vision between scene and spectator, miraculously perpetuated on panel. Almost as much a theologian as he was a scientist, Jan van Eyck used his incomparable skills to present as close a simulacrum of

divine reality as any artist ever achieved.

The same artist's portrait of the shifty, rabbit-featured Giovanni Arnolfini (55) shows a Lucchese banker long resident in Bruges, whose likeness is better known from Jan's image of Giovanni with his Italo-French wife (London, National Gallery), which was probably painted later, near the time of their marriage. Here, Giovanni's turban is in the Italian style, wrapped around a faceted wooden core like those so often drawn by Piero della Francesca and Uccello as a favorite perspectival exercise.

Better preserved is the portrait of a leading Burgundian noble, Baudoin de Lannoy (55). Grasping his white baton, indicative of high military command, he wears a huge fur hat and a richly brocaded robe adorned with the collar of the Order of the Golden Fleece. None of this finery is very becoming to the large-headed sitter's tough

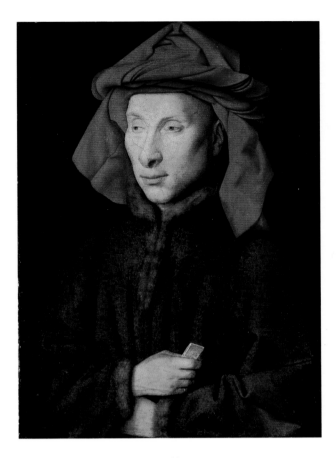

JAN VAN EYCK, *Giovanni Arnolfini*, 1434

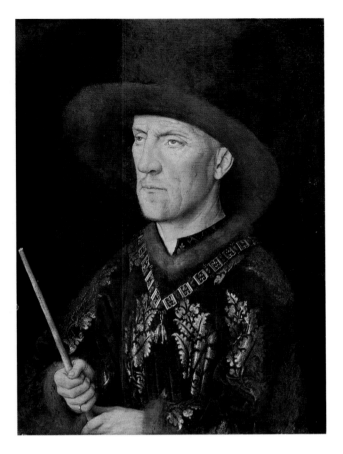

JAN VAN EYCK, *Baudoin de Lannoy*, c. 1431–35

features, painted as if his image were destined to function as an obsessively concentrated military ID, which, in a way, is just what it was.

Simplified — "Cubified" — a *Last Judgment* altarpiece wing by Petrus Christus (*56*) follows one by Jan van Eyck (Metropolitan Museum of Art) but removes Jan's magical mystique in favor of a reductive modernity. The companion wing is divided across the center, the Annunciation above and the Nativity below (*56*). These are nearer the art of Tournai than that of Bruges, where Jan ended his days and where Petrus Christus carried on his tradition. They recall the art of Robert Campin (*59–60*) and Rogier van der Weyden (*58, 66–69*), painters that Christus followed after the death of Jan van Eyck, his first pictorial role model, in 1441.

Far more succesful is Christus's scene of a Carthusian monk kneeling before the Virgin and Child (*54*), known as the *Exeter Madonna*. Here St. Barbara has one hand on the donor's shoulder, the other on her clumsy tower. This little panel may

have been painted as a substitute for the Eyckian School altarpiece (New York, Frick Collection), when the same donor, moving from one Carthusian monastery to another, took the picture now at the Frick along with him.

An early Netherlandish Nefertiti look-alike, also painted by Petrus Christus (*57*), may be the portrait long kept in the Medici Collection as a work by this artist. The sitter's hat raises the possibility that she may be French, as listed in the Medici inventory. Simplified in approach, compared with Jan's art, this rendering of a rich Northerner, her erminetrimmed robes suggesting noble blood, shows Christus at his endearingly naive best.

Like Jan van Eyck, Christus was a considerable traveler, probably active in Milan, Venice, and Genoa as well as working for those centers' mercantile colonies in Bruges. Berlin's extensive collection of Christus's works is rivaled only by that of New York's Metropolitan Museum of Art.

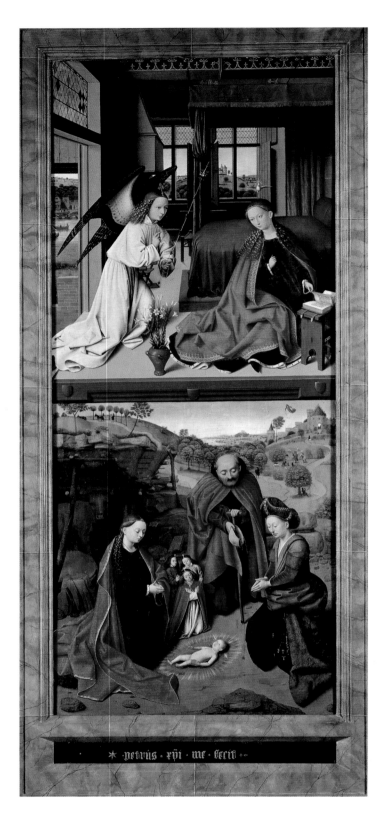
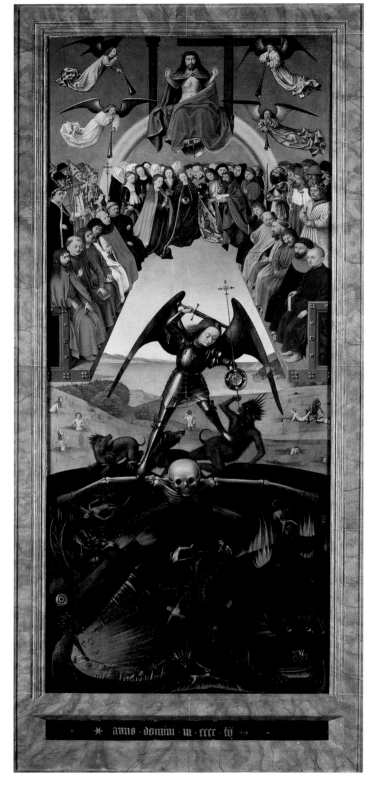

PETRUS CHRISTUS
Two wings from a triptych, 1452:

The Annunciation and The Nativity (left)
The Last Judgment (right)

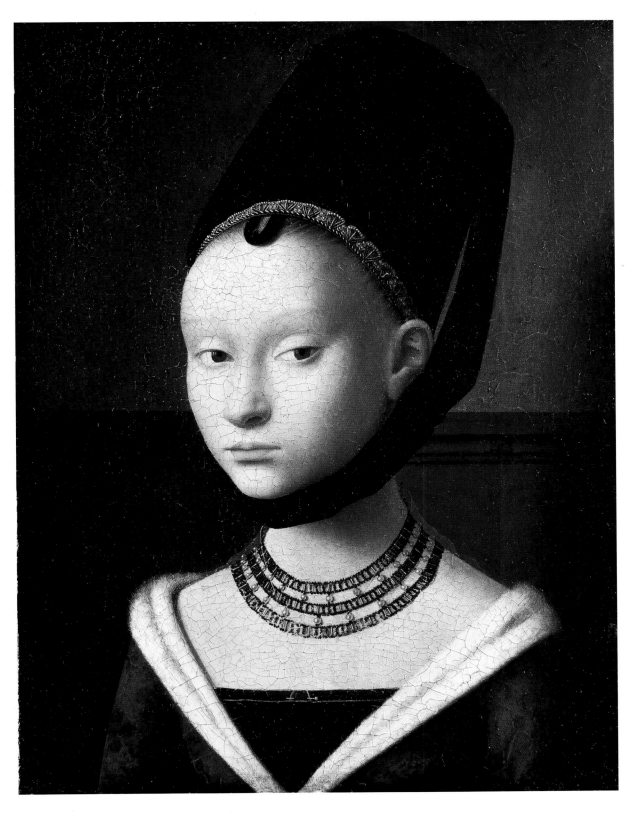

PETRUS CHRISTUS
A Young Lady, c. 1470

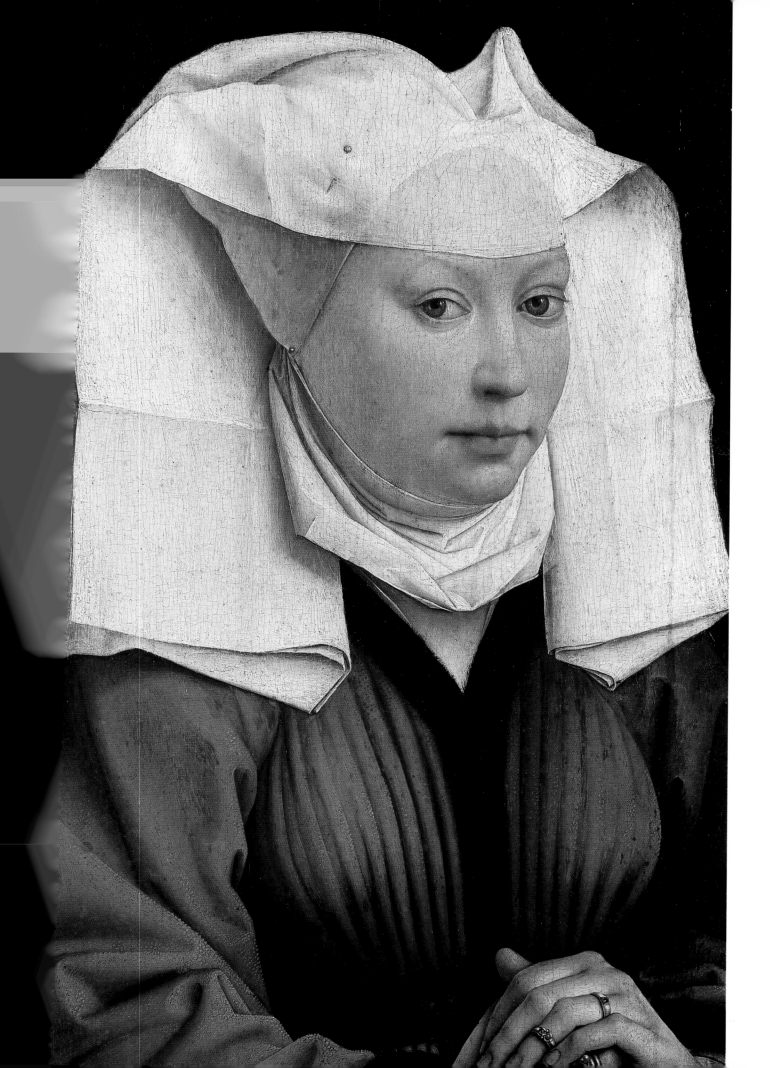

Triumph at Tournai: Campin, Daret, and van der Weyden

Where the incomparable, inimitable Jan van Eyck defies any academic pigeonhole — far beyond such simple categories as "Medieval" or "Renaissance" — his compatriot and contemporary Robert Campin is far more accessible to artists and scholars alike. Bold, realistic, dramatic, that painter's oeuvre was much easier to emulate than Jan's pictorial magic, which often seems to be seen in miniature no matter what its real size might be. Campin proved enormously influential all the way through the fifteenth century, his powerful works still closely copied at its end.

The Tournai artist's direct approach to experience, his striking fusion of the mundane and the monumental, of the secular and the divine, endowed religious scenes and portraiture with rare strength and immediacy. Painters and engravers throughout Northern Europe responded to his message of the importance of being truly, massively in earnest; of the here and now being the key to the there and then, and to the once and future. This is an art where chivalry is usually alien to the stoical resources of stalwart narrative.

Berlin's is the world's only collection where several works by Campin are found along with key paintings by the only two of his many documented apprentices whose art has been identified — Jacques Daret and Rogier van der Weyden. The Gemäldegalerie for Old Masters also includes major pictures by most of the leading artists in Campin's sphere of influence, including major works by Hans Multscher (74–75) and Konrad Witz (70).

Opposite:
ROGIER VAN DER WEYDEN
Tournai, 1399/1400–Brussels, 1464
Lady Wearing a Gauze Headdress, c. 1435

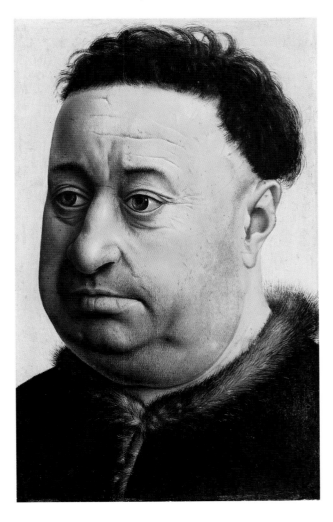

ROBERT CAMPIN, Tournai, c. 1375–1444
Robert de Masmines, c. 1425

Campin may have expanded upon a native tradition of broad realism, one of radical gravity originating with the funerary reliefs that were a notable product of Tournai sculptors. Some of their stone carvings very possibly were designed by our painter, who is known to have polychromed statuary.

Campin might well be compared with the powerful masters of the Trecento — to Giotto (26) or

Ambrogio Lorenzetti (36–37). With the great Italians he, too, was a devoted student of nature, of the wonders of the body and landscape. With those earlier southern masters, a vital force reminiscent of antiquity's informs Campin's art. He also possessed a rare sense for the silent drama of space, an almost Protestant fixity of spirit — a pictorial "Here I stand." Without signed works, the Tournaisien's oeuvre remains the tip of a highly contested iceberg. Some scholars tend to divide the panels ascribed to Campin among several different hands; others have seen the best of this stylistic cluster as the first phase of works by his most gifted apprentice, Rogier van der Weyden.

It was Campin, not the official and possibly somewhat younger ducal painter Jan van Eyck, who established the major courtly Netherlandish portrait style of the fifteenth century, which was further developed by van der Weyden. Typical of Campin's bold line of attack is a male portrait (59), one of two in Berlin by this painter, this panel probably of the influential Burgundian courtier Robert de Masmines. That daring white background is calculated to heighten every aspect of the sitter's jowly, stubbly physiognomy, his ducal ties indicated by the court's characteristic short haircut and fur-trimmed robes. The same sitter may also appear in the role of Nicodemus in Rogier van der Weyden's stupendous *Deposition* (Prado).

Almost Rogier-like, a sweet Madonna of Humility is the exception to Campin's habitual severity. Seated on the ground, she is the subject of the *Madonna by a Grassy Bank* (60). The Virgin is sheltered by a brick enclosure with Marian flowers — marguerites — at the top. According to Frankfurt's curator Jochen Sander, this may have been the right half of a diptych, its lost facing pendant's subject accounting for the Infant's alarmed expression. Mary's humble position contrasts with her great gold halo and the rays of divine light projected from the upper corners. The cloth of honor behind Mother and Child also belies their lowly state and anticipates their coronation in Heaven. This Virginal type was refined by Rogier before he employed it in his *Middelburg Altar* (62–63), and is found again in many of Schongauer's engravings and paintings (112).

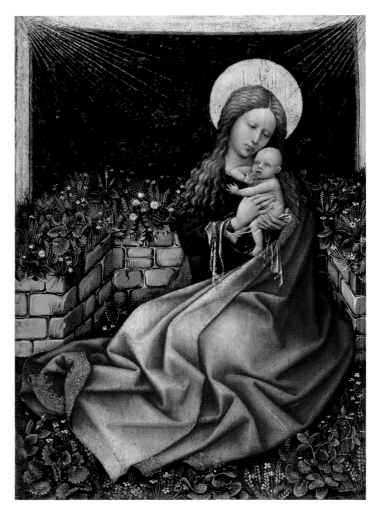

ROBERT CAMPIN
Madonna by a Grassy Bank, c. 1425

Berlin owns two of the five surviving panels documented as painted by Jacques Daret in 1434–35 for the altar of the French royal abbey of St. Vaast, in Arras. This is the central monument by which not only Daret's work but that of Campin himself was identifiable. Its *Nativity* is a reprise of the far more powerful one in a somewhat earlier style (now in Dijon), which is almost certainly from the hand of Campin.

Berlin has *The Visitation* (64) and *The Adoration of the Magi* (65); the remaining two panels are of the Nativity (Madrid, Fondaciòn Colleciòn Thyssen-Bornemisza) and the Presentation in the Temple (Paris, Petit Palais). The lavish altar, which originally included costly alabaster statuary, was dedi-

cated in 1435, an event of such moment that it was attended by the future pope, with ambassadors such as Cardinal Albergatti, and possibly the major humanist Leone Battista Alberti.

Though Daret's figures may seem almost additive, their settings show an assured exploration of space. The landscape, with its pollarded willows, and the sharp-featured reverence of the shrewd donor, continue Campin's ways of seeing and painting. These would prevail in the Netherlands and Germany for much of the next sixty years and contribute to changing French and Italian techniques and perspectives. The elegant Mary and Elizabeth in Daret's *Visitation* are close to figures by Rogier van der Weyden, his fellow apprentice. So the *St. Vaast Altar* also acts as an identifying bridge between the art of Campin, pioneer of early Netherlandish painting, and that of his best pupil, Rogier.

Berlin also has the world's largest collection of Rogier's works. In addition to portraits and several paintings from his studio, it includes three of his major multipaneled altarpieces. Earliest of these may be the *Miraflores Altar* (66–67), named for the Spanish Carthusian monastery at Miraflores, with scenes from the life of the Virgin. Deep set within their original frames, the Marian subjects are surrounded by illusionistic sculptural arches painted with trompe l'oeil scenes that pertain to the moment they enclose. An angel at each arch's keystone bears a crown for Mary with a scroll explaining why she is to receive this honor for the event in her divine motherhood shown below. Most tragic is the centrally placed *Pietà*, which is flanked by the beginning of her Son's earthly life in the Adoration (left) and his appearance to his Mother (right) after the Resurrection, seen in the distance. Like mystery play scenes unfolding within the architectural confines of a church portal, this tripartite restaging of the joined lives of Mary and Jesus shows Rogier's genius for sacred drama as still performed inside a Gothic setting.

Larger in scale and more modern in style is the painter's *Middelburg Altar* (62–63), a triptych whose central *Nativity* is juxtaposed with the *Madonna and Child Appearing to Caesar Augustus and the Tiburtine Sibyl* at the left. To the right, the Star of Bethlehem that appears to the Magi is seen in the unusual form

ROGIER VAN DER WEYDEN WITH WORKSHOP
Charles the Bold, Duke of Burgundy, c. 1460

of a radiant Infant. On the wings' exterior is an *Annunciation* executed in grisaille by an untalented studio assistant. This altar may have been painted for a church in the charitable foundation of Middelburg, a model town established by the childless Pieter and Marie Marguerite Bladelin, where they moved in 1450. Pictures like this defined the future of much German as well as Netherlandish painting. It is close to many widely circulated engravings by Martin Schongauer (112), who was also a painter able to communicate pictorial achievements with singular sensitivity.

Rogier's most complex, dramatic triptych is devoted to scenes from the life of St. John the Baptist (68–69) — the central Baptism of Christ is

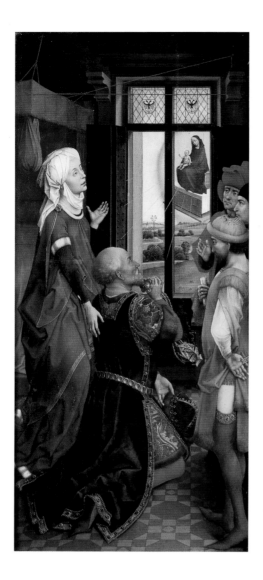

ROGIER VAN DER WEYDEN
Middelburg Altar, c. 1452:

Madonna and Child Appearing to Caesar Augustus
and the Tiburtine Sibyl (left)
The Nativity (middle)
The Star of Bethlehem Appears to the Magi (right)

flanked by the birth of John at the left and the Baptist's martyrdom at the right. The Gothicism of the enclosing arches is now modified by a more mural-like quality than that of the *Miraflores Altar*. The athleticism of some of the figures might have resulted from Italian or classical sources Rogier saw during his Roman journey for the Holy Year of 1450.

By adding grace notes to Campin's forthright faces, slimming down his teacher's silent, awesome figures yet retaining their sense of assured confrontation, Rogier established a new mode, perfecting the early Northern ikon of aristocratic likeness. He anticipated Sargent's dictum that "a portrait was a picture of a person with the nose a little longer." The hauteur of Rogier's lords and ladies is enhanced by almost Botticellian heads, slender fingers, and elegantly outlined garb. All bespeak being

to the manor born, if not bred. These Certifiably Instant Ancestors, whomever they might be, display the formulaic aristocratic airs that were much later bestowed upon their sitters by such artists as van Dyck (*308–11*), Gainsborough (*496, 498, 503*), and Sargent.

A portrait of Charles the Bold (*61*) from Rogier's workshop is more suggestive of Britain's Prince Charles's present-day uncertainties than of the Burgundian duke's infamously bellicose, lusty character. Only the elegant hands, displayed about a sword pommel, along with the jeweled attribute of the Order of the Golden Fleece, convey noble authority.

A magnificent *Lady Wearing a Gauze Headdress* (*58*), similar to another in Washington's National Gallery, typifies Rogier's assured approach to this genre. Each is a striking juxtaposition of fire and

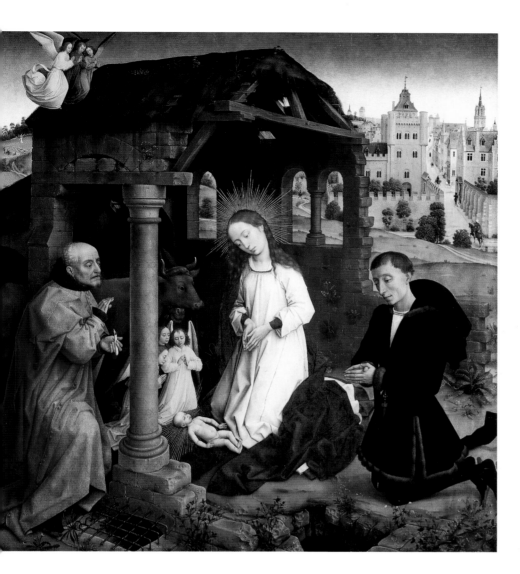

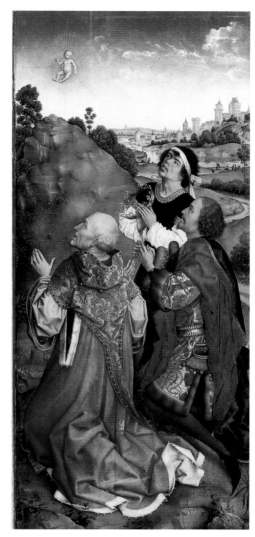

ice, of the austere and the erotic. Fashionable, yet nunlike, the Berlin sitter's wimple anticipates Mondrian's exploration of the mysterious beauties of white on white. An almost voluptuous delight seems to have been taken in hiding the woman's doubtless beautiful hair. Such sensual deprivation is punctuated by that single exclamatory veil pin. No early Netherlandish *Mona Lisa*, this sitter. Instead of smiling to herself, she has a reticently seductive gaze, bee-stung lips, and raised breasts accentuated by the close-fitting folds of a fur-trimmed, tightly belted robe. Lavishly beringed, the lady's fingers are folded in her lap, hands and arms artfully terminated by the panel's frame.

Portraits such as this make it easy to understand why the courts of Milan and Ferrara were especially admiring of Rogier's art. The first sent a young painter, Zanetto Bugatto, to Brussels to complete his apprenticeship under the great Fleming; the second treasured his devotional triptych and commissioned a portrait of an Este bastard, Francesco, who was then boarding at Brussels' ducal court (Metropolitan Museum of Art).

As that city's official painter until his death in 1464, and as designer of innumerable tapestries that were circulated throughout western Europe, Rogier became the best-known Northern artist of the later fifteenth century. He was still much admired by Dürer when the German master made his journey to the Lowlands in 1521. Rubens, too, recalled his skills — one great portraitist seldom fails to appreciate another's powers in that uniquely demanding practice. Nowhere can one see quite so clearly the variety and tenacity of Rogier's art as in Berlin.

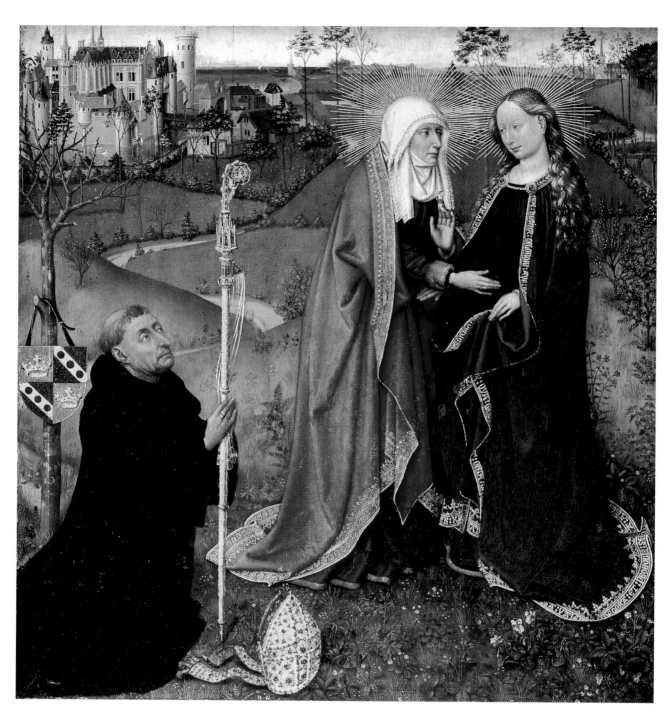

JACQUES DARET
Tournai, c. 1400/1403–1466
Two wings from the *St. Vaast Altar,* 1434–35:

The Visitation (left)
The Adoration of the Magi (right)

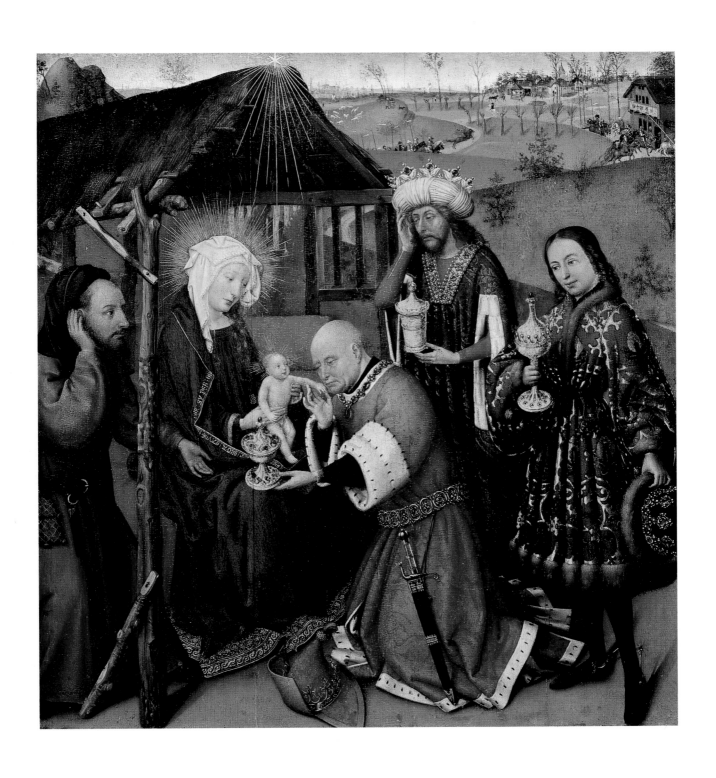

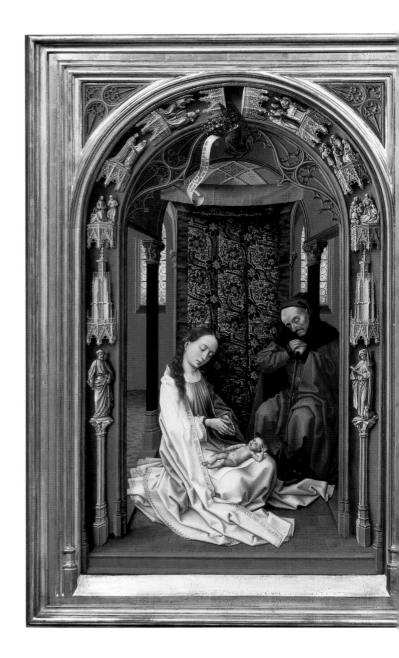

ROGIER VAN DER WEYDEN
Miraflores Altar, c. 1438–45:

The Adoration (left)
Pietà (middle)
Christ Appearing to His Mother (right)

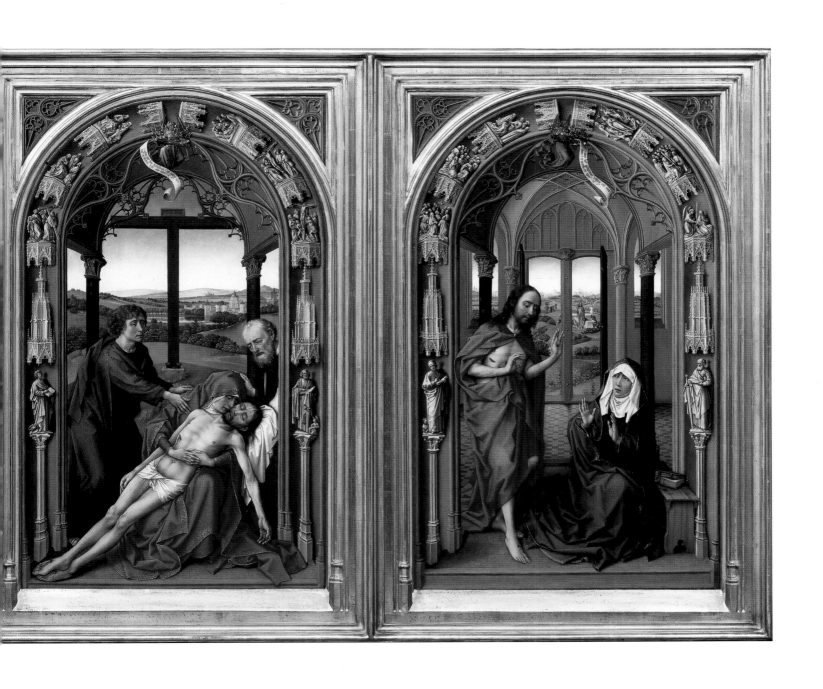

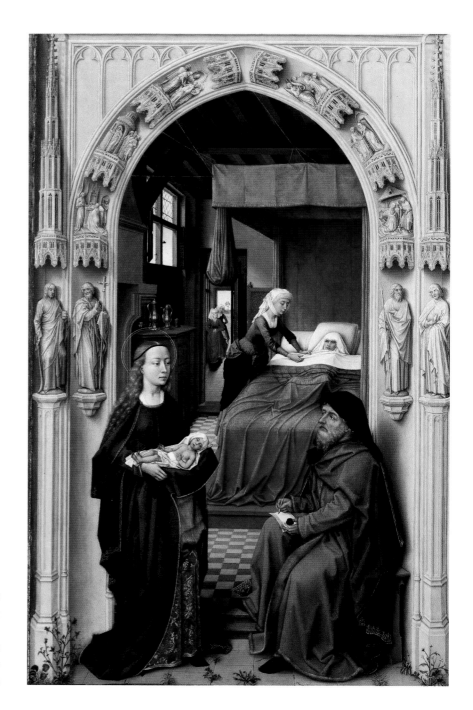

ROGIER VAN DER WEYDEN
St. John the Baptist Altar, after c. 1455:

The Birth of John the Baptist (left)
The Baptism of Christ (middle)
The Martyrdom of John the Baptist (right)

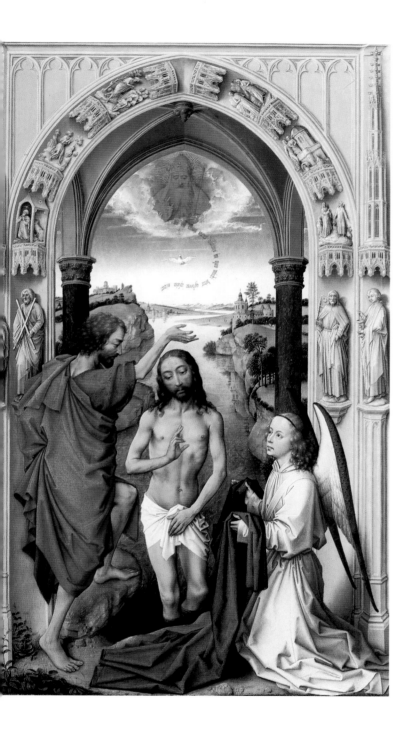

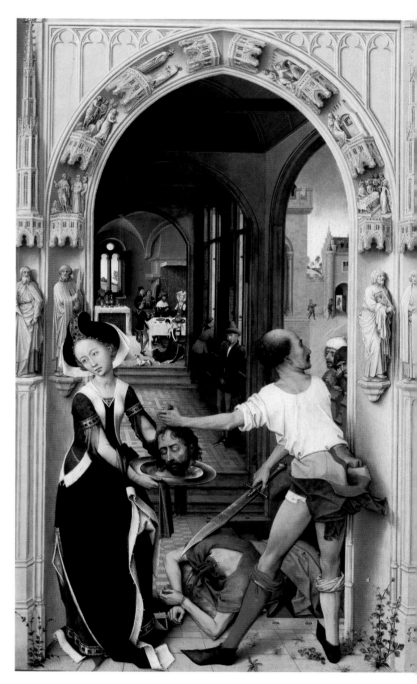

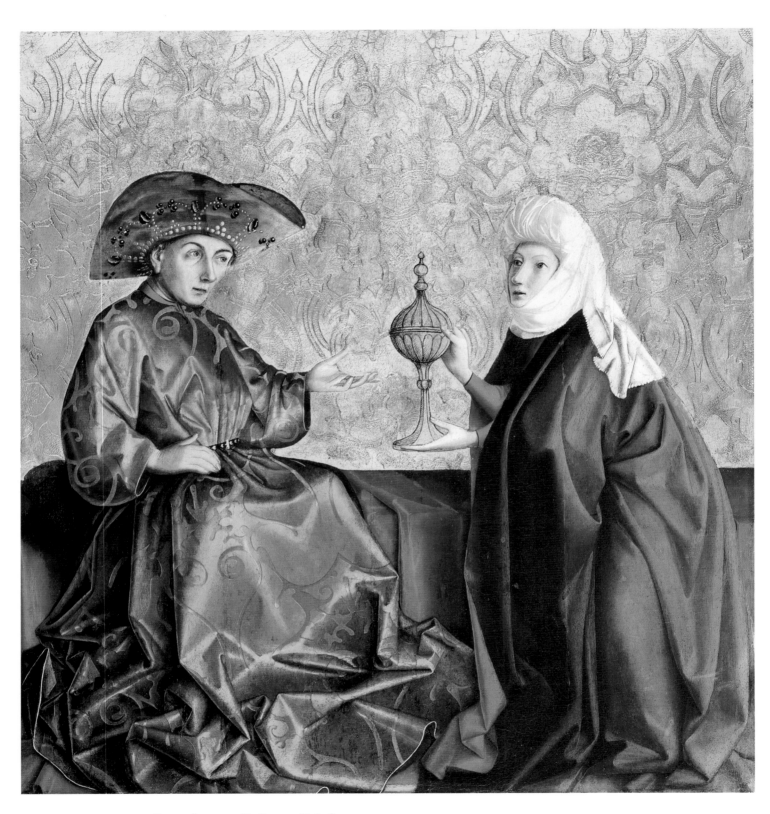

KONRAD WITZ, Rottweil, c. 1400 (?)–Geneva (?), before 1447
The Queen of Sheba before Solomon, before 1437

Monumental German Masters of the Mid-Fifteenth Century

THREE great painters from German-speaking regions — close to the Netherlands' Robert Campin (*59, 60*) — are among the most powerful Northern artists of their times: Konrad Witz, Hans Multscher, and the Master of the Darmstadt Passion.

Witz worked like a sculptor. Though painted, his figures are felt in the round. Sharp-featured and highly individualized, they have a polychromed appearance. Most important of Witz's three paintings in Berlin is *The Queen of Sheba before Solomon* (*70*), which was originally on the inner side of the right wing at the upper left of a very large altar, the subjects of its juxtaposed images taken from a popular medieval devotional text, *The Mirror of Human Salvation*. Basel, the painter's residence for his final twelve years, was the altar's original site — in the church of St. Leonhard.

Other panels are now in Dijon (*Augustus and the Tiburtine Sibyl*) and Basel (*Antipater before Caesar, Esther before Ahasuerus, Ecclesia, The Annunciate Angel, Abraham before Melchizedek, David and Abigail, Sabothai and Benaja, Synagogue,* and *St. Bartholomew*).

Bought in 1913, during a critical period of war and revolution, *The Queen of Sheba before Solomon* could be seen as close to the then new German school of Expressionism, to the art of Käthe Kollwitz and Ernst Barlach. With its almost tribal, archaic features, this bold and uncompromising panel has an incipient antiacademic agenda, king and queen ready for the *Demoiselles d'Avignon* as their maids-in-waiting.

Berlin's four massive panels by the Master of the Darmstadt Passion, a Middle Rhenish painter, belonged to a once vast, long-disassembled ensemble, which probably included centrally placed reliefs or statuary, and dates to 1440–50. Other panels, *The Way to Calvary* (Darmstadt, Landesmuseum) and a lost *Crucifixion*, show "brocaded" golden backgrounds.

The complete outer and inner sides of the left and right wings are in Berlin. When closed, one would have seen the *Virgin and Child Enthroned* (*76*) adjacent to *The Throne of Grace* (*76*) — a seated Trinity. Side by side, these two very large, seated groups create a powerful sense of pathos, tracing Christ's mortal life from beginning to end, from infancy with his Mother to death with his Heavenly Father. Like a head sculpted by Claus Sluter, God the Father's is invested with regal grandeur, also attested to by the throne and the cloth of honor, both attributes of royalty.

Everyone's arms are apart, even those of the little donor at the lower left of the left wing. Mary's arms open to embrace Jesus and the lily branch of the Annunciation; her Son's hands reach out to grab the stalk of flowers. God the Father's arms are apart to support his dead Son. Even the dead Jesus' arms are apart, displaying the holy wounds. This repetitive yet inspired body language is passion's play at its most persuasive. Only by such eloquent gesture, by this inventive intimation, can dogma come to life.

Scenes on the wings' inner sides (*77*) — *The Epiphany* (left wing) and *Constantine and His Mother Helena Venerating the True Cross* (right wing) — are seen obliquely. These complex narrative subjects displayed against gold backgrounds are suitably mystical and timeless in effect.

Hans Multscher's *Landsberger Altar* (*74–75*) is one of the few major early Northern works, other than those from the Eyckian circle, to be signed and dated. Even more unusual is the fact that this was done twice over. The artist's name is "carved" on the wall of *The Pentecost*, in which the apostles sit in circular solemnity, the Holy Ghost just over Mary's head. On *The Death of the Virgin* a German inscription has been written, also as if incised: "Pray God for Hans Multscher of Richenhofen, Burger of Ulm, who made [this work] in the Year of our Lord 1437." Fragments of a *Virgin and Child* (Landsberg an Lech) and of a *St. Catherine* (Augsburg) suggest that the

BERNHARD STRIGEL, Memmingen, c. 1460–1528
Christ Taking Leave of His Mother, c. 1520

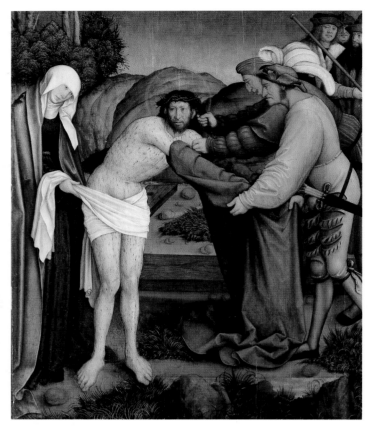

BERNHARD STRIGEL
The Disrobing of Christ, c. 1520

central subject, sculpted by Multscher, was a *Mystical Marriage of St. Catherine.*

Eight panels, almost square in format, comprise this altar dedicated to the lives of Christ and Mary. Though their backgrounds are all gold, there is nothing remote about these scenes. Shaped by this great sculptor, every figure shares a heroic matter-of-factness, seen at its most forceful in *The Resurrection* (75). Here Christ's stoical gravity comes close to the monumental art of Piero della Francesca. In human form, yet freed from mortal coils, this superb presence suggests a bearded Gothic equivalent to a bodhisattva.

Still life elements found in *The Annunciation to the Shepherds and Nativity*, *The Adoration of the Magi*, and *The Death of the Virgin* provide welcome contrast to the figures' almost overwhelming severity. Judas leads a gaggle of Roman soldiers to arrest Christ, who sweats blood in his Agony in the Garden. A cross-bearing angel intimates the sacrifice to come. Beastly little brats stone Christ on the way to

Calvary, following a popular Italian late-Medieval motif suggesting man's (and boys') meanness from Day One.

Just as frozen choreography lies at the heart of the *Landsberger Altar*, the same is true for two panels by Bernhard Strigel. The first shows a rare theme, Christ Taking Leave of His Mother (72). Each of its three groups — most notably that of Mother and Son embracing at the center, fused in a moment of Expressionist pathos, but also those of the three Marys at the right and the waiting apostles at the left — points to figural clusters worked out in the round. A companion panel from the same altar shows *The Disrobing of Christ* (72), the moment following the Flagellation and the Ecce Homo when he is stripped of his mock-regal robes before the Crucifixion. *Landsknechten* — German mercenaries — are cast as Roman soldiers, a contemporary characterization of the banality of evil, as it would be described by a latter-day Prussian, Hannah Arendt.

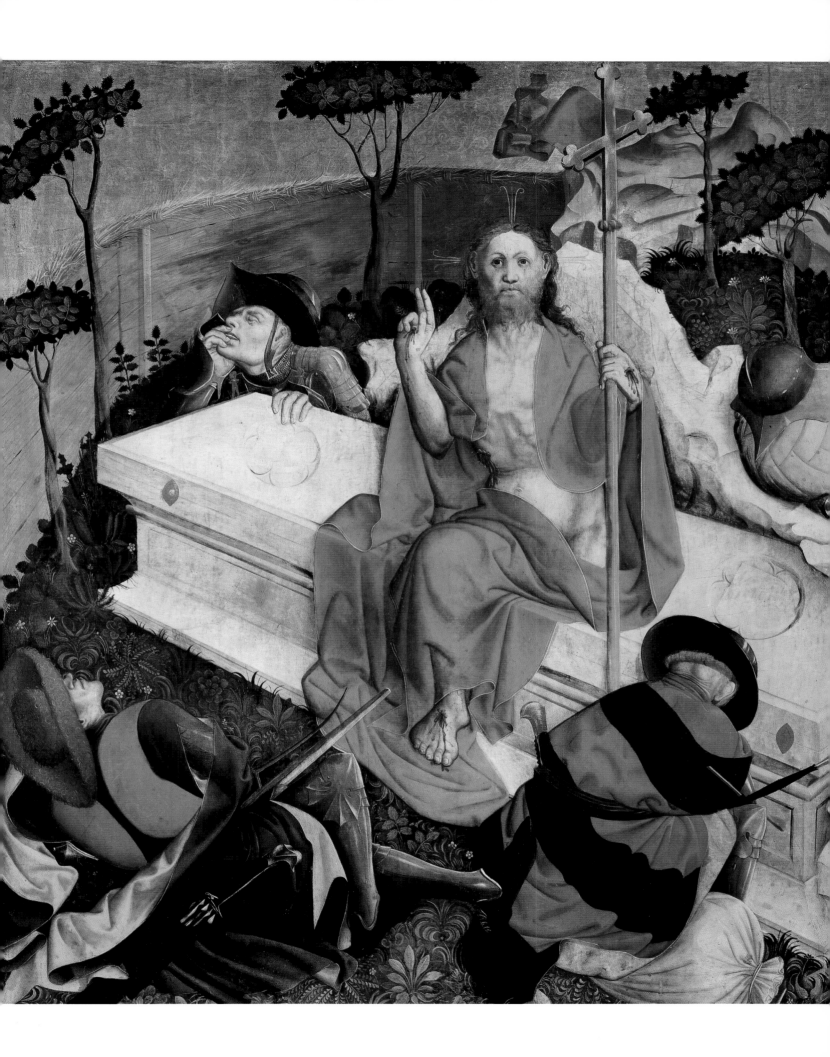

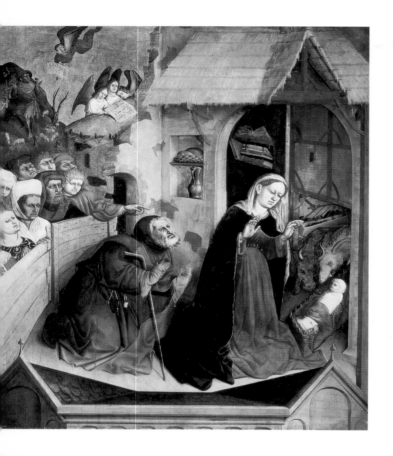

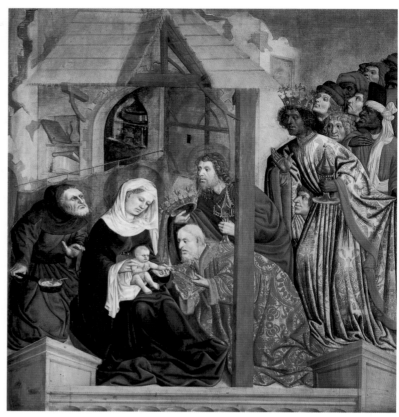

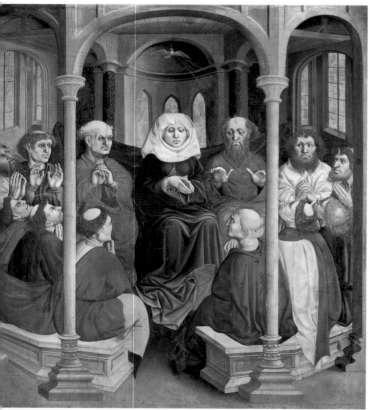

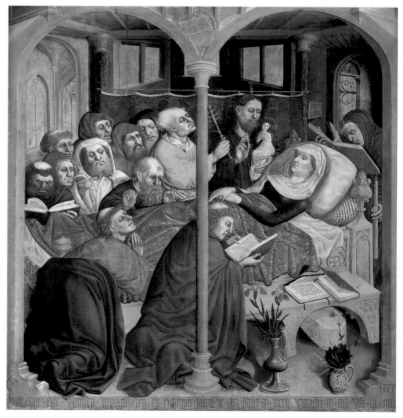

Reichenhofen (Allgäu), c. 1400–Ulm (?), before 1467
Landsberger Altar, 1437:

The Annunciation to the Shepherds and Nativity (top, left)
The Adoration of the Magi (top, right)
The Pentecost (bottom, left)
The Death of the Virgin (bottom, right)

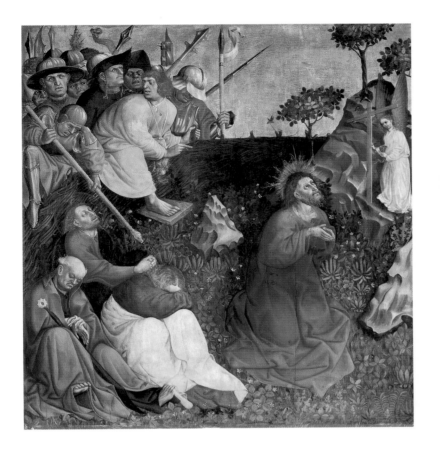

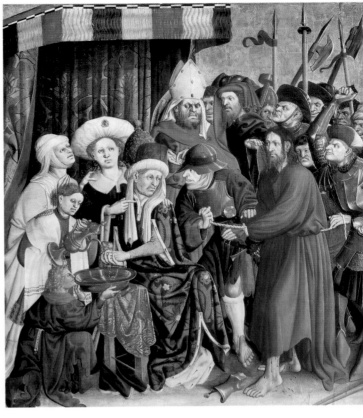

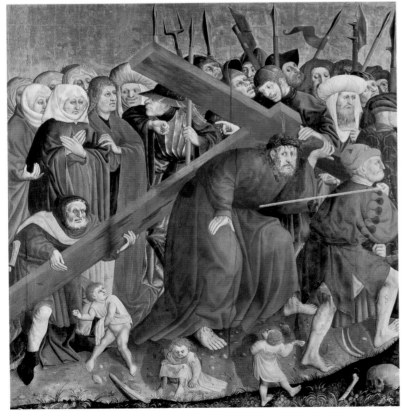

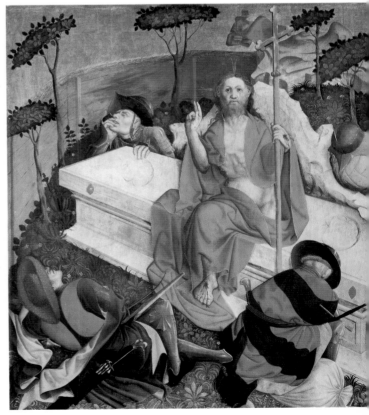

The Agony in the Garden (top, left)
Christ before Pilate (top, right)
The Way to Calvary (bottom, left)
The Resurrection (bottom, right)

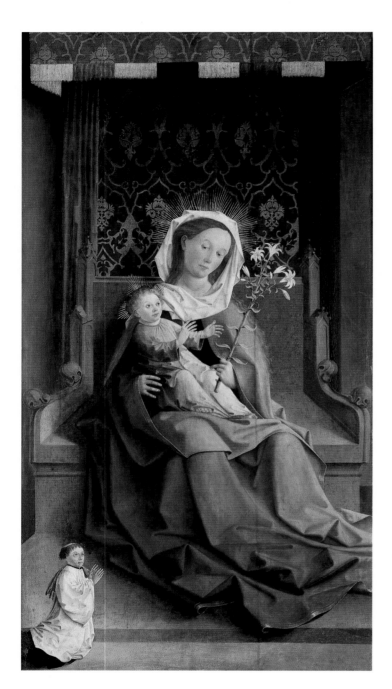

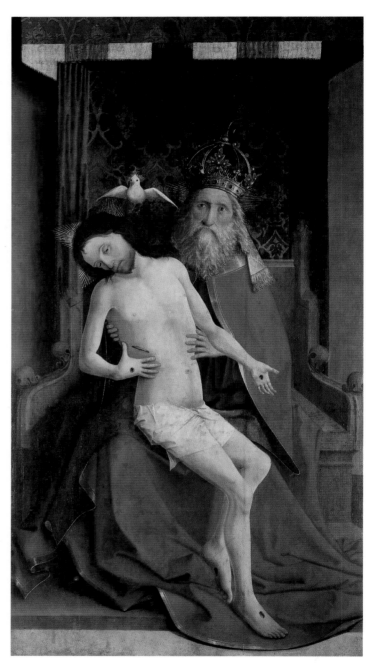

MASTER OF THE DARMSTADT PASSION
Middle Rhenish, active mid-fifteenth century
Four panels from the *Darmstadt Altarpiece*, 1440–50:

Outer wings (above)
Virgin and Child Enthroned (left)
The Throne of Grace (right)

Inner wings (opposite)
The Epiphany (left)
Constantine and His Mother Helena Venerating the True Cross (right)

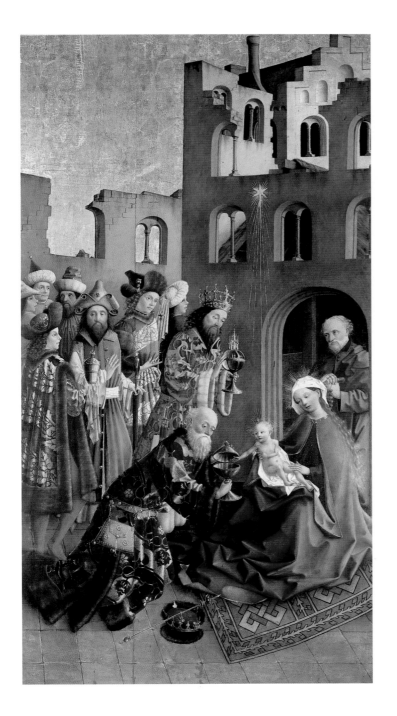
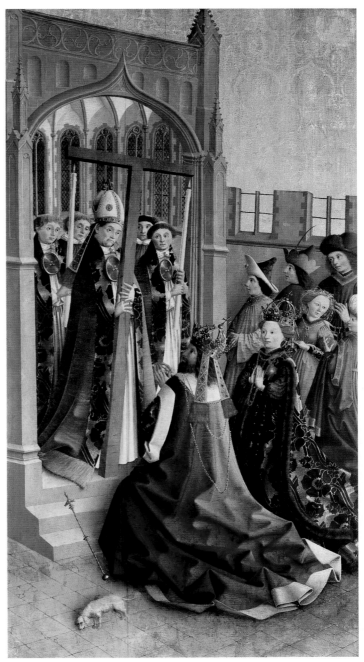

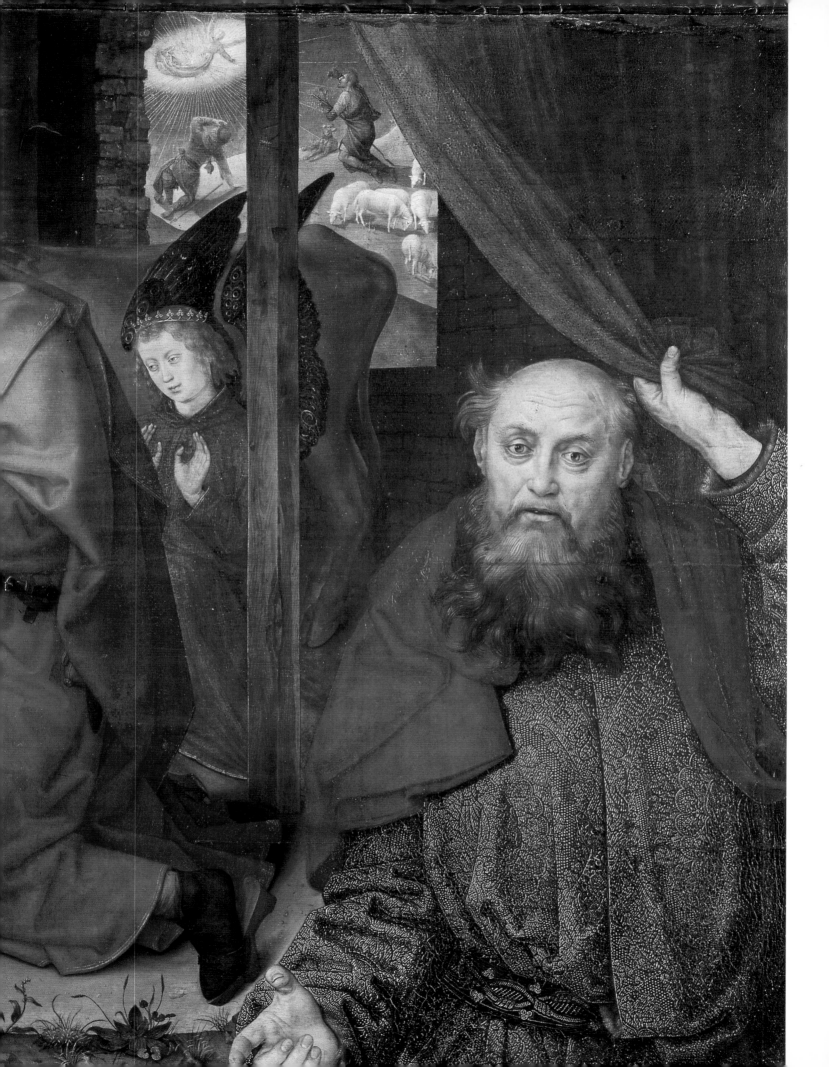

Gothic Master of Renaissance Melancholy: Hugo van der Goes

THE MOST perceptive and original Northern artist of the later fifteenth century, Hugo van der Goes, occupies a unique position in painting's history because of his insight into character and class and through his intensely observant, almost surreal, rendering of nature and space. Hugo headed the painters' guild in Ghent and soon benefited from the patronage of the duke of Burgundy in Bruges. This was later continued in Brussels by the duke's daughter Mary and his son-in-law Maximilian. It was here that the Master of the Joseph Roundels (84) and Colijn de Coter perpetuated Hugo's art until the century's end.

Berlin has the world's most varied collection of works by van der Goes and his circle. These include Hugo's masterpieces: two large panels and an important fine canvas. Outstanding examples by painters close to Hugo are those by Geertgen tot Sint Jans (91, 93) and the Master of the Virgo inter Virgines (84), who were active in the North Netherlands; by the Bruges Master of 1499 (84); and Bermejo's *Death of the Virgin* (85).

Hugo's paintings were often on very fine canvas, a light, delicate support that made them readily transportable. Many went to Italy, including *The Small Deposition*, a diptych whose right half shows *The Lamentation* (81) with the three Marys and St. John the Evangelist. In the left section (New York, Wildenstein & Co.), the dead Christ, supported by Nicodemus and Joseph of Arimathaea, is taken from the cross. Typical of Hugo's daring is the cropped, close-up, "accidental" way in which this dual image is presented, with the immediacy and often tragic proximity of photojournalism. Paintings like these, in water-soluble colors on canvas, were usually rendered in paler, cooler tints than those on panel. Works in gouache on canvas tend to be less hardy than those on wood, and hence less well preserved.

Like van der Goes's vast *Portinari Altar* (Florence, Uffizi) of c. 1475–76, the *Monforte Altar* (82–83), his next-largest work, may also have been painted for export; it was long preserved in Monforte de Lemos, the northern Spanish monastery from which it was bought in 1914, paid for with a wagonload of silver bars. The altar's brilliant color led the monks at Monforte to ascribe this *Adoration of the Magi* to Rubens, which is not as unlikely as it sounds since Hugo's art was especially revered in Rubens's Antwerp. The earlier master may well have been active there, in addition to Ghent, Bruges, Brussels, Cologne, and Dijon. The *Monforte Altar* is among Hugo's most virtuosic works, second only to the huge *Portinari Altar*.

In *The Adoration of the Shepherds* (80–81), Mary's profound melancholy is unrelieved by the wealth and recognition proffered by the Magi. The artist's loving treatment of flora, so close to Dürer's own, must have impressed the Nuremberg master on his Netherlandish journey. Since then, the altar has been cut down at the top and lost its wings. They showed *The Circumcision* and *The Presentation in the Temple*.

This long, narrow panel combines the subjects of the Nativity and the Adoration of the Shepherds. Possibly placed below a large altarpiece, or perhaps functioning as an altar frontal, it was almost certainly not an independent scene. Teeming with mysteries, van der Goes's complex image shows the Infant with arms outstretched as if already crucified; a bundle of wheat nearby alludes to the Eucharist.

Hugo's dramatic presentation suggests the overt theatricality of a mystery play. The biblical concept of revelation — quite literally the drawing back of a curtain (its rod having been actually built up into the third dimension by raising the gesso or applying a wooden strip across the surface) — is made pos-

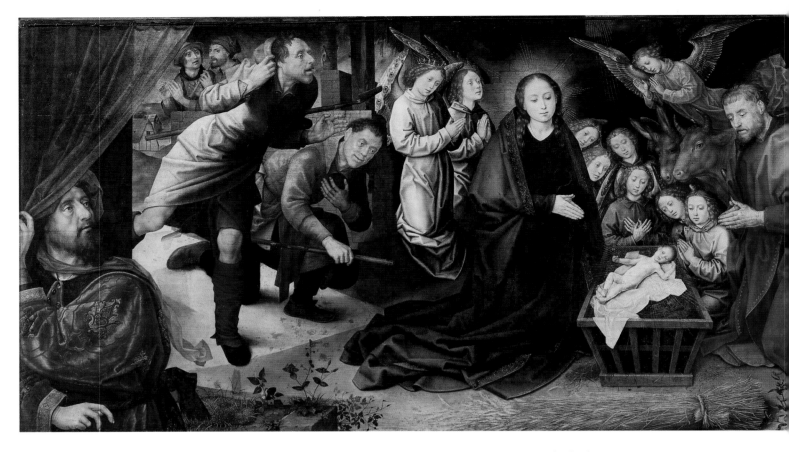

HUGO VAN DER GOES, Ghent, c. 1440/45–Red Cloister, near Brussels, 1482, *The Adoration of the Shepherds*, c. 1480

sible by the prophets at the far left and right of the central subject, who have made it visible by pulling back the veils. These may actually refer to the curtains that often screened altars between performances of the Mass. As Hugo went to Dijon, he would have seen prophets by Claus Sluter, the great sculptor from Haarlem, so closely followed by van der Goes for his own figures.

The *Monforte* and *Portinari* altars both deal profoundly with the shepherds' stunned fusion of veneration and ignorance. Here Hugo's study of peasantry may have alluded to the fact that wool was the European economy's central staple.

Following van der Goes's facial types and sense of motion, the Master of 1499 painted a little *Annunciation* (84), bearing witness to his keen appreciation for the older artist's insights, which he studied in both Ghent and Bruges. Six large tondi by the Master of the Joseph Roundels, though stiff in style, also follow van der Goes's guidelines. This artist's series of scenes from the life of Joseph were painted in Brus-

sels between 1470 and 1500. He may be Jacob van Latham, court painter to Philip the Fair.

Four of these roundels are in Berlin, the others in the Metropolitan Museum and an unknown collection. Asenath (84), daughter of a priest of On, has locked herself in a tower to worship pagan idols. Falling in love with Joseph, she married him after throwing her idols from the tower.

North Netherlandish artists such as Geertgen tot Sint Jans and the Master of the Virgo inter Virgines responded to different aspects of Hugo's oeuvre. The first, in his naive *Madonna and Child* (91), continued van der Goes's groupings, if not his psychological penetration; the second extended the master's original palette and moody figures along more mannered paths, as seen in *The Adoration of the Magi* (84).

Possibly active in Delft and Gouda as well as Amsterdam between 1470 and 1500, the Master of the Virgo inter Virgines is the most independent of Hugo's North Netherlandish followers. While he is keenly aware of the earlier artist's psychological

HUGO VAN DER GOES, *The Lamentation (The Three Marys and John the Evangelist)*, c. 1480

insights, Hugo's North Netherlandish disciple adds his own austerity and pessimism.

The Virgo Master's *Adoration of the Magi* is somewhere between a puppet play and a takeover plot, which, in a sense, is what it proved to be. The sinister and the tragic underlie this moment of cosmic recognition, so much sadder than Hugo's *Monforte Altar* (82–83) of the same subject. This sinister pictorial response to biblical narrative is entirely characteristic of the Virgo Master.

Gerard David (87) and Hans Memling (89), Bruges's leading later-fifteenth-century masters, along with the Iberian Peninsula's greatest artist of the time, Bartolomé Bermejo, all took to heart Hugo's cool yet emotional color and profound psychology. A very small yet powerful Berlin panel, *The Death of the Virgin* (85), suggests Bermejo's variant of a major work by Hugo (Bruges, Groeninge Museum).

French painters of the fifteenth century were also close to van der Goes's art. Berlin has major works by the Master of St. Gilles (85) and by Jean Fouquet (98), both emulating the exquisitely cool but emotional color of the Netherlandish artist, whose evocative use of space and sensitive scrutiny of physiognomy is here felt far beyond the southern Netherlands.

Hugo is known to have traveled to Cologne in 1481 with several of the Augustinian monks whose order he joined as a lay brother. An *Epiphany* (85) painted in Cologne around 1500 by the Master of the Aachen Altar may well reflect some lost commission that van der Goes might have delivered there.

An unidentified Ghent artist, despairing of his inability to equal the van Eycks' altarpiece in that city, committed suicide. Hugo seems to have done so too, when he was attached to the Augustinian Red Cloister in Brussels. Were these despairing painters one and the same?

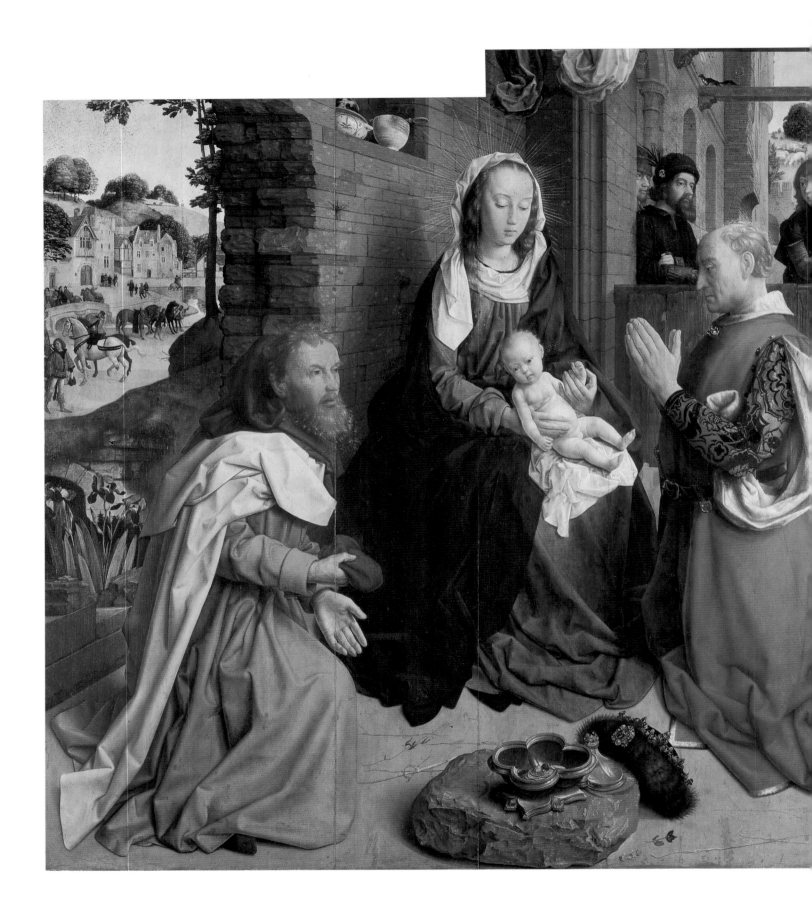

HUGO VAN DER GOES
Monforte Altar (The Adoration of the Magi), c. 1470

MASTER OF 1499
Bruges (or Ghent?), active end
of fifteenth century
The Annunciation

MASTER OF THE JOSEPH ROUNDELS
Brussels, active c. 1500
Joseph and Asenath, c. 1500

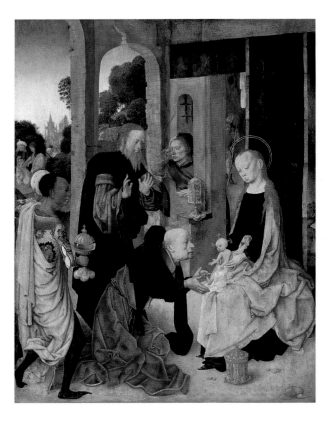

MASTER OF THE VIRGO INTER VIRGINES
northern Netherlands, active 1470–1500
The Adoration of the Magi, c. 1485

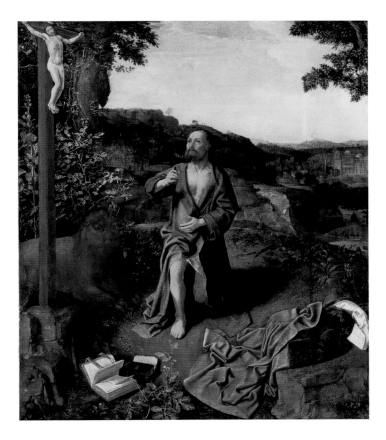

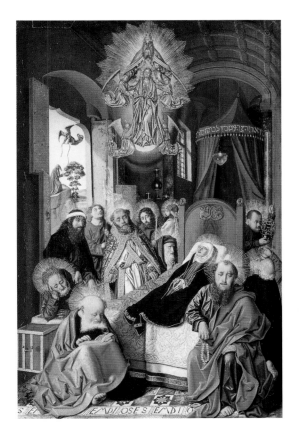

MASTER OF ST. GILLES
Paris, active c. 1500
St. Jerome Penitent, c. 1500

BARTOLOMÉ BERMEJO
Córdoba (?), c. 1440–c. 1500
The Death of the Virgin, c. 1460–62

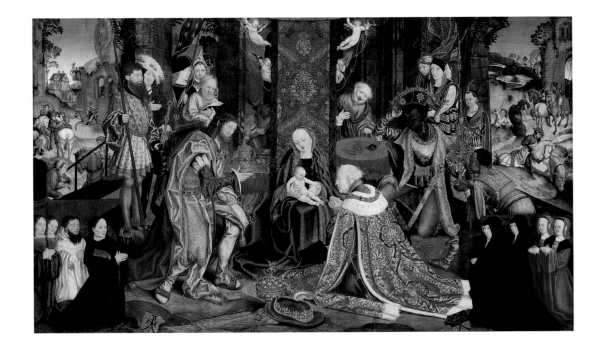

MASTER OF THE
AACHEN ALTAR
Cologne, active c. 1500
Epiphany, c. 1510

Recollection in the Tranquility of Bruges

Artists from the northern Netherlands and Germany led the prosperous painters' colony of this major inland seaport near the river Scheldt. Like the School of Paris, none of Bruges's major masters could claim local birth: Jan van Eyck came from what is now eastern Belgium, Christus from near the northern border, David from Haarlem, and Memling from Germany. But for David, Bruges's post-Eyckian generation is one of Little Masters, many of whom were eponymous — known and named for their modest works.

Typical of the city's innumerable lesser masters is one named after a cycle of scenes from the legend of St. Barbara. His *Epitaph for the Nun Janne Colijns* (88) is a poignant reminder of the fact that few early paintings were pictures in our contemporary sense of the word. Almost all had commemorative functions, recording events, ancestry, marriage, birth, and death. This pictorial epitaph hung near the well-born nun's burial place. Janne is shown at the lower right, praying before the Ecce Homo, her coat of arms just below Adam's skull of Golgotha, which also functions as a "Vanitas" to temper familial pride.

By 1500, Gerard David — a close student of Eyckian techniques and Goesian subtleties — had made a rich career for himself in Bruges, from whence he traveled to Italy for major commissions. David seldom hesitated to go back to far earlier images, and such enlivening archaisms infused what by then had become a somewhat placid, if not downright stale, facility, by then all too characteristic of the School of Bruges. These old/new elements were stimulating reminders of the early genius of Jan van Eyck or Robert Campin, and David's return to such art of the good old days is evident in a large *Crucifixion* (87), where many of the figures hearken back to the most inventive masters active long before. This is

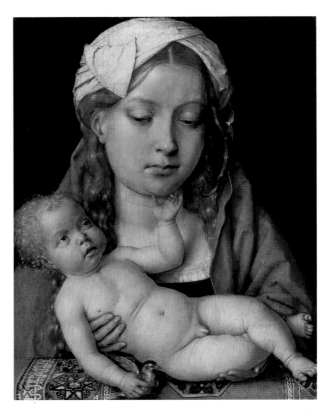

MICHIEL SITTOW, Reval, Estonia, c. 1469–1525
Madonna and Child, c. 1515

Opposite:
GERARD DAVID
Oudewater, near Gouda, c. 1460–Bruges, 1523
The Crucifixion, c. 1515

seen in such features as the oblique placement of the cross and the garb of the Roman soldiers, and from details like the lively dog digging up Adam's bones, at the right, buried at the base of the cross, his skull giving the site the name of Golgotha. The panel's top seems to have been rounded off at a later date, adding an excessively harmonious touch alien to the otherwise staccato composition.

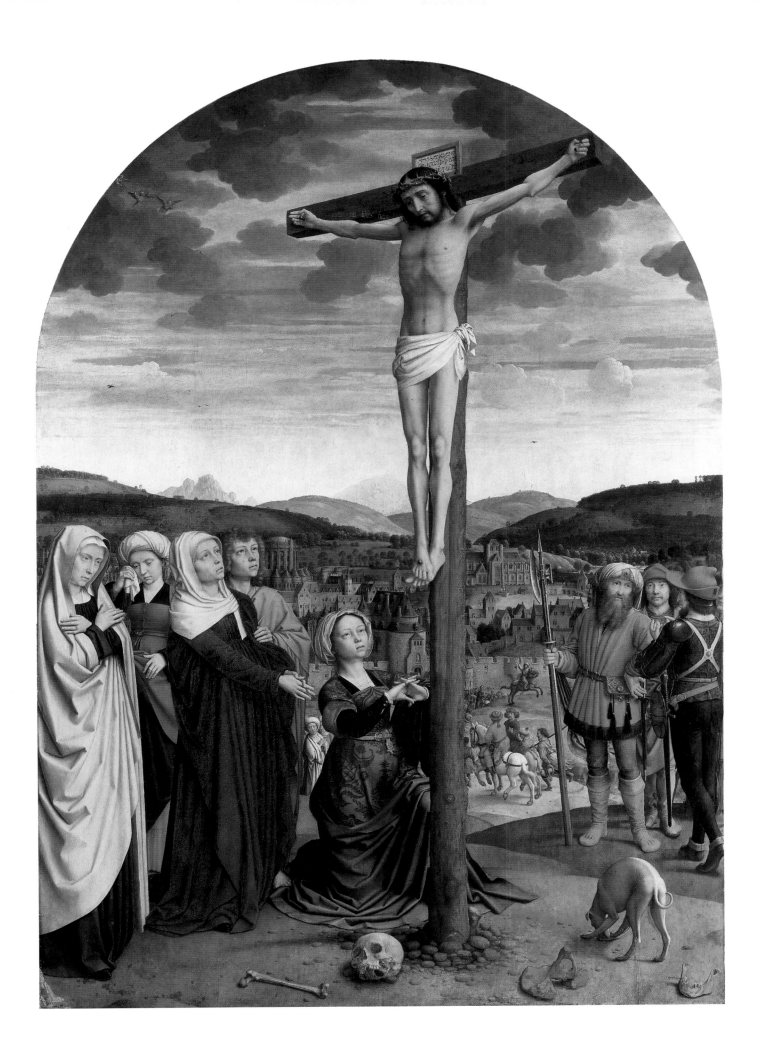

MASTER OF THE LEGEND OF ST. BARBARA
Bruges, active 1470–1500
Epitaph for the Nun Janne Colijns, c. 1491

One painter who came from as far away as present-day Estonia to study in Bruges was the unusually adroit technician Michiel Sittow. His smoothly painted *Madonna and Child* (86) is the left half of a diptych, the right panel of which shows the Spanish donor, Don Diego de Guevara (Washington, National Gallery). Though many Eyckian elements are still in evidence, the new arts of Italy are also clearly stated, such as the Child, who is very Florentine in character.

The School of Bruges was ever popular in the fifteenth century. It got off to a flying start with the incomparable art of Jan van Eyck and was continued by his successor, Petrus Christus. The formulaic but appealing painting of Hans Memling was con-

servative, technically highly skillful, and spiritually reassuring. His was the other side of the coin of later Netherlandish painting as represented by the work of Hugo van der Goes and Rogier van der Weyden, whose paintings may display anxiety or aristocratic introspection.

Born near Cologne, where he probably received his first training, Memling may have gone to Brussels, where he worked with van der Weyden; he would then have gone on to Bruges, where he became extremely and deservedly successful. His was and is an art that proclaims, "All's right with the world," a message that appealed equally to Northern, Italian, and Spanish patrons through its sweet equilibrium. At the peak of his career, Memling

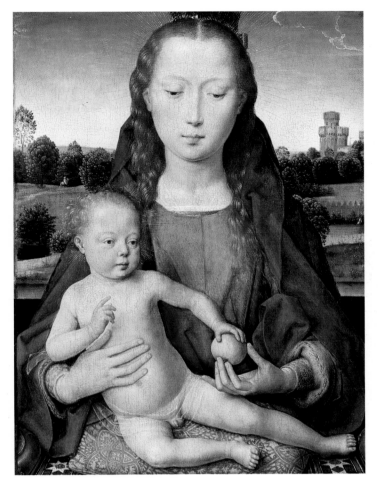

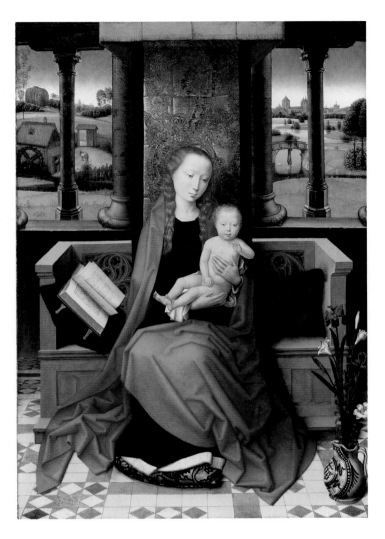

HANS MEMLING
Seligenstadt, near Frankfurt-am-Main, c. 1435–Bruges, 1494
Madonna and Child, 1487

HANS MEMLING
Madonna and Child Enthroned, c. 1480–90

may already have assumed a certain nostalgia, close to a Gothic revival — approximating, in the happiest sense, a Burgundian déjà vu that allowed the foreign patron or collector to associate himself or herself with a more modest variant of the opulence and substance of ducal high life.

Often working for Italian and Spanish clients, Memling was also open to such Renaissance elements as a new sense for abstract form, and for the characterization of the Child that was close to these foreign sources. His *Madonna and Child* (89), painted for Benedetto Portinari, was originally a diptych flanked by a portrait of the donor. His patron saint, Benedict, was seen on the cover of the altar (both now in the Uffizi).

An impromptu throne has been made from a bench for a *Madonna and Child Enthroned* (89), a cloth of honor draped behind the subjects. While it is unquestionably beautiful in detail — in such features as the flowers in an Italian ceramic vessel, or the wonderfully painted open holy book and a vibrant landscape — this picture no longer hangs together, as if the artist selected random motifs from his pattern book but could not quite create a unifying setting.

Even before the impact of the later Italian Renaissance was felt in the Lowlands, the art of the Northern region had become exhausted from within. Neither conviction nor invention sufficed to sustain the achievements of the masters of the past.

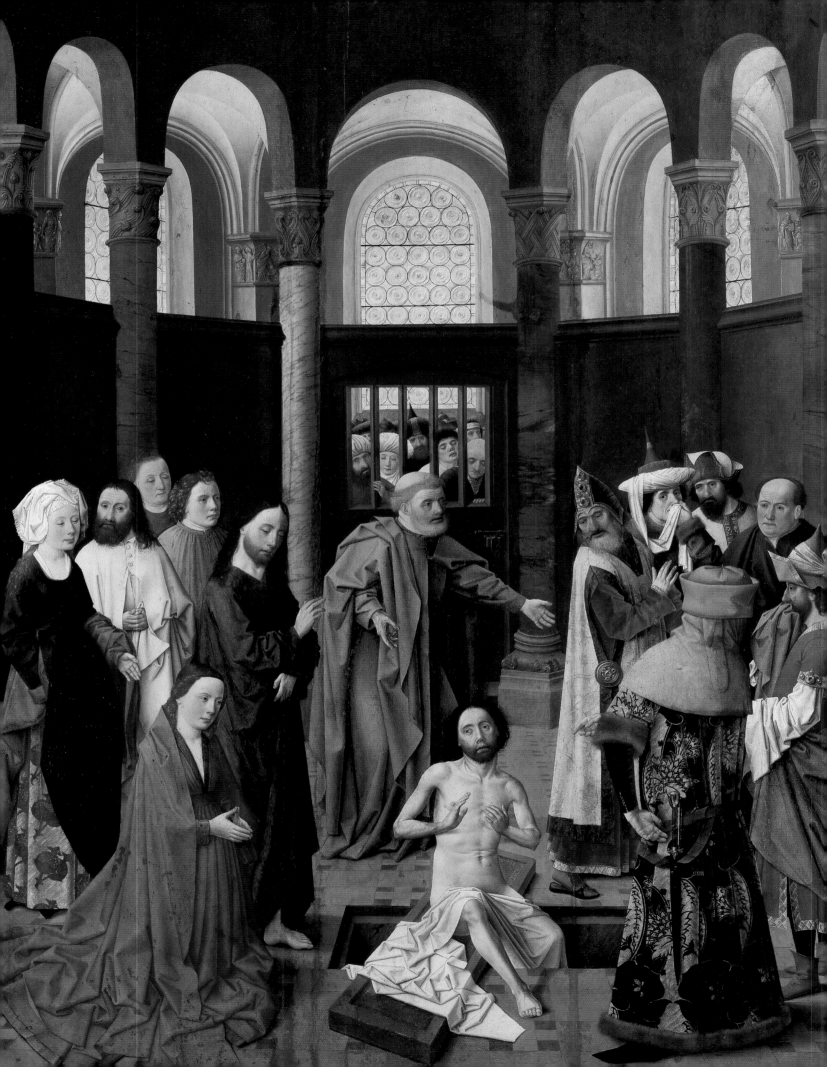

Plain Truth: North Netherlandish Old-time Religion

Until the burgeoning of foreign trade, the northern Netherlands were far poorer than the southern territory comprising present-day Belgium. Without courtly opulence to rival that of the Burgundian dukes, fifteenth-century art of the Lowlands to the north was characterized by a certain austerity and primitivism, sharply observed characters, and an overall impression of simplicity close to studied illiteracy. Many gifted painters such as Petrus Christus, Dieric Bouts, and Gerard David left this region to work in Bruges or Louvain, where they could count on more abundant patronage and easier lives.

Berlin has the sole surviving painting of the otherwise almost legendary Aelbert van Ouwater of Haarlem. His amply documented *Raising of Lazarus* (*90*) is a large, well-preserved panel. Close to the art of Dieric Bouts, who came from the same center, this work is rendered in a less-courtly fashion than works by Bouts. The scene is set within a Romanesque apse, reflecting the medieval tradition of burial within the church. Here Aelbert follows a contemporary convention linking that early building style to the Synagogue. (The Gothic was tied to the Church.) Christ blesses the raised Lazarus, whose sisters Martha and Mary are to the left with three apostles; Peter is at the center, the rabbis to the right.

Two major examples of the endearing art of Geertgen tot Sint Jans of Haarlem are in Berlin. The paintings by this lay brother of the Order of St. John follow some of the lines laid down by another lay brother, Hugo van der Goes (*80–83*). Geertgen reworks Hugo's models in charmingly simple fash-

Opposite:
AELBERT VAN OUWATER
Oudewater, near Gouda (?), c. 1415–Haarlem, c. 1475
The Raising of Lazarus, c. 1450–60

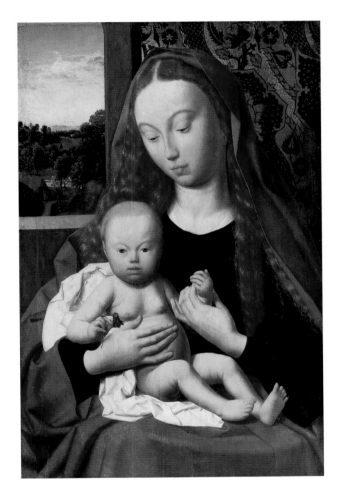

GEERTGEN TOT SINT JANS
Leiden (?), 1460/65–Haarlem, before 1495
Madonna and Child

ion. In a very large-scale panel, a pensive Madonna and Child (*91*) share a sad reverie, indicated by the columbine that Jesus clutches. Also known as ancholie, the flower symbolizes introspection or melancholy.

Equally introspective is a pensive panel of St. John the Baptist in the Wilderness (*93*), possibly painted for the artist's own devotional use. Sitting

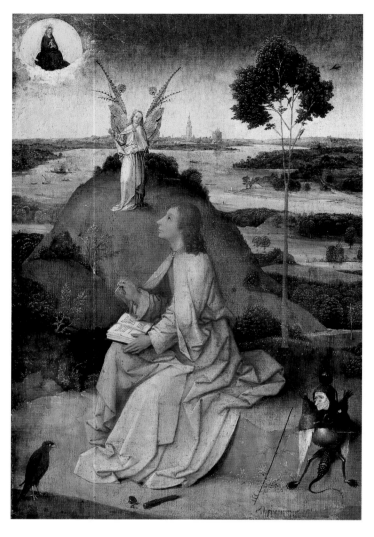

HIERONYMUS BOSCH
's-Hertogenbosch (?), c. 1450s–'s-Hertogenbosch, 1516
St. John on Patmos, c. 1485–90
Verso: *Scenes from the Passion of Christ*, c. 1485–90 (above, right)

alongside the little Lamb of God, the moody Baptist is placed in a landscape teeming with birds and rabbits, its abundant foliage seeming more stitched than brushed.

Hieronymus Bosch, whose cunning naïveté personifies the almost Puritan quality of North Netherlandish art, is well represented in Berlin by *St. John on Patmos* (92), whose vision of the Woman of the Apocalypse is seen at the upper left. On the back of the panel is the Pelican of Piety (92). This scene takes place within a flooded Dutch landscape, indicating the end of the earth. Representing

Christian sacrifice for salvation, that bird is seen near the center of a cosmic circle, where it strikes its breast to draw blood with which to nurture its young. Beginning with the Agony in the Garden (roughly at three o'clock), the cycle of salvation is read clockwise, ending with the Entombment, at about two o'clock.

This grisaille orb, with its intricately devised Passion cycle, suggests a reworking of Eyckian ideas, which is also found in Bosch's *Garden of Earthly Delights* (Prado); the outer wings of that surreal altar also depict a cosmic image in grisaille.

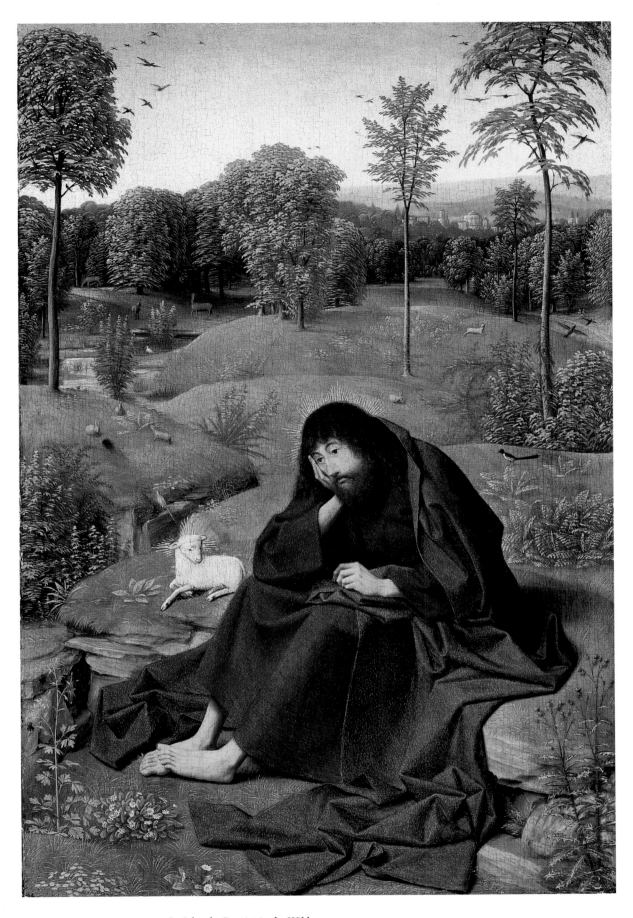

GEERTGEN TOT SINT JANS, *St. John the Baptist in the Wilderness*

Early French Choice

THERE is very little very early French painting in Berlin for the good reason that there's very little anywhere but the Louvre. But, as butchers of yore said, what Berlin does have is "choice." First of these paintings is a relatively large canvas — perhaps the earliest surviving work on that support from France — of a *Virgin and Child with Angels* (95). Monumental in feeling, this group is close in style to Jean Malouel, court painter to the dukes of Burgundy between 1397 and 1415, and it may come from his hand. He was uncle of the three Limbourg brothers, illuminators of the duc de Berry's *Trés Riches Heures* (Chantilly, Musée Condé). Emerging in obscure circumstances in a Berlin church at the end of World War II, this painting, on perpetual loan to the Gemäldegalerie, is one of European art's greatest rarities.

The canvas has a memorable background of moths, the symbol of death and resurrection, which were seen originally against a bright blue that has darkened with time. Dating near 1410, it follows the gracefully hieratic mode of the International Style, seen especially in the cascades of calligraphic drapery and the elegantly elongated fingers of Mother and Son.

Known in Italy as tondi, paintings in circular format were particularly popular in France around 1400, as they were associated with cosmic authority, and with the then current idea of the "mirror of majesty," since early looking glasses were circular in format. The powerful associations of the circular are particularly apt for a *Coronation of the Virgin* (94) in which Christ's orb, along with Mary's crown and halo, all echo the panel's round confines. Christ is seated under a regal canopy, its curtains drawn by paired angels. These imperial attributes are in striking contrast to his bare head and feet. Mary, kneeling before him, her train held by an angel in

French, *The Coronation of the Virgin*, c. 1410–15

acolyte's robes, is about to be sprinkled with holy water.

Jean Fouquet's portraiture is the finest from mid-fifteenth-century France, and the very best of all may be his *Estienne Chevalier with St. Stephen* (98). This is the right half of the *Melun Diptych*, whose *Virgin and Child* is in Antwerp's Koninklijk Museum voor Schone Kunsten. The altar was installed in the funerary chapel of Estienne Chevalier at the cathedral of Melun. The Virgin's features have long been believed to be those of Agnes Sorel, mistress of Charles VII, who died in 1450.

Born in Melun, from one of the most powerful French families, Estienne Chevalier was ambassador to England (1445), treasurer of France (1451), and then secretary of state. He was also among Fouquet's major patrons, commissioner of the artist's *Heures*, his finest manuscript, now at Chantilly

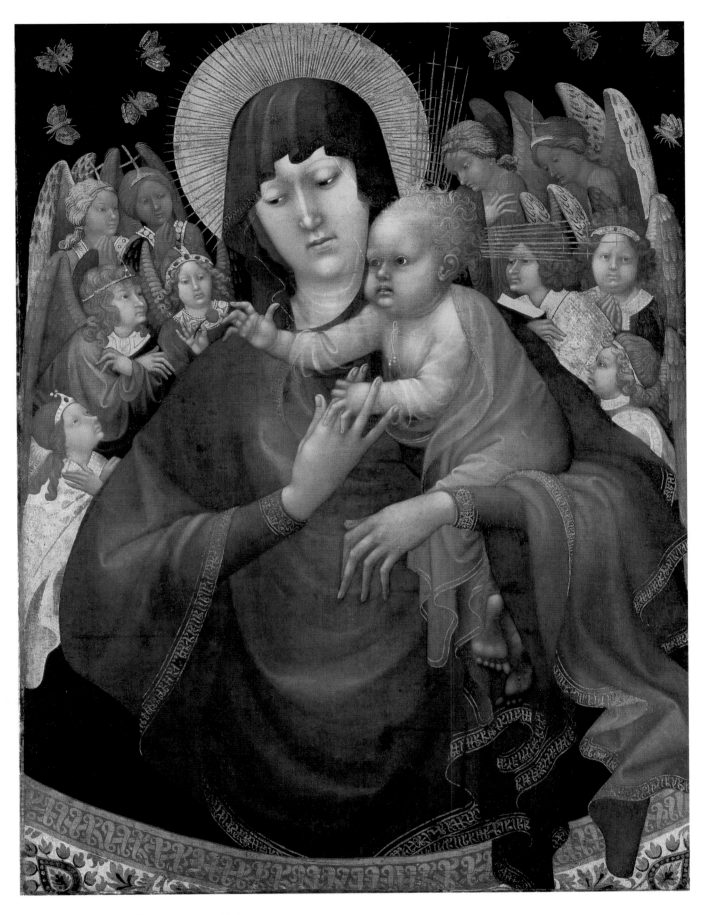

JEAN MALOUEL (?), Nijmegen, c. 1370–Paris, 1419
Virgin and Child with Angels, c. 1410

(Musée Condé). Early in the nineteenth century, both the manuscript and the Berlin portrait were in the Brentano Collection in Frankfurt, an important center for the Gothic Revival.

Fouquet's setting is close to that of mid-Quattrocento architecture, his approach to portraiture also partly determined by the art of Fra Angelico and Piero della Francesca, both active in Rome near the time of the French painter's Roman residence, when he was the papal portraitist.

Berlin also has the major panel paintings long convincingly ascribed to Simon Marmion, who was, like Fouquet, a manuscript illuminator. These are the wings of an altarpiece from the Benedictine abbey at St. Omer (96–97), which are devoted to the life of its patron, St. Bertin. Supposedly they were so coveted by Rubens that he offered to cover their surface with gold coins as his purchase price.

Originally the wings protected an altar made in silver-gilt relief. Nine scenes from the birth to the death of the saint read from left to right. The altar's patron, Bishop Guillaume Fillastre, who was also abbot of St. Bertin, is shown kneeling at the far left. St. Bertin's investment in the Order's robes, at Luxeuil, is the third scene from the left; in the fourth he is received as a pilgrim at Thérouanne; to the right of that is the dedication and building of a new Benedictine monastery. On the right wing, the far left scene depicts Bertin separating wine from water and the next two show him admitting converts to the Benedictine Order. Following those, St. Martin of Tours expels demonic Temptation from the monastery (the seductress is seen to the right, a lady in courtly attire betrayed by her clawed feet).

With the abbey's dissolution, the altar was removed and sawed apart. The wings' uppermost ends are now in the National Gallery, London, the left of which shows an angelic chorus; the other represents Bertin's soul as it is borne to Heaven. Berlin's erudite curator Reiner Hausherr has reconstructed the altar's original appearance, placed within an elaborate frame of wood and wrought

SIMON MARMION
Amiens (?), c. 1420/25–Valenciennes, 1489
Wings from the altar of the Abbey of St. Bertin
at St. Omer, c. 1459

iron. Painted on the exterior of each long wing, shown as if they were stone reliefs, were grisaille prophets of the coming of Christ, along with his ancestors, with *The Annunciation* seen at the center.

Like illuminations cut from their text, these little scenes don't quite stand alone, a certain tentativeness justifying their attribution to Marmion. He is known to have resided at Valenciennes in 1458, where the wings were completed the following year. Just as Fouquet provided illuminations as well as paintings for Estienne Chevalier, Marmion also worked in both media. His *Grandes Chroniques de St. Denis* (St. Petersburg, National Library) was ordered by the wings' patron, Abbot Guillaume Fillastre, as a gift for Philip the Good of Burgundy.

Were a Boschian *Last Judgment* to be updated to suit a Raphaelesque taste, the result might well resemble an early-sixteenth-century triptych by the

Franco-Flemish master Jean Bellegambe of Douai (*99*). Though employing both late-Medieval and High Renaissance manners, the artist is not at home with either, having lost his native heritage in pursuit of a new one. Assimilation is a perilous process, particularly when it is dependent upon derivation from secondhand sources. Bellegambe's Roman Renaissance information came from consulting reproductive prints by Marcantonio Raimondi and other artists working after Raphael. With the ravages of the Reformation, very few paintings in this manner survive. Berlin's Bellegambe is the major monument to a critical moment in French faith and culture.

Like so many painters active in Renaissance and late-medieval France, Corneille de Lyon was actually from the Netherlands, born in The Hague. His exquisite, very small portraits have a Holbein-like precision, but a far greater chic. They may have

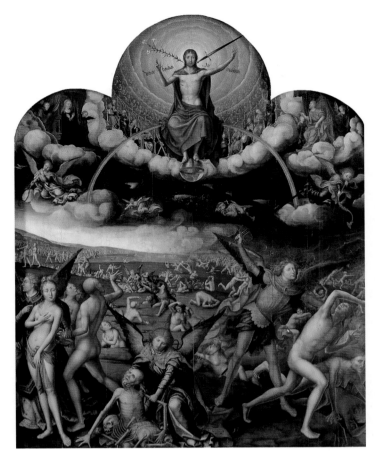
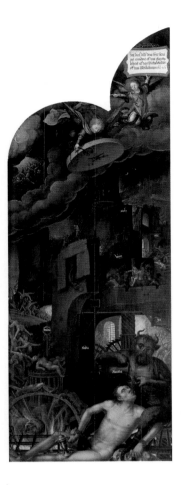

JEAN BELLEGAMBE, Douai (?), c. 1470–c. 1534
The Last Judgment, c. 1525

been collected in quantity by his contemporaries, as were the portrait drawings of the French nobility drafted by his fellow Netherlanders, the Clouets. The equivalent of the society photographs of later centuries, most of Corneille's formulaic little panels employ a dark green background, as in Berlin's *Young Lady* (99), and they tend to stop just above the waist. Along with miniatures on ivory or parchment, these somewhat larger-scaled likenesses lent themselves to ready transportation. There is a magical fusion of proximity and distance in Corneille's exquisite little paintings, a special, elegant intensity that gives them great appeal, explaining why so many works attributed to Corneille de Lyon are really late-nineteenth-century forgeries.

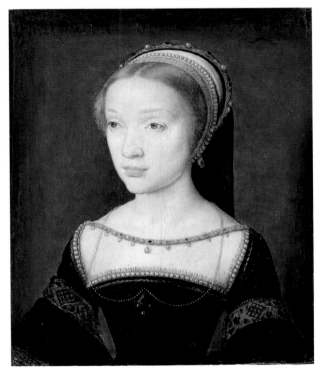

CORNEILLE DE LYON, The Hague, active 1533–Lyon, 1574
A Young Lady

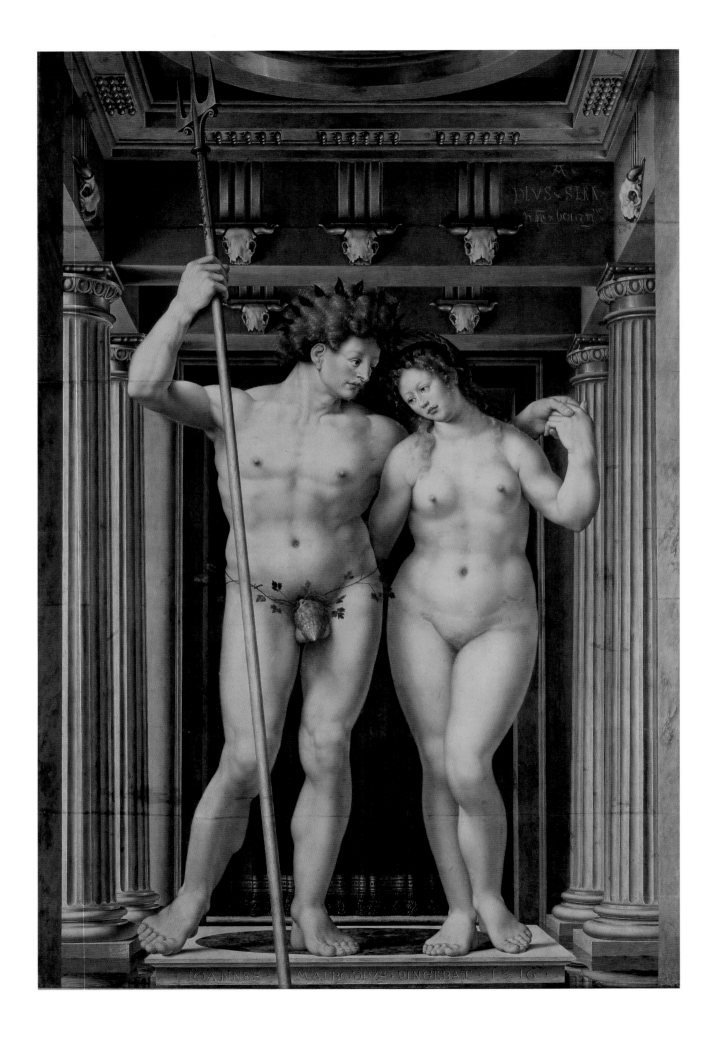

CARVED IN IVORY AND MARBLE: GOSSAERT'S EROTIC ARTS

JAN GOSSAERT was the first of the so-called early Netherlandish artists to incorporate High Renaissance references without losing his heritage. These new elements came from having a rich, sophisticated patron, Philip of Burgundy, admiral of Zeeland, who had the means to take Gossaert along to Italy in 1508. There the artist drew after antiquities as well as contemporary works.

Philip was also given the wealthy diocese of Utrecht. He craved erotic art, much of which was installed in his château at Souburg. Happily, Gossaert's slick technique and ductile forms were admirably suited to Philip's needs. Whether painting a bold *Adam and Eve* (101) or a more finely wrought *Neptune and Amphitrite* (100), Gossaert's main goal was that of a pictorial primal coupling, a rousing evocation of intertwined limbs and libidos, such nudes devised to excite.

At Souburg, Gossaert worked with the Venetian or German painter known as Jacopo de' Barbari, who was also well known to both Dürer and Cranach. The enigmatic master's nudes, especially those in his fine engravings, come close to Gossaert's, though in which direction the influence flowed is hard to know.

Standing within a classical setting defined by two perfect forms — a circle within a square — the naked, seductive sea god and goddess's maritime kingdom refers to Philip's admiralty. This large panel presents northern Europe's most accomplished assimilation of classical and Renaissance sources since the French art of Fouquet; it is far more assured than Dürer's ventures into the

Opposite:
JAN GOSSAERT
Maubeuge (Hainault), 1470/80–Breda, 1532
Neptune and Amphitrite, 1516

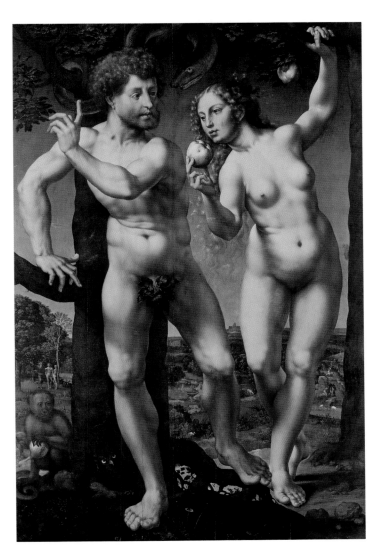

JAN GOSSAERT, *Adam and Eve in Paradise*, c. 1525

Antique. Suitably, the panel is signed in Latinate form, and dated 1516.

The oldest and best excuse for painting the nude was long provided by the Fall of our First Parents, who can still be seen in their stripped state. In Gossaert's panel of that event, Adam is already furnished with an oddly feathered, organic "fig leaf."

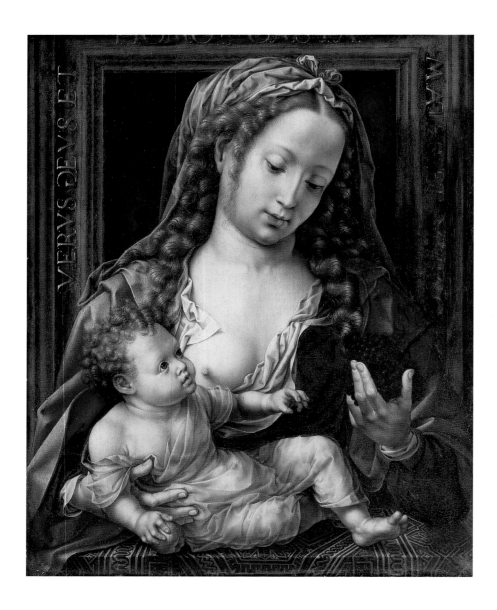

JAN GOSSAERT
Madonna and Child, c. 1530

He objects to Eve's brandishing a large apple before him as the serpent overhead turns menacingly toward him. The couple is rendered in an unstable fusion of verisimilitude and idealism, an attempted corporeal merger of the twin heritages of Netherlandish mirrorlike technique and of Greco-Roman canons. The result comes close to parody in the odd contrast between realistic heads attached to classically marbled torsos and limbs.

The panoramic topography of Paradise seen here is still in the manner of Gerard David (87). An ape, crouching in Adam's corner, will never be one of Noah's passengers, as that species was omitted from the Bible. It may be included here as a form of

signature, as the traditional symbol of Imitation (artists were known as "the apes of Nature"). In a sense, the Fall is another form of foolish imitation, of Eve and Adam's playing "monkey see, monkey do" and so capitulating to the serpent's wiles.

Gossaert was a fine portraitist and Berlin has one of his best, that of a nobleman (*103*) who may be Adolphe of Burgundy, the admiral of Souburg's half-brother and successor. The sitter's cool gaze contrasts with the swirl of emblematic valuables surrounding his codpiece, which is accentuated by the gentleman's gesturing hands. These objects include a ring, short sword with a pommel, keys, and a dagger inscribed "AUTRE QUE VOUS JE

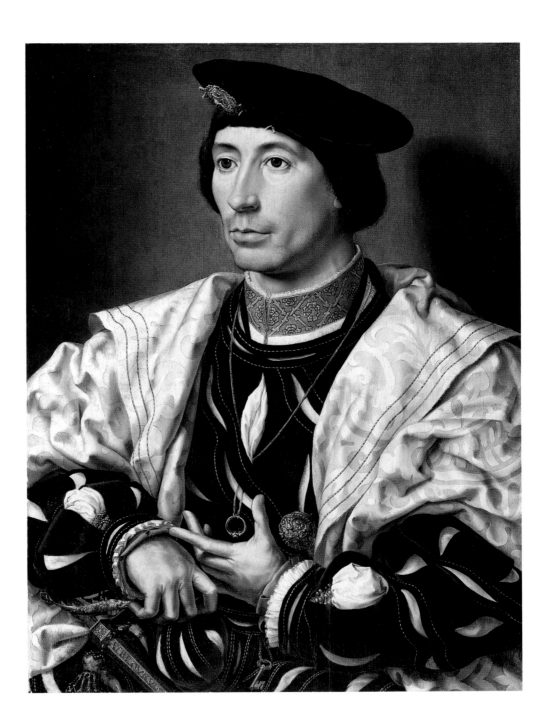

JAN GOSSAERT
*A Nobleman (Adolphe of
Burgundy?)*, c. 1525–28

N'AIME" (I love you only) — an efficient motto for Duke Philip the Good, who enjoyed countless lovers and left innumerable bastards, including Adolphe and his half-brother Philip, who had the château at Souburg. A fish on the swordguard may identify Gossaert's patron as an admiral. Love was literally on the sitter's mind, as a jeweled medal in his cap shows Venus and Cupid.

Very like Michiel Sittow's *Madonna and Child* (86) is one painted by Gossaert (102) near the end of his life. He also takes a virtuosic delight in Italianate and late Gothic detail. Mother and Son are seen against a still-Eyckian trompe l'oeil, reddish-brown stone slab, a fictive frame within a frame.

An *Agony in the Garden* (105), with an unusually youthful Christ, is brilliantly painted as a nocturne, illuminated solely by moonlight. Here, as in several of the artist's later works, Gossaert goes back to a

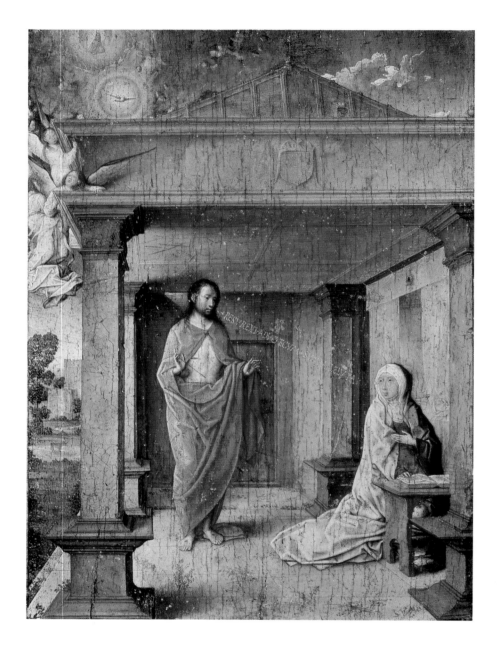

style largely independent of Italian sources. The wings for this central subject are now joined as a single panel and show *The Penitent St. Jerome in the Wilderness* (Washington, D.C., Kress Collection, National Gallery of Art). They, too, are nocturnes. Such consistent illumination in a triptych — within and without — is unusual, if not unique.

A Flemish artist known as Juan de Flandes spent all his known working life in Spain, bringing the Ghent-Bruges tradition to the Iberian Peninsula, where he adapted his work to multiple-unit, very large altars — *retablos* — and to their small-scale equivalents, like the forty-seven-part altar for Isabella of Castile. It was possibly painted in collaboration with Michiel Sittow. Fifteen of the surviving panels are now in Madrid's Royal Palace, with others in London, New York, and Washington. Berlin's shows *Christ Appearing to His Mother* (104). The other members of the Trinity are to the upper left. Mary's house, like the open stages of the later mystery plays, is Renaissance in style.

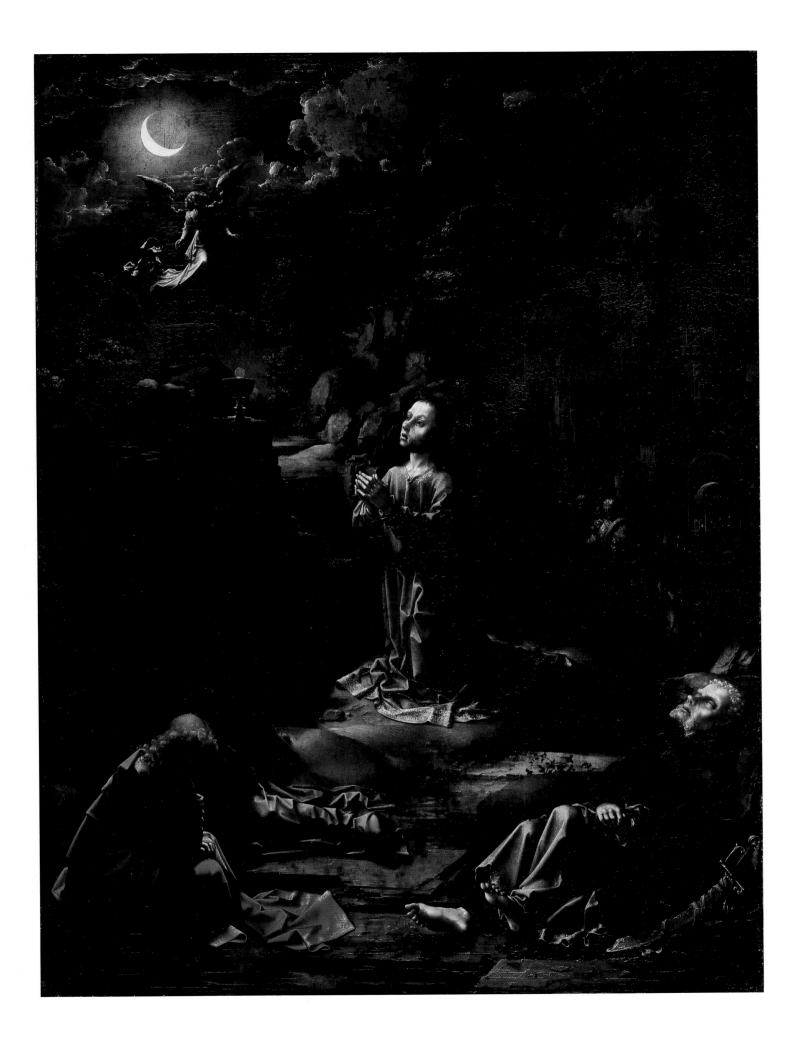

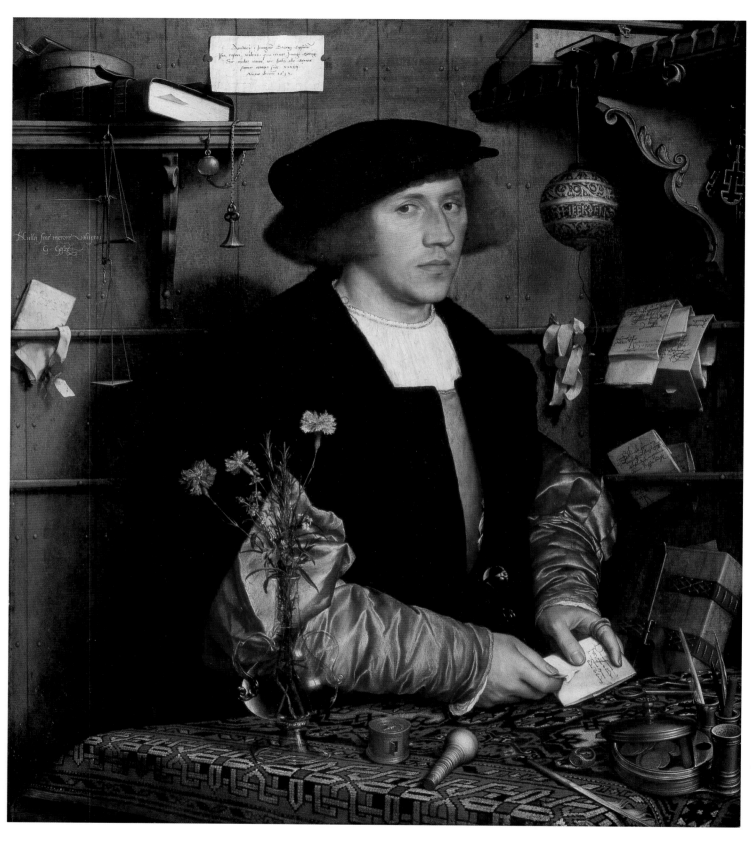

HANS HOLBEIN THE YOUNGER, Augsburg, 1497/98–London, 1543
The Merchant Georg Gisze, 1532

HOLBEIN, CAMERA AT COURT

As son and brother of gifted Augsburg painters, Hans Holbein the Younger had all the advantages of training in an early Northern Renaissance center of rich patronage. That South German city was a hub for banking and for working in precious metals, and Holbein designed many decorative projects for execution in silver, gold, and enamel. Similar studies for illustrations and typography were devised by him for Basel publishers. Much of his life as an artist was spent in England, the Lowlands, Lucerne, and Basel (where Holbein's wife and children lived), before he died in London from the Plague of 1543. Wherever he lived, Holbein attended humanistic circles, befriending Erasmus before he came to know Sir Thomas More. Close to new approaches through classical and Christian learning, the artist was also close to Reformation currents.

Holbein's early travels probably included northern Italy, where his studies could have contributed to the ease with which he employed decorative vocabularies and pictorial formulae drawn from the ancient past. The young painter also responded to the breadth and authority of the Renaissance portrait from Lombardy and perhaps the Veneto. Whether painting German merchants resident in London or French ambassadors to the court of Henry VIII, Holbein combined attributes of class with a vigorous sense of character. When engaged by intricate symbolic references, he never allowed them to eclipse a keen sense for place and person.

Like Jan van Eyck a century before, Holbein recorded the features of prospective noble brides. These paintings show rare sensitivity and individuality, qualities called for because Henry VIII wanted to know these candidates as women more than as dowries, eager to see how they might be in bed as well as on the throne.

Just as Holbein helped define the new portrait ikon, the image of English royal power, so could he convey a tender, informal approach in preparatory studies of sitters drawn on tinted paper, and in less official images, such as the *Lady with a Squirrel* recently acquired by London's National Gallery. At a time of often rigid depiction, following the autocratic directives of the Spanish court (*261*), Holbein exerted a sharp focus upon the inner as well as the outer man and woman. For their sense of quiet confrontation and fidelity, often Protestant in conscience, Holbein's portraits can suggest mirrors of rectitude.

Berlin's most brilliant, best-known Holbein is his likeness of the Danzig merchant Georg Gisze (*106*). The artist uses all pictorial, emblematic, and literary devices to turn this large image into what antiquity characterized as a Speaking Likeness, the same concern seen in the Giorgione inscription (*108*) and addressed in Rembrandt's *Mennonite Preacher Cornelis Claesz. Anslo and His Wife Aeltje Gerritse Schouten* (*368–69*).

Gisze was painted near the beginning of Holbein's second, and final, year of English residence. A *cartellino* attached to the wall with sealing wax is a verse in Greek and Latin, identifying the conspicuously erudite subject: "Distich on the likeness of Georg Gisze. What you see here shows Georg's features and image; his eye is this lively, his cheeks formed just so. In his thirty-fourth year in the Year of Our Lord 1532." A Latin motto, inscribed right on the wall in white, reads, "No joy without its price." A letter opened by Gisze gives his London address as resident of the Steel Yard, the special quarters for foreign, especially Hanseatic, merchants.

Flowers in a Venetian glass vase — carnations, rosemary, hyssop, and cornflowers — represent love and/or engagement, fidelity, purity, and modesty. If not overt references to "Vanitas," the bouquet bespeaks the passage of time and the need for its

*The Merchant Georg
Gisze* (detail)

wise use. The language of the flowers suggests this picture may have been an engagement or wedding portrait, to be sent overseas to Gisze's fiancée. Holbein's encyclopaedic use of emblems — visual symbols largely literary in reference — helps establish the sitter's calling, identity, and state of heart, adding resonance to this quasi-documentary presentation of a prosperous trader "at home abroad."

William H. Köhler noted that the original appearance of the composition may have been like Gossaert's portrait of a merchant (Washington, D.C., National Gallery), as X rays show many changes in the composition; originally Gisze was seen frontally and placed before a corner rather than a wall.

As in so many of his best works, here the painter returns to the magic realism of Jan van Eyck's generation, with its delight in reflections, textures, and shadows. He continues the earlier dialectic of light but embraces the new humanism, the culture of the revived classical gymnasium, with its self-conscious pride in Greek and Latin, its shrewd bonding of profit and erudition.

A late Holbein, dating near the year of his death, probably depicts Duke Anton the Good of Lorraine (1489–1544) (*109*). The image focuses on the subject's face with a minimum of diversion; only the red silk sleeves are allowed to shift attention from the head. Such a very large nose was an attribute of command in the sixteenth century, resembling that of François Ier, Europe's wealthiest king. As the presumed sitter was in François's service, so prominent a feature was doubly desirable.

Though the age of this sitter is compatible with that of the duke's, Anton is not known to have gone to England, nor is Holbein recorded in the Lorraine at the time of this painting. It was owned by the prominent Pre-Raphaelite Sir John Millais. Like their German forerunners the Nazarenes (*57.1–7*), the Pre-Raphaelites modeled their arts on far earlier Italian and Northern painting. It is easy to imagine Millais, with his penchant for magical, quasi-photographic realism, fashioning his work after Holbein's searchingly microscopic manner, one long admired in England.

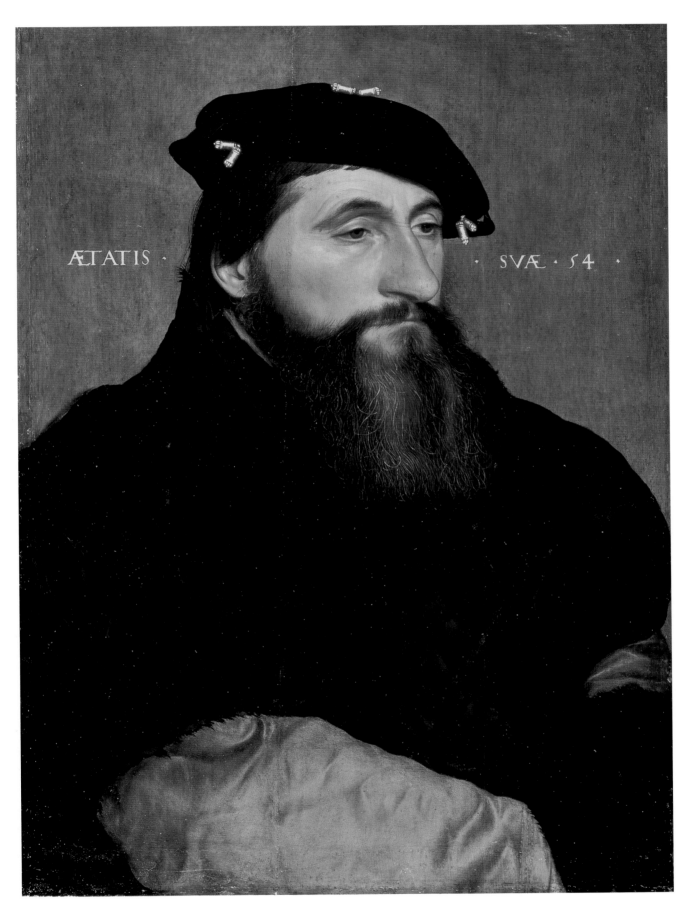

ÆTATIS · · SVÆ · 54 ·

HANS HOLBEIN THE YOUNGER
Duke Anton the Good of Lorraine (?), c. 1543

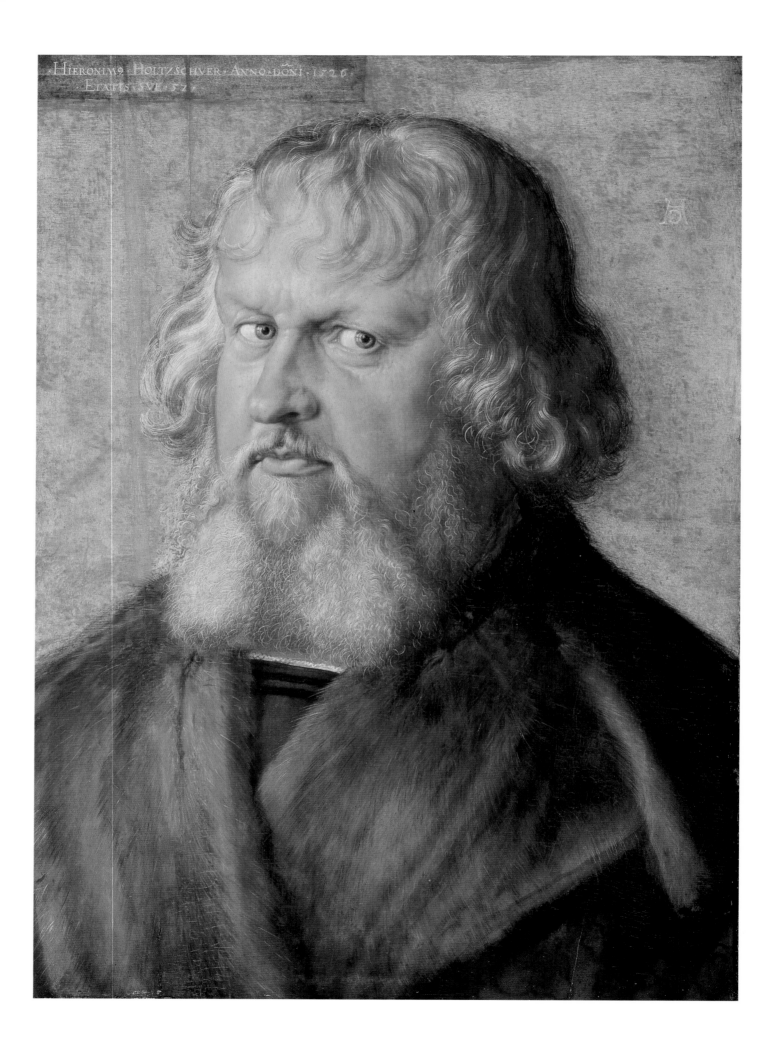

Germany's One-Man Renaissance: Albrecht Dürer

BUT FOR one or two far earlier and anonymous masters, painting in Nuremberg did not amount to much before Dürer. Typical of that school near its early-fifteenth-century best are two panels from the *Deichsler Altar* (687), which was ordered by a member of this family for the city's Dominican church, and probably placed near the tomb of a Deichsler who died in 1419. St. Peter Martyr faces the Virgin and Child, all of them against a symmetrically starred sky. The rendering of the three figures suggests sources in contemporary polychromed sculpture rather than life itself.

Images like these are close in style to works such as the Master of the Presentation's *Christ as Man of*

Sorrows below the Cross (113). This Austrian, his painting datable between 1420 and 1440, has a lyrical tenderness the Nuremberg master couldn't muster. Since both were active at the end of the International Style, theirs is a forthright, provincial manner tempered by an almost Sienese simplicity. In the Austrian panel, Christ still seems alive after the Deposition, as if a Man of Sorrows, patiently awaiting burial in the tomb at the far left. Back-to-back, seated on the ground, Mary and John support one another in grief's desolation. An assistant at the Deposition enters the dollhouse-city of Jerusalem, having done an all too "ordinary day's work."

Such paintings are too early to have concerned the young Dürer. He turned to Martin Schongauer of Colmar for his role model. Schongauer was active both as engraver and painter, and was master of a dramatic narrative style upon which Dürer modeled his own. Dürer went to Schongauer's hometown to study with him in 1492, but came too late — the master had just died. Schongauer's engravings left a potent visual heritage, one that would stay close to Dürer for a lifetime.

Of the ten or so paintings universally accepted as being by Schongauer, Berlin has one of the finest — a *Nativity* (112). Here the Colmar master drew upon the art of Rogier van der Weyden (58, 66–69) and Hugo van der Goes (80–83) for the elegantly persuasive humility of the Virgin and for a quality of directly observed peasant life seen in the shepherds. What Schongauer adds is a shrewd

Opposite:
ALBRECHT DÜRER
Nuremberg, 1471–1528
Hieronymus Holzschuher, 1526

ALBRECHT DÜRER
Protective cover for Holzschuher portrait, 1526

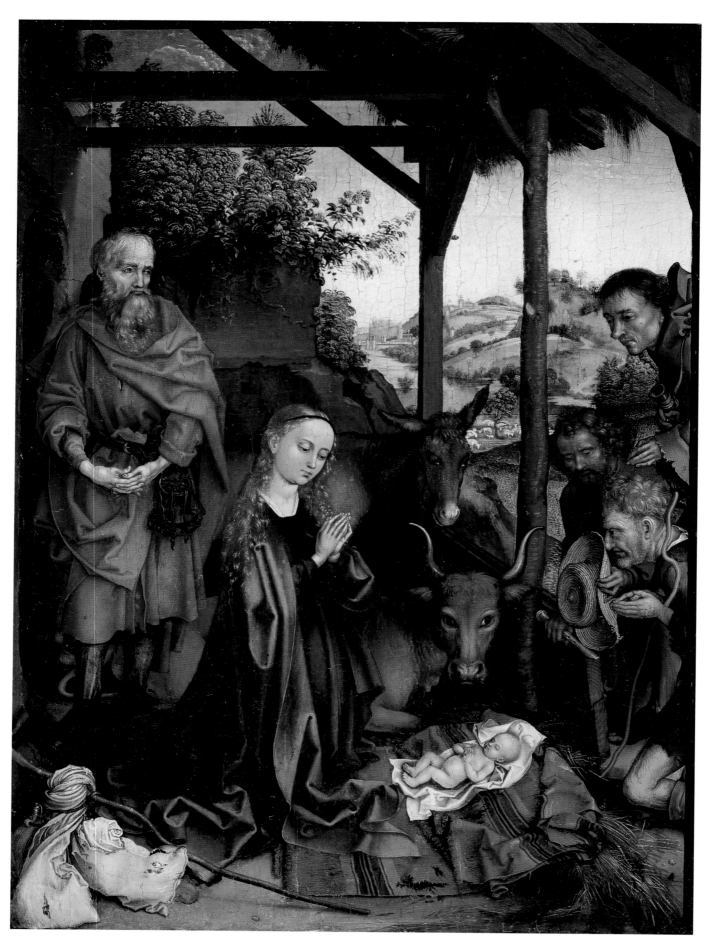

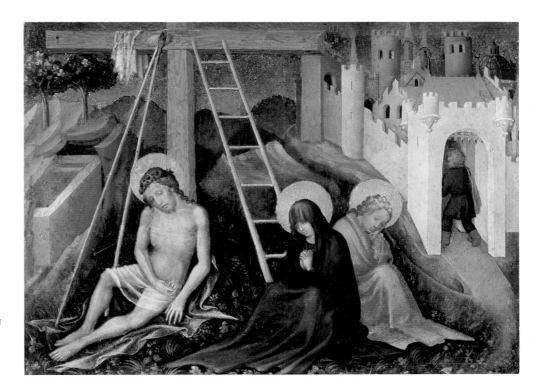

fusion of graphism and sentimentality. He follows an account in which the ox breathes warmth over the naked babe, whose parents are so poor they cannot afford to clothe him. Where the artist also comes close to the viewer is in that touching vignette of Joseph's torn bundles and the impatient perplexity of his interlocked hands and slightly sulky demeanor. Is he asking himself "What do those hicks want? Why don't they go home?" The shepherds were believed to represent the Jews, the first, with the Gentile Magi, coming from afar, as the second, to acknowledge the divinity of Christ.

Dürer's life span is neatly divided between the fifteenth and sixteenth centuries, the first half in the late-Medieval tradition and the second in the High Renaissance. He was apprenticed to his goldsmith father before boldly breaking with the paternal plan and entering a local, mediocre painter's studio in Nuremberg. Better-educated than most artisans, the handsome boy had some schooling, and his passion for learning was soon lavishly supplemented by an intimate friendship with one of Germany's leading humanists, the lusty, broad-minded, appreciative Nuremberg merchant prince Willibald Pirckheimer.

Dürer's parents were surprisingly well connected. Both his mother and father were friends of the leading local intelligentsia and furnished their son with the right godparents, including Anton Koberger, the world's wealthiest publisher. The artist's maternal grandfather was the Medici agent in Nuremberg, and his father was goldsmith to the Holy Roman Emperor, so, long before his own achievements, Dürer was linked to major courts and cultures north and south of the Alps.

Vastly industrious as well as extremely intelligent, Dürer picked up much knowledge before, between, and during his two southern travels, in the late fifteenth century and again around 1506. He responded to the spontaneity of the drypoints and panel paintings of a witty, animated artist known from a series of courtly sketches as the Master of the Housebook — or the Master of the Amsterdam Print Cabinet (for the Rijksmuseum Print Room, where most of his drypoints are preserved). This master was possibly active in Bruges, Freiburg, Mainz, and Ulm, where he was in the employ of Dürer's future patron, Emperor Maximilian.

A *Passion Altar* of c. 1475, now divided between Berlin, Frankfurt am Main, and Freiburg im Breisgau, conveys the Housebook Master's rare gift for humanity, the physiognomies intense but beyond caricature. *The Last Supper* (114) is seen in old-fashioned perspective, with the figures in the foreground smaller than those at the far end of the

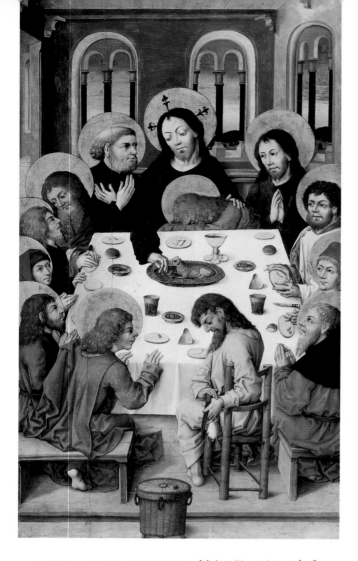

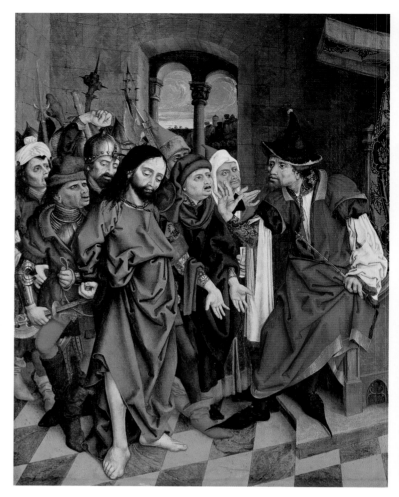

MASTER OF THE HOUSEBOOK, Mainz (?), active end of
fifteenth/beginning of sixteenth century
Panel from *Passion Altar*, c. 1475–80: *The Last Supper*

MASTER LCZ, Bamberg, last quarter of fifteenth and
beginning of sixteenth century
Christ before Pilate, c. 1500

table. It includes the traditional group of Christ com-
forting St. John, who is so overcome by learning of
the Betrayal that he buries his head in Christ's lap.
Judas, in the foreground, consoles himself by weigh-
ing his purse — payment for the Betrayal.

Another gifted, little-known painter active in close
proximity to Dürer during his youth is the Master
Lcz. Working in Bamberg, his masterpiece is the
Strache Altar, now divided between Berlin, which
owns the *Christ before Pilate* (114), Darmstadt, Nurem-
berg, Paris, and a private collection in Sigmaringen.
Original, glowing, almost pastel-like, yet deeply
expressive in coloring, this monogramist's art, like
that of Hugo van der Goes (81–83), broke with the lit-
eral, descriptive mode of the immediate past.

Paintings ascribed to the young Dürer often
remain controversial, yet the Berlin diptych of the

Martyrdom of St. Sebastian (115) is a likely candidate
for his authorship, close to the oeuvre of Martin
Schongauer, yet endowed with the tough individual-
ity found in Dürer's first works on panel.

Berlin's staggering collection of Dürer's portrai-
ture presents one of the chillier aspects of his formi-
dable skills; the Nuremberger's kindlier perspectives
are devoted to nature, not man. Eccentric, the
image (116) of the humanistically inclined Duke
Frederick III (the Wise), Elector of Saxony (1463–
1525), comes as close to a court portrait as any from
Dürer's hand. The duke was the first ruler to
employ the artist on several official projects; some
of those, for Wittenberg, were classical in content.
Painted in watercolor on fine canvas, the sitter's
somewhat odd image presents the elegantly dressed
Frederick in an Italianate pose and was probably exe-

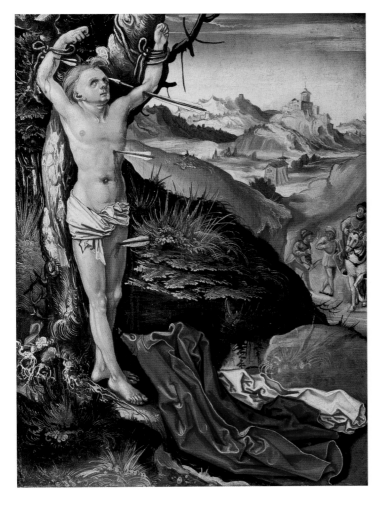

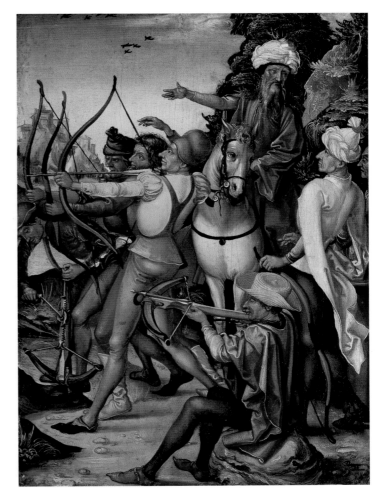

MASTER OF THE SEBASTIAN DIPTYCH
Upper Rhein, probably Strasburg, active c. 1510
The Martyrdom of St. Sebastian

cuted in April 1496 when the Elector came to
Nuremberg.

Grandest of Berlin's Dürer portraits is that of
Hieronymus Holzschuher (110) of 1526, the inscrip-
tion giving the sitter's age as fifty-seven. Holz-
schuher's coat of arms (111) — bearing the wooden
shoe, from which the subject's name is
derived — and that of his wife appear on the por-
trait's original cover. Both the likeness and its lid
were bought by the Berlin Museum from the sitter's
Nuremberg descendants in 1882.

The panel, a late work, is so acutely, archetypally
Düreresque that skeptics found it too good to be
true and considered the *Holzschuher* to be a forgery.
Long a leading figure in Nuremberg government,
twice senior *Bürgermeister*, the powerful old sitter's
piercing gaze is not unlike those of Dürer's four

"Apostles" of the same year (Munich, Alte Pinako-
thek). The sitter and his painter were friends; both
belonged to the same local club, the Sodalitas
Staupiciana. Such conviviality contributes to the
portrait's vital bonhomie. Holzschuher suggests a
model for Hans Sachs in Richard Wagner's *Die
Meistersinger*, that opera set in the Nuremberg of
Dürer's day.

Also in 1526 Dürer made another likeness (119),
that of Jakob Muffel (1471–1526), aged fifty-five. Like
Holzschuher, Muffel wears a lavishly furred collar,
but he is clean shaven. There's nothing apostolic or
genial about Muffel's sharp-eyed, rodentlike look.
Less well preserved than the Holzschuher portrait,
this portrait was transferred from panel to canvas. If
it ever had a cover, that was lost long ago. Muffel,
too, was a leading figure in Nuremberg's govern-

ALBRECHT DÜRER, *Duke Frederick III (the Wise), Elector of Saxony*, c. 1496

ment and friend to Dürer and Pirckheimer. This painting is inscribed "EFFIGIES," meaning that it was completed (if not begun) after Muffel's death.

Of Dürer's few finished portraits of women, that of a so-called young Venetian woman (118) of c. 1506 is certainly among the most appealing. He must have felt close to this sitter since the "AD" monogram is intimately placed, as if "embroidered" upon her neckline. In somewhat Italianate attire, she may have belonged to the large German mercantile colony in Venice, the Fondaco degli Tedeschi, which also commissioned Dürer's largest panel, *The Madonna of the Rose Garlands* (Prague), about 1506, for installation in a local church, bringing Dürer to Venice for its execution. The Fondaco was like London's Steel Yard, where Holbein's *Georg Gisze* (106) was painted.

A *Madonna and Child* in the National Gallery in Washington, D.C., and Berlin's *Madonna with a Siskin* (120) represent Dürer's most Venetian devotional images, each closely modeled upon works by Giovanni Bellini (226–27), the painter from that city whom Dürer most admired. That Berlin's *Madonna* was painted away from home is also suggested by its inscribed *cartellino*, on which the artist refers to himself as *"germanus"* and states the date of its creation as 1506. Mary's face is close to the young Venetian woman's who was painted at about the same time.

Perched on the naked Infant's shoulder is the siskin or finch whose supposed diet of thorns symbolizes Jesus' future sufferings. The odd object held in the Infant's right hand may be a sugar tit for him to suck or for the bird's pecking. Stylistically, this panel, which is not well preserved, suggests the title of that old chestnut of science fiction, *When Worlds Collide*. But for his glorious watercolors, Dürer had little effective color sense, a flaw compounded by the northerner's bedazzled reaction to the awesome challenge presented by the radiance of Venetian tonal harmonies. Berlin's *Madonna* reflects these conflicts and inadequacies.

The young German was also enthralled by High Renaissance pyramidal compositions, but seldom adapted them entirely successfully. Here Mary's doll-like head, at the apex of a massive triangle, is suddenly dwarfed by what goes on so uncontrol-

lably below. She is given large, masculine hands, massive shoulders, a swollen torso and knee. All these seem to belong to someone else and contribute to a surreal, synthetic quality.

As he aged, Dürer became increasingly impatient with the tedium and unprofitability of painting, and wearied by tightfisted, narrow-minded, thankless patrons. He turned ever more to the publication of print series and to the preparation of scientific treatises on perspective, human proportion, and other instructive subjects, pursuing the absolutes of measure, not the accidents of appearance. These publications were consulted throughout Europe.

Berlin's works by this omnivorous, many-skilled master, whose formidable intellect ultimately eclipsed even his own awesome talents, present the artist as the keenest of analysts, close to Leonardo da Vinci (whose art he so much admired) in his exploration of the terrain of human physiognomy with the same detached obsession an astronomer might direct toward observing the craters of the moon. Ultimately this made it impossible for Dürer to maintain his independent yet Catholic stance, finding in Luther and Renaissance science the reassurance and authority that the corrupted contemporary Rome could no longer deliver.

One of his Nuremberg pupils, Hans von Kulmbach, only nine years Dürer's junior, predeceased his master by six years. Kulmbach, as Barbara Butts has shown, came to Dürer after studies with Lucas Cranach the Elder (137–44) and Jacopo de' Barbari in Wittenberg. He entered the Nuremberg master's studio just when Dürer was reorganizing it, upon his return from Italy c. 1507. Soon Dürer sent Kulmbach commissions he was unwilling or unable to take on himself, sometimes devising works that Kulmbach would then execute.

The latter's operatic *Adoration of the Magi* (121) of 1511, like the art of Hans Baldung (122–27), has a freedom and fluidity Dürer rarely achieved, even though for this large painting Kulmbach drew upon his teacher's woodcuts. That great column behind Mary supports her at the moment of the Nativity, as described by St. Bridget of Sweden. It is a tribute to Dürer as teacher that he helped his students evolve individual styles, never having them goosestep in the wake of his awesome achievements.

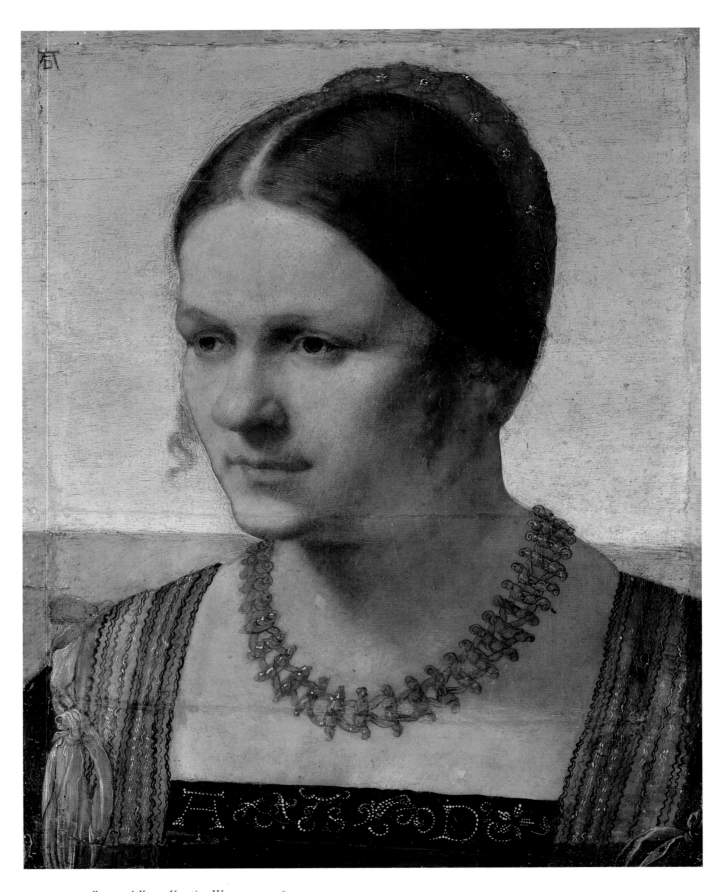

ALBRECHT DÜRER, *A Young Venetian Woman*, c. 1506

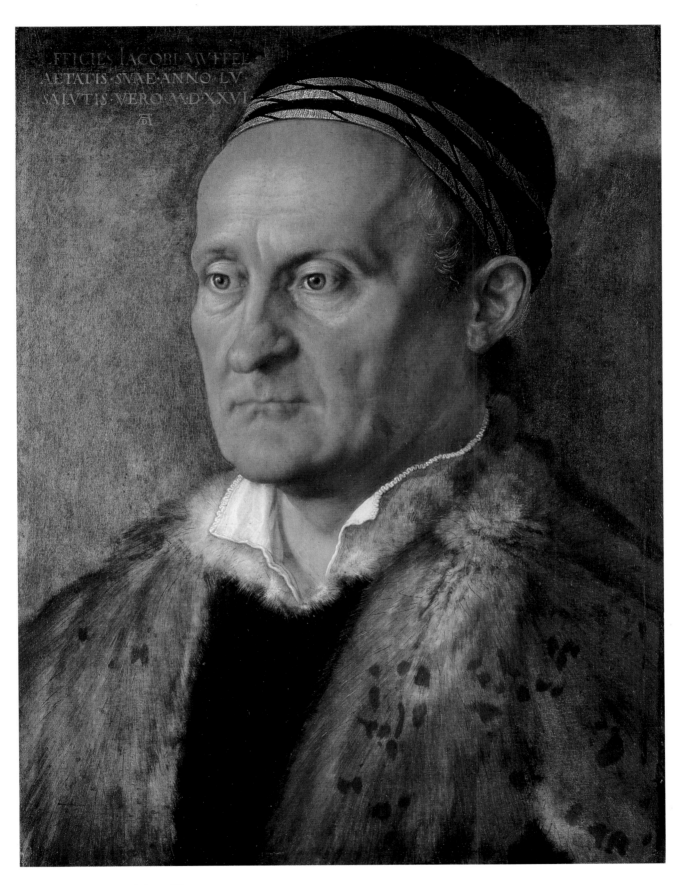

ALBRECHT DÜRER, *Jakob Muffel*, 1526

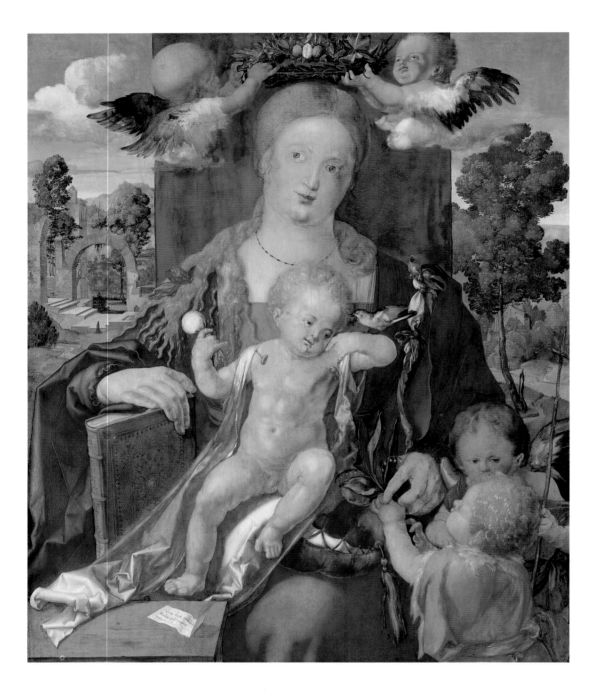

ALBRECHT DÜRER
Madonna with a Siskin, 1506

Opposite:
HANS VON KULMBACH
Kulmbach (?), c. 1480–
Nuremberg, 1522
The Adoration of the Magi, 1511

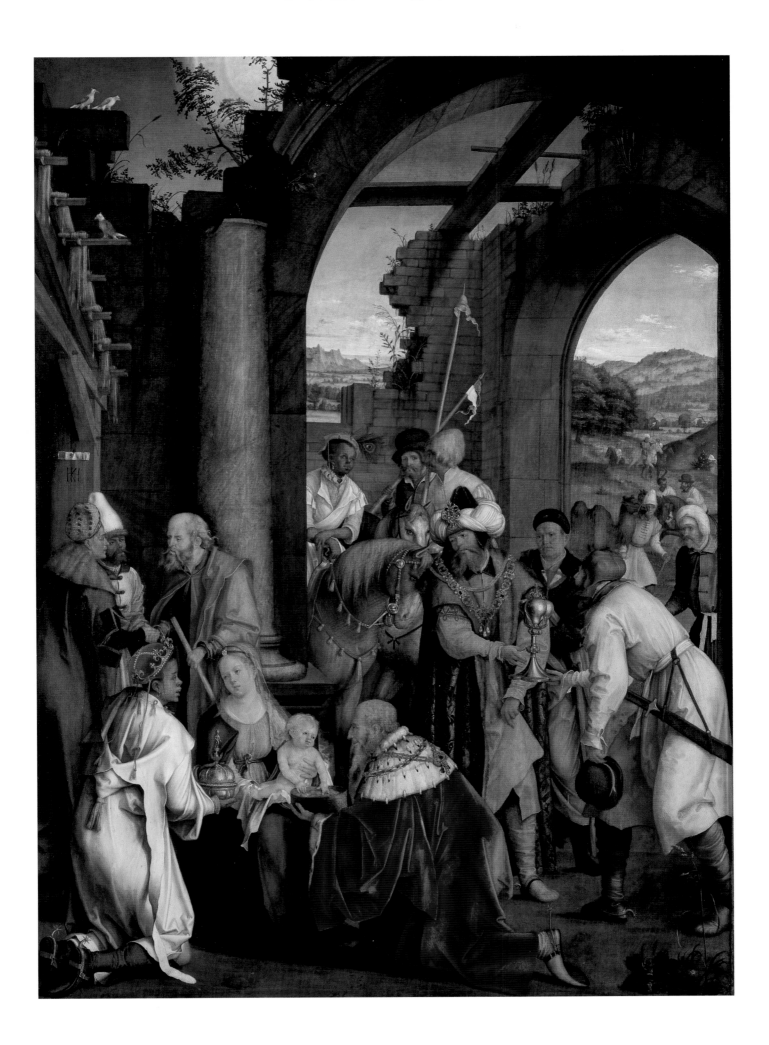

BALDUNG BEWITCHED

NORTH or south of the Alps, the Renaissance often kept a surprising distance from the voice of predictable reason or the light of conventional truth. Star-crossed, distanced from the rational, scientific worlds, the underbelly of its enlightenment is very different from the True, the Good, or the Beautiful. Occult, astrological, and alchemical forces, ancient in origin, returned to the forefront, each in its own way a harbinger of pure science, of psychology, astronomy, chemistry, and physics. Astrological signs were worn on sleeves or hats and embroidered on garters. Far from singles-bar chatter, the zodiac was understood as the staff of life, determining every facet of human existence from conception to the hereafter. Luther proved far more tolerant of the "Black Arts" of astrology than the Catholic Church. Even adherents of the latter, such as the great painter Parmigianino, dabbled in that dubious sphere, exploring the *arte nigredo*, finding the processes of etching, with its reversals of black and white, of positive and negative, close to new spiritual strengths and insights.

Hans Baldung was a major master of this spellbinding world of sorcery, of enchanted horses and all the bizarre fringe benefits of occult practices. Berlin has the world's largest collection of works by this baffling, bewitching, bothersome painter and printmaker.

Baldung was active most of his life in Strasbourg. From 1503 to 1506 he was in Nuremberg, in Dürer's workshop, just the same age as the artist's other major pupil, Hans von Kulmbach (*121*). Soon only the latter, with Mathias Grünewald and Hans Burgkmair, could compete with Dürer and Baldung for monumental breadth of vision. Dürer thought so highly of his student that he would give away Baldung's prints along with his own to the artists he most admired. He, Cranach, and Baldung shared

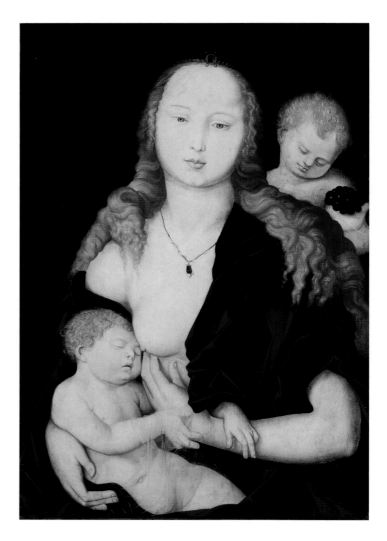

HANS BALDUNG
Swabian Gmünd, 1484/85–Strasbourg, 1545
Virgin and Child, c. 1539–40

the distinguished patronage of Cardinal Albrecht of Brandenburg.

Secular paintings and woodcuts are Baldung's best-known works. Still shocking and uncompromising today, these scenes of bewitched grooms and enchanted horses, of the Fall, of the Three Ages, all bring out revelations of a world of passion and dread, lust and the black arts, seldom seen on so large a scale or stamped with such graphic emotional insistence.

Even Hans's portraits have an eccentric, loopy authority, as seen in Berlin's splendid *Ludwig, Count von Löwenstein (1463–1524) (123)*, which may have faced a lost pendant showing his wife. Later legit-

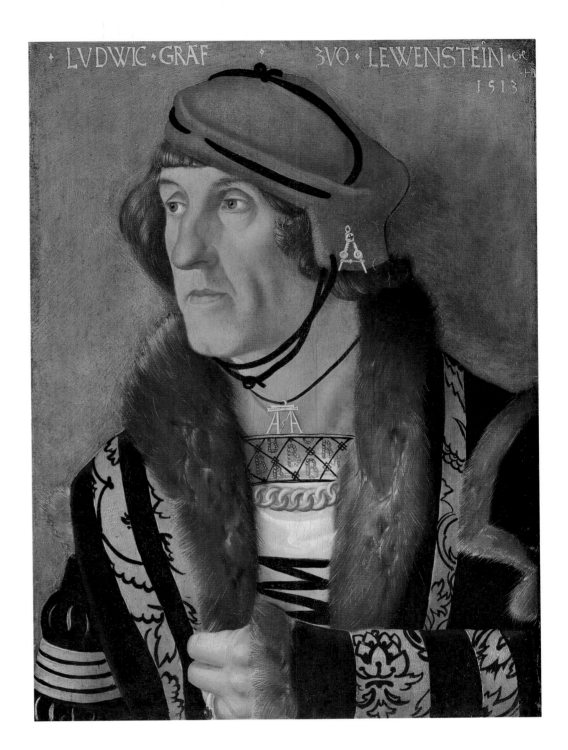

+ LVDWIC · GRÄF · · ZVO · LEWENSTEIN · CR
1513

HANS BALDUNG
Ludwig, Count von Löwenstein
(1463–1524), 1513

imized, Ludwig was the bastard warrior son of Duke Frederick I the Victorious and an Augsburg resident, Clara Tott. At the time of his murder in 1524, he had received titles from and was active as military councilor to Maximilian I.

Distinctly Fauve is the artist's (and patron's) delight in bold coloring, the portrait abounding in daring contrasts in pattern, modeling, and line. Covered with glittering jewels, emblems, and devices, a single bejeweled "A" is suspended from the count's cap, a double "A" hangs from a cord around his neck, and wired-pearl "B"s are wrought within a trellislike, open-worked band below the neck, a great golden linked chain seen further down. For all its barbarous overlay and surround of castmarks, the count's face, portrayed in 1513, looks startlingly contemporary. This could be a portrait of a Ruhr steel magnate, or a retired astronaut.

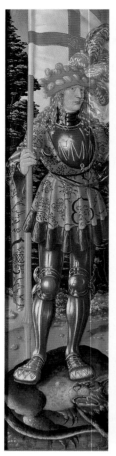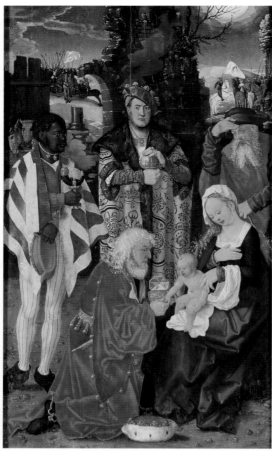

HANS BALDUNG
The Three Kings Altarpiece, 1507

Central panel and interior wings:
St. George; The Adoration of the Magi; St. Maurice
Exterior wings: *St. Catherine of Alexandria; St. Agnes*

A surprisingly middle-aged Pyramus is mourned by his Thisbe in Baldung's image of c. 1530 (*125*), based on the tale told by Ovid (*Metamorphoses* IV, 55ff). In that fatal Babylonian romance, neighboring lovers, forerunners of Romeo and Juliet, plan an elopement to escape parental objections. The couple vow to meet at a nearby spring. Thisbe comes first, only to find a lioness, freshly returned from a kill, her jaws covered with blood, drinking from its waters. Running away, Thisbe drops her cape, which is soon chewed by the lioness and left blood-flecked at the fountain. Arriving at the scene, Pyramus believes his beloved to have been the beast's victim, and plunges a sword into his breast. Finding her lover's corpse, Thisbe follows his fatal course.

Here Pictura has all too little to do with Poesis. Like Cranach's *David and Bathsheba* (*140*), this is another courtly *tableau vivant*, or, in Baldung's case, *mourant*. Pyramus is viewed feet first, almost at crotch level, his splendidly plumed ostrich-feather hat nearly outweighing the lover's most important attribute. Demure, clasping her hands in a singularly restrained simulacrum of grief, Thisbe scarcely suggests the suicidal. She seems more interested in acquiring Pyramus's hat than in sharing his fate. Cupid, perched atop the ill-starred fountain, is the more convincing mourner. He, along with the dramatic nocturnal landscape and brooding skies, reflects that sense of death and transfiguration Baldung's primary figures could not, or would not, convey.

Similarly ambiguous is the same painter's *Virgin and Child* (*122*), in which a second infant (the infant

Opposite:
HANS BALDUNG, *Pyramus and Thisbe*, c. 1530

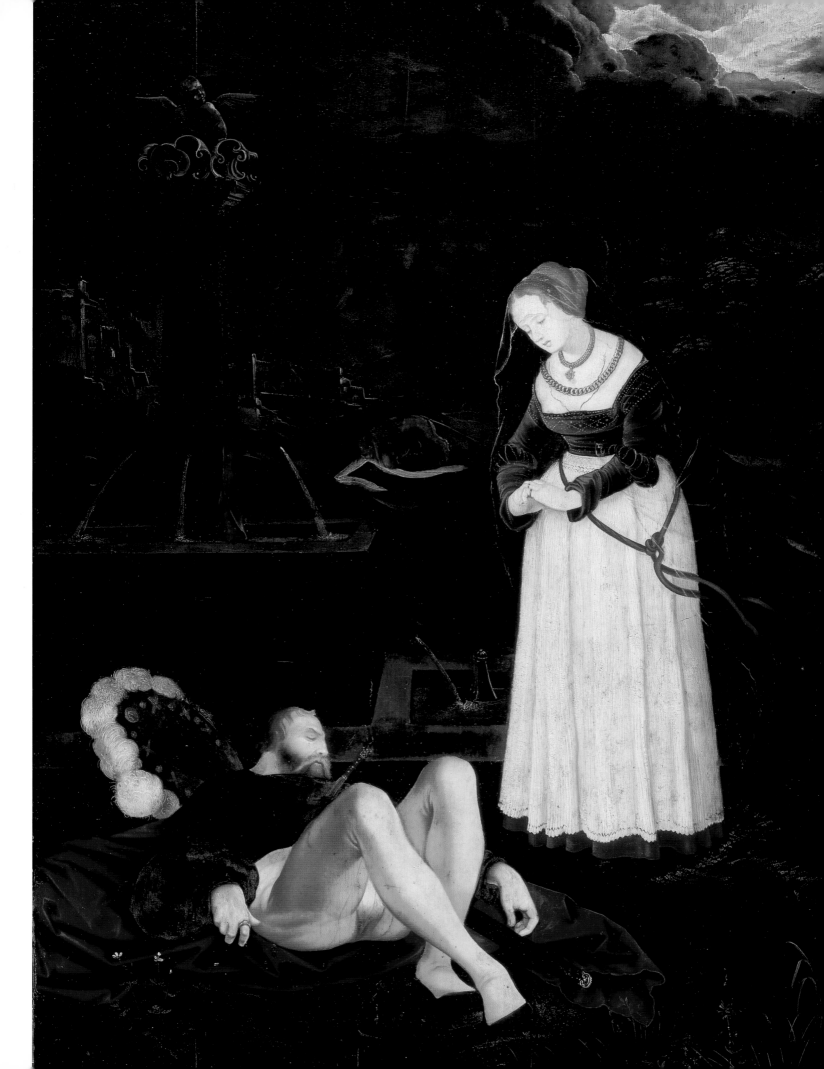

Baptist?) is seen over Mary's shoulder. An unorthodox Virgin, her bared breast is accentuated by a dark crimson velvet background. This image recalls that in Fouquet's Antwerp *Virgin and Child*, pendant to Berlin's *Estienne Chevalier with St. Stephen* (98), where the singularly sexual Mary may commemorate the deceased royal mistress, Agnes Sorel.

Magnificent for its bold color is Baldung's *Three Kings Altarpiece* (124) of 1507, which was painted for the cathedral of Halle shortly after he left Dürer's studio. SS. Catherine of Alexandria and Agnes appear to the left and right in the outer wings; SS. George and Maurice within. The highly individualized central Magus suggests a donor portrait. The same head appears in a pendant *St. Sebastian* triptych (Nuremberg, Germanisches Nationalmuseum) painted by the same artist in the same year for the same church. Despite his gaudy restatement of Venetian color, Baldung may be following another Italian region, that of Florence, in adhering to Alberti's view that a satisfactory narrative (*"istoria"*) needed to include the viewer by having one painted participant face the spectator.

Far more sophisticated and impressive are Baldung's *Crucifixion* (127) and *Lamentation* (126); the second was later conventionalized by arching the top. Even the wood of the crosses seems cruelly alive in this panel. The Bad Thief's body is still tied to his tree, one tormented foot visible just above the Magdalen's head. Mary is given an ironic appearance of pregnancy in these panels, as if to double the loss of her Son.

In *The Crucifixion*, the equestrian figure of the Roman Centurion who was healed of blindness by Christ's blood and so converted to the new faith may be seen to the right. The Magdalen embraces the cross in a daringly choreographed gesture of erotic abandon, its wooden shaft pressed between her thighs. Her enduring passion for Christ allows for the Scarlet Woman's investment with Fidelity's attribute: the dog at her side. Turbulent skies register the moment of Christ's death, just when the eclipse takes place. In their realistic bikini briefs, the thieves have nothing to do with Yesteryear, let alone Yesterday. As with most of Baldung's art, they are as disquieting as the prospect of tomorrow. To Christ's left, the Bad Thief looks away, as the Good Thief

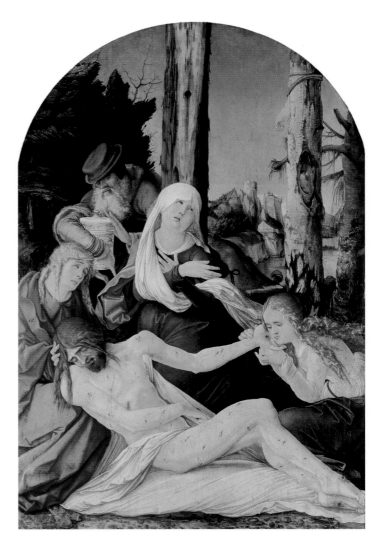

HANS BALDUNG, *The Lamentation*, c. 1515

faces the Savior's suffering. Poised with startling delicacy, Christ's legs are frozen in rigor mortis, one foot over the other. His expression is one of tender yet horrifying pathos, caught just after proclaiming God's abandonment. Few but Baldung could take as often shown a subject as the Crucifixion and invest it with new excitement and bold insight.

Signed and dated 1512 at the foot of the cross, this panel was ordered by an abbot of a monastery in Breisgau, who is seen kneeling in humbly diminutive scale at the lower right.

Opposite:
HANS BALDUNG, *The Crucifixion*, 1512

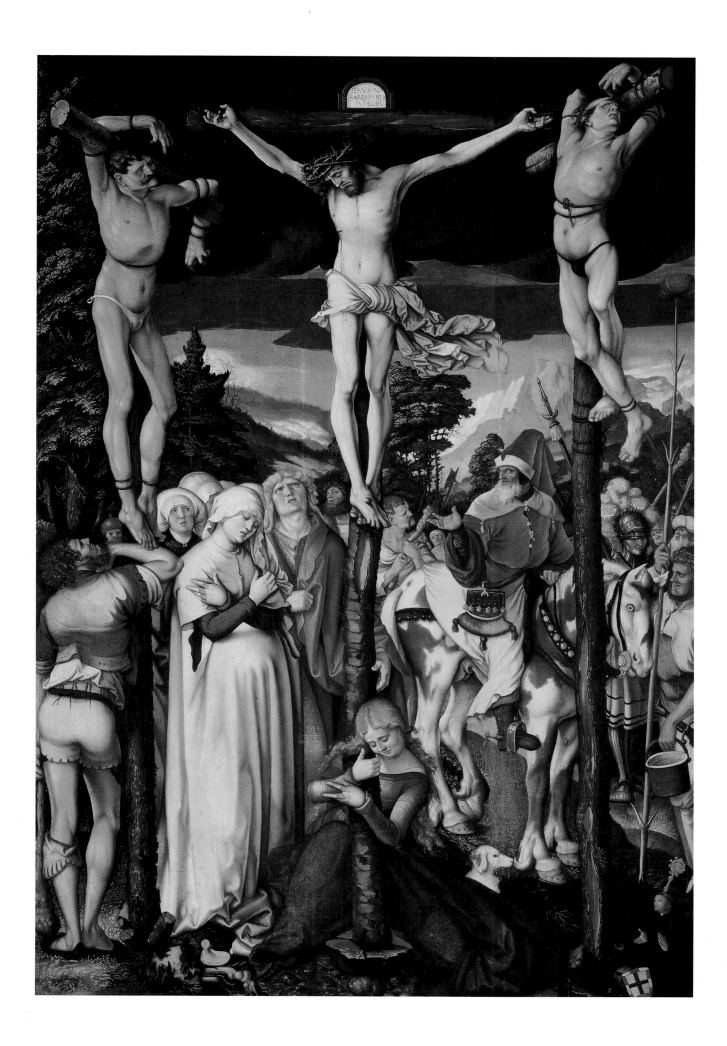

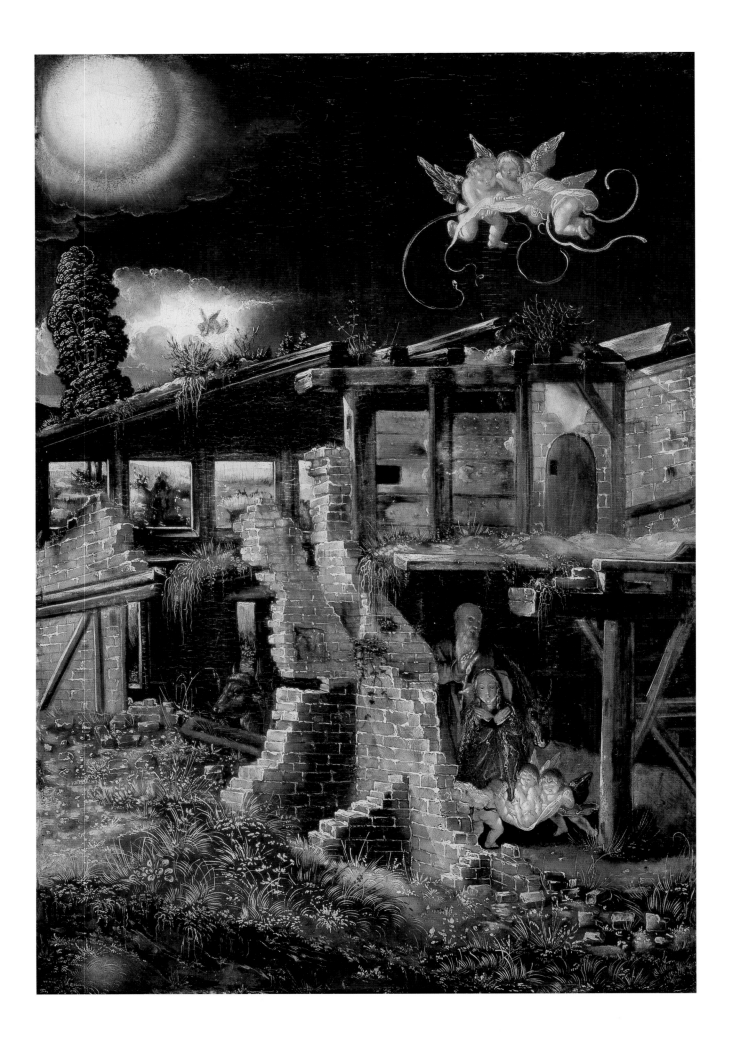

INTIMATING INNOCENCE: DANUBIAN ART

For a few brief years in the early sixteenth century, several Austrian and German artists captured a quality of mysteriously knowing nature and naive faith never again found or felt so intensely or on so small a scale. Often also active as printmakers, these artists, including Albrecht Altdorfer and Wolf Huber, conveyed a sense of cosmic wonder, viewing an Orphic world before the Fall as if from afar, and for the first time. Looking down upon Gothic forests and mountain peaks, these Danubian artists captured the villages and wildernesses below with a magical romantic precision.

Other painters active long before, such as Jan van Eyck (53, 55), as well as contemporaries like Leonardo da Vinci, represented great distances and shifts in light and scale, but striving for absolute illusion, their renderings were realized by scientific striving. Far from such documentary or rational goals, the Danubians came close to the occult; their images seem to tremble with an expressive fear, wonder, and delight, beyond facsimile. Even the newly invented etching needle, when in these artists' mystical grasp, seemed to record a trembling, spontaneously seismographic graphic response to nature's marvels.

A freshly triune mystery, one that rejoins Northern and classical mythology to Christianity, pervades these artists' works. Far from any single faith or spiritual perspective, the visions of Danubian painters are often informed by persuasive Pantheism — nymphs and shepherds, fauns, wildmen and wildwomen of the woodlands, along with saints and sinners, all leading lives of gentle synergy.

Opposite:
ALBRECHT ALTDORFER
Regensburg, c. 1480–1538
The Nativity, c. 1513

A sort of sacred anthropology informs the satyr life of Danubian art. Half human, half animal, Altdorfer's engaging missing links (132) anticipate Adam and Eve, creations before Creation, pictorial echoes of lost ties between classical and Christian worlds. Close to Antiquity, these partly Gothic nymphs and satyrs, innocent of Original Sin, rejoice in prelapsarian familial accord, where All's Right with the World, whether naked, befurred, or half and half. Feathery trees, twinkling stars, childlike people, whimsical animals, homely angels modeled upon familial *Kinder*, along with an informal approach to portraiture, all lend an inviting freshness to this bright or flickeringly illuminated, singularly animated art.

Usually small in size, art of the Danubian School shares a sense of fairy-tale luminosity, a perpetual late-Gothic *Nutcracker* staged for an intimate, exclusive audience of one — the viewer. Even serious subjects, in Danubian hands, take on elements of fantasy. Conversely, the secular often assumes a state of mystery, if not sanctity. Usually set in or near the forest primeval — the *Urwald* — Holy Writ, increasingly translated into German, was now suffused by the Teutonic imagination, as preached/painted just when a new sense of language and identity was first forged and felt in Austria in the years close to 1500.

Staged as a nocturne, Albrecht Altdorfer's *Nativity* (128) takes place in a stable so ruinous that an additional miracle may be found in its not having collapsed upon the Holy Family sheltering within. The stable clearly enjoyed a loftier function before housing ox, ass, and homeless family, probably first built in Bethlehem as part of the palace of David, ancestor of the Virgin.

Unlike the grave angels of the fifteenth century, often shown in liturgical garb, Danubians preferred Italianate cherubs wearing very little but their

wings. Here the three in the sky may be singing the *Gloria in excelsis Deo*, calling the shepherds to the scene. Their Adoration is the subject of an impressive work in Berlin from the Altdorfer School.

Danubian art is filled with music, usually provided by cloudlets of fife- and drum-playing putti. Often Orphic in reference, pagan pleasure in the seduction of sound — or silence — animates these pictures, hovering as they do between the medieval and classical spirit. A bizarre pagan fountain with an idol at the center takes up more space than the Holy Family in Altdorfer's *Rest on the Flight into Egypt* (131). Based on models from the Veneto, the formal fountain constrasts with the Family's intimate presentation. As the baby is washed or changed, music-making angels cluster around the basin's edge. A Leonardesque landscape unfolds to the left, with blue waters meeting blue mountains meeting blue skies. This closely observed nature study may seem at odds with the naive mysticism of the foreground. But it isn't, as mysticism is rooted in admiration for God's works. Signed and dated 1510, the *Rest* is a votive panel, so indicated by the inscribed tablet propped up against the fountain base. Its words dedicate Altdorfer's panel to the "Divine Mary," addressing her as if she were yet another classical deity.

A turbulent, darkening sky, signifying the eclipse at Christ's death, is seen behind Altdorfer's obliquely placed *Crucifixion* panel (133). The scene, painted c. 1526, has an almost matter-of-fact quality, its Alpine setting appropriate for polychromed outdoor sculptural groups of the same subject, still to be found in Europe. Mary Magdalen is seen from the back in a melancholic pose, as the other Marys leave with St. John the Evangelist and a bearded elder just before the Deposition takes place.

In *The Stigmatization of St. Francis* and *The Penitence of St. Jerome* (133), Altdorfer presents two different paths to sanctity, one by imitating Christ, the other by remorse and denial. In this early diptych of 1507, the painter has yet to achieve a new synthesis of humanity and nature. Here the two large-scale saints, almost Ferrarese in appearance, are seen close-up, in contrast with the infinite space of their landscape settings.

Safely labeled as an allegory (134–35), Altdorfer's

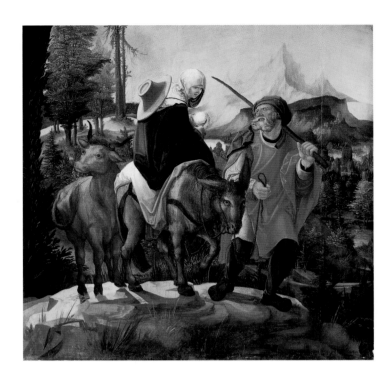

WOLF HUBER, Feldkirch, 1480/85–Passau, 1553
The Flight into Egypt, c. 1525–30

panoramic panel is subtitled *Beggary Sits on Pride's Train*, after a proverb that preaches of the ruinous consequences of extravagance. In this sweeping scene, painted in 1531, two courtiers stand before a palace, one raising a welcoming covered cup, or *pokal*, awaiting an approaching, lavishly dressed couple. The present and future progress of this lord and lady is dragged down by a beggar family schlepped along on the nobleman's massive train and symbolizing improvidence.

Wolf Huber, another Danubian artist, painted a retable with scenes from the Life of the Virgin, of which only two panels survive: Berlin's *Flight into Egypt* (130) and a *Visitation* (Munich, Bayerisches Nationalmuseum). In the first, the Holy Family seems to pose on a rocky outcropping as if it were a statuary group. Huber's concern for bravura modeling recalls the contemporary, often brilliantly colored, finely carved limewood figures of Austria and Germany.

Opposite:
ALBRECHT ALTDORFER, *The Rest on the Flight into Egypt*, 1510

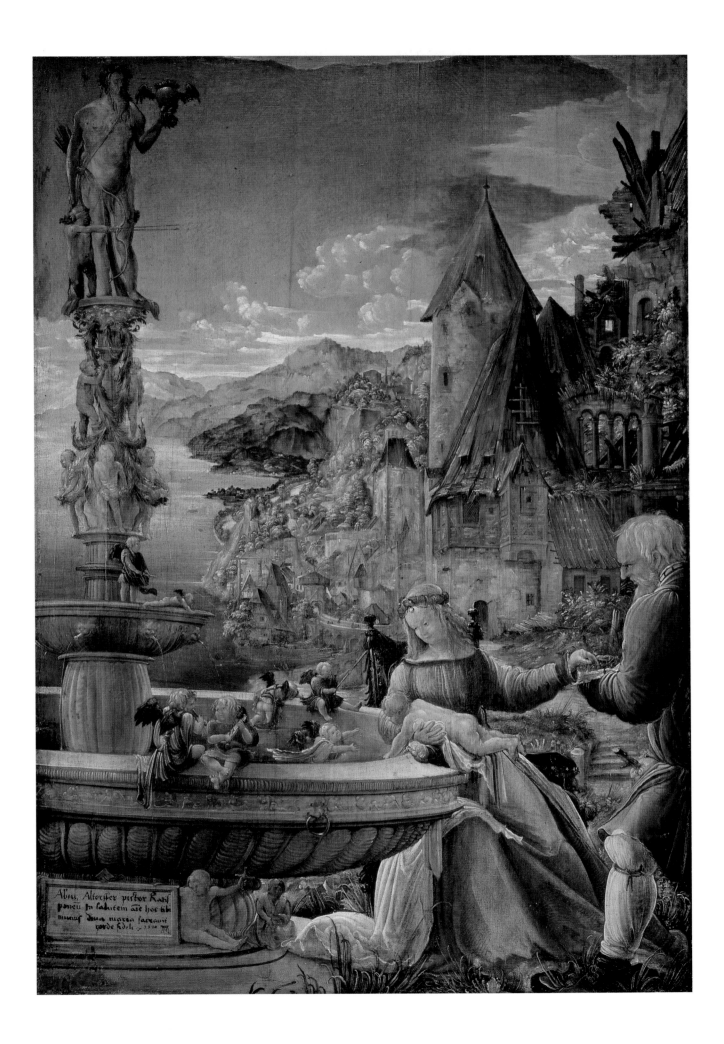

ALBRECHT ALTDORFER
Landscape with Satyr Family, 1507

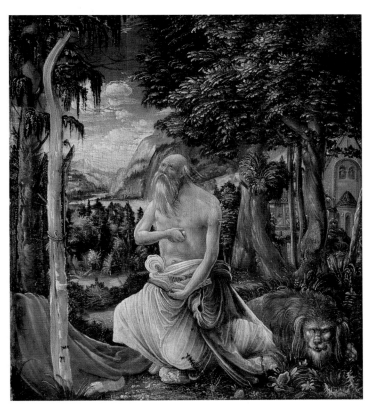

ALBRECHT ALTDORFER
Diptych, 1507:

The Stigmatization of St. Francis (left)
The Penitence of St. Jerome (right)

ALBRECHT ALTDORFER
The Crucifixion, c. 1526

Overleaf:
ALBRECHT ALTDORFER
Allegory: Beggary Sits on Pride's Train, 1531

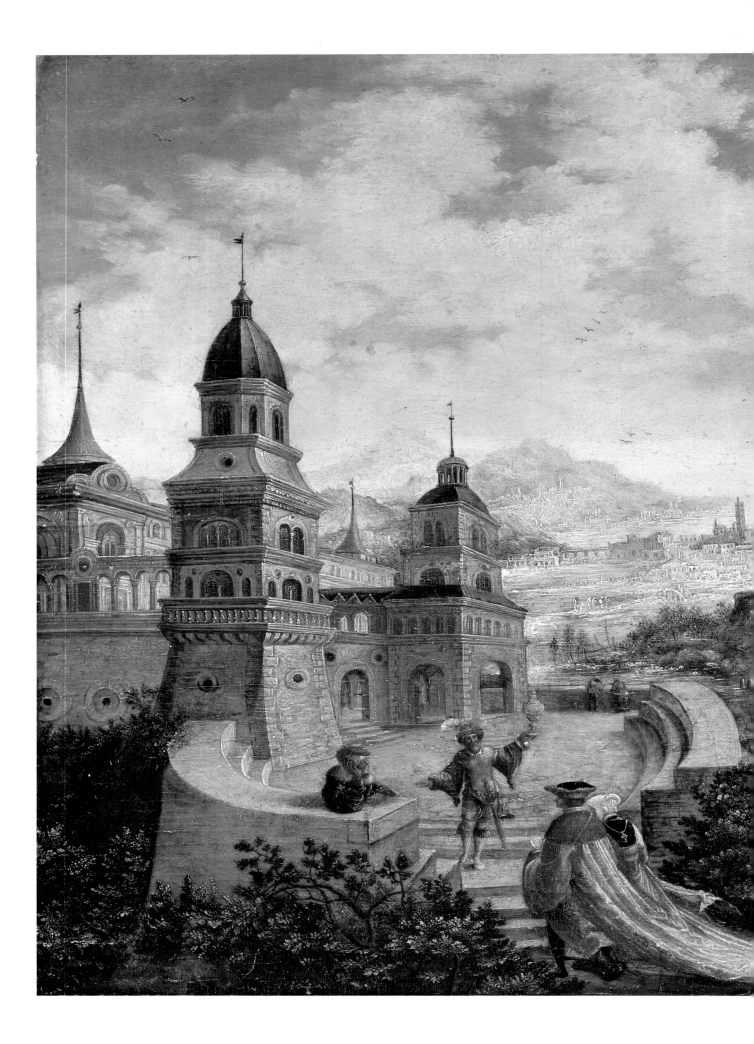

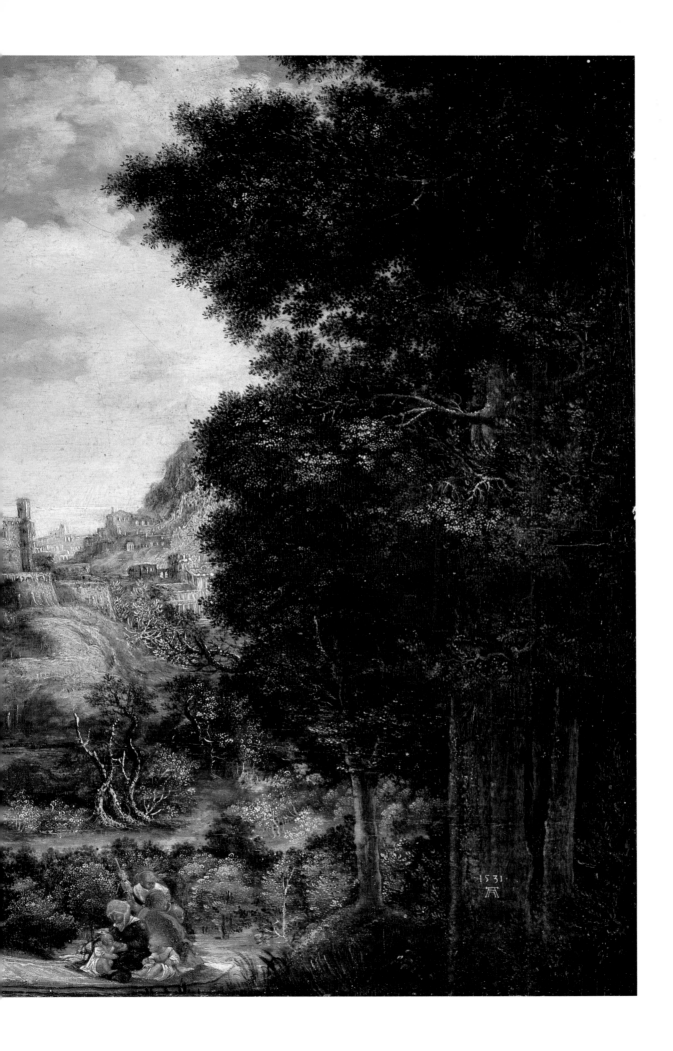

CRANACH AND COMPANY

Like the Holbeins of Augsburg and the Bruegels of Antwerp, the Cranachs of Saxony — Lucas the Elder and Lucas the Younger — proved to be yet another dynasty of Northern painters, entrenched masters of secure, popular pictorial formulae who captured generations of patronage. Lucas Cranach the Elder was attached to the Saxon court of Frederick the Wise (116), and his works were designed to please a powerful Protestant patron who never needed to keep up with the Schmidts. This permitted the painter to stray into more personal fields, embracing the erotic and satirical as well as the official and the propagandistic.

Aristocratic, often ironic, authority is conveyed with a certain banality and occasional humor by the Cranachs. These attitudes furnish the contradictory hallmarks of their often repetitive oeuvre. Portraiture (142–44), inevitably, played a central role. Faces in demand, with other popular subjects, were often produced in quantity by a large studio, some painted with an almost stenciled insensitivity.

The chase, whether after woman or beast, was central to courtly art. Unusually sexual images — of single nudes, often of naked pagan gods, or Adam and Eve — all proved practically indistinguishable from one another in Cranach's art. Hunting scenes where the quarry includes birds, bear, boar, deer, fox, and other beasts also abound in his paintings and prints. Neither genre was beloved by Dürer, doubtless among the reasons he rejected Frederick the Wise's proffered role of court artist at Wittenberg. Cranach's was a far lustier soul and brush, so he was more at home with the art of the chase. Highly charged eroticism such as his was seldom found in the more delicate, intellectual, introverted, and talented art of Dürer.

Where the latter rarely painted nudes, Cranach made his sinuous models strut their stuff. Slant-eyed, narrow-waisted, high-breasted, these painted ladies of day and night warmed the cockles of many a Saxon prince's heart. Whether depicted to order or almost mass-produced to fulfill some fashionably neo-Platonic conceit or a pre-centerfold display of pulchritude (often one and the same), these nubile nudes came in life-size, as in the *Venus and Cupid* (137), or practically pocket-size, like the implausible *Lucretia* (137), seen poised catlike on a lunar terrain. Outraged virtue is farthest from her mind, as she points a dagger destined never to scratch her snowy breast, that skin made all the more dazzling by its dark, dark background. Such craftily cosmetic contrast is found in many of Cranach's works; seldom failing to arouse interest, it is stimulated further by these nudes' abundant jewels and chic coiffeurs. Artfully transparent veiling makes their privates twice public, veiled and revealed at the same time.

Typical of Cranach's oft-tried and all-too-true approach to biblical subjects recast as courtly contemporary *tableaux vivants* is his *David and Bathsheba* (140). Classical images were often debunked in Medieval and Renaissance arts — that same free view of the distant past now made the Bible (or at least sections of its first testament) fair game for Cranach's satire.

Calculatingly, Bathsheba consents to no more than a foot-washing, a flashing ankle clearly enough to arouse the lusty regal harpist's passion. Head on hand, as if muttering, "Here we go again," a long-suffering courtier is all too well aware of his womanizing monarch's capacity for getting into royally hot water. Complicity between Bathsheba and her girlish ladies-in-waiting further satirizes the biblical narrative. *Judith Victorious* (142) of c. 1530 shows an equally lighthearted heroine.

Berlin's large *Fountain of Youth* (138–39) of 1546 is as much a monument to male conceit as to

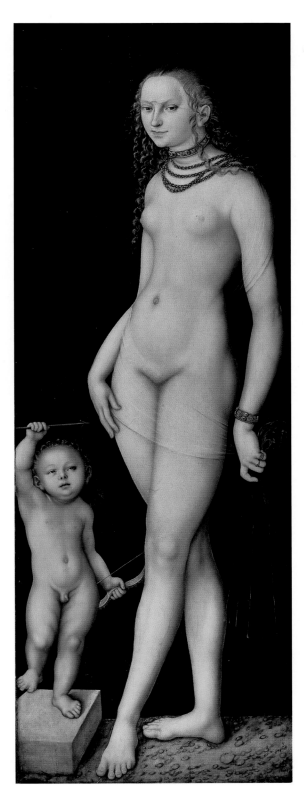

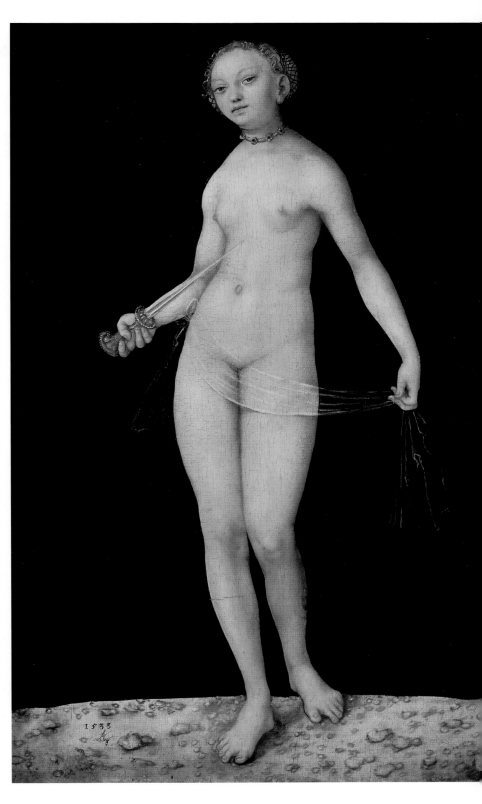

LUCAS CRANACH THE ELDER
Kronach (Franconia), 1472–Weimar, 1553
Venus and Cupid, c. 1530

LUCAS CRANACH THE ELDER
Lucretia, 1533

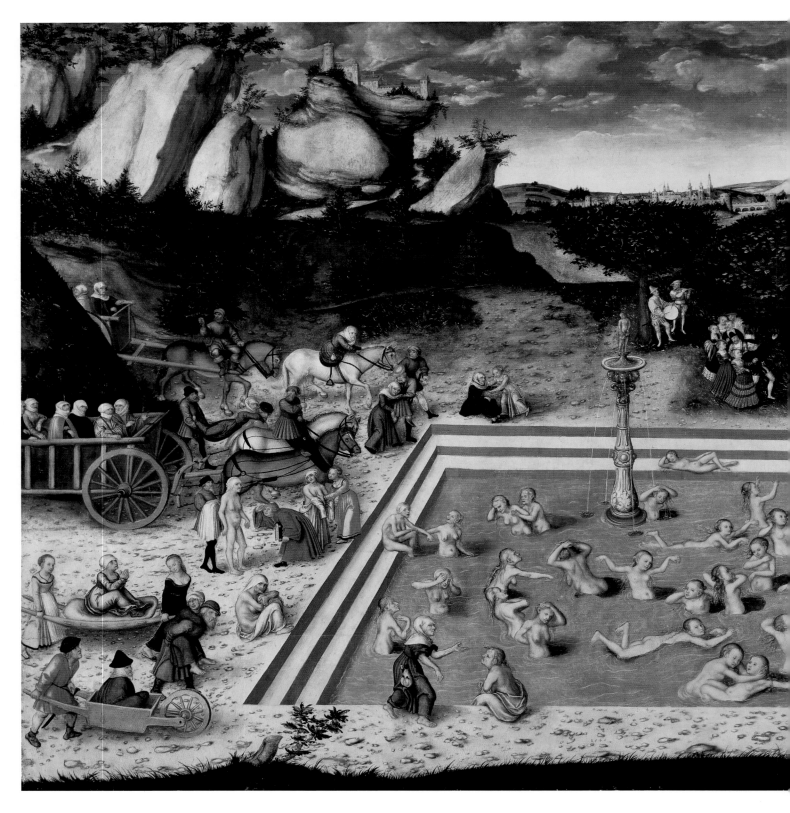

LUCAS CRANACH THE ELDER
Fountain of Youth, 1546

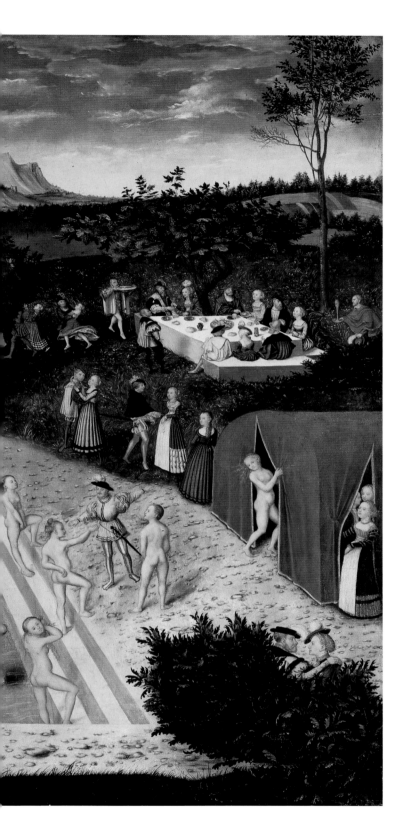

fleeting female beauty: no old man seems to need the gift of youth for himself, although such men's restorative baths were shown in medieval times. This pool is solely for aged wives, who will regain their desirability by bathing in Venus's magically rejuvenating waters. Her fountain rises at the pool's center, the love goddess's restorative powers restricted to those of her own sex. Old women brought by cart, wheelbarrow, litter, or on their mates' backs to the pool soon cavort in its waters.

The ratio of young men to old is far greater on the right — youthful — end of the pool, where men supposedly drop decades by proximity to pubescence! Even the landscape is more inviting and verdant to the right, as if it were nurtured by Venusian waters. On the left, a law professor with a great book under his arm peers at an aged nude woman with an offensively clinical stare, holding spectacles to his eyes, as if to register the Before so as to appreciate better the After. This theme of restored youth, found in classical literature, was also popular in the later Renaissance, in Rabelais, and in alchemical writings, also among the many arcane frescoes in Francis I's *Galerie* at Fontainebleau.

Berlin has the finest of Cranach's early, Danubian paintings, predating his Wittenberg appointment. These were mostly executed in Vienna.

An enchanting, and enchanted, *Rest on the Flight into Egypt* (141) of 1504 is Cranach's first signed and dated work and was probably painted in Vienna. Among the artist's most spontaneous, ingenuous images, it is close in spirit to Altdorfer's panel of the same subject (131), but Cranach's is far less complex. Cranach may have turned to a Dürer woodcut, *The Holy Family with Hares* (c. 1496–97), for the figure of Joseph, as that print's theme also pertains to the Rest on the Flight in the most general way.

This is one of the happiest of Christian images, partly because the pagan love cult of the Amorini, Venus's naked little attendant cherubs, is drawn upon. Exactly five are present, balancing the five dressed figures — Joseph, Mary, and the three

angelic music makers. If the Christ Child is added to the equation, the nudes win out numerically, contributing a sense of warm classical gaiety entirely at odds with their Alpine setting.

A portrait of the wife (143) of a Vienna University law professor has a pendant dated 1503 (Nuremberg, Germanisches Nationalmuseum). Man and wife are each flanked by a sprouting and a dying tree. Significantly, the two healthy trees face each other, seen on the inner sides of the pendants when hung together. Their emblematic message suggests that only in each other's presence may this couple flourish.

Religious subjects were particularly in demand from newly Protestant painters, whose woodcuts, found in the Luther Bible, were essential to that reformer's propaganda. Berlin has Luther's likeness (a schoolpiece) and that of his wife (142), the former nun Katharina von Bora (1499–1552), probably painted by Cranach the Elder near the time of Katharina's marriage to Luther in 1525. In addition to her skills as a housewife were her talents as a keeper of livestock, including a fishpond.

Too often, Cranach's later portraits have a certain formulaic superficiality, but this is not true for his likeness of Johannes Carion (1499–1537/38), of c. 1530, on permanent loan from Berlin's State Library (144). It was painted by Cranach during the artist's journey to the Berlin court of Joachim I, Kurfürst of Brandenburg, in 1529. This panel reflects sensitivity and gravity, suitable to its sitter's status as Brandenburg court astronomer and mathematics professor at that family's Viadrina University at Frankfurt an der Oder. A Latin inscription states, "I am Carion, the famous author of much-read works, which I wrote on the basis of my labor and my studies. I study the stars and praise the names of the constellations." Astronomy and astrology were interchangeable in the Renaissance.

Close to Cranach but more rigorous in appearance is a formidable *Lady* (145) by the South German Master of 1548. Lavishly beringed and otherwise bejeweled, she sports a pearl-studded cap, a costly girdle, three chains, and a gem-embroidered collar. For all her finery, this is a serious sitter, unbedazzled by earthly possessions. These baubles may be on her head but not on her

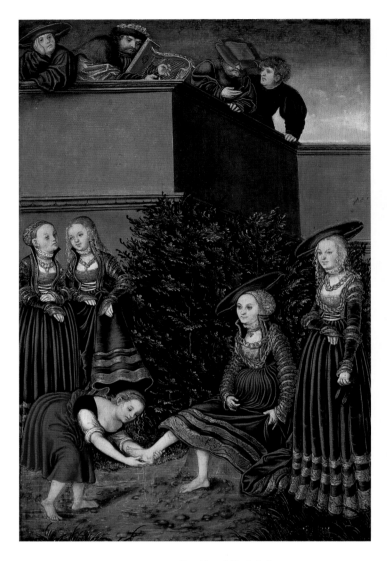

LUCAS CRANACH THE ELDER, *David and Bathsheba*, 1526

mind. Sharp intelligence and formality are the basis of this image, which may have faced that of a mate.

Equally grandly attired is a young, bareheaded knight whose costly Italianate armor, inscribed 1527, was probably intended for victorious parade, not bloody battle (145). Painted by the Master LS of Augsburg in 1540, the subject of this portrait — a Rehlinger of Suabia, probably Conrad, born in 1507 — grasps a sword and a battle-axe. Horse and helmet seem strange omissions.

Opposite:
LUCAS CRANACH THE ELDER
The Rest on the Flight into Egypt, 1504

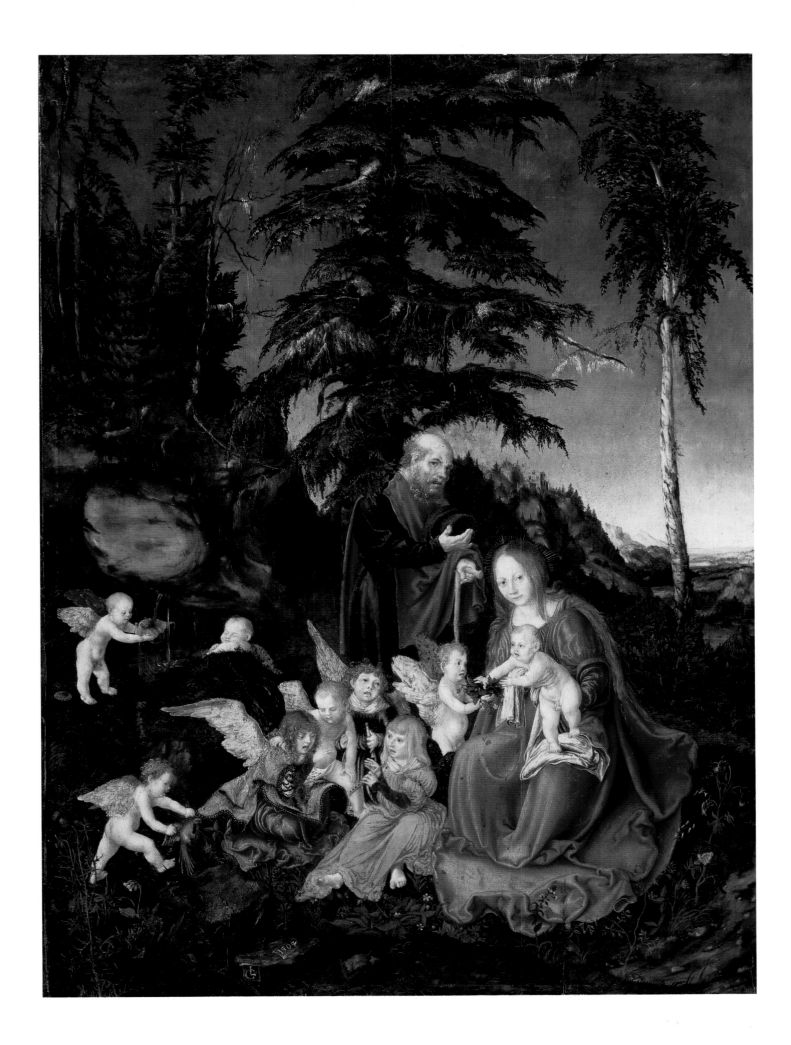

LUCAS CRANACH THE ELDER
Katharina von Bora, c. 1525

LUCAS CRANACH THE ELDER
Judith Victorious, c. 1530

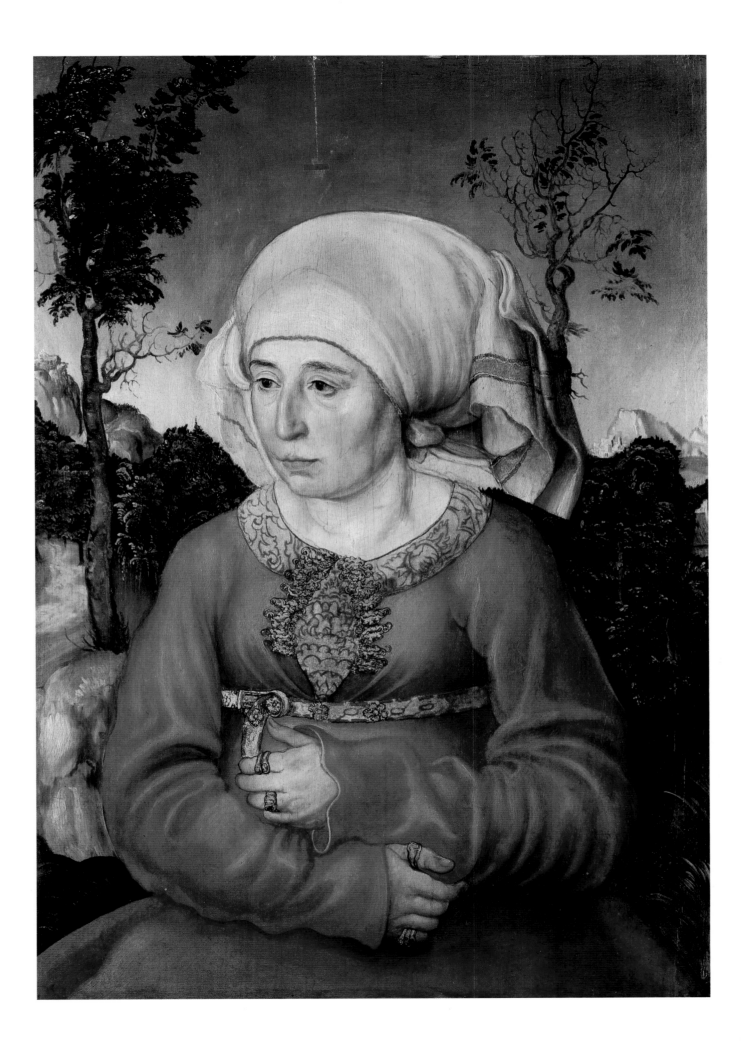

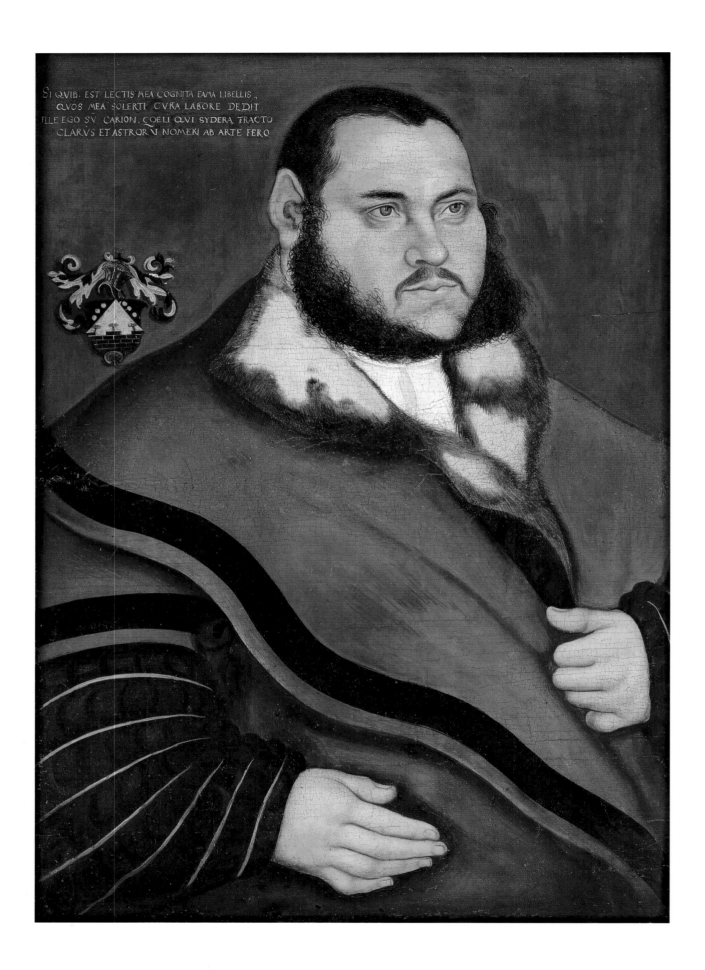

SI QVIB. EST LECTIS MEA COGNITA FAMA LIBELLIS,
QVOS MEA SOLERTI CVRA LABORE DEDIT
ILLE EGO SV CARION, COELI QVI SYDERA TRACTO
CLARVS ET ASTRORVM NOMEN AB ARTE FERO.

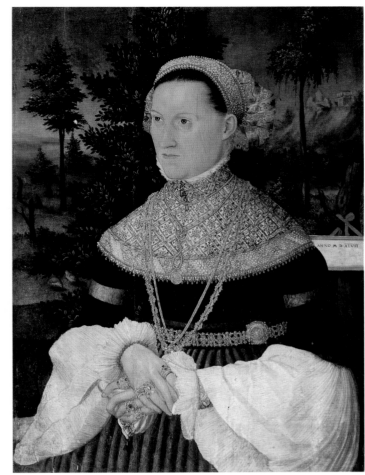

MASTER OF 1548
South German
A Lady, c. 1550

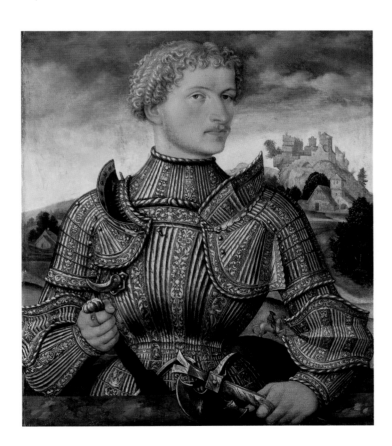

MASTER LS
Augsburg, active c. 1540
A Knight of the Rehlinger Family, 1540

Opposite:
LUCAS CRANACH THE ELDER
Johannes Carion, c. 1530

From Gothic Illusion to Renaissance Idea: Jan van Scorel and Lucas van Leyden

IMPATIENT with the late-Medieval artisanal obsession to re-create illusion by painstaking technique, "modern" artists of the mid-sixteenth century, like those of the twentieth, decided "Flat Is Beautiful" and embraced the abstract beauties of outline and area, cherishing the new Renaissance worship of Idea as communicated by Design, which they equated with drawing, not verisimilitude.

This new rejection of the literal, mirrorlike image was an intellectual one that first emerged in the North among university-educated artists in the environs of Utrecht whose initial training had been for the priesthood. Jan van Scorel was a canon attached to that city's rich cathedral. Later, in Rome, he became the official painter to the Dutch Pope Adrian VI.

This brisk new "Dutch" intellectuality and economy can be seen in Jan van Scorel's *Portrait of a Man* (*150*). Though the right half of a diptych — the man originally faced a *Madonna* (Russia, Tambov Museum) — this portrait has a hidden agenda. The sitter's most highly prized virtue is stoicism, a classical attribute, symbolized by the suicide of Lucretia shown on the verso of his own portrait (*150*). After rape by Sextus, son of Tarquin, king of Rome, the Roman matron preferred death to further dishonor, so she killed herself. Here Scorel turned to a much-used Marcantonio Raimondi engraving after Raphael as his source.

A new stress on the literary rather than the literal, on the artist as thinker, may have begun with the prodigy Lucas van Leyden, Dürer's major Northern rival as engraver. His paintings, like those of earlier North Netherlandish masters, have an almost caricatural economy of means. Such artists include Lucas's teacher Cornelis Engebrechtsz of Leiden, whose circular *Virgin and Child with St. Anne* (*146*) shows a theme especially popular in the North

CORNELIS ENGEBRECHTSZ, Leiden, 1468–1533
Virgin and Child with St. Anne, c. 1500

at the time. The ringed format echoes the theme of Christ as Savior of the world, who is seen here blessing the apple held in St. Anne's hand, yet another rounded object. It refers to the redemption required after eating that first apple.

Shaped by Venetian art and Paduan plaquettes, by the new academy of Squarcione (*205*), Lucas van Leyden's art has a mischievous, ironic twist, a witty awareness of what Venice and the Antique had to offer in restaging biblical and classical subjects. His *Virgin and Child with Angels* (*147*) shows a free-and-easy approach to an unidealized Mother and her lively, curious Child, so reminiscent of Carlo Crivelli (*207*).

Opposite:
LUCAS VAN LEYDEN, Leiden, 1494–1533
Virgin and Child with Angels, c. 1520

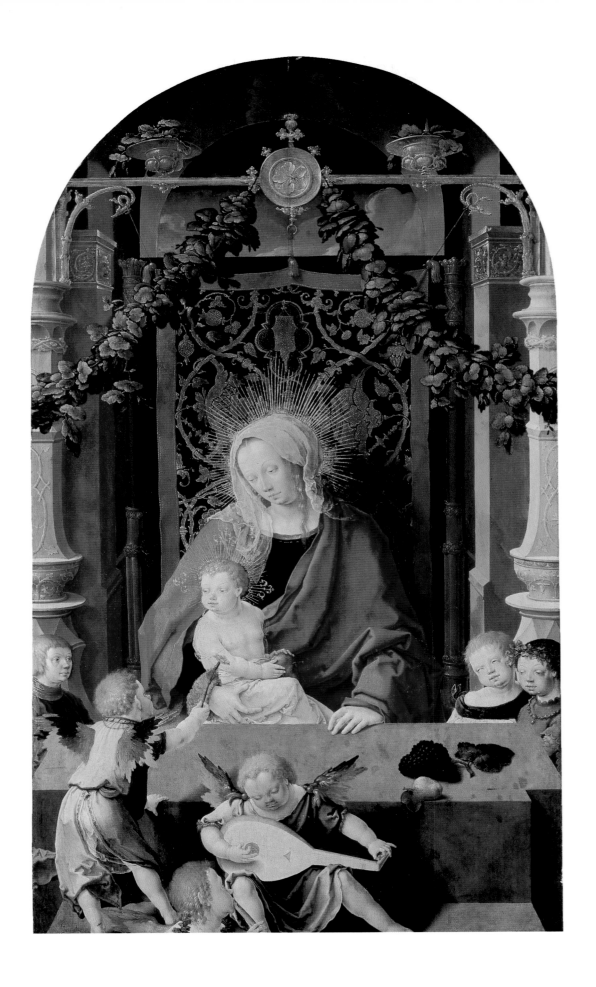

LUCAS VAN LEYDEN, *The Game of Chess*, c. 1508

St. Jerome (*149*) was a popular Renaissance subject; the Church Father's role as translator of the Bible endeared him to scholars of most stripes. While his master's penitence appealed to the devout, Jerome's scrawny lion is unable to witness so painful a sight, so Lucas shows him slinking off into the desert.

Chess (*148*) was a popular medieval allegory for power struggles on most levels, including the battle of the sexes. Here the lady proves a winner in every sense. Several versions of Lucas's popular painting survive.

A bold, fresh image of the obscure St. Jerome of Noordwijk (*151*) is by an unknown Netherlandish artist. This too is probably a portrait, in the guise of the sitter's patron saint.

Flanders's first artist to understand fully and to re-create the full-blown pictorialism of the later

Renaissance was Frans Floris de Vriendt. Like his brother Cornelis — a leading architect and sculptor — Frans exemplified dynamic sympathy for the new monumental arts of Italy. While he came from the cosmopolitan harbor of Antwerp, it was Venice, that city's sister seaport, that provided his major visual role model.

Large, but still sketchlike, Floris's panel *Venus at Vulcan's Forge* (*153*) dates from the early 1560s. Here the goddess of love waits while her husband forges the armor for Achilles's Trojan conquest. The broken-winged, serpent-entwined lance on the ground refers to the caduceus of Mercury, Cupid's father. Lacking the rigidity and old-fashioned polish of Gossaert (*100–103, 105*), or the somewhat wooden quality of Floris's North Netherlandish contemporary Maerten van Heemskerck, it is the free brushwork and breadth of his Italianate pictorialism that

LUCAS VAN LEYDEN, *St. Jerome Penitent*, c. 1515–16

make Floris parent to generations of Northern artists. Close to Titian and Tintoretto, all his figures share a painterly freedom and grandeur that, along with van Heemskerck's art, proved a harbinger of Rubens.

In fact, works by van Heemskerck may strike new viewers as Rubenses taken from the oven too soon. There's some merit in that view. Predating the Flemish master by almost eighty years, van Heemskerck and his Haarlem teacher Jan van Scorel (150) were the founders of North Netherlandish pictorial humanism. Like Gossaert, Floris, and Scorel, van Heemskerck also went to Italy to study Rome's antiquities and the stupendous arts of Raphael, Michelangelo, and Giulio Romano. He then returned home, where he became known as "the Raphael of Holland," a prolific designer of prints as well as a leading painter.

His *Momus Criticizes the Gods' Creations* (152) is based on Lucian, but van Heemskerck may have used a Renaissance text instead. Dated 1561, the large canvas is inscribed: "Fatherless and born of night, my name is Momus. / Envy's companion, I delight in all criticism, down to / The very last detail. / Man should be made with a latticed breast, so / Nothing is concealed from those seeing and hearing." Winged Momus stands at the far right, holding a statuette with the required latticed breast, all too ready to judge the works of the three deities, each of whom claims superiority in creativity. Athena is next to him, pointing to a house of her design in the background. Crippled Vulcan, god of ironworkers, gestures toward his masterpiece, which resembles his wife Venus. Neptune, at the far left, saddles the horse he has just made.

JAN VAN SCOREL
Schoorel, near Alkmaar, 1495–Utrecht, 1562
Portrait of a Man, c. 1535

Verso:
Lucretia, c. 1535 (above, left)

Netherlandish
St. Jerome of Noordwijk, c. 1530

MAERTEN VAN HEEMSKERCK, Heemskerck, near Alkmaar, 1498–Haarlem, 1574
Momus Criticizes the Gods' Creations, 1561

FRANS FLORIS DE VRIENDT, Antwerp, 1516–70
Venus at Vulcan's Forge, c. 1560–64

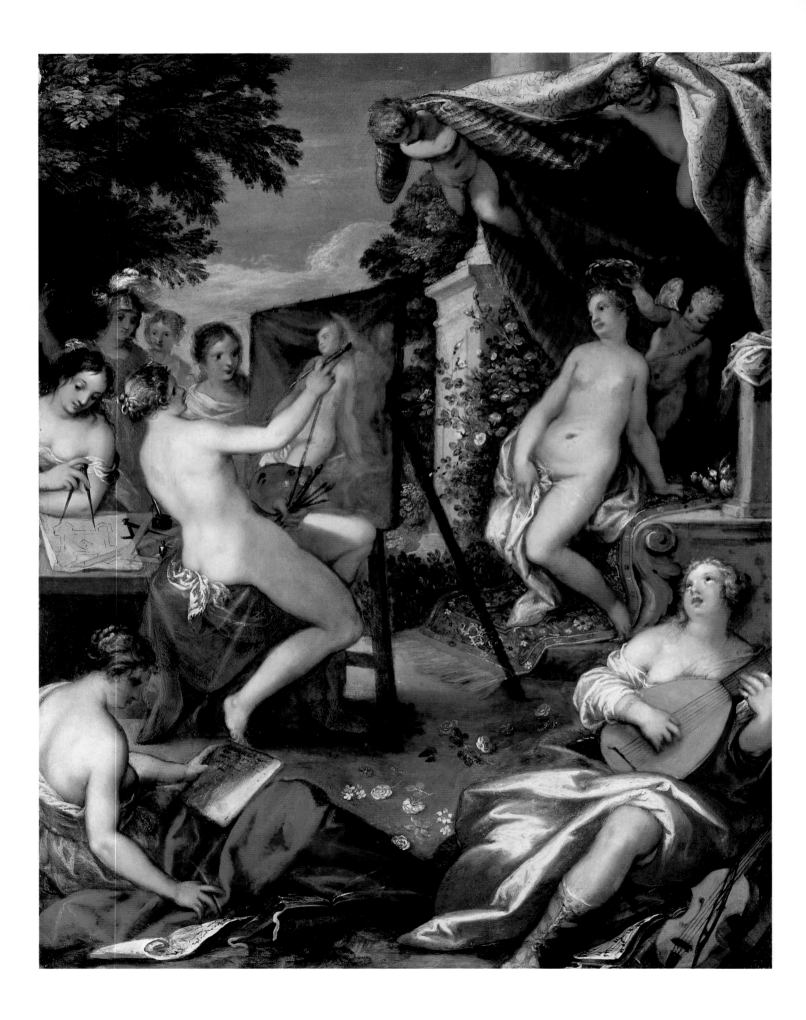

NEW NORTHERN MANNERISM

THOUGH Northern Mannerism is rightly first placed in the circle of Lucas van Leyden, a less inhibited, less anxious approach to Italianism comes with the following generation. Exhibiting a broader treatment, these painters no longer thought in quite such graphic terms. Art of the late sixteenth and early seventeenth centuries showed a new freedom in dealing with experience, with the body in space, and with the challenges of adventure. Such liberating trends resulted in the origins of Rubens and Rembrandt.

The ever-philosophical French ally themselves to wisdom, seeking its aid from birth to death and beyond. Like fairy godmothers, the nine muses, collective images of wisdom, personify the Liberal Arts, and were often summoned to guide French kings through their lives. The muses appear on royal funerary monuments, such as one for the heart of François Ier (Paris, St. Denis). Present in Berlin's canvas (158), the muses may commemorate the birth of a French prince, possibly a son of Henri II and Catherine de' Médicis. Or this work might instead have been painted for a later princeling, as the canvas looks closer to the so-called Second School of Fontainebleau, a certain provinciality having crept into the picture.

Copper was a popular painting support in the late sixteenth and early seventeeth centuries, and it was used for an *Allegory of the Arts* (154) by Johann Rottenhammer. Pictura is inspired by her beautiful model (Venus), as Architecture devises a centrally planned château-fort; Poetry writes and Music strums the lute. Faintly in the manner of Veronese (272), this cheerily erotic tableau is typical of inter-

national Mannerism, as is the biography of its author, who was in Italy for six years, married a Venetian, and had Adam Elsheimer (156, 157) as his Roman assistant.

A similarly realized allegory, shrewdly if implausibly dedicated to Temperance (159), shows a group of predominantly nude figures partying in a glade, personifications of the best of both worlds — Eros and Virtus. This scene was painted in the early seventeenth century by Cornelis Cornelisz. van Haarlem, who had obviously picked up many a trick from the suave School of Fontainebleau, where so many Northern artists flourished in their association with sophisticated Italian and French colleagues. A cofounder with Carel van Mander and Hendrick Goltzius of Haarlem's Academy in 1583, Cornelis made that city the Netherlands' center for an elegantly Latinate manner.

A work by Abraham Bloemaert (158) shows a rare subject taken from the *Aethiopica*, a Greek novel of A.D. 240 written by a Phoenician, Heliodorus, and devoted to an Ethiopian adventure that takes place in the Nile Delta. Attacked by pirates (at the upper right), our heroine, the Grecian maiden Charikleia, kneels over her wounded mate Theagenes. Bloemaert looked long and hard at Venetian and Lombard sixteenth-century painting for the realization of his bold figures, but the landscape style and sophisticated colors are his own.

Biblical subjects long provided the most socially acceptable nudes. When Cranach painted Bathsheba (140) she barely flashed an ankle. By the time Cornelis Cornelisz. van Haarlem depicted the same subject (159), near the century's close, not only is she completely nude, but so are two of her attendants. This painter's sinuous figures are close to those painted in his Haarlem Academy, in Prague, and in the Loire Valley. Theirs is a figure style derived from the later painters of Fontainebleau.

Opposite:
JOHANN ROTTENHAMMER, Munich, 1564–Augsburg, 1625
Allegory of the Arts

That key training ground in Italianism north of the Alps was visited by Cornelis in 1579 and left an indelible, sculptural impression on his art.

Italians, stunned by decades of Michelangelo's bloated Schwarzeneggerismo, stupefied by endless paeans to pumping iron, by blindness to the feminine and to nature, left bleary-eyed by the polychromatic Sturm und Drang of the vast canvases of Tintoretto (the Florentine master's Venetian disciple), were ready for another way to faith, to life, and, above all, to a nature those titans seldom saw. This need was addressed by the miniature cosmic vision of Adam Elsheimer. Working on copper, which allowed for a high degree of finish and detail, the Frankfurt-born artist was active in Rome, where Peter Paul Rubens admired his luminous little scenes. In 1598 Elsheimer came to Venice, where he worked with Johann Rottenhammer of Munich, whose *Allegory of the Arts* (154) shows the sinuous manner that Elsheimer was leaving behind. Elsheimer absorbed the Serenissima's heritage of luminism in his *Holy Family with Angels* (157). While retaining memories of Danubian romanticism, of Altdorfer's (128) treatment of the same theme, he has turned to Titian's *Assumption of the Virgin* (Frari) and to Tintoretto's sense of dramatic chiaroscuro, immeasurably reducing these for his bright little vista.

Some of Rottenhammer's eroticism is still in evidence in a Giorgionesque scene by the younger artist, an Ovidian tableau *Nymph Fleeing Satyrs* (156). Where the nude may lack articulation, the landscape doesn't. This scene anticipates the art of Claude and Guercino, bringing to the North a novel romantic freedom without losing the stimulus of actuality, of a true sense for topography. The artist could already be responding to Caravaggio's dramatic oeuvre (276, 279), possibly painting a view in Rome, where he died at an early age.

Almost like manuscript illuminations, the painter's works on copper captured a Lilliputian magic that could encompass Arcadia or Marian devotion with equal persuasiveness. The Pisan artist Orazio Gentileschi (280–81) came to know Elsheimer in Rome, and learned much from the Northerner. Rubens's uncharacteristically small-scale, intense *Lamentation* (390) could almost have been painted in mourning for Elsheimer, whose art, along with that of Caravaggio, he so much admired when in Rome.

Knowingly or not, Elsheimer preserved the intimate scale and haunting light of the Danubian School. Only with Caspar David Friedrich (508–20) did these evocative explorations reappear, probably without reference to Altdorfer or his colleagues, this time under the aegis of another Gothic revival, and once again with complex nationalistic over- and undertones.

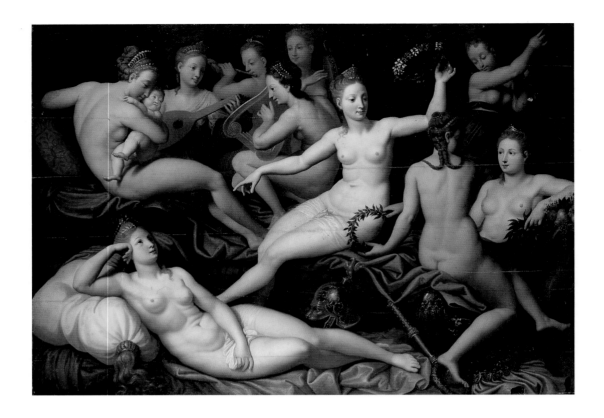

French
Allegory of the Birth of the Dauphin, c. 1560

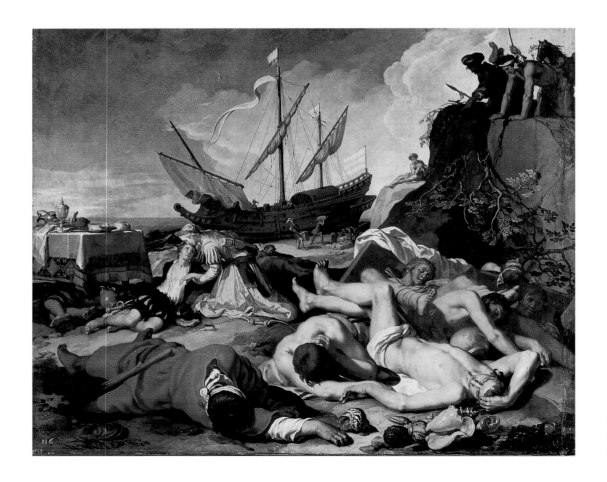

ABRAHAM BLOEMAERT
Gorkum, 1564–Utrecht, 1651
Charikleia and Theagenes, 1625

CORNELIS CORNELISZ.
VAN HAARLEM
Haarlem, 1562–1638
Temperance

CORNELIS CORNELISZ.
VAN HAARLEM
Bathsheba

PIETER BRUEGEL
Breda (?), 1525/30–Brussels, 1569
Two Chained Monkeys, 1562

BRUEGEL'S WORLD

Like post–World War II Berlin, sixteenth-century Antwerp was a city riven with contradictions, torn between progressive humanism and reactionary, Spanish-inspired theology. Occupation by the cruel duke of Alba's troops provided a painful contrast with the tantalizing prospect of religious tolerance just across the Dutch border. With its vast stock exchange and huge new harbor, Antwerp was also Europe's northern center for capitalism and shipping. Newly nationalistic appreciation for the glories of the Flemish landscape and the invention of a patriotic mythology of cultural heritage permeated the city. At the same time the metropolis teemed with immense cultural innovation and unrest, it was enlivened by a revolutionary anthropology and an idealization of the Peasant and Everyman.

Novel revelations of earth and heaven alike — whether by means of the Antwerp-born Abraham Ortelius's cartography, the humanistic printing activities of the same city's Christophe Plantin, or the radical religious movements of the Libertines and other Protestant sects — contributed to the complex images created by Pieter Bruegel the Elder and his circle. The wealth of stimulating contradictions then shaping Antwerp's culture fueled her art, which was already both humanistic and primitivistic. "Peasant Bruegel's" wisdom and subversive faith were often concealed under a *faux naïf* stance. He employed hereditary hieroglyphs of insight, presented in the unexceptional form of proverbs, as a reminder of rich native resources. Many of the radical perspectives that were intolerable to Antwerp's Spanish occupancy and absolutism were restated in subtle, ambiguous fashion in Bruegel's art, though scholars will always quarrel just where, when, and how. His "simple" arts provide the corollary of an enormously sophisticated, deeply conflicted society. This is demonstrated by

the fact that Bruegel's oeuvre was acquired by the same local patrons who collected the most recent Italian-inspired painting.

Folk wisdom — pithy, reductive, cryptic — is at its vital best in proverbs. Close to visual clichés, these apposite observations, encoded in as few words as possible, convey much to those ready for their often tedious, all-too-humble truths. Erasmus had published many Latin proverbs in his *Adagiorum Collectanea* in 1500, thus elevating the genre to new humanistic heights. Pieter Bruegel the Elder crammed at least 118 proverbs into a single composition, painted on oak, signed and dated "BRVEGEL 1559." This neo-Eyckian panel, with its compelling miniature quality, is first known from the inventory of 1668 of Peter Stevens, an Antwerp charitable official.

The artist entered the harbor city's guild in 1551, then left for Italy shortly thereafter. Landscape and folkways were his greatest concerns, and both are joined in his brilliant overview, *Netherlandish Proverbs* (162–63). It may be pendant to the *Fight Between Carnival and Lent* (Vienna, Kunsthistorisches Museum) — both are of the same year and each initiates the large-size panels for which Bruegel is best known. The style and encyclopaedic content of *Netherlandish Proverbs* also recall the same painter's *Children's Games* of 1560 (Vienna, Kunsthistorisches Museum).

Like a human ant colony populated by a crowded community with the wisdom or folly of its actions, the swarm of miniature men, women, children, animals, and props on this panel serves as an almost subversive manifesto of human folly. Mapping what's wrong with all of us, Bruegel's bird's-eye view is a mercilessly moralizing mirror of a misguided Our Town, one peopled by the fruits of the Fall, by the all-too-human condition, exhibited in a comic, didactic fashion.

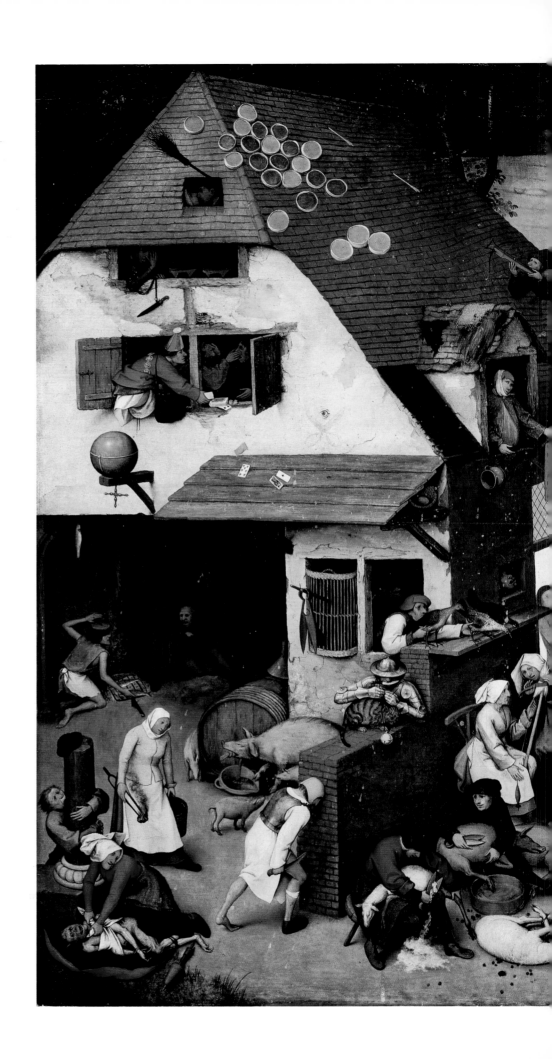

PIETER BRUEGEL
Netherlandish Proverbs, 1559

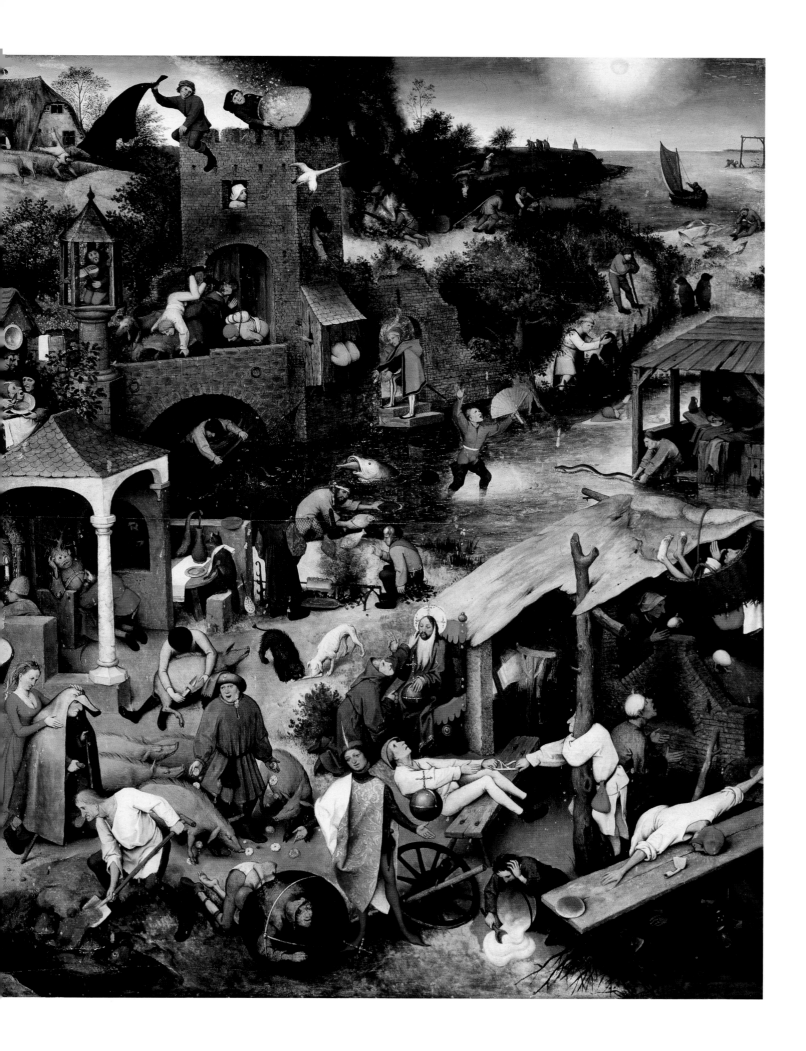

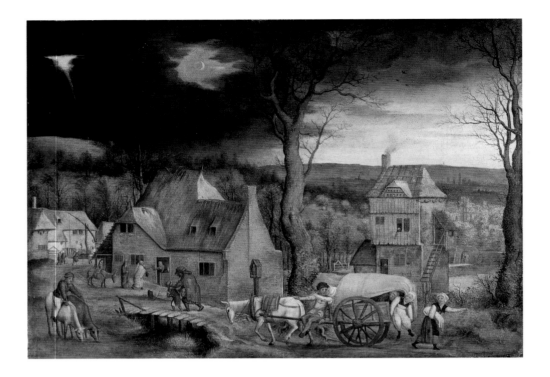

CORNELIS MASSYS
Antwerp, c. 1510–
after 1562
*The Arrival of the Holy
Family in Bethlehem*,
1543

In a single work, this stupendous master of the diminutive charts the absurd World Upside Down, as symbolized by the crossed blue orb and the chamber pot seen on the inn-front at the far left. This orb is balanced (right-side up) on the thumb of the dandy in the foreground who points so knowingly to the low ways by which "terrestrial success" must be achieved. Deprived of free will, these men and women are all enslaved by vice or, at best, by its mildest follies.

Many of the costumes in this panorama are old-fashioned, and it may well be that the picture refers not only to the style but also to the content of a lost work from the Eyckian circle. Jan was himself famous as a cartographer, and the panel's high horizon points to paintings of the early fifteenth century. Much of Bruegel's archaizing imagery, like that of Bosch, reflects a stylistic time warp, returning to the innumerable genre subjects lost to us from the late fourteenth and early fifteenth centuries.

This overview of innumerable Lilliputian transactions and pursuits, of hundreds of eloquent details, is no less than a vision of the world. Bruegel shows us our folly and lust, laziness, impiety and greed. The artist holds up a cosmic mirror of who and what we are in terms of impatience, of self-deception, of the thousand and one vices that bedevil the postlapsarian condition, making Bruegel a moral encyclopaedist in the Medieval tradition.

Some of the artist's proverbs are still in use today, such as "belling the cat," "don't count your chickens before they are hatched," "hiding one's light under a bushel," "falling between two stools," "the luck of the draw," and "the blind leading the blind." Other painted sayings come closer to metaphor, shown as personifications of "patient as a lamb," "armed to the teeth," "keeping the nest egg," "speaking from both sides of his mouth," "the die is cast," "sitting on hot coals," and "led by the nose," among many others.

The Bible provides the artist with at least one vignette: "Casting pearls before swine"; another comes from Aesop: "The crane invites the fox to dinner." Several give the devil his due: Going to him for confession signifies telling your secrets to enemies, while "lighting candles for the devil" is to make friends in all camps. "Lying under the eaves" conveys the illicit joys of unwed intimacy. "A roof covered with tarts" signifies a rich house, and "a broom sticking out" provides a graphic emblem for a house without men!

Closest to "Peasant Bruegel," reputed to have donned farmer's clothing to join rustic revelry

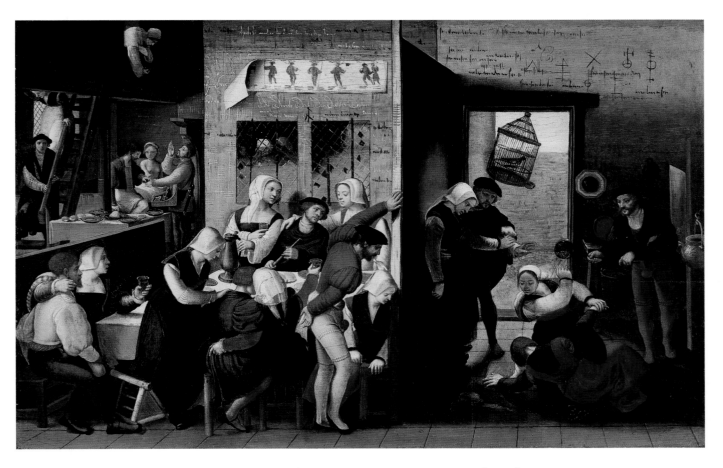

ATTRIBUTED TO JAN SANDERS VAN HEMESSEN, Hemiksem, near Antwerp, c. 1500 (?)–Haarlem, after 1563
The Prodigal Son, c. 1540

unrecognized, may be the earthy proverbs rooted in the day-to-day experience of agriculture, words of folk wisdom that come from the barnyard. Labored, if not unknown, today, these lines were common in the artist's times. "The sow pulls a bung from its barrel" signifies mismanagement. An angry person is one who was "brought up in a harness." "One shears sheep, the other piglets" compares rich and poor. A futile pursuit "drags a millstone."

So pithy a saying as "pissing on the moon" is far less politely phrased than "reaching for the moon." Once again, "The chamber pot's upside down" refers to the beloved theme of the world upside down, which is part of the popular culture of the Lowlands, still seen in today's devotion to Belgium's beloved bronze fountain of a urinating baby boy, the *Mannekin Piss*. Meanwhile, "He shits on the world" still speaks for itself.

Bruegel's small panel of two chained monkeys (*160*), painted in 1562, shows its subjects confined

within an aperture opening upon a view of Antwerp's harbor. These forlorn prisoners from the jungle are painted with scientific exactitude after species imported from Africa. Monkeys are emblematic of the painter's imitative function as well as of human folly.

Striking for its faithful attention to rustic detail is *The Arrival of the Holy Family in Bethlehem* (*164*) by Cornelis Massys. Shown after having been turned away from the inn, the Family's presence seems almost incidental to such a loving delineation of landscape.

Brothel or tavern scenes were often given a moralizing bent by including some notably innocent male participant, to be seen as a, if not *the*, prodigal son. Such a figure is found between the two women to the left of the door in a panel attributed to the Antwerp artist Jan Sanders van Hemessen (*165*).

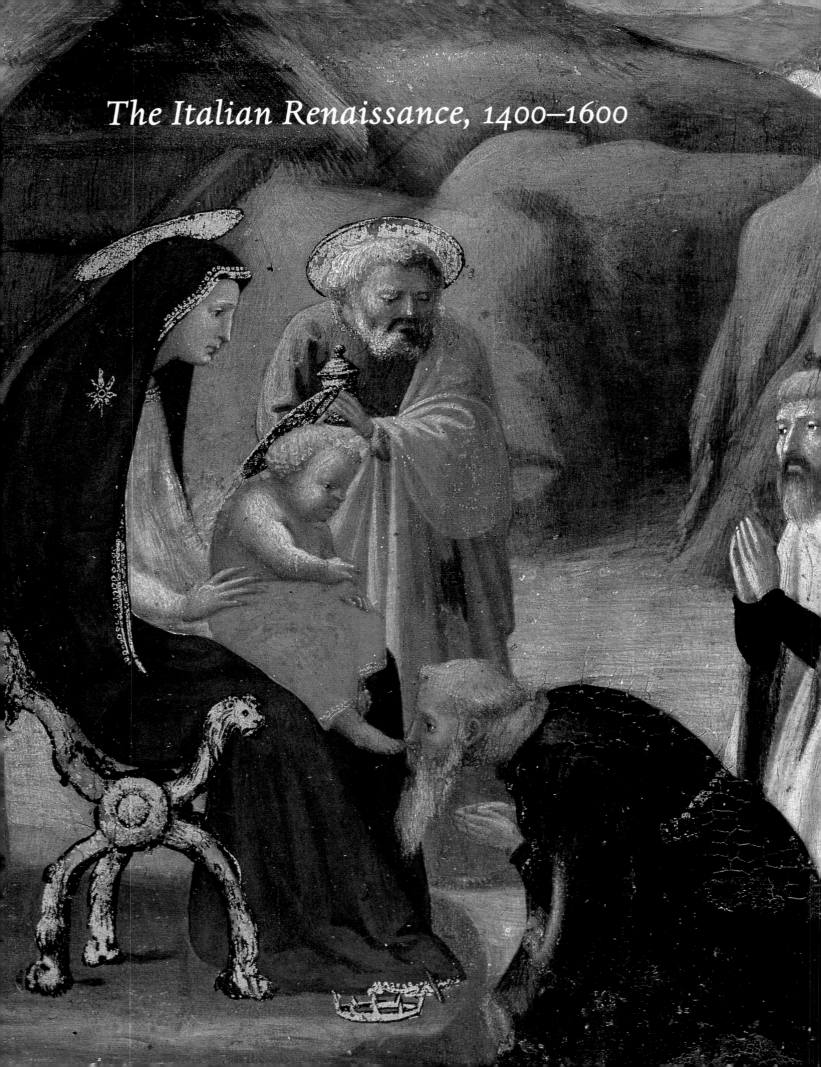

The Italian Renaissance, 1400–1600

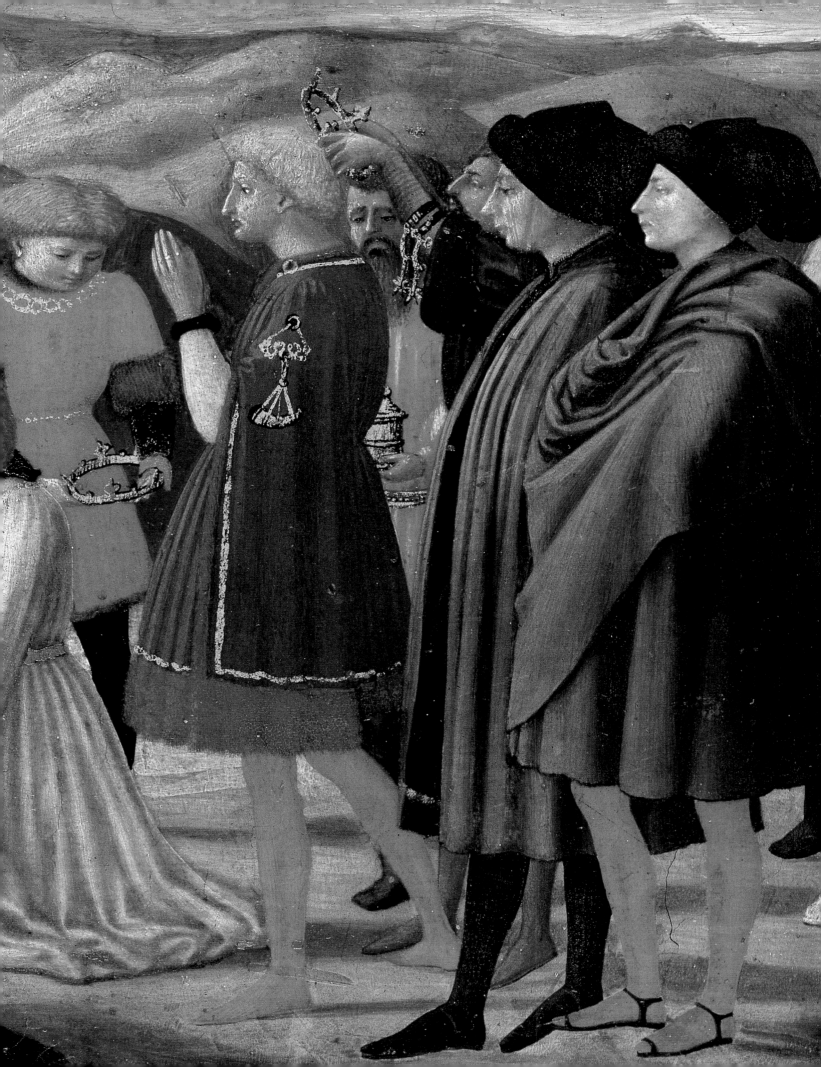

BUT FOR the pungent authenticity of childhood's vision or its recollection, later innocence — or naïveté — seldom makes for memorable images. While Italian painting before Raphael was long referred to as that of "the Primitives," only fifteenth-century Sienese art may sometimes deserve that odd appellation. Her patrons and painters sought deliberate simplicity, as if pursuing an oxymoronic state of enlightened ignorance, seldom following their powerful pictorial heritage, whether that of Duccio's neo-Byzantine majesty or the Lorenzetti's (*36–37*) mastery of space, narrative, and genre.

Quattrocento Siena settled for far more modest goals. Of her earlier masters, only the memory of Simone Martini, courtliest of them all, was still cultivated. Mystical in an intimate key, Siena provided touchingly modest pictorial recitations. These were given a fairy-tale spin by colors of unrivaled prismatic beauty and often recall enlarged illuminations.

Even Siena's secular art has a certain enchantment; her painted, often documentary, account-book covers, used for protecting records of disbursements and cash received, seem almost as far from the facts of life as her pictorial hagiography. Faithful to a monastic treasurer's role, a financial record cover, or *biccherna* (*168*), of 1329, by an unknown artist, shows the Cistercian monk Don Niccolò da Sangalgano at his official booth, putting golden coins — funds that came from taxes, customs, tolls, loans, and fines — into a sack. His Order, with that of the Umiliati, usually managed this office; the arms of the *Provveditori* (administrators) are seen to the right. This panel was owned by one of the Nazarenes, Johann Anton Alban Ramboux (*530*) of Cologne, who was also among the first major European collectors of early Italian art.

By 1400 Siena, so long a very rich republic, had

Sienese
Don Niccolò da Sangalgano at His Collection Booth
(*biccherna* cover), 1329

Opposite:
MASTER OF THE OSSERVANZA TRIPTYCH
Siena, active second quarter of fifteenth century
St. Anthony at Mass Dedicates His Life to God, c. 1435

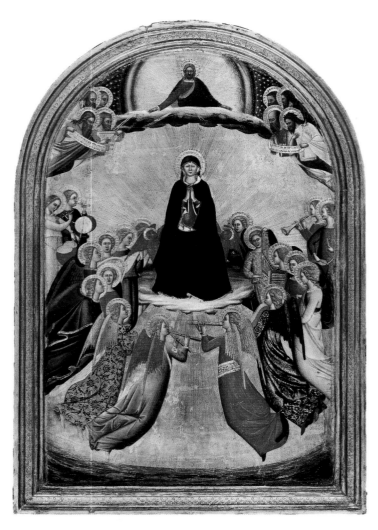

Sienese
The Assumption of the Virgin, first quarter of fifteenth century

fifteenth century may reflect some great lost Trecento image of this key theme.

Surprisingly, Siena's almost childlike, reductive vision appealed to some of the most advanced painters of the mid-Quattrocento. Just as the Douanier Rousseau spoke to Picasso, Piero della Francesca found the radiantly Gothic color of Sassetta a source of lucidity close to that of early Netherlandish art, lending the luminosity that was critical to Piero's oeuvre. Sassetta's great altar of St. Francis was installed in Borgo San Sepolcro, Piero's hometown, in 1444. Berlin has a predella panel from that Franciscan altar (two others are in the Louvre) showing *The Blessed Raniero of Borgo San Sepolcro Appearing to a Cardinal in a Dream* (173). Sassetta's *Madonna of Humility* (172) is the central section of a triptych (its wings in the National Gallery of Art, Washington, D.C., and the Frick Museum, Pittsburgh).

Too productive for his own good, Giovanni di Paolo painted innumerable arid works after he had created his earlier, often stirring or enchanting, imagery. Berlin's panels are among his best. *St. Clare Rescuing the Shipwrecked* (174–75) is one of four predelle, with another also in Berlin, others at Yale and in Houston. *St. Jerome Appearing to St. Augustine* (175), of c. 1465, is a predella to a panel in the Louvre. Giovanni's squashed treatment of space shows a blithe disregard for Florentine perspectival sophistication.

Active from 1430 to 1450, the Osservanza Master's work is very close to Sassetta's. His *St. Anthony at Mass Dedicates His Life to God* (169) is one of eight panels that possibly surrounded a full-length image of the saint by Sano di Pietro (Paris, Louvre). The authorship of all eight panels is widely disputed, variously given to the Osservanza Master, Sano di Pietro, and Sassetta.

In the *Mass*, the saint is shown twice, once in wealthy garb, in the foreground, and again in monastic attire, kneeling to the right. The tile floor, inlaid-wood patterning, or intarsia, and contrasting dark green and white marbles used for the architecture do more than define space; like a late Kandinsky or a Mondrian, they move the viewer's eye and heart in a liturgical equivalent to the latter's *Broadway Boogie-Woogie*.

lost her vast pan-European banking empire — which had arisen earlier and become greater than that of Florence — only to find herself a born-again innocent, orphaned from her heritage. Ignorant of, or denying, the power of her past, and now without the requisite funds, Siena was forced to abandon the gargantuan rebuilding plan for her cathedral, its lavish interior suggested by the Master of the Osservanza Triptych (169).

But for those frescoing her Ospedale della Scala, most of Siena's later painters renounced, or were incapable of maintaining, the intellectuality of her ever-richer Florentine neighbors' perspective. Whether from necessity or choice, the School sought for — or destiny decreed — an inspired simplicity. A powerfully composed, anonymous *Assumption of the Virgin* (170) from the early

PIETRO DI GIOVANNI AMBROGIO, Siena, 1410 (?)–1449, *St. Augustine's Departure (?)*, shortly before 1430 (?)

In the second half of the fifteenth century, with so many of Siena's painters active as sculptors or architects, a new sense of the third dimension entered her art. Such ambitious exploration is discernible in a very large, illusionistic panel (*176–77*) ascribed to many artists, recently to Francesco di Giorgio Martini, who was active as a painter, sculptor, and architect. This trompe l'oeil was doubtless designed for some site-specific function (possibly for the headboard of a bed), or to extend a preexisting space.

Little better known than the still-enigmatic subject of his painting (*171*), Pietro di Giovanni Ambrogio is a painter of unusually distinctive personality who invests both figures and space alike with emotional intensity. Possibly showing a journey undertaken by St. Augustine, his mother St.

Monica waving from the shore, this well-preserved panel presents Pietro's original color at its keenest.

Intelligence seldom conveys the sensation of faith. Sophistication lies far from St. Francis's passionate feeling for, and embrace of, nature. A sense of divine mission empowered the illiterate St. Catherine of Siena to lead the papacy back from Avignon to Rome. Her republic's artists reflected upon the experience of landscape as Godscape and were the quickest to realize the inspired solitude of devotional life. Far from any sense of progress, Siena's Quattrocento art contented itself with nostalgia, exploring inner space. Wise children, her painters of that period may have understood more of our needs than we may care to believe, or believe in caring.

SASSETTA
Siena (?), c. 1400–Siena, 1450
The Blessed Raniero of Borgo San Sepolcro Appearing to a Cardinal in a Dream, 1444

Opposite:
SASSETTA
Madonna of Humility, c. 1432–36

GIOVANNI DI PAOLO
Siena, active 1420–1482
St. Jerome Appearing to St. Augustine, c. 1465

Opposite:
GIOVANNI DI PAOLO
St. Clare Rescuing the Shipwrecked, c. 1455–60

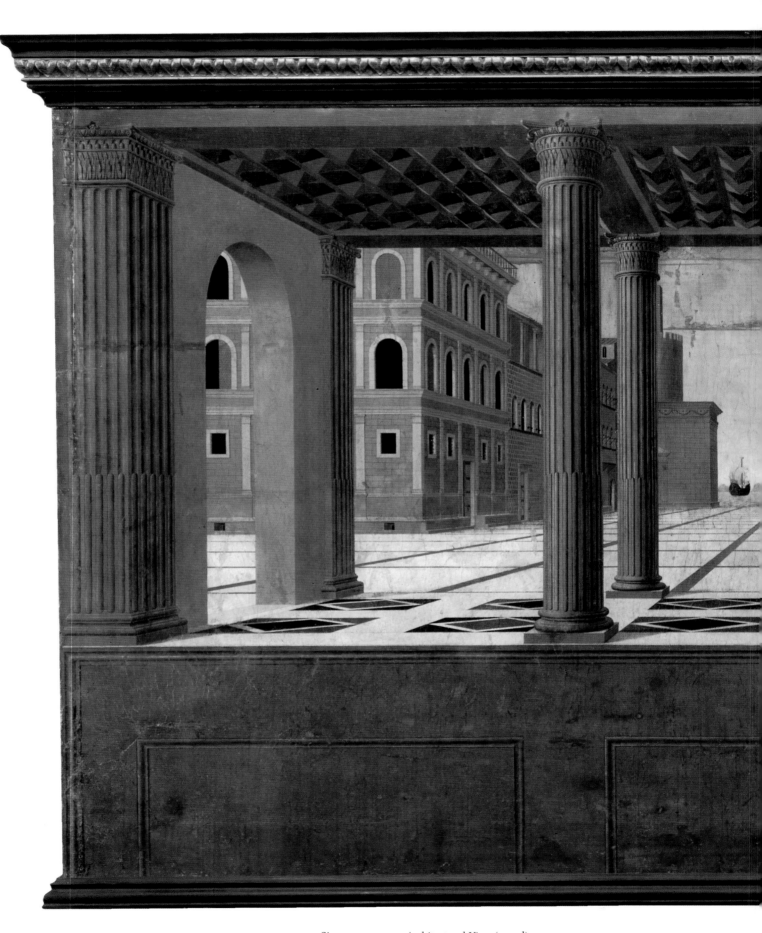

ATTRIBUTED TO FRANCESCO DI GIORGIO MARTINI, Siena, 1439–1502, *Architectural View* (panel), c. 1477

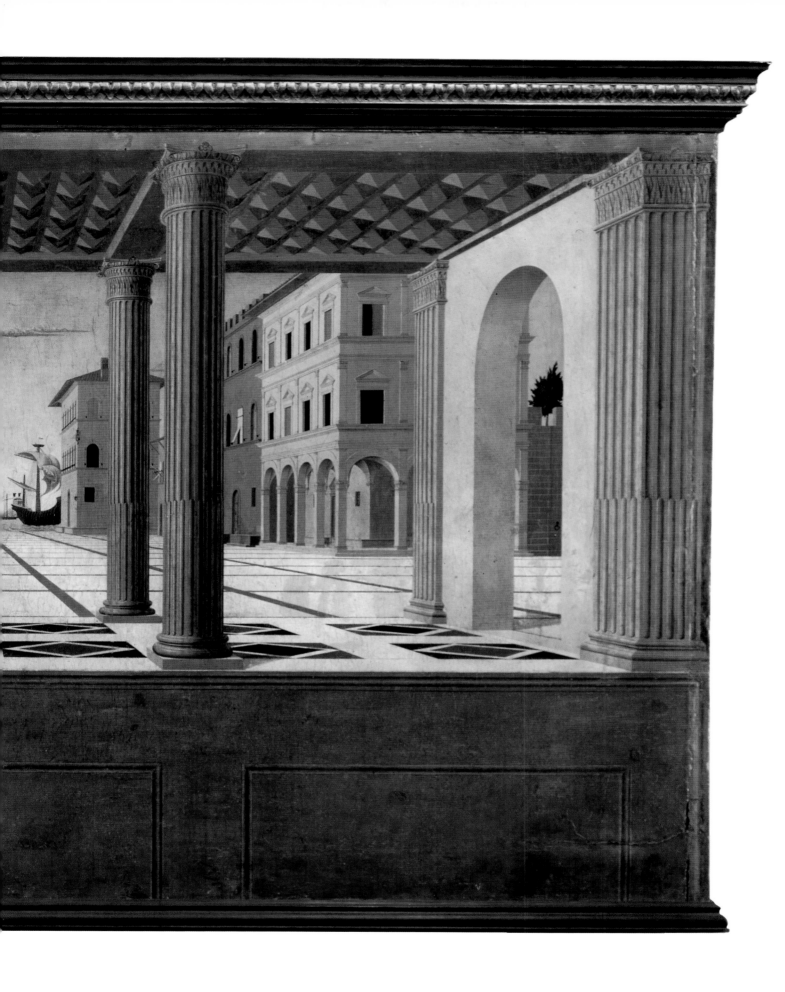

MASACCIO, *THE* FIRST RENAISSANCE PAINTER

MAJOR German interest in Masaccio began with two painters of the Romantic period, Gottlieb Schick and Eberhard Wächter. During the French occupation of Rome, they fled to Florence, where they rediscovered the splendors of the early Quattrocento. By that time, Masaccio's Brancacci Chapel had already been reproduced in print form by Thomas Patch in 1770.

To talk of "early works" in the career of an artist who died at twenty-seven sounds absurd, especially when the project in question, the *Pisa Altar*, was finished when Masaccio was twenty-six. Nevertheless, it falls in this category, stylistically as well as chronologically, because the altarpiece was confined within an old-fashioned format: a richly carved, conservative Gothic retable, with little images of saints set into the frame, one on top of the other, of which Berlin has four (*180*), two of Carmelite saints, and one each of SS. Jerome and Augustine, their forceful modeling distinctly like that of Donatello.

The altar Masaccio painted for S. Maria del Carmine, the Carmelite church in Pisa, is his best-documented work; all payments were recorded and his patron is known. Since it has all three predella panels and the four little saints from the frame, Berlin lacks but four of the *Pisa Altar*'s surviving panels. These include the great central *Madonna and Child Enthroned with Angels* (London, National Gallery) and the panels from the very top: *St. Andrew* (Malibu, Getty Museum), *St. Paul* (Pisa, Museo Nazionale), and the centrally placed, uppermost, *Crucifixion* (Naples, Gallerie di Capodimonte).

Three panels (*181*) from the altar's predella — with scenes from the lives of SS. Peter and John the Baptist and SS. Julian the Hospitaler and Nicholas — were probably just below lost full-length panels of those saints. Berlin's panels, which occupied the lowermost register, include the cen-

trally placed *Adoration of the Magi*, and are in telling contrast with the stoical, timeless figures of Mother and Son just above. In the predella, Madonna and Child appear in more intimate, personal fashion, attended by Joseph, as the three kings pay homage to the Infant as the leader of the Gentile world.

With its quotations from Pisan Gothic sculpture (recognized by Eve Borsook), and from the abundance of classical statuary stored at Pisa's Campo Santo, the Berlin panels show Masaccio moving toward a radical reappraisal of antiquity and Gothicism alike. He is about to achieve a breakthrough in terms of new luminism, monumentality, and naturalism, all of which would be fully realized within a few months in the Brancacci Chapel fresco cycle (Florence, Carmine). Those magnificently lit hills in the Berlin *Adoration of the Magi* point to the landscapes rediscovered in all their radiance with the recent cleaning of the Florentine series.

Masaccio's use of light and cast shadow led the way to a new generation of Florentine art first followed by Fra Angelico (*182, 188–90*) and by Fra Filippo Lippi (*191*), whose career began at the Carmine. The original appearance of the *Pisa Altar* may have been close to one in Berlin ascribed to Gherardo Starnina, who also was active at the Carmine.

Flanking the *Adoration of the Magi*, the predella panels show some of the mastery of the nude also found in the Brancacci Chapel, as well as a driving new concern for the figure in action. These innovations abound in the paired panels showing the *Crucifixion of St. Peter–The Beheading of St. John the Baptist* and *St. Julian Slaying His Parents–St. Nicholas Saving Three Sisters from Prostitution*. Yet none of these panels, with their awkwardly divided subjects, is as fully realized as the *Adoration of the Magi*, and they doubtless involved the work of studio assistants.

One of the odder Tuscan worthies, Julian, like Nicholas, was included as the altar donor's patron

ATTRIBUTED TO
TOMMASO DI SER GIOVANNI,
KNOWN AS MASACCIO
San Giovanni Valdarno, 1401–Rome, 1428 (?)
Birth Salver, c. 1420

saint. A bizarre legend tells how Julian slew his parents in the belief that they, resting in his nuptial bed, were his wife with a lover! Seen again to the right, Julian is distraught upon meeting his wife after the deed was done. Penance through a life of good works led to his canonization.

By throwing a ball of gold to each of three daughters shown mourning their penniless father's impending death, St. Nicholas provided them with dowries, so saving the trio from lives of prostitution. Centuries later, three gold balls came to symbolize pawnshops, which were long under Church management.

All the finest aspects of the *Pisa Altar* — its exploration of luminism, figures in action, profound emotion, landscape — are intensified in Masaccio's magnificent Florentine frescoes at the Carmine and at the Dominican church of Santa Maria Novella. For the fullest realization of his vast gifts, Masaccio needed to work on a large scale, one offering lots of pictorial elbow room. Splendid though the *Pisa Altar'*s Berlin panels may be, asking Masaccio to paint "small" would have been like commissioning a miniature from Michelangelo. Wall painting, so

close to ancient techniques, allowed for a broader treatment of light, scale, and space than did tempera on wood or canvas. Only true fresco, with its requisite speed of execution, provided that key aspect of "action painting" needed to bring out the best in Masaccio. No one else's best was better than his.

A large birth salver — *descho da parto* — (179) shows an important entourage with the banner of the governing body of Florence, the *Signoria,* approaching a wealthy woman in childbed. This panel is traditionally ascribed to Masaccio but may well postdate that master, possibly painted by a Sienese artist active in Florence nearer the mid-century mark. A later *descho* in Berlin, with a devotional subject, is by Signorelli (238), this one less usual for its documentary narrative. Very well preserved, with a crudely painted baby playing with a puppy on the verso, Berlin's large Masacciesque roundel is among the finest of all *deschi,* distinguished for the beautiful spatial organization, with its circular confines, and for the intense realization of character, close to the art of Pietro di Giovanni Ambrogio (171).

MASACCIO
Four panels from the *Pisa Altar*, 1426:

Two Carmelite Saints (top)
SS. Jerome and Augustine (bottom)

Opposite:
MASACCIO
Three predella panels from the *Pisa Altar*, 1426:

The Crucifixion of St. Peter–
The Beheading of St. John the Baptist (top)
The Adoration of the Magi (middle)
St. Julian Slaying His Parents–
St. Nicholas Saving Three Sisters from Prostitution (bottom)

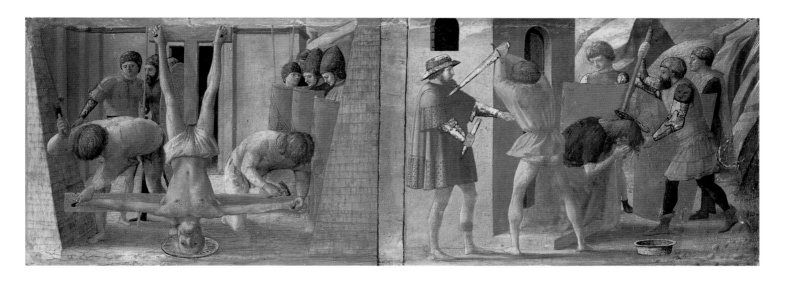

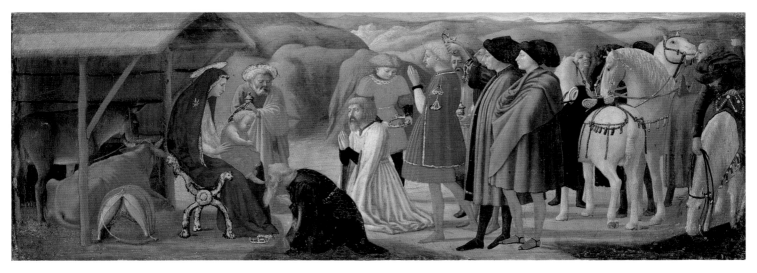

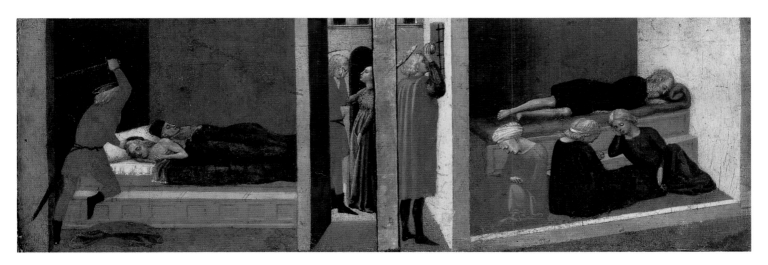

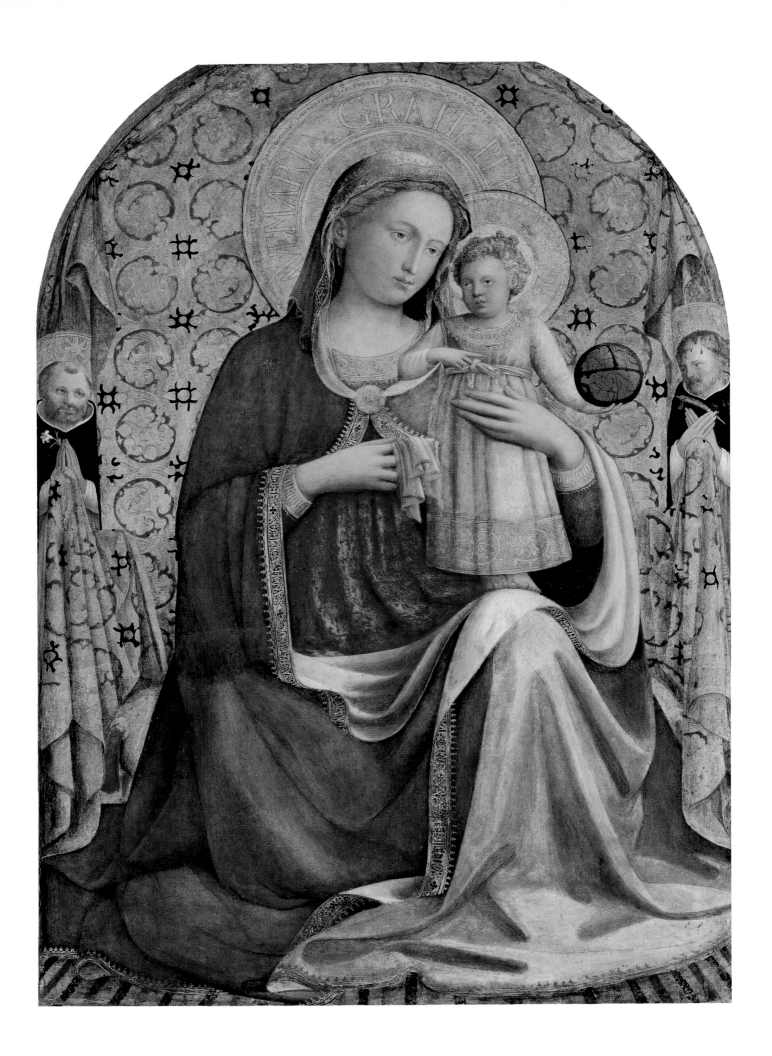

FLORENCE'S WORKER-PRIEST PAINTERS:
DON LORENZO MONACO, FRA ANGELICO, FRA FILIPPO LIPPI

THAT three of Florence's leading early Renaissance artists belonged to holy orders is among the stranger aspects of that city's art. Don Lorenzo Monaco, Fra Angelico, and Fra Filippo Lippi, contemporaries and key followers of Masaccio, were the three decisive figures in the shaping of early Tuscan modernism.

All three benefited from the protection, the education, and the freedom provided by their Camaldolensian, Dominican, or Carmelite affiliations. Monastic scriptoria helped these young artists discover subtleties of light and color uniquely accessible to manuscript illumination. Their Orders permitted them to take on outside commissions and to travel widely. Where Don Lorenzo lived "off-campus," in his own house-workshop, Lippi's freelance life engendered his painter-son Filippino (236), who was born to a nun, the friar's frequent model Lucrezia Buti.

Berlin abounds in works by Lorenzo Monaco, eldest of the monastic trio and the one closest to the International Style, that courtly revival of the exclusive world of Simone Martini (29). Born in Siena as Pietro di Giovanni, he was trained in the Florentine workshop of Agnolo Gaddi, Taddeo's son. Don Lorenzo's frescoes, large altarpieces, and manuscripts came to dominate Florentine art of the early fifteenth century.

His large workshop was kept busy fulfilling commissions. Gracefully conservative, with occasionally surprising insights into light, color, and experience, Lorenzo Monaco's vogueish art has a certain sameness to it. Florentines found Don Lorenzo's images appealing, their elegant, inventive conservatism beyond style, subtly updated by elements from Ghiberti's reliefs. A very well preserved *Nativity* (183) has additional predelle of martyrdoms to the left and right — those of SS. Peter (Baltimore, Walters Arts Gallery) and Paul (Princeton University Art Gallery). Further panels include *St. Jerome* (Dortmund, Cremer Collection) and *St. John in the Wilder-*

LORENZO MONACO, Siena, c. 1365–Florence, before 1426, *The Nativity*, c. 1390

Opposite: FRA GIOVANNI DA FIESOLE, CALLED FRA ANGELICO
Mugello, near Florence, c. 1395 (?)–Rome, 1455
Madonna and Child, c. 1433

LORENZO MONACO, Two predella panels, c. 1394–95: *The Beheading of St. Catherine of Alexandria; The Last Supper*

ness (Leicester, Art Gallery). Federico Zeri, the great scholar of almost all Italian art, found the altarpiece that goes with these panels stored at the Accademia, Florence, its *Madonna and Child* now in Toledo, Ohio. Originally this altar was probably the principal one at S. Maria del Carmine, seen near Masaccio's frescoes in the same church's Brancacci Chapel.

A narrow panel by Lorenzo Monaco of the Last Supper (*184–85*), with *The Beheading of St. Catherine of Alexandria* (*184*) to the left, were among other widely scattered panels of the high altar of the Florentine monastic church of San Gaggio (also known as Santa Caterina al Monte). In the first, Christ and the apostles are fitted within a boxlike space. Judas is placed "below the salt," at the far side of the table from Christ and John, as witness to the latter's despair upon learning of the impending betrayal.

The language of piety and the choreography of devotion spoke and moved through the arts of sacred experience, often communicated by Fra Angelico with touching eloquence. The Dominican priest's sacred intelligence helped him generate a new way of picturing religious themes, bringing prayer to life and life to prayer in newly cyclical, narrative fashion.

Of all that city's painters, Angelico, five years Masaccio's junior, may also have been his wisest and most immediate follower in Florence. The friar was also responsive to the new monumentality of a great sculptor, Nanni di Banco (c. 1385/90–1421), whose work had meant much to Masaccio. So another "worker priest," the Dominican Fra Angelico, appropriated the powerful novelties of the early Renaissance's major classicizing figures and recast them in a context of accessible pietism.

Angelico's art at its very best can be seen in two scenes from the life of St. Francis (*188–89*). Two other sections complete this predella (Vatican, and Altenburg, Staatliche Lindenau Museum), which was possibly painted for an altarpiece at Pontassieve. The warmer light and gentler color derive from Masaccio and possibly from new northern Italian sources. Like the related subject of the Doubting Thomas (*279*), the *Lamentation* — gift of J. P. Morgan to Wilhelm von Bode, who presented it to the museum — shows a skeptical Franciscan (Brother Jerome) whose faith is restored upon touching Francis's stigmata. *The Apparition at Arles* depicts Francis, shortly after his death, appearing to members of his Order and bestowing upon them

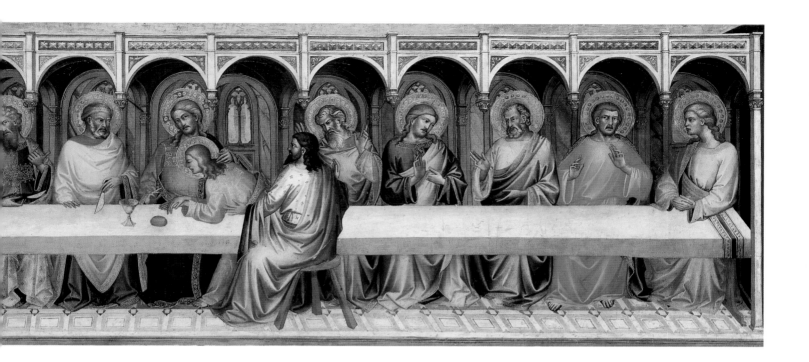

the blessing *pax vobiscum* ("peace be with you"). All these scenes show a keen awareness of Giotto's art, especially the *Lamentation over St. Francis*, which demonstrates Angelico's adaptation of the Trecento master's monumental, sculptural figures, with their secure expression of emotion and solid occupancy of space.

Very different is the *Madonna and Child* (182), which is dated near 1433, the year when Angelico painted his most monumental work, the *Linaiuoli Triptych* (Florence, Orsanmichele). Berlin's humble image approaches the new lyricism of Ghiberti, Quercia, and Masolino. Though the Dominican has adopted the fourteenth-century devotional formula for his Madonna, with Mary seated close to the ground, he cannot help investing her with a richly tasseled pillow and a lavishy brocaded cloth of honor. SS. Dominic and Peter Martyr are tucked in at the left and right.

Close to Trecento sources, to the School of Orcagna in particular, is Angelico's late *Last Judgment* triptych (190) of c. 1450, painted when the popular artist had a large studio. It may be by Zanobi Strozzi, who was predominantly a manuscript illuminator. Originally on a single panel, the scene was cut into thirds at a much later date. It presents several earlier stylistic currents, the figure of Christ recalling heroic statuary made for the facade of the Duomo, a lost *Last Judgment* by Masaccio possibly reflected in the central scene.

Filippo Lippi provided a blander, more decorative, secular religiosity, comfortingly "at home at home," equally at ease in a church, within a Medici Palace chapel, or in a country house. Sweet-faced, just a little dull, his holy ones often bespeak a certain juvenile sameness; Lippi's art seldom surprises once his daring early works were behind him. Like Fra Angelico, he learned much from Masaccio and Donatello.

Among Lippi's many skills was the contrivance of an Arts and Crafts style, a Good Design approach that brings together lovingly inlaid furniture, beautifully embroidered textiles, and well-kept gardens along with all the other appurtenances of a cultivatedly upper-class Florentine domesticity to which the saints were given entrée, residing in settings worthy of a Brunelleschi's or a Michelozzo's devising.

Overleaf:
The Lamentation over St. Francis (detail)

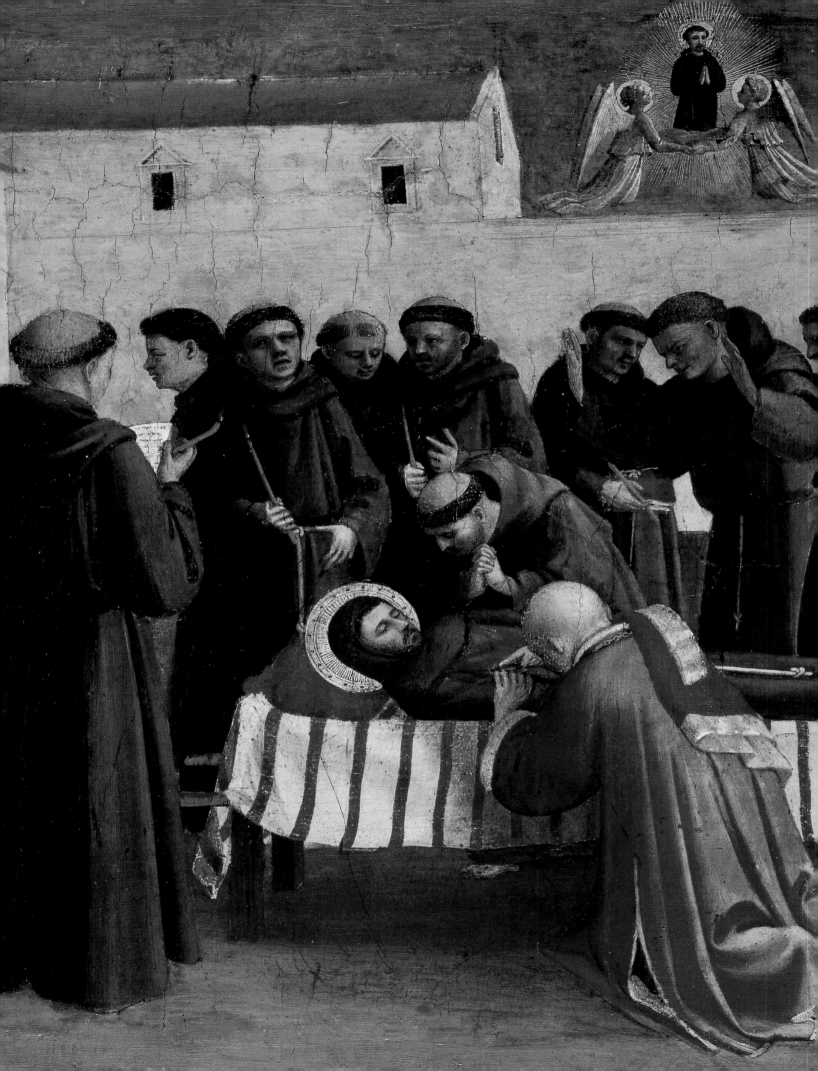

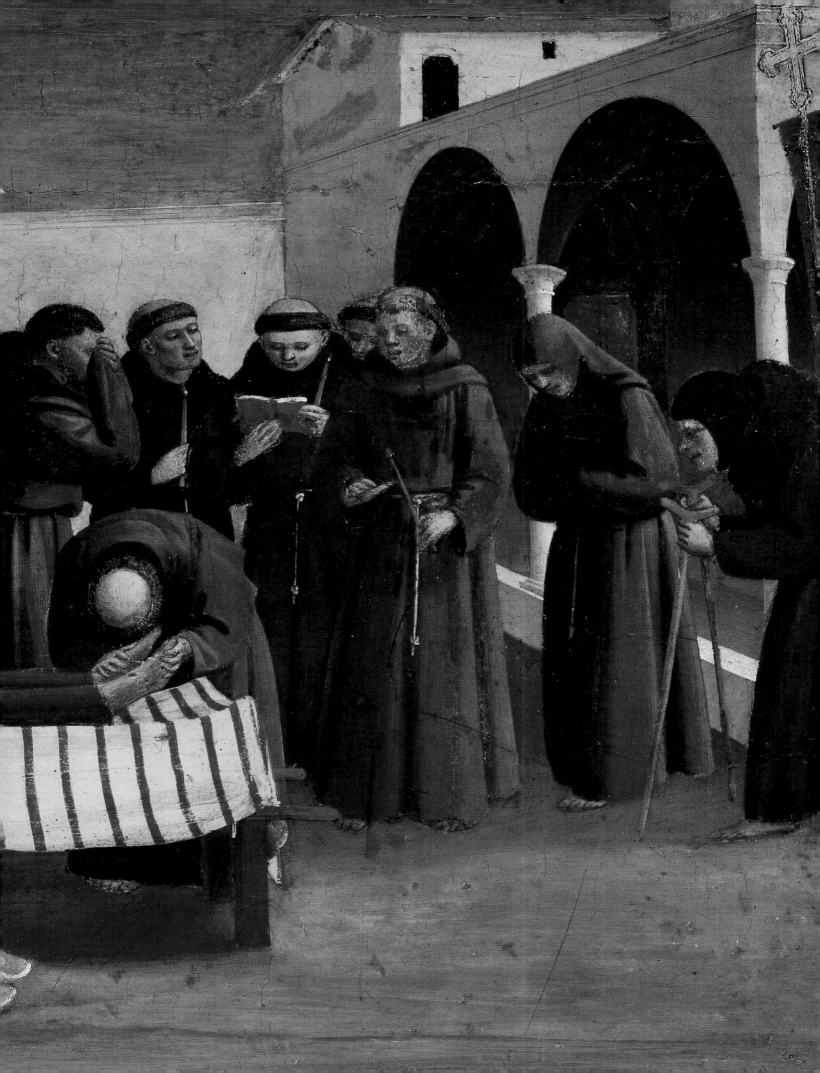

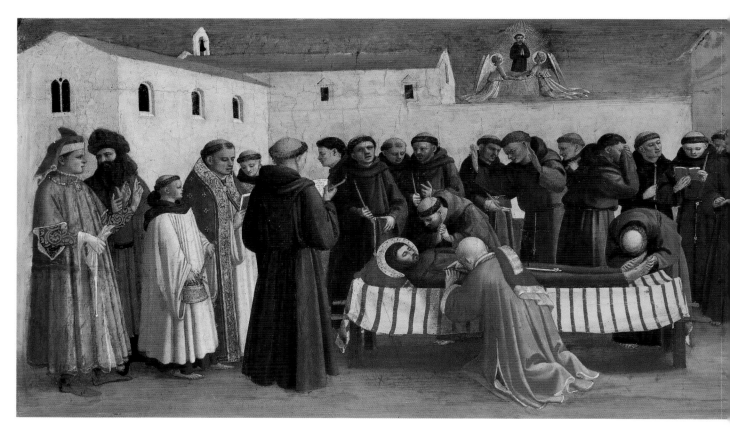

FRA ANGELICO
Two scenes from the Life of St. Francis, c. 1440–50: *The Lamentation over St. Francis; The Apparition at Arles*

FRA ANGELICO, Triptych: *The Last Judgment*, c. 1450

Lippi's best-loved altarpiece (*191*), sometimes called the *Adoration in the Forest*, was painted c. 1459 for the ornately decorated chapel within the Medici Palace, its walls covered by Benozzo Gozzoli's scenes of the approaching Magi. Mary adores her Infant Son as the first and third members of the Trinity look down from above. The young John the Baptist — the patron saint of Florence — and St. Bernard of Clairvaux, founder of the Cistercian Order, are at the left.

Abundantly flowered and wooded, the background has a tapestrylike quality not far from Northern hangings imported by the Medici. Here the Infant's nakedness, his finger to his lips, may

indicate future suffering and sacrifice. Lippi's name is inscribed on an axe, which, with the setting's many chopped-down trees, alludes to John's words "Now also the axe is laid unto the root of the trees: every tree therefore which bringeth not forth good fruit is hewn down, and cast into the fire" (Luke 3:9).

Benozzo Gozzoli is represented in Berlin by a brilliantly colored predella panel of Florence's early Christian bishop and patron saint. *St. Zenobius Resurrecting a Dead Boy* (*192*) — replica of the one in New York's Metropolitan Museum of Art — shows the revival of a lad who had fallen to his death after his mother had left him in Florence as she continued on her pilgrimage to Rome. This and the other predelle

FRA FILIPPO LIPPI
Florence, 1406 (?)–Spoleto, 1469
The Adoration, with the Infant Baptist and St. Bernard, c. 1459

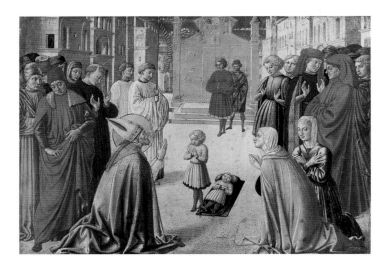

BENOZZO GOZZOLI
Florence, 1420–Pistoia, 1497
St. Zenobius Resurrecting a Dead Boy, c. 1461

(Milan, Philadelphia, Washington, and Windsor Castle) were painted c. 1461 for a *Madonna and Saints* (London, National Gallery) installed at the Medici-sponsored Dominican monastery of San Marco, where Gozzoli's teacher Fra Angelico was long active. Gozzoli knew where to look for inspiration, here turning to the art of Domenico Veneziano (*218, 223*).

Hopeful Chests — Painted Cassoni

Among the commonest secular commissions for Florentine painters was that of decorating *cassoni*, ornate hope chests whose embellishment was often paid for by the groom. They were filled with parts of the dowry to be borne in triumph through the city streets as part of the wedding procession. These functional objects were sometimes painted by major artists such as Domenico Veneziano. More often they came from the workshops of lesser masters, where their decoration often repeated designs preserved in studio pattern books and selected by the client.

Defined by the temporal, by decorations for theatricals and court pageantry and triumphal processions, the art of the *cassone* is an invaluable reminder of the way Renaissance society saw itself — often beyond the conventions and expectations of Christianity. In northern Italy and Florence, the easy, intimate identification with classical subjects, with the lifestyles of the Greeks and Romans, to say nothing of Mount Olympus itself, was one of happy, amusing presumption, very different from the stilted formality of later Neoclassicism or Neo-Platonism. So these *cassoni* are keys to the way Florence lived, to familial and other relationships, to celebrations of alliance and of state, to a fondness for Petrarch's *Triumphs* and other late-medieval accounts of the sudden sighting of pagan messengers, divinities, and nymphs in the Tuscan hills.

Berlin has two unusually lavishly and gracefully "narrated" *cassoni* devoted to the classical legend of the loves of Cupid and Psyche (*193*). Painted at mid-century, they follow Bocaccio's popular retelling of Apuleius's text. These hope chests were ascribed by Paul Schubring to the Master of the Argonaut Panels, a Florentine painter named for the chests that he decorated with Psyche's legend (Prague; Philadelphia Museum of Art). Berlin's may be for the marriage of Piero de Medici in 1448.

In the first *cassone*, seen within a palace, from left to right, Sol (Apollo) makes love to Entelechy, Psyche being the fruit of their union. The latter stands on a balcony, adored by suitors. Jealous Venus, flying overhead, is eager to punish Psyche, her terrestrial rival. In the next building to the right, a temple of Apollo, Psyche's father throws her from a cliff. She is rescued by Zephyr the wind god's clouds. Brought to the palace of Amor, Psyche marries Venus's son Cupid, the god of Love. Her envious sisters visit her, sowing seeds of suspicion against Cupid in Psyche's mind, as she is not allowed to see him. Disobeying that command, Psyche views the sleeping Cupid by the light of an oil lamp. He flies away, abandoning her.

The second *cassone* shows Psyche overcome with grief, lying on the floor. Cupid, speaking from a tree, tells her to go to Ceres's temple to ask for forgiveness. Psyche goes to the palace of Venus, and Cupid bids Zeus to elevate her to the Heavens, where he weds her once again.

Ambivalent and ambiguous, civilized yet barbaric, teeming with sex, violence, retribution, and resolution, the legend of Cupid and Psyche is typi-

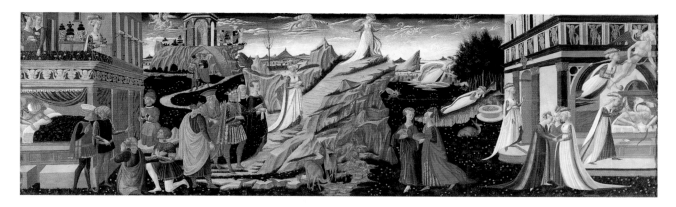

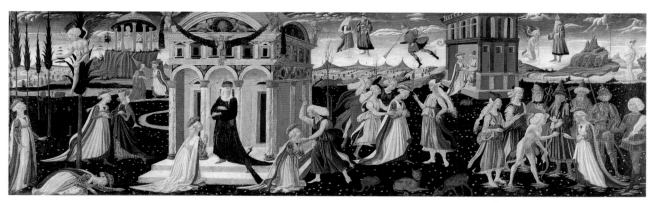

MASTER OF THE ARGONAUT PANELS, Florence, active third quarter of fifteenth century
Two *cassone* panels with the Legend of Cupid and Psyche, c. 1448

cal of the ancient literature that spoke so directly to the Middle Ages and the Renaissance. All too human, the deities' caprice and inconstancy determine our fate. Safe and sorry, with the requisite happy ending, Psyche's hegira would seem a less-than-happy augury of a woman's role in marriage, but it was illuminated by sufficiently profound truths to make her tale an enormously popular Renaissance narrative. Where the twentieth-century reader-viewer sees this legendary account steeped in Freudian/Jungian guise and disguise, those of the Renaissance probably read their *cassoni* in more allegorical fashion, as expositions of the fact that the path to love, to say nothing of the path from it, was seldom a smooth one. Since marriages were arranged, brides and grooms alike had relatively little to say in the matter; the mixed messages of mythology came closer to home than the fiancés — who often selected subject and artist alike — may have cared to know.

Some *cassoni* and related painting dispensed with figures altogether, clearing the stage of gods or mortals to devote their long, narrow field of vision to the mysteries of space, to the ins and outs of urban architecture and public places, preparing an empty set ever ready for the play.

Sienese painters told and retold subjects in so effectively intimate a fashion that their approach appealed to their Florentine contemporaries, who were always receptive to the wise innocence of their neighbors' art and found it almost as captivating for its omissions as for its commissions. Siena's pictorial minor key, one of intimation rather than explication, was heard and felt on the Arno, where a more calculated, rational approach could chasten hope or cool desire. So, surprisingly, Siena is alive and well in Florentine *cassoni* and *spalliere;* her artistic presence is felt in those richly narrative, tapestry-like panels on hope chests or walls, recalled by Florentine artists whenever an old-fashioned tale had to be told or colorful song sung, in a romantic crossing-over from medium to medium.

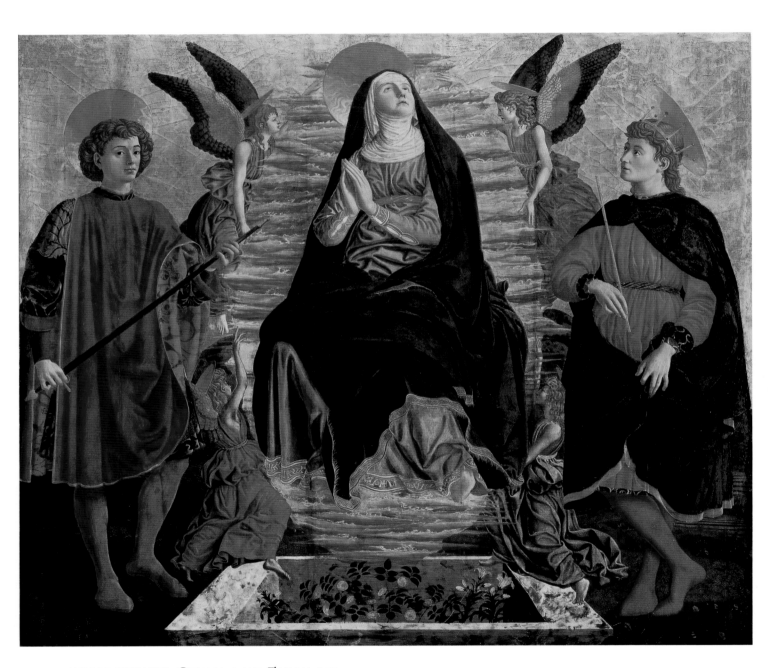

ANDREA CASTAGNO, Castagno, c. 1421–Florence, 1457
The Assumption of the Virgin with SS. Julian and Miniato, c. 1450

CRAFT INTO ART

AS A CENTER for goldsmithery and humbler metalwork, Florence was long famous for her skills in design and craftsmanship, for an unusually assured approach to decoration, whether in the arts of jewelry or intarsia, weaving or embroidery. Even Brunelleschi, godfather-inventor of Renaissance architecture, began as a goldsmith (and none too good a one at that). Lorenzo Ghiberti, the Florentine goldsmith, sculptor, architect, and designer of stained glass, long in charge of the building of the Duomo, was among the city's most influential artists; Donatello, Paolo Uccello, Masolino, and Michelozzo, among many other major painters and sculptors, were all in his large workshop at one time or another.

The power of the "craft underpinnings" for the finer of Florentine arts can hardly be overestimated, as so many of the city's greatest painters and sculptors came out of an "applied arts" orientation. This enlargement of initial focus was also sometimes found in the North, where Dürer (110) made a bold break with his apprenticeship in his father's silversmith's workshop to study painting instead. That risky, demanding shift from the applied arts to art beyond application defines the sole valid separation of the "minor" from the "major."

Only court artists were ever ready to devise and decorate anything and everything from privies to banners, horse-trappings, armor; funerary monuments to beloved dogs, rabbits, and squirrels, thus fulfilling the traditionally varied role of the so-called "Renaissance artist." Far more characteristic of painters of that period was an increasingly specialized, even snobbish, self-image in which the artist pledged exclusive service to his freshly minted muse, Pictura.

Many of these new Florentine painters came from careers in metalwork. True for the Pollaiuolo brothers Antonio (128–29) and Piero (c. 1441–before 1496), Domenico Ghirlandaio, Andrea del Verrocchio (203), and Sandro Botticelli (233–35). Sometimes the break was far from clean; Antonio Pollaiuolo was painter to the Neo-Platonic Academy, yet such a prestigious humanistic association did not curtail his work in precious metals; the same held true for Verrocchio, with his ongoing career in "multi-media."

Patrons — new-rich and old-rich merchant princes and *condottieri* (mercenaries) — needed a fresh combination of conventional religious sentiments, a handsome, impressive decorative vocabulary, and a newly assured return to Greece and Rome. This tall order often called for remarkable marriages between old and new, North and South, Antique and Gothic values.

Neither conventionally Gothic nor typically Renaissance, an altarpiece by Andrea Castagno (194) is divided between these traditions and benefits from the best of both. This work was commissioned for the Florentine hill church of S. Miniato fra le Torre by its rector, Ser Lionardo da Orte, and was painted by Castagno c. 1450.

Powerful yet delicate, the four angels supporting the radiant, cloud-streaked mandorla of Mary's corporeal Assumption are taken from Donatello's early reliefs. Her drapery, too, has a jagged excitement close to that sculptor's works. But the decorative and intense color, the complacently ephebelike, richly attired Tuscan saints Miniato and Julian, the festive flowers, and the victorious angels all could as easily participate in some Medicean pageant utterly devoid of religious significance.

By midcentury, with Alberti's writing *On Painting* (1436), gold backgrounds like this were out of favor, but that didn't faze Castagno or his patrons. This *Assumption* is a pictorial thrill a minute, daring and dynamic. Blending theater and theology, the curtain for this ongoing mystery play never goes down.

Berlin has the world's richest collection of works by one of these artisan-into-artist teams, that of the brothers Pollaiuolo. Antonio was the older and the more powerful. Working in many media, including engraving, he infused these with a vital, virile line. His graceful *David Victorious* (198) is surprisingly small, even Botticellian; he suggests not biblical heroism but the dangers that may lie in store for a middle-aged man who loses his head over the airs and graces of a willowy Florentine youth. Sculpture by Donatello and Verrocchio had already made David more of an erotic concern than one that was traditionally Florentine-Republican, which bore the putative symbolism of all such Tuscan images. The incomplete panel may have extended to the side, en suite with other men and women heroes — popular themes of the late Middle Ages and early Renaissance.

Possibly by Antonio Pollaiuolo, or by Allesio Baldovinetti, the *Young Woman in Left Profile* (199) of c. 1465 is among the most exquisite Quattrocento portraits. Its conservative format presents the sitter's head in outline, only her upper torso permitted a slight torsion. Feminist criticism holds such presentation of women as indicative of their sexual objectification, as contrasted with that of their male counterparts, who were more often seen in three-quarter view. So shown, the man is aware of, and engaged with, the viewer, while the woman, in profile, must remain oblivious to being seen. The ledge suggests one painted for an altarpiece by Pollaiuolo for the Portuguese Chapel of the Florentine church of San Miniato, its foreshortening creating a sense of space.

Eccentric and exploratory, moving toward the monumental new ordering of the High Renaissance without losing the sense of discovery of the earlier period, Piero di Cosimo remains hard to categorize. His *Venus, Mars, and Cupid* (200–201) may have been painted as part of a suite of marital furniture, such as a bedstead, hope chest, or frieze.

Making love, not war, has exhausted Mars. He is literally disarmed as well as stripped by and for passion as putti toy with his armor in the background. Lovebirds and turtledoves coo nearby. Venus embraces her son Cupid, while a rabbit, another symbol of love and fertility, nuzzles his hand. This long, low panel pays willing tribute to the Triumph of Love, life's most pleasurable leveler. Vasari, who was the proud possessor of this painting, described it in his *Lives of the Artists* of 1550 and noted that it hung in his house, preserved there "as a memento of the artist, whose singular flashes of genius always give him joy."

"Transitional" is one of those fancy words, usually more evasive than helpful. Yet in the case of Verrocchio, it helps get to the heart of the matter, to the understanding of an artist who leaves the static, hieratic values of the first half of the fifteenth century for a more inventive, dynamic view of the passage of light, time, and motion. These ambitious areas of experience were first realized by Verrocchio's matchless young assistant, Leonardo da Vinci.

Like the latter, Verrocchio was a great sculptor as well as painter, one who also worked in relief and in precious metals. Such versatility is found even in two dimensions, for the painter's *Madonna and Child* in Berlin (203) has a sense of the oblique, of outreach and exchange. Exploration of landscape and an equally keen concern for light's passage and of chiaroscuro are often part of the painter-sculptor's concerns. Here, fascination for mysterious coils of drapery and twisted veils, for the dynamic found even in the row of ties along Mary's sleeve, bespeak a new role for the artist, one enhanced by technical variety and virtuosity, close to Leonardo's obsession with the labyrinthine and the interlaced.

The Master of the Gardner Annunciation, who was active in Florence from 1450 to 1500, is known for painting that makes up in grace and authority what it may lack in originality. A powerful example of the successful way he continues his Florentine heritage is a very well preserved *Madonna and Child* (202). This is the central section of a large triptych, whose wings — *Mary Magdalen* and *John the Baptist* — are at Altenburg. Jesus holds a pomegranate, offering a seed to his Mother; the fruit symbolizes Christian fertility and unity.

The story of Tobit, a book from the Apocrypha, was a particularly popular text because it is devoted to the wanderings of a boy, Tobias, in search of a cure for the blindness of his father, Tobit. Throughout his journey, Tobias is protected by a guardian

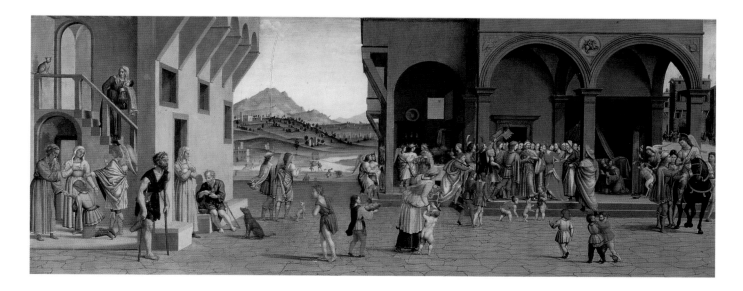

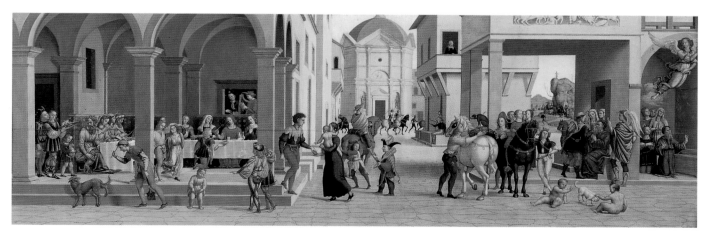

ASCRIBED TO GIULIANO DI PIERO DI SIMONE BUGIARDINI, Florence, 1475–1554
Two *spalliere* with scenes from the Story of Tobias

angel, Raphael, and accompanied by his faithful
dog. As so many young Florentines were commer-
cial travelers or apprentices, often at worrisome
distances from home, their parents had sufficient
grounds for concern. Tobias's happy tale, along
with its reassuring filial piety, was one they seldom
tired of telling, whether in art or life.

The first of two grand, richly narrative friezelike
images known as *spalliere* (197) and dated c. 1500 is
ascribed to Giuliano Bugiardini. The panel shows,
from left to right, Tobias taking leave of his parents,
journeying with Raphael to catch the fish whose
liver will cure Tobit, his engagement to Sarah, and

their bridal night. Finally, Raphael battles the Devil,
then departs. The pendant presents Tobias leaving
Sarah after a dance and banquet, his mother on a
hilltop in the background.

Compared to the still somewhat medieval Cupid
and Psyche *cassone* panels (*193*), reminiscent of
tapestry, with their romantic choreography, these
Tobias *spalliere* are far more academic. Constructed
according to the principles of one-point perspective
so important to Florentine art, the Tobias pendants
point to contemporary theater, with its artful use of
drops and flats.

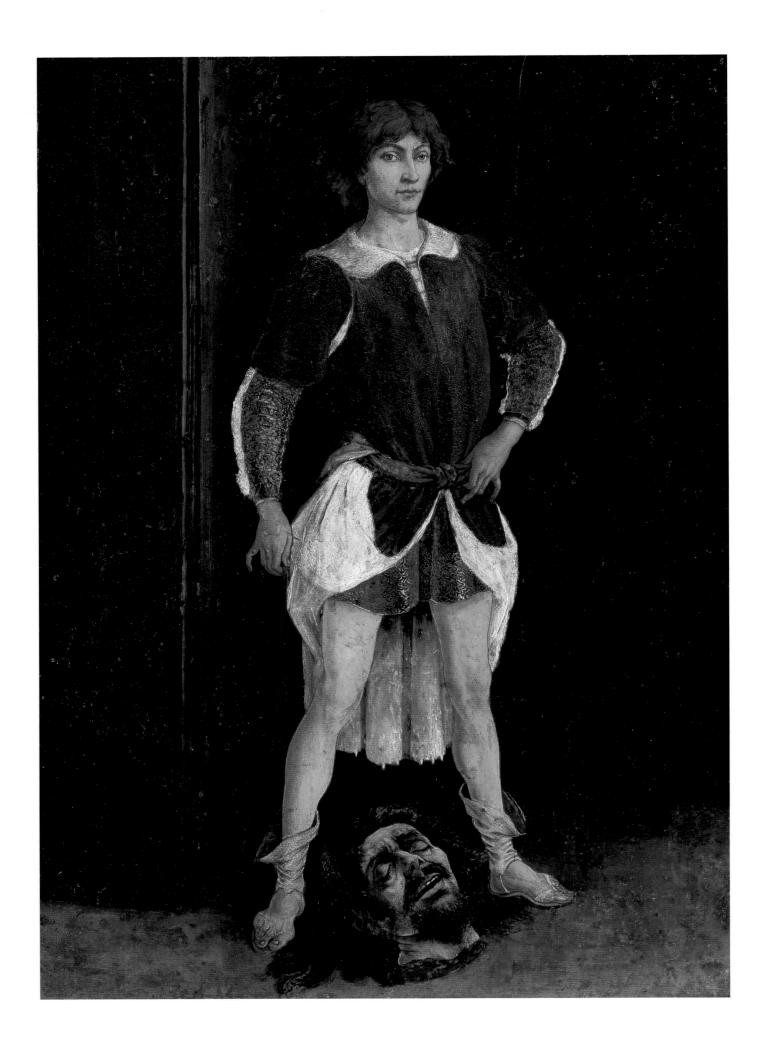

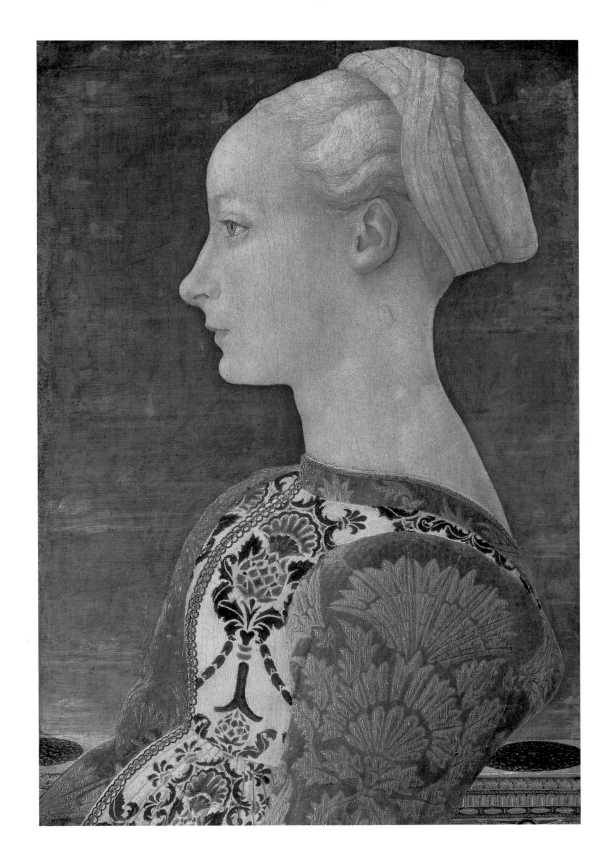

ANTONIO POLLAIUOLO
Florence, 1431 (?)–Rome, 1498
(or Alessio Baldovinetti,
Florence, 1426–1499)
A Young Woman in Left Profile,
c. 1465

Opposite:
ANTONIO POLLAIUOLO
David Victorious, c. 1472

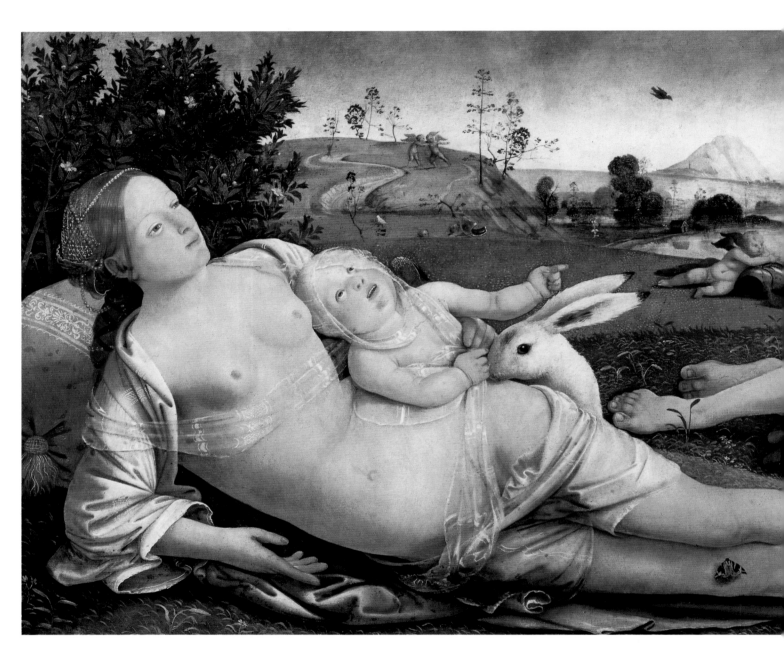

PIERO DI COSIMO
Florence, 1461/62–1521 (?)
Venus, Mars, and Cupid, c. 1505

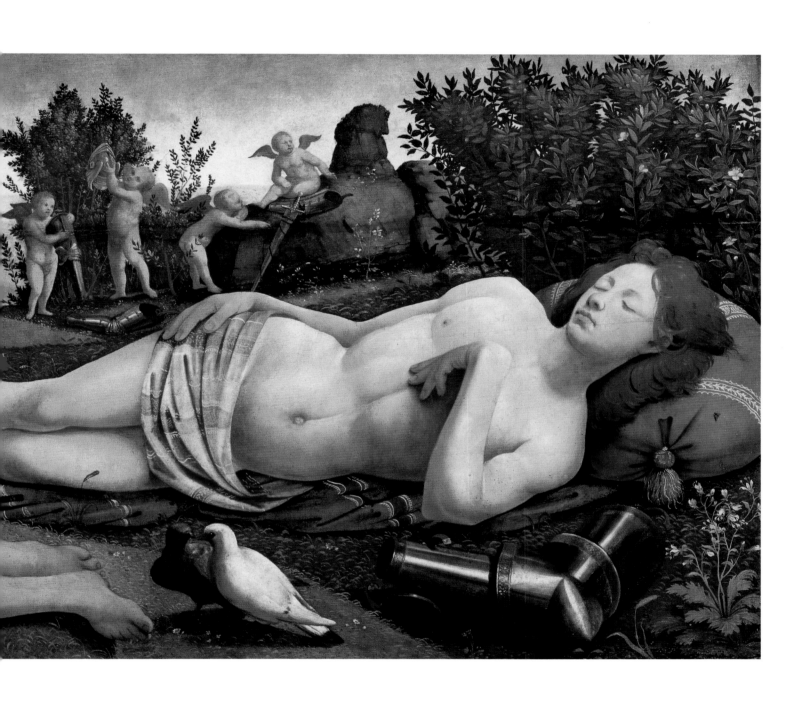

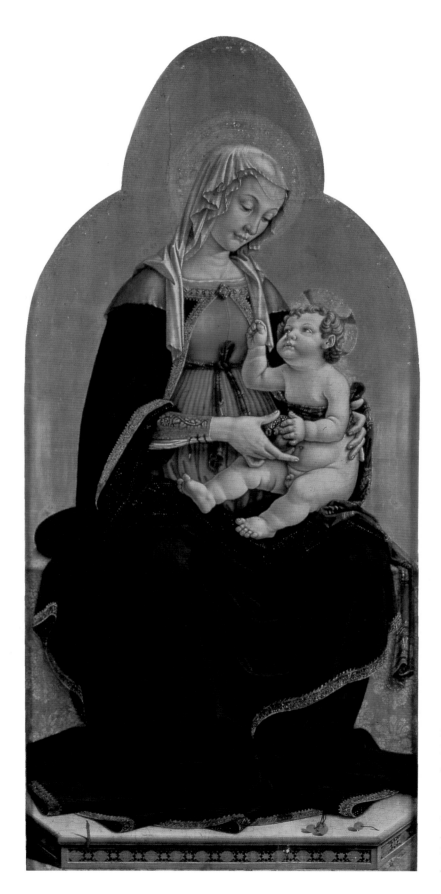

MASTER OF THE GARDNER ANNUNCIATION
Florence, active 1450–1500
Madonna and Child, 1481

Opposite:
ANDREA VERROCCHIO
Florence, c. 1435–Venice, 1488
Madonna and Child, c. 1470

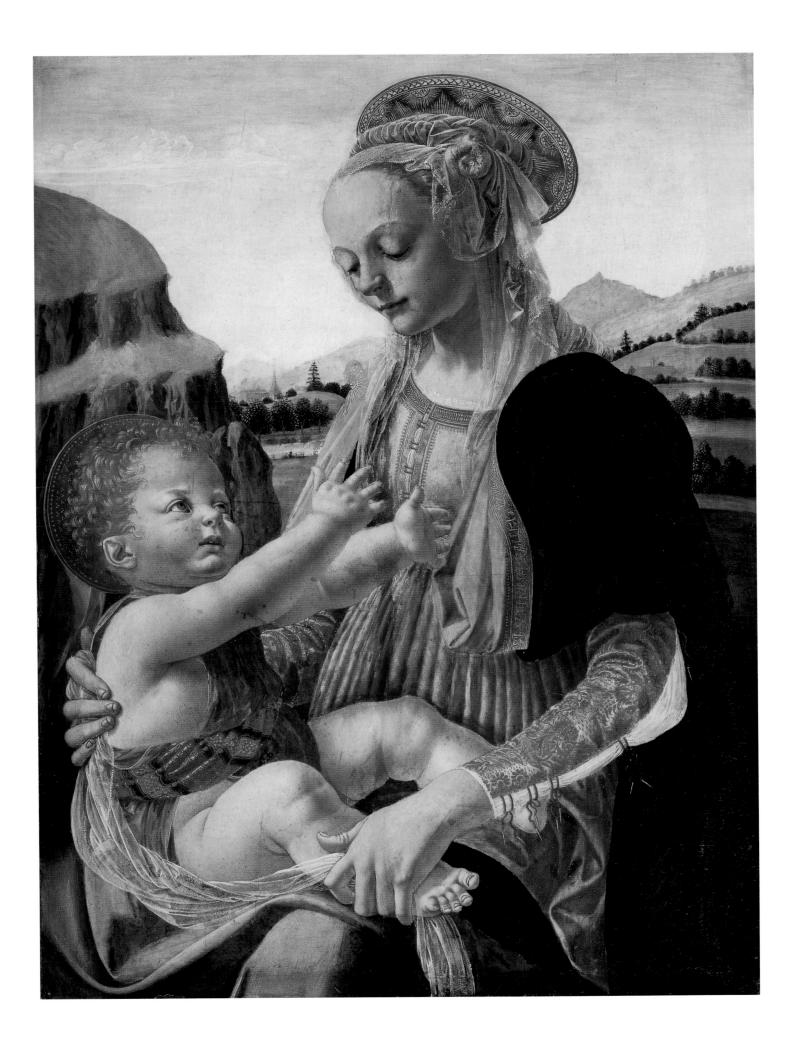

Classical Exploitation: Padua's Early Academic Arts

ERLIN's collection is among the world's richest in early art from the Veneto. After 1405 this region encompassed both Venice and Padua, which was the Serenissima's university center. The German capital's assemblage of paintings from Padua is so strong that it compares in quality to its collection of Venetian painting of the same period.

A friend of Goethe, the painter Friedrich Bury (1763–1823) traveled to northern Italy in 1790, where he made many copies after Giovanni Bellini and Mantegna, thus contributing to a new German taste for the work of these painters. Mantegna's classical style was also in accord with the various later-eighteenth- and early-nineteenth-century revivals of ancient statuary and decor, which were much influenced by the excavations at Pompeii and Herculaneum.

Medieval and Renaissance Padua abounded in all the vices and virtues of Academe and offered a rich mix of the intellectual and the pretentious, both grounded upon the local revival of antiquity. The mathematically oriented city's university drew students and faculty from all over Europe. Florentines went there for geometry, a subject central to their perspectival studies; young Germans came to study humanism and science and to make valuable commercial contacts in Italy. Also an area of great Roman Catholic power, with many influential local religious institutions, Padua was the burial place of St. Anthony, who was enshrined in the great, almost Byzantine basilica known as the Santo, still one of Europe's leading Franciscan pilgrimage sites.

Almost forgotten is the fact that later-fourteenth- and early-fifteenth-century Padua was Europe's most advanced center for painting, building upon Giotto's frescoes in the Arena Chapel. By the 1430s this progressive distinction was almost defunct, but it was soon revived by an unlikely, even outrageous,

individual: an ambitious tailor and embroiderer named Francesco Squarcione. His art school — the first to take on antique airs and graces — was called an academy, so defined as a result of the founder's study trips to Greece. Probably stimulated by Paduan humanists, who made it a practice to show special interest in the visual arts, the school used casts of antiquities as well as Florentine engravings and drawings for teaching purposes.

Squarcione's academy attracted talent from as far away as Dalmatia. His own greatest skill lay in the exploitation, not the tutoring, of tuition-paying apprentices. Working hard for a little instruction, the students' patience was kept green by their master's promise of eventual legal adoption, which would make the lucky one his heir. Within a few decades, painting in Venice, Mantua, Padua, Ferrara, and Bologna had come to be directed, in large part, by Squarcione's "graduates."

Berlin has by far the finer of his two surviving pictures on panel, a *Madonna and Child* (205). Partly in profile, the group suggests a large, painted plaquette. Bronze candlesticks to the left and right and swags of fruit in the antique manner present a bravura approach to sculptural form, such illusion increased by a ledge that supports the Infant's foot. Fusing fear and force, the Child's pose is that of an anxious infant Hercules, rushing into his girlish Mother's sheltering arms. Inscribed on the ledge, in classicizing fashion, is the artist's name: OPVS SQVARCIONI PICTORIS. Obviously indebted to Filippo Lippi (191), who was in Padua in 1434, and to Donatello, Squarcione probably knew the latter's oeuvre long before the sculptor set up his Paduan studio in 1443.

Why discuss this eccentric artist, or his image, which is arresting more for the courage than for the communication of its convictions? Because these goals were to be exceeded beyond Squarcione's

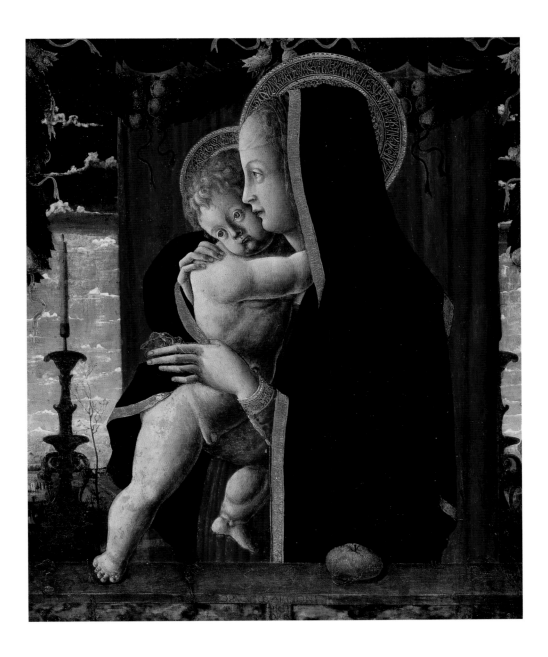

FRANCESCO
SQUARCIONE
Padua, 1397–1468 (?)
Madonna and Child,
c. 1460

wildest imaginings by his best student, Andrea
Mantegna, one of the most forceful of all artists.
Squarcione's ambiguous images (were they mod-
eled on life or art?), their amateur classicism, their
idiosyncratic merging of stoicism and Gothicism,
amount to infectious quirks that caught his stu-
dents' fancy, causing each to turn them to his own
advantage. Mantegna alone could transcend his
teacher's inspiring eccentricity to attain unparal-
leled grandeur.

A carpenter's son, Mantegna was disaffected by
his teacher's false ways. He took Squarcione's bag of
tricks to Venice, where the angry young man
entered the studio of Jacopo Bellini (*219*), then the

city's leading painter, and married his new teacher's
daughter Niccolosia in 1452. Soon Mantegna sued
Squarcione for exploitation, misrepresentation, and
breach of promise, and won his case.

As brother-in-law to Giovanni Bellini, the leading
Venetian artist of the later fifteenth century (*220,
226–27*), and to Giovanni's far-less-gifted sibling Gen-
tile (*219*), Mantegna now belonged to a formidable
troika that led much of the art of Venice, Padua,
Verona, and Mantua. He died in the last city, where
he had become court painter to the Gonzaga. With
Piero della Francesca, Mantegna was Italy's out-
standing classical master of the later Quattrocento.

Since the authority of his images carried well

without color, prints after Mantegna's works, pre-
pared by engravers in the artist's employ, soon
made him Europe's best-known artist, and his com-
positions circulated throughout the West. Copied in
almost all media, these prints acted as Dürer's
portable Italian academy.

A work painted not long after Mantegna came to
Venice is a horizontal *Presentation in the Temple* (*208*),
its faux-marble frame suggesting a tomb, a funerary
association that is reinforced by the scene's severity
and Jesus' shroudlike swaddling. A witness to the
right may be the artist himself, and his wife may be
seen at the far left, near the prophetess Anna, who
recognized Christ's destiny at the Presentation. Gio-
vanni Bellini recast this scene in his own version
(Venice, Galleria Querini-Stampaglia).

Mantegna's *Presentation* is thinly painted in tem-
pera on fine canvas, a support first popular in the
North (*95*). Mantegna favored it for the special
restraint and finesse permitted by the unvarnished
canvas's matte quality, which never shows reflec-
tions. The *Presentation* is very well preserved, rare
for early Italian canvases. The linear golden haloes
were added at a far later date.

So near and yet so far from Squarcione's superfi-
cial Donatellism is an early, tender *Madonna with
Sleeping Child* (*209*) by Mantegna that also recalls the
sculptor's oeuvre. Like the *Presentation*, it is on can-
vas. Mary looks extremely young, her youth seen as
an attribute of virginity. As she cradles the sleeping
baby, her brooding gaze suggests a presentiment of
the *Pietà*, when she will hold her son for the last
time. Byzantine and Roman elements often con-
tribute to Mantegna's art, which is fortified by
all the power (and none of the pretense) of
eclecticism.

In his search for major popularity as a portraitist,
Mantegna painted monumental likenesses that com-
bine the particularity of Eyckian physiognomy (*53,
55*) with the authority of ancient Roman busts. His
Cardinal Lodovico Trevisan (*209*) suggests a statue
come to life, a bust animated by light washing over
its forceful features. Trevisan was physician to Pope
Eugenius IV and became cardinal following his suc-
cessful leadership of the papal army and navy.

Forthright in his continuation of the Squar-
cionesque manner, Giorgio Schiavone of Dalmatia

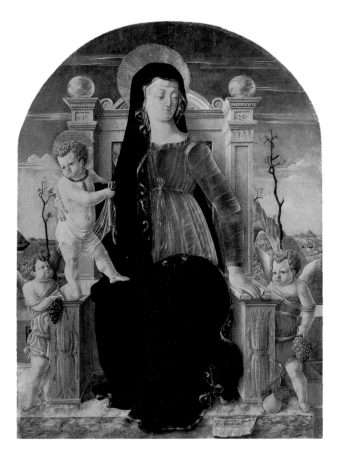

GIORGIO SCHIAVONE
Scardona (Dalmatia), c. 1436–Sebenico (Dalmatia), 1504
Madonna and Child Enthroned, c. 1456–60

was at the Paduan academy by 1456. The putti of his
Madonna and Child Enthroned (*206*) are particularly
Donatellesque, reminiscent of those sculpted for
the Santo's High Altar. Originally the central
section of a triptych, the wings of this altar, now in
Padua's cathedral, show four Franciscan saints. Schi-
avone's signature appears on a little piece of paper,
or *cartellino*. Giving his name as "Sclavoni of Dalma-
tia," he is proudly designated as Squarcione's pupil.

An enigmatic *Madonna and Child* (*211*) that is still
rooted in the style of Jacopo Bellini (*219*) is some-
times given to a Venetian, Lazzaro Bastiani, or to
one of three pupils of Squarcione — Schiavone,
Marco Zoppo, or Mantegna. Putti painted on the
picture's original frame continue the Madonna's
mournful message: they hold the Instruments of
the Passion, each group separated by clusters of
cherub heads.

Close to the art of Squarcione and Vivarini is that

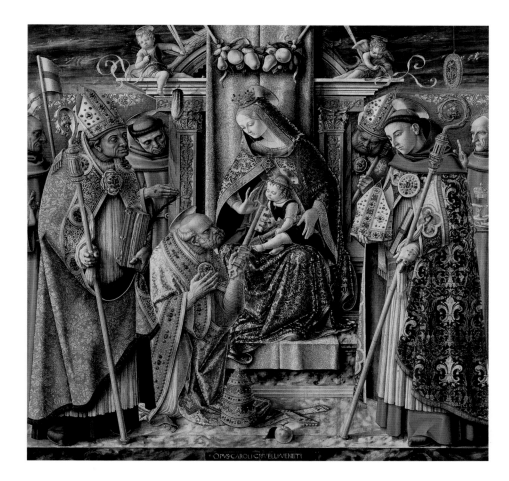

CARLO CRIVELLI
Venice, c. 1430/35–
Marches, 1494/95
*Madonna and Child Enthroned
with Presentation of Keys to
St. Peter, with SS. John of
Capistrano, Emidius, Francis,
Louis of Toulouse, James of the
Marches, and an Unidentified
Bishop, 1488*

of a Marchigian painter, Carlo Crivelli of Venice, who, with his brother and their large workshop, painted many works found in the Veneto and farther south. An important large signed altarpiece, *Madonna and Child Enthroned with Presentation of Keys to St. Peter* (207), was possibly ordered in 1488 for a church in Camerino. To the far left is Emidius, patron saint of Ascoli; Francis is behind him, with John of Capistrano, fighter of the Turks, holding a banner. On the right are Louis of Toulouse, a bishop, and James of the Marches, who holds a monstrance. Putti, swags of fruit, and a hard-edged, sculptural style once again recall a Paduan esthetic partly rooted in Donatello's art.

Another major work of the Paduan School is one by Mantegna's fellow pupil in Squarcione's academy, the Bolognese artist Marco Zoppo. His masterpiece (210) is a very large altar from Pesaro that is almost square in format and was painted for the Franciscan church of S. Giovanni Evangelista. Known as a *Sacra Conversazione*, its compositional scheme places saints in a way that causes them to surround or flank a central group. Here SS. Francis and Paul stand to the left and right of Mary's throne, with huge figures of John the Baptist and Jerome at the far left and right. Mary extends an apple to Jesus, affirming their roles as new Adam and Eve for humanity's salvation. The great panel is inscribed MARCO ZOPPO DABOLOGNIA PINSIT MCCCCLXXI IVENEXIA, the last term referring to Venice, where the lame painter went to live with his daughters, Lucretia and Minerva, and a pack of fierce hounds.

The odd juxtaposition of artificial and natural elements is one of the hallmarks of Zoppo's Paduan training, as found in the throne's flower-bearing seashells and the central arch of fruited branches springing from urns. Such contrivances are in striking contrast to the highly evolved landscape background. Zoppo's ominous figures come close to Mantegna's major Paduan frescoes for the Eremitani Chapel. Their grouping recalls the bronzes Donatello cast for the High Altar of the Santo, the Francis resembling the same saint's statue in Padua.

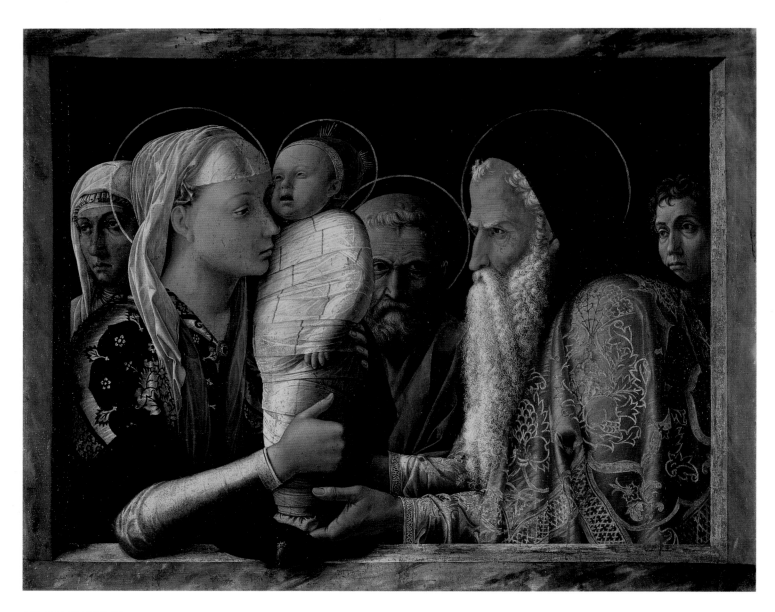

ANDREA MANTEGNA
Isola di Cartura, near Padua, 1431–Mantua, 1506
The Presentation in the Temple, c. 1465–66

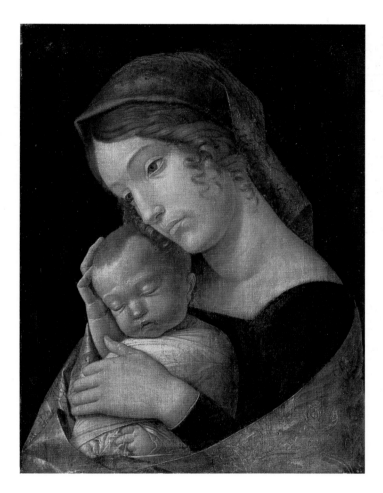

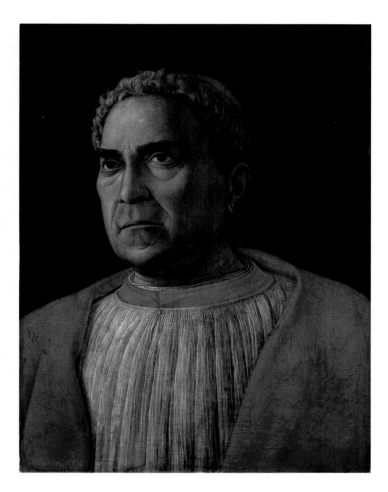

ANDREA MANTEGNA
Madonna with Sleeping Child, c. 1465–70

ANDREA MANTEGNA
Cardinal Lodovico Trevisan, c. 1459–60

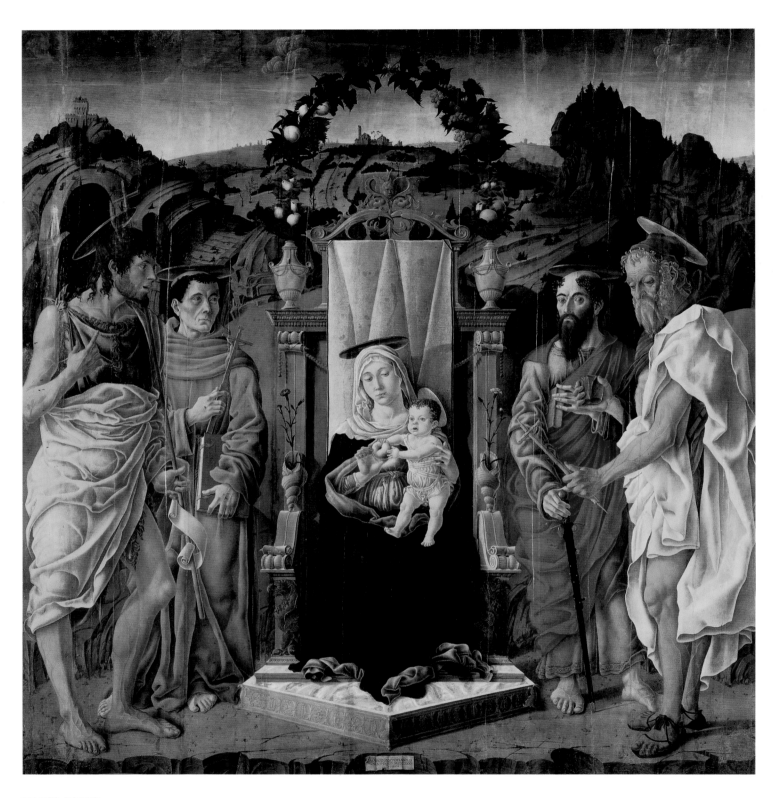

MARCO ZOPPO
Cento, 1433–Venice, 1478
Madonna and Child Enthroned with Saints, 1471

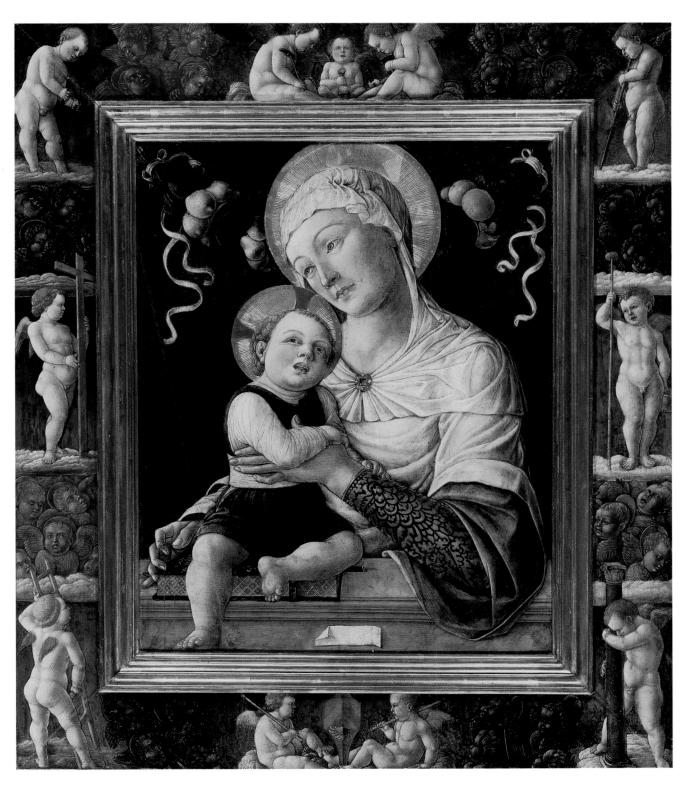

LAZZARO BASTIANI (?)
c. 1425–Venice, 1512
Madonna and Child in Painted Frame

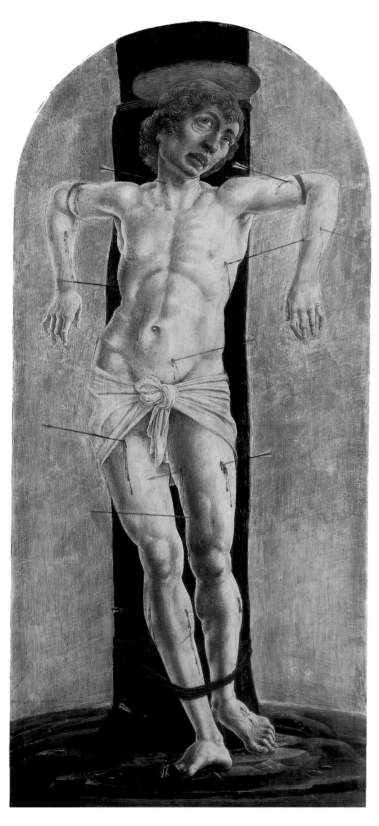

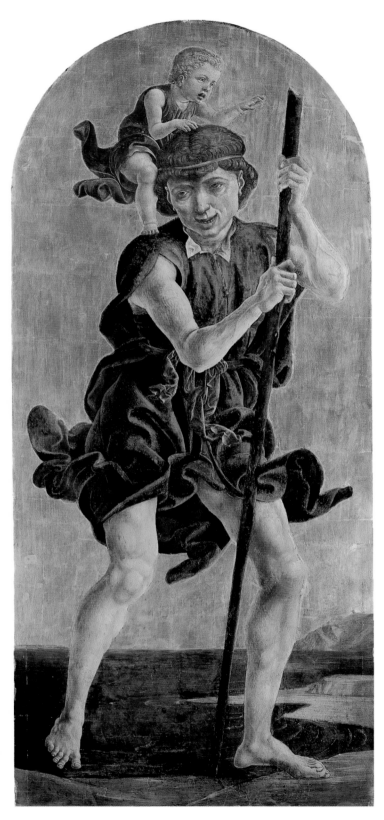

COSIMO TURA, Ferrara, 1430 at latest–1495
St. Sebastian, c. 1484

COSIMO TURA
St. Christopher, c. 1484

Painters on the High Wire: Art at the Este Court

Violence and caprice, Northern pietism, Near Eastern astrology, and fashionable humanism all converged in the fiercely sophisticated culture of the despotic, impetuous Este dukes. Their wealthy court at Ferrara, in northeastern Italy, was the fiefdom of successive and successful warlords, or *condottieri*, who were often in Venetian employ. The dukes enjoyed several splendid, labyrinthine pleasure palaces and hunting lodges outside the walls of their capital, whose innumerable canals lent Ferrara similarity to Venice.

Este painters, knowing their patrons' fondness for Netherlandish art, especially that of Rogier van der Weyden (*58, 62–63,66–69*), took on a mannered quality, as if they were working after Northern carved limewood figures, or oils, or following the elegant profiles of a Tournai tapestry. One Este resided at the Burgundian court in Brussels, where he was portrayed by Rogier van der Weyden (New York, Metropolitan Museum of Art). Northern pictorial techniques came to Ferrara at an early date; in fact, the decoration of Leonello d'Este's *studiolo* at Belfiore included at least one panel (London, National Gallery) that is among the earliest datable examples of Italian artists using oil glazes in the Netherlandish manner.

Free from fear of archaism, fond of humanism, but never cowed by it, Ferrarese painters sometimes used gold backgrounds, though these had been long condemned as old-fashioned. Cosimo Tura's *St. Sebastian* and *St. Christopher* (*212*) show a sense for the extremes of modeling that reflects Ferrara's proximity to Squarcione's Paduan academy and to Donatello's studio in the same city. Both paintings, close to sculpture, are full of surprises and are almost Surreal in their evocation of emotional tension. Where Christopher suggests a goldsmith's model blown up to vast size, the bird's-eye view of a seascape below recalls lessons learned from Masolino's Venetian visit en route to Hungary in 1427, after he frescoed a similarly panoramic beach scene on the Brancacci Chapel vault, which predated the view by Tura.

Unlike the legendary Christopher, the giant who functioned as Jesus' living ferryboat, Tura's figure does not seem to be exhausted from bearing the ever-heavier Infant across the waters. Rather, he projects a Castagno-like (*194*), Herculean virility. (The Ferrarese artist's oeuvre was long confused with the Florentine's and both were known for their athletic force and crisp outline.)

The finest of Berlin's Ferrarese paintings, and among Ercole de' Roberti's best anywhere, is a *St. John the Baptist* (*214*), which was probably part of a larger complex. Once again Florentine sculpture comes to mind, this time a late phase of Donatello's art, when he, like Ercole, returned to Gothic pietistic sources. The virtue inherent in asceticism — St. John's path to divinity — is this image's message. The Baptist's anorexic physique is that of the anchorite living on locusts in the desert, mortifying his flesh to clear his mind and heart for Christ.

Typically Ferrarese is the way this personification of renunciation is endowed with elegance. The calculated fall of John's drapery, the suave knotting of his camel hide at the waist just so, the saint's balletic pose and graceful arms all recall the chic contrivance of a courtly masque, a quality of theater that, paradoxically, intensifies the conviction of figure and setting alike. Fierce communion between the saint and the crucifix suspended within his staff conveys the profundity of Ercole's art, his mastery of vision and emotion also extending over the panoramic landscape and fantastically carved, Mantegnesque rocky terrain below.

In contrast, recalling the monumental classicism of Piero della Francesca, *The Muse Polyhymnia*

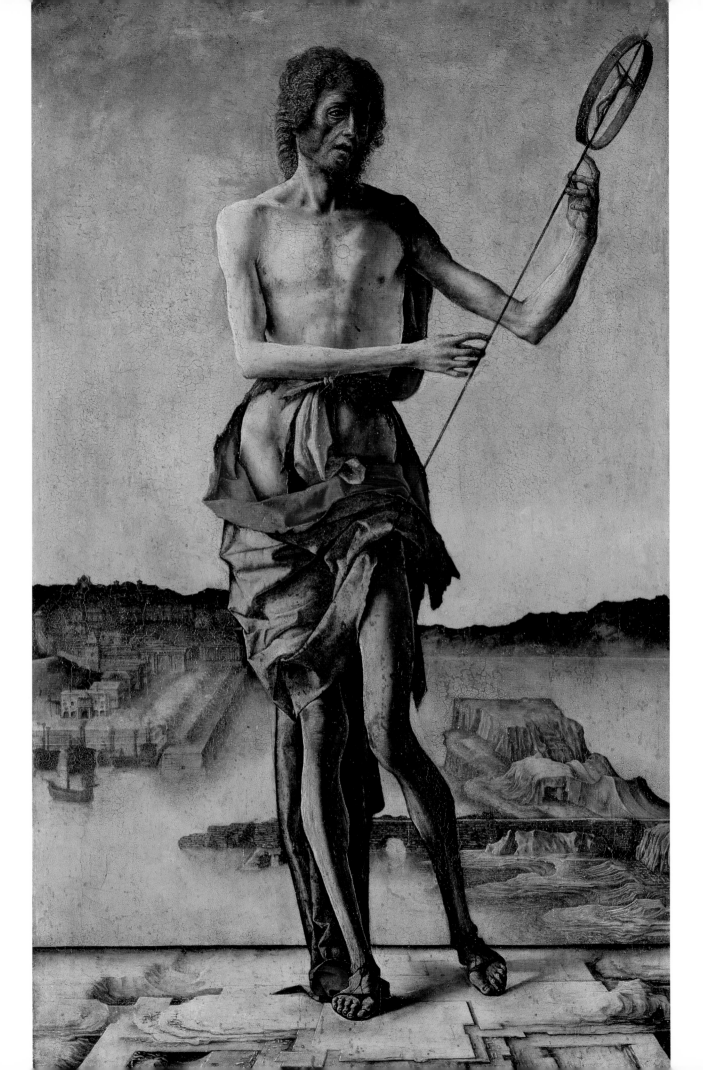

(*215*) — long known as *Autumn* — one of a series of *Muses*, seems singularly placid. The muse of serious songs of adoration and heroism is one of nine sisters of sacred song; working overtime, Polyhymnia was also the discoverer of agriculture, and is shown here as vintager. Her columnar body and simple drapery suggest early Greek statuary in a rustic mid-Renaissance restatement of the *Charioteer of Delphi*, now holding farm instruments and grapevines rather than bronze reins. This muse's rustic labors were most important to Ferrara, since that duchy was one of the richest agricultural regions of northeast Italy, with many waterways making it unusually easy to export produce.

Of the Muse cycle, *Euterpe* and *Melpomene* are in Budapest (Szépmüvészti Muzeum) and the others are in Milan (Poldi Pezzoli), Florence (Marchesa Strozzi), and London (National Gallery), all attributed to various hands. Originally these musical figures decorated a chamber in one of Leonello d'Este's palaces, probably the Studiolo of the Muses at Belfiore, begun in 1447.

Dating c. 1450, *Polyhymnia* is probably by Francesco del Cossa, though most recently it was ascribed to an anonymous Ferrarese artist who was active c. 1450. It has also been attributed to the Sienese Angelo di Pietro (called Macagnini), who is known to have begun the cycle in 1447 with two paintings and was succeeded by Cosimo Tura after his death in 1456. Slight damage to the panel may be due to the partial burning of Belfiore during a Venetian attack against Ferrara in 1483. By then the acrobatics of that ducal center's singularly sophisticated school of painting were just about played out.

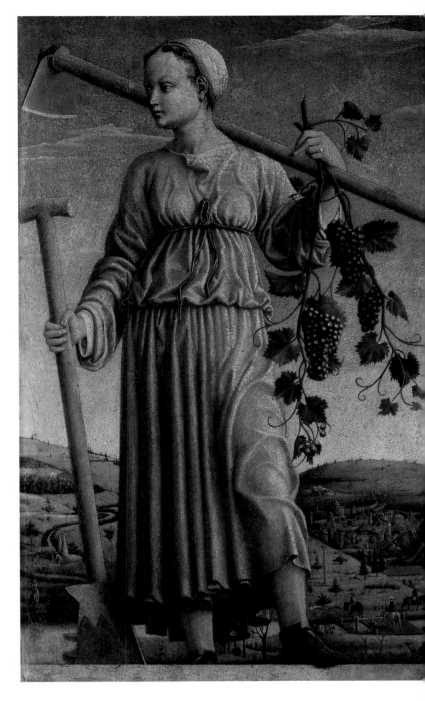

Ferrarese
(Francesco del Cossa [?], Ferrara, c. 1435–c. 1477, or Angelo Macagnini [?], Siena [?]–Ferrara, 1456)
The Muse Polyhymnia, c. 1450

Opposite:
ERCOLE DE' ROBERTI, Ferrara, by c. 1450–1496
St. John the Baptist, c. 1480

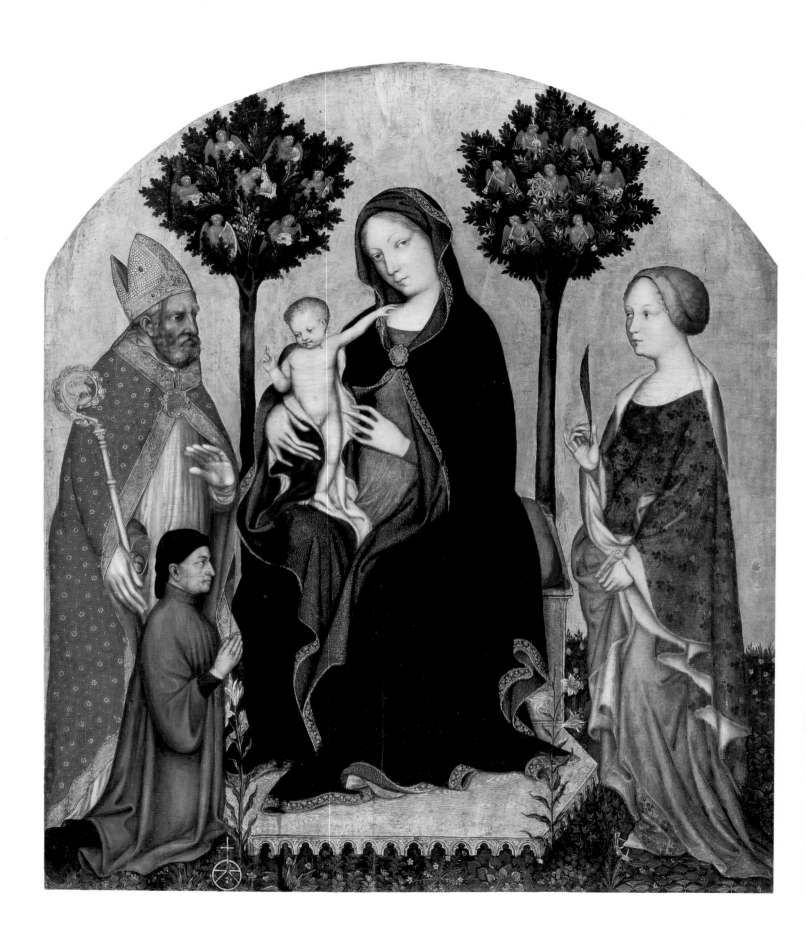

Venice Before Titian: The Serenissima's Quattrocento

BERLIN may have the major collection of early Venetian paintings outside Italy. Her holdings from the Quattrocento are especially strong and unusually varied. This could be because Italian art of that period came close to northern Europe's, nearing the oil techniques of the Lowlands and the pietistic spirit of early Northern engravings. All these qualities were unusually appealing to German collectors.

A dazzling series of Trecento works by Antonio Veneziano (*35*) and Lorenzo Veneziano (*34*) helped pave the way for the Serenissima's achievements in the next century. In the 1490s, when young Dürer first went there, the city's instinctive, infectious love for antiquity and for the nude went to his head and heart, loosening and illuminating his approach, liberating the Nuremberger's representation of color, light, and form. Dürer (*120*) never lost his love for Giovanni Bellini's art, which he admired on his first Venetian journey, and still praised as the republic's best when he returned some eleven years later (1505–7).

Only in Berlin's museum for old masters can one see works by the whole Bellini family along with the art of Gentile da Fabriano (*216*), teacher to the patriarch, Jacopo (*219*), and probable godfather to Jacopo's son Gentile (*219*). Jacopo's son-in-law Andrea Mantegna is also brilliantly represented (*208–9*), as is the Serenissima's art of the late century, with works by Carpaccio (*228–29*) and Cima da Conegliano (*230–31*).

From the Marches, probably first trained in Venice, Gentile da Fabriano's early altar was painted

Opposite:
GENTILE DA FABRIANO
Fabriano, c. 1370 (?)–Rome, 1427
Virgin and Child Enthroned with SS. Nicholas of Bari and Catherine of Alexandria and a Donor, c. 1395–1400

for the Church of San Niccolo in the painter's native Fabriano. It entered the Prussian royal collection in 1837 with the aid of Ambassador Bunsen, a collector of such works and friend to the Nazarenes. Gentile's signature was on the frame, which burned in World War II.

The painting presents the Virgin and Child enthroned with SS. Nicholas of Bari and Catherine of Alexandria and a donor. Paired trees, an oak (left) and a laurel, flank the central group, making it into a "Madonna degli alberetti." Each tree is crowded with seven birdlike, music-making angels, an odd device found only in the Marches. These groups form separate orchestras, the left a *bas ensemble*, the right an *haut ensemble*. This remarkably specialized concern with music, long close to Venetian culture, continues in the art of Giovanni Bellini, Giorgione, and Titian.

The two directions of North Italian art, the specific and the idealized, are clearly indicated here, with the sharply defined rendering of the donor portrait in contrast with the generalized images of the Virgin and St. Catherine. More than anywhere else in Italy, portraiture was a central concern in Venice, soon to be highly developed by the Bellini, Mantegna (*208–9*), and Antonello da Messina (*224*).

The most exquisite painting by Venetian Quattrocento masters before Bellini is that of Domenico Veneziano. His surviving oeuvre is limited to the *St. Lucy Altar*, a few frescoes and their fragments, four or so *Madonnas*, and a tondo.

Berlin has this large circular painting, which presents the Adoration of the Magi in a suitably cosmic circular confine (*223*). The tondo is painted in a densely narrative International Gothic style, reminiscent of Northern manuscript illumination and the art of Pisanello, to whom the picture was long ascribed. According to Francis Ames-Lewis's most plausible view, Domenico deliberately assumed the

DOMENICO
VENEZIANO
Venice (?), c. 1405/10–
Florence, 1461
*The Martyrdom of
St. Lucy,* c. 1445–48

style of Pisanello to catch the eye of the Medici.
The Venetian wished to show how he, too, was
master of the richly narrative and portrait arts then
so popular at the Ferrarese court.

Ames-Lewis believes that there are several Medici
portraits concealed within the tondo: those of
Cosimo and his sons along with the bearded
Paleologan emperor. They all attended the council
of Eastern and Western churches at Ferrara in 1438.
As the Medici belonged to the Florentine religious
society of the Magi, they might well have wished
for a depiction of this subject; the painting's format
and theme were popular in their collection, from
which Berlin's picture originates.

The *St. Lucy Altar* was painted toward 1450 for the
little church of S. Lucia dei Magnoli in Florence. Its
principal section, a *Madonna and Child with Four
Standing Saints,* is now in the Uffizi. Blending Vene-
tian light and color with a new Florentine concern
with rational space, Domenico's is among the first
and finest essays toward a *Sacra Conversazione* in the

Renaissance mode. Berlin has a predella panel show-
ing the titular saint's martyrdom (*218*). Of the four
others, two are in Washington (*The Young Baptist in
the Wilderness* and *The Stigmatization of St. Francis*).
The other two — *The Annunciation* and *St. Zenobius
Reviving a Boy* — are in the Fitzwilliam Museum
(Cambridge).

Two sections from an altarpiece (*219*) — one of
St. John the Evangelist, the other of the Apostle
Peter — are characteristic of Jacopo Bellini's early
art, the figures still Gothic, their shell niches Renais-
sance. Berlin owns one of the finest Venetian Inter-
national Gothic altarpieces, an *Adoration of the Magi*
(*222*) by Antonio Vivarini. Both this work and the
same subject as painted by Domenico Veneziano
(*223*) convey a cosmic sense of overview, Antonio by
a rectangular panorama, Domenico by orblike all-
inclusiveness. Each artist's vision is enhanced by a
use of distant landscape still close to the late-Gothic
illuminator's art. The painters are also concerned
with Tuscan factors — Antonio with the art of Fra

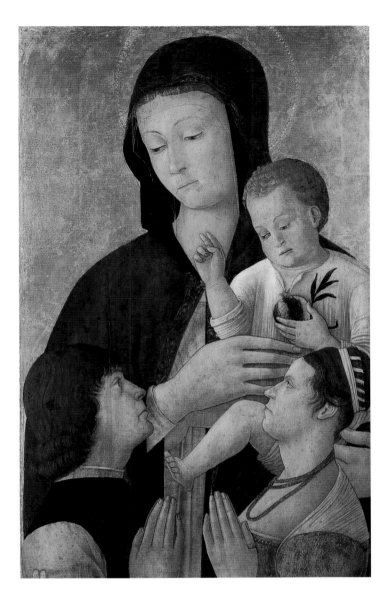

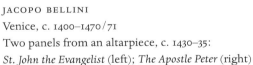
JACOPO BELLINI
Venice, c. 1400–1470/71
Two panels from an altarpiece, c. 1430–35:
St. John the Evangelist (left); *The Apostle Peter* (right)

GENTILE BELLINI
Venice, probably 1429–1507
Madonna and Child with Donors, c. 1460

Angelico and Masolino; Domenico with the northern Italian courtly taste then engaging the Medici.

Jacopo Bellini's son Gentile is represented by a stiff, fragmentarily preserved *Madonna and Child with Donors* (219), which retains an old-fashioned gold background. Squeezed in at the bottom, blessed by the Christ, the donors look up expectantly, possibly praying for offspring.

Venice was one of the first Southern centers to have made close study of Northern oil technique, supposedly brought there by Antonello da Messina. Berlin has two of the Sicilian's finest portraits

(224–25), both signed, one dated 1474 and the other 1478. These combine an Eyckian sharpness of focus and particularity with a Latin sense of classical stability and restraint. Antonello is said to have learned the oil technique in the Netherlands, but may well have acquired this skill closer to home, from Northern artists active in Sicily or Naples.

This medium allowed for a new luminosity, and was probably employed by Giovanni Bellini in his magnificent *Resurrection* (220). Its magical quality of light, used here for a permanent image of the Easter miracle, is a warmer, more classical version

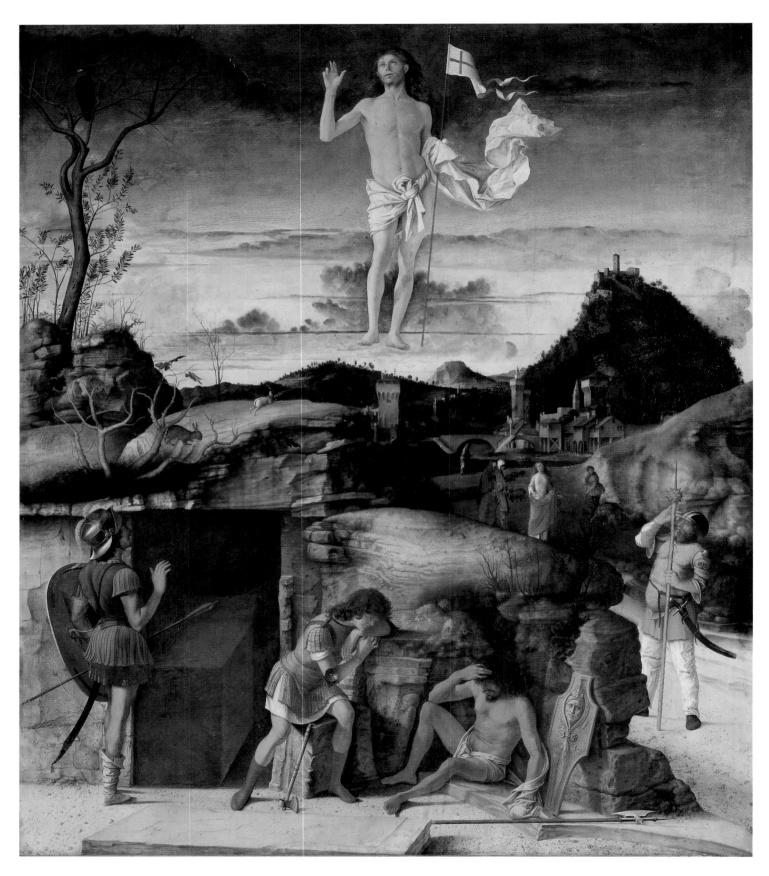

GIOVANNI BELLINI, Venice, c. 1430/31–1516, *The Resurrection*, 1475–79

of Eyckian radiance. Originally installed in the mortuary church of S. Michele in Isola on Murano, the panel (now transferred to canvas) was painted between 1475 and 1479. The artist follows Northern currents in his scrutiny of nature. Mystical yet realistic, his combination of faith and focus gives the painting a singularly convincing quality, its theme of resurrection a comforting one for the painting's funerary setting.

Bellini's art assimilates antiquity: classical idealism and Netherlandish realism are united in a moment of unrivaled harmony. Here Gothic pathos is illuminated by Venetian veneration for ideal beauty from the distant past.

A relatively early Giovanni Bellini *Madonna and Child* (ii) places the figures in grave confrontation, the baby standing on a tomblike ledge. It supports an apple that refers to Christ as the Redeeming New Adam. A slightly later *Madonna and Child* (226), with a younger-looking Virgin, anticipates the artist's most popular, almost sentimental works, often produced with studio assistance. Mary's gaze, outward and upward, lets heaven and spectator alike share her concern for the future.

Bellini's heroic *Dead Christ Supported by Two Angels* (227), executed in the 1480s, was centrally placed in the uppermost register of a polyptych. It shares the new stoicism of the painter's brother-in-law Andrea Mantegna (208–9); both artists were inspired by the sculptural force of Donatello, who was long resident in nearby Padua.

A radically different work, one that is more narrative than monument, is an *Entombment* of c. 1505 (228) by Vittore Carpaccio. Time, not timelessness, is this artist's concern. A personal sense of documentation, of history painting somewhat in the manner of Mantegna, defines the artist's scene. Christ, whose tomb is prepared at the upper left, is laid out on the Stone of Unction, resembling a dead knight in Jacopo Bellini's Louvre drawing book.

Unlike the telescopic close-ups of Northern art, Carpaccio's perspective allows for proximity without the mysteries of intimacy. The same study of Near Eastern dress seen in *The Entombment* appears in Carpaccio's 1511 work, *The Ordination of St. Stephen as Deacon* (229), part of his series of five painted canvases for the Scuola di S. Stefano.

Close to, and trading with, the Near East, Venice was often the point of departure for crusaders. Many mercantile colonies from Egypt and Turkey were also settled in the Serenissima, so her artists knew the garb of all these lands. This can be seen in *The Healing of Anianus* (230), an unusually strong panel by Cima da Conegliano, later enlarged at top and bottom. Undated, this large work was one of four for the chapel of the Lucchese silk weavers, located in the Venetian church of Santa Maria dei Crocicchieri (Crusaders). All four probably pertained to the evangelist Mark, patron saint of Venice. Berlin's scene shows the marketplace of Alexandria, where a shoemaker, Anianus, holds his hand, wounded by an awl, out to the Christ-like Mark for healing. Anianus became a convert, and, eventually, Alexandria's bishop.

Two other paintings in the cycle date from 1499 — *Mark's Arrest* (Vaduz, Liechtenstein Collection) by Giovanni Mansueti, and a now lost *Mark Preaching* by Lattanzio da Rimini. These, with Berlin's panel and an unidentified subject — probably that of the *Theft of Mark's Body,* stolen from Alexandria by two Venetians and brought to the Doge's Chapel in A.D. 828 — must all have been painted c. 1499. While Cima's architecture is in the local Byzantine tradition, his perspectival effects first came there from Florence with Uccello and Filippo Lippi (191), followed by the local art of Jacopo Bellini (219).

Paying pictorial homage to a new architectural grandeur, a later-fifteenth-century *Sacra Conversazione* followed one painted by Antonello for San Cassiano in 1475–76. This major work along related lines by Cima da Conegliano (231) was installed in the sacristy of S. Michele in Isola, on Murano, c. 1495–97. SS. Peter, Romuald, Benedict, and Paul are seen from left to right, standing below a mock-mosaic cupola, with open skies glimpsed behind them and the Mother and Child. Continued by Giorgione, with fewer saints, in the *Castelfranco Madonna* (Castelfranco, Veneto), such compositions remained alive and well in Venetian art, as can be seen in Paris Bordone's *Madonna and Child with SS. Roche, Sebastian, Catherine of Alexandria, and Fabianus* (273), painted for the Church of S. Maria dei Battuti in Belluno toward the mid-sixteenth century.

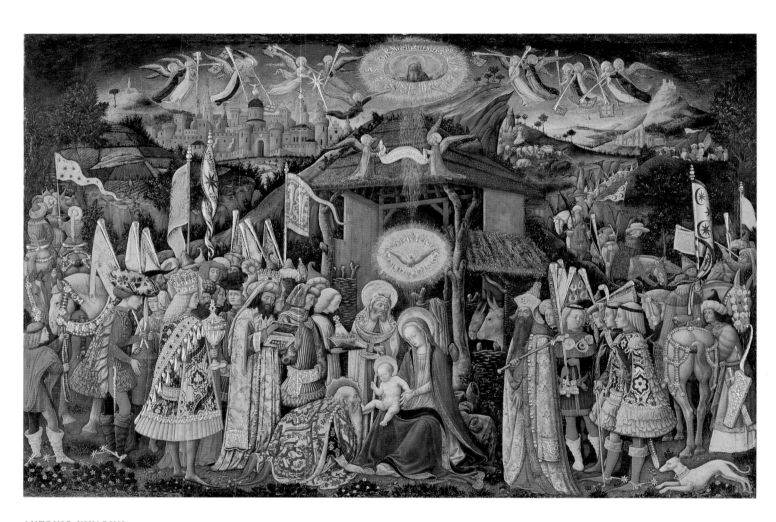

ANTONIO VIVARINI
Murano, c. 1418/20–Venice, c. 1476/84
The Adoration of the Magi, c. 1445–47

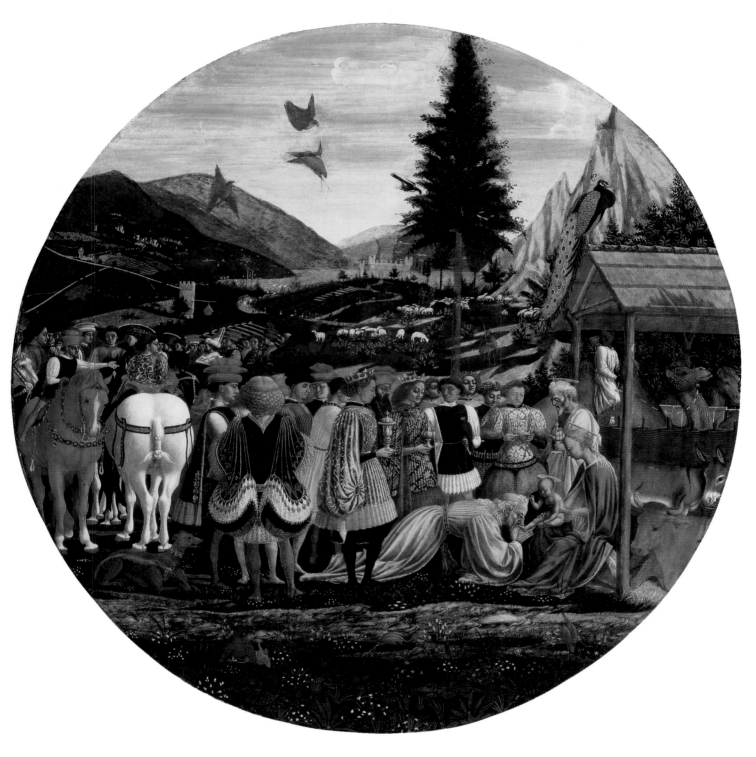

DOMENICO VENEZIANO
The Adoration of the Magi, c. 1439–41

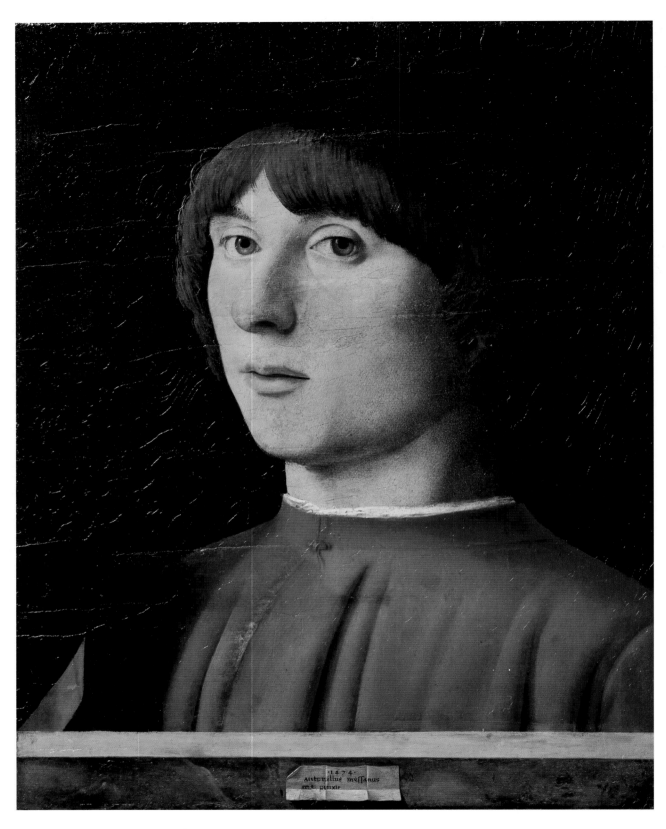

ANTONELLO DA MESSINA, Messina, c. 1430–1479
A Young Man, 1474

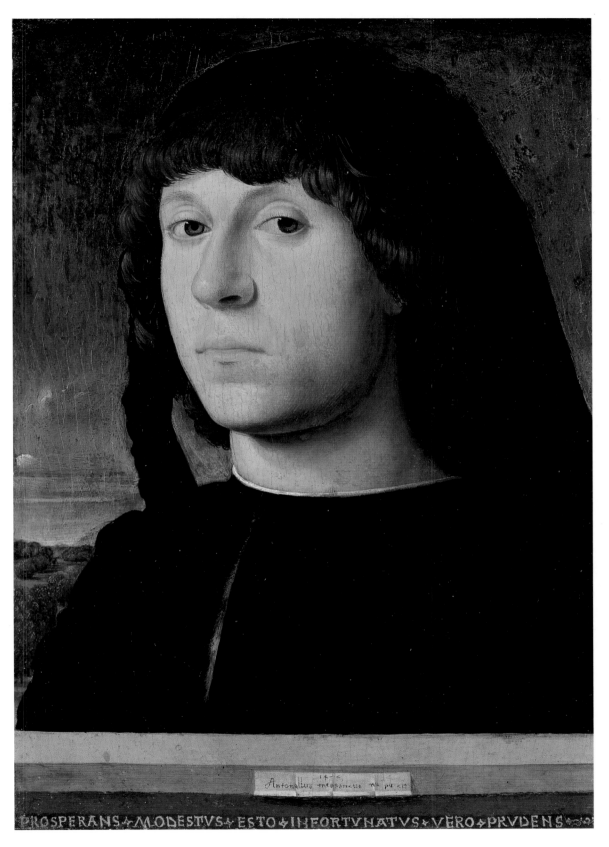

ANTONELLO DA MESSINA

A Young Man, 1478

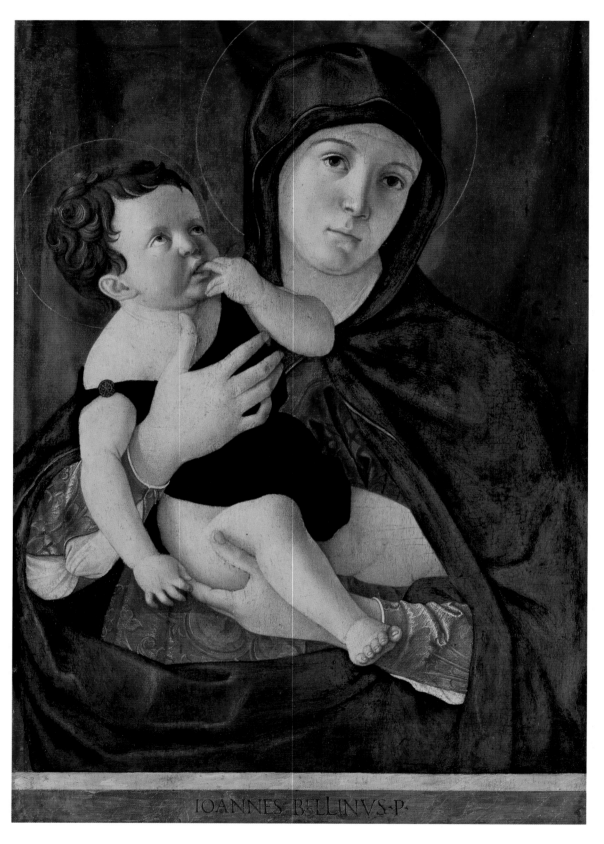

IOANNES BELLINVS·P·

GIOVANNI BELLINI
Madonna and Child

Opposite;
GIOVANNI BELLINI
Dead Christ Supported by Two Angels, c. 1480–85

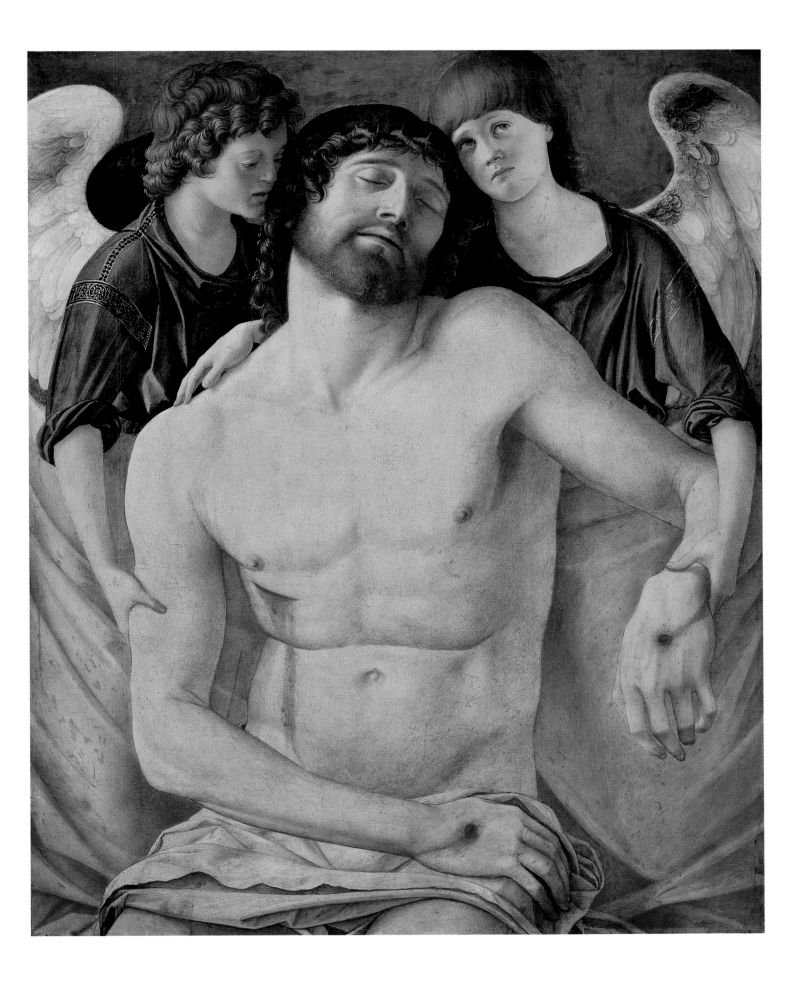

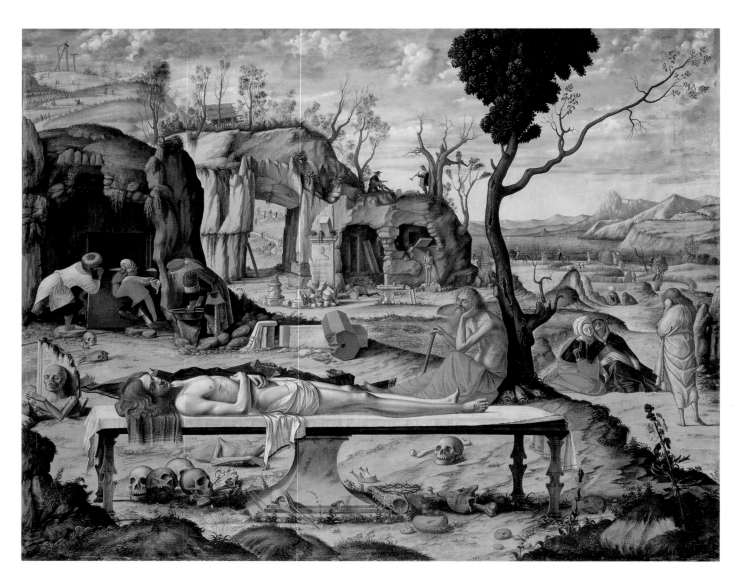

VITTORE CARPACCIO
Venice, c. 1465/67–1525/26
The Entombment, c. 1505

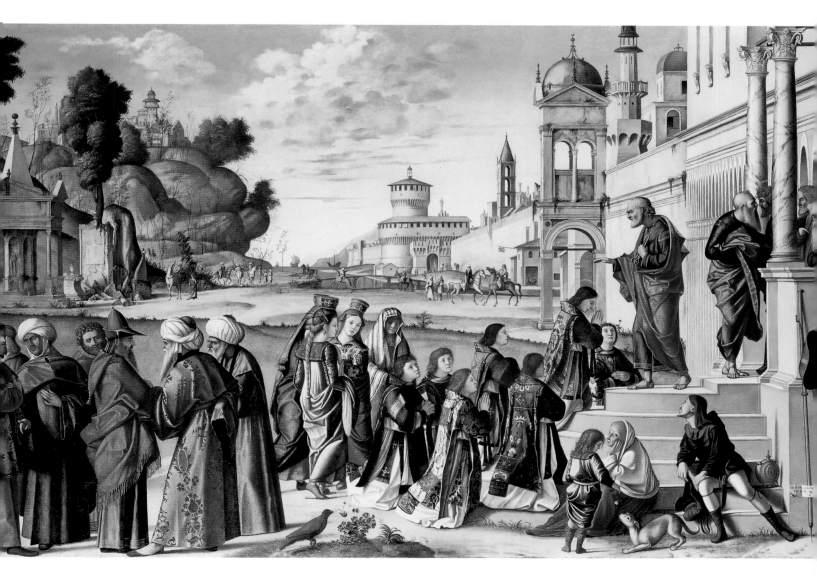

VITTORE CARPACCIO
The Ordination of St. Stephen as Deacon, 1511

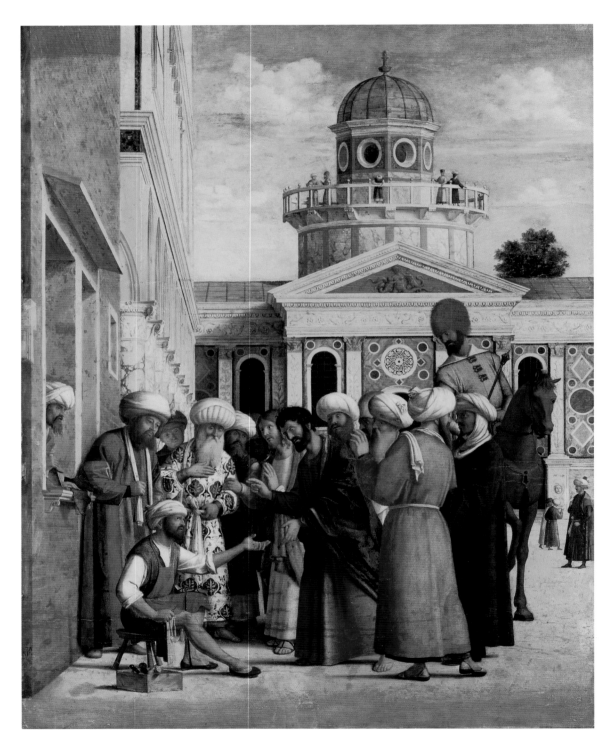

CIMA DA CONEGLIANO
Conegliano, c. 1459/60–1517/18
The Healing of Anianus

Opposite:
CIMA DA CONEGLIANO
Madonna and Child Enthroned with SS. Peter, Romuald,
Benedict, and Paul, c. 1495–97

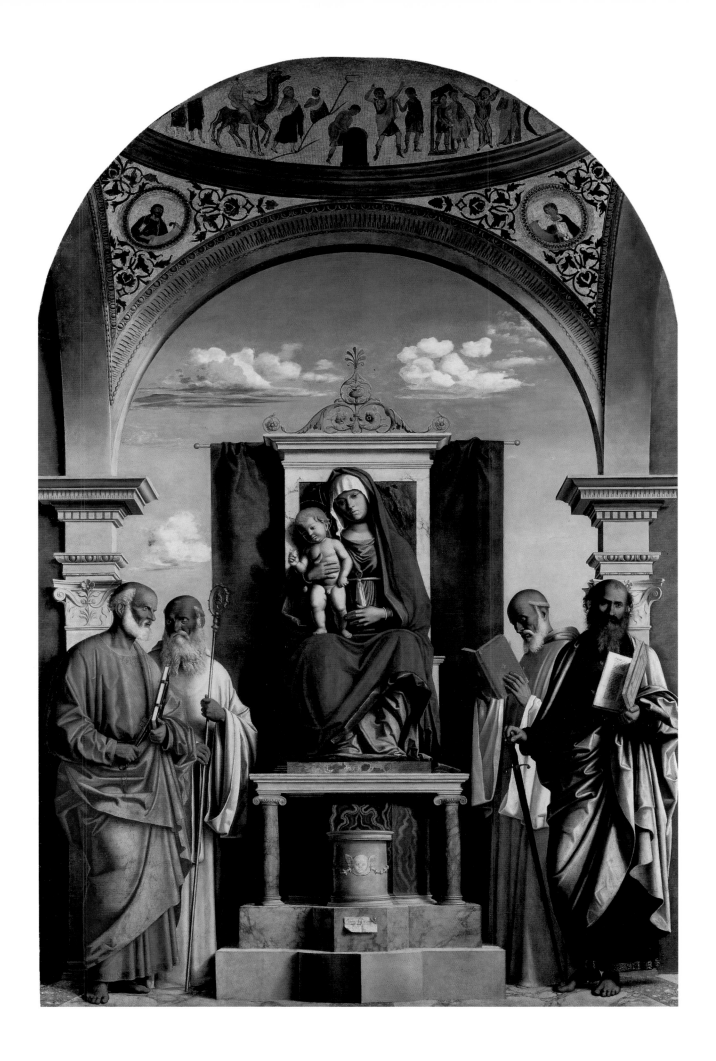

WITH LINE SO FINE: BOTTICELLI IN BERLIN

O F ALL Quattrocento painters, Sandro Botticelli may have been the one our nineteenth-century ancestors loved best. Arts and Crafts movements — whether the Kelmscott pieties of William Morris, the Yellow impieties in Beardsley's Books, or the sinuously botanical abstractions of Tiffany, Art Nouveau, or *Jugendstil* — all adored Botticelli's Beauties. Did the Pre-Raphaelites' models, in laudanum-inspired fantasy, see themselves as arsenic-bleached Botticelli Venuses reborn? Or were their more learned painter-poets doing the dreaming for them? There is little cause for wonder that woodcuts from Japan, often so close to Botticelli's fine lines, should have led a scholar from that nation to prepare the world's first monograph on the Florentine master — a fine study by Yukio Yashiro.

Hundreds of thousands of sepia-toned photographic reproductions in oaken frames showed the Florentine painter's beauties displaying their miraculously safe fusion of the erotic and the chaste, his windblown Venuses or nursing Virgins all taken from the same androgynous model. Angels, ephebes, Madonnas, even if so much alike, seldom bore. Like the classical artist and the constant reinvention of the identical ideal, Botticelli and his many studio assistants delighted in the multiplication of perfection.

As with Michelangelo's art, that of Botticelli was defined, limited, and exalted by the body. Botticellian ideals lay somewhere between sculpture and celestial scene painting, banishing accident, and enslaved by rigorous preconception.

Probably meaning less than meets the eye, Botticelli's ravishing, enigmatic, mythological subjects — flowering carpets of desire, Medicean tapestries of quasi-classical erudition — have been doomed to ceaseless twentieth-century icongraphic deciphering. As painter to the parvenu, he furnished villa and palace, chapel and church with exquisite images of faith in Eros or Christ, each delineated with equally elegant, almost languid conviction. A certain passive, resigned restraint, where disappointment — if not tragedy — in love and life seems a foregone conclusion, pervades Botticelli's images. His strongest emotions temper amity with regret, violence with surcease; tactfully, they never come too close to home.

As the year 1500 approached, many people sensed the oncoming of Apocalypse and world's end. Savonarola's sermons to this effect fell upon responsive ears, including Botticelli's. Penitent for his exquisitely sensual images, he tossed many of them upon the reformer's bonfire of the vanities. The painter soon joined the fiery monk's following. Informed against for homosexuality, he was fair (or unfair) game for the Dominican's threats of hellfire and brimstone. Surprisingly, of all the innumerable paintings, prints, and drawings after Dante's *Divine Comedy*, only Botticelli's magnificent penned sketches (Vatican and Berlin) convey the immediacy of Satan's realm, as well as Heaven's celestial joys. They remain the sole satisfactory graphic equivalents to Dante.

Most of Botticelli's career is represented in the Berlin collections. An early, very important *St. Sebastian (234)* was painted in 1474, when the artist was twenty-nine, for the great Florentine church of Santa Maria Maggiore. Unfortunately the panel's top corners were curved at a later date. This image is still close to the achievements of Antonio Pollaiuolo *(198)* and Verrocchio *(203)*. The latter was Botticelli's teacher.

Madonna and Child with Singing Angels, a magnificent tondo *(233)*, symbolizes the round mirror of Marian purity and conveys the unspotted speculum of the Immaculate Conception. Madonna and Child are flanked by singing, lily-bearing angels, their

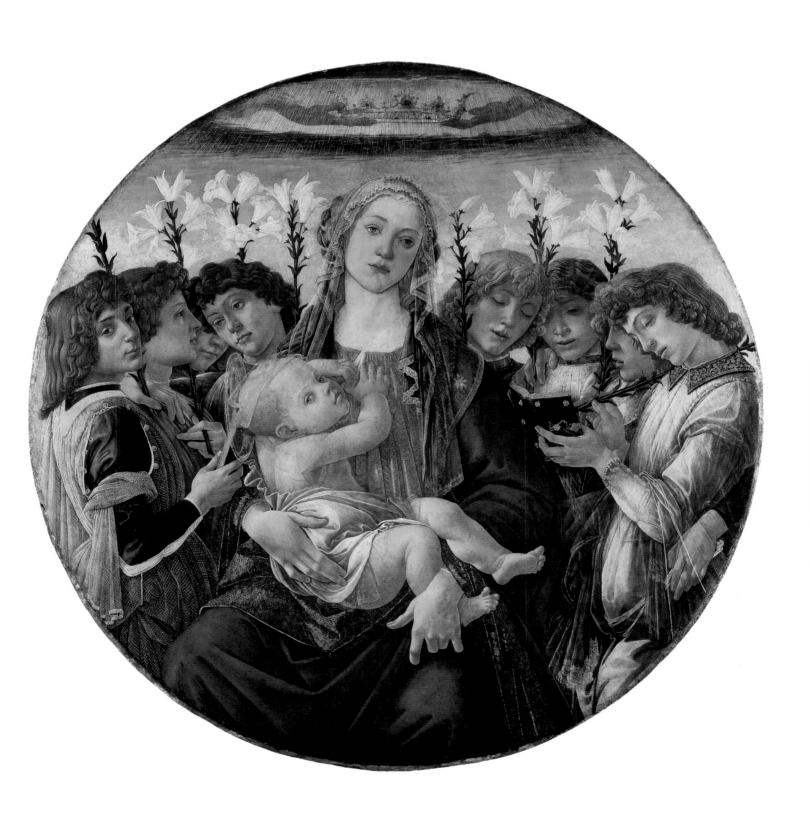

SANDRO DI MARIANO FILIPEPI, KNOWN AS BOTTICELLI, Florence, 1445–1510, *Madonna and Child with Singing Angels*, c. 1477

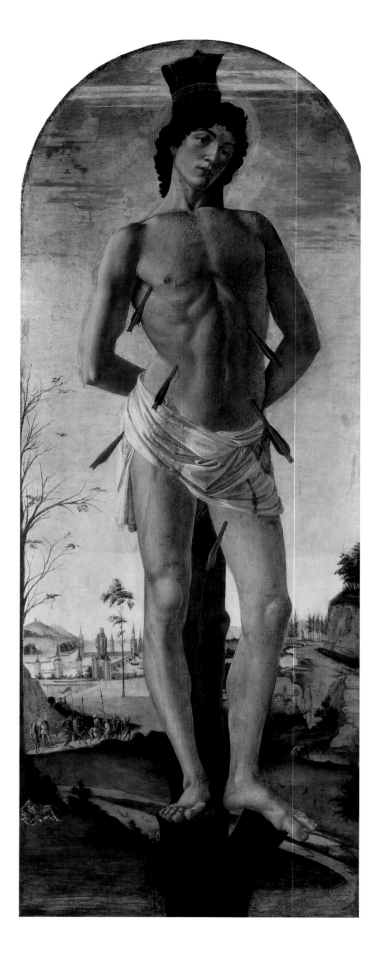

flower that of the Annunciation and Incarnation.

No matter how languid its restatement in this exquisite tondo, the adolescent angels' strength stems from Florentine sculpture, from the virile vocabularies of Donatello and Verrocchio. As He reaches for his Mother's breast, the Child's glance seems almost conspiratorial. Her gaze nears resignation as if seeing into the future, witnessing sorrows to come. At the Last Judgment, when Mary intercedes with her Son for mercy toward humankind, she will remind him of her nurture.

The finest of Berlin's Botticellis may be a monumental altarpiece dedicated to SS. John the Baptist and John the Evangelist, which was painted in 1484 for the Bardi Chapel in Brunelleschi's Santo Spirito (235). The ascetic Baptist, clad in camel's hide, points to the Child, his scroll proclaiming Jesus' taking on the sins of the world. The Evangelist holds pen and Gospel. Mary, a severe figure, is once again about to nurse the Infant.

Almost as dramatic as the expressively elongated figures is their verdant background, decorated with vases of roses, lilies, and olive branches, backed by niches of woven palm leaves and branches of cypress and myrtle. Speech scrolls from the Book of Ecclesiasticus pertain to wisdom, thus emphasizing Mary's seat as Solomon's Throne of Wisdom. Our Lady of the Flowers was one of the Florentine cathedral's first names, a fact Botticelli seldom forgot. Here art rivals nature in its skilled manipulation of leaves and flowers, as if the painter, by formalizing the informal, were bent upon improving Creation, a conceit followed by Leonardo.

BOTTICELLI
St. Sebastian, 1474

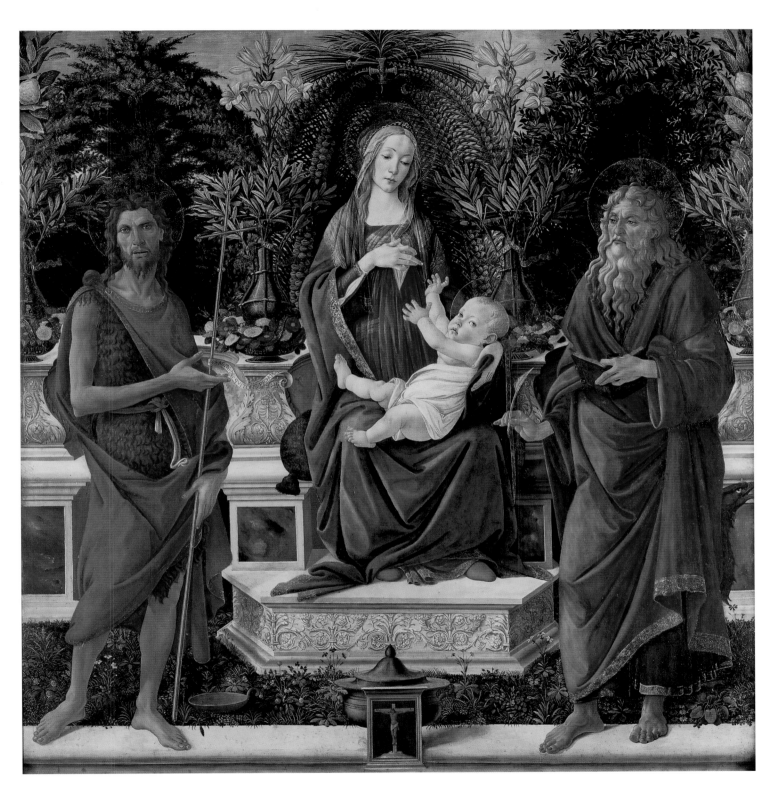

BOTTICELLI

Madonna and Child Enthroned with SS. John the Baptist and John the Evangelist, 1484

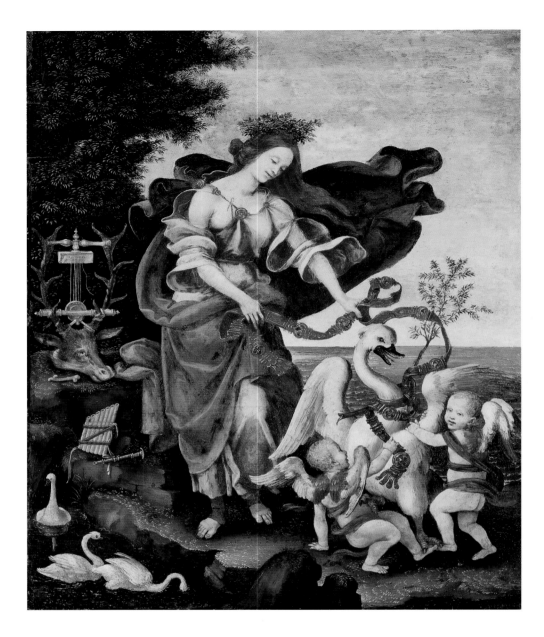

FILIPPINO LIPPI
Prato, 1457–
Florence, 1504
*Allegory of Music
(The Muse Erato),*
c. 1500

The very large-scale *Profile Portrait of a Young Woman* (237) and the full-length *Venus* (237) — which is based upon the central figure in the *Birth of Venus* (Uffizi) — may both be from the artist's studio. They epitomize the sinuous perfection of Botticelli's women, which would soon be popular in the art of Lucas Cranach (137), the Botticellian ideal found north as well as south of the Alps.

An *Allegory of Music* (236) by Filippino Lippi shows the seventh of the nine Muses, Erato — the Lovely One — muse of erotic poetry, with her Amors and Apollonian swan. This panel may have been en suite with a complete Muse series, like the Ferrarese *Polyhymnia* panel (215). Perhaps the horizon extended to include more of Erato's inspiring sisterhood. Filippino, who likely studied with Botticelli as well as with his own father, Fra Filippo Lippi, found a ready market in late-fifteenth-century Florence for his elegant, decoratively mannered art, one capable of realism when called for. This artful mix of skills prompted Lorenzo de' Medici — one of whose circle may have ordered this panel — to find Filippino to be Apelles' superior. Here Lorenzo doubtless saw himself as Alexander the Great, with an even better painter than that emperor's Apelles in his Florentine service.

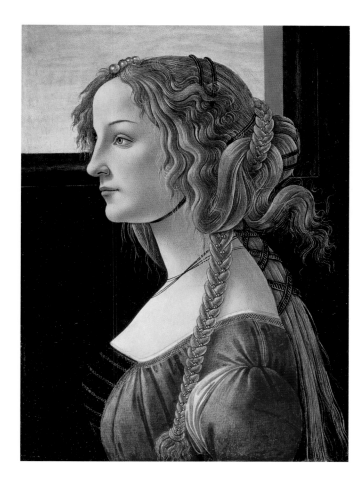

STUDIO OF BOTTICELLI
Profile Portrait of a Young Woman, after 1480

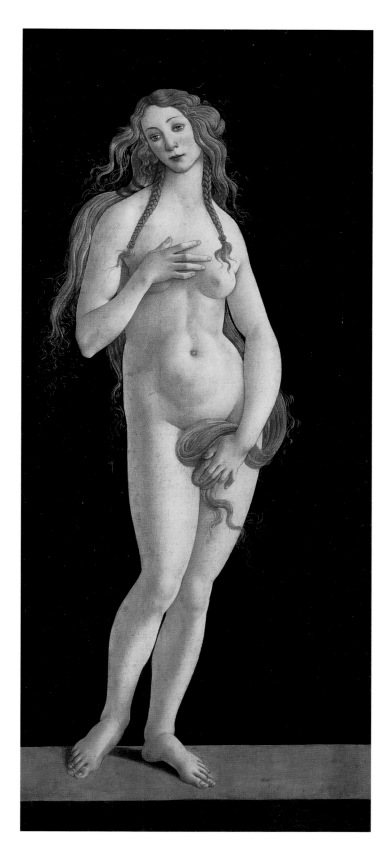

STUDIO OF BOTTICELLI
Venus

Luca Signorelli, Master of Muscular Christianity

LUCA SIGNORELLI painted too much, too readily, and lived too long. Striking for its strength, the very best of Signorelli's works make most of his extensive, almost mass-produced, oeuvre come as a painful disappointment. In the words of the nursery rhyme, "When he was good, he was very, very good . . ." and Berlin's three Signorellis are second to none. One of these, a tondo (*238*), may have been used as a *desco da parto*, a painted circular tray for sweetmeats brought as a gift to a rich Tuscan mother in childbed. This work's subject suggests that function, as it stresses babies. The infant Baptist, in the arms of his father, Zachariah, performs a symbolic baptism over Jesus, who is held by Joseph. At the right, Elizabeth looks into her cousin Mary's eyes, their pose recalling the Visitation. So half the composition repeats the past; the other rehearses the future.

A late-medieval cult of the Baptist and the Savior as babies became ever more popular, stressing long-term links between the cousins, who were thought to have been intimate since infancy. Where so many of these "Babies Beautiful" verge upon sentimentality, Signorelli saves the day with his decisive, sculptural figures, their setting invigorated by the dynamic interplay between the figures and the squared tiles seen within a circle.

But Signorelli's fame depends upon strapping, muscular men, not baby boys. These sexually charged male nudes, partly indebted to the art of Masaccio and of Piero della Francesca (who was possibly his teacher), later inspired Michelangelo. Such neo-pagan pictorial worship of virility was central to Signorelli's achievements and explains his popularity in Florence, with its powerful homoerotic cultural subtext. Perhaps Berlin's greatest pictorial loss to the Second World War was this painter's so-called *School of Pan*, the quintessence of

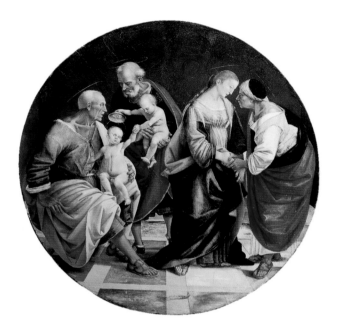

LUCA SIGNORELLI, Cortona, c. 1445/50–1523
The Holy Family with Zachariah, Elizabeth, and the Infant Baptist, after 1512

such complex sexual subjects flourishing within the Quattrocento's humanism.

For Siena's Bichi Chapel in S. Agostino, Signorelli frescoed recently discovered scenes of the *Birth of the Virgin* and the *Adoration of the Christ Child*. He also furnished the chapel with a great altarpiece in 1498. In this altar's wings, St. Catherine of Siena, the Magdalen, and the kneeling St. Jerome (*240*) face SS. Augustine, Catherine of Alexandria, and Anthony of Padua, who also kneels (*241*). Here the great swoops of Catherine of Alexandria's drapery, along with that figure's gravity, come close to the art of the High Renaissance. Originally arched, these panels were shown by Max Seidel to have flanked a statue of St. Christopher ascribed to Francesco di Giorgio (Louvre). Two fragments of panels of male nudes, painted by Signorelli as preparing for baptism (Toledo, Ohio, Museum of Art), were seen

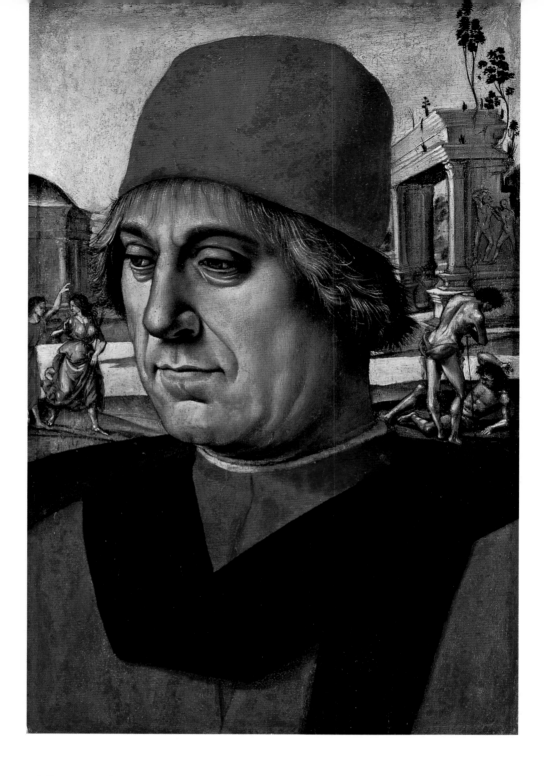

LUCA SIGNORELLI
*Portrait of an Elderly
Man*, c. 1492

behind the statue. The predella is now divided
between the National Gallery of Ireland in Dublin,
the Stirling-Maxwell Collection, Pollockshaws, Scot-
land, and the Sterling and Francine Clark Art Insti-
tute in Williamstown, Massachusetts.

Very few portraits survive from Signorelli's hand.
Indubitably his finest is the portrait in Berlin, proba-
bly of a humanist (*239*). It is often said to be of a
jurist, that profession and humanism considered

practically inseparable. Victories before a temple
approach athletes in front of a triumphal arch, these
all'antica themes pertinent to the sitter's scholarly
calling or pretensions. The action taking place in
the background may be on his mind, as suggested
by his downcast eyes. The hard-won balance
between hat, head, V-shaped scarf, and the far-
smaller figures is among the major triumphs of this
great portrait.

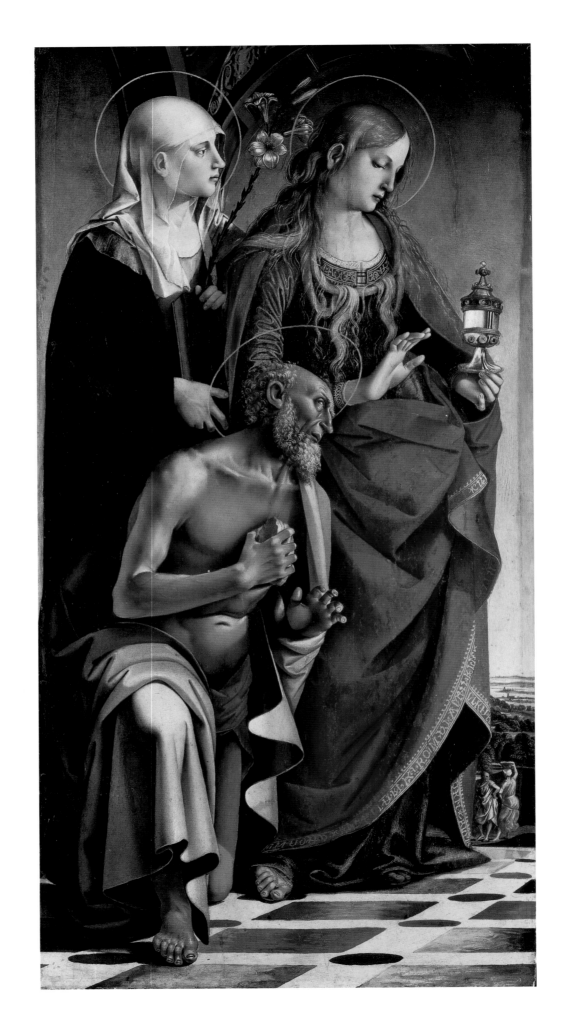

LUCA SIGNORELLI
Two wings from the
St. Agostino Altarpiece,
1498:

SS. Catherine of Siena,
Mary Magdalen, and
Jerome (left wing)
SS. Augustine, Catherine
of Alexandria, and
Anthony of Padua
(right wing)

240

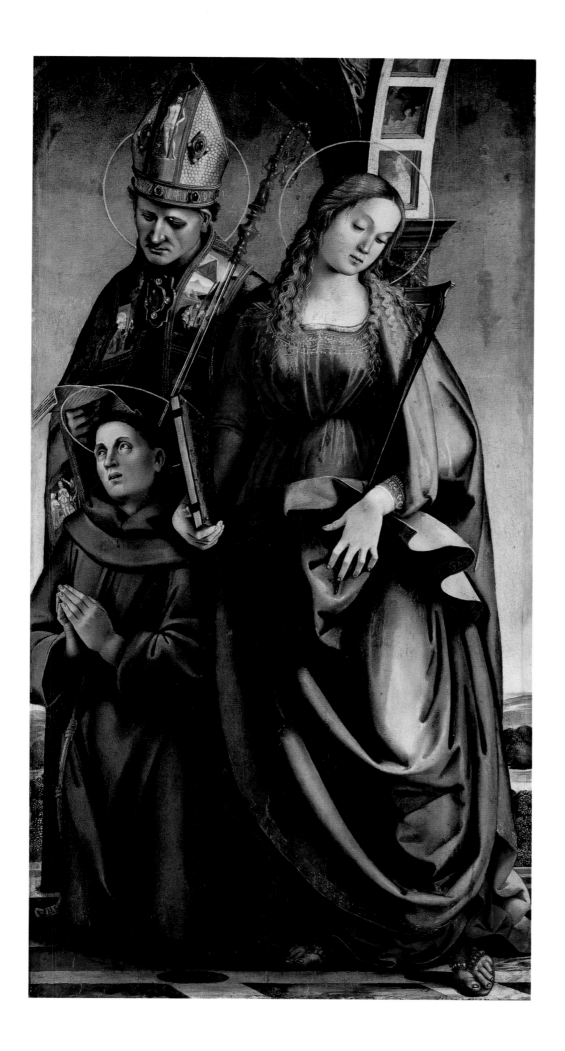

FROM LOMBARDY

STOICAL yet sad, a *Madonna and Child* (242) by the Lombard master Vincenzo Foppa betrays traces of Gothic intensity but the powerfully blocked out forms of Mother and Child point to new developments initiated by Fra Filippo Lippi (191) and followed by Piero and Mantegna (209). Here Mary and Jesus take on the roles of the new, redemptive Adam and Eve, symbolized by the Virgin holding a fruit for her Son's taking.

Powerful images like this lose a lot without their original, richly architectonic frames. Extremely expensive, these carved and gilded enclosures were often designed by painters to set their scenes upon and within spatial stages under their own control. Modern frames — or, as we see the printed images, with none at all — rob the picture of a much-needed transition from the present to the past, everything more "up front" than was the artist's intent.

Of all artistic achievements, Leonardo's act was the hardest to follow. Intended as the sincerest form of flattery, imitation of da Vinci almost always turns to instant caricature, all too evident in a huge altarpiece of the Resurrection (243) with figures by Marco d'Oggiono and landscape by Giovanni Antonio Boltraffio. Berlin doubtless paid a monumentally pretty penny for this putative early da Vinci. Clearly the fine landscape is based upon that master's art, as is the pose of St. Lucy. More conventional is the image of the patron saint of prisoners, and that of the supposed artist, Leonardo. His identifying shackles are in the foreground. Trouble starts with the figure of Christ, who suggests an aspiring bearded lady bearing the banner cross heavenward. Only Leonardo could have realized so ambitious a concept of the Resurrection, but he was too far from this work to help out. Nevertheless, major Leonardesque altarpieces

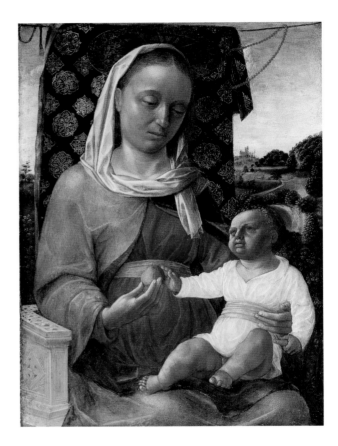

VINCENZO FOPPA
Brescia, 1427/30–1515/16
Madonna and Child, c. 1460–70

with landscape settings are rare. There is the remotest possibility that the painting may prove to be one of the many projects begun by the artist and then left to the inferior hands' completion. Like the Foppa, this vast panel also suffers from the loss of its original frame.

More successfully, if conventionally, Leonardesque is a *Vertumnus and Pomona* (243), by the master's Milanese assistant Francesco Melzi. Here wily Vertumnus, the Roman god of orchards and fruit, appears to the beauteous, demure

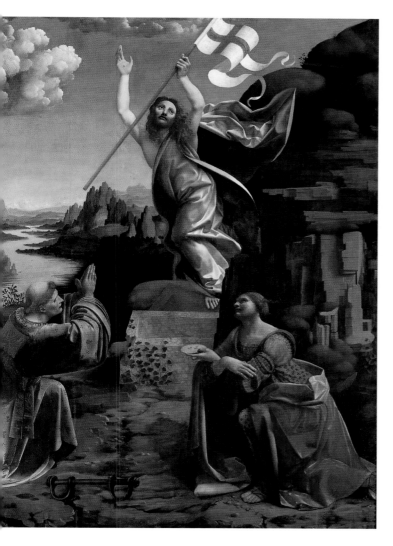

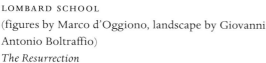

LOMBARD SCHOOL
(figures by Marco d'Oggiono, landscape by Giovanni
Antonio Boltraffio)
The Resurrection

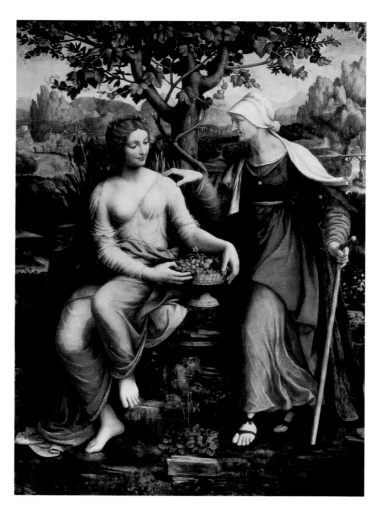

FRANCESCO MELZI
Milan, 1493–c. 1570
Vertumnus and Pomona

Pomona in the form of a seemingly harmless old lady and grazes the mortal's shoulder with a lustful hand. These ingenious seductions by the gods, as narrated in Ovid's *Metamorphoses*, provided many an artist's bread and butter.

Ever popular, the Roman's lively accounts of the conversion of some pretty boy or girl into an animal, vegetable, or mineral to escape the unwanted attentions of a Greco-Roman god or goddess, or of punishment for mortals who frustrate divine lust, explain the creation of most plants, animals, stars,

and jewels. These *metamorphoses*, or changes in form, also pertain to the miracle of art — that almost alchemical change of oil, tempera, or stone into a simulacrum of life itself.

Ironically, this Pomona, personification of the Leonardesque *belle ideale*, may have been used by a nineteenth-century restorer as a key source for repairing a wax bust ascribed to da Vinci, which was among Berlin Museum maestro Wilhelm von Bode's proudest purchases.

THE PERFECT ARTIST: RAPHAEL

THE SON of a minor painter, Raphael Santi was born in Urbino, seat of Italy's most exquisite small court, that of Federico de Montefeltro. Just as the young artist was to become the inventor of High Renaissance painting, so would his contemporary, Bramante, also a native of Urbino, establish High Renaissance architecture, another area in which Raphael excelled. The same court gave birth to the codification of contemporary aristocratic concepts, formulated by Baldassare Castiglione's *The Courtier*, written there in 1528. Toward the end of the fifteenth century Urbino's cosmopolitan if small patronage center included much Netherlandish art among the works commissioned by Federico, who also patronized Piero della Francesca and Uccello.

Young Raphael worked with Pietro Perugino of Perugia and owed much to the Umbrian master's aesthetic ideals. For all his smooth, somewhat sentimental art, Perugino had a lot to offer. Purity of outline and strength of modeling, a powerful sense for abstract form, keen sensitivity to color, a searching eye for detail, and splendid mastery of technique were all at his command.

Perugino, too, consulted Northern art, such as Schongauer's engravings. For further inspiration, Raphael went from the Umbrian's slightly boring, formulaic art to the far more challenging, monumental painters and sculptors of Florence — Verrocchio (*203*), Leonardo, and Michelangelo — and also took over some of Signorelli's (*238–41*) virile attitudes.

Soon the young painter was given major commissions in the Vatican, where he was also curator of Greek and Roman art. No painter may ever have equaled Raphael's capacity to learn so much from antiquity, re-creating its achievements with such stunning virtuosity and intelligence. A brilliant designer of tapestries and of *objets de vertu*, the artist worked equally successfully on many scales. Capable of the most incisive, presumably realistic portraiture, he was, at the same time, a matchless master of the decorative ensemble. Keyed to mural values, he painted the incomparable *Stanze* frescoes for the Vatican, with their awesome command of humanist values. Though he was one of the world's greatest colorists, Raphael designed effectively for his print shop, which was conducted by Marcantonio Raimondi; these projects were uniquely well suited to reproduction in engraved form. Such prints diffused the achievements of the High Renaissance throughout Europe (*150*).

Raphael's art was the foundation for the academic ideal for over four centuries. Now that the academic is once again seen as new, this painter can be recognized for what he always was — a genius with a rare gift for synthesis. Matchless in all his undertakings, Raphael may only be faulted for occasional blandness — his heritage from Perugino — a minor shortcoming that becomes meaningless when one remembers Raphael's early death, supposedly from a surfeit of wine and women, if not of song. A celebrated musician, he sang his own compositions to the accompaniment of his lute.

Berlin has no less than five Raphael Madonnas, more than any other museum. Close to the securely serene art of Perugino is the *Madonna with the Christ Child Blessing and SS. Jerome and Francis*, also known as the *Von der Ropp Madonna* (*247*), c. 1502. Similar in style and date is the *Solly Madonna* (*245*), where Mary reads as the baby turns his head toward her book. He holds a finch, prefiguring the Passion, an event presumably prophesied by Mary's reading.

Opposite:
RAPHAEL
Urbino, 1483–Rome, 1520
Solly Madonna, c. 1502

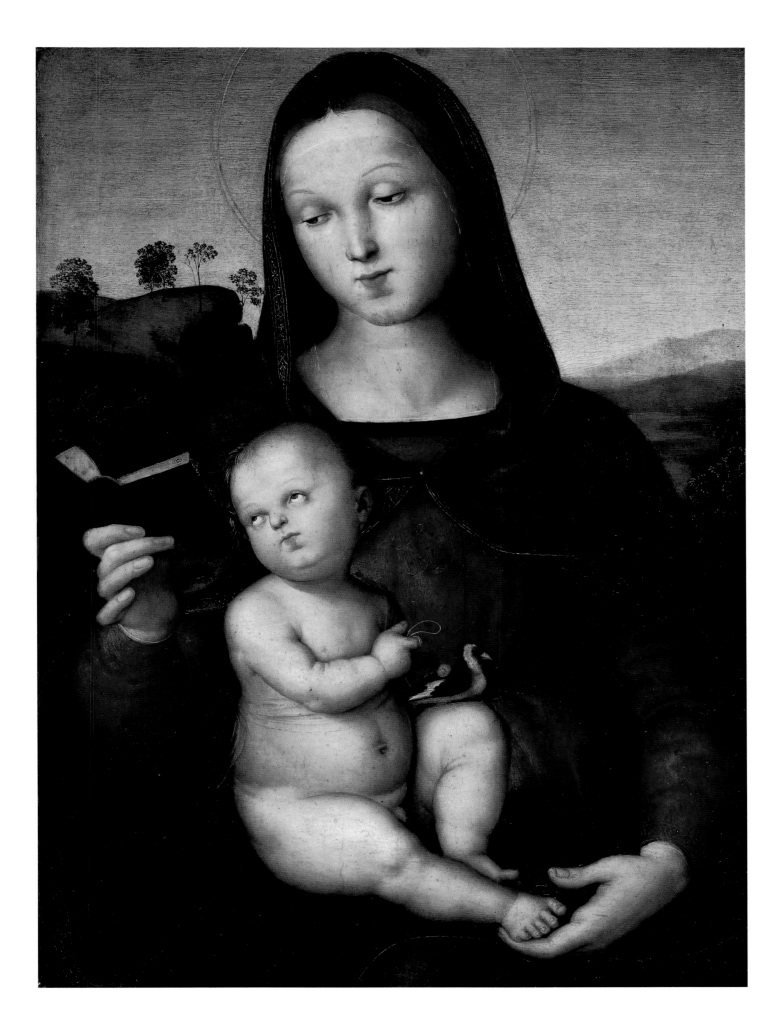

In the *Diotalevi Madonna* (246), c. 1503, there is still something Gothic about Mary's too-small head. Seated on her lap, Jesus blesses the infant St. John the Baptist. The landscape is somewhat reminiscent of Northern art, which is true for all of Berlin's Raphaels.

The circle — a perfect form — was popular in the fifteenth and earlier sixteenth centuries as a symbol of cosmic harmony. Raphael used it for the *Terranuova Madonna* (248) of c. 1505. Here, once again, Jesus is shown with the infant Baptist and a third holy infant to the right. The triangular shape formed by Mary and the two standing infants is a staple of the High Renaissance. A scroll linking the Baptist and Jesus is inscribed in Latin with the words "Behold the Lamb of God," which were pronounced by John at the Baptism of Christ and stress Jesus' sacrifice and role as the Redeemer.

Most original and mature of Berlin's Raphael Madonnas is the *Colonna Madonna* (249), named for that Roman princely and papal family. Painted c. 1508, the painter's first year in Rome, its coloring is remarkably blond; a similar tonality throughout suggests that the painting may not be entirely finished. Mary is distracted from her reading by Jesus. He looks to the spectator while reaching for her neckline, clearly wanting to nurse. A complex torsion to these figures is a far cry from the complacent, static world of Perugino.

If none of these devotional images indicate fully the "classic revolution" Raphael was to achieve in his fresco painting in Rome, all five do show the promising colorist and his striking potential for gestural harmony and subtle balance.

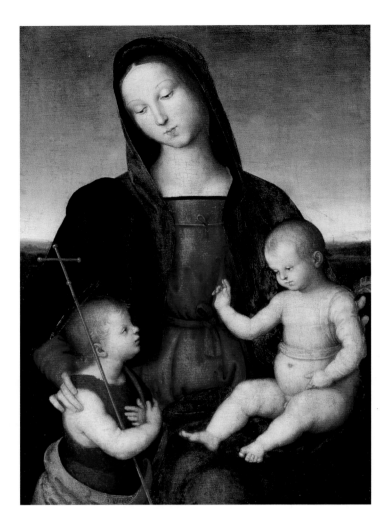

RAPHAEL
Diotalevi Madonna, c. 1503

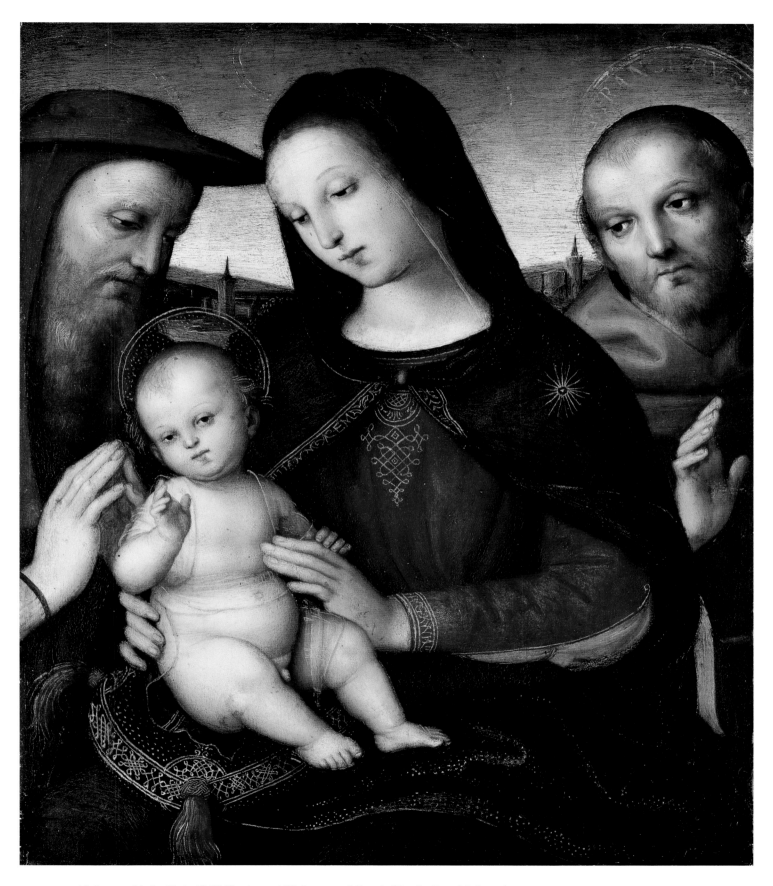

RAPHAEL, *Madonna with the Christ Child Blessing and SS. Jerome and Francis (Von der Ropp Madonna)*, c. 1502

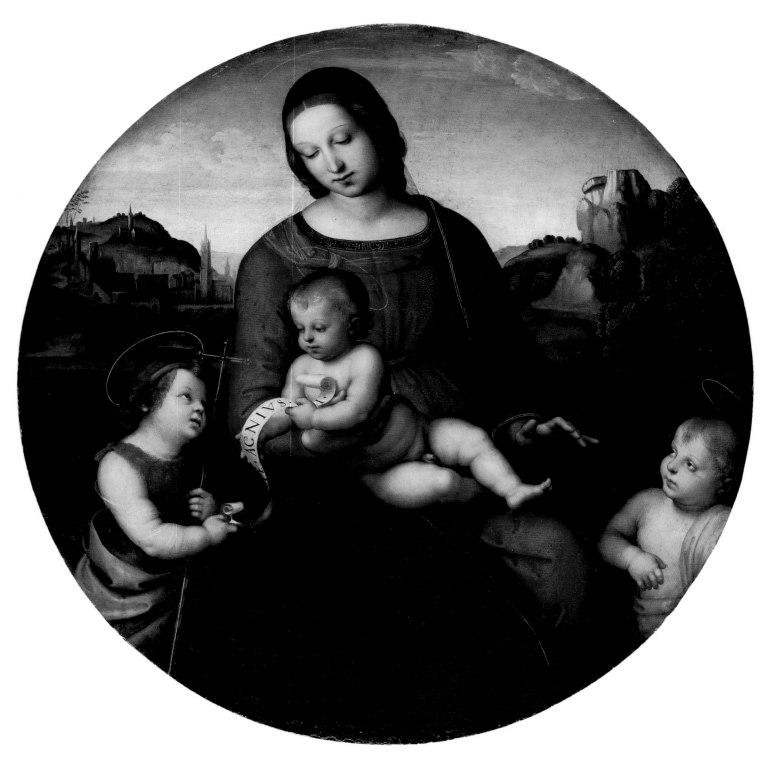

RAPHAEL, *Terranuova Madonna*, C. 1505

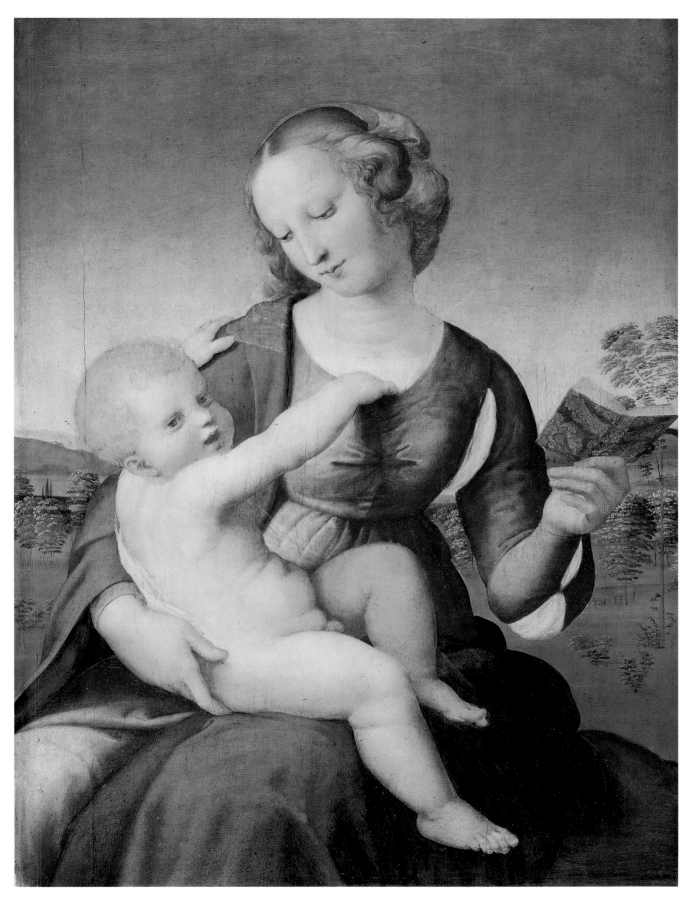

RAPHAEL, *Colonna Madonna*, C. 1508

ON THE CUTTING EDGE OF THE RENAISSANCE

BALANCE, symmetry, harmony — all these qualities of the High Renaissance soon demanded their opposites: tension, suspense, dissent. Mannerism, a phase, if not a part, of the art of the late fifteenth and early sixteenth centuries, may simply be the flip side of the predictable, the officially approvable. Berlin has three major examples of this movement, all male portraits that date from the first third of the sixteenth century.

Characteristic of this inwardly turning phase of Florentine painting is an image of a young man (251), c. 1517–18, by Rosso Fiorentino. Rosso worked with Jacopo Pontormo, under Andrea del Sarto, and both young artists evolved a style stimulated by Northern sources. The sitter's languid hands and relaxed coiffure have nothing to do with his sharp gaze, undiminished by a landscape background totally at odds with the sitter's decidedly urban toughness. Strips later added all around diminish the sense of tension that is one of Rosso's hallmarks, which he brought to Fontainebleau, where he was the pioneer figure in establishing the Florentine-oriented school there.

Rosso's style was soon followed in such patronage centers as Prague and Utrecht, in the art of Lucas van Leyden (147–49) and Jan van Scorel (150). The Florentine's painting led to an abbreviated, direct manner. This replaced the often obsessive technical finesse that had long dominated Northern art.

A Young Man (Matteo Sofferoni?) (252) was painted by the Florentine Francesco Franciabigio. The date of October 24, 1522, and the artist's name are on a *cartellino*. Self-contained, if not introspective, this likeness points to the mood of the period, when melancholy, whether genuine or affected, was a socially desirable state.

Franciabigio was a student of Piero di Cosimo

(200–201) and was among the first Florentines to take on a monumental — if not a completely High — Renaissance manner. He also worked with Andrea del Sarto and assumed a Raphaelesque stance. His most successful images are portraits such as this, where the challenge of the particular brings out special, unsuspected strengths.

Infused with Michelangelesque monumentality is a magnificent likeness of a young Roman woman (253) by the Venetian Sebastiano del Piombo, who went to Rome to paint in collaboration with the great Florentine. Only the landscape shows the artist's Venetian roots, close to Campagnola and Titian (263).

Berlin has one of the leading examples of Mannerism's complex, inwardly oriented art: the *Ugolino Martelli* (1519–1592), by Agnolo Bronzino (255). Ugolino, scion of a Florentine banking family, is placed in the courtyard of the family palace, where Donatello's unfinished *David* (now in Washington's National Gallery) is seen. Painted c. 1535–38, Ugolino wears the dark attire made fashionable by increasing Spanish influence. Just as Florence had lost its republican status, and had come to be governed by Medici dictators, this portrait betrays a Michelangelo-like concern with a superman who rises above and beyond the "limitations" of a Florentine workaday business world. Ugolino's darkly clad torso spirals into a world of neo-Platonic contemplation, even if his elegantly weaselly, unintelligent features do not inspire confidence in this young man's capacity for rarified thought.

Less self-conscious and self-important is a casual small picture of a woman holding a cat (254). This late work by the Florentine Mannerist master Francesco Bacchiacca shows the Renaissance fondness for exotic pets; women were also depicted with squirrels and rabbits close to hand.

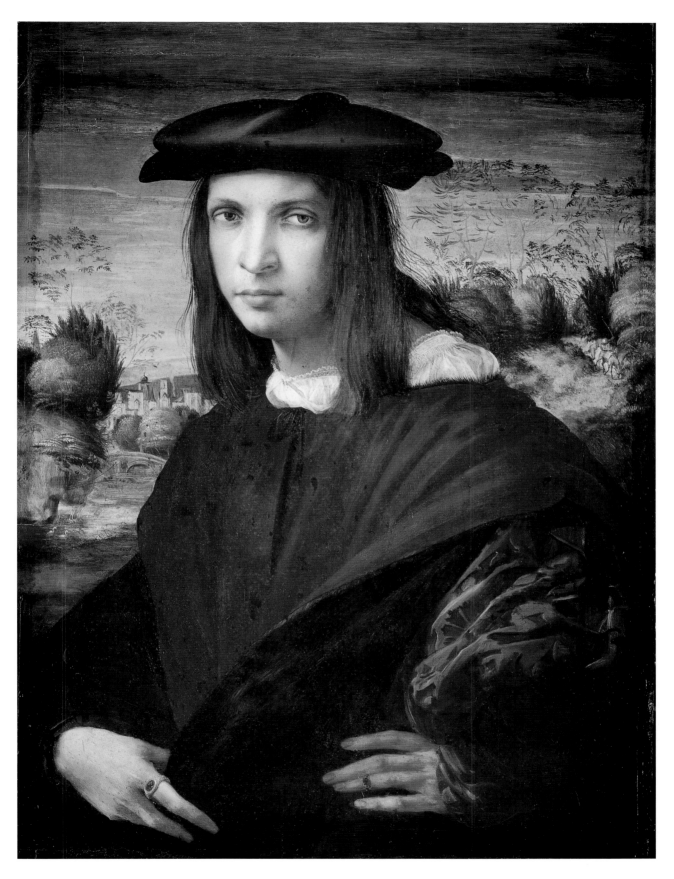

GIOVANNI BATTISTA DI JACOPO, KNOWN AS ROSSO FIORENTINO
Florence, 1495–Paris, 1540
A Young Man, c. 1517–18

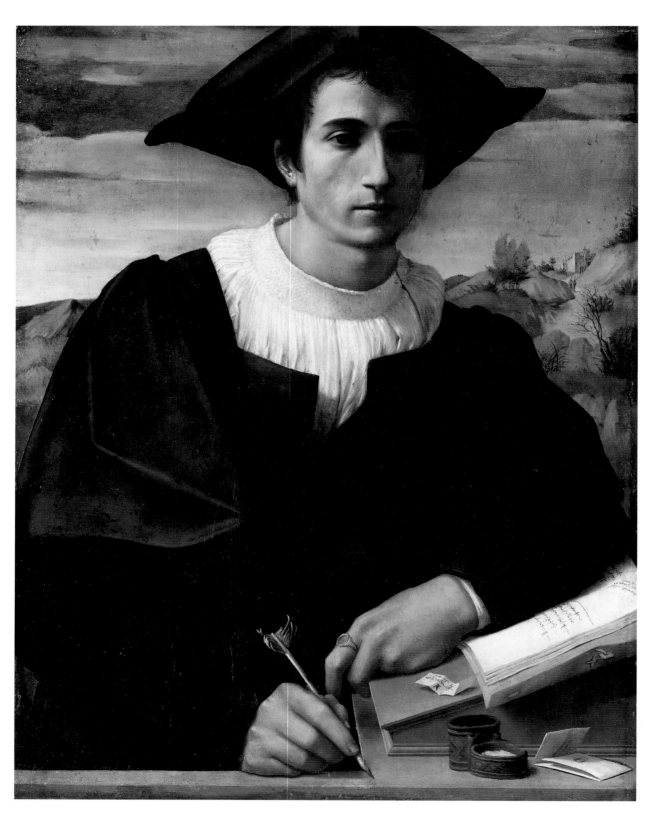

FRANCESCO DI CRISTOFANO, KNOWN AS FRANCIABIGIO, Florence, 1482–1525, *A Young Man (Matteo Sofferoni?)*, 1522

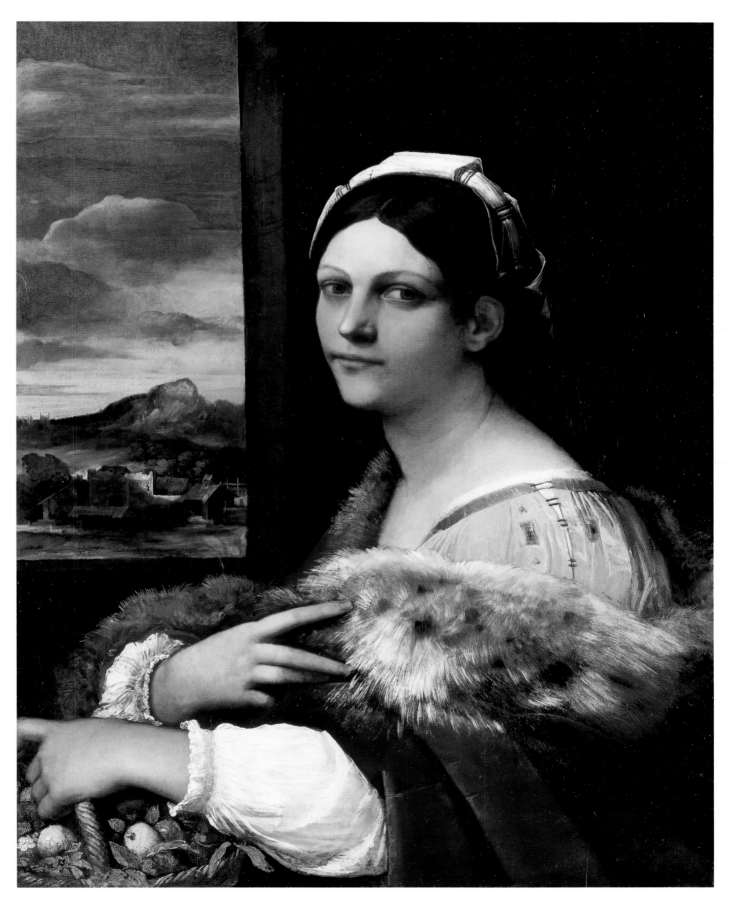

SEBASTIANO DEL PIOMBO, Venice, c. 1485–Rome, 1547, *A Young Roman Woman*, c. 1512–13

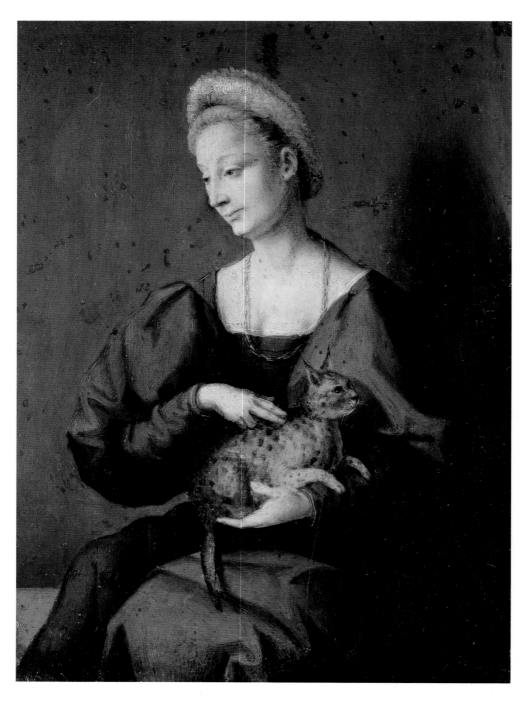

FRANCESCO UBERTINI, CALLED BACCHIACCA
Florence, 1494–1557
Woman with a Cat

Opposite:
AGNOLO BRONZINO
Monticelli, near Florence, 1503–Florence, 1572
Ugolino Martelli (1519–1592), c. 1535–38

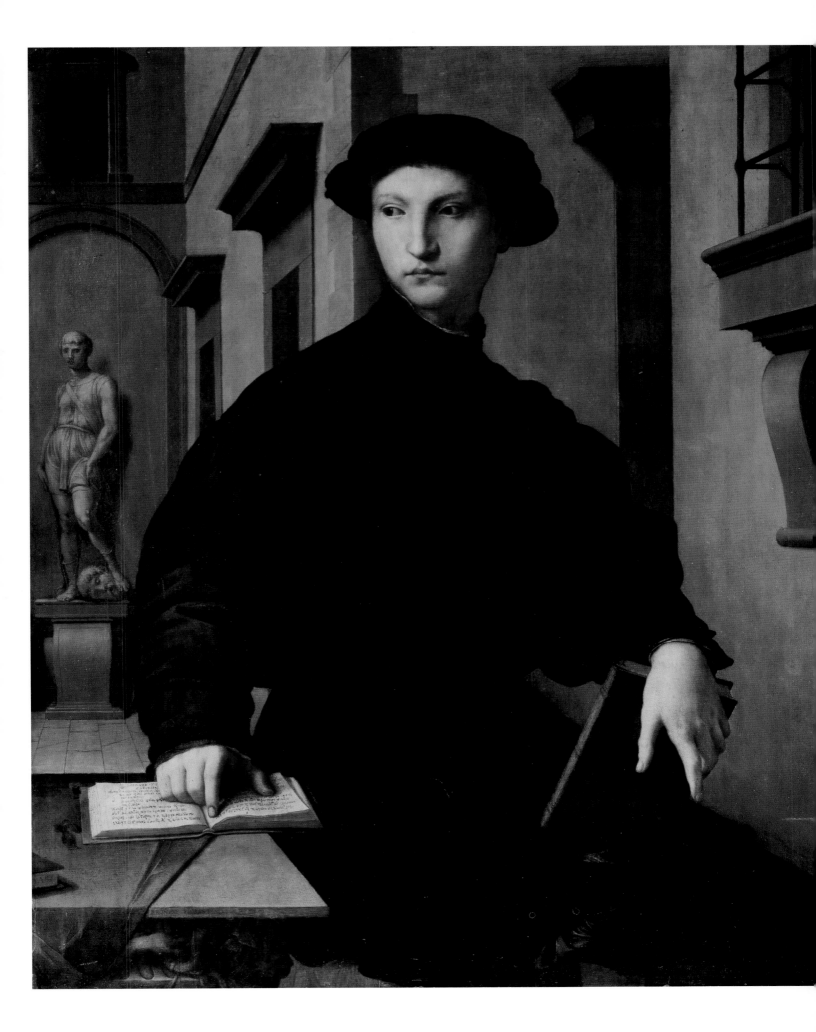

BEYOND CLASSIFICATION: LORENZO LOTTO

STRIKING for its prophetic modernity, its almost surreal sentiment and jarring yet exquisite color, the oeuvre of Lorenzo Lotto defies any ready category. "Renaissance," "Mannerist," "Realist" — none of these terms communicate his startling individuality or the almost hermetic world originating with his images. These strikingly inventive works are intensified by occasional insights and conventions derived from Northern European art.

Possibly a fellow pupil of Titian's and Giorgione's in Giovanni Bellini's studio, Lotto went entirely his own way, having little use for conventional Venetian concepts of harmony or beauty. Such independence may have led to his receiving many more commissions outside Venice than in the Serenissima herself.

Among Berlin's awesome holdings of six pictures by Lotto — three portraits, two mythological subjects, and a devotional one — the last is the most singular. To present Christ taking leave of his mother (257), Lotto had to become the ultimate choreographer, staging a dance of tragic departure set within an odd, open basilica, close to a purely theatrical architecture, though supposedly it is Mary's home in Bethany. The canvas's scenographic quality follows the fact that this tragic leave-taking was a popular subject in mystery plays, which were usually staged in churches, with Mary identified as Ecclesia.

Not a biblical subject, Christ's leave-taking comes from the *Meditationes* of Pseudo Bonaventura, and is also known as one of the Seven Sorrows of the Virgin. Christ kneels, expecting Mary's blessing before He goes to Jerusalem. Knowing the consequences of this journey, she swoons into the arms of the Magdalen and John the Evangelist. Her mother, St. Anne, is behind the Virgin, with SS. Peter and Thomas (?) to the left.

Typical of Northern Italian art is the prominence of the kneeling donor, Elisabetta Rota Tassi, in the foreground of Christ's farewell to Mary. The donor's dog is at her side. As she reads, the painting's subject is called to Elisabetta's mind by prayer. Her husband, Domenico Tassi, probably appeared in the lost *Nativity* pendant, a nocturne. As a pair, the pictures, likely commissioned for the donors' funerary chapels in Bergamo, may communicate the separate truths of the funeral service: "The Lord giveth and the Lord taketh away." Joy is inherent to the first; maternal sorrow as a form of death — Mary's swoon that of the Co-Passio (seen again at the Deposition) — is the message of the second.

For all its fidelity to light, space, texture, and gesture, this large painting moves beyond rational space and historical time to become an eternal *Imago Pietatis*, a devotional image of singular daring, making the viewer witness to intimate, unbearable pathos. Lotto knew how the extremes of experience — agony or ecstasy — lie beyond the body. Here the Mother of God is overcome, swooning in the certain knowledge of her son's imminent death. Humanity's redemption, the purpose of mother and son's common sacrifice, is indicated by the apple in the foreground. That's why Lotto places his own name on the *cartellino* next to the fateful fruit, as if including himself as well as his art in this pictorial drama for individual salvation.

Dürer is known to have been deeply influenced by Venetian art (220); conversely, Venetian painters like Lotto often followed the Nuremberger's vigorous graphic narratives, especially his woodcut *Life of the Virgin* series. Though neither of Dürer's images of this episode are close to Lotto's, that compelling, cosmic oculus at the painting's top center recalls one in Dürer's *Large Passion*, seen just above Christ's head at the *Last Supper*.

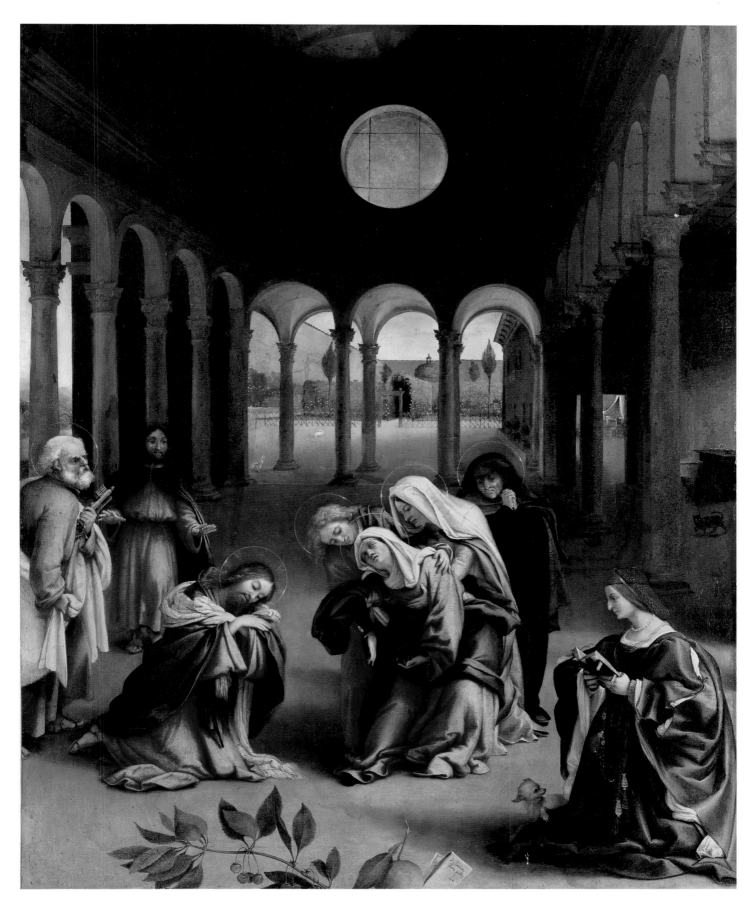

LORENZO LOTTO, Venice, c. 1480–Loreto, 1556, *Christ Taking Leave of His Mother*, 1521

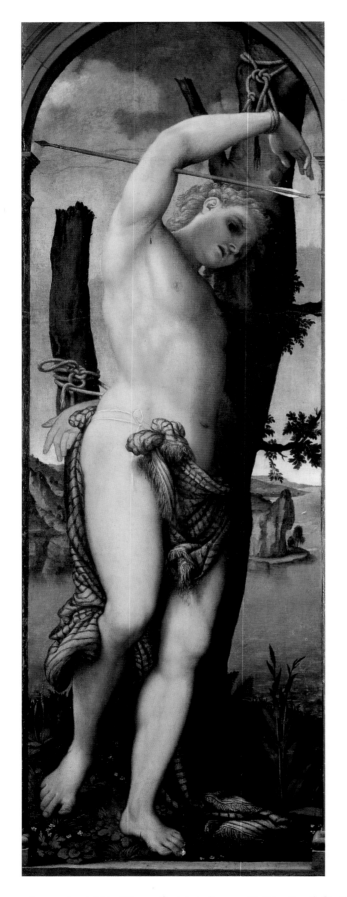
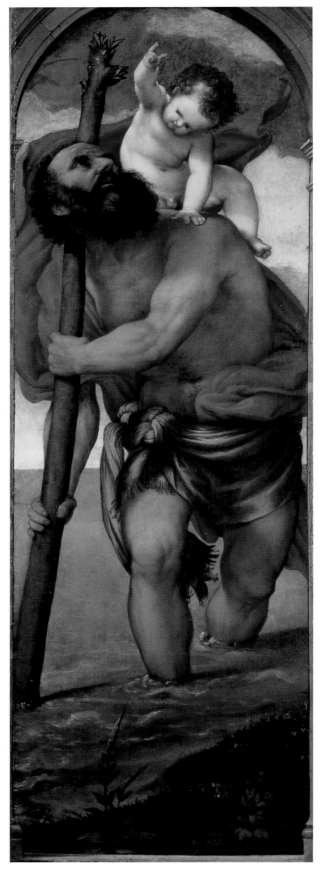

LORENZO LOTTO, Wings of a triptych, 1531: *St. Sebastian* (left); *St. Christopher* (right)

Unusually restrained and introspective is Lotto's portrait of an architect (260). The subject has long been identified as Sebastiano Serlio (1475–1554), who was a friend of the painter's. Two other architects, also known to Lotto, have been proposed as well: Jacopo Sansovino (1486–1570) and Giovanni del Coro. In startling contrast to this somber likeness is one of two portraits of young men (259), which is the more remarkable for its brightly lit background that includes a Venetian vista to the right. This canvas dates from 1526, when the artist returned to Venice from Bergamo.

Side panels of two standing plague saints — Sebastian and Christopher — would have faced each other when placed in their original polyptych by Lotto. The artist contrasted the *all' antica* pose of the young, blond Sebastian (258), who appears to be rather languid in his martyrdom, with the brawny, elderly, bearded figure of Christopher (258). There is even a strange dialogue between the heavy tree trunk to which Sebastian is tied and the narrow, almost equally lengthy club grasped by Christopher. Each panel is signed; that of Christopher is dated 1531. Arched elements at the tops are nineteenth-century additions.

Giovanni Battista Moroni, born near Bergamo, received many commissions from Spain's empire to the east, which in his time extended to Milan, where he painted that city's governor, Don Gabriel de la Cueva, Count of Albuquerque (261). Clearly a tough customer, the count's bold motto echoes his fearlessness. The Latin text carved on a pediment states that such fortitude prevails even in the face of death. Don Gabriel's stylishly slashed hose and sleeves are typical of the throwaway chic of this period. Fine in perception and execution alike, Moroni's approach to portraiture follows that of Lotto (259–60).

A curious northern Italian double portrait (261), combines the cool and the hot in a manner that recalls Lotto. By Francesco Beccaruzzi of Treviso (that city's marketplace is seen in the background), this canvas presents a singularly self-assured, richly dressed athlete, bat in hand, pressing a ball upon his page's shoulder as the latter works at lacing his master's breeches.

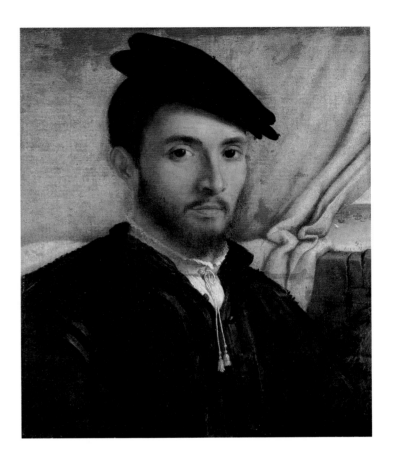

LORENZO LOTTO
A Young Man, 1526

During the sixteenth century Anthonis Mor may have been the most popular court portraitist as he crisscrossed Europe, "playing the royal and imperial circuit." Born in Utrecht, he traveled to Rome, Lisbon, Madrid, Brussels, and England. His sharp eye and precise hand contributed to likenesses close to, but less freshly conceived than, those by Hans Holbein (106, 109).

Margaret, Duchess of Parma (1522–1586), the illegitimate daughter of Emperor Charles V, was portrayed by Mor in 1562 (261). She made not one but two politically opportune matches, first to Alessandro de' Medici in 1536, and in 1538 to Ottavio Farnese, duke of Parma. Margaret was governess of the Netherlands from 1559 to 1567, a position that gave her great power.

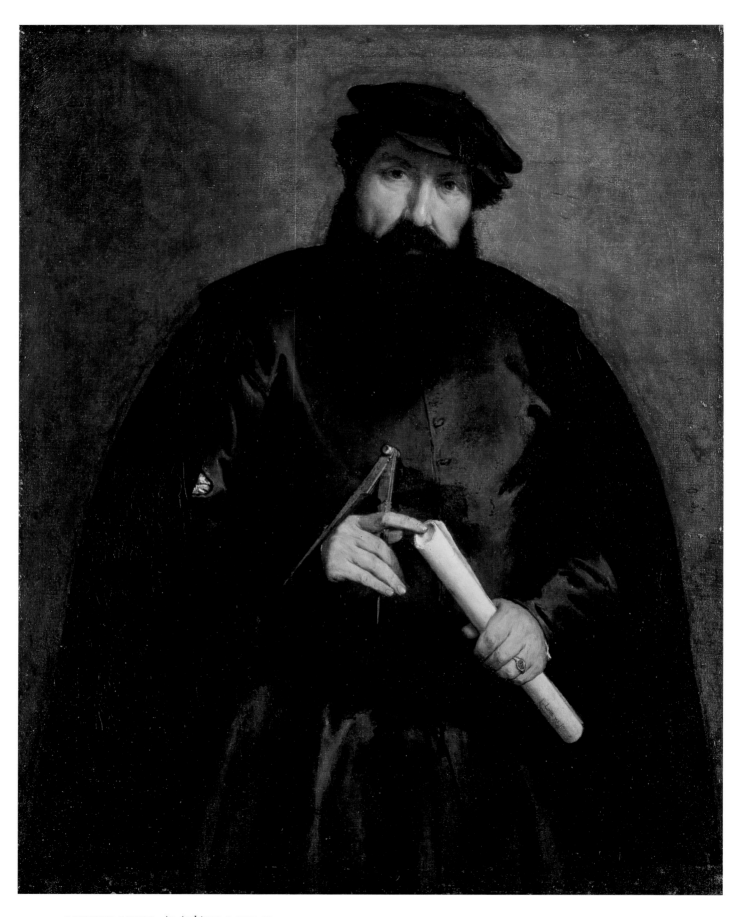

LORENZO LOTTO, *An Architect*, c. 1525–30

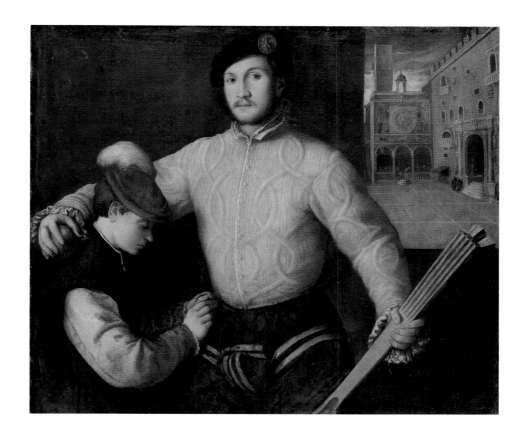

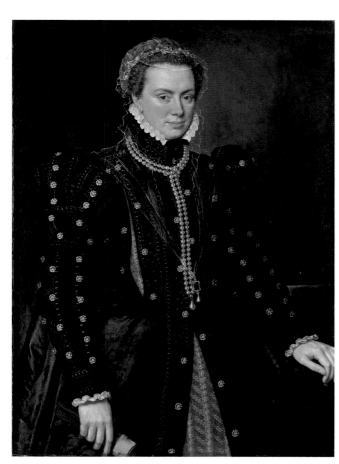

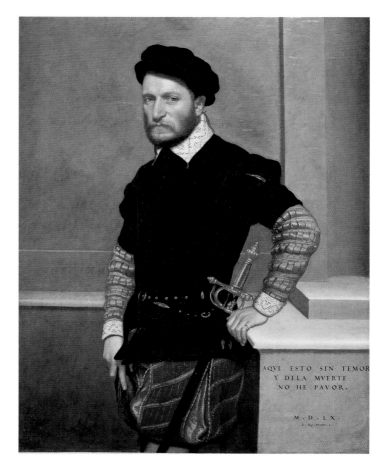

ANTHONIS MOR, Utrecht, c. 1517/20–Antwerp, c. 1576/77
Margaret, Duchess of Parma, 1562

GIOVANNI BATTISTA MORONI, Bergamo, c. 1520/24–1578
Don Gabriel de la Cueva, Count of Albuquerque, 1560

Titian, the Once and Future Painter's Painter

FOLLY lies in value judgments as to who is the "greatest" artist. Why not choose Leonardo? Jan van Eyck? Velázquez? Vermeer? Yet, forced to choose, Titian might well be the one. Never forgotten, never out of favor, never a slave to taste, Tiziano Vecellio may be the only painter whose work has spoken to all successive generations, each finding new qualities for emulation.

With almost every pictorial skill in mind and at hand, Titian was completely at home with classical, Christian, or secular subjects. He was a master of the nude, of court and other portraiture, of landscape and narrative pictures, as well as a great *animalier,* and a designer of magnificent woodcuts. There was little, if anything, he could not, or would not, paint. Only the most elaborate spatial games of perspective and certain aspects of genre seem far from his inclination, probably because he wouldn't, rather than couldn't, be bothered with pictorial exercises or common, hence unprofitable, themes.

The best of Titian's later paintings and drawings remain eternal happenings, pictorial events of the greatest excitement as well as the first magnitude. His rich color, drama, erotic and spiritual penetration, were emulated by many masters. Rubens (*290*), Rembrandt (*356*), Watteau (*444*), Goya (*422*), Delacroix and Turner, Manet (*591–93*), Renoir (*602–3*), Monet (*596–601*), Kokoschka (*635*), and de Kooning all followed his lead. Where later idolatry of Raphael caused that master's art to suffer as it was loved unwisely and too well and he was converted into Academe's patron saint, no such sterile fate awaited Titian. His vital canvases, defying ready imitation or beatification, could never be loved or venerated to death or squeezed dry by the Academy.

Never leaving the Netherlands, Rembrandt and Hals both depended upon the breadth of Titian's art to break away from the limitations of their culture's materialistic complacency. Many Impressionists, Fauves, and Expressionists (Abstract or not) looked long and hard at the Venetian's achievements. So, if greatness is to be equated with making the deepest dent in art's history, then Titian (with Raphael running second) proves the major master.

Though none too scrupulous, Titian was painter to Holy Roman emperors, empresses, kings and queens, dukes, duchesses, and viceroys along with most leading Catholic institutions and the just plain rich. He was a vast success throughout his legendarily long career. While most Renaissance artists harped on and on about their gentlemanly, learned status, about just how their painting was the equivalent of poetry, in Titian's case this all proved to be true, by deed and by gift, making words superfluous in arguing his case. No scholar (thank God), Titian was most certainly a poet, his Apollonian and Bacchic scenes visual equivalents to, and inspired by, the literature and lyrics of a classical past or present. Ennobled by Holy Roman Emperor Charles V, Titian (*268*) proudly wore that ruler's golden chain, presented to the painter in 1533.

Young Titian, like young Picasso, benefited from working at the same time as an immensely talented, somewhat senior, painter. The Venetian's peer was Giorgione, who was twenty years older. (Picasso's was Henri Matisse, twelve years his senior.) Both Renaissance artists may have been in the studio of Giovanni Bellini (*220, 226–27*), learning his luminous techniques and orienting themselves in his late, monumental altarpieces. They also collaborated on frescoes for the facade of the German trading company in Venice, the Fondaco degli Tedeschi. Giorgione died young from the plague, and his death may have resulted in Titian's completing canvases left unfinished in the studio.

Giorgione at his best — and his very, very small certain oeuvre leaves nothing but that — affords an

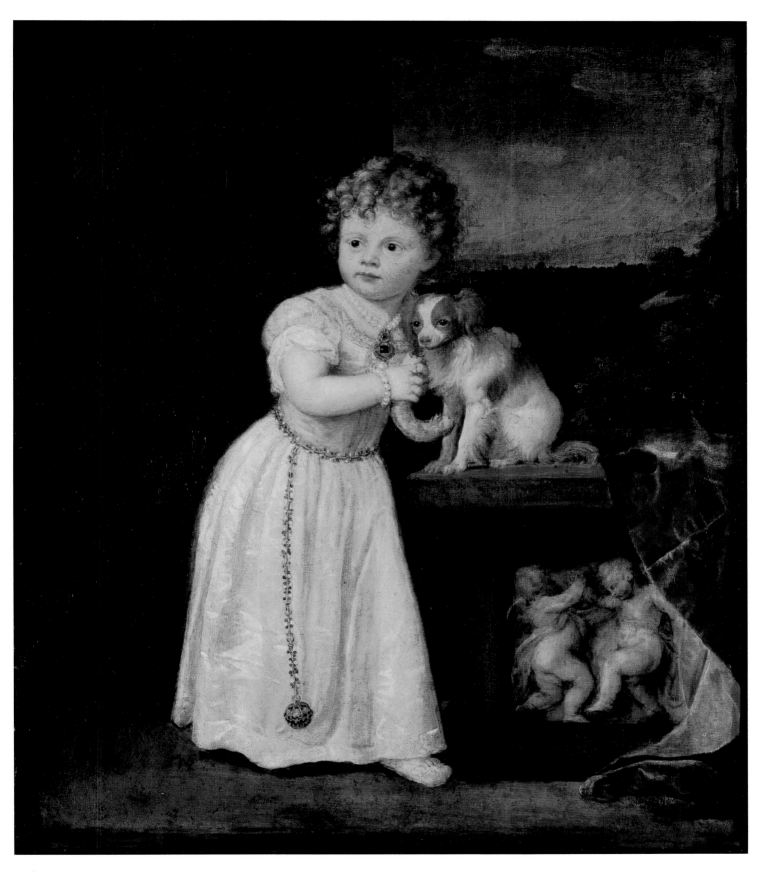

TIZIANO VECELLIO, CALLED TITIAN, Pieve di Cadore, c. 1488/90–Venice, 1576
Clarissa Strozzi, 1542

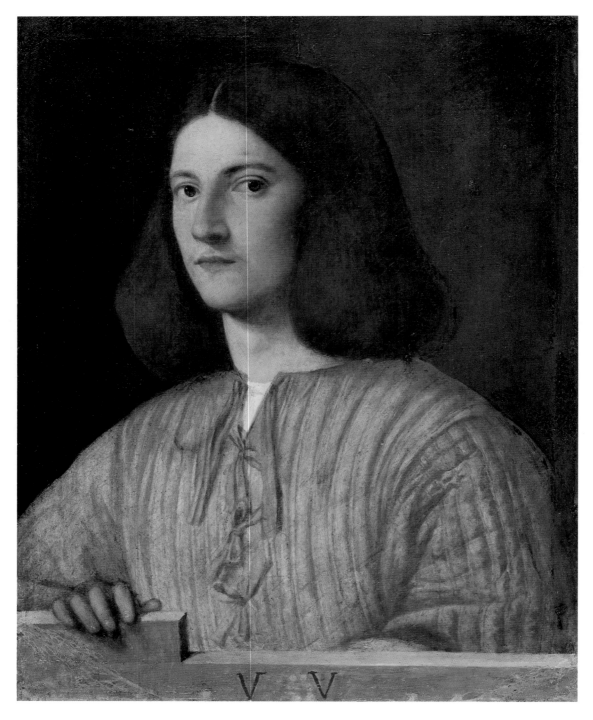

GIORGIO DA CASTELFRANCO, CALLED GIORGIONE, Castelfranco (Veneto), c. 1477/78–Venice, 1510
A Young Man, c. 1505–6

extraordinarily intense combination of the observed and the idealized, one that lends "reality" to the visionary, and perfection to actuality. These contradictory traits, almost miraculously resolved, can be seen to best advantage in Berlin's *Young Man* (264). Vermeer-like, the shirt's violet tints radiate light in their opalescence. The letters inscribed on the ledge are found in contemporary Venetian portraits and allude to an ancient motto that refers to the concept of the Speaking Likeness.

Relatively early, from about 1525, is a *Bearded Young Man* (265), in which Titian experienced some

difficulty placing the head on the torso; the face floats in almost mystical fashion like some secular Vera Ikon. Nevertheless, this is more than an instructive exercise in Titian at a little less than his magnetic best. Here he is working in a precise, conservative style. Could the canvas have been cut down? It is easy to imagine a young Velázquez (423) looking long and hard at a likeness such as this for its compelling fusion of the specific and the generalized, an essential combination for commercially successful, persuasive portraiture. Van Dyck (308) admired this canvas, which he drew on his Italian journey (Chatsworth Sketchbook).

Few High Renaissance portraits of children survive, and the greatest of those that do is Titian's *Clarissa Strozzi* (263), painted in 1542 when the girl was about two. His little subject was the first of seven daughters born to parents from Florence's two wealthiest families (her mother was a Medici), who were living in Venetian exile until 1545. Like so many portraits, this one may have been made for delivery to some doting, faraway relative.

For all its requisite status symbols — pearl necklace and girdle, jewels and rich clothing — nothing interferes with what matters most: fleeting infancy. This is conveyed by Clarissa's absorption in her happy task, feeding a pretzel to a puppy. Could this nurture return to Plutarch's parallels between raising a child and caring for a pet? Do the swans in the distance refer to innocence? Is the antique (or pseudo-antique) element similarly and purposefully invested with humanistic erudition? All have been suggested, but remain suppositions. Only by feeding her pet could Clarissa be freed from her fear of the piercing scrutiny of a bearded, formidably middle-aged Titian.

Like Giotto, Titian was unusually venal, sometimes working in concert with the occasionally pornographic poet Pietro Aretino, who acted as his unofficial publicist / agent. Fancying himself the scourge of princes, the poet was more their pimp, helping circulate Titian's magnificently nude canvases throughout Europe, distributing these (with other works) among the Habsburg courts in Spain, the Netherlands, Germany, Austria and Hungary, and the court of the Habsburgs' French brother-in-law François Ier.

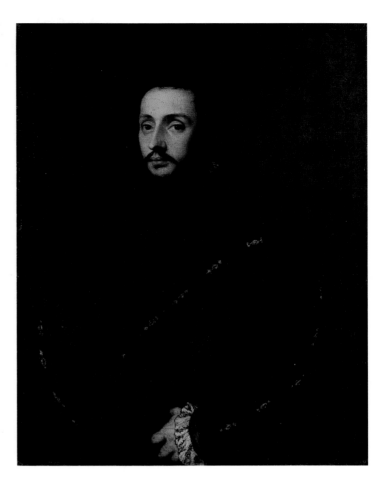

TITIAN, *A Bearded Young Man*, c. 1525

Sexual yet courtly, Titian's erotic paintings of dressed musicians playing away at sometimes suggestive instruments while staring fixedly at naked blondes might have been *hors de combat* for Europe's more prudish courts, yet the painter imbued such scenes with requisite veils of polite allegory.

Aretino possibly devised the symbolic window dressing (astrological references, cupids, et al.), saving amorous cycles from a destructively Inquisitive or otherwise questioning queenly eye when sent to Spain. These "Venuses," many of them painted for Charles V and delivered in the late 1540s and early 1550s, kept their painter in ample velvets and real estate.

Typical of Titian's endless flow of *bella biondas* is his *Venus and the Organ Player* (266–67). These titillating combinations of naked women and dressed, music-making men — the *Déjeuners sur l'herbes* of their day — called for intensive symbolic flim-flam

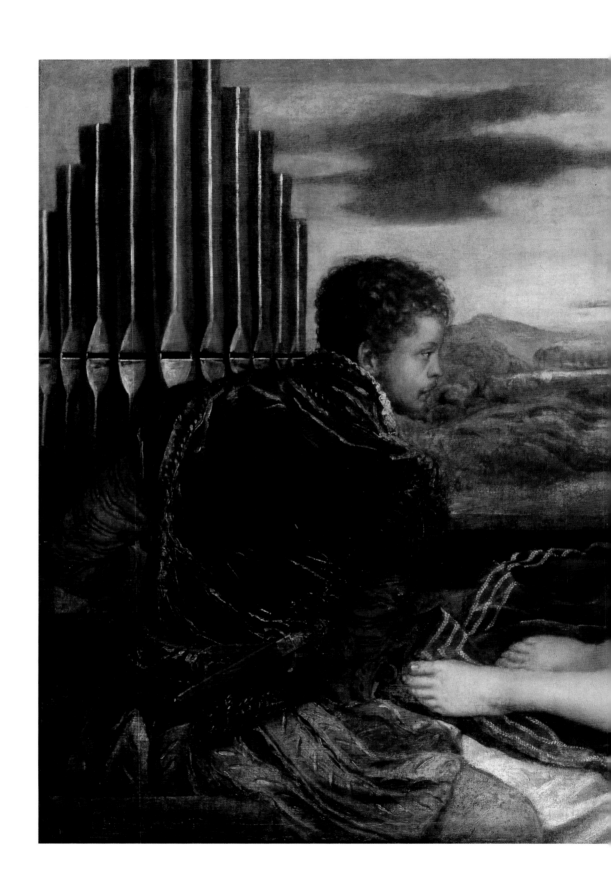

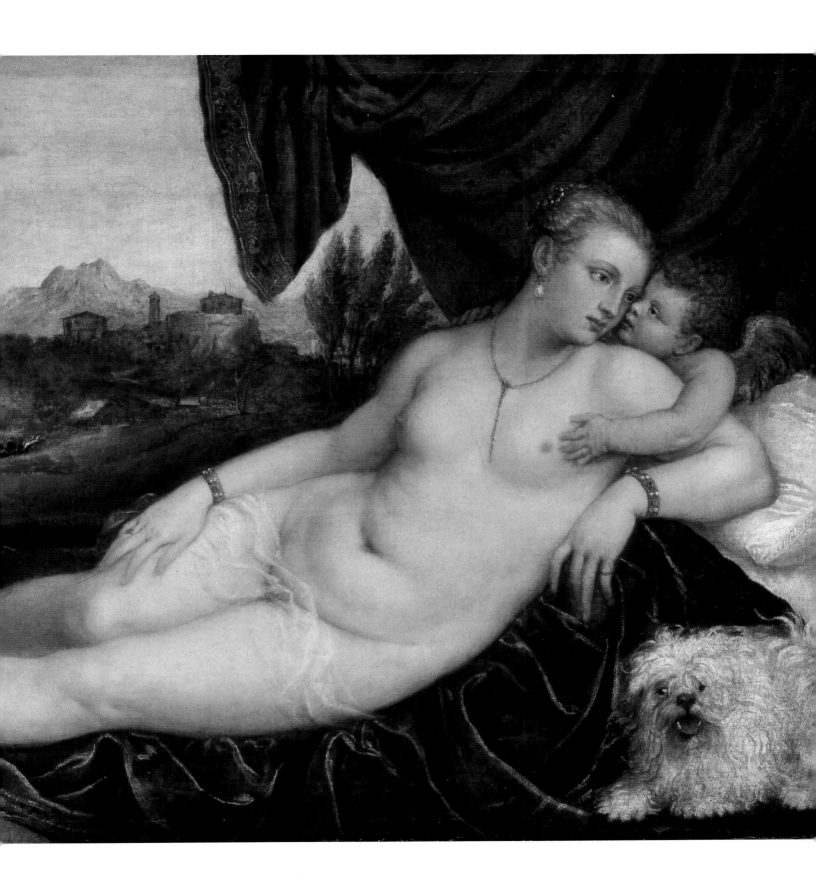

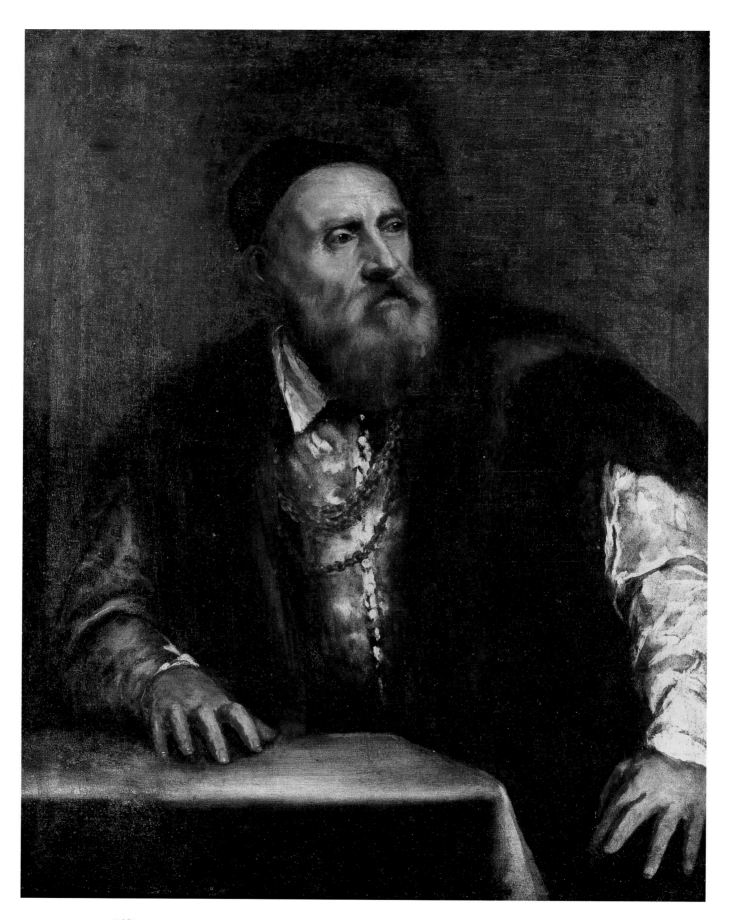

TITIAN, *Self-Portrait*, c. 1572

to ensure social acceptability. Could the amusing resemblance between the organ player and Prince Philip of Spain have any purposeful basis? Neo-Platonic beliefs in harmony, in the hierarchies of Venus, in Love's purity, in the role of Cupid, necessitated humanists' working overtime to process and package the requisite purifying erudition, precedent to the selling of these ravishingly multiple pictorial *entendres*.

The *Woman with a Fruit Bowl* (269), one of many versions of a popular subject, is from the mid-1550s. For all her come-hither glance, this is an image that knows its place, shown by Santore to be an "Anonymous Beauty," despite all the attempts to invest these unlikenesses with labels, such as "portrait of the painter's daughter, Lavinia."

Titian's art kept improving with age, so much so that Germans even invented a special scholarly term to identify the splendor of his pictorial swan song: *der Spätstil*, or Late Style. With time's weight and warning, only the essential is worth seeing or painting. Now the selective eye and hand work together as speedily as possible, art and artist alike informed by that quality of existentialism only elicited by the keenest intimation of approaching death.

Just who little Clarissa Strozzi had to confront is shown some thirty years later in Titian's symphonic, aged *Self-Portrait* (268). Here the artist seems to be hearing and seeing distant voices and sights, as if responding to stirring intimations of mortality. Berlin's canvas has none of that "I'm looking in a mirror to paint my portrait" quality so often endemic to this genre. It is as if two individuals are involved, the great painter and the great sitter, each honored equally by the other's presence and participation.

Economical yet extravagant, this final phase of Titian's art is a triumph of contradictions — celestial fingerpainting, where daring rainbows of color streak over a shuddering, shimmering surface. Actual and ideal vibrate toward one another, as in the making of a late Rodin plaster or watercolored pencil sketch, where beginnings and endings seem increasingly the same. These final images are truly action paintings, not Pollockian pourings from buckets of color, but outpourings of naked spirit onto canvas.

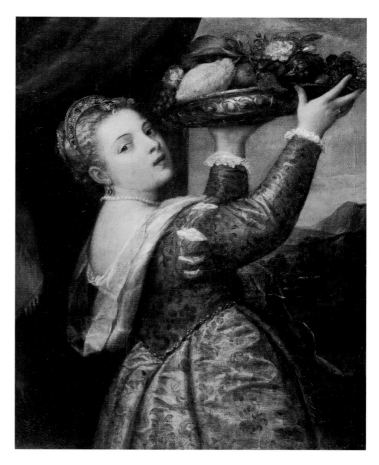

TITIAN, *Woman with a Fruit Bowl*, c. 1555

Like Picasso, Titian was nasty, whether old or young. The difference between their late pictures lies in the artists' respective capacity for self-acceptance. Picasso could never forget his impotence; that weapon's loss obsessed and limited the old Catalan's art. Seizing night as well as day, Titian's terminal oeuvre proved uniquely equal to his often black vision; illumination of darkness glows among his very finest late works. The painter's *Self-Portrait*, perhaps the ultimate achievement in that genre, remains incomplete, the hands barely sketched in, giving an arresting, eternal sense of "work in progress." Is Titian saying, "If you want to see what my hands can do, see the look upon my face"? Or did Death finish this work for him?

North Italian Passions

Some paintings of beautiful nudes may shock for what they show; others for what they don't. Both have been punished by vandalism for their respective sins of pictorial commission or omission. Velázquez's *Rokeby Venus* (London, National Gallery) was cut up by a suffragette for the picture's suggestively Correggiesque rear view. Correggio's *Leda and the Swan* (271) was hacked to bits by a distraught widower, the Duc Louis d'Orléans, this canvas's owner, who slashed away in a transport of religious righteousness at some point between his wife's death in 1726 and his monastic retreat of 1731.

Happily Louis did pick up the pieces, and his court painter, Charles-Antoine Coypel, put them together Humpty-Dumpty–like, as best he could. Poor Leda's head had to be started from scratch, as this area aroused ducal ire above all others. Redone several times, the last "repair" (of 1834–35) gave her an odd resemblance to Berlin's future love goddess Marlene Dietrich.

The canvas was one of four Correggio painted for Duke Federico da Montefeltro II of Mantua, who was unusually fond of spicy mythology, even for those lusty times. The full complement of Correggio's "Loves of Jupiter" (1531–32) includes Berlin's *Leda*, the *Danae* of the same format (Rome, Galleria Borghese), and two vertical canvases, *The Rape of Ganymede* and *Jupiter and Io* (Vienna, Kunsthistorisches Museum). With this beautiful quartet Federico received the ultimate in exquisitely erotic imagery, never equaled by any other painter. Parmigianino, Primaticcio, Boucher (462), Prud'hon (who also restored Berlin's painting), Ingres, and Renoir (602–3) all did their best to emulate Correggio's silvery chiaroscuro and subtle flesh tints, to copy his ineffable blend of real and ideal, making Zeus's loves so delicious and so disturbing — and so downright unbearable to that born-again, monastery-bound, widowed French duke.

Frederick the Great bought this painting in Paris for Potsdam in 1770 and Napoleon looted it for the Louvre in 1806. Of all Frederick's purchases of earlier art, this ravishing canvas was most en suite with the lighthearted French approach the king so prized when he was a younger man and before he went in for a grander, more monumental mode.

Veronese's richly illusionistic yet elegantly restrained frescoes provided the perfect pictorial decor for the splendid, rustic villas Andrea Palladio built on the Brenta, making their spaces seem far grander than they really were. Similarly, his ceiling paintings for the Palazzo Ducale in Venice helped that often oppressive palace take on a sense of celebration and harmony seldom present in the chambers themselves. A master of portraiture and of silvery, almost pastel, tonalities, Veronese was one of the first painters whose drawings were also in demand in his lifetime. These highly finished works were sold to collectors already framed and glazed for hanging.

All Veronese's vogueish attributes — his ready turn to a festive surface treatment, his love for beautifully nude blondes — might seem to make this artist an unlikely candidate for tragic devotional subjects, yet just the opposite is true. The painter's images of the Lamentation have a tragic motion all their own. As seen in a *Dead Christ Supported by Two Mourning Angels* (272), one of two in Berlin, they often convey a haunting reminder of a happy world, thereby increasing the pathos of the Passion. This heightened sensibility is achieved by the shocking contrast between flashes of elegantly *changeant* drapery (the angels' suavely tinted attire) and Christ's still-beautiful, abused flesh. Such calculated inconsistency can make suffering far more moving than a more predictable, uniform pall.

Large and grand, lacking only a suitably monumental frame or setting to echo its Palladian archi-

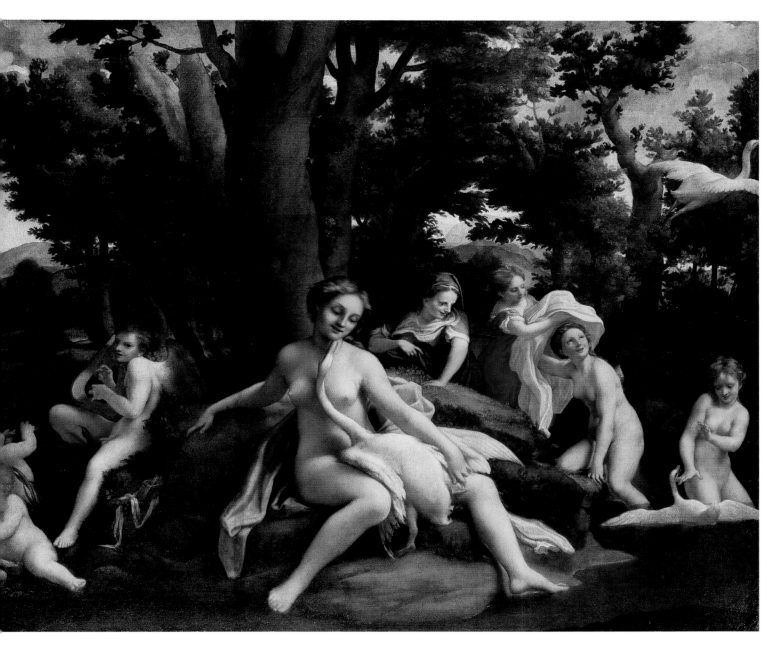

ANTONIO ALLEGRI, CALLED CORREGGIO, Correggio, c. 1489–1534, *Leda and the Swan*, c. 1532

tecture, is a major altarpiece by Paris Bordone (273). Madonna and Child are accompanied by plague saints — Roche, Sebastian, and Catherine of Alexandria — who are shown with the obscure early Christian papal martyr Fabianus. Praised by Vasari, this canvas came from Santa Maria de' Battuti, in Belluno, a church linked to flagellants, a peni- tential group that did good works, including caring for the sick, which relates to their altar's patron saints. The influence of Titian, Bordone's teacher, as well as other earlier Venetian sources — Giorgione and the late monumental altars of Giovanni Bellini — is evident.

PAOLO CALIARI, KNOWN AS VERONESE
Verona, 1528–Venice, 1588
The Dead Christ Supported by Two Mourning Angels, late 1580s

Opposite:
PARIS BORDONE
Treviso, 1500–Venice, 1571
Madonna and Child with SS. Roche, Sebastian,
Catherine of Alexandria, and Fabianus, c. 1535

Splendor and Intimacy:

The Baroque, 1600–1700

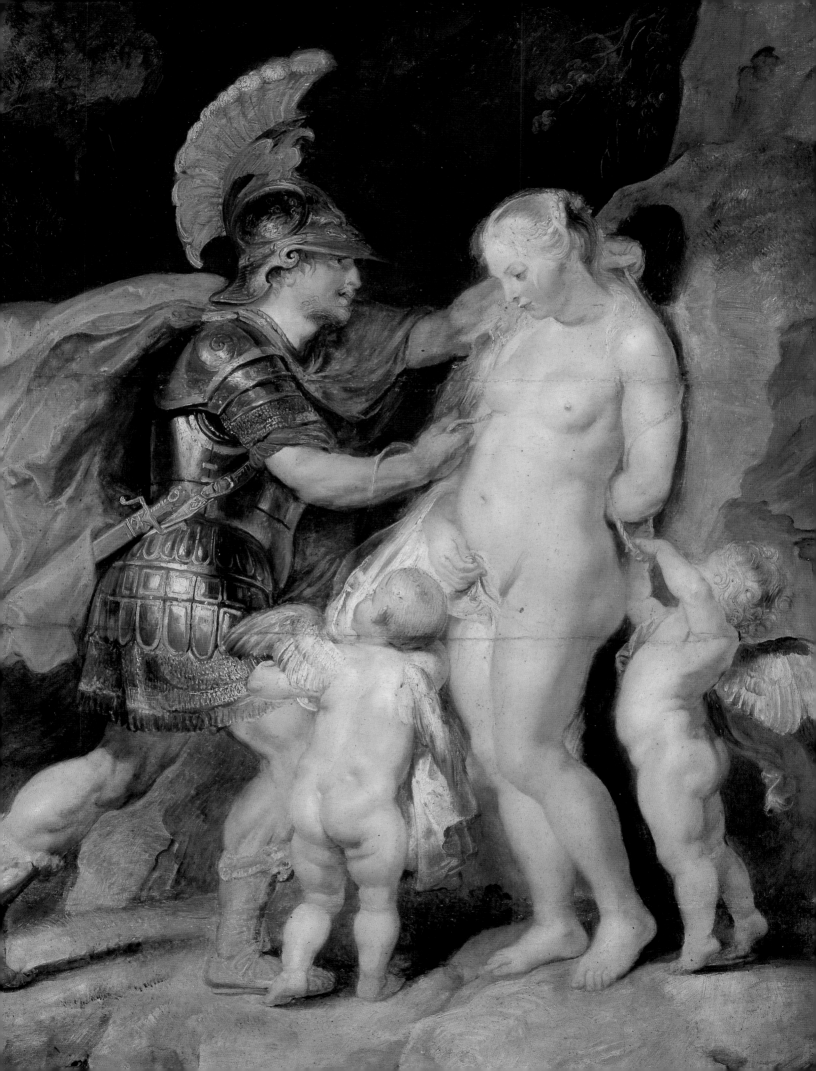

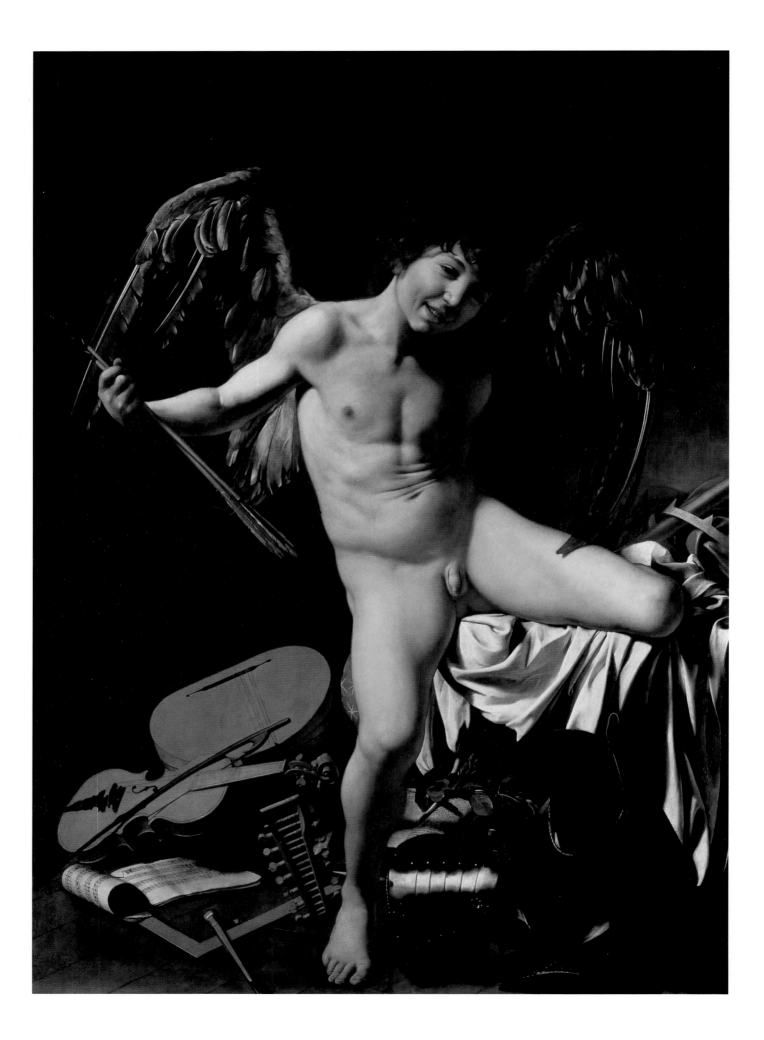

O CARAVAGGIO!

EROTIC themes and sexual images, not necessarily one and the same, have always been central to art. But not before the sixteenth century was painting's canvas sufficiently broad, and the oil technique so widely practiced, as to allow free reign to persuasively life-sized simulacra of all that was sensual throughout Europe.

Suddenly, daringly, the impetus of the corporeal became the here and now, as seen in Giulio Romano's insistently libidinous Mantuan frescoes. Painted for the powerful Gonzaga court, these were much admired by most of Europe's leading art patrons. Few others could take up where he had left off, although the Bolognese, from time to time, certainly succeeded. Only with Michelangelo Merisi, known as Caravaggio, was there a sudden flood of fully realized sexual — especially homoerotic — art. Not since antiquity had "boy art" been realized with such assurance. Its resurgence was largely due to the fact that Caravaggio enjoyed the patronage of the Roman establishment — Cardinal del Monte, the Borghese, and many others connected with the Catholic Church, who were keenly responsive to this genre, both by overture and innuendo.

Flesh, painted so palpably that the canvas seemed pinchable, was furnished with knowing grins and all the rest. Still lifes teemed with suggestive musical instruments along with equally sexual fruit. Close-ups of ecstatic faces and convulsed hands caught in the rich abandon of orgasm never fooled anyone that such goings-on were caused by putative snakebite.

Opposite:
MICHELANGELO MERISI DA CARAVAGGIO, CALLED CARAVAGGIO, Caravaggio, near Bergamo, 1571– Porto Ercole (Tuscany), 1610
Amor Victorious, c. 1602

Caravaggio's art, like Jan van Eyck's Adam and Eve of the *Ghent Altar* (1432), left nothing to the imagination. *Becoming* the imagination, his images almost usurped the libido, as they stimulated and simulated Eros. When this bag of pictorial tricks was unleashed upon religious art, unprecedentedly effective images came to be, entirely in keeping with the drama of the mid-sixteenth-century Counter Reformation. Death, torture, the experience of faith, all assumed stunning actuality. In Caravaggio's hands, articles of devotion became just as potent as his subjects' provocation of sexual desire.

Born near Bergamo in northern Italy, Caravaggio must have learned much from that city's concern for illusionism, particularly the local presence of two of Lorenzo Lotto's (257) strongest works. Equating art and life is a hazardous undertaking. It seldom works. But Caravaggio was indeed gay, violent, and impetuous, close to the shamanistic musicians of our century. In 1606 he had to flee Rome, after he killed a man in a brawl. The last four years of his short life were spent in Spanish territory, working in Naples and Messina, as well as on Malta.

Much art is called "Caravaggesque" because of its dramatic use of artificial illumination, but, in fact, it is actually a continuation of earlier Antwerp currents that were popular throughout Europe. Certain centers, such as Utrecht, with its strong Catholic affiliation, were close to elements from Caravaggio's heritage and genesis alike.

Few nastier, if more effective, images of the triumph of love may ever have been devised than Caravaggio's *Amor Victorious* (276), in which Eros's all-conquering powers initiated the new century with this painting of c. 1602. It is far more incisive for instant carnality than Petrarch's labored and high-toned Trecento literary allegory on which this image is based.

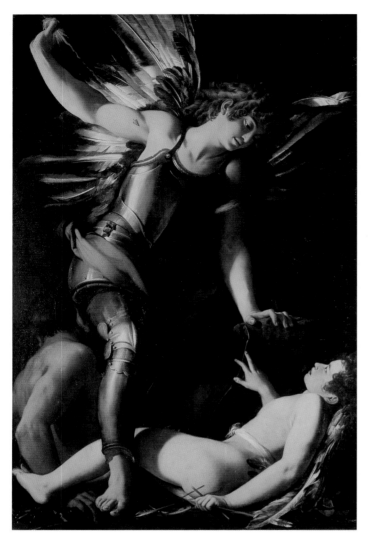

GIOVANNI BAGLIONE, Rome, 1573–1644
The Triumph of Heavenly over Earthly Love, c. 1602–3

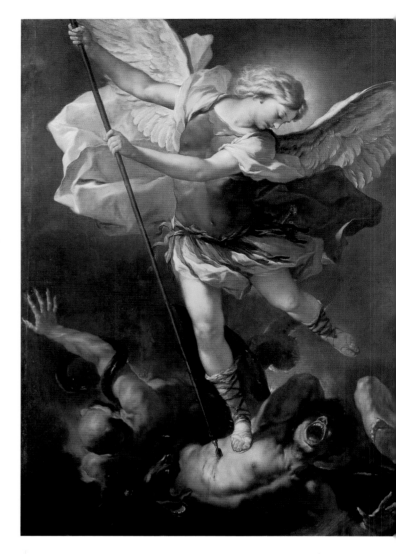

LUCA GIORDANO, Naples, 1634–1705
St. Michael, c. 1663

A naked, Pasoliniesque Roman ragamuffin, great wings stuck to his bare back, wears only a conspiratorial grin as he grasps Cupid's arrows. Seen in proto-pornographic fashion, "shot" against a very dark background, this boy-toy's arms, wings, and legs skewed in swastika-like formation, ready him for any early-seventeenth-century equivalent to a cruising Lambretta or Lancia. An endlessly revolving pinwheel of erotic excitement, Cupid is the source, not the agent, of sexual pleasures.

Painted in equally convincing detail is Eros's still life strung along the bottom of the canvas, a *bas de page* emblematic of the cosmic "All" that is conquered by Virgil's "Love." War, music, architecture, and kingdoms are represented along with a starred

celestial sphere (added later by the artist) suggestively placed just below Cupid's rump to show that even the heavens are vulnerable to Love's arrows.

Marchese Vincenzo Giustiniani, whose massive collection was the basis for so many of Berlin's sixteenth- and seventeenth-century Italian pictures, felt *Amor Victorious* to be his most brilliant canvas. The collector concealed it under a special green curtain, possibly to save the other paintings from unfair bedazzlement, or equally likely, to ensure that this canvas would be seen solely by those who shared his tastes. The curtain was placed there on the advice of Joachim von Sandrart, the German painter who catalogued the Giustiniani brothers' sculpture collection in 1635.

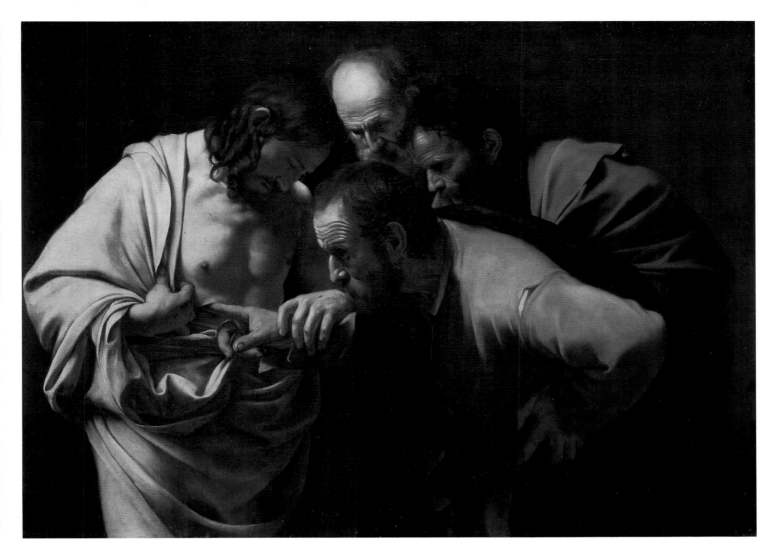

CARAVAGGIO
The Doubting Thomas, c. 1595–1600

Earthly Love gets his comeuppance (or go-downance) from Heavenly Love in *The Triumph of Heavenly over Earthly Love* (278), by Giovanni Baglione, which was ordered by Cardinal Benedetto Giustiniani as a pendant to Caravaggio's canvas. Caravaggio complained about this painting, faulting it for the characterization of Amor, who was initially painted as a tall, armed man but thereupon changed by Baglione to a nude figure. This Roman painter sued Caravaggio in 1603 for having circulated obscene satires about him. He also wrote *The Lives of Painters, Sculptors, and Architects*, which was printed in Rome in 1642 and is a major source of biographical information about the city's art in the first half of the seventeenth century.

Berlin's grandest devotional Caravaggio is *The Doubting Thomas* (279) of c. 1595–1600. Perfectly suited to the artist's skills and character, the subject tells of, by, and through men's bodies how the apostle assured himself of the actuality of the resurrected Christ. Drawing back his enveloping attire — somewhere between a shroud and a toga — Christ bares his breast with his right hand, grasping Thomas's wrist with his left to guide the doubter's erect index finger to the lancewound. Cut down in appearance (if not in fact), the canvas's characters stop precipitously just above the knee, so lending a quality of bearing down and into the scene, as if a zoom lens had focused in radical fashion upon what counted most in a dramatically lit

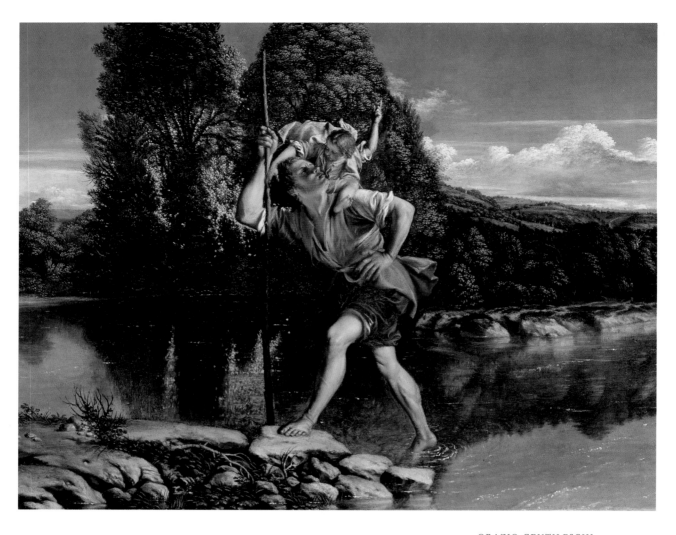

ORAZIO GENTILESCHI
Pisa, 1563–London, 1639
Landscape with St. Christopher,
c. 1605–10

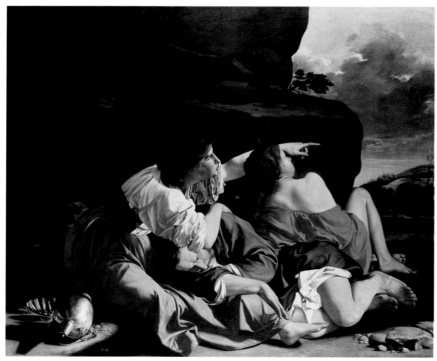

ORAZIO GENTILESCHI
Lot and His Daughters, c. 1622–23

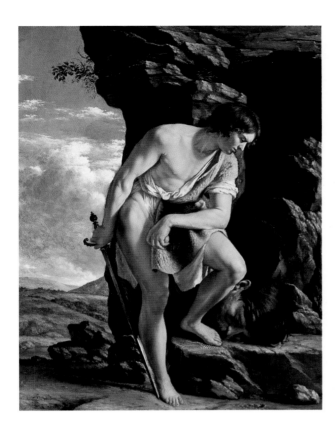

ORAZIO GENTILESCHI
David with the Head of Goliath, c. 1610

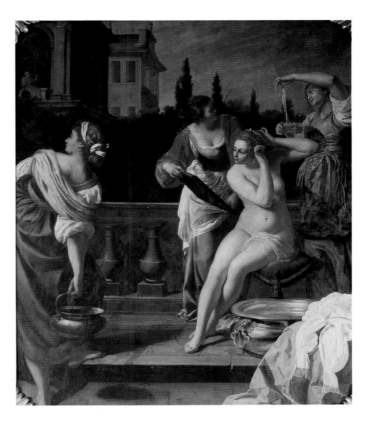

ARTEMISIA GENTILESCHI, Rome, c. 1597–Naples, after 1651
Bathsheba

close-up screened for immediacy.

Caravaggio's most sensitive and original Italian follower was Orazio Gentileschi, a Pisan who knew the artist well. He perfected his own startlingly realistic approach to space, luminism, and drama as seen in a *Landscape with St. Christopher* of c. 1605–10 (*280*) and *David with the Head of Goliath* of c. 1610 (*281*), both painted on copper, and *Lot and His Daughters* of c. 1622–23 (*280*). The subject of David and Goliath was one close to Gentileschi, who painted it several times. His daughter Artemisia worked along bolder, larger lines, as seen in her *Bathsheba* (*281*). Luca Giordano, like Caravaggio in Naples, continued the latter's manner but in almost Rococo fashion, as can be seen in his *St. Michael* (*278*).

Jettisoning decorum for experience, dumping Mannerism and Classicism for instantaneity, the artist's achievements won Caravaggio great fame by 1603, when the Haarlem painter and writer Carel van Mander noted, "He is doing extraordinary things in Rome."

By the 1620s both Caravaggio's *Death of the Virgin*

(Paris, Louvre) and his equally monumental *Madonna of the Rosary* (Vienna, Kunsthistorisches Museum) had been brought by Flemish artists to northern Europe, soon entering leading court collections. So the painter's dramatic achievements were soon known even to those artists like Rembrandt who never went to Italy. Caravaggio's rustic, impolite perspective conformed with previous traditions that were especially popular in Utrecht. Pre-Caravaggist artists like Antwerp's Pieter Aertsen already showed an approach close to the Italian's. An anonymous North German's large *Parable of the Unfaithful Servant* (*282*) shows how aspects of independent "Caravaggism" appear in a panel for a courthouse combining scenes of crime and punishment.

In Utrecht, Dirck van Baburen's broadly narrative *Christ Washing the Apostles' Feet* (*282*) typifies that school's more formulaic, stagey approach. St. Peter's pose, as he protests that Christ should not lower himself to such a humble role, anticipates the violently active figures Bernini sculpted on some of his Roman fountain bases.

Splendor and Intimacy: The Baroque, 1600–1700 281

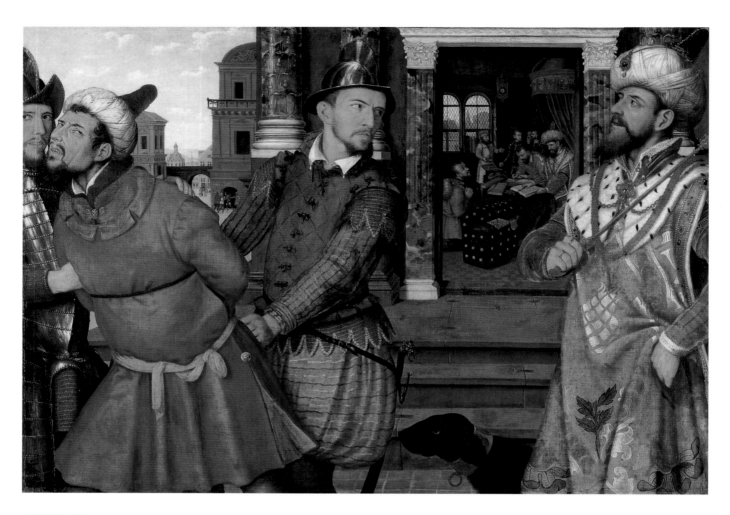

ANONYMOUS
North German
*Parable of the
Unfaithful Servant*,
c. 1560

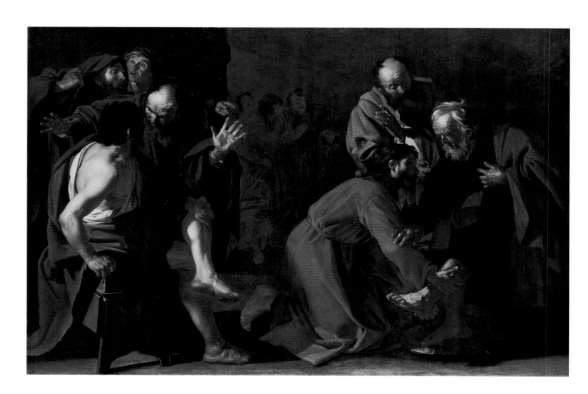

DIRCK VAN BABUREN
Utrecht, c. 1595–1624
*Christ Washing the
Apostles' Feet*, c. 1616

JOHANN LISS, Oldenburg (Holstein), c. 1597–Verona, 1631
The Ecstasy of St. Paul, c. 1628–29

Other Utrecht painters display far more subtle, individualized attitudes. Matthias Stomer's late works of the later 1630s — such as that of barren old Sarah bringing her toothsome maid Hagar to a wary, elderly Abraham so that husband and servant can produce a son (284) — exemplify his choice of sordid and all too human biblical subjects. Their popularity in the Lowlands points to the intimate, tolerant association of artist, patron, and society with the worst as well as the best of the Chosen People, who were appropriated by the Dutch for their very own spiritual ancestors, and were cherished as much for their vices as their virtues to bring them close to home.

A similar sense of Baroque drama is found in Gerrit van Honthorst's *Liberation of St. Peter* (284). So beloved for his nocturnes that Italians called him "Gherardo della Notte," the Utrecht artist made Peter's liberating angel into a light source, so illuminating the dank prison by a celestial blaze.

Hendrick TerBrugghen has his own deftly, subtly colored way of dealing with biblical and genre sub-jects, seen in *The Supper at Emmaus* (285). An early work, it is inspired by a Bassano composition. The Dutch master painted an *Esau Selling His Birthright* (285) in the 1620s. TerBrugghen departed in varying ways from Caravaggio's manner to evolve his own. Rubens's discerning eye found TerBrugghen to be Utrecht's "only painter" during his journey there in 1627. As usual, he was probably right.

Two little-known Caravaggist German painters were active in Venice. *The Ecstasy of St. Paul* (283), painted by Johann Liss c. 1628–29, takes its subject from II Corinthians 12:2–4. The saint is surrounded by his books, gazing up in astonishment as the heavens open, presenting a vision of the Trinity. Johann Carl Loth assumed aspects of Caravaggism in the *Apollo, Pan, and Marsyas* (283). This image is filtered through North Italian sources, adding a more delicately movemented touch.

If the taste for the Italian artist's oeuvre has fluctuated over nearly four centuries, his sense for the drama of light upon the body has always justified Caravaggio's Christian name — Michelangelo — that artist's character in so many ways close to the later painter's.

JOHANN CARL LOTH, Munich, 1632–Venice, 1698
Apollo, Pan, and Marsyas

MATTHIAS STOMER
Amersfoort, 1600–
Sicily, after 1641
*Sarah Leading Hagar to
Abraham*

GERRIT VAN HONTHORST
Utrecht, 1590–1656
The Liberation of St. Peter

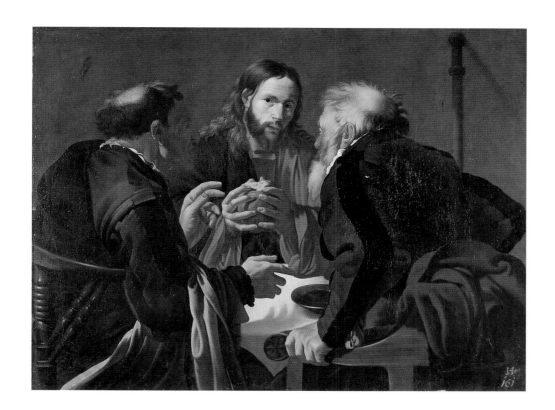

HENDRICK TERBRUGGHEN
Deventer, 1588–Utrecht, 1629
The Supper at Emmaus, c. 1621

Below:
HENDRICK TERBRUGGHEN
Esau Selling His Birthright,
c. 1625

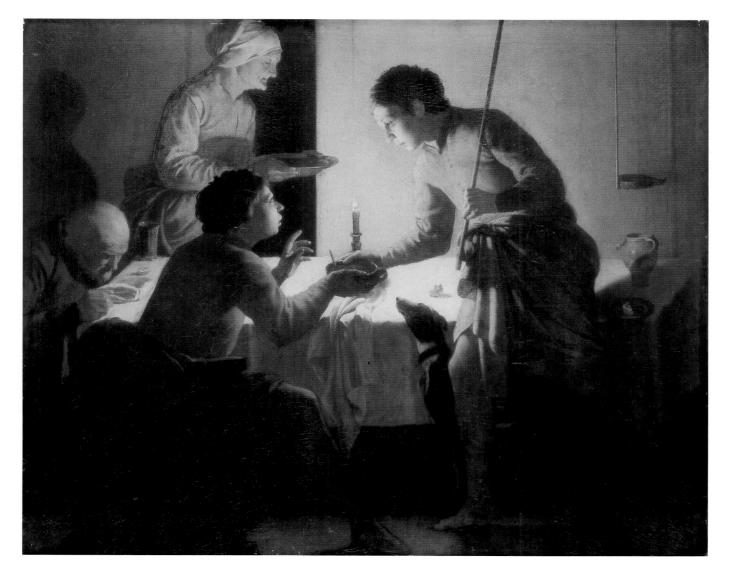

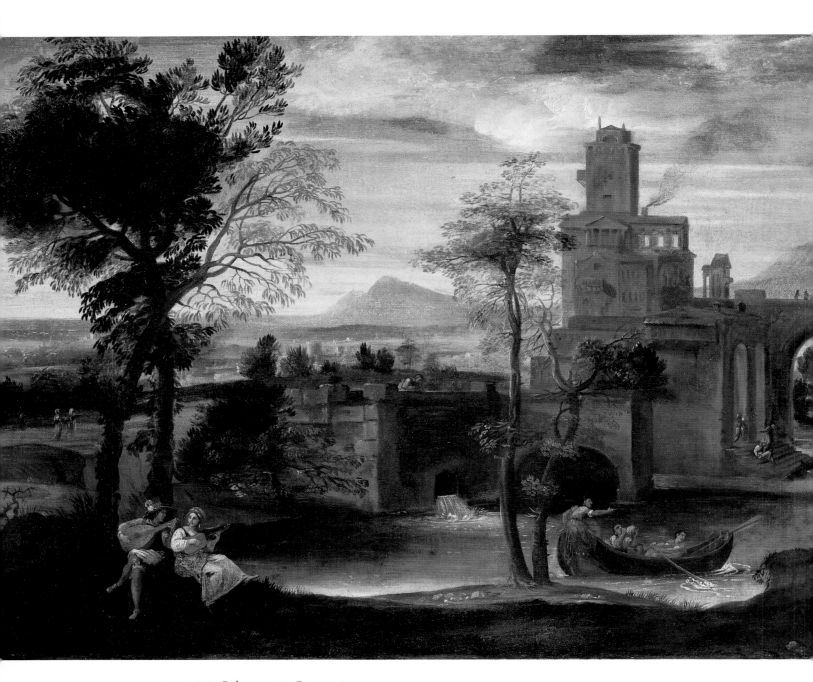

ANNIBALE CARRACCI, Bologna, 1560–Rome, 1609
Roman River Landscape with Castle and Bridge, c. 1600

A ROMANTIC *Roman River Landscape with Castle and Bridge* (286–87) by Annibale Carracci, dating from c. 1600, came with the Giustiniani collection and may have been painted for the Palazetto Farnese when the painter arrived in Rome. What is possibly Berlin's major independently purchased Italian Baroque acquisition, a *Christ Served by Angels in the Wilderness* (288) of c. 1608–10, was painted by the Bolognese master's brother Ludovico. Its androgynous, Correggiesque key participant imbues this canvas with a compelling fusion of pietism and eroticism.

A grand, Bernini-like painting by Guido Reni — *The Death of Cleopatra* (288), c. 1625–30 (and enlarged at top and bottom at a later date) — was probably bought by Frederick the Great a year before the completion of his picture gallery at Sanssouci. Such voluntary snuff art was ever a best-seller, and Reni is known to have painted at least three other versions of the Egyptian queen's ecstatic demise.

Salvator Rosa was quirky and original, as well-known for his writing as for his painting. He was among the most popular painters of the eighteenth and nineteenth centuries, when his literary, picturesque approach affirmed the latest art theories. *Pythagoras and the Fisherman* (289) — one of two canvases from the life of the philosopher (the other is in the Kimball Art Museum, Fort Worth) — shows what a fine colorist and dramatist Rosa could be when painting at his best.

Surprisingly, Berlin lacks a monumental work by the Bolognese master Guercino, but an early, very beautiful *Mystical Marriage of St. Catherine of Alexandria* of 1620 (289) shows that artist in a little-known, almost eighteenth-century light. This work came from Sir Denis Mahon's prize collection, largely devoted to, and key to, the rediscovery of Guercino.

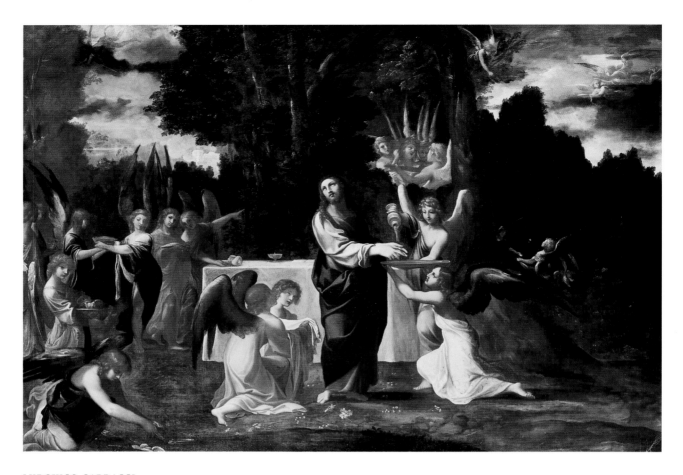

LUDOVICO CARRACCI
Bologna, 1555–1619
Christ Served by Angels in the Wilderness,
c. 1608–10

GUIDO RENI
Bologna, 1575–1642
The Death of Cleopatra, c. 1625–30

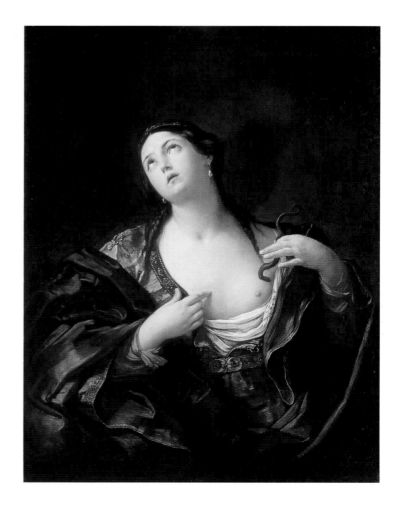

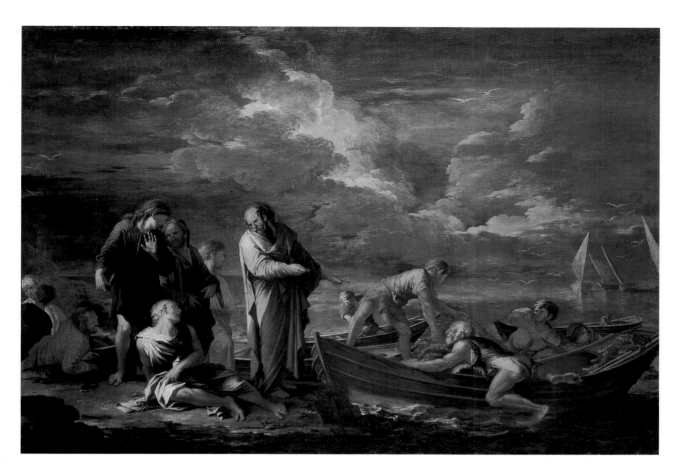

SALVATOR ROSA
Naples, 1615–Rome, 1673
Pythagoras and the Fisherman, 1662

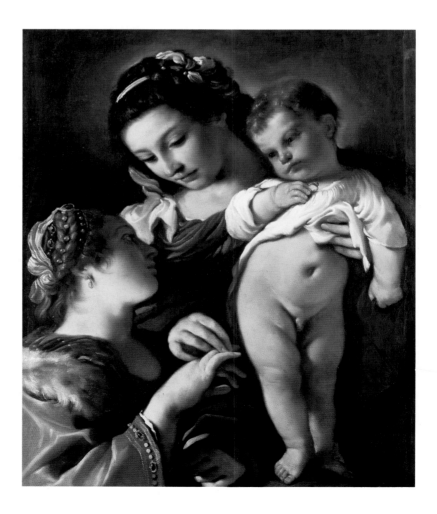

GIOVANNI FRANCESCO BARBIERI,
CALLED GUERCINO
Cento, 1591–Bologna, 1666
*The Mystical Marriage of St. Catherine of
Alexandria*, 1620

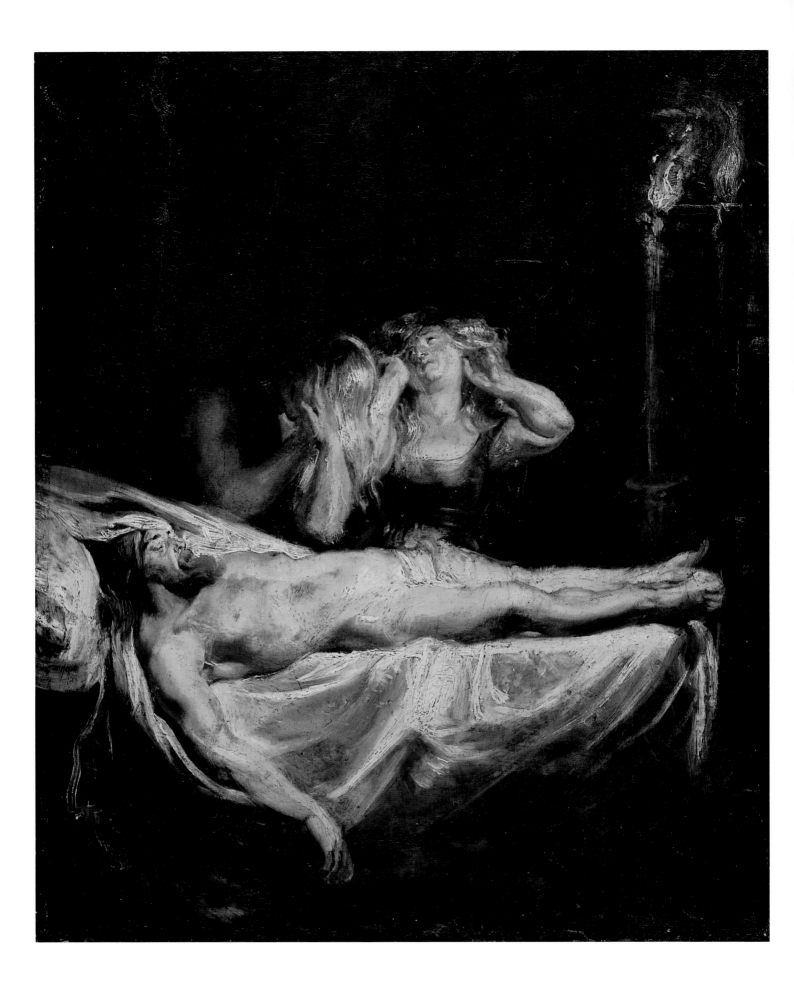

RUBENS, PRINCE OF PAINTERS

BEFORE Rubens, no Western artist of equally great talent had been as well born, as well educated, as well mothered, as well placed, or as widely and powerfully patronized. His father, a Protestant lawyer, left Antwerp for Westphalia to escape persecution. There Peter Paul was born and baptized a Calvinist; then his parents separated. Mother and son returned to Antwerp, where he was humanistically schooled, rebaptized a Roman Catholic, and soon became a page at a neighboring court.

The first key Flemish apostle of Renaissance grandeur had been the far earlier Antwerp master Frans Floris (153), and Rubens doubtless turned to his achievements for initial guidance. In Antwerp, young Rubens received three successive apprenticeships with local artists: Adam van Noort, Tobias Verhaecht, and the superior Italianate painter Otto van Veen. Rubens stayed with the latter until his first journey to Italy in 1600, where he remained until 1608.

Among major painters, only Giorgio Vasari, Sir Joshua Reynolds, and Eugène Delacroix may have known as much about art and its history as Rubens did. Significantly, both the English and the French master placed the Fleming among their very favorites, each having been deeply influenced by Rubens's re-creation of the visual triumphs of Renaissance Venice, Mantua, and Rome, along with those of classical antiquity. Despite great erudition Rubens retained his individuality throughout a long and vastly productive career, for, above all, he was a supreme master of the imagination.

Young Rubens traveled widely. In Mantua he was attached to the court of Vincenzo Gonzaga, then sent throughout Italy to paint copies for him, and voyaged to Spain in 1603–4 with gifts from Vincenzo to Philip III. The young artist's other major Italian patronage and study areas were Genoa and Rome, where he was close to the art of the Carracci.

Due to his later appointments to the courts of the Infanta Isabella and the Archduke Ferdinand, Spanish viceroys of the Netherlands, Charles I in England, Marie de' Médicis in France, and Philip IV in Spain, much of Rubens's life was spent "on the road" or in preparing works for export. He also fulfilled massive commissions for leaders of the church and state in Italy, Austria, and Germany, causing him to observe in 1621, "My talents are such that I have never lacked courage to undertake any design, however vast in size or diversified in subject." Among the keenest admirers of Italian and antique achievements, Rubens also remembered earlier Netherlandish art with its glowing textures, gleaming flesh, and vibrant color harmonies.

This painter possessed of protean gifts proved to be an effective ambassador, scholar, courtier, humanist, lover and family man, classicist, architect, knight, numismatist, collector of antiquities, print designer, agent-connoisseur-adviser, pageant master, and fervent Roman Catholic. Equipped with rare energy, he would be up by 4:00 A.M. and could paint while dictating a letter and carrying on a conversation with a visitor, all at the same time. The artist was blessed with rare gifts of organization and a sense for realism and idealism. Rubens's creative, inventive response to conservative theology and to classical values validated the vast pictorial cycles demanded by his patrons. These filled Antwerp's new Jesuit church and Charles I's new banqueting hall ceiling at Whitehall. Twenty-four huge canvases of Marie de' Médicis's *Life* were

Opposite:
PETER PAUL RUBENS
Siegen, 1577–Antwerp, 1640
The Lamentation, c. 1609–11

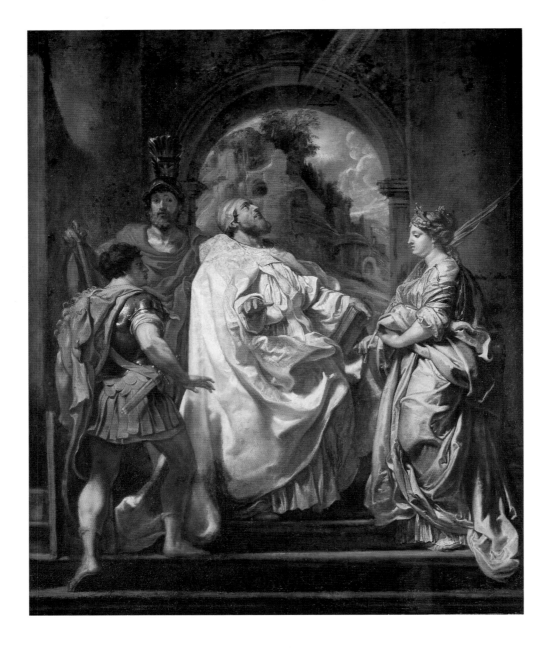

painted for the Palais du Luxembourg, and Philip IV's Torre de la Parada contained 112 mythological subjects designed by Rubens that were largely executed by his colleagues. The dramas of splendid triumphal entries and eucharistic events were celebrated with sketches, etchings, and tapestries as well as vast paintings, for Rubens possessed an unrivaled capacity for commemorating occasion and institution. Affirmation lies at the center of his art; he could accord as much grandeur to the celebration of Flemish peasant life as to the splendor of Marie de' Médicis's Parisian court.

He was that rarest of phenomena, at once a popular painter *and* an artist's artist, as close to Con-

stable, Delacroix, or Renoir as to the painters of his own day. A handsome man, gracefully mannered, with beautiful wives and children, Rubens enjoyed harmony's enviable balance of opposites. While he was profoundly romantic, he was equally rooted in the classical tradition; his Roman Catholic orthodoxy never conflicted with his passion for antiquity. Venus and Virgin are almost interchangeable in the Fleming's art.

Rubens was a leading citizen of Europe's Roman Catholic world, and spoke fluent French, German, Italian, Latin, and Spanish, making him ideally suited to the ambassadorial role given him by the Infanta. As court painter to Ferdinand and Isabella,

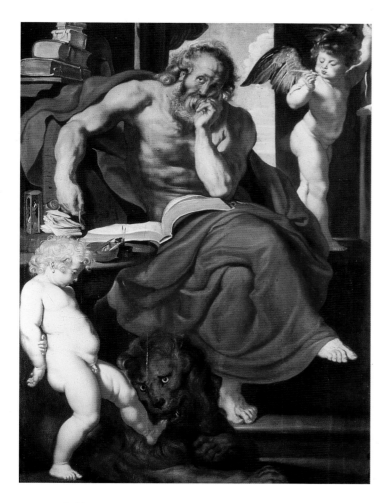

PETER PAUL RUBENS
St. Jerome in His Hermitage, 1608–9

and Daniel Seghers. His status as court painter freed Rubens from registering assistants with the guild, paying taxes, or subscribing to guild rules, all of which contributed to his prosperity.

Predictably, most great Rubens collections remain in or near those noble Catholic houses and religious institutions that gave him major patronage. Prussia is the exception proving this rule; its Protestant monarchy acquired his works posthumously. Berlin's taste for Rubens's art was continued by the city's nineteenth-century collectors and curators, who were among the Fleming's greatest enthusiasts. So the capital can claim one of the world's most varied gatherings of his works, rivaling those of Paris, London, Madrid, Munich, and Vienna. And Berlin's splendidly representative collection of Rubens's oeuvre would have been greater still had eight canvases not burned in the Flakturm fire, including three magnificent works — *The Conversion of St. Paul, Neptune and Amphitrite*, and the *Bath of Diana*. Though the urban museum collection is now reunited, Rubens's canvases at Potsdam, many of which have been there since the eighteenth century, will remain in situ.

First of Berlin's major pictures by Rubens is the *SS. Gregory, Maurus, Papianus, and Domitilla* (292), a canvas that ranks among his most important early works. Sketched c. 1606, it is for an altarpiece at the Roman church of Santa Maria in Vallicella (Chiesa Nuova) and was painted when the artist was twenty-nine. Another, more elaborate, version is in Grenoble (Musée des Beaux-Arts), while the final picture is in the church for which it was painted. Though drawn from many sixteenth-century Italian sources, the originality of this work, not its eclecticism, is what matters. The full-blown central form and venturesome sculptural drapery betray an explosive young talent, a pictorial forerunner of Bernini's marbles and *modelli*.

With the possible exception of Sir Thomas Lawrence, no major painter was a child prodigy, which is brought to mind by Rubens's early *St. Jerome in His Hermitage* (293). Painted in Rome in 1608 or upon the young artist's return to Antwerp the next year, it shows his naive dependence upon a Michelangelesque source, turning the Sistine Ceiling's admittedly androgynous *Erythrean Sibyl* into

Rubens lived with recent memories of religious wars and iconoclasm, of fierce local resistance to the Habsburg empire. The result was that his art often served the neo-orthodoxy of his patrons and that of the Jesuit and other Catholic Orders.

The Fleming was a shrewd judge of character and talent, and maintained a large, efficient, successful atelier in his little palace of an Antwerp townhouse. Innumerable "Rubenses" that began with his design and ended with a few of his brushstrokes artfully placed where they counted most streamed from Rubens's very profitable workshop. The artist was also active in collaboration with men like "Velvet" Brueghel, Anthony van Dyck, Frans Snyders,

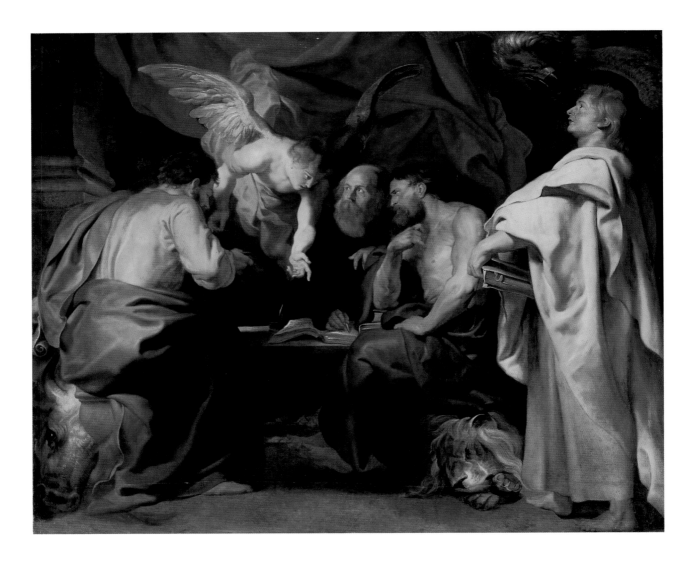

the Church Father — an unhappy notion from every viewpoint.

Pure dynamite, a very small, nocturnal *Lamentation* (291) of c. 1609–11 seems more like the work of Géricault than Rubens in its violent carnality, which probably stems from both artists' concern for Caravaggio. Possibly executed in Italy, it did not leave there prior to Berlin's purchase from the Demidoff Collection in Florence. Recalling a French Renaissance royal *gisant*, the robust, naked dead Christ could not be less ascetic. A Venus mourning her middle-aged Adonis, this Mary is as unlikely a virgin as the maenad alongside is a Magdalen. Magnificently unconventional, this shocking little tableau is one that Rubens, understandably, may never have developed in larger format — who would have bought it?

Still Italianate, reminiscent of Giovanni Lan-

franco, Federico Barocci, and Caravaggio, is an ebullient *Sacra Conversazione* among the Four Evangelists (294), each gospel writer shown with his attribute. For all its spiritual excitement, Rubens's canvas manages to communicate a sense of divine business as usual, uninterrupted by the majestic flourishes of drapery and the almost intrusive presence of Matthew's inspiring angel. The painter's knowledge of ancient Roman portrayals of philosophers informs this dramatic canvas with unusual plausibility. It may date as early as 1614, just when Rubens was getting all his Italian sources together — classical, Renaissance, and sixteenth-century — and adding his own tincture of Northern bravura technique and luminosity.

Berlin also lost all of its fine works by Jacob Jordaens in the Flakturm fire, but a *Return of the Holy Family from Egypt* (295), painted c. 1616 and

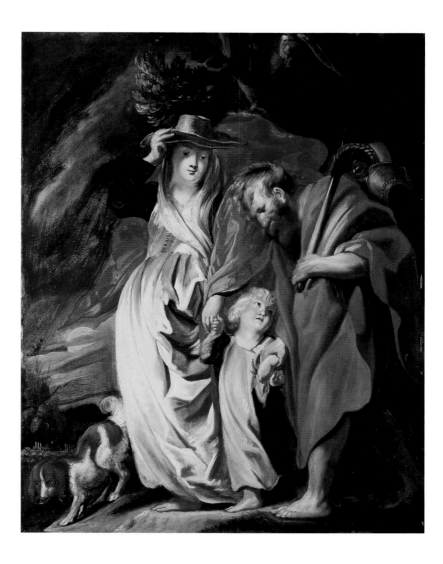

bought in 1957, shows that Antwerp master also working after Barocci, with a new freedom of color and brushwork.

Rubens's talents had fully matured by 1618, about the year he painted *St. Sebastian* (296). Here classical concepts of ideal beauty are tempered by enlivening individuality, the martyr's features a little like the artist's. Clearly Rubens has not forgotten Michelangelo's marble *Slaves*, two of them already long in France, nor the art of antiquity, since he modeled the saint's head upon a celebrated Hellenistic bust of the *Dying Alexander* (Uffizi). This marble was used to show artists an *"exemplum doloris"* — an effective example of the tragic extremes of pain and sorrow.

At forty-one, Rubens had become a free agent, very much his own man at last. Having assimilated whatever he wanted, he was quite rightly pleased

with his splendid *St. Sebastian*. In 1618 he wrote of it to Sir Dudley Carlton (friend and adviser to Britain's Charles I, and his ambassador to The Hague) as a "naked Saint Sebastian entirely by my own hand," which he kept at home "for his own pleasure." The artist would only part with it, along with other canvases, in exchange for coveted antiquities owned by the English connoisseur, doubtless a fair exchange.

A *Perseus Liberating Andromeda* of 1622 (297) is close to an earlier version in the Hermitage (St. Petersburg). Horizontal in format, Berlin's allows Rubens — among the greatest *animaliers* — to do full justice to the winged steed Pegasus in a placid scene lacking the Titianesque *poesie* of another, later, version, also in Berlin (300). Boucher-like, a chubby, nude Andromeda may have appealed to Frederick the Great's Frenchified taste: he bought this canvas for Sanssouci. As is so often the case,

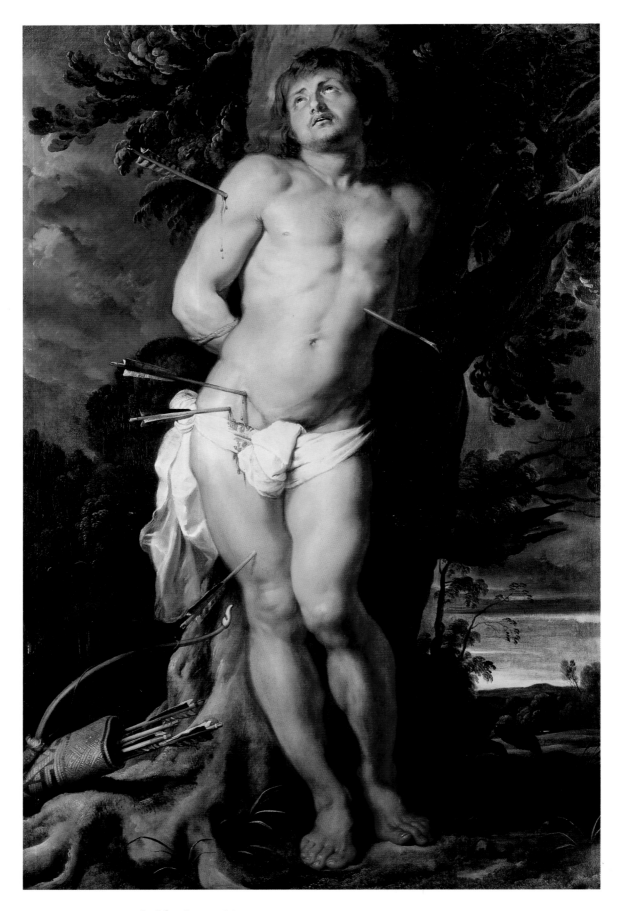

PETER PAUL RUBENS, *St. Sebastian*, c. 1618

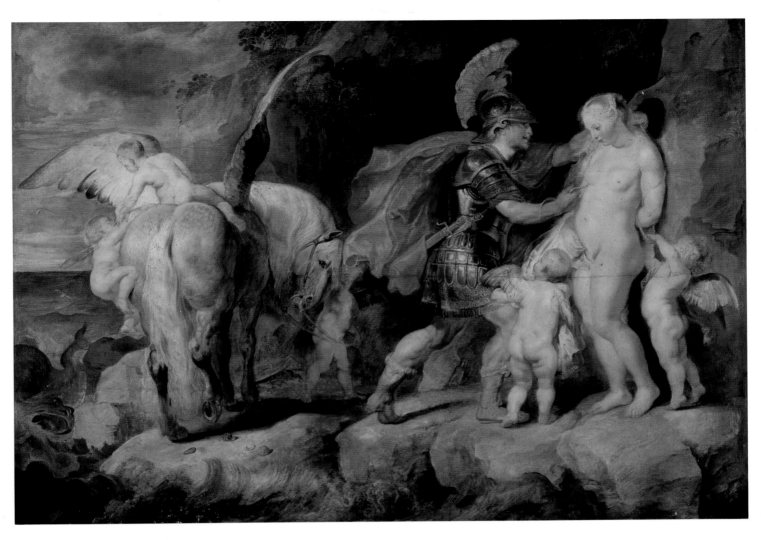

PETER PAUL RUBENS, *Perseus Liberating Andromeda*, 1622

Rubens turned to antique statuary. His figure source was the *Venus Felix* (Vatican). Andromeda, daughter of the king of Ethiopia, was to have been sacrificed to a sea monster but was rescued from this fate by Perseus, who, happily, was just on his way home from having slain the dreaded Medusa. As he strides toward her, cutting her chains, our hero's full armor and Andromeda's nubile nudity create a cheerily erotic contrast of steel and bondage.

For all his modernity, Rubens often worked very much like a late-Medieval Northern master, either by employing assistants or by acting in collaboration with independent masters. This cooperation is found in his conventional, if not archaic, *Madonna and Child* (302), c. 1624–25, where flowers, book, still life, carpet, background, and Mary's dress may well be the work of several studio specialists, each highly skilled in his respective, realistic field.

A large sketch of the *Madonna and Child Enthroned with Saints* (298), c. 1627–28, presents a saintly extravaganza of a *Sacra Conversazione*, including even one more worthy than the popular medieval Fourteen Holy Helpers. Here Rubens evidences his Venice-inspired powers of choreography, working these saints into an architecturally plausible context. This is one of two *modelli* for the altar in Antwerp's Augustinian church. St. Augustine, the church father, is seen in the foreground holding a heart, symbol of Divine Love.

Sanssouci's sketch of *Music-Making Angels* (299) has been the subject of almost endless dispute among Rubens mavens; their most recent conclusion places it as part of a tapestry project, probably for the *Triumph of the Eucharist* woven for the

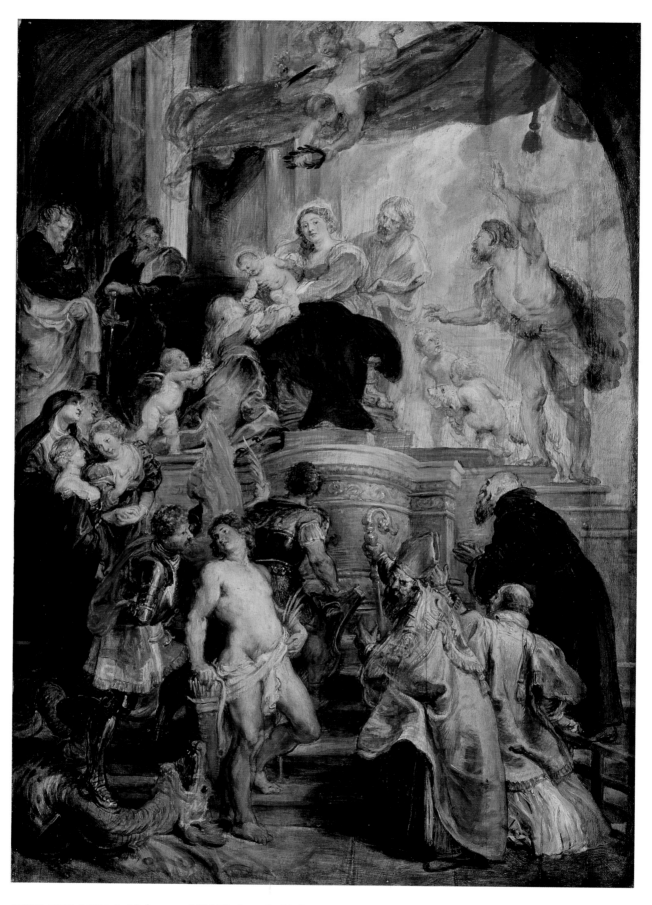

PETER PAUL RUBENS, *Madonna and Child Enthroned with Saints*, c. 1627–28

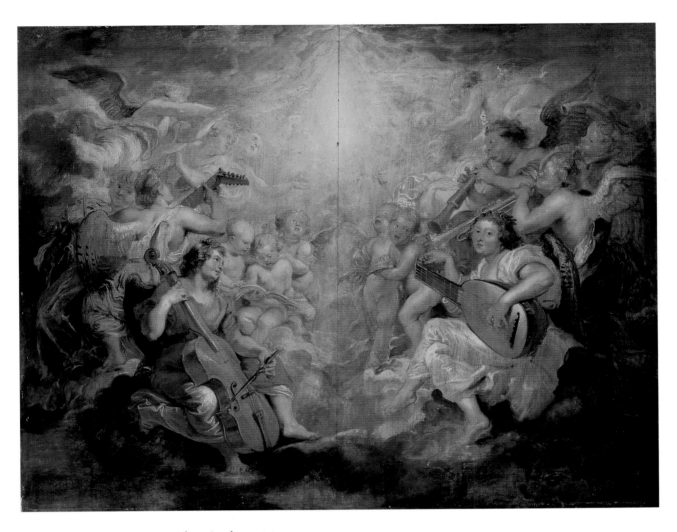

PETER PAUL RUBENS, *Music-Making Angels*, c. 1628

Madrid convent of the Poor Clares, which was ordered by the Archduchess Isabella Clara Eugenia and delivered in 1628. About 1638, the Fleming returned to the vertical composition employed twenty years earlier in the *St. Sebastian* for a weeping *Andromeda* (300), whose subject is about to be freed from her chains by Perseus, seen riding Pegasus to her rescue. Here is the mature Rubens, very possibly Titian's wisest follower, at his ripest as radiant colorist, a glorious rainbow of hues at his command. Echoes of past achievements and presagings of future freedoms illuminate this vibrant image, one that still suggests a sketch in its seemingly spontaneous generation.

As Mantuan court painter, young Rubens copied many Correggio paintings of mythological subjects whose tender eroticism lights up the Fleming's *Andromeda*. Though her glowingly full-bodied presence is in chains, she conveys a vibrant sense of potential motion that lies somewhere between Lady Hamilton's Romantic re-creations of classical poses and the passionate abandon of the choreography devised by Isadora Duncan to express the Sturm und Drang of the dancer's emotions.

Painted with an authoritative freedom Renoir could (and did) envy, Rubens's *St. Cecilia* (301) dates from c. 1639–40, a time marked by the artist's rejuvenation, when he was invigorated by a beautiful second family from his much younger wife, Hélène Fourment, here posing as the patron saint of sacred music. Cecilia is surrounded by *amorini* emblematic of divinely inspired sound; her harpsichord is supported by sphinxes of eternal wisdom. Whether Cecilia has kicked off her sandals because she is on holy ground or simply for creative comfort is up to you to decide. Rubens kept this panel for himself.

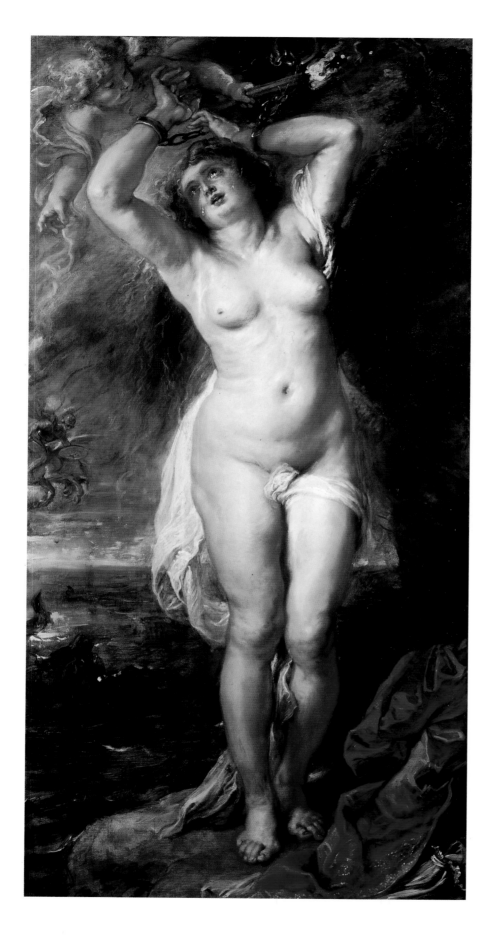

PETER PAUL RUBENS
Andromeda, c. 1638

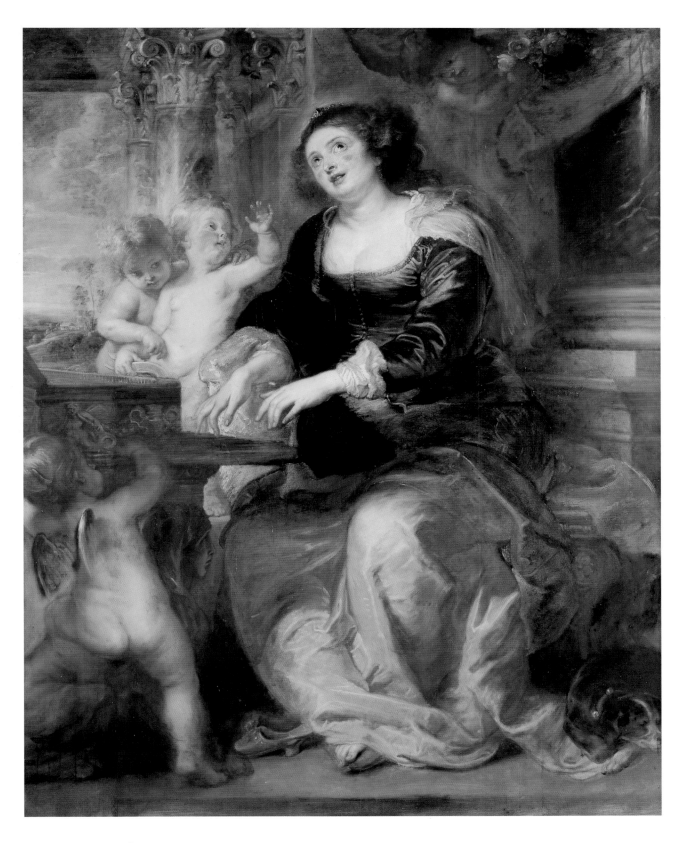

PETER PAUL RUBENS
St. Cecilia, c. 1639–40

PETER PAUL RUBENS
Madonna and Child, c. 1624–25

PETER PAUL RUBENS
Isabella Brant (?), c. 1626

When it came to Paris it became a subject for draw-ings by Watteau. Logically, Frederick the Great, that passionate admirer of Watteau's art, bought this painting in 1757 to add to the treasures in his picture gallery at Sanssouci.

Sketched for familial enjoyment, Rubens's *Infant with a Bird* (*303*) may be of his godson Philip, born in 1611, son of his beloved, deceased brother; or it may depict Rubens's oldest son Albert, who was born in 1614. In either case, the painter returned to an earlier image to paint this one in the mid-1620s. It suggests a speed of execution equal to the flight of the infant's bird. Intimately, lovingly observed, this rendering is a reminder that the Fleming is Hals's contemporary and often shares a similar sense of spontaneity. The theme of the baby Jesus with a bird is medieval, used by Dürer (*112*).

The artist's first wife, Isabella Brant, may be the

subject of a portrait of about 1626 (*302*), the year of her early death. Its bold red background typifies Rubens's self-imposed pictorial challenges, trusting that his elegiac, posthumous image, with its mas-sively enlarged eyes and strong yet graceful hands, could and would win out over the regally demand-ing, flaming color.

Few artists can claim equal success as landscape and figure painters, but Rubens is among them, an early master of the romantic vista. This is evi-denced by his dramatic *Landscape with the Shipwreck of St. Paul* (*304–5*), c. 1620. Here, as in the second version of the *Perseus Liberating Andromeda* (*297*), the surface has a novel, almost Impressionist, sense of freedom, a sketchlike quality of working outdoors, not in the studio.

Large, and far more formal, is the *Landscape with Cows and Duck Hunters* (*307*) of c. 1635–38, among the

PETER PAUL RUBENS
Infant with a Bird,
c. 1624–25

artist's most dazzling syntheses of Virgilian and
contemporary rustic realities. Such scenes proved
essential to the British landscape tradition. This
large canvas, bought for Berlin from the duke of
Devonshire in 1927, has an unusually distinguished
provenance. Acquired from the duc de Richelieu by
Lord Cavendish, it was then bequeathed to the earl
of Burlington after 1815. It is one of three such
scenes and was well-known to Waagen from his
organization of the "Art Treasures" exhibition in
Manchester. Berlin's canvas contributed to Con-
stable's view that "in no branch of the art is Rubens
greater than in landscape."

Adriaen Brouwer, a Fleming who worked with
Hals in Haarlem, later went on to Antwerp, where
he was much admired by Rubens, who collected
many of his coarse, uncompromising scenes of
peasant life. Surprisingly, Brouwer's landscapes can
have an almost Romantic quality, not that far from
those of Rubens but sketchier and more in the mod-
ern manner, as in the *Dune Landscape by Moonlight*
(*306*).

PETER PAUL RUBENS, *Landscape with the Shipwreck of St. Paul*, c. 1620

ADRIAEN BROUWER
Oudenaarde, 1605/6–Antwerp, 1638
Dune Landscape by Moonlight, c. 1635–37

PETER PAUL RUBENS
Landscape with Cows and Duck Hunters, c. 1635–38

DISTINCTION AND FINESSE: THE ART OF VAN DYCK

FEW PAINTERS can combine remarkable delicacy and resilience of touch with authority and even excitement. Anthony van Dyck is one who does. His talents were recognized early on, after his studies with Hendrik van Balen. He went on to work more as partner than apprentice in Rubens's large Antwerp studio. Like his senior colleague, van Dyck received major commissions all over Europe — in Italy, especially Genoa, Paris, and at the courts of Brussels and Great Britain. There he followed Rubens in receiving a knighthood, and died during the plague.

Berlin has splendid examples of van Dyck's two major skills: his gift for singularly expressive religious imagery whose classical quality never obscures a special sense of present engagement; and his better-known genius for portraiture of rare elegance and profundity, particularly from his Genoese period (1622–25). Three of the latter include portraits of an aristocratic elderly Genoese couple (310–11) and another of the Marchesa Geronima Spinola (309).

Whether by use of an adroit pose, an emphasis upon beautiful hands or dramatically placed Venetian architectural elements, a curtain, or a vista, the painter endows his subjects with seemingly intrinsic, authentic social significance beyond mere affluence or too conspicuous consumption. Van Dyck's

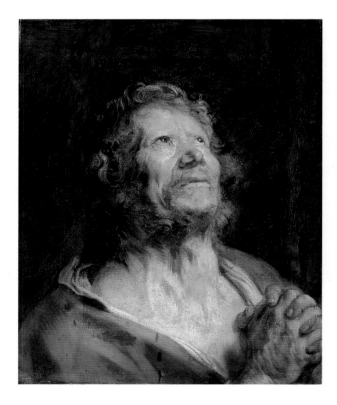

ANTHONY VAN DYCK, Antwerp, 1599–London, 1641
An Apostle with Folded Hands, c. 1618–20

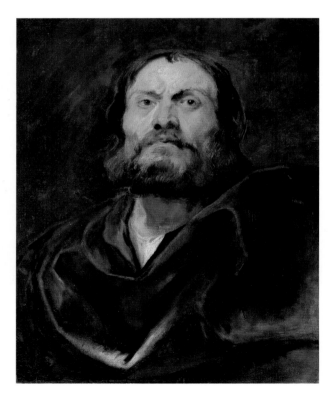

ANTHONY VAN DYCK
An Apostle, c. 1618

artful formulae, following in the footsteps of van der Weyden (58), have been lovingly retraced by all society portraitists ever since.

Most surprising are van Dyck's Apostles, some of which were painted for *Apostolodores* cycles along Spanish lines, others as preparatory studies for paintings like Berlin's *Descent of the Holy Spirit* (309). These busts share an informal authenticity and lack of academic decorum that bring Christ's immediate followers right up to now, nearer reportage than Beaux Arts virtuosity. The *Apostles* (308) suggest spiritual self-portraits as defined by their subjects, making them of special importance for Fragonard's imaginary "portrait" sketches of the next century,

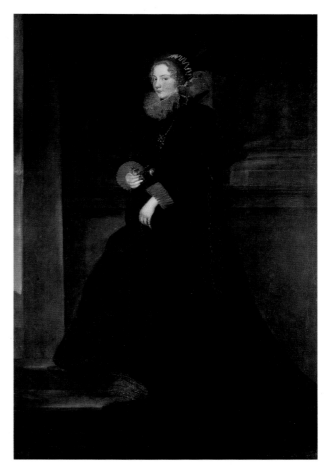

ANTHONY VAN DYCK
Marchesa Geronima Spinola, c. 1624–26

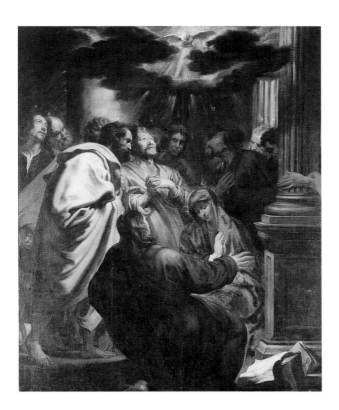

ANTHONY VAN DYCK
The Descent of the Holy Spirit (Pentecost), c. 1618–20

when the Fleming's works were highly prized by Parisian collectors and painters alike.

Dramatic chiaroscuro in young van Dyck's religious imagery is seen to best advantage in his turbulent, expressive *Descent of the Holy Spirit (Pentecost)*. This belongs to a series of five works that also includes the *Two SS. John* and the first version of *Christ Crowned with Thorns* (both formerly in Berlin, now destroyed) and *The Arrest of Christ* (Corsham Court, Lord Methuen collection). It was painted c. 1618–20 in Rubens's studio for a Bridgettine Cloister at Hoboken and then went to the great Abbey of the Dunes near Bruges.

Overleaf:
ANTHONY VAN DYCK
An Aristocratic Genoese Couple, c. 1622–26

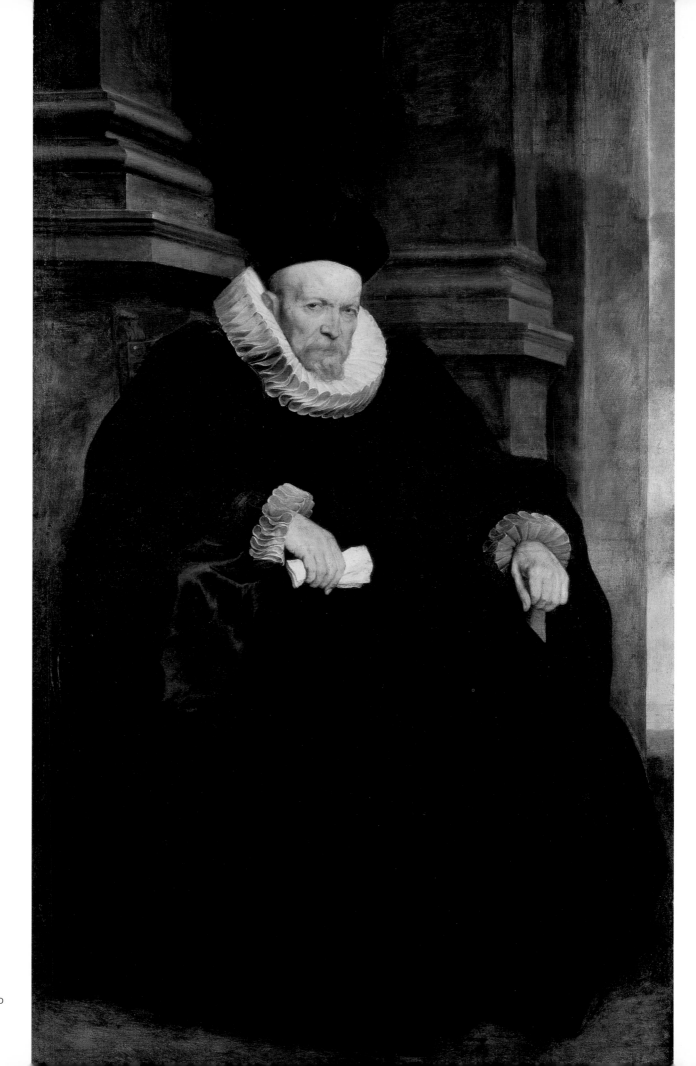

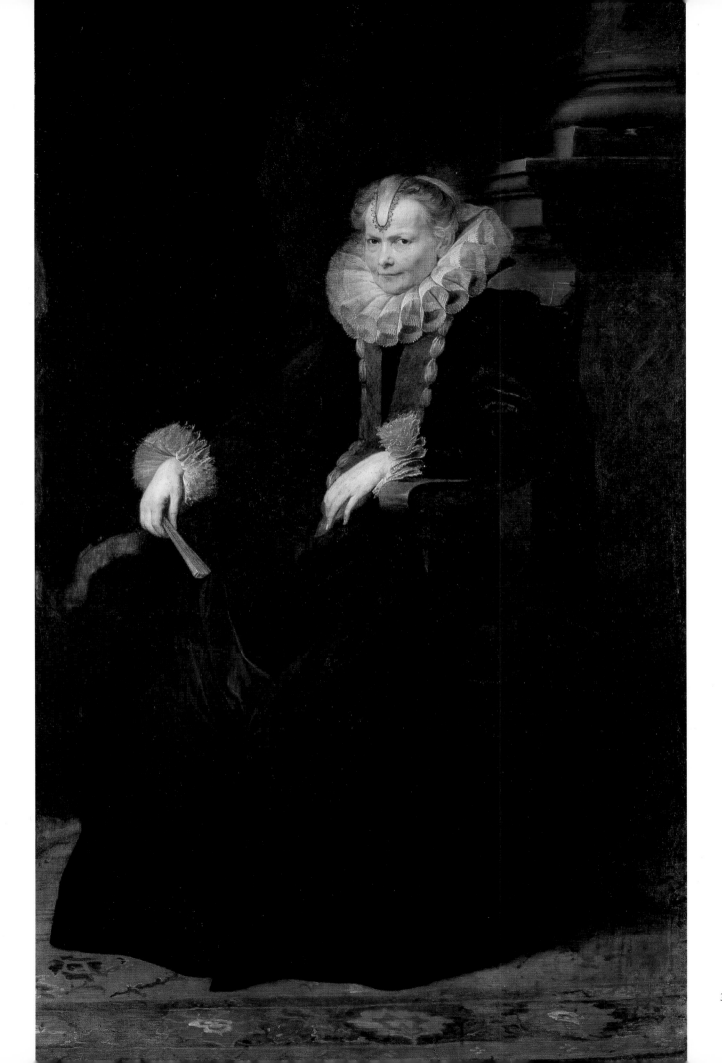

COLLECTIVE PLEASURES

Dutch and Flemish painting provides almost enough pictures of wealthy men and well-dressed young women banqueting in the open air — known descriptively if unimaginatively as "Merry Companies" — to lessen the weight of all those contemporary moralizing images of domesticity. These parties recall Venetian festivity, where even the Bible was combed for subjects of social jollity. They also anticipate Watteau's *fêtes galantes* (456), in which amorous guests in silks and satins cavort in parks, on terraces, and indoors, their love accompanied by music's soothing charms.

Berlin's two best Baroque Merry Companies are both by Willem Pietersz. Buytewech. In one the setting is Italianate (313), painted c. 1616–17, a reminder that Netherlandish painters fled southward for their most carefree times. Those who lived in Rome had their own social club for wine, women, and song, one providing all the assets and few of the liabilities of nineteenth-century *scènes de la vie bohème*. This scene may represent a biblical subject, that of the Prodigal Son. Prominent, the peacock on the banqueting table symbolizes Superbia (Pride), as noted by Rüdiger Klessmann, leading to the Son's downfall until he was redeemed by his father's all-forgiving love. That Buytewech's company is merry in Rome is suggested by the somewhat Early Christian and classical architectural elements. Wine chills as passions rise — some of the latter less than welcome judging by the couple in the background. That motif of amorous miscalculation was to be isolated in Watteau's *Le Faux Pas* (Louvre). Buytewech, who was active in Haarlem, once worked in collaboration with Hals, whose insights may well have been sharpened by those of his keen associate.

A second Buytewech *Merry Company* (314), dated c. 1622–24, is staged inside, harmonized by a fiddler.

The underlying subject may be that of the Return of the Prodigal Son, who is seen against a picture of a wooded landscape. Remarkably similar to Buytewech's terrace scene (313) is a *Merry Company Banqueting on a Terrace* (315) by Esaias van de Velde, whose work is often close to the Rotterdammer's.

Frans Hals's gifted brother Dirck painted an indoor festivity (315) with far too many suggestive musical instruments to make it a church social; the ribald nature of this image is also indicated by the preponderance of men over women, a prerequisite for gang behavior.

Jan Steen was Europe's greatest Baroque chronicler of fresh festivity, recording how those celebrations of faith, folk, and family illumined an often harsh life for middle and lower classes alike. *Tavern Garden* (316) shows Steen at his best — witty, adroit, compassionate, but never sentimental. Just as Watteau learned a lot from Hals, he may have gained greater insight still from Steen's more delicate, small-scale visual intricacy. That ironic, smiling figure holding a basket is probably the Dutch painter himself, a participant in the merriment. Also a tavern keeper or brewer, this great painter may have been the keenest Baroque analyst of the tragicomedy of human collectivity.

Close to Jacob Jordaens, Steen often painted the same subjects as the Flemish artist, but he never employed the Antwerp master's ponderous fashion. *"So de oude songen, so pypen de jongen,"* meaning "As the old sing, the young pipe," was a Netherlandish proverb both painters liked. In his work of that name, sometimes entitled *Baptism* (317), Steen orchestrates this comparison of the extremes of youth and age into a symphony sensitive to life's stages, of the very young learning from the very old in a cycle of life and death along with renewal and rebirth.

Steen's *Argument over a Card Game* (318) depicts a

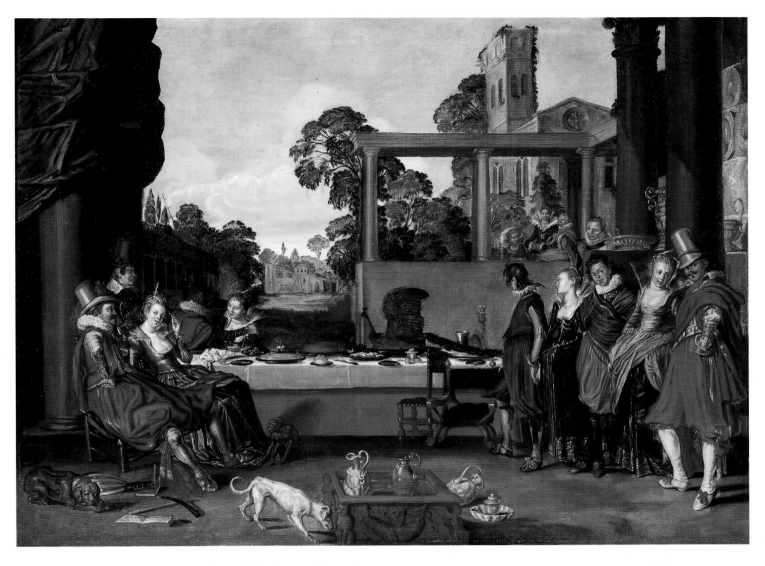

WILLEM PIETERSZ. BUYTEWECH, Rotterdam, 1591/92–1624
Merry Company on a Garden Terrace, c. 1616–17

dissolute, drunken tavern scene with the laughing Steen as Democritean painter-philosopher at the far right. This scene lies somewhere between Pieter Bruegel the Elder and William Hogarth in style and content. Another roistering gathering — *Carnival Clowns* (*319*), by Willem Cornelisz.Duyster — recalls a Mannerist approach in its decorative coloring. It is close in mood and subject to an *Actors' Changing Room* (*319*) by the artist's fellow Amsterdamer, Pieter Codde.

An outdoor musical party (*320*) features the Flemish painter David Teniers the Younger at the

cello as the Ape of Imitation tries to dislodge a stone finial just overhead in order to end the concert precipitously. Painted c. 1645–46, this is a scene of familial harmony — its concord facilitated by wines cooling to the right.

A studio's appearance, rightly or wrongly, may be taken to be a guide to the artist's life and work. This is the subject of an early picture (*320*) by Jan Miense Molenaer, a Haarlem painter close to Frans Hals (and married to that master's student Judith Leyster), that presents an unusually animated scene. His self-portrait is at the far left, as well as in the

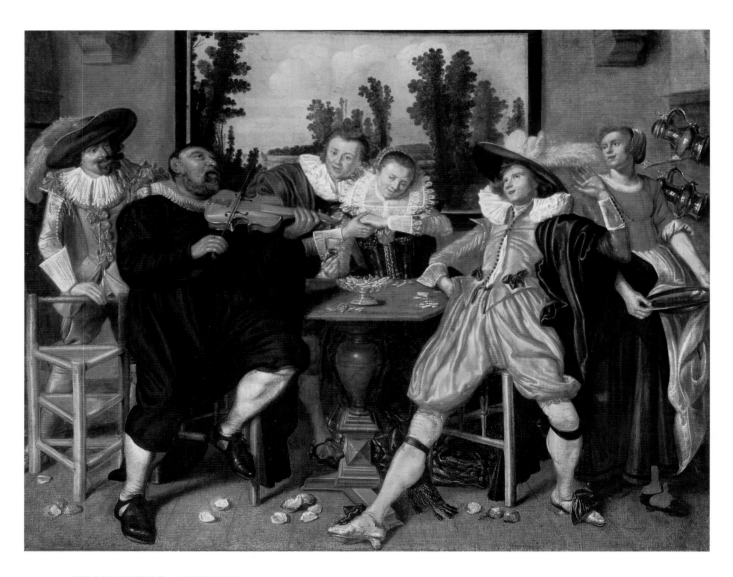

WILLEM PIETERSZ. BUYTEWECH
Merry Company, c. 1622–24

painting of this subject placed upon the artist's easel; Leyster stands alongside. Seen between a double worldview in the background, a bearded music maker is placed like Rembrandt in his great self-portrait of 1665 (Kenwood, Iveagh Bequest). Music harmonizes the spheres as a dwarf dances with a dog.

Portraits of couples, like Rembrandt's memorable painting of the Anslos (*368–69*), can be very large and grand if the sitters' finances allow. Size and grandeur tend to be more in demand as age increases and beauty diminishes — when authority and a certain spiritual and / or material triumph

seem to be the order of the day. Earlier in life, smaller-scale images are more intimate and economical, like that of a music-making couple (*321*) by Willem Cornelisz. Duyster. Here a pensive, richly dressed young woman is listening to a lutanist who has his back to her. Duyster's signature, on the instrument case at the far right, links the visual and musical arts. Rather than appearing to be a marital portrait, this picture may instead come closer to a genre scene, its implicit sentiment, "If music be the food of love, play on."

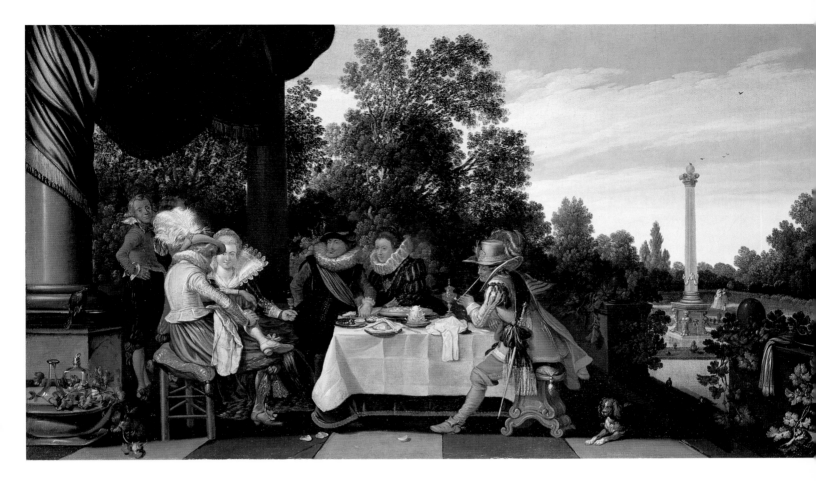

ESAIAS VAN DE VELDE
Amsterdam, c. 1590/91–
The Hague, 1630
*Merry Company Banqueting on
a Terrace*, c. 1615

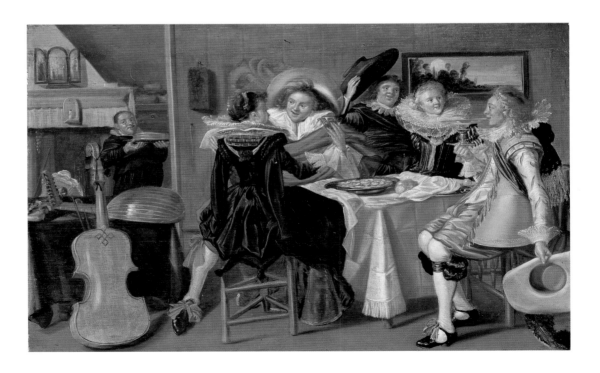

DIRCK HALS
Haarlem, 1591–1656
Merry Company at Table,
late 1620s

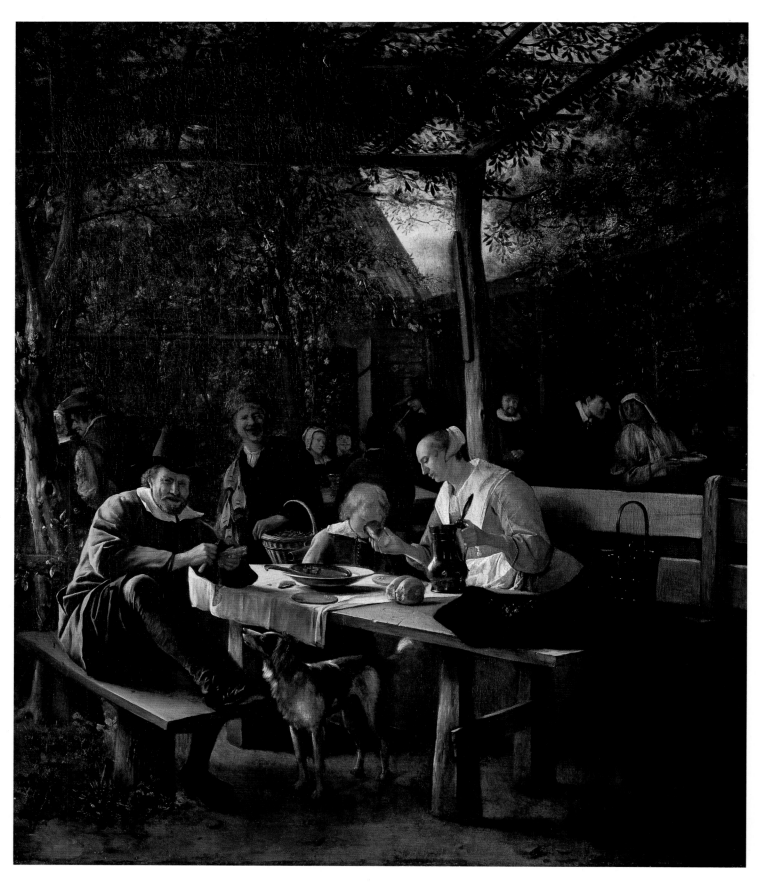

JAN STEEN, Leiden, 1625/26–1679, *Tavern Garden*, c. 1660

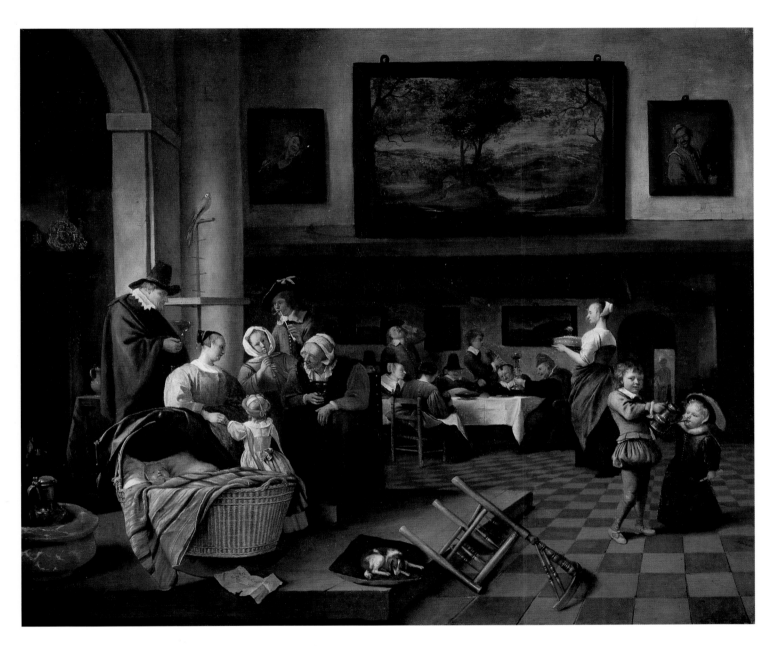

JAN STEEN, *"So de oude songen, so pypen de jongen" (Baptism)*

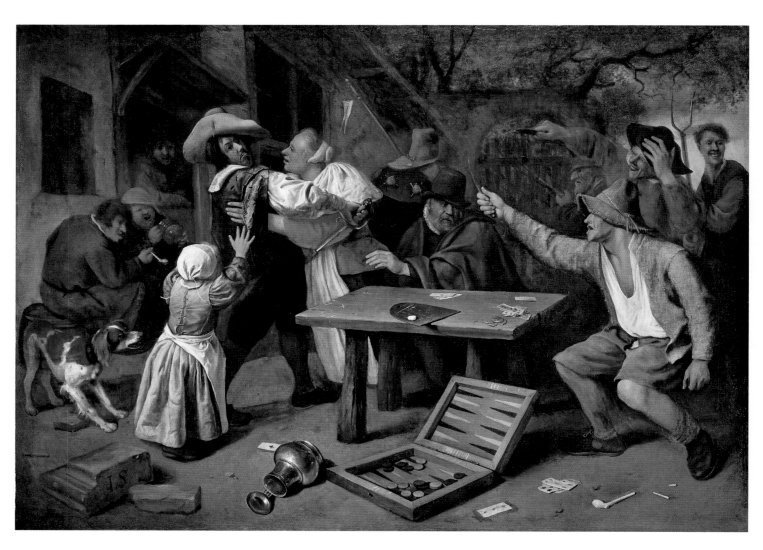

JAN STEEN, *Argument over a Card Game*

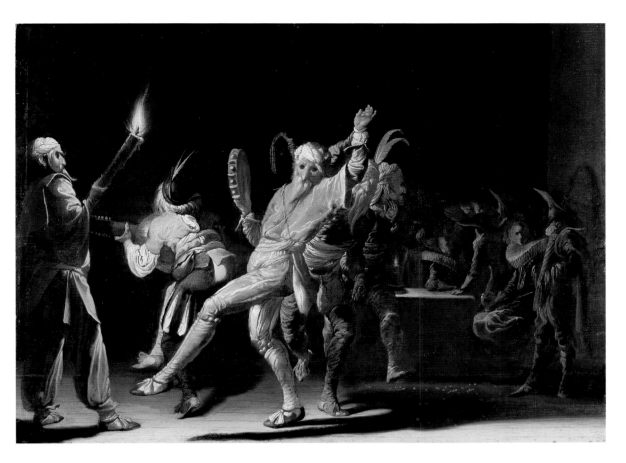

WILLEM CORNELISZ. DUYSTER, Amsterdam, 1599–1635, *Carnival Clowns*, c. 1620

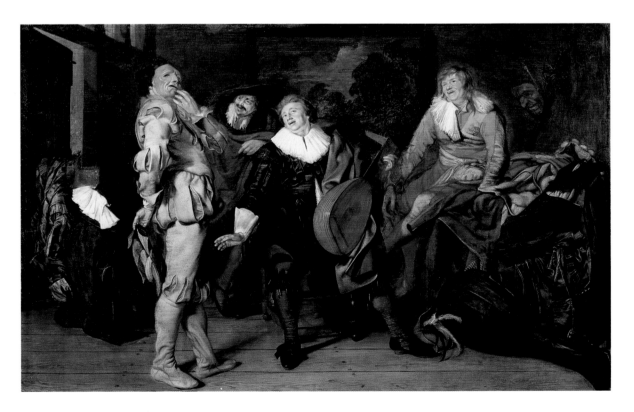

PIETER CODDE, Amsterdam, 1599–1678, *Actors' Changing Room*, c. 1630s

Splendor and Intimacy: The Baroque, 1600–1700 319

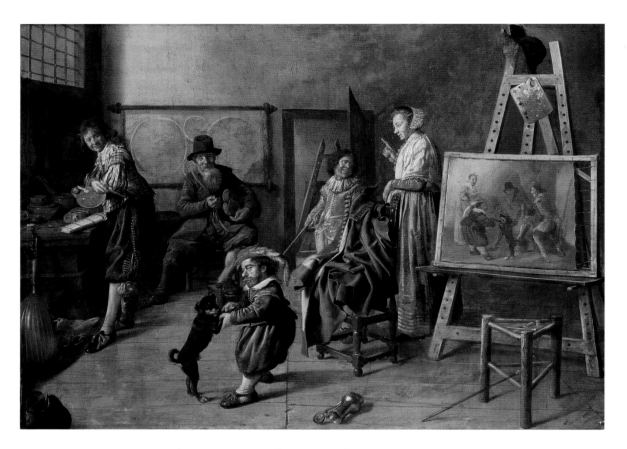

JAN MIENSE MOLENAER, Haarlem, c. 1610–1668, *The Artist's Studio*

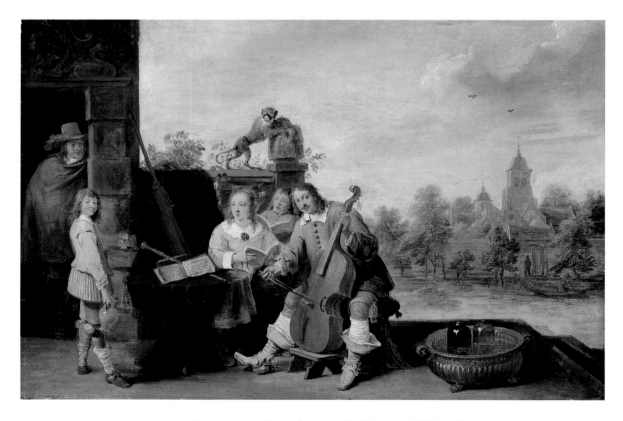

DAVID TENIERS THE YOUNGER, Antwerp, 1610–Brussels, 1690, *The Painter and His Family*, c. 1645–46

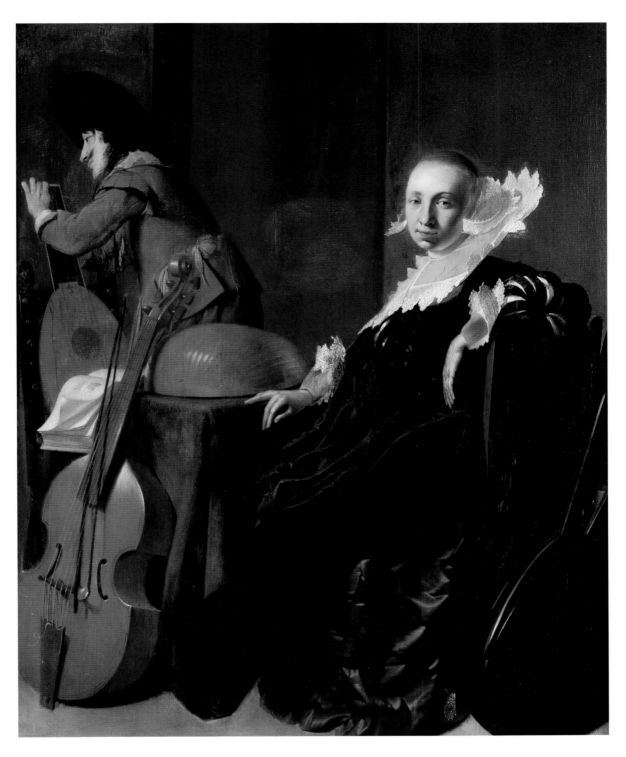

WILLEM CORNELISZ. DUYSTER, *A Music-Making Couple*

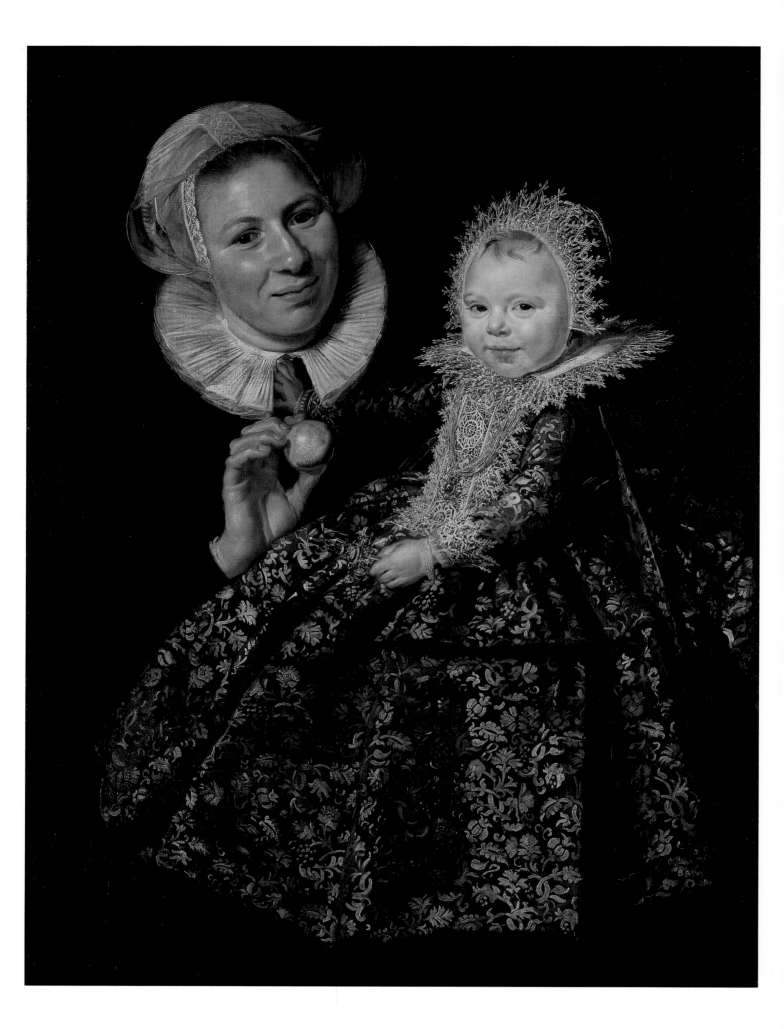

Haste Makes Art: Hals's Portraits

WHERE Rembrandt worked in many genres, a prolific printmaker and draftsman as well as painter, Frans Hals stuck to a single last: portraiture. Tantalizing glimpses of landscape and still life in his likenesses show his command of these fields, but Hals didn't care. Whether by need or inclination, portraits were what he painted. There are none better. Hals must have seen Venetian examples, along with earlier Netherlandish ones by Frederic Sustris and Lambert Lombard. He was familiar with the long-standing Netherlandish tradition of group portraiture, like Werner van den Valckert's *Five Regents of the Groot-Kramergild* of 1622 (*324*), a genre in which Hals and Rembrandt were both to excel. Far earlier in date, Pieter Pietersz.'s skillful image of the Amsterdam publisher Laurens Jacobszoon and his wife and three sons (*324*), of 1598, could have been important for Hals since its painter worked in Haarlem. Like Hals's parents, Pietersz. also came from Antwerp. Hals learned a sense of informal encounter, an unself-conscious posing, from these earlier group portraits and then went on to paint the supreme examples himself (Haarlem, Frans Hals Museum).

Since Hals's century, few artists have brought new insights to likeness. These include Edgar Degas and Thomas Eakins. Interestingly, both nineteenth-century artists were close students of a novel device, photography. Hals's concerns went far beyond the traditional limits of likeness. In a new form of collaboration between artist, model, and viewer, the painter's role lies somewhere between that of interpreter and agent. He gives the spectator a freshly participatory role, reconstituting the image from suggestions barely sketched by his brush. Novel concepts of pictorial decorum and process are also Hals's, established by scintillating brushstrokes rivaled only by Titian (*268*) and Velázquez (*423*).

Hals gives most sitters the incalculable benefit of sustained affirmative action along with occasionally shattering deconstruction, these seemingly shared by artist and viewer alike. A definitive sense of "That's him!" or "That's her!" — of such absolute inevitability of appearance that the image is beyond beauty — is what imbues the best of Hals's paintings with such enduring, enormous excitement; these are among the most dynamic and soul-satisfying likenesses ever painted. Because the artist remains invisible, his virtuosity a matter of course, just part of the package, *who* you see is what you get. And that's more than enough.

Dutch forerunners close to Hals's spirit were seldom notable as portraitists. They included "Witty Willem" Buytewech, about a decade Hals's senior, whose roistering Merry Companies (*313, 314*) and free graphism liberated the drawstrings of Dutch art. Leading the way to Hals's world — he and Hals once working on the same picture — Buytewech took the stuffing out of portraiture. Following the Venetian lead, glance and gesture came to the fore, as if paintings, like people, could enjoy eye contact. Gloves and hats assumed the eloquence of letters, the language of likeness taking on life as it stripped itself of protocol's distancing.

Frans Hals was born in Antwerp, presumably to Protestant parents who fled the duke of Alba's persecution after 1585 and settled in Haarlem in 1591, where Frans's entire career took place. He studied there with the Italianate Mannerist Carel van Man-

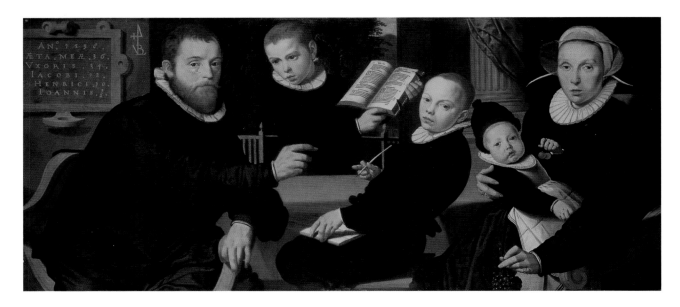

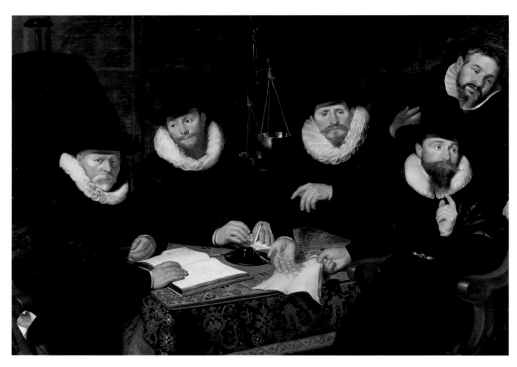

der, almost always working on canvas to allow for maximum flexibility of vibrant brushstroke. Hals married twice, had ten children, and seemingly led a brawling life that ended in destitution despite many significant commissions in the 1620s and 1630s. Two of Hals's brothers and five of his sons also became painters. Frans's students included major Little Masters such as Jan Miense Molenaer (*320*), Adriaen Brouwer (*306*), Philips Wouwerman (*333*), and Adriaen van Ostade, who, in turn, taught

the great Jan Steen (*316–18*). Berlin's museum director Wilhelm von Bode wrote his dissertation on Hals. Maintaining a lifelong passion for the artist, he bought several of the Dutch master's canvases in the mid-1870s.

A comparison of *The Infant Catharina Hooft (1618–1691) with Her Nurse*, an early Hals of c. 1619–20 (*322*), and Titian's portrait of little Clarissa Strozzi (*263*), dated 1542, reveals the striking rapport between the painter of Venice and that of Haarlem.

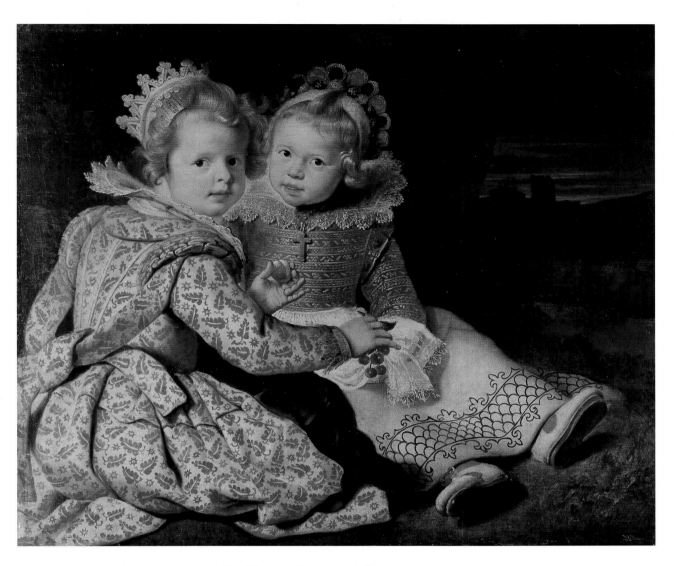

CORNELIS DE VOS, Antwerp, 1603–1676, *Magdalena and Jan-Baptist de Vos*, c. 1622

Richly dressed, the infant could just as well be a little boy as a girl. Similarly formal attire was lavished upon the children of Cornelis de Vos (*325*). Children are notoriously hard to paint, whether they are the artist's own or someone else's. About 1622, when de Vos portrayed his four-year-old daughter Magdalena and his son Jan-Baptist, one year her junior, he dressed them in party finery but seated them outdoors, with a textile hanging behind them. A setting sun at the upper right is in striking contrast to the ebullience of these fruit-eating infants. When de Vos painted this unusually successful image, he was among the leading Antwerp artists and dean of their guild. He would be a key collaborator of Rubens's, whose way of painting children (*303*) was far less conventional than that of de Vos.

Less sunny by far, more typical of Hals than his *Infant Catharina Hooft*, is his penetrating *Tyman Oosdorp* (*326*) of 1656.

In pendants of a prosperous young Haarlem couple in their Sunday best (*329*), the man and the woman look at the artist very differently: she directly, he with an evasive, rakish tilt. Hals is more taken with the individuals' radically differing forms of self-involvement, which, over the long haul, is probably of greater marital significance than any overt "togetherness." As is often true for portraits of a marriage, the man is brought closer to the foreground, making him loom the larger in fiction, if not fact.

Following a Renaissance portrait formula, Hals presents another sitter within an oval, one hand

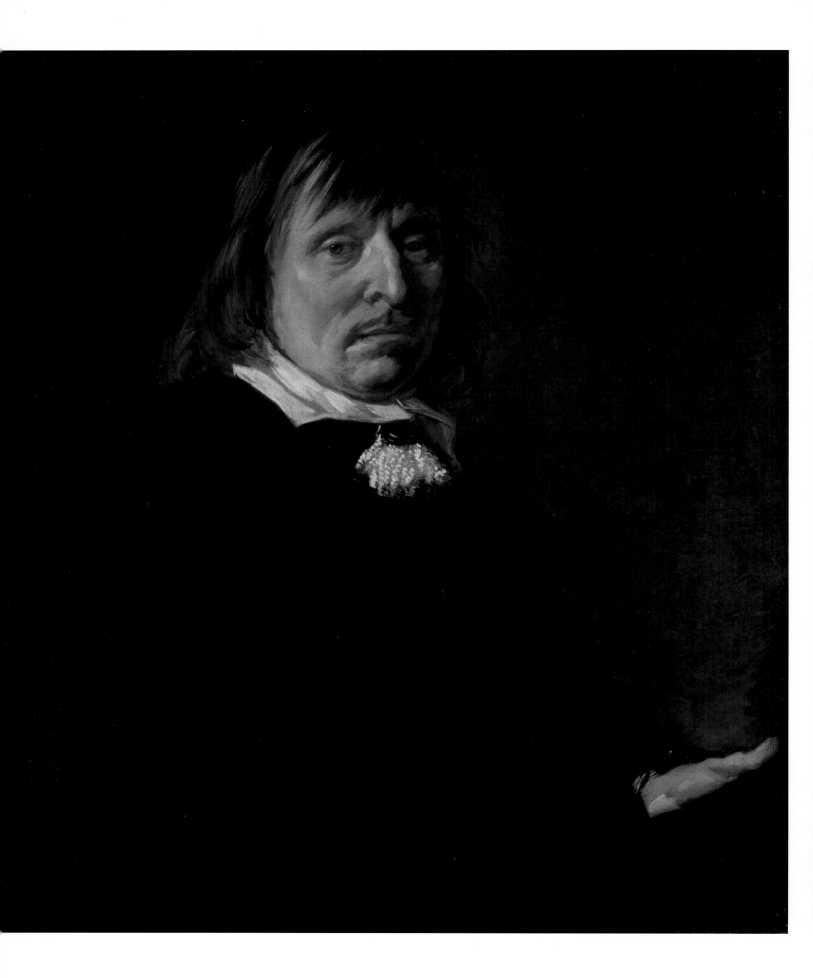

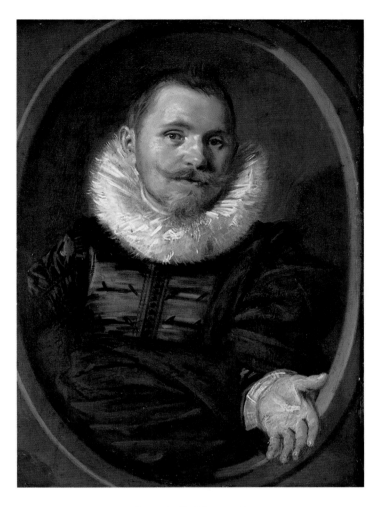

FRANS HALS, *Portrait of a Man*, c. 1627

projecting beyond the frame in trompe l'oeil fashion, in a very small, almost miniature image (*327*) that dates from the 1620s, possibly 1627. Hals's brisk rendering has something of a commedia dell'arte character, of potential appeal to Watteau (*446*), the Dutch master's most insightful follower in the succeeding century.

Surprisingly Caravaggesque, the *Boy with a Flute* (*329*) recalls similar busts of plumed, piping youths by Hendrick TerBrugghen and is typical of the Utrecht School. (Smiling fisherboys à la Hals were painted ad nauseam by his untalented student Judith Leyster.) In this Hals, the flautist's awkward

Opposite:
FRANS HALS, *Tyman Oosdorp*, 1656

articulation even suggests the possibility of Leyster's participation. Hals's younger brother, Dirck — the only one of all the other painter-Halses to be identifiable — specialized in scenes of low company having a high time (*315*), these close in genre to this boy and his Freudian flute.

Equally animated, though now with the artist clearly in control, is Hals's *"Malle Babbe"* (*328*), which has "Crazy Babette of Haarlem" written on an old sticker on the back. Tankard in hand and owl on her shoulder, she was probably painted c. 1629–30. Far from Athena's wise owl, Northern folklore saw Babette's bird as dirty and evil. Because it includes such a picture hanging on the wall, we know from Jan Steen's *Baptism* (*317*) — also given the proverb-title *"So de oude songen, so pypen de youngen"* — that Babette modeled for Hals once again, smoking. This lost canvas was pendant to Hals's boozing *Pickelharing* (Kassel, Staatliche Gemäldesammlungen), shown on the same wall. The pairing was probably intended as a moralizing, silent sermon on the evils of excessive smoking and drinking.

Hals was much copied by Gustave Courbet and Edouard Manet (*591–93*); the former saw *"Malle Babbe"* on exhibition in Munich in 1869, and painted his own version (Hamburg, Kunsthalle). An early writer on Hals noted how he referred to the brushstroke as his handwriting, a revealing insight into the personal and expressive graphism of the painter's way of working. Like Malle Babbe herself, Hals also exercised magic: no Westerner ever got more mileage from a single brushstroke than he.

Some intimation of Hals's approach to landscape may be gleaned from works by his presumed pupils Adriaen Brouwer (*306*) and Adriaen van Ostade. Born in Flanders, Brouwer was first active in Haarlem with Hals, then proceeded to Antwerp, where he became a great favorite of Rubens, whose collection included many of his works. A painter's painter, Brouwer's pithy, brutal sketches of lowlife have an uncompromising modernity pointing to the vivid approach of a Goya (*422*). For Rubens, such squalid burlesques and beggarly revels must have come as comic relief after devising endless canvas acres of apotheosis and grandeur, his pictorial bread and butter.

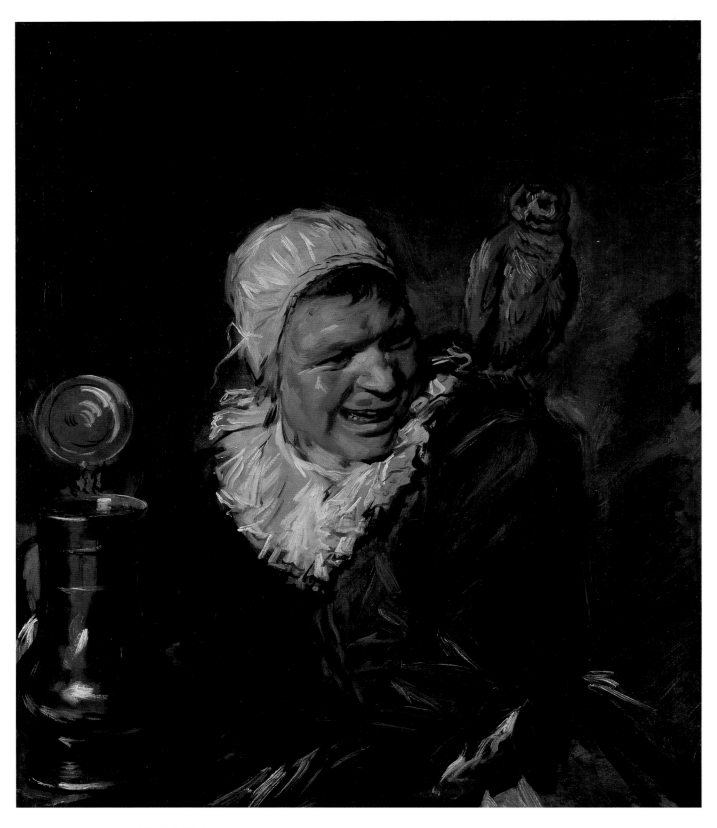

FRANS HALS, *"Malle Babbe,"* c. 1629–30 ·

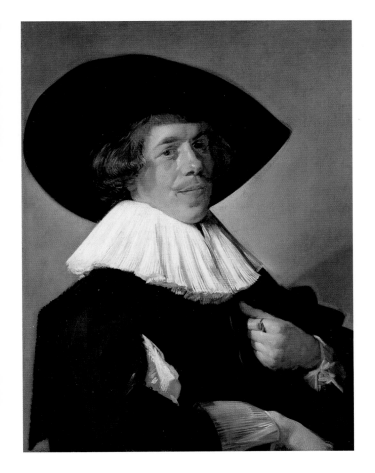

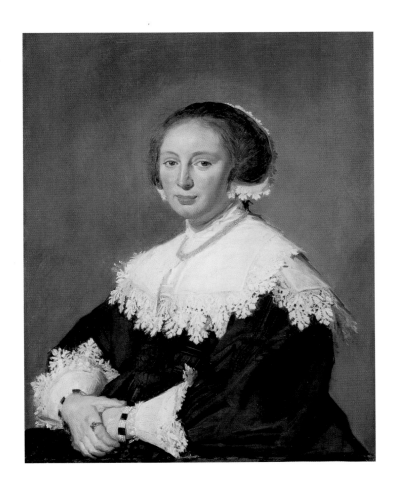

FRANS HALS
Portrait of a Man, c. 1630–33
(left)

Portrait of a Woman, c. 1630–33
(right)

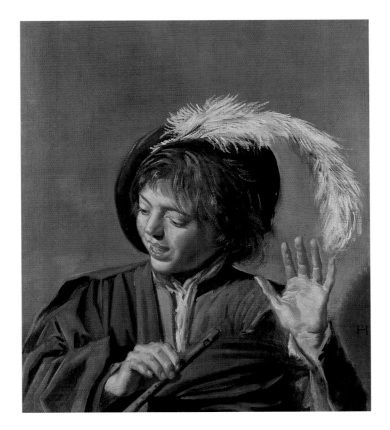

FRANS HALS
Boy with a Flute, c. 1623–25

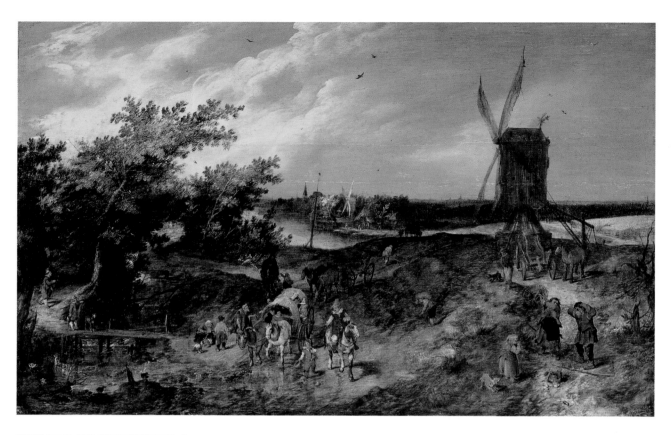

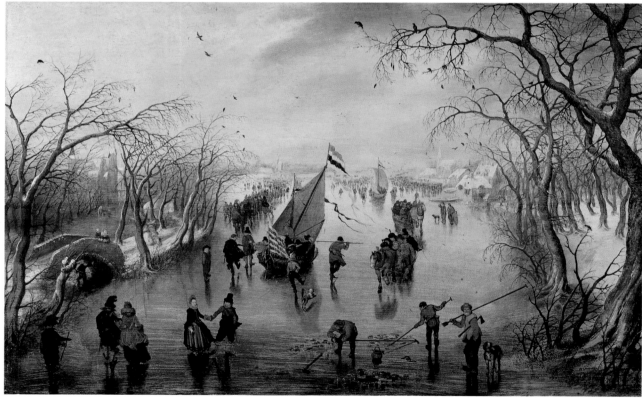

ADRIAEN PIETERSZ. VAN DER VENNE, Delft, 1589–The Hague, 1662, *Summer*, 1614 (top); *Winter*, 1614 (bottom)

Lowlands Winter Tales and Seasonal Quartets

WHERE Italy and Spain largely deny winter's presence, feigning perpetual surprise upon its advent — ever "unseasonably," if not "incomparably," cold — Germany and the Lowlands relish the joys of snow and ice, sledding and skating, cutting down the *Weihnachtsbaum*, treasuring the *Gemütlichkeit* of the *Nutcracker*, curling up by a tiled or porcelain stove as the icy winds blow and snows fall. For once, even the farmer enjoys respite and time for romance. So it is no coincidence that the Berlin collections abound in winter landscapes and with seasonal suites where the contrasts of warm and cold, of green and white, get their due.

Visual cycles stressing the special qualities of every-three-month series go back to antiquity, when they were seen as symbols of divine providence, the gods looking after mortals' needs by attending to their nurture, each monthly triad paving the way for the next, in a cycle for life's sustenance. So these images, in groups of three, eventually moved from the consoling embellishment of Roman sarcophagi to decorating dining rooms, one season to a wall.

A *Summer* (*330*) and an unusually benign *Winter* (*330*), each signed and dated 1614, are paired by Adriaen Pietersz. van der Venne. The brilliantly lit scene of ice skating, ice fishing, and ice sailing is one of fun and flirtation, since warm weather is the time when the poor work in the fields and the wealthy travel. Still in the cosmic spirit of Pieter Bruegel (*162–63*) and Jan van Eyck (*53*) these scenes suggest a magical overview, as if the whole world, if not in God's arms, is at least in the artist's line of vision. Mortal and divine creativity have become one and the same. Even the ever so serious Jan van Goyen went in for this contrived contrast between seasons, seen in two very small roundels of *Summer* (*331*) and *Winter* (*331*).

"First" is usually a foolish word in history, ever needing modification, as in "surviving," or

JAN VAN GOYEN, Leiden, 1596–The Hague, 1656, *Summer*

JAN VAN GOYEN, *Winter*

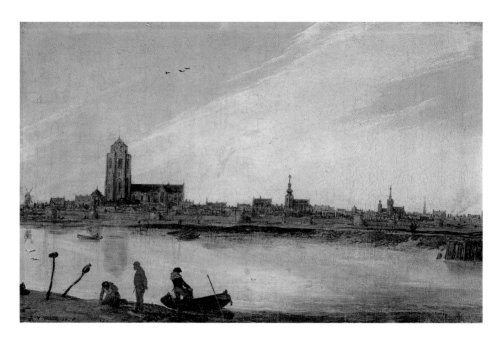

ESAIAS VAN DE VELDE
Amsterdam, c. 1590/91–
The Hague, 1630
View of the Zierikzee, 1618

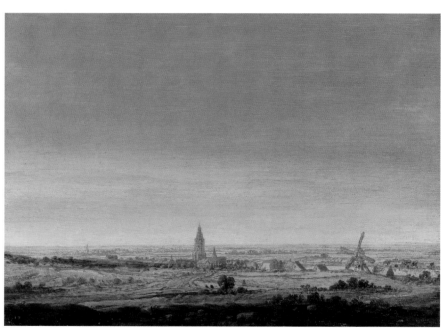

HERCULES PIETERSZ. SEGHERS
Haarlem (?), 1589/90–The Hague
or Amsterdam, before 1638
Landscape with City on a River,
late 1620s

"known." Few early independent landscapes remain — Dürer's wonderful watercolors among them — and Esaias van de Velde is one of the earliest Dutch painters to have made a name for himself for town views, his first dated 1615. A son of Flemish emigrants, he had lived in Haarlem since 1610. Autumnal in feeling, a painting of his dated 1618, *View of the Zierikzee* (*332*), shows him to have been a founder of Dutch realistic painting as well. Here, the restricted coloring and restrained approach pave the way for Esaias's pupils Jan van Goyen (*334*) and

Salomon van Ruysdael (*347, 348*). Had he never realized a single picture, the fact that van de Velde attracted and developed students of such distinction makes this little-known artist a giant among painters of the early seventeenth century. Still more powerfully original as painter and printmaker is Hercules Seghers, whose *Landscape with City on a River* (*332*) is much in van de Velde's manner.

The ultimate in proto-Rococo seasonal contrasts is found in two canvases by Philips Wouwerman, *The Path Through the Dunes* (*333*) and *Winter Land-*

PHILIPS WOUWERMAN
Haarlem, 1619–1668
The Path Through the
Dunes

PHILIPS WOUWERMAN
Winter Landscape with
Wooden Bridge

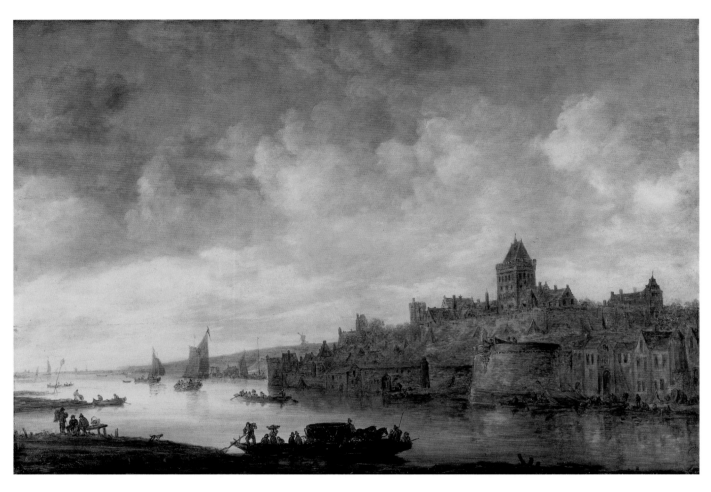

JAN VAN GOYEN
View of Nijmegen, 1649

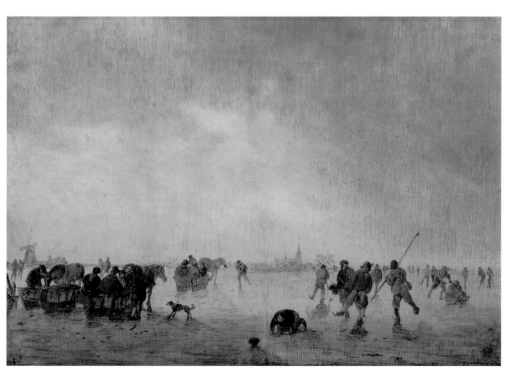

JAN VAN GOYEN
Landscape with Skaters, 1643

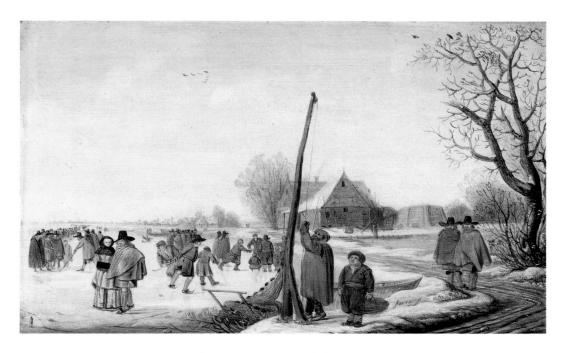

BARENT AVERCAMP, Kampen, 1612/13–1679, *Landscape with Frozen River*, c. 1655

scape with Wooden Bridge (*333*), both similar in size. Reveling in an expanse of sky, in the physical insignificance of humankind, Wouwerman pays homage to the elements, to Nature's irrational, unbalanced aspects, with all of us in her thrall, never more so than in late fall or the dead of winter. Qualities of the picturesque, of the *rocaille* — those irregular, decorative tricks of the eighteenth-century artist's trade — are anticipated by these scenes, where the seasonal seems no more than an exercise in cosmic caprice.

A severely, effectively restricted palette makes for unusually successful images in the case of Jan van Goyen. One of his favorite views was that of Nijmegen (*334*), shown in a magisterial, possibly autumnal, image of 1649, where a coach is being ferried across the water in the foreground. Van Goyen's small *Landscape with Skaters* (*334*), signed and dated 1643, may have been far less horizontal than its present format suggests, as it seems to have been cut down. As a fisherman mends his nets in the foreground, fancier folk play on the ice in another winter landscape, this one painted by Barent Avercamp (*335*).

Among the loveliest landscapes of rustic life are those by Adriaen van de Velde, whose *Cows on a Meadow* (*339*), signed and dated 1658, must have inspired the art of George Stubbs and John Constable. His *River Landscape with Horses and Cows* (*340–41*) has a similar prophetic quality. Idealized yet quintessentially close to its subject, van de Velde's *Farm* (*342*) of 1666 presents a lustrous vision of Dutch agrarian life within an uncharacteristically richly wooded setting. This brightly illuminated landscape is a forerunner of some of Friedrich's light-struck vistas, where God's works are still implicit, not yet explicit, in his art. That the Dutch panel should have long been in a major English collection of Dutch baroque art (Lord Francis Pelham Clinton Hope) is appropriate, since in so many ways van de Velde's realistic yet somehow reverent study of animal life anticipates much English art.

Both documentary and dramatic, *The Bull* (*338*), by Paulus Potter, is painted as a fact of life. Berlin's brilliant museum director, Wilhelm von Bode, once said of this painter, "Potter was so much in tune with animals that their depictions were always free of anthropomorphism, but when he painted people, those images were marked by zoomorphism."

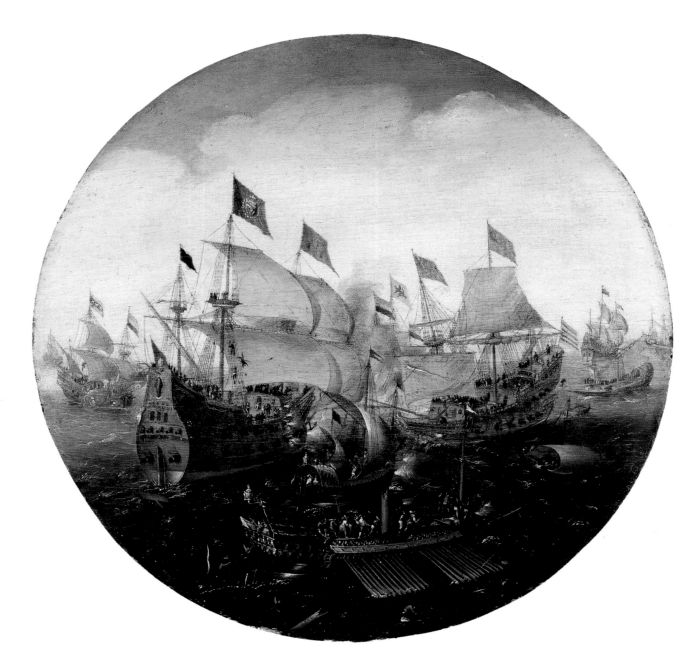

The Ford (343), by Jan Siberechts, signed and dated "1670/A anuers," is a tribute to the fertility and the ease of summer. One milkmaid is bathing at the water's edge while another follows her cattle through the ford. There may well be some sort of in-joke between the classical stance of this woman, elegantly balancing her milk can on her head, and the pissing cow at her side. A lovely, Corot-like grove to the upper right shelters grazing horses and cattle.

Lowlands summers at their most verdant are seen in Paulus Potter's Start of the Hunt (344–45).

The artist's short life did not prevent his realizing rustic scenes of unprecedented power.

By the seventeenth century, the Dutch Republic had become one of the world's leading maritime powers. Like England, it too defeated the Spanish Armada, in 1588, a subject of endless popularity for Dutch patrons, shown by Aert Anthonisz. in his circular depiction of 1604 (336), among his earliest works. Born in one of Europe's greatest seaports — Antwerp — much of his career was spent in another — Amsterdam.

Conqueror of the seas, whether repelling inva-

Opposite:
AERT ANTHONISZ.
Antwerp, 1579/80–
Amsterdam, 1620
Battle at Sea, 1604

JAN PORCELLIS
Ghent, c. 1584–
Zoeterwoude, near
Leiden, 1632
*Single-Masted
Damlooper and
Rowboat on a Breezy
Day*

sive waters by dike or windmill or by explorations around the African Coast and over to the Far East, the Dutch Republic, with England, was a small nation soon assuming powers far beyond its borders. Understandably both countries were keen patrons of marine painting. Whole families of Dutch specialists in that genre, such as the van de Veldes, settled in England to fulfill the demand for celebrations of wave-ruling.

A probable student of the first major Dutch marine painter, Hendrick Vroom, Jan Porcellis continued working in that field, active in the great sea-ports of Antwerp, London, and Amsterdam. All his skills are evident in the *Single-Masted Damlooper and Rowboat on a Breezy Day* (*337*). Flying the red, white, and blue Dutch flag, this vessel was designed for ready passage over dikes and dams. Complex in format, painted in grisaille, almost but not quite square in shape, this panel has an inherent quality of abstract surprise; it is as if the painter seeks deliberate escape from a proto-Albersian *Homage to the Square!*

PAULUS POTTER
Enkhuizen, 1625–Amsterdam, 1654
The Bull, 1649

ADRIAEN VAN DE VELDE
Amsterdam, 1636–1672
Cows on a Meadow, 1658

Overleaf:
ADRIAEN VAN DE VELDE
River Landscape with Horses and Cows, c. 1660

ADRIAEN VAN DE VELDE
The Farm, 1666

Opposite:
JAN SIBERECHTS
Antwerp, 1627–London, 1703
The Ford, 1670

Paulus Potter . f . 1652

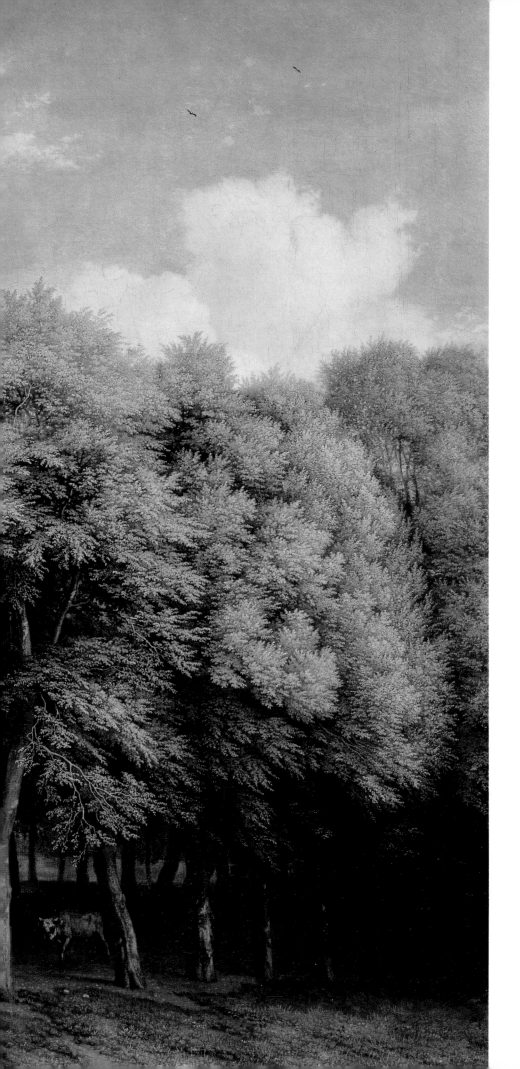

PAULUS POTTER
The Start of the Hunt, 1652

LORDS OF ALL THEY SURVEYED: THE RUISDAELS

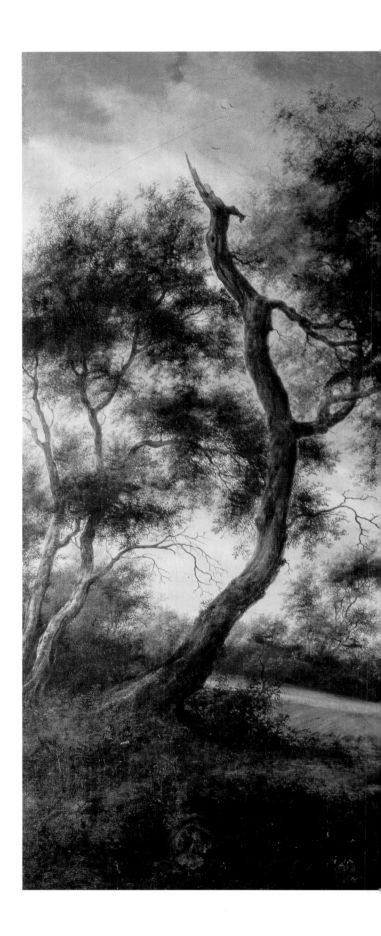

T HAT the brothers Isaac and Salomon Jacobsz. van Ruysdael of Haarlem should both have been highly accomplished landscapists is remarkable. That Isaac's son Jacob — who spelled his surname "Ruisdael" — proved to be a far greater master of the same genre is all the more striking. Isaac was also a framemaker, tapestry designer, and art dealer; Jacob was active as a draftsman and etcher, the latter skill in keeping with his dramatic use of light and shade. All three were prominent members of the Haarlem painters' guild, and often painted in the same region, Egmond-aan-Zee, near Alkmaar. Berlin has one of the world's largest collections of Jacob's work, at least thirteen canvases (the Rijksmuseum has thirteen as well), complemented with five by Salomon.

Though these canvases, grand regardless of size, usually pertain to a specific site, their debt to Venetian images of Arcadia should not be forgotten, especially since these were so readily available in prints by Domenico Campagnola and woodcuts after Titian. Without such landscapes and those after Giorgione, the Northern, seventeenth-century Baroque landscape could not have been realized. Berlin's best example of a Giorgionesque panorama is one by the Venetian-born Sebastiano del Piombo, found framed by a window in his *Portrait of a Young Roman Woman* (*253*).

Two magnificent works by Salomon van Ruysdael present his command of both land and sea. The first is a *Dutch Landscape with Highwaymen* (*346–47*), signed and dated 1656; the other is a *River Landscape at Arnheim* (*348*), signed on a boat in the foreground and dated 1642.

Jacob van Ruisdael's *Village at the Woods' Edge* (*349*) involves the viewer in a strange fusion of intimacy and threat. One emotion intensifies the other in this arresting Yin and Yang of the perils of human existence, as suggested by defenseless cottages

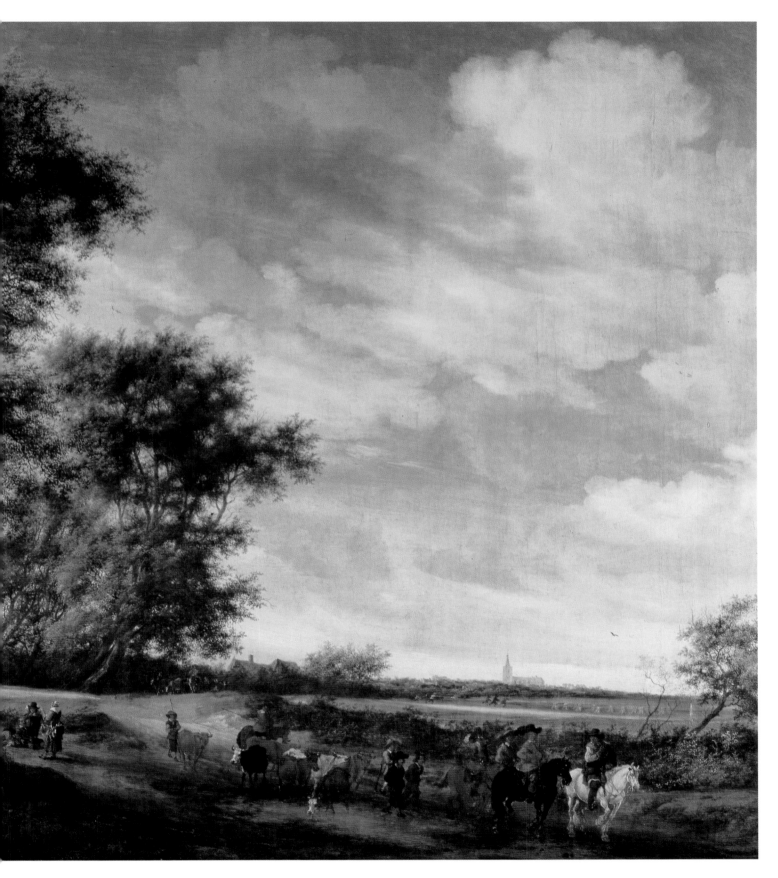

SALOMON JACOBSZ. VAN RUYSDAEL, Naarden, 1600/1603–Haarlem, 1670, *Dutch Landscape with Highwaymen*, 1656

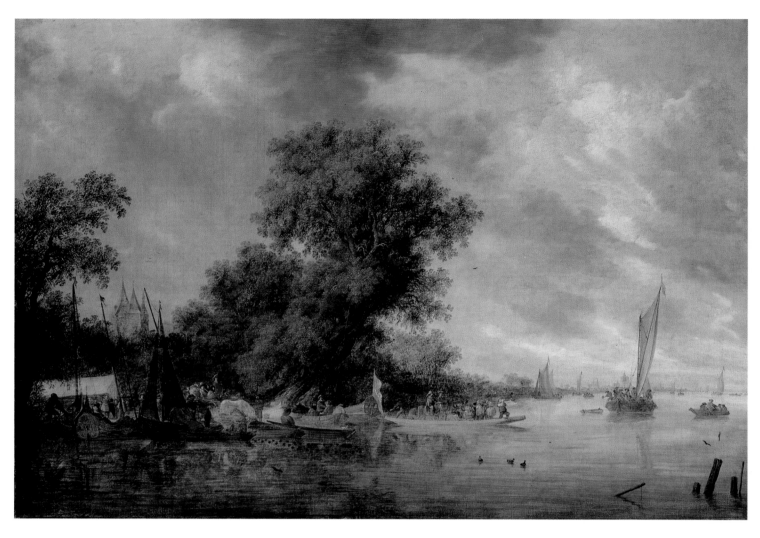

SALOMON JACOBSZ.
VAN RUYSDAEL
River Landscape at Arnheim, 1642

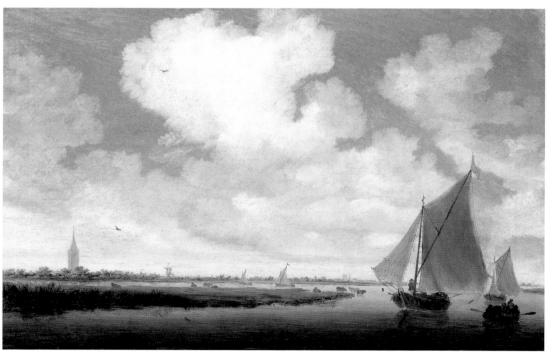

SALOMON JACOBSZ.
VAN RUYSDAEL
Sailboats on the Wijkermeer,
 c. 1648

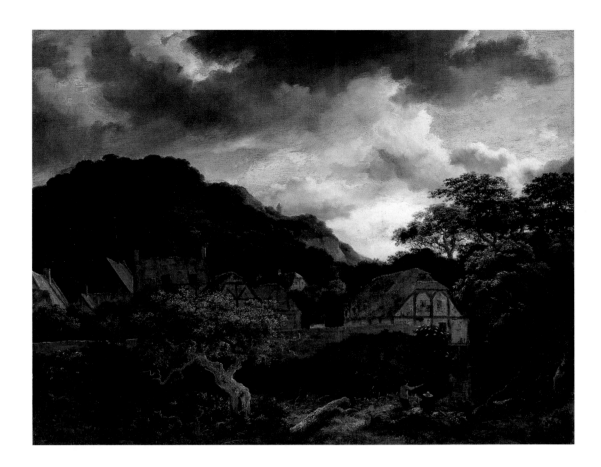

JACOB ISAACSZ.
VAN RUISDAEL
Haarlem, 1628/29–
Amsterdam, 1682
*Village at the Woods'
Edge*, c. 1651

below stormy skies and ominous-looking hills. English landscape painting of the eighteenth and nineteenth centuries is unimaginable without paintings like these, and Gainsborough (*496*), for one, made a number of drawings after Jacob's scenes.

Jacob was a friend of the Dutch Romanist Nicolaes Berchem — whose *Return from the Falcon Hunt* (*349*) is in Berlin — and they traveled to Germany together in the early 1650s, where Jacob learned of different approaches to a new topography.

The deceptively fresh, yet often formulaic, scenes presented by Dutch painters create a sense of experience, of optical and narrative adventure, that is far from Claude Lorraine's more predictable view of nature, perilously close to cliché as it teems with classical convention and reference. With the best of their contemporaries, the Ruisdaels dared to go against the classical grain, though some of Jacob's later canvases may indicate a certain interest in French art. No longer a stage for human tragicomedies, for mortal demigods, as in Poussin's visions (*411–14*), the Dutch masters let Nature come into her own, an attitude that sometimes anticipated Romanticism.

NICOLAES PIETERSZ. BERCHEM
Haarlem, 1620–Amsterdam, 1683
Return from the Falcon Hunt, c. 1670

The seeming spontaneity and lucid objectivity of Salomon's vision, as in his *Sailboats on the Wijkermeer* (*348*), points to the ways Richard Parkes Bonington would later come to subtle pictorialism, and to the chiaroscuro of nineteenth-century marine photography as exemplified in the work of Gustave Le Gray.

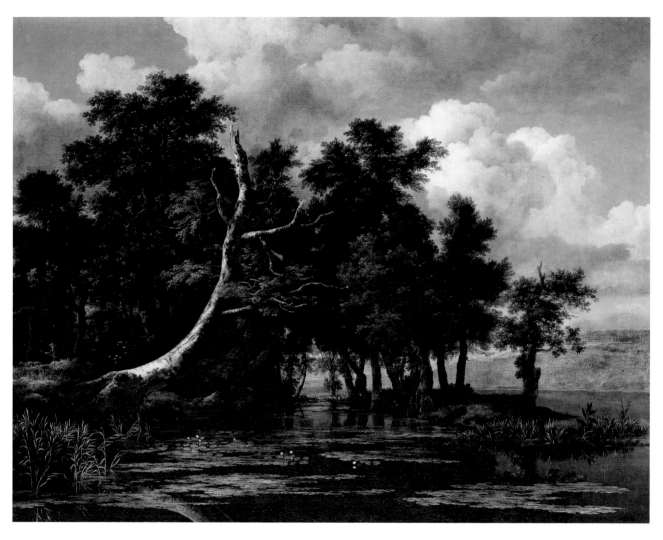

JACOB ISAACSZ. VAN RUISDAEL, *Oaks by a Lake with Waterlilies*, c. 1665–69

Though it includes a shepherd to the left, Jacob's *Oaks by a Lake with Waterlilies* (350) needs no figures, as it is so clearly a contemplation of the character of time and nature, of rest and motion, dealing with the passages from life to death. Goethe recognized the poet in Jacob van Ruisdael. Though that view was engendered by the more overtly narrative *Jewish Cemetery* (Detroit and Dresden) of 1653–54, it might just as well have been inspired by Berlin's symphonic canvas. Life and death are presented in symbolic contrast, the dead white tree in the foreground highlighted against the dense oak grove.

Most people living in seventeenth-century Holland were town- or city folk, often too busy, or far away, to reflect upon the beauties of landscape. Paintings like those by the Ruisdaels opened walls and windows as well as minds, letting the imagination roam as freely, and speedily, as the skies.

Rougher in texture, more modern in feeling than the *Oaks by a Lake with Waterlilies* is Jacob's *Woodland Scene with Lake* (351), done in a rich impasto, sides cut in precipitous fashion as if to remind us of the arbitrary delimitations of life and sight.

Far less conventionally picturesque, nearer to paintings or etchings by Hercules Seghers (364) or Rembrandt (364), the low horizon line of *Haarlem Seen from the Dunes to the Northwest* (352–53), by Jacob van Ruisdael, includes sheets being bleached by sunlight at the lower right. The great church of St. Bavo — where the artist would be buried soon after this late work was completed — rises in the distance, along with the city's other spires, all dwarfed by the billowing skies above.

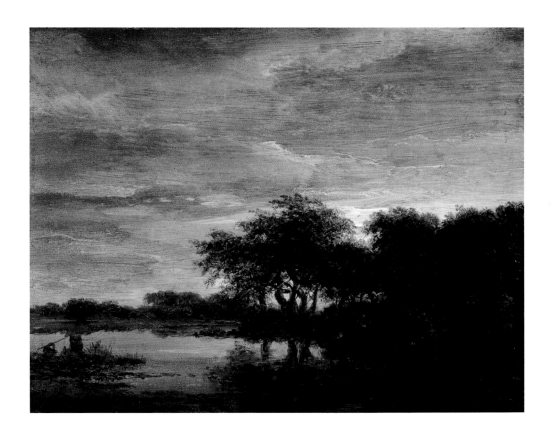

JACOB ISAACSZ.
VAN RUISDAEL
*Woodland Scene with
Lake*, c. 1657

Another exquisite sky is seen in *A View of the Dam with the Weigh House at Amsterdam* (*354*). Here Jacob is completely at home in an urban setting: Amsterdam's great square. In fact, he moved there in 1650, near the end of his life, and lived near the Dam, where he could have mingled with the fashionably dressed pedestrians (those in the painting sometimes given to another hand). The Baroque weigh house is to the left, in contrast with the late-medieval shopping center known as the House under the Sail, which, with the Oude Kerk, is to the right.

Coming from a poor, widowed family, the very young Jan van der Heyden was apprenticed to a glass painter. His teacher in landscape painting is unknown. Like so many leading Dutch artists, van der Heyden, to make ends meet, needed a second job, and his was that of inventing improved fire-hoses (etching a series of these under operation) and bettering street illumination.

Many of van der Heyden's urban views are on the arid side, singularly detailed, seemingly re-creating every single brick, as if painted after

consulting a telescope or camera obscura. But Berlin's Amsterdam view (*355*), from the celebrated Pelham Clinton Hope Sale of 1898, is unusually open and free. Close to Vermeer in its brilliance and sense of surprise, this city view, like so many of the best Dutch landscapes, gives the sky its due, letting that eloquent void stress the intrusive, shabby character of urban sprawl. There, to paraphrase "Holy, Holy, Holy!" (Heber's hymn of 1827), not only is man vile, but so are all his dismal prospects.

Jacob van Ruisdael's pupil, Meindert Hobbema, the last of the major Dutch landscapists, was painter of the proto-Rococo *Village Street under Trees* (*355*) of c. 1665. Just as Hobbema adopted an alien career and became active as a wine gauger for the Amsterdam customs house, so did his master. Jacob seems to have turned to surgery as a second career when the art market collapsed in the 1670s and he was in his late forties. With Jacob's death in 1682, major Dutch landscape painting came to an end; even Hobbema had ceased painting by the 1660s, when the demand for these magisterial images was all but gone.

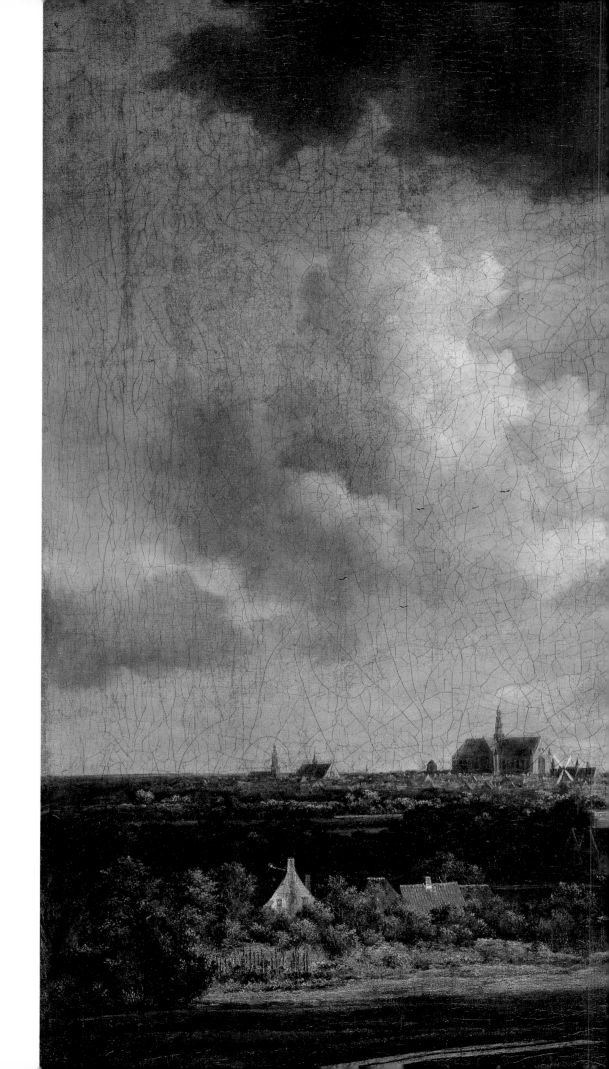

JACOB ISAACSZ.
VAN RUISDAEL
Haarlem Seen from the Dunes to
the Northwest, c. 1670

352

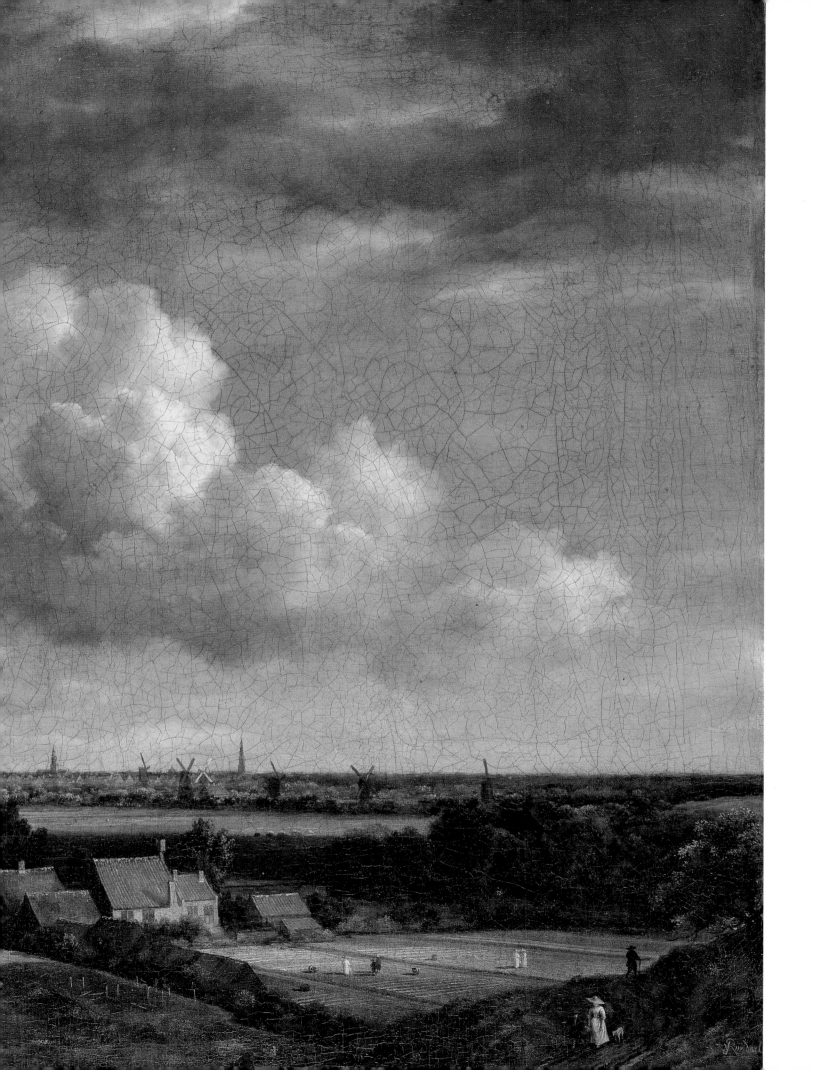

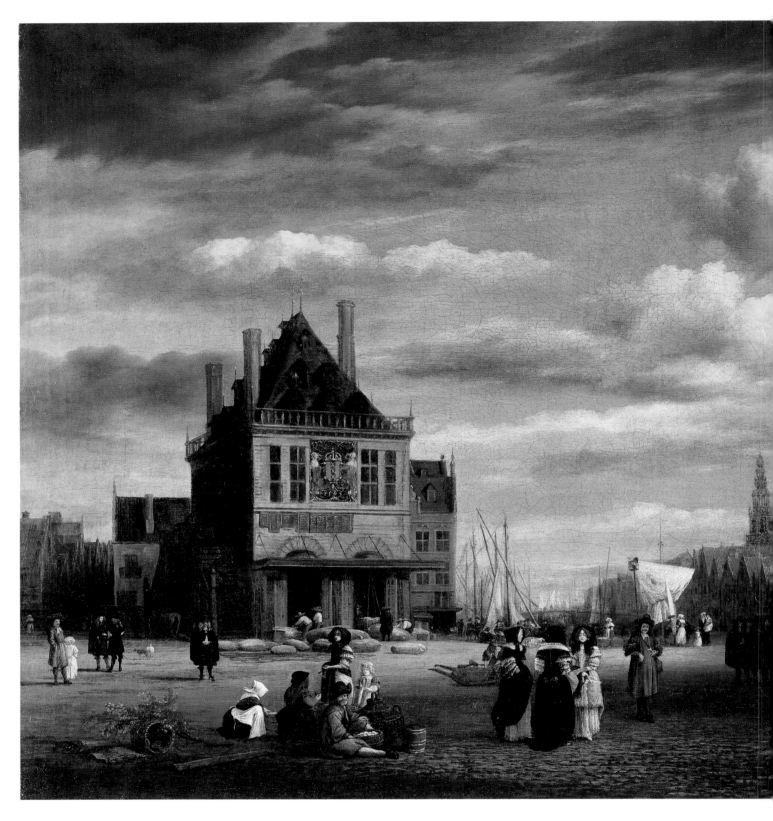

JACOB ISAACSZ. VAN RUISDAEL

A View of the Dam with the Weigh House at Amsterdam, c. 1670

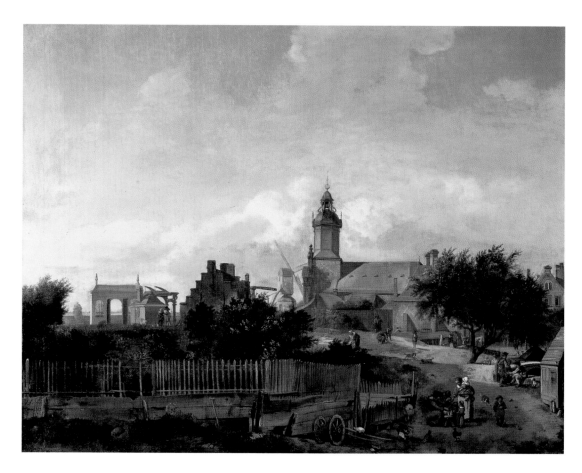

JAN VAN DER HEYDEN, Gorinchem (Gorkum), 1637–Amsterdam, 1712
Amsterdam: Street Before Harlem Tower

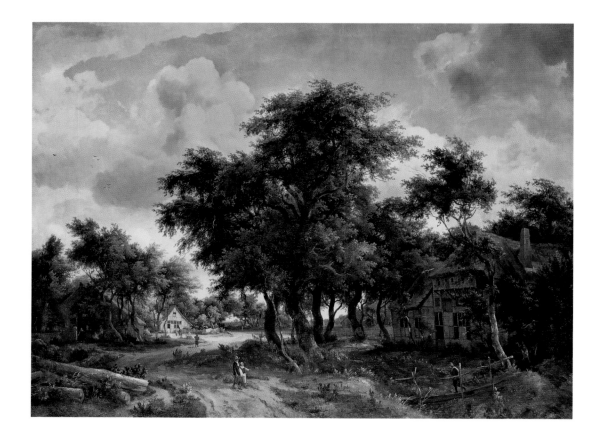

MEINDERT HOBBEMA
Amsterdam, 1638–1709
Village Street under Trees, c. 1665

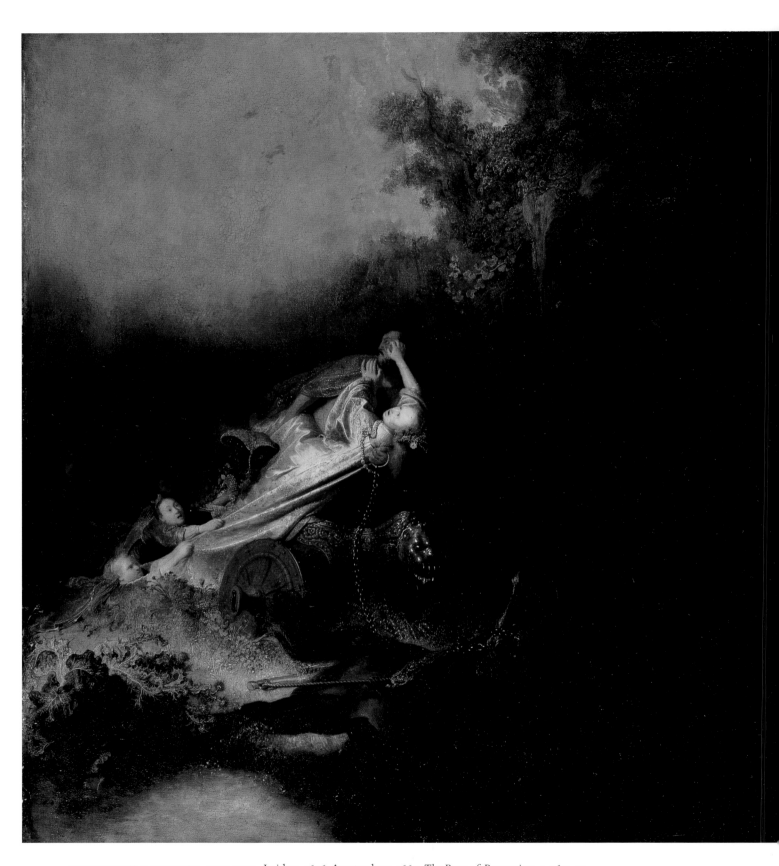

REMBRANDT HARMENSZ. VAN RIJN, Leiden, 1606–Amsterdam, 1669, *The Rape of Proserpina*, c. 1631–32

REMBRANDT'S VISION

Collecting and scholarship concerning the oeuvre and life of Rembrandt Harmensz. van Rijn long bordered upon a German monopoly. The artist's works, like Rubens's, were widely collected by the Hohenzollern, many of these acquired by inheritance from the Houses of Orange and Hanover. Rembrandt's Prussian popularity continued riding high long after the last emperor's exile to the Lowlands after World War I, when his paintings remained among the favorites of Berlin's art historian–curators and its public.

Rembrandt, son of a prosperous miller — the family name derived from their mill's location on the Rhine — was given an early humanistic education in Leiden, where he first worked in the studio of Jacob van Swanenburgh. He then studied in Amsterdam under the accomplished, Italianate painter Pieter Lastman (*361*). The young artist may have moved there for the many important portrait commissions that made him preeminent in that field for many years. He was also highly successful as a teacher until the too-well-known later years of personal and financial loss. Contrary to sentimental mythology based upon his art's humanity, the painter was far from saintly and, in fact, proved to be singularly mean-spirited.

Like Rubens, Rembrandt, who was registered at Leiden's university, received an unusually extensive education for a seventeenth-century painter. Unlike Rubens, Rembrandt never went south of the Lowlands. What he knew of antiquity or the Renaissance had to cross the Alps, so classical ideals never played the powerful role they had upon the Fleming's art.

Rembrandt's early *Parable of the Rich Man* (*358*) of 1627 is Caravaggesque in its dramatic lighting and effective use of theatrical props such as account books and legal documents. It reflects a lively concern with the art of Utrecht, that Netherlandish cen-

ter known for paintings displaying a striking chiaroscuro, also an aspect of the earlier art of Antwerp, following such masters as Cornelis Massys (*164*) and Jan Sanders van Hemessen (*165*). Here Rembrandt paints the parable in which Jesus declares that "the kingdom of heaven is like unto a merchant man, seeking good pearls, who, when he had found one pearl of great price, went and sold all that he had and bought it" (Matthew 13:45–46).

Another biblical subject, this one from the Old Testament, painted on panel in 1628, depicts Samson's downfall while he lies asleep in Delilah's lap (*358*). She is about to cut his hair, the secret source of his strength, in a scene that has long symbolized women's sexual allure as their strength and men's weakness. Here the biblical strongman's dependence upon his mistress Delilah is, possibly unconsciously, intensified by Rembrandt's placing him between her legs, his head resting upon her breast. This suggests the classical theme of *Caritas Romana*, in which an imprisoned Roman is saved from starvation by nursing at his daughter's breast.

Berlin has two of the artist's most exquisite earlier works, each rendered in unusual detail — the *Rape of Proserpina* of c. 1631–32 (*356*) and the *Minerva* of 1635 (*358*). Both entered the museum from the Prussian royal collection. Though on wood, they look as if they had been painted on copper, qualifying them for the highly prized category of "cabinet paintings" — pictures that fulfill the requisite innate preciousness demanded by the most conservative collectors. But these two panels of mythological subjects go far beyond technical virtuosity and commercial value: each conveys a special sense of experience in intensely capsulated, intimate fashion.

A new, bravura style informs *Samson Accusing His Father-in-Law* (*359*), a canvas of 1635, also from the Prussian royal collections. In terms of physiog-

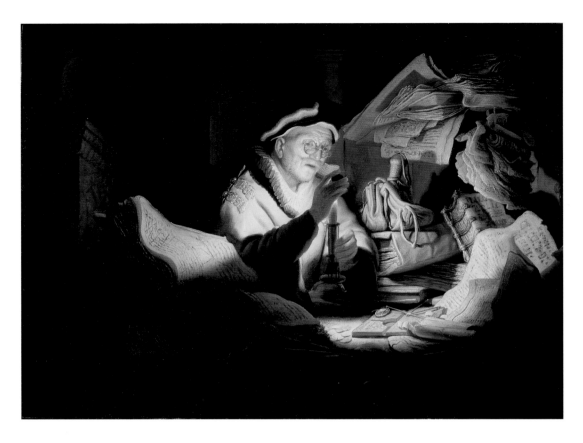

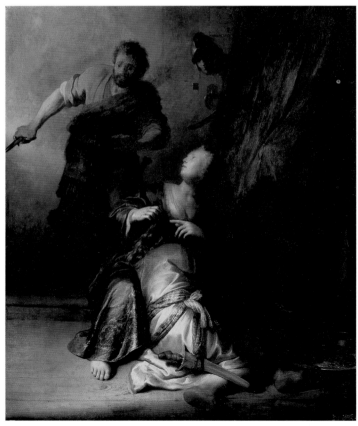

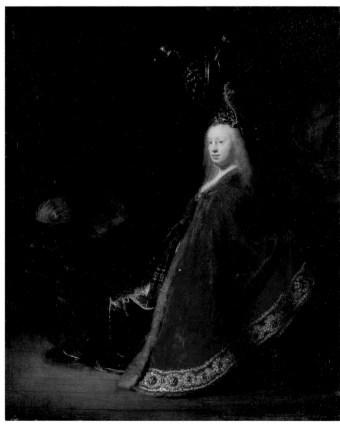

REMBRANDT, *Samson and Delilah, 1628*

REMBRANDT, *Minerva, 1635*

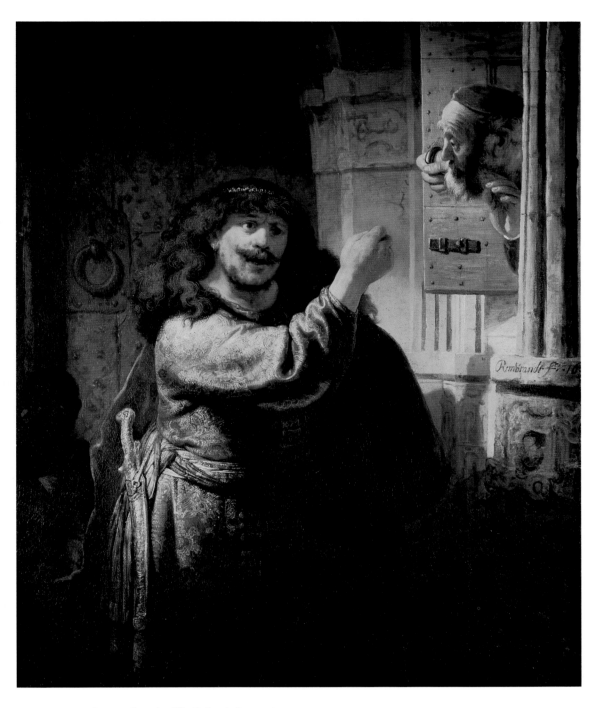

REMBRANDT, *Samson Accusing His Father-in-Law*, 1635

nomy, Samson is almost a Rembrandt look-alike. Enraged, he shakes a fist at his Philistine father-in-law, furious that his promised bride was given to someone else. This rhetorical, all-too-obvious image suited the artist's early love for extremes of gesture. Samson's image is invested with the costly Near Eastern armor and textiles Rembrandt collected at disastrous expense, employing their pres-

ence to add a documentary character to his biblical and classical subjects.

No artist made more self-portraits than Rembrandt. They ranged from the etched or drawn physiognomical, Socratic "Know Thyself" to the coarse celebrations of early, smug success, and terminated in compassionate explorations of the painter's aged facial terrain, surveyed with the lin-

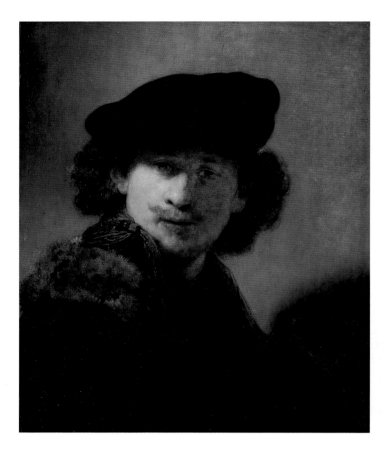

REMBRANDT
Self-Portrait with Velvet Beret and Furred Mantel, 1634

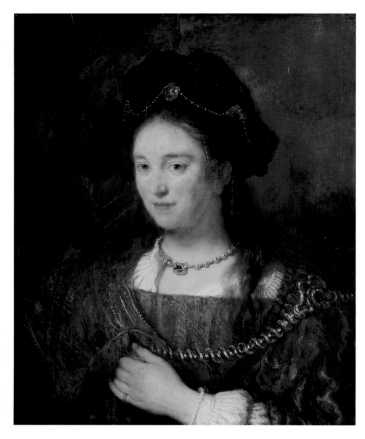

REMBRANDT
The Artist's Wife, Saskia, 1643

gering, dependent affection of a farmer appraising his wintery fields.

At twenty-eight, when he was well established in Amsterdam, the artist presented himself in rich, romantic attire (*360*). In 1634, the year of this portrait, he had married the well-born, yet not wealthy, Saskia van Uylenburch, the orphaned daughter of a leading jurist from Friesland and niece of a prominent Amsterdam art dealer. His expression fuses resignation and expectation. This would prove all too suitable to the sudden end of Saskia's life, eight years later, after she gave birth to their only child to survive.

Like Rubens's dramatic portrait of Isabella Brant, his deceased first wife (*302*), Rembrandt's life-size effigy of Saskia (*360*), of 1643, was painted one year after her death. She is portrayed in similarly theatrical fashion, decked out in "historical" attire, gems, and turban, through which Rembrandt strove for a timelessness to reinforce the power of her lost presence. Saskia had been closely studied in the more

than twenty portraits for which she posed. In addition to the poignant pictorial sentiment of "When this you see, remember me," the genesis of this image necessitated the votive act of recollection by re-creation, fixing the tragic brevity of visual memory, if not of life, beyond time's erasure. This painting's support, an unusually durable and costly mahogany, as noted by Rüdiger Klessmann, allows for subtle, glimmering highlights. A self-portrait on mahogany (England, private collection) is its probable pendant.

Susanna and the Elders (*361*), also painted on mahogany, in 1647, was once owned by Sir Joshua Reynolds, who was among Rembrandt's greatest admirers. This composition is still dependent upon one by Rembrandt's teacher, Pieter Lastman, of 1614 (*361*). The subject was popular for its moralizing *and* erotic aspects involving lust, wifely virtue, and, ultimately, justice triumphant. Susanna prays for strength to resist the evil Elders who threaten her with damaging lies if she fails to accommodate

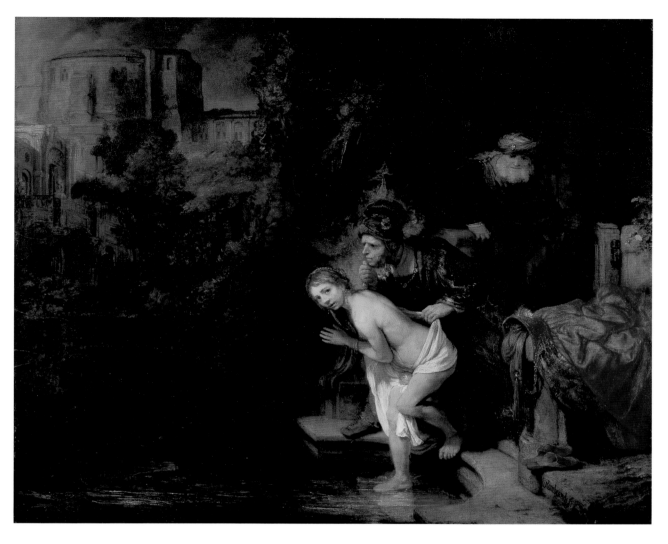

REMBRANDT
Susanna and the Elders, 1647

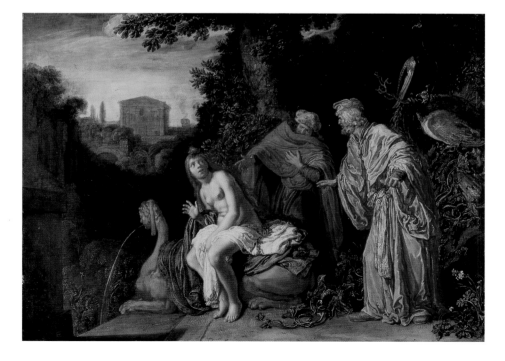

PIETER LASTMAN
Amsterdam, 1583–1633
Susanna and the Elders, 1614

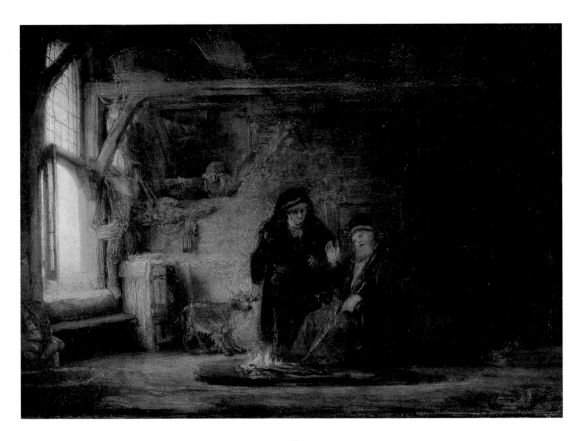

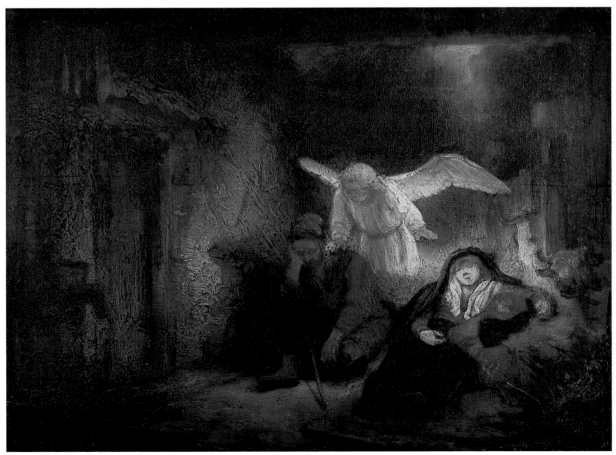

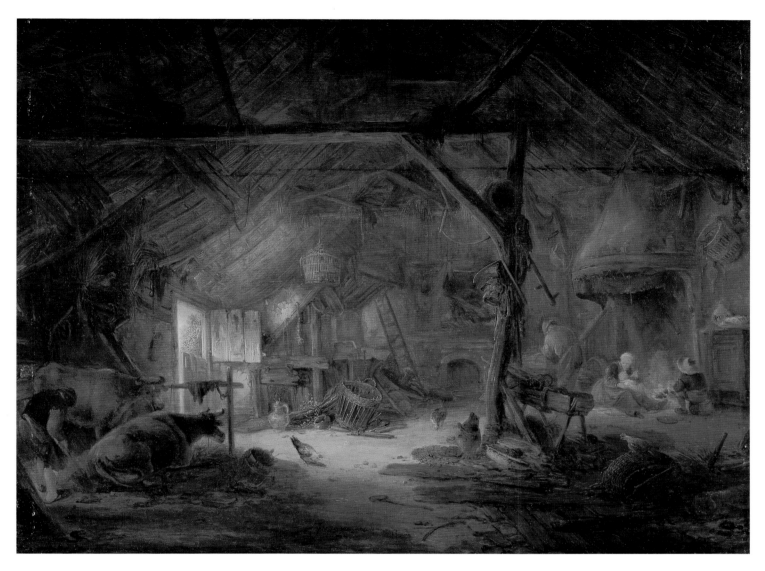

ISACK VAN OSTADE, Haarlem, 1621–1649, *Barn Interior*, 1645

their passion. Rembrandt adds an almost cinematic sense of narrative, making this scene like a still from some Cecil B. De Mille epic. The story — sometimes called the world's first detective story — has a happy ending: Susanna was condemned to death, but the prophet Daniel, then a young judge, refused to accept this false sentence and ruled for the Elders' fatal stoning instead.

Intimately observed subjects — *Tobit's Wife with the Goat* (362) and *Joseph's Dream* (362) — demonstrate Rembrandt's gift for restaging humble biblical settings in terms of his own times, allowing for an easy identification with those tellingly familial events, whether blind Tobit's reluctance to accept the kid that was given to his hardworking wife lest

it prove stolen, or old Joseph's forewarning of the Massacre of the Innocents.

The artist, whose own father was blind in later life, may have identified himself with Tobit's son, Tobias (197), who found the cure that restored his father's vision. This was a popular subject in Rembrandt's art, as suggested by Julius Held. Close to many different Christian sects in Amsterdam, and to the city's Jewish community, the painter also saw his works as a way to restore sight by insight, enhancing the viewer's understanding, sympathy, and faith. An Isack van Ostade *Barn Interior* (363) shows how Rembrandt's contemporaries caught on to the mixture of realism and exaltation that made his scenes of humble life of such singular emotional impact.

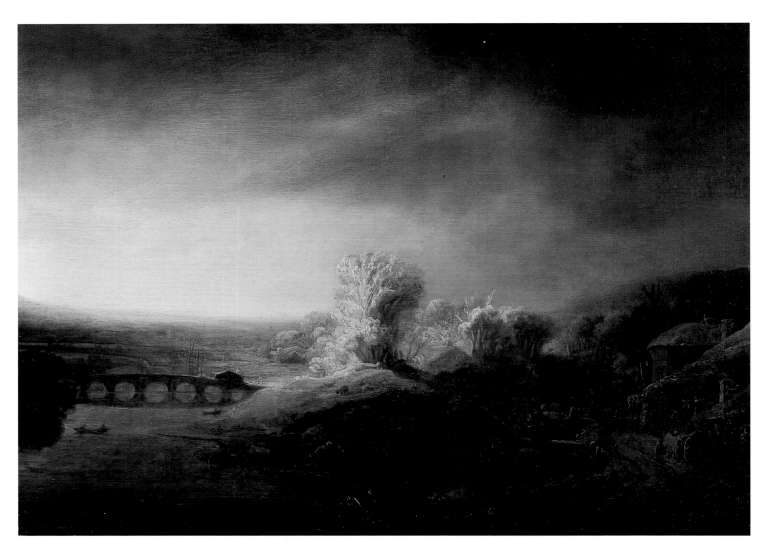

REMBRANDT
Landscape with a Long Arched Bridge,
late 1630s

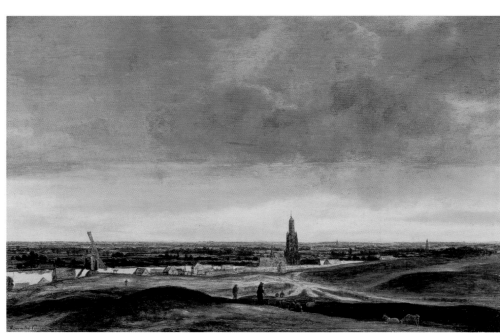

HERCULES PIETERSZ. SEGHERS
Haarlem (?), 1589/90–The Hague or
Amsterdam, before 1638
View of Rhenen, c. 1625–30

Whether by Rembrandt or an equally gifted associate, a *Landscape with a Long Arched Bridge* (*364*) shows the Dutch painter's mastery of that challenging genre, combining intimacy and grandeur, as did Guercino. Where the Italian artist usually saved such rustic skills solely for drawing, there are enough persuasively Rembrandtesque landscape oils to ascertain the Dutch artist's having painted some. Often, like this one, they are under the impress of his singularly gifted contemporary Hercules Seghers, whose *View of Rhenen* (*364*) demonstrates the low horizon and incipient drama that, along with Seghers's unique etching style, were very well known to Rembrandt. Both artists' landscapes seem far more than just what meets the eye, becoming transcendental visions of Creation and creativity, reflecting eternity and mutability alike.

Among the most unusual of Berlin's many Rembrandts is a *St. John the Baptist Preaching* (*366–67*), which was probably commissioned and first owned by the artist's important patron and friend, Amsterdam's burgomaster Jan Six (1618–1700). Though very large, the highly restricted coloring suggests this may have been an elaborate sketch for an etching. Variously gloomy, hopeful, or confounded, the crowd assembled near the Jordan to hear John preach includes many priests who have joined the multitude gathered in the Judean wilderness for baptism to be performed by John. He preaches the message of the coming of the Messiah who will baptise them by the fire of the Holy Spirit.

With a similarly arched top, *Christ and the Woman of Samaria* (*366*) shows the meeting at Jacob's well and Jesus' request for water. As if observed firsthand, almost shocking in its documentary immediacy, Rembrandt's scene is among the most effective renderings of the dramatic dialogue that concludes with the woman's saying "I know that the Messiah cometh, which is called Christ: when he is come, he will tell us all things," and Christ's reply: "I that speak unto thee am he" (John 4:25–26). Such moments of sudden exchange and recognition are among those so well understood and conveyed by Rembrandt, perhaps because art at *its* best often approximates that same process, a "dialogue for seeing" rather than hearing.

Rendered in a thick impasto, this daring panel of

1659 makes it seem as if the subject had never been shown before. Obviously that's far from true. In fact, as Rüdiger Klessmann suggested, a lost painting of this subject, ascribed to Giorgione, was in the Dutch artist's possession and may have contributed to this striking composition's genesis. Its singularly expressive quality certainly explains the painter's enduring popularity.

Often Rembrandt's friends proved to be his most fortunate patrons, receiving not only their likenesses but a portrayal of the quality of their lives. Both are found in *The Mennonite Preacher Cornelis Claesz. Anslo and His Wife Aeltje Gerritse Schouten* (*368–69*) of 1641, painted just after the completion of Rembrandt's most famous commission, his so-called *Night Watch* (Rijksmuseum). Forerunner of what the English were to call a "conversation piece," this large canvas, all too obviously striving for a certain informality, shows a prosperous couple very much at home, their house that of the Lord.

In Rembrandt's artful restaging of the domestic drama of marriage, Cornelis (1592–1646) seizes the limelight, caught in a rhetorical gesture suitable to his role as leader of and preacher to Amsterdam's Mennonites. Far from forgotten, Aeltje (1589–1657) listens into the night with critical attention as her husband expounds upon the Word, which he has found in those sacred books on the Anslo's richly carpeted working table. Like a Utrecht School still life, these texts, a lectern, and the guttering candle have a vitality all their own. Here they are not intended as a "Vanitas," but point to the source of Anslo's life and learning and are emblematic of his ministerial vocation. As Rembrandt was very close to the Mennonites, this major canvas, if not a labor of love, gave the Anslos far more than their money's worth. Unlike most ministers, Anslo actually had a lot to spend, as his vocations included that of highly successful businessman.

Joost van den Vondel, the Netherlands' leading poet of the day, while appreciating Rembrandt's virtuosity as demonstrated by the etched portrait of Anslo, which probably just predated this double portrait, commented: "Now Rembrandt, paint Cornelis's voice / For what can be shown, counts least. / Only hearing perceives the invisible. / To see Anslo, he must be heard." Just as the poet

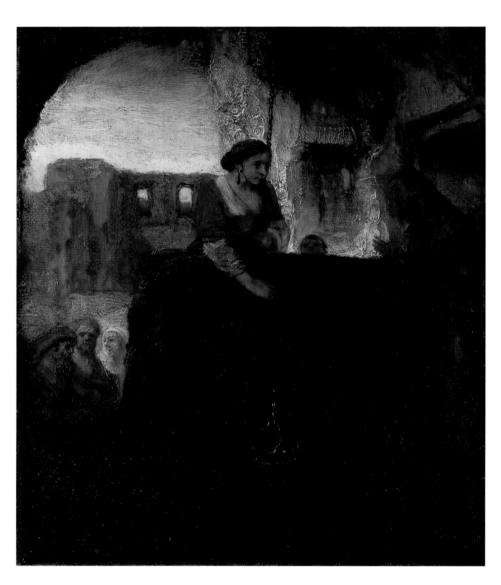

REMBRANDT
Christ and the Woman of Samaria, 1659

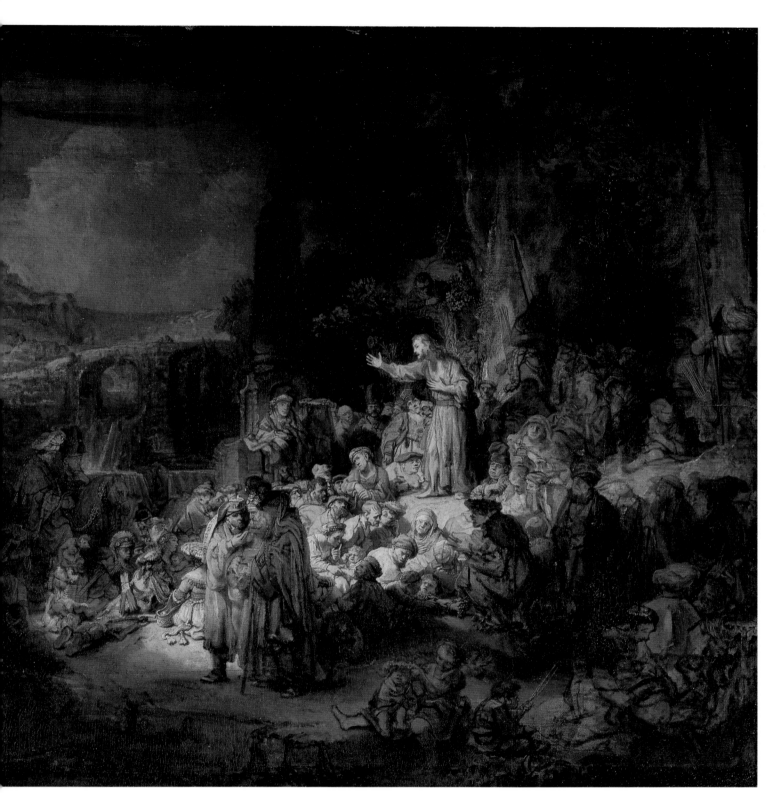

REMBRANDT
St. John the Baptist Preaching, c. 1634–36

REMBRANDT

*The Mennonite Preacher Cornelis Claesz. Anslo
and His Wife Aeltje Gerritse Schouten*, 1641

368 *Masterworks in Berlin*

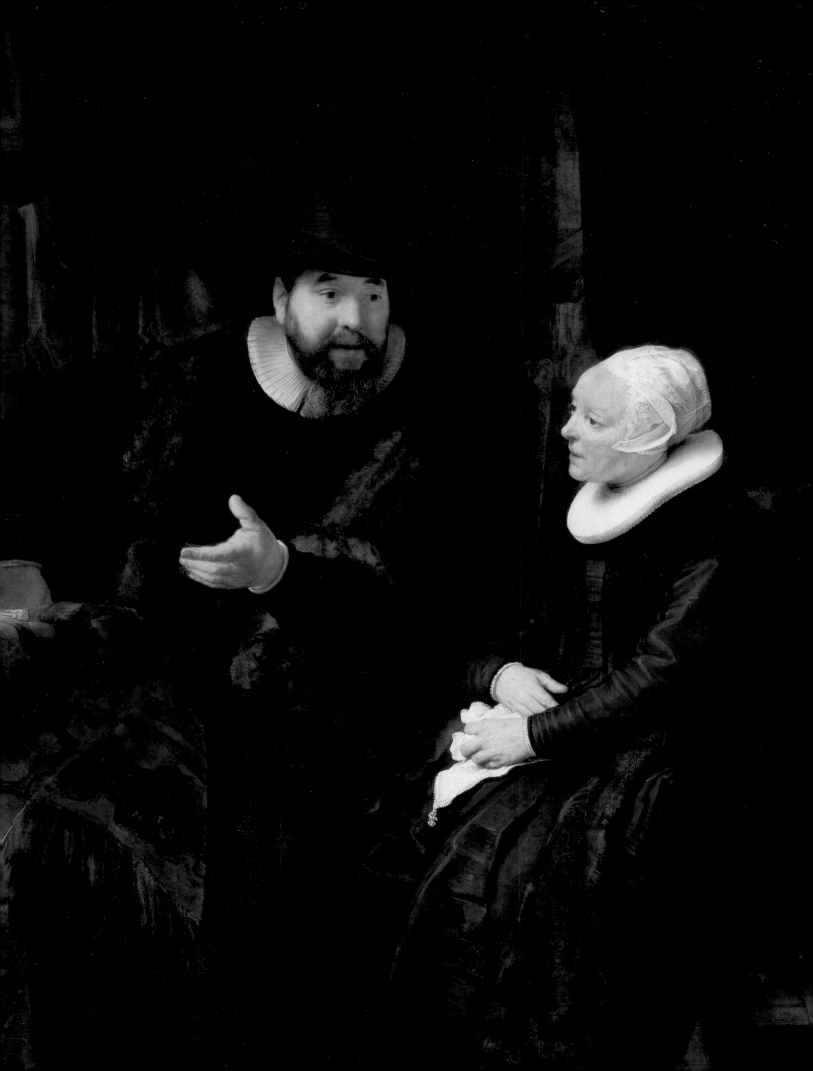

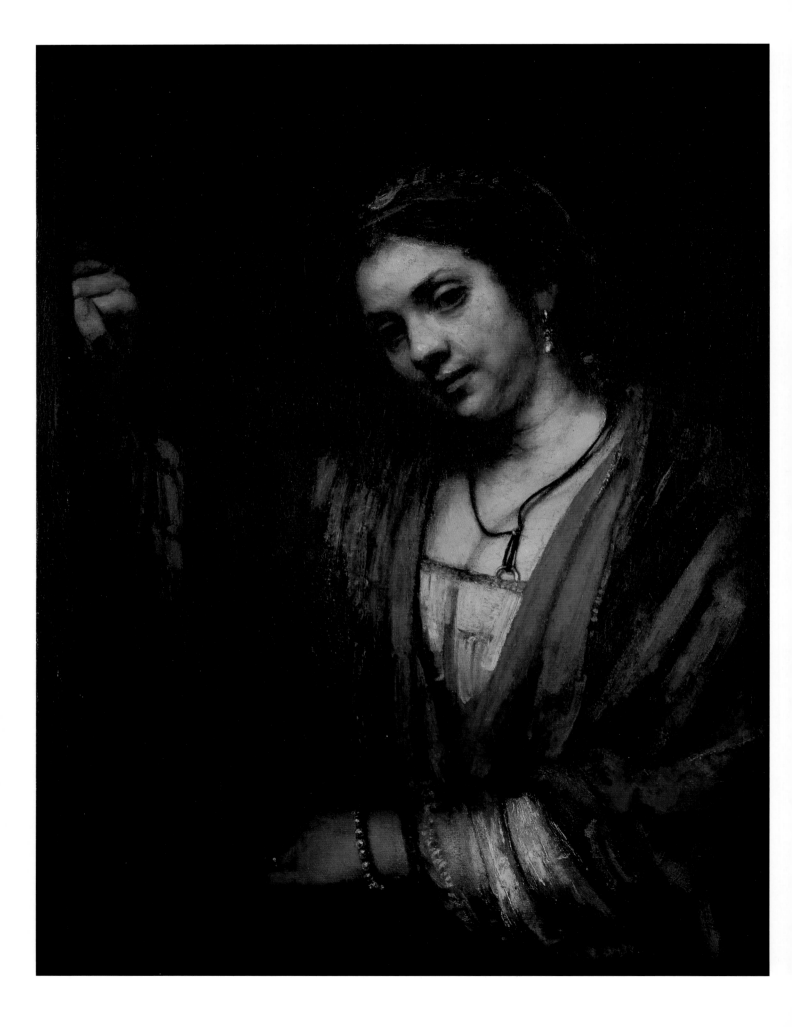

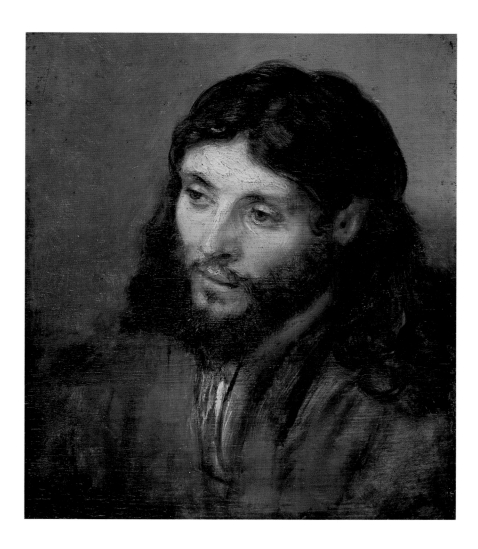

Opposite:
REMBRANDT
Hendrickje Stoffels, c. 1659

REMBRANDT
Head of Christ, c. 1655

returned to a classical *topos* — the need to paint the so-called "speaking likeness" — so did the painter rise to the challenge, coming as close to the word, both the spoken and the written, as possible.

Those rounded upper corners of the canvas were probably cut in the eighteenth or nineteenth century, when that unfortunate format was fashionable.

Though Rembrandt often treated his faithful mistress Hendrickje Stoffels (c. 1625/26–1663) shabbily, he often portrayed her magnificently. In a canvas of c. 1659 (*370*), hers is a pensive, possibly Sibylline image, standing at a double door. Jan Kelch suggested that the key or ring suspended over Hendrickje's heart may be emblematic of domestic virtues, of housewifery, all too appropriate to Hendrickje's servant origin and fate. Yet in this archetypically Baroque canvas — Hendrickje bathed in radiance and encircled with pearls — she is seen in a make-believe exaltation far beyond that of *Hausfrau*. By the time of this picture's painting, Rembrandt had had to sell his vastly varied collection at auction in 1656, and to begin working nominally as an employee for Hendrickje, and for his son Titus. They had set themselves up as art dealers to save him from further debt.

Some of Rembrandt's heads of soulful young men, possibly modeled upon residents of Amsterdam's large Ghetto, are often catalogued as representations of Christ. Berlin has a fine example of this genre (*371*), c. 1655, which may correspond with an image recorded in the artist's bankruptcy inventory as "a portrait of Christ painted from life." Just that unlikely fusion of distant past and present permeates Berlin's panel, making it both lifelike *and* Christlike.

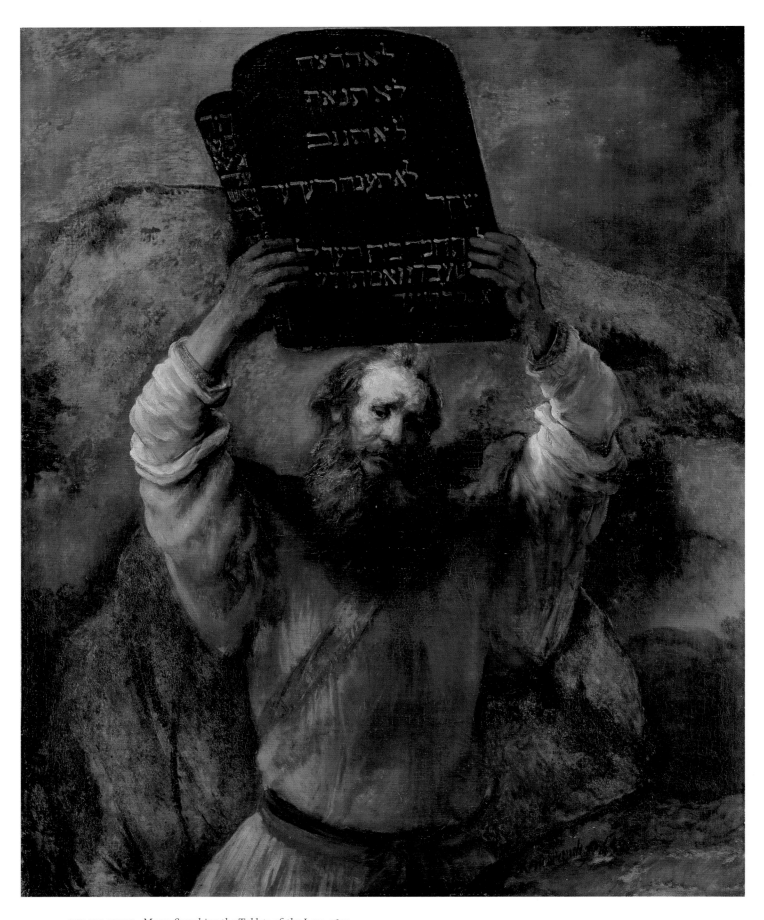

REMBRANDT, *Moses Smashing the Tablets of the Law*, 1659

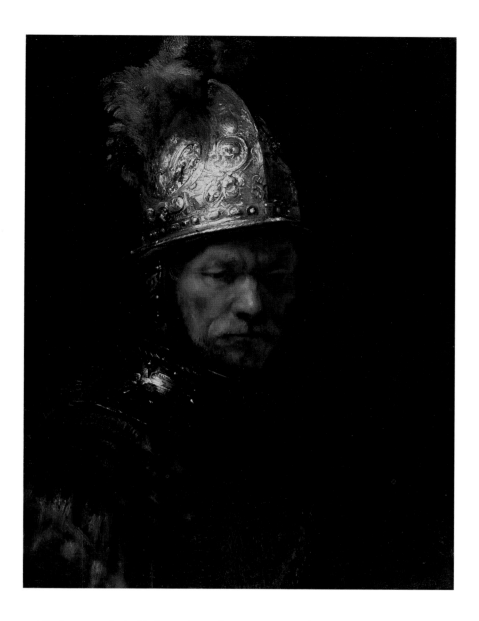

CIRCLE OF REMBRANDT
The Man in a Golden Helmet,
c. 1650–55

Uncharacteristically large in scale is a canvas of *Moses Smashing the Tablets of the Law* (*372*) of 1659, from the Prussian royal collection. It was probably painted for Amsterdam's massive, magnificent city hall — part palace of justice, prison, and bank. This Titianesque image testifies to the identification of the Dutch Republic, like that of Venice, with the Children of Israel. Preserved by dikes, the Dutch, too, were the Chosen People, perpetually saved from the surrounding waters. A haven of political and religious tolerance, the Dutch state often saw its national destiny in terms of the Old Testament, so Moses' image enjoyed special popularity, with Exodus seen as both prophecy and celebration of the founding and perpetuation of the Dutch Republic. The work was painted about the same time as

the artist's poorly preserved *Jacob Wrestling with the Angel*, which is also in Berlin.

The Man in a Golden Helmet (*373*), of controversial authorship, remains among "Rembrandt's" most popular pictures, although now it is generally placed in his circle and dated c. 1650–55. Rendered with virtuosic power, the glittering Renaissance helmet and gorget, in relief, almost demand touching. Such images of elders in antiquated armor are usually of Mars, but this is no Roman war god, or even a professional model; he is just another shabby old man, one of many who shuffled through the studio of the artist who was far more the poet of age than of youth.

If our canvas has any special significance, it may be that beloved chestnut of "Vanitas," conveyed

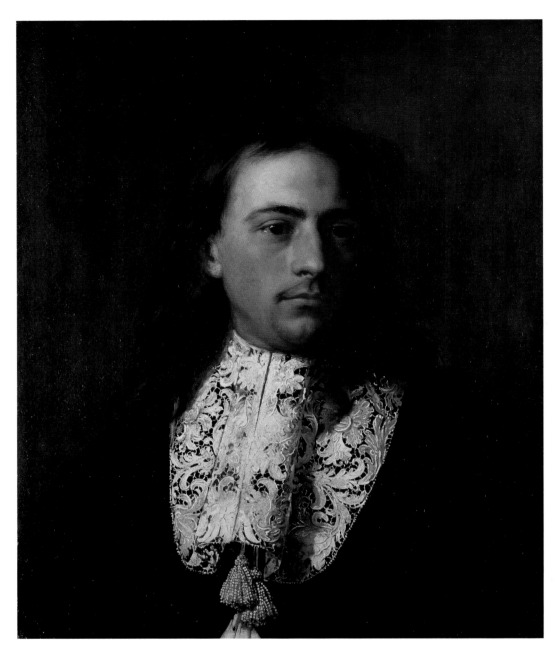

ATTRIBUTED TO CARLO MARATTA, Camerano (the Marches), 1625–Rome, 1713, *A Young Man*, 1663

here by the striking contrast between the *Ars longa* of the brilliantly preserved, gilded helmet, possibly from Rembrandt's extensive collection, seen in such painful contrast to the timeworn visage of its wearer, personifying *Vita brevis* — his past glories defeated by time. Should this moralizing rearmament prove a later addition, designed to make some Amsterdam bum more purveyable, then it would be a "Vanitas" of quite another kind!

Also from Leiden, Jan Lievens shared Rembrandt's teacher and studio. The two students'

works verge on the interchangeable, which is true for the *Old Man in Oriental Garb* (*375*) painted in Leiden c. 1628–30, when both artists used the same model. This canvas was recorded by Rembrandt's friend Constantin Huygens in his autobiography as an important Lievens of a *Dux Turcicus*, but has long been listed in Berlin as a Rembrandt.

Rembrandt was popular as a teacher and had a very large and profitable workshop with many student followers, including such outstanding painters as Gerard Dou, Aert de Gelder, Carel Fabritius,

Philips Koninck, Ferdinand Bol, Govert Flinck, and Nicolaes Maes. Sometimes master and pupil worked in collaboration, making it hard to ascertain just what belongs in Rembrandt's oeuvre. (That dubious process, primarily of commercial significance, has now been undertaken by a self-anointed Dutch committee.)

Portraiture by Rembrandt's contemporaries can be painfully class-conscious. But a *Young Man* (374) ascribed to Carlo Maratta, inscribed in Latin as painted in Rome in 1663 when its sitter was twenty-four, is a welcome exception to that generalization in its sense of "me first, class second." Catching the light in the fashion of a Bernini bust, the subject seems to be gaining a sense of self as he loses his hair; nor are his features diminished or overwhelmed by that compelling cascade of lace just below. Could he belong to Rome's colony of Catholic Englishmen who followed their king, James II, to the Eternal City?

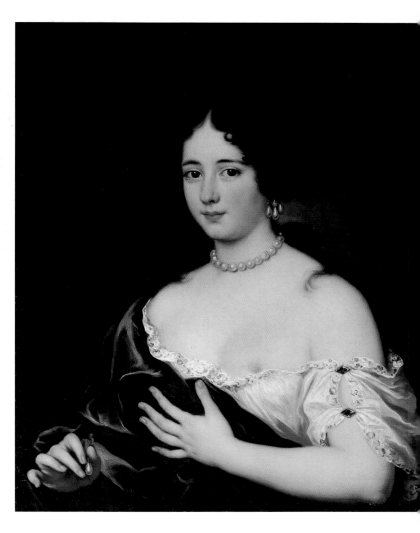

ATTRIBUTED TO JACOB-FERDINAND VOET
Antwerp, 1639–Paris, 1700 (?)
Maria Mancini as Cleopatra, c. 1663–72

Equally successful, if more conventional, is the canvas attributed to Jacob-Ferdinand Voet, a Fleming active in Rome, of Maria Mancini (375), who poses as Cleopatra, about to dissolve a great pearl in wine and down it, so winning a bet with Mark Antony concerning her awesome capacity for conspicuous consumption. As wife of a Colonna duke, and niece of Cardinal Mazarin, Maria herself could almost afford to make such a costly concoction a regular dietary supplement.

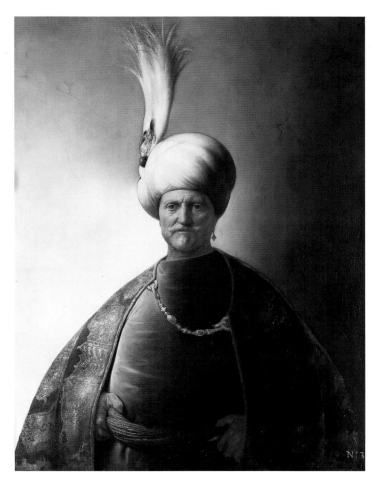

JAN LIEVENS, Leiden, 1607–Amsterdam, 1674
Old Man in Oriental Garb, c. 1628–30

THE METAPHYSICS OF LIGHT:
VERMEER AND HIS CIRCLE

P EARLS, mirrors, freshly whitewashed
walls, black-and-white marble tiles, brass
studs — all these gleaming, glowing,
often-polished surfaces pay homage to the
mysteries of light; their mass of varied reflections
affirm the precedence of Light over Word. That Jan
Vermeer of Delft, the leading master of such reflec-
tive revelation, was a convert to Roman Catholicism
seems in keeping with the almost transubstantiative
quality of his art. The exquisite appreciation and
communication of luminous beauties endow them
with a sacramental sense. Like the silvery mirrored
surfaces that so many paintings from Vermeer and
his circle suggest, these images are usually intimate
in size, which is in keeping with their domestic
subjects and promotes the qualities of accessibility.
Yellow and blue, colors so central to Vermeer's
vision, were, as noted by John Gage, the "dominant
colors of his supremely luminous palette." He
observed how these were stressed by the painter's
contemporary, the Dutch scientist Christiaan
Huygens, as the constituents of white light.

All the hallmarks of Vermeer's art are found in
The Glass of Wine (*376–77*). Light streams in from the
left, through the armorial glass panes of the cur-
tained window, illuminating a carpet-covered table
and richly dressed couple. Why doesn't the man
remove his cavalier's hat? Or his cloak? What gives
him the right to treat the woman in such a propri-
etary fashion? Is his serenade over or about to
begin? Is the woman, seen guzzling her wine, jam-
ming the glass into her face, a lady or a whore? Such
questions seldom arise from images less compelling
than Vermeer's. Only he, endowing every object

JAN VERMEER VAN DELFT, Delft, 1632–1675
The Glass of Wine, c. 1660

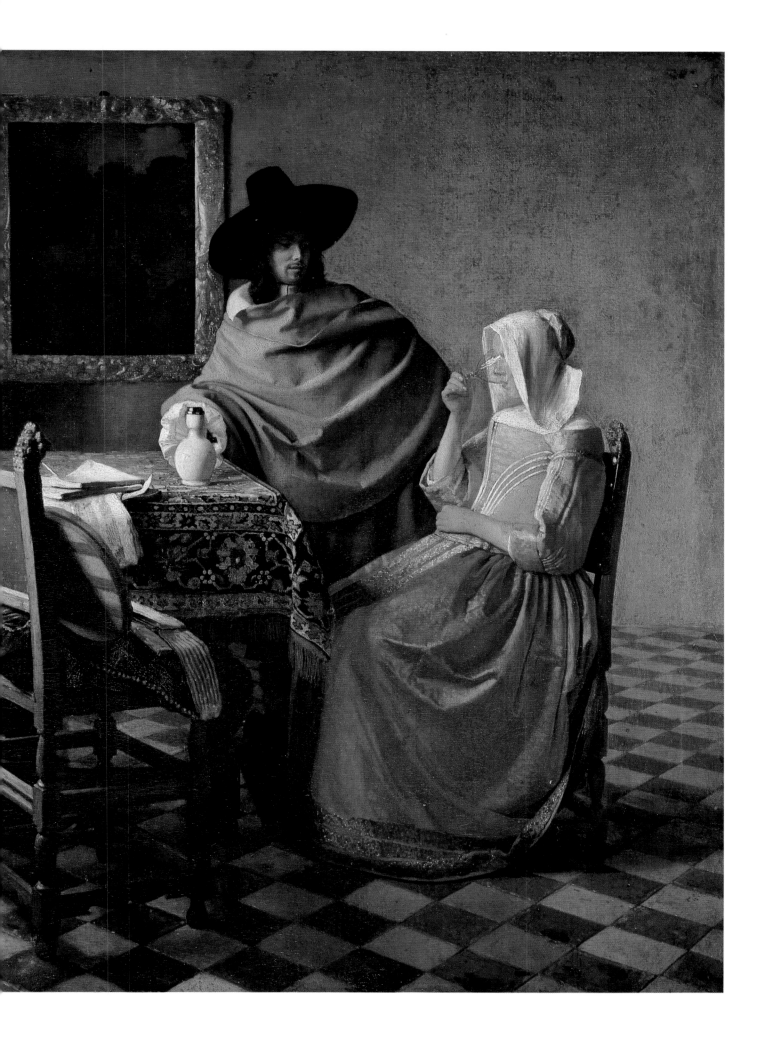

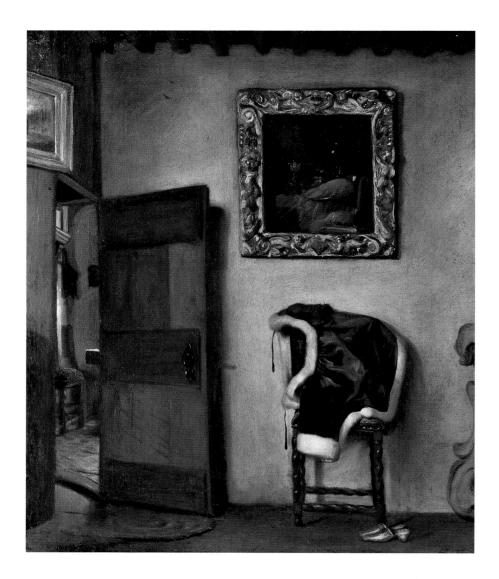

and gesture with seeming significance, often reduces the viewer to so a childish a state, one of "Why? Why? Why?"

The worlds's oldest profession was as entrenched in the Netherlands as in Venice, well established at all the seaports, river ports, and canal ports surrounding the Dutch Republic. Possibly Vermeer's images of men and women belong to a category of calculated ambiguity, leaving it to the beholder to seek and find whatever message might be desired, from one of crass commerce to pure love.

Facing a window, a very richly dressed young woman with a pearl necklace (*379*) studies herself in a mirror. This image may continue the components of "Vanitas" first found in still lifes, such moralizing possibly present in many Vermeers. Steeped in

silence, often alone, the women in his paintings impart a sense of eternity. Imbued by the absolute, they seem perpetually inanimate. Though this scene's components can be traced to contemporary emblem books, allowing for a jigsaw puzzle of symbol interpretation, such a scholarly, verbal-tit-for-visual-tat analysis and explanation may prove far from the artist's intent — or his buyer's wishes.

Vermeer's elusive, oblique arts are found in an appropriately anonymous Dutch canvas (*378*), sometimes ascribed to Hendrick van der Burch, who was also active in mid-seventeenth-century Delft. As with several canvases by Vermeer, this image is distinguished by its absence of overtly mattering subject. An ermine-trimmed satin jacket has been tossed over a chair, and precious slippers rest below;

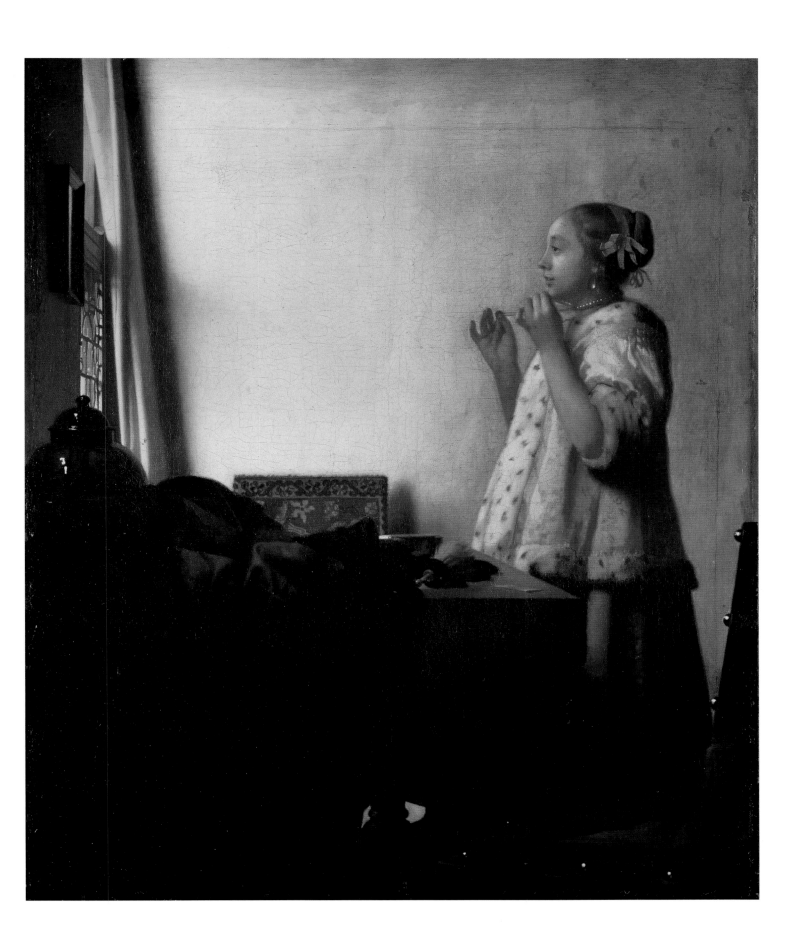

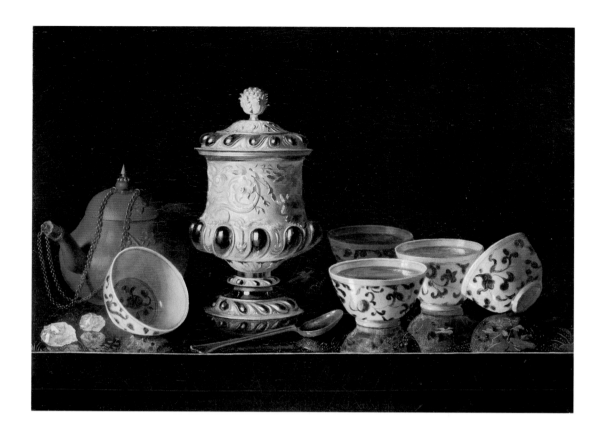

both are seen under an opulent still life in a richly carved and gilded frame. None of these wealthy props are congruent with their more modest domestic setting. Are these the working clothes of a successful prostitute? We'll never know, and thus our almost emblematic ignorance becomes part of this image's enigmatic draw.

A picture limited to still life elements can also take on a reflective, Vermeeresque air, as in Pieter Gerritsz. van Roestraten's *Still Life with Chinese Teabowls* (*380*). As every element is mirrored by the table's gleaming surface, the painter may be preaching at his own Tea Ceremony, providing a pictorial commentary or gloss on the duplicitous nature of reality and illusion. Tea, with tobacco, was among the major Dutch imports, the Netherlands by then being the most far-flung of colonial trading empires.

Time, love, life, beauty, joy, and fortune tend to go, rather than come, and that obvious observation is possibly as close to the meaning of the images of Vermeer and his circle as we are likely to get. His glittering paint surface might be seen as taking on an exquisitely Socratic, mirrored message of Know Thyself. For example, weighing gold was often understood as a foreshadowing of the Last Judg-

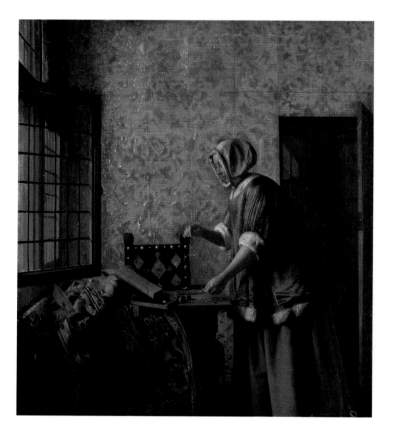

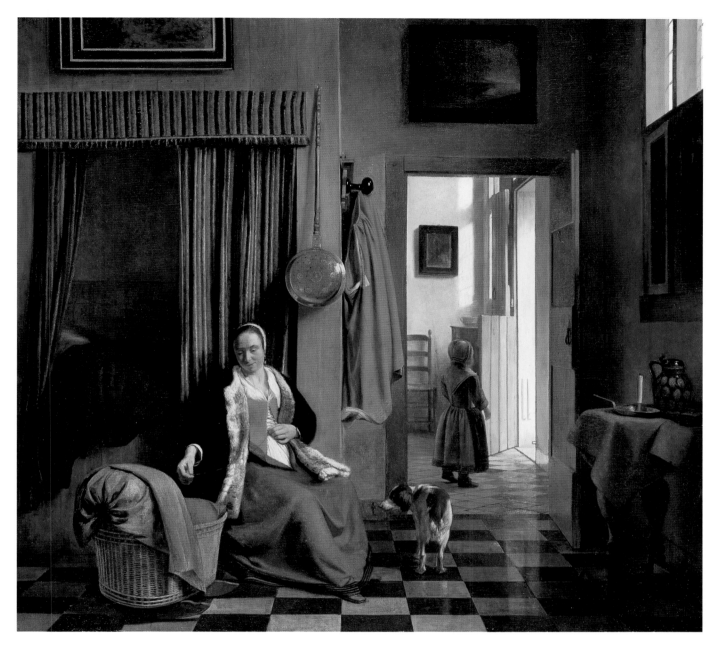

PIETER DE HOOCH, *The Mother*, c. 1659–60

ment, when all souls would be weighed in the balance. Vermeer addressed this subject in his art, as did his senior, Pieter de Hooch, whose *Gold Weigher* (*380*) is peculiarly reminiscent of one by the Delft master (Washington, D.C., National Gallery), who was the source of some of de Hooch's finest interiors and views.

Among the latter's most monumental yet intimate paintings, *The Mother* (*381*) displays an abstract organization that points to a much later Dutch master, Mondrian. The subjects of de Hooch's paintings tend toward the labor intensive, their worthy homemakers kept busy by more than one activity at a time with little, if any, help in sight. This mother sews as she more or less watches over her two children. This paean to a modern madonna is a painting to, as well as of, domestic virtue in keeping with the dictates of contemporary Dutch Calvinism; it exhorts family members to fulfill their obligations to one another in the name of Christianity.

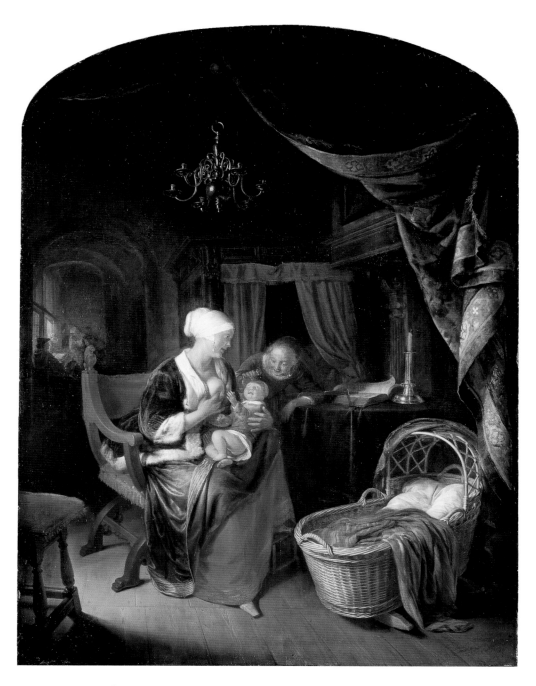

GERARD DOU, Leiden, 1613–1675, *The Young Mother*, c. 1655–60

Much the same theme — in far more sentimental fashion — is seen in *The Young Mother* (*382*) by Gerard Dou. The painter was a lifelong resident of Leiden, and his painting is close to Rembrandt's chiaroscuro but is more superficial and conventional. His setting is also more theatrical: a great tapestry, like the one that frames Vermeer's *The Painter's Studio* (Vienna), is raised to reveal this almost staged vignette of a nursing mother.

Vermeer and de Hooch share their rarified perspectives with several other painters working at their very best. They include Gabriel Metsu, Gerard TerBorch, and Jacob Ochtervelt. A domestic tableau by the last (*383*) contrasts the security of a wealthy home with the hazards of itinerant musicians who stand outside its opened door. Firmly placed within the residence's extended space, the viewer, made affluent by placement in so prosperous a situation,

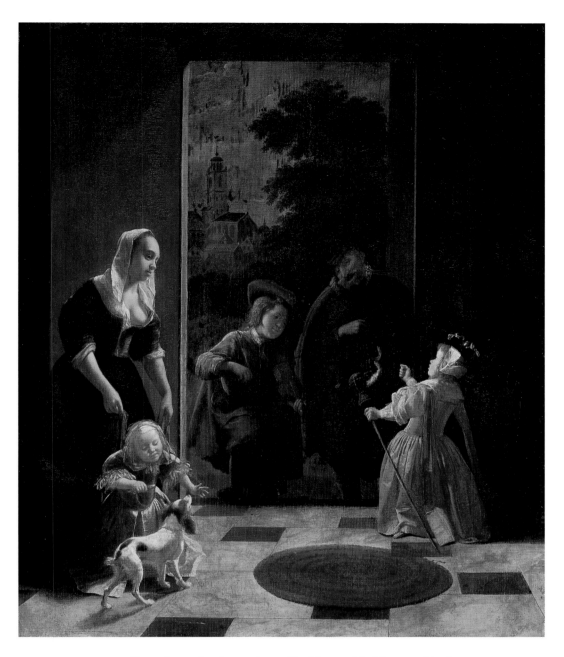

JACOB OCHTERVELT, Rotterdam, 1634–Amsterdam, 1682, *Itinerant Musicians*, c. 1660–65

is aware of the poverty of those without.

Satin highlights illuminate the *Lutanist* (*385*) of 1662, by Cornelis Bega, and the oeuvre of Gerard TerBorch. Seen from the back, dressed in flowing silks, their hair exquisitely coiffed and braided, two women are shown by TerBorch in separate Vermeeresque canvases. In one (*384*), the seated madam guzzles her wine as a cavalier pinches a coin to "buy the favors" of a woman waiting to the left,

facing a grandly curtained bedstead. Eighteenth-century prudery gave this painting the title *"The Fatherly Admonition,"* yet it may illustrate Otto van Veen's proverb from his *Amorum Emblemata* of 1609 to the effect that money talks. A recent suggestion that the woman might personify an unattainable Petrarchan ideal — as far from a *bordeeltje* as possible — seems absurd. More to the point is the view that the painstaking execution of her satin garb, a

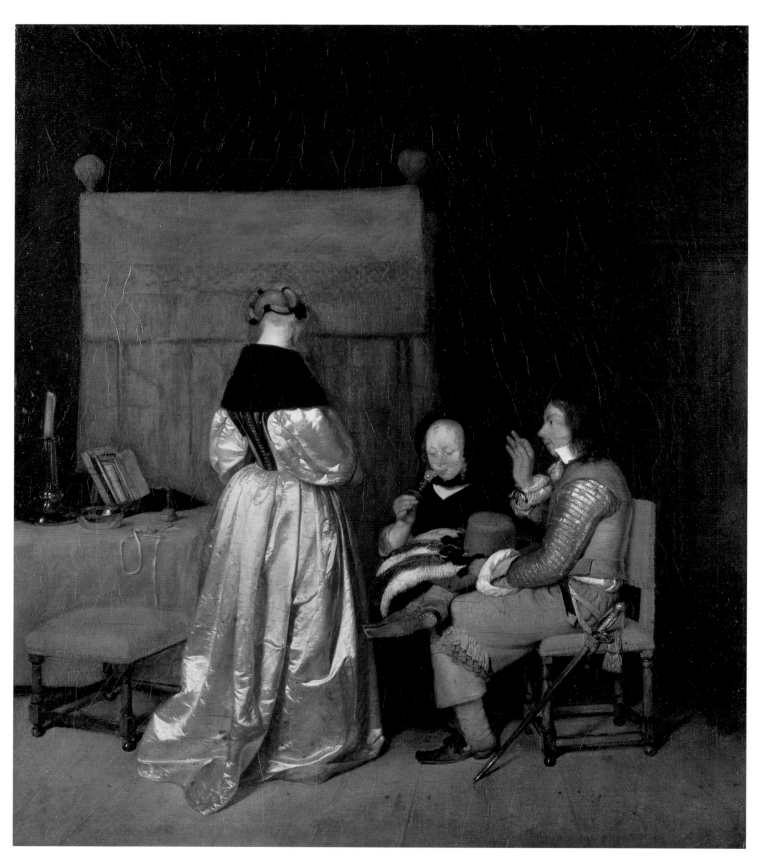

GERARD TERBORCH, Zwolle, 1617–Deventer, 1681, *"The Fatherly Admonition,"* c. 1654–55

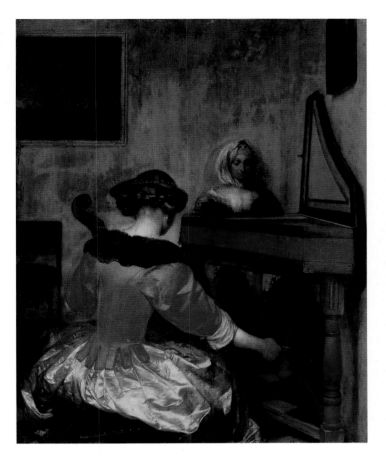

GERARD TERBORCH
The Concert, c. 1675

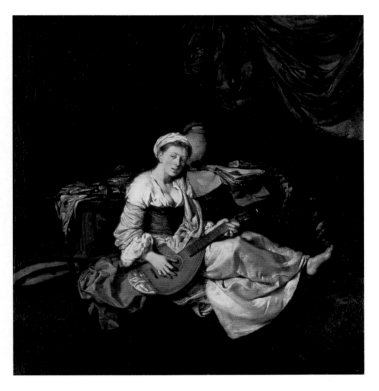

CORNELIS BEGA, Haarlem, 1631/32–1664
Lutanist, 1662

simulacrum of "something of value," enriched the value of the image.

Among TerBorch's most beautiful canvases is a scene of two women, one at the cello, the other at the harpsichord (*385*). Originally, the cellist sat opposite a young man playing the cembalo, as is known from old copies. Perhaps the male accompanist was painted out c. 1900 to hide damages in that area. The keyboard player was painted in by the restorer, who is said to have used his wife as his model. Renowned as a *Fijnschilder* — the most technically refined of the Dutch painters — famous for his delicate, small-scale, highly polished technique, TerBorch could prove to be even more than that. As a master of daring color, his pictures project the complex emotions of human exchange. Completely different are his little, almost monochromatic portraits that can prove singularly penetrating. Most *Fijnschilder* enjoyed steady

patronage, often from a single source, permitting them the luxury of creating such time-consuming, highly finished canvases.

Paradoxically, the *Fijnschilder* often used their polished skills to reflect the widest spectrum of their society, from the life of the prostitute to that of the exemplary mother, from the drunken squalor of a lowly tavern to chic partying. It is as if these artists were painting the nature of Netherlandish life to encompass the widest parameters of the marriage vow — in sickness and in health, for richer or poorer. While these often oddly neutral images are neither overtly exploratory nor documentary and seldom take a stand, they may contain a discreetly concealed moral that is now apt to be known solely to emblem book or proverb fanciers or to scholars.

Equally impressive, with far greater monumentality, is a seated *Lady* (*386*) by Thomas de Keyser. This artist's life was spent in Amsterdam, where his

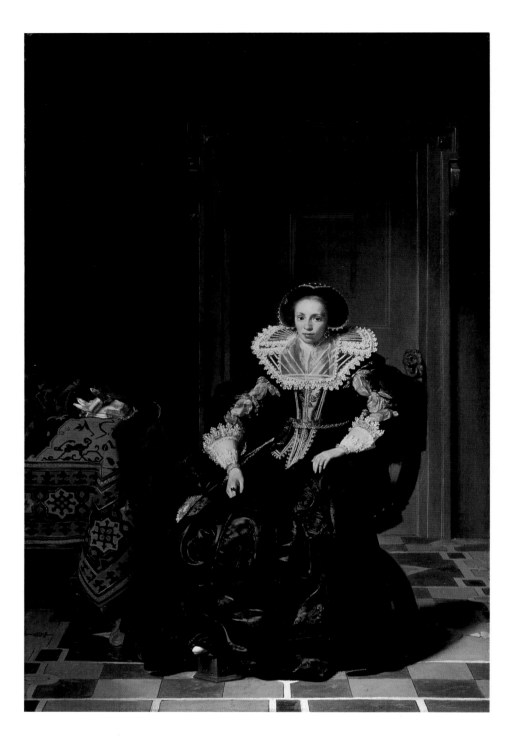

THOMAS DE KEYSER
Amsterdam 1596/97–1667
A Lady, 1632

lustrous, fervent likenesses of the local aristocracy and intelligentsia stand out from those by most of his peers. Seated against a Michelangelesque, Mannerist doorway, an extremely richly dressed young woman poses in the wintertime, her foot resting on a brazier. White gloves laid on the carpet-covered table alongside stress her upper-class status.

TerBorch's atypical *Knifegrinder's Family* (*387*) is awesome in its almost Quietist approach. This gives

his subject — labor and poverty — the spiritual intensity of a parable. This painting comes close to the Le Nain brothers' (*410*) respectful response toward the too-hard-won dignity of the deprived. Here TerBorch can even make flea picking a covenant between mother and daughter. The intense austerity of this canvas recalls Montaigne's observations of peasant life, seeing the severe gravity of their lives as assuming a personification of Nature.

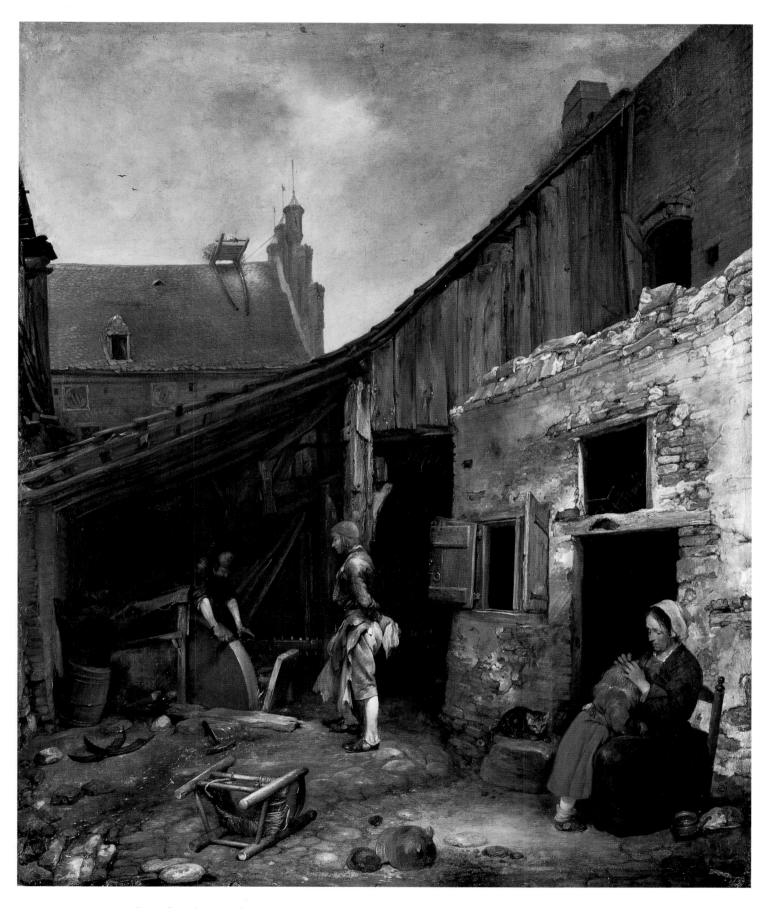

GERARD TERBORCH, *The Knifegrinder's Family*

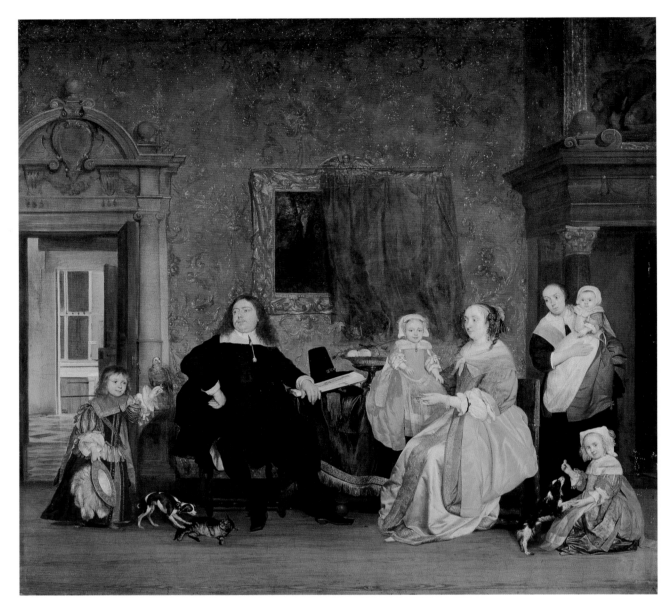

GABRIEL METSU, Leiden, 1629–Amsterdam, 1667, *Burgomaster Gillis Valckenier and His Family*, c. 1675

Close to TerBorch's intimism is that of Gabriel Metsu. He managed to escape the complacent or voyeuristic dimensions of a subject beloved by the Dutch, that of the sick girl (*389*). Often these "sick" girls were prostitutes, chagrined by a diagnosis of pregnancy or other "ailment" that would keep them temporarily out of pocket. Here the situation is far sadder, food being brought to a woman who seems terminally ill.

Celebrating the reciprocity between affluence and fertility, a painting by Metsu, often identified as *Burgomaster Gillis Valckenier and His Family* (*388*), presents a prosperous pater, mater, and their prog-

eny in a suitably wealthy domestic interior. The walls are covered in tooled and gilded Spanish leather, but for all their small scale, these figures are not eclipsed by so daunting a setting. The eldest son, in festive dress, plays the part of falconer, possibly emblematic of the family's name.

Metsu was as skilled as he was eclectic and combined aspects of the arts of his teacher Dou with those of Vermeer, de Hooch, TerBorch, and Jan Steen. Presenting many of his subjects with elegant informality, artful in pose and use of setting, he reduces the scale of grand group portraits by van Dyck and Rubens, initiating an intimate, convenient

splendor, which would later prove the goal of society portraitists who worked within the formula known as the Conversation Piece.

None of the spit and polish that burnishes most Dutch domestic interiors is to be found in Esaias Boursse's grubby room with a seamstress (*389*). Working by a mantelpiece whose racks hold faience plates, she is too busy and too old to care for the lonely, neglected little girl who stares vacantly at the spectator. Forever moralizing, the Dutch artist may be suggesting that a stitch in human time may be worth any number expended upon the merely material.

The squalid scene's compelling realism verges upon the actuality of a "peep box" image in its sudden sense of spatial exploration. Illusionistic vistas were created within those Dutch seventeenth-century wooden boxes whose painted inner sides were to be glimpsed through peepholes. When

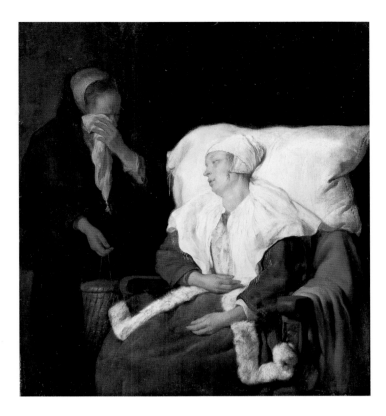

GABRIEL METSU
The Sick Girl, c. 1658–59

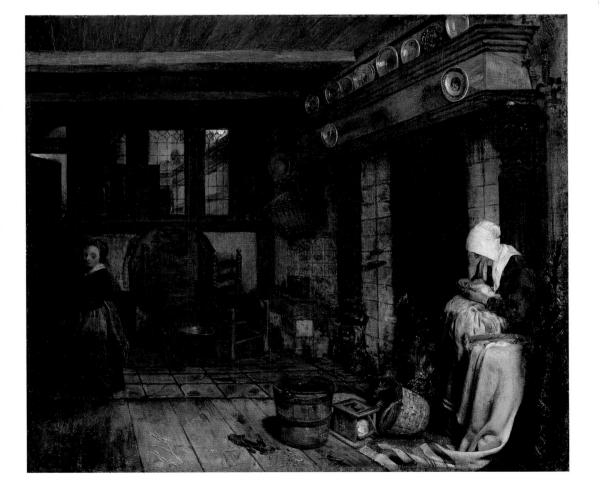

ESAIAS BOURSSE
Amsterdam, 1631–en route to
the East Indies, 1672
*Dutch Interior with Woman
Sewing*, c. 1660

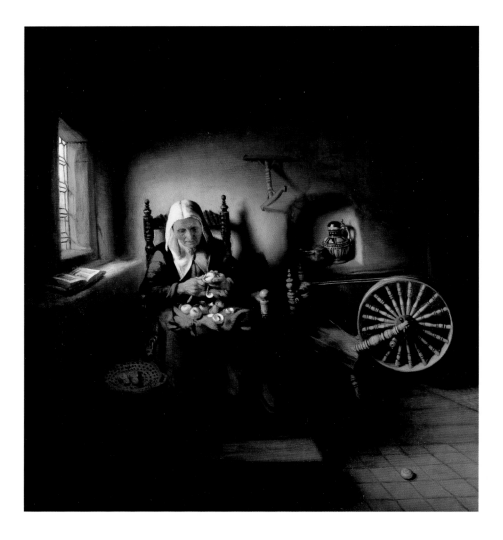

viewed in this way, their pictured contents seemed to be "in the round," such trompe l'oeil effects based upon perspectival principles.

Nicolaes Maes was active in Rembrandt's studio in the late 1640s, and his early works show his teacher's approach to style and subject. Canvases such as *Old Woman Peeling Apples* (*390*) suggest that Maes was making a small step toward the Fabritius brothers' forceful, individual concern with line and light. (Maes's timorous venture was made all the easier by the Fabritius's partially Rembrandtesque origin.) Haloed by light, this waxworks granny knows her place, forever in the kitchen, depicted as the happiest fate any old woman (without cash) could wish for. Along with countless images of elderly Bible readers of both sexes, sentimental, exemplary pictures like this proved to be commercial staples, steady sellers bought in part to show the

old folks the way they should be — helpfully out of the way, whether praying or peeling in solitude.

These pictorial sermons are but one side of Netherlandish art, close to Calvinist, or conservatively Roman Catholic, precepts. The other aspect of Dutch and Flemish genre painting is surprisingly sympathetic to happy or sad drunks, innumerable merrily dissolute companies (*318*), successful or sick prostitutes (*384, 389*), and rowdy, squalid inns and beggars, along with paintings teeming with double and triple entendres and phallic fish and birds. Sacred and profane scenes were cherished alike by contemporary purchasers and later collectors.

Both Fabritius brothers, Barent and Carel, were close to Vermeer, though they started in Rembrandt's academic workshop in Amsterdam before returning to their native Delft. Vermeer succeeded Carel as syndic of that city's painter's guild. Barent's

Slaughtered Pig (*391*), signed and dated 1656, is startling for its affectless objectivity. More than mere genre, this scene has an instructive quality, following a popular subject of Rembrandt's: the slaughtered ox. Most such images have a seasonal aspect because city and country folk bought oxen in October for slaughter in the next month; the sausages, smoked meats, and other products would last them through the long but not lean winter months. With its

emphasis upon whites, light colors, golden textures, Barent's canvas, though far from Vermeer's elegant subjects, shares aspects of that painter's concentration upon light passages and bright texture.

Passion for the purity of light and line, so strong an element in Dutch art, is found at its most abstract in the art of Pieter Jansz. Saenredam. He restricted his subject matter largely to the portrayal of whitewashed Dutch ecclesiastical interiors,

EMANUEL DE WITTE, Alkmaar, 1617–Amsterdam, 1692, *Interior of a Baroque Church*, c. 1660

Opposite: PIETER JANSZ. SAENREDAM, Assendelft, 1597–Haarlem, 1665, *Choir of St. Bavo, Haarlem*, 1635

which he shows stripped of centuries of medieval embellishment by the Reformation's iconoclasm, as seen in the *Choir of St. Bavo, Haarlem* (*392*). Here the artist sees that cathedral as the temple of Jerusalem, including tiny figures from the Presentation. Music — so close to the harmonic principles upon which the building's design was often based — meant much to Saenredam, causing him to place his monogram and the date, "P.S.A. 1635," on

the balustrade of the cathedral's organ loft. It was in this great church that he and Hals were buried.

Love of whites and lights, of elegantly described and delimited space, is also found in the *Interior of a Baroque Church* (*393*), an uncharacteristically Italianate canvas by Emanuel de Witte. Similar interest in a Latin smoothness and elegance is seen in an Arcadian romance of amorous shepherds (*395*) by Adriaen van der Werff. The phallic obelisk and

CORNELIS VAN POELENBURGH, Utrecht, c. 1586–1667, *Amaryllis Giving Myrtill the Prize*, c. 1635

herm and tree all accentuate the lust of a supposedly rustic couple far too artfully coiffed and discreetly unclothed to be peasants. They are much in keeping with the popular Arcadian literature of Joost van den Vondel and other Neoclassical writers of the time.

Dutch classicism, modeled upon Italian and French sources, may also be seen in *Amaryllis Giving Myrtill the Prize* (*394*), by Cornelis van Poelenburgh, a student of Abraham Bloemaert (*158*). Van Poelenburgh spent almost ten years in Rome and was later in the employ of the Grand Duke of Tuscany and was also active in England. Most of his later life was spent in the Dutch humanist center of Utrecht.

This work was inspired by Giovanni Battista Guarino's immensely popular text *Il pastor fido*.

Dressed as a girl, Myrtill is given the prize for "best kisser." Its coy subject typical of the popularity of Arcadian themes throughout Europe, this canvas is part of a series painted for Prince Frederick Henry of Orange that included the scene of the same couple's marriage, Dirk van der Lisse's *Amaryllis as a Blind Cow* (both in the Jagdschloss Grunewald), and another Guarino canvas by Saftleven.

Smoothing over and classicizing Dutch art robbed it of much of its original appeal. Almost overwhelmed by the grandeur of the French and Italian academic achievement, painters and patrons alike now sought conventional magnificence over the fresh, if sometimes rudely inquiring, eye and original brush.

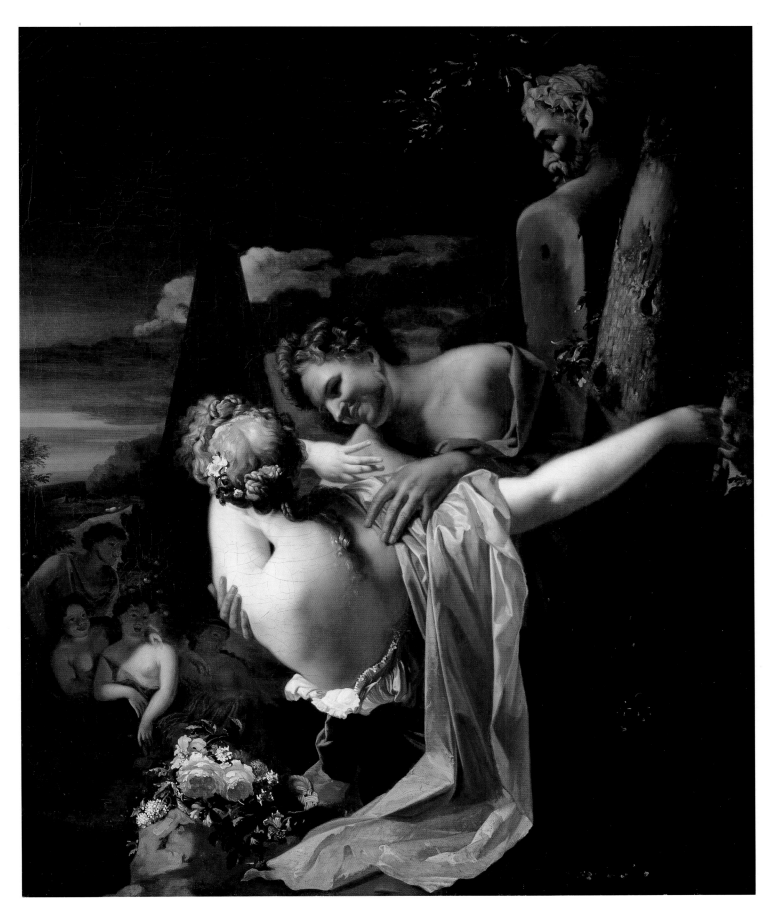

ADRIAEN VAN DER WERFF, Kralinger-Ambacht, 1659–Rotterdam, 1722, *Amorous Shepherds*, c. 1690

JAN BRUEGHEL THE ELDER, Brussels, 1568–Antwerp, 1625, *Bouquet of Flowers*, c. 1609–15

STILLED LIFE, INTERIOR LANDSCAPES

BERLIN is as dazzlingly well furnished with Dutch and Flemish Baroque still life paintings as it is rich in this area's other genres, so the city's collections provide a panorama of the quietest art by most major Netherlandish masters. Though traditionally and conveniently isolated from landscape or portraiture, still life partakes of both. Each is a world in itself, and the still life defines its own physiognomy — the face of farm and fishery, of woodland chase and virtuoso craftsmanship.

As an inner, controlled equivalent to nature — a landscape of the mind — still life is the most artful manipulation of outer references. A bottle or kettle takes on the dimensions of a mountain, a flower that of a tree; a ewer assumes the visual impact of a waterfall. Foods, exotic and domestic fruits and flowers, animals dead or alive, all are sometimes seen along with objects emblematic of human ingenuity or utility. Their juxtaposition bespeaks new worlds of experience and providence. Catches from sea or land, along with more pacific harvests, create an illusion of eternal abundance, of cupboard and larder unfailingly filled.

Boundless providence prevailed in the fertile Lowlands' fields and seas at the time of these images' painting. That society proved of unusual social responsibility, a Republic where the material and the moral often matched one another in rare equilibrium. Gluttony, too, equal to the Victorians', made these feasts for the eye less fantastic than some might appear. Even the so-called "slender banquets," often painted in semi-grisaille, strike today's viewer as far from austere.

Baroque emblem books ascribe special significance to most domestic and other impedimenta; all such images (with their proverbial legends) furnish mind and eye by their depiction. Yet to say that the still life painter intended a moralizing reading of every work based upon this pictorial literature, making each into a monument to "Vanitas" — to the passage of time, to crass worship of this world's goods — "ain't necessarily so."

Paradoxically, even if they lack overt symbolic significance, still lifes by their very being heighten consciousness of survival and decay, of time's nature and Nature's time, of the enigmas of experience and of appetite, these made the more mysterious for not moving at all.

The Dutch Republic was singularly house-proud, and its Calvinist standards of cleanliness proved unprecedentedly close to godliness. Never before and nowhere else was a woman's work quite so impossibly far from the hope of ever being done. The Republic's housewives were known for preserving Europe's most rigorous domestic standards in a relentless cycle of washing, ironing, polishing, beating, dusting, bleaching, slaughtering, preserving, curing, cooking and baking, sewing and knitting, to say nothing of their striving to meet uniquely high demands for patient, loving parenting.

By supplying needed contemplation in tranquility, still lifes inspired welcome respite, essential surcease from that domestic circus. Dutch and Flemish canvases afforded stress-free interludes, providing real visions of a material yet natural order uniquely accessible and affecting in its legitimate coefficients of *Luxe* and *Calme*. Since they were seldom expensive, paintings bought for investment and pleasure even adorned maids' rooms in the seventeenth century.

Like portraiture, still life addresses the experience of age, not youth, whose ceaseless changes of motion and emotion are alien to this genre's stable concerns. Like Everest, still lifes are simply *there*, but unlike mountains, their exploratory challenge is limited to the eye. This safe genre is far from the excesses of sentimentality or controversy. If secure

in hand and eye, a capable artist can seldom go far astray in this domain, one so close to the charms of vicarious gratification.

Intrinsically philosophical, still lifes can't help becoming a commentary on the nature of being, of time; theirs is a dialogue between material and immaterial. If it rarely rocks society's boat, this genre (to continue in marine metaphors) is like a message in a bottle — it seldom sinks.

The earliest of Berlin's major still lifes are not independent, but are found in Hugo van der Goes's (82–83) and Hans Multscher's (74–75) works. More dramatic, dating from the next century, is the still life section in the foreground of Caravaggio's *Amor Victorious* (276). If Berlin can't claim that painter's extraordinary, possibly independent, still life against a white background — the Brera's *Fruitbasket* (Milan) — it has a far earlier example of a similar genre: the fruits in the foreground of Lorenzo Lotto's *Christ Taking Leave of His Mother* of 1521 (257).

Independent still lifes came on the scene relatively late, first as furniture parts, pictorial labels to identify the contents behind the cupboard or cabinet doors. These images usually perished along with the container to which they were attached. The earliest and finest of Berlin's flowerpieces is one by Jan Brueghel the Elder, who spent much time in Brussels' ducal botanical gardens and wrote of the need to work from life — *alla prima* — never using plant studies prepared by others. Yet that ideal working procedure was impossible for so encyclopaedic a rendering as Berlin's unlikely arrangement, whose forty-nine flowers, often blooming at radically different times of the year, defy the seasons.

The massively implausible *Bouquet of Flowers* (396) results from, and pays tribute to, the Age of Exploration, which permitted, for the first time, species to be brought back from the Near and Far East, the New World, and Africa. Like a blossoming globe, Brueghel's panel maps out discovery in terms of botany. Marina Heilmeyer and Bernard Zepernick identified the five flowers in the bridal, or Arcadian shepherdess's, wreath as well as the forty-four in the ceramic container, which is reminiscent of the art of Bernard Palissy. As if to proclaim its aque-

DANIEL SEGHERS, Antwerp, 1590–1661
Floral Wreath Surrounding Relief after Quellinus

ous contents, the vase is embellished by cartouches of river and sea deities.

The inscription for another of Brueghel's flowerpieces may apply to Berlin's as well: "Why gaze upon these flowers / So beautiful before you and / All too soon sapped by sun's strength / Heed God's words, eternally in bloom / For all else turns to nought." This panel, doubtless first seen in a richly and variously ridged architectonic frame of dark wood, or in one covered with reddish tortoiseshell, may have lost its corners.

A pupil of Jan Brueghel the Elder, the Jesuit Daniel Seghers continued his teacher's painstaking, virtuoso approach. He frequently painted a floral wreath surrounding a grisaille depiction of a Baroque statue by Erasmus II Quellinus (398). From 1645 to 1651, Seghers worked for the Brandenburg court, where he may have completed this picture.

Even Paradise (399) becomes a zoological still life

Opposite: JAN BRUEGHEL THE YOUNGER, Brussels, 1601–Antwerp, 1678, *Paradise*, c. 1620

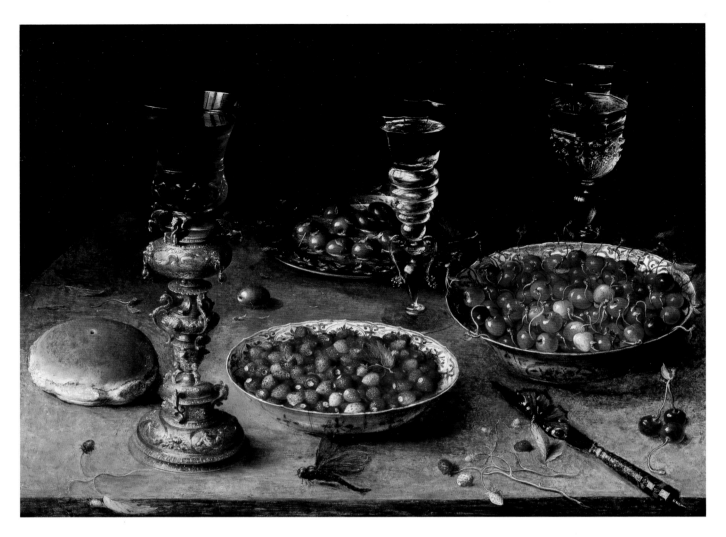

OSIAS BEERT, near Antwerp, c. 1580–Antwerp, 1623/24, *Still Life with Cherries and Strawberries in Porcelain Bowls*, 1608

when seen by Jan Brueghel the Younger, as if it were a pictorial catalogue of the famous ducal collection of wild animals in Brussels, so much admired by Dürer a century before.

Among Berlin's early still lifes is one by Osias Beert (*400*); its tabletop supports several blue and white bowls — Chinese or early Western copies. These are filled with cherries, olives, and *fraise de bois*, or wild strawberries, the fruits of Heaven. The cherry was often associated with the Virgin. A magnificent cup made of precious metal — like those Mannerist designs by Holbein or Erasmus Hornick — is in the foreground, with two wine glasses in the Venetian manner. The moth alighting upon a knife might refer to mortality.

Early, too, are still lifes by Balthasar van der Ast. His paintings often include exotic seashells, which

were as highly prized as tulips. Seen against a white background (*403*), a basket of fruit is given a trompe l'oeil prominence; all those little insects and the salamander, along with the moth, provide a telling intimation of the brevity of existence as they gnaw upon the staff of life. The same painter's *Still Life with Apple Blossoms* (*403*) is strikingly like those by the nineteenth-century American painter Martin Heade. Here again, flowers and insects placed upon the enduring stone ledge are a reminder of perishability and flux.

A splendidly orchestrated groaning board by Jan Davidsz. de Heem includes a small ransom of hothouse peaches, grapes, melons, and lemons with equally costly *fruits de mer*, including lobster (*404*). These opulent masterpieces of Nature's creation are complemented by rum and wine glasses, a

nautilus shell, and a ewer encompassing another shell, all designed in the manner of Hornick or van Vianen. That oddly organized cascade of fruits and vegetables recalls the weird constructs by the Mannerist Archimboldo (1537–1593), who assembled his portraits from garden produce.

De Heem's canvas was painted after he moved from Utrecht and Leiden to Antwerp, and its opulent manner is more typical of the Flemish than of the Dutch taste. The curtain rising at the right states that this is theater, a stage set with a lavish fantasy of Baroque abundance, just the sort copied by the young Matisse when he sought guidance to color, shape, and light from the masters of the Baroque.

Equally grand in display is Frans Snyders's *Still Life with Fruit Basket and Game* (*405*). This Antwerp master was close to Rubens, in whose studio he worked after Rubens returned from Italy in 1609, and where Snyders stayed until Rubens's death in 1640, at which time he went on to collaborate with his brother-in-law, Cornelis de Vos (*325*), and van Dyck (*308–11*), among others. Far more restrained

and closer to the art of van der Ast is a *Hungry Cat with Poultry, Lobster, Game, and Fruit* (*405*).

Dazzling variations on the same theme — the double-edged predicament of having wealth's earthly glories and acknowledging their fleeting possession — are found in Kalf's two canvases (differing only slightly in size) of marble tabletops with Herat carpets (*406, 407*), each sporting fruit and glasses, one with a covered Huan-Li porcelain sugar bowl with a Foo-dog handle, as well as a Venetian wine glass and a Northern rum glass. The open pocket watch refers to time's passage. Vermeer-like in their luminous, almost crystalline, impasto, when seen as pendants these paintings interact like an a cappella chorale, echoing one another's enlightened materialism.

Seldom that far from Inquisition, Spanish culture contributes an anonymous, characteristically austere still life of a desktop (*401*) from the mid-seventeenth century. Once again, time is of the element, an hourglass suggesting the vanity of scholarly pursuits in the face of terminal yet eternal truths.

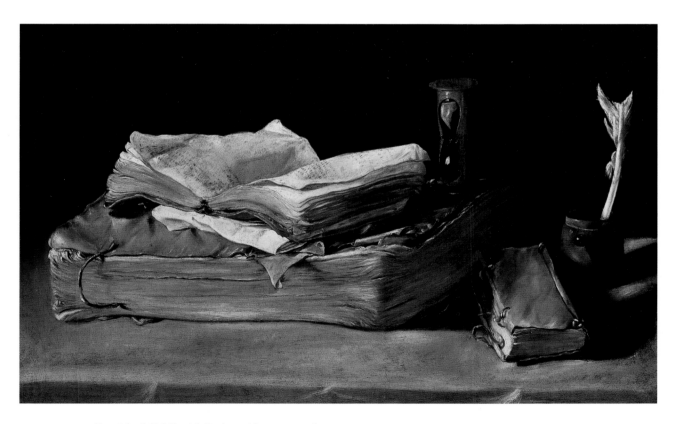

ANONYMOUS, Spanish, *Still Life with Books*, mid-seventeenth century

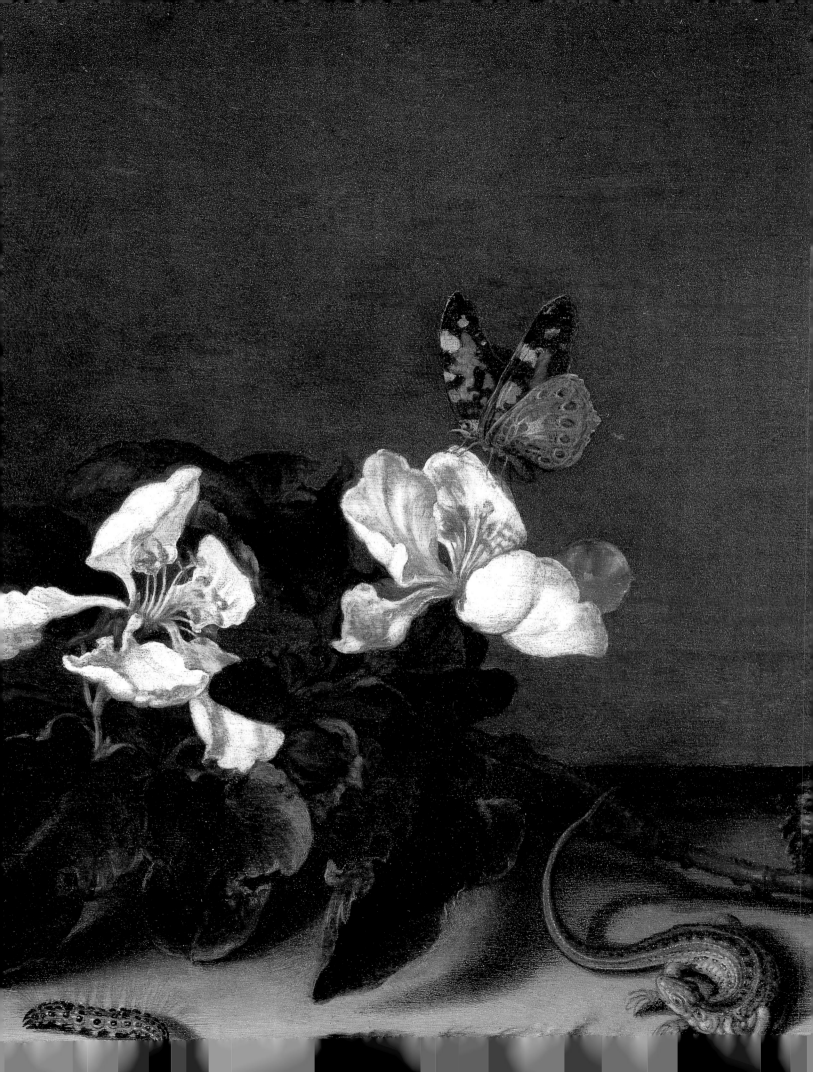

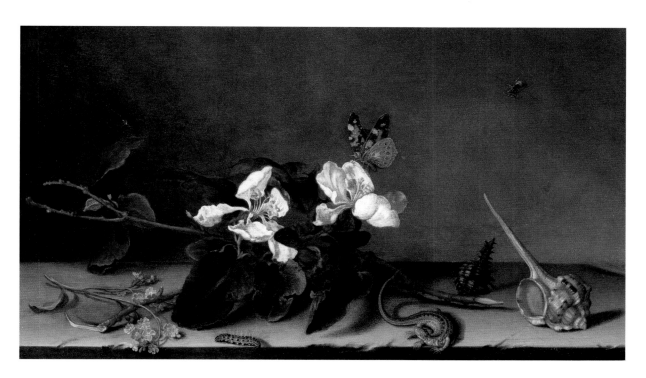

BALTHASAR VAN DER AST, Middelburg, 1593/94–Delft, 1657, *Still Life with Apple Blossoms*, c. 1635
Opposite: (detail)

BALTHASAR VAN DER AST, *Still Life with Fruit Basket*, c. 1625

JAN DAVIDSZ. DE HEEM
Utrecht, 1606–Antwerp, 1683/84
Still Life with Fruit and Lobster, c. 1648–49

Opposite:
FRANS SNYDERS, Antwerp, 1579–1657
Still Life with Fruit Basket and Game, c. 1620 (top)

Hungry Cat with Poultry, Lobster, Game, and Fruit, c. 1615–20 (bottom)

405

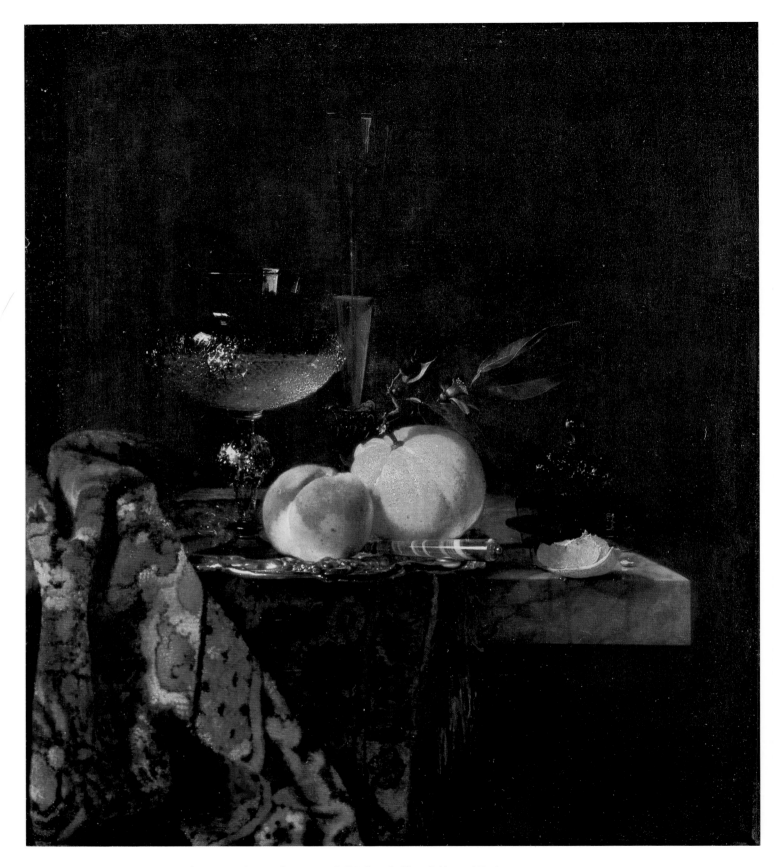

WILLEM KALF, Rotterdam, 1619–Amsterdam, 1693, *Still Life with Glass Goblet and Fruit*, c. 1655

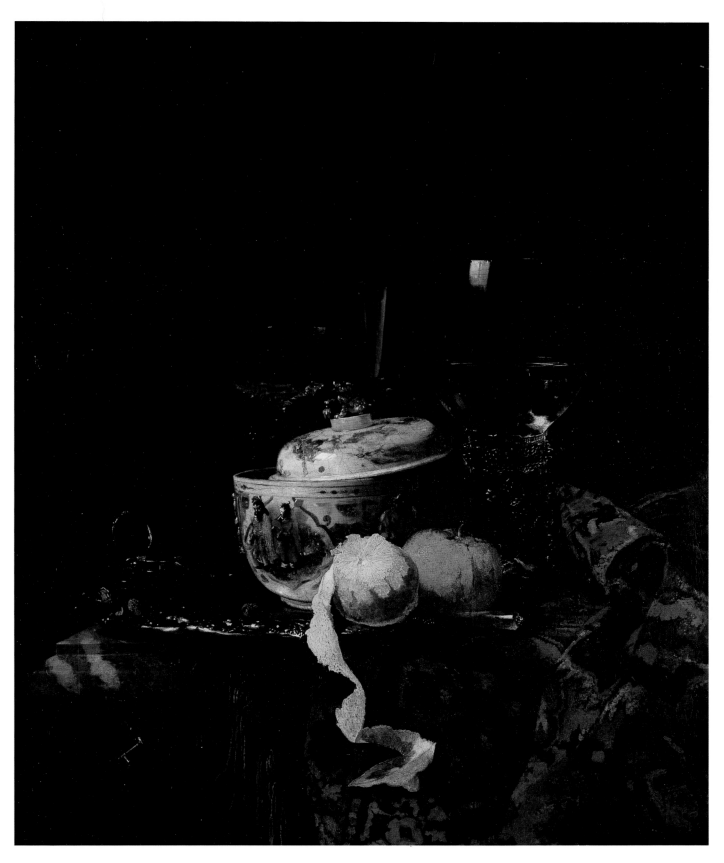

WILLEM KALF, *Still Life with Chinese Porcelain Bowl*, 1662

Rational Magnificence, Splendid Humility: French Baroque Painting

Though Frederick the Great was to say *"Jeune, j'amais Ovide; vieux j'estime Virgile,"* the increasing severity and austerity such a transition from love's adventures to those on the fields of farm or battle might imply did not extend too far in the emperor's shift from the enchanted French art of the eighteenth century to the grand stoicism of the seventeenth.

The Berlin collections were to include major works by the early Vouet and Claude. Sadly, several of these were among the losses of the Flakturm fire, along with some Poussins. Generally, Dutch and Flemish art of the same period was far more highly favored in Berlin, beloved for its heartier, franker spirit, far from the formality and introspection of France.

So, though the capital now has little French seventeenth-century art, what there is, is fine. Among the earliest of these canvases is a scene of a peasant couple eating (408), ascribed to Georges de La Tour and dated c. 1620. If the picture was not cut down, this scene was probably meant to be seen from below, perhaps installed as an overdoor. Almost too detached and objective a representation, it is as if the artist were witnessing the arcane ways of an alien species, distancing himself beyond all conscience. Did poverty and hunger deserve no more than so superficial a Diane Arbus–like scrutiny?

Berlin's most amusing French Baroque painting by far is that of a buffoonlike military figure (Tuscan general Alessandro del Borro?), genially displaying his corpulence in fullest profile (409), a Barberini

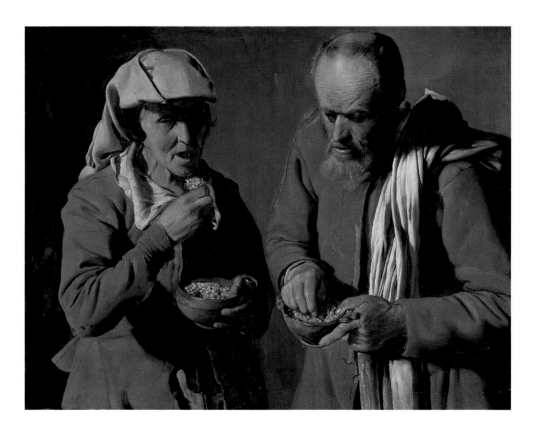

ATTRIBUTED TO
GEORGES DE LA TOUR
Vic-sur-Seill, 1593–
Lunéville, 1652, *Peasant Couple Eating*, c. 1620

Opposite:
ATTRIBUTED TO
CHARLES MELLIN
Nancy, c. 1597–
Rome, 1649
The Tuscan General Alessandro del Borro (?),
c. 1645

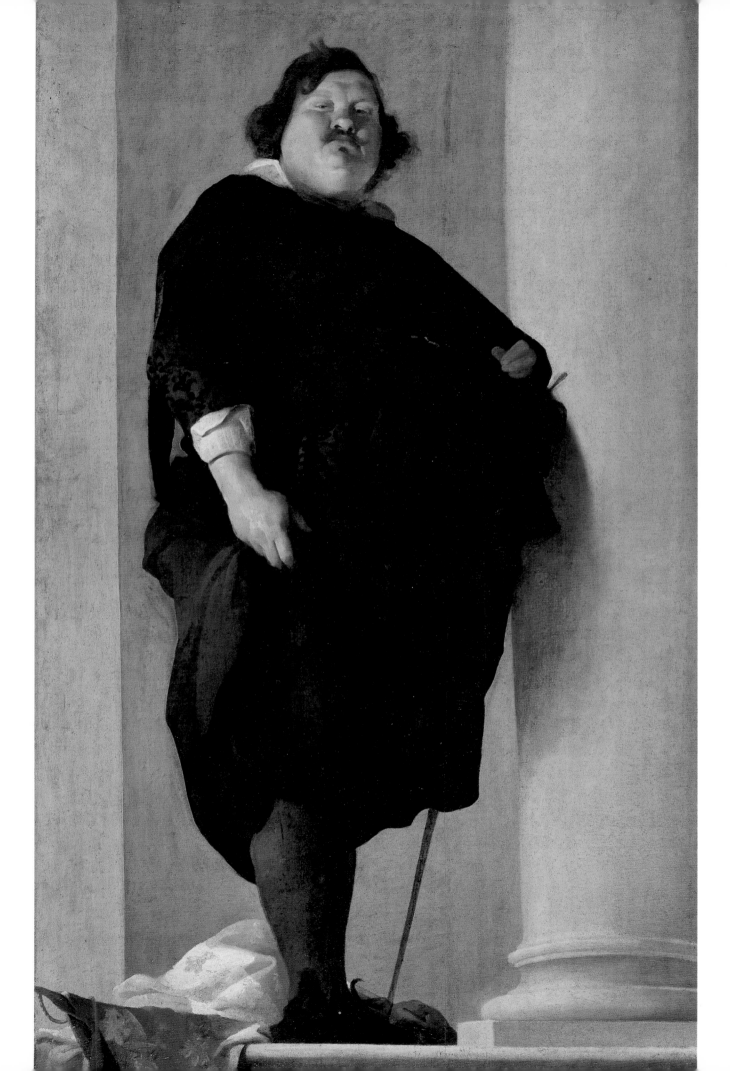

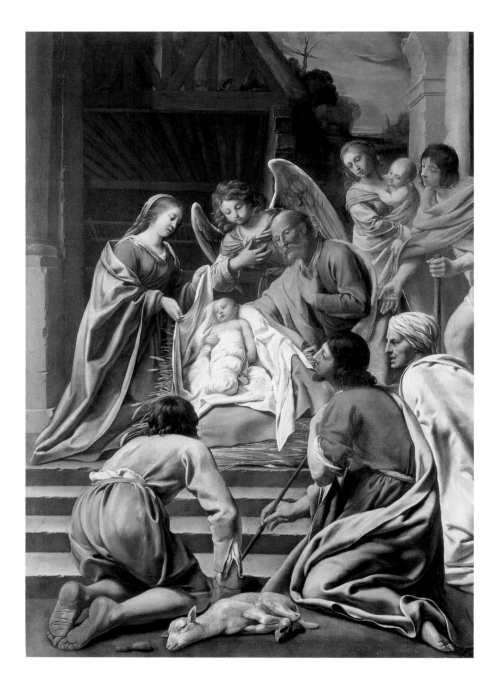

CIRCLE OF THE BROTHERS
LE NAIN
Antoine (1588–1648),
Louis (1593–1648),
Mathieu (1607–1677),
Laon–Paris
The Adoration of the Shepherds

banner at his feet. Bought as by Bernini, the attribution then went to Sacchi and the canvas is now ascribed to a little-known master from the Lorraine — Charles Mellin, a Vouet pupil whose career was spent in Italy. Perhaps the painting's jovial theatricality was enhanced by a special trompe l'oeil installation. A pendant to this canvas (Los Angeles County Museum) shows an actor who, like the soldier, is probably a character in a comedy.

An *Adoration of the Shepherds* (410) from the Le Nain circle comes close to the brothers' fusion of compassionate frankness and elegant restraint. That

strange combination guaranteed the Le Nains' rustic arts' favorable reception at the French court. Somewhat stagey, this canvas may be by a more conventional artist, still close to Roman academicism, who was ill at ease with the austere model he chose to follow.

With the radiant coloring of his earlier art, in *Helios and Phaeton with Saturn and the Four Seasons* (411) of c. 1629–30 Nicholas Poussin paid elaborate allegorical tribute to the passage of Light through Time, to the Four Times of the Year, as well as the changing illumination of the day, thereby stressing

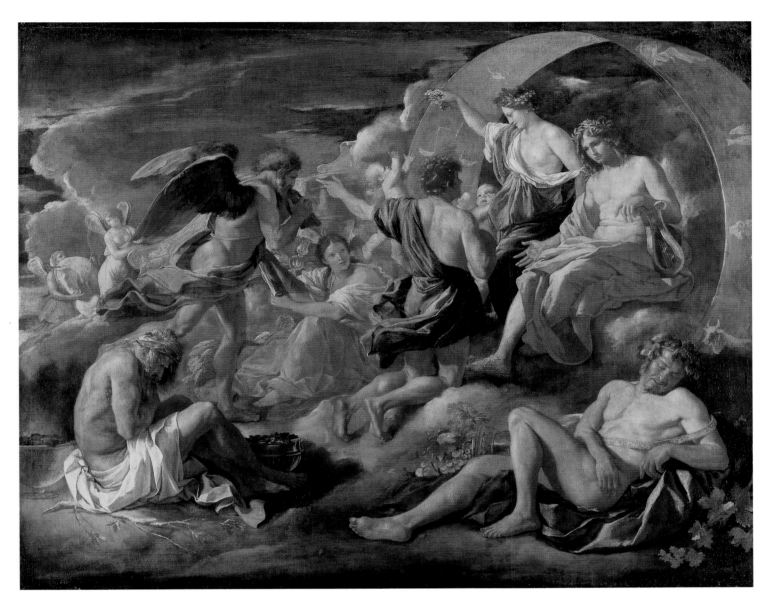

NICOLAS POUSSIN
Les Andelys, 1594–Rome, 1665
Helios and Phaeton with Saturn and
the Four Seasons, c. 1629–30

NICOLAS POUSSIN
The Infant Jupiter Nurtured by the Goat
Amalthea, c. 1638

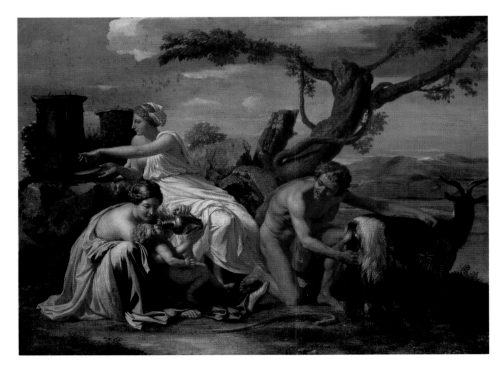

NICOLAS POUSSIN
St. Matthew Writing His Gospel, 1640

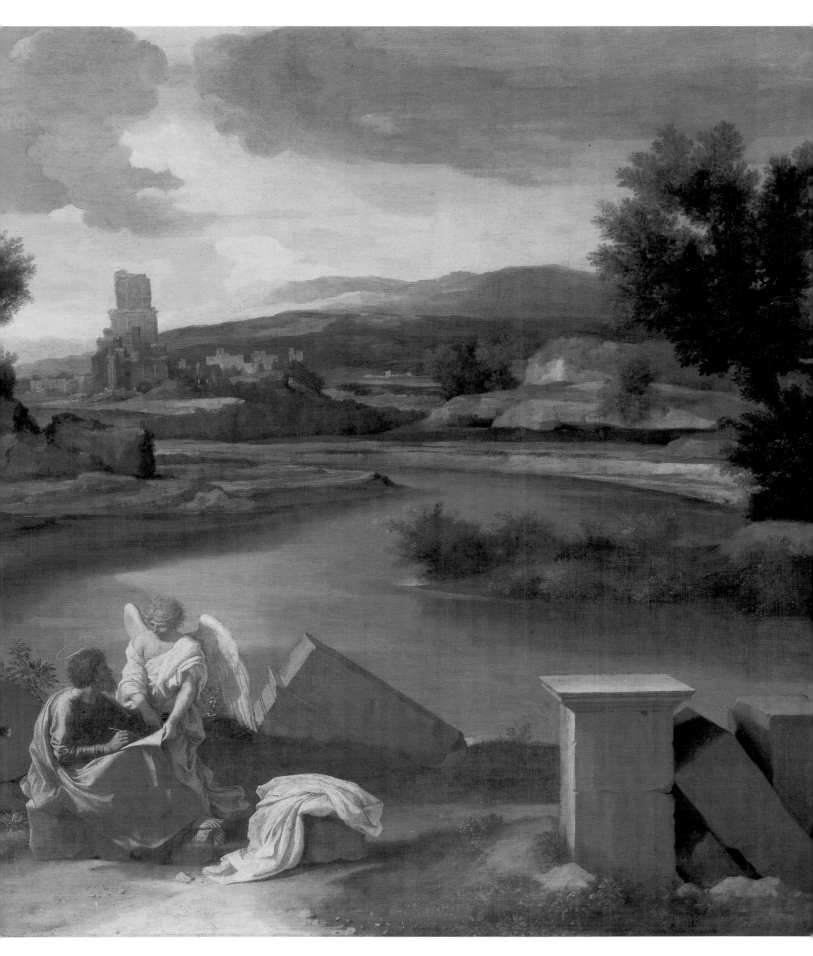

NICOLAS POUSSIN, *Self-Portrait*, 1649

transience and mortality. Most Roman of classical French painters, he sweetens the bitter pill of such temporal, Zodiacal realities by employing golden light and beautiful people, in a typically lyrical tribute to Antiquity's incomparable eloquence and insight. Handsome but not well preserved, this canvas, with one of the Nurture of Jupiter (*411*), was in the Prussian royal collection.

Compelling for the unorthodox, demanding relationships between figure scale, shattered architectural elements, foreground, and background, Poussin's *St. Matthew Writing His Gospel* (*412–13*) is pendant to a *St. John on Patmos* (Chicago, Art Institute), both painted in 1640. Images of divine inspiration, they explore the special circumstances under which the word of God is made manifest. Seen in the Roman Campagna, the Tiber flowing behind them, Matthew and his angel are placed in the ruins of a temple, as if the fabric of paganism had collapsed with the writing of the evangelist's gospel.

Strength, faith, courage, probity are among the many virtues and components of Stoicism, that school of classical philosophy closest to Poussin's rigorous standards. All may be most personally stated in the art of the self-portrait. Yet Poussin was loath to undertake that genre, doubly disapproving of such a commission's vanity and of his own forbidding appearance. But artists' self-portraits were ever more popular, assiduously collected by the Medici. So Poussin acceded to the requests for such an image from two of his major French patrons — Jean Pointel and Paul Fréart de Chantelou, both prominent members of the bourgeoisie.

Berlin's (*414*) was prepared first, in 1649, for Pointel, a Parisian banker, when the artist was fifty-five. Chantelou's canvas (Louvre) was begun in the same year, and completed in 1650. Poussin preferred the latter, a more glamorous and popular image. It abounds with references to the artist's studio, perspective, and friendship, and includes Pictura, muse of painting, with the painter wearing a diamond ring — Stoic symbol of constancy.

In Berlin's canvas, the artist holds a *porte-crayon* (alluding to the art of drawing and *disegno*) and a treatise on light and color (its spine inscribed *De lumine et colore* in the seventeenth century but not by the artist). This likeness is a soliloquy contrasting the artist alive and dead — as implied by the living foreground and the funerary background whose relief elements may also refer to Sculpture. An inscription in the painter's poor Latin is on the tomblike wall; it reads NICOLAVS POVSSINNVS ANDELYENSIS ACADEMICVS ROMANVS PRIMVS PICTOR ORDINAR- IVS LVDOVICI IVSTI REGIS GALLIAE. ANNO DOMINI 1649. ROMAE AETATIS SVAE. 55 ("Nicholas Poussin of Andelys and member of the Roman Academy, first Painter in Ordinary to Louis Rightful King of France, Year of Our Lord, 1649, Rome, his age 55"). The swag suggests the triumph of art over death; the genii, one asleep, one awake, could refer to art, death, or both. Matthias Winner has plausibly suggested that Poussin's complex image incorporates two contemporary French prints honoring Raphael, by Nicolas Chapron. The first is his self-portrait, venerating the bust of Raphael; the second, of 1649, presents Raphael in the guise of his fresco of Isaiah.

Still baroque for its amplitude and grandeur is Nicolas de Largillière's likeness of his friend the leading French sculptor Nicolas Coustou (*416*), of c. 1710–12. He rises among the Louise Bourgeois– like living rocks on the studio floor. In his early sixties, the sculptor (1658–1733) is seen relatively *deshabillé* but for his powdered wig. Coustou points to stone in the foreground, from which his *Spring* (formerly on the garden facade of the Hôtel de Noailles, rue St.-Honoré) will be carved in 1712, its *modello* to the left. The sculptor's gaze suggests absolute confidence in the agent of his portrayal, making the viewer more than a mere witness, sharing Largillière's role and so participating in this stirring allegory to Art's creative, perpetuating powers — be it by Painting or Sculpture — and to the enduring gifts of friendship.

Building upon Poussin's art yet returning to Venetian sixteenth-century sources for more warmth and ease, Jean-François de Troy was a productive master of handsome classical subjects. His works have a certain by-the-yard sameness, as they were designed to fill the yawning voids of contemporary French buildings' endless galleries, which were ever hungry for tapestry or painting to warm their chill, if exquisite, expanses. Whether *The Education of Bacchus* or *Bacchus and Ariadne* (*418*), the components are almost all the same, but for a little

Opposite:
NICOLAS DE
LARGILLIÈRRE
Paris, 1656–1746
*The Sculptor Nicolas Coustou
in His Atelier,* c. 1710–12

SÉBASTIEN BOURDON
Montpellier, 1616–Paris, 1671
The Adoration of the Magi,
c. 1642–45

change here or there based on notebooks, seldom if ever going to nature. Autumnal tints also heated up those seventeenth-century passages or salons, welcome additions to fine limestone masonry or exquisite *boiserie.*

Most of Berlin's French Baroque paintings are kept at Sanssouci because that was where they were originally installed, bought for Frederick the Great's picture gallery. Outstanding among these are *Christ Healing the Blind Man* (418) by Eustache LeSueur, who was much influenced by Poussin. Among the few painters who managed to shake themselves free from Roman monumentality — despite studying there — was Sébastien Bourdon, whose silvery

color is seen to good advantage in an *Adoration of the Magi* (417) of c. 1642–45. Bourdon's training under a glass painter may have led to the lightening of his tonality.

Painted on copper, a rendering of *Earth* (419) that was probably part of a series of the Four Elements was painted by Louis de Boullogne the Younger in 1698. Quintessential "Official Art," this is the classical approach that rewarded its painter with directorship of the Académie Royale and his appointment as First Painter to Louis XV. A certain playfulness points to the art of the next century, the Grand Manner of the Baroque about to give way to greater intimacy.

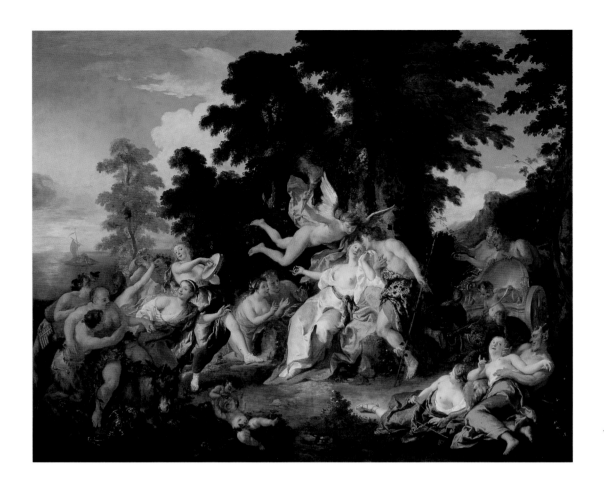

JEAN-FRANÇOIS DE TROY
Paris, 1679–Rome, 1752
Bacchus and Ariadne, c. 1717

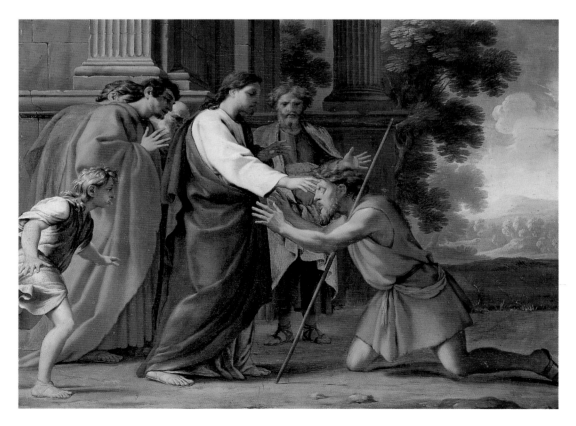

EUSTACHE LESUEUR
Paris, 1616–1655
Christ Healing the Blind Man

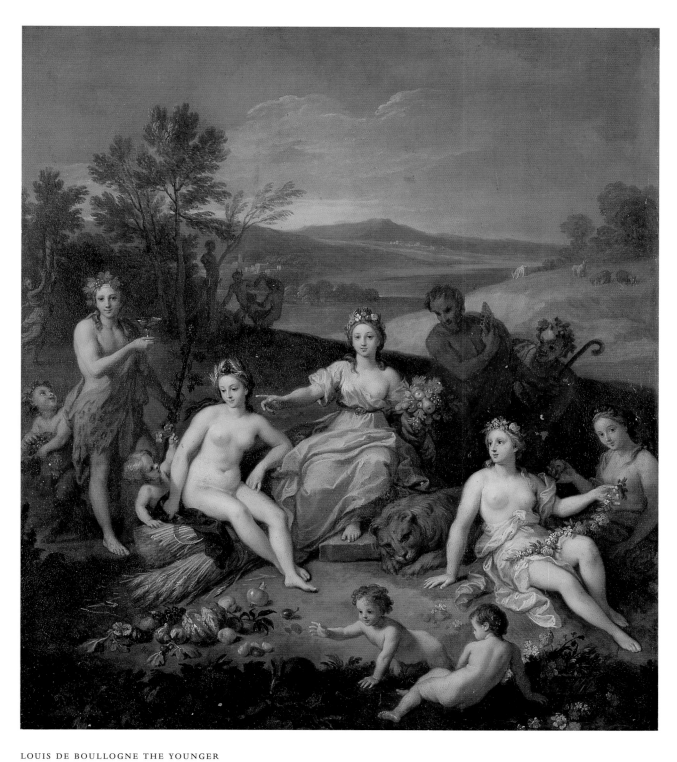

LOUIS DE BOULLOGNE THE YOUNGER
Paris, 1654–1733
Earth, 1698

Spanish Scenes

I N T H E nineteenth century, Berlin's curators claimed to be working as hard as possible to build up their Spanish Baroque section, but they found stiff competition from European and American museums. In addition, Berlin's holdings of later Iberian pictures suffered from the loss of a magnificent Zurbarán, a fine Murillo, and her best Goya in the bunker fire of 1945. That may be why Germany, which contributed so much to the study of early Spanish art and can be largely credited with rediscovering Goya and El Greco, should have such scanty holdings in these areas.

Waagen knew just where all the best Spanish paintings were to be bought, but somehow could not bestir himself to acquire them. At one point, a bankrupt Spain offered the entire Prado to Berlin, but Bismarck vetoed the deal as unfair to that nation, even though the Spanish treasury had initiated it.

Typically Spanish for its fervent pietism is Luis de Morales's *Madonna and Child with a Spindle* (420), which brings to mind a work by Leonardo and his studio, the *Madonna of the Yarnwinder* (Duke of Buccleuch). The Infant is shown holding a spindle, referring to his attire at birth and at death, to the miraculously expanding garment woven by his mother that lasted a short lifetime. The image's depth of emotion is often found in Spanish religious art of later times.

Happily Berlin has a magnificent portrait by Velázquez (423) that is unusual for showing a woman on quite so large a scale. This plays down her plumpness and is in keeping with the sitter's importance — if she is indeed Doña Inéz de Zuñiga, sister of the count of Olivares, and duchess of San-Lucar, which is one of several suggested identifications. Another is Doña Leonora da Guzman, Condesa de Monterrey, wife of the viceroy of Naples and Spanish ambassador to Rome when Velázquez went there in 1630.

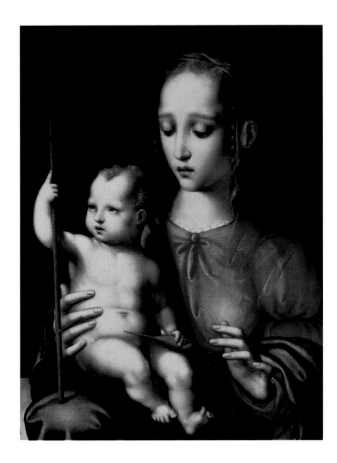

LUIS DE MORALES
Badajoz (Estremadura), 1509 or 1520–1586
Madonna and Child with a Spindle, late 1560s

Another forceful Spanish portrait, of Don Alonso Verdugo de Albornoz at the age of twelve (422), is by Francisco de Zurbarán. Overwhelmed by his armor, by his fashionably slashed pantaloons and those gross rosettes, this sad child, though grasping sword and baton, seems ill-suited to a military destiny. Pose, space, and format alike were rigidly followed for Spanish portraiture of the period and this image was probably designed en suite with those of Don Alonso's ancestors. Much like those stiff, naive,

Opposite: BARTOLOMÉ ESTEBAN MURILLO, Seville, 1618–1682, *The Baptism of Christ*, c. 1655

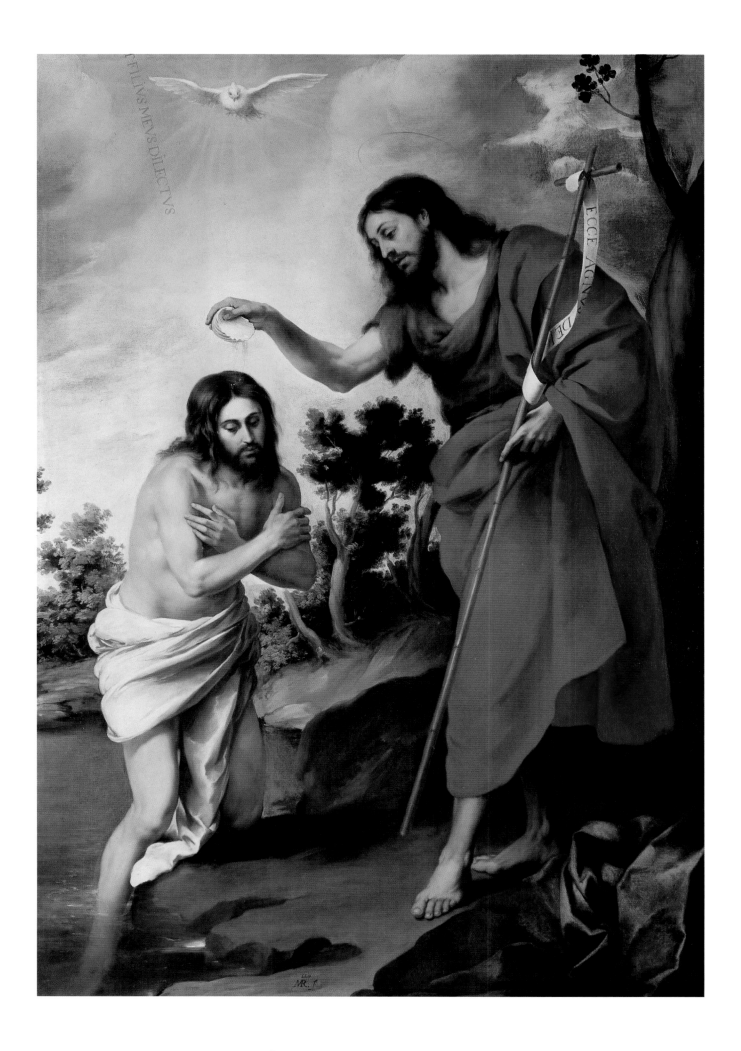

FRANCISCO JOSÉ GOYA Y LUCIENTES, Fuentetodos, near Zaragoza, 1746–Bordeaux, 1828, *The Philippine Junta*, 1815 (left)

FRANCISCO DE ZURBARÁN, Fuente de Cantos (Estremadura), 1598–Madrid, 1664, *Don Alonso Verdugo de Albornoz*, c. 1635 (right)

early American portraits by itinerant artists, there is something about this little boy's likeness that suggests his body was painted sight unseen and only the head was portrayed in the model's presence.

Too well known for his easy, predictable sentimentality — whether presented in depictions of Immaculate Conceptions or ragamuffins — Bartolomé Esteban Murillo was also capable of powerful religious and secular art, the former demonstrated by Berlin's *Baptism of Christ* (421). It belongs to a cycle of John the Baptist's life that Murillo painted c. 1655 for the refectory of the Augustinian monastery of S. Leandro in Seville. Other canvases from this series are in the Chicago Art Institute and the Fitzwilliam Museum, Cambridge. This canvas has been cut down on all sides,

but still demonstrates Murillo's almost sculptural gifts for gesture and drapery; it also betrays his laziness or incapacity when it came to individualizing physiognomy.

Goya's expressively smeared, atypical history painting of 1815, *The Philippine Junta* (422), recalls the artist's relentlessly cruel court portraits and other late work. This sketch for a very large canvas, now in the museum at Castres, in southern France, shows the congress presided over by Spain's King Ferdinand VII. It was painted in the increasingly black tonality that would culminate with the fourteen unforgettably tragic murals, sometimes called the *Black Paintings*, that Goya provided for his own Quinta del Sordo (House of the Deaf Man), which are now in the Prado.

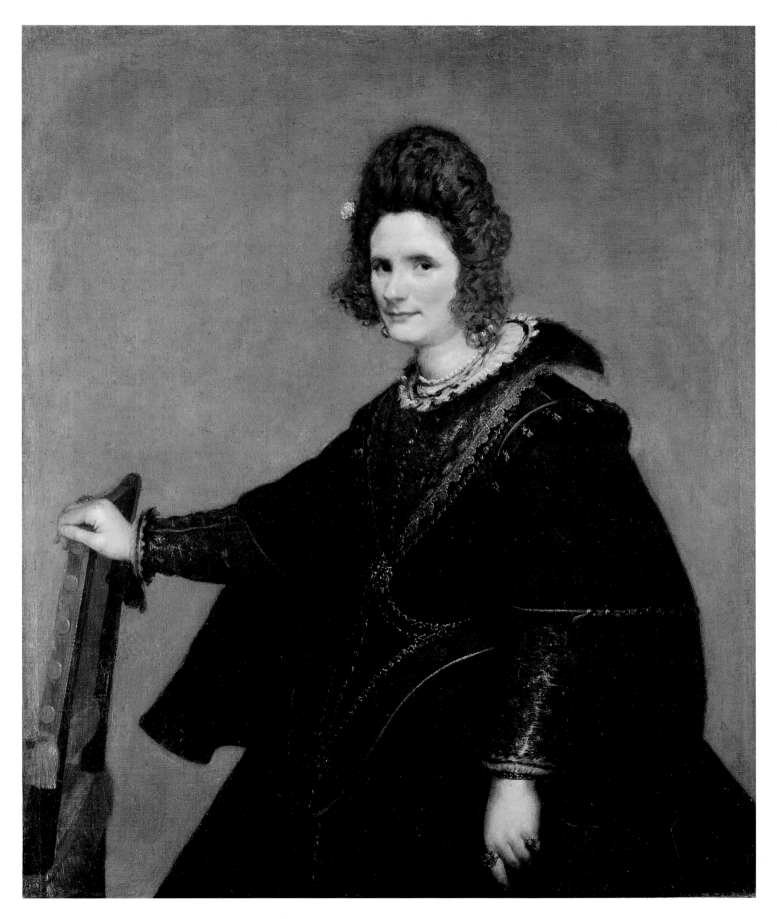

DIEGO RODRÍGUEZ DE SILVA Y VELÁZQUEZ, Seville, 1599–Madrid, 1660, *Portrait of a Lady*, c. 1630–33

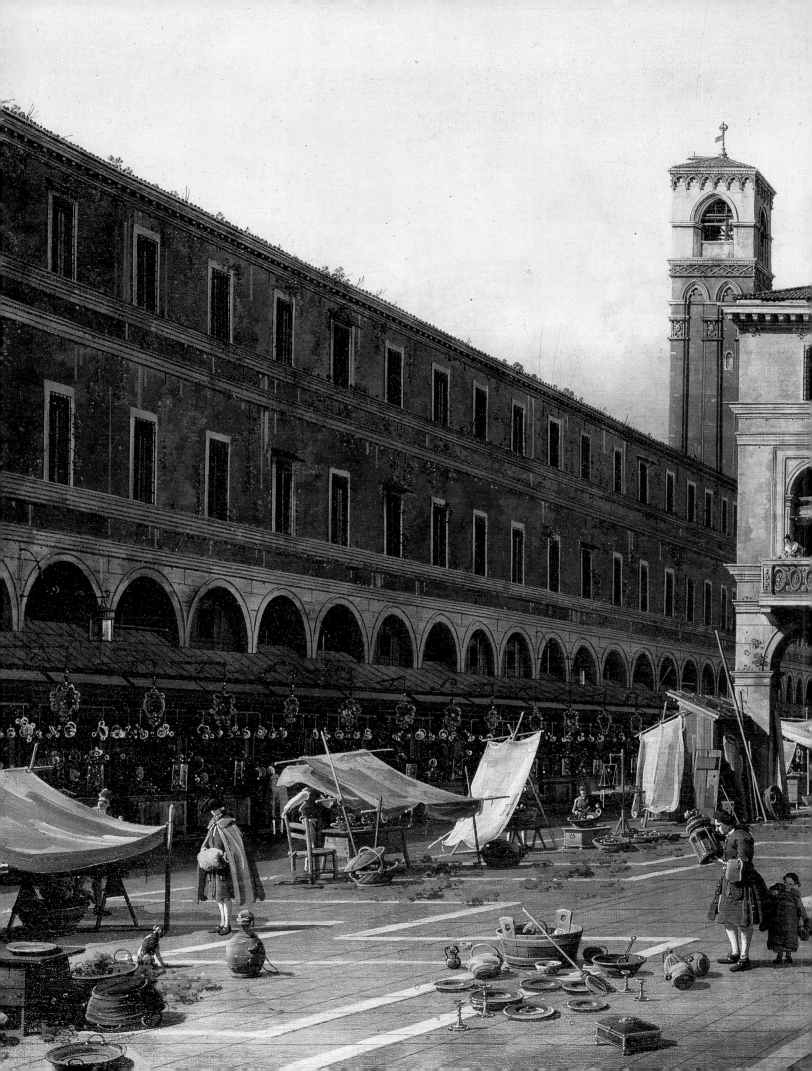

Souvenir and Circumstance:
European Painting, 1700–1800

Frederick, the Great Collector:
German and Austrian Painting of His Century

OF ALL Berlin's "picture palaces," her oldest may be the most beautiful. This is Jagdschloss Grunewald, a relatively modest hunting lodge begun by the Kurfurst Joachim II of Brandenburg in the early sixteenth century. In the woods, close to the city's suburbs, Grunewald is readily reachable by the U-Bahn (Exit Onkle Tom's Kabine — easily translatable for any reader of Harriet Beecher Stowe), followed by a long walk or a shorter bus trip or taxi ride.

The date 1542 is found in the lodge's banqueting hall. This is the sole surviving Renaissance interior in the Berlin area. As much as the paintings themselves, it is their setting's austere appeal — with its magnificent arches, whitewashed walls, and twisting oaken stairs — that makes for a memorable visit. Inummerable lovely views of Lake Grunewald, teeming with wildfowl, are seen through the lodge's many window-alcoves (added by Frederick I c. 1705). All makes for a vivid return to Prussia's past.

Though the lodge was unobtrusively enlarged by Frederick the Great around 1770, it still brings the visitor back to the days before the Hohenzollern showed one and all just how very rich they had become by marriage or military victory, when links with the Lowlands and England brought the region into an ever more centralized and powerful position. In the beginning of the eighteenth century, the Prussian capital still lacked the expansive glamour of Munich or the exquisite glitter of Dresden. The kingdoms of Bavaria and Saxony were then far ahead of Prussia in terms of their rulers' spending money, the splendor of their capitols' urban settings, and their lavish art collections.

But for scholars of Dutch, Flemish, and German art, not that many of Jagdschloss Grunewald's pictures — all Northern and mostly dating between the sixteenth and early eighteenth centuries — merit this journey. Among the many works here by

ATTRIBUTED TO MATTHÄUS MERIAN THE YOUNGER
Basel, 1621–Frankfurt, 1687
Landgrave Friedrich of Hessen-Eschwege

Lucas Cranach the Elder is his *Judith Victorious* (142). Also found in the lodge are eccentric portraits of local nobility, including that ascribed to Heinrich Bollandt of the little Erdmann August, Crown Prince of Brandenburg-Bayreuth, holding a tender spray of rosebuds (428). An eccentric likeness of Landgrave Friedrich of Hessen-Eschwege (1617–1655) surrounded by falcon, hawk, and buz-

JOHANN CHRISTOF MERCK
Berlin and Postdam, active c. 1695–c. 1726
Ulmer Dogge, 1705

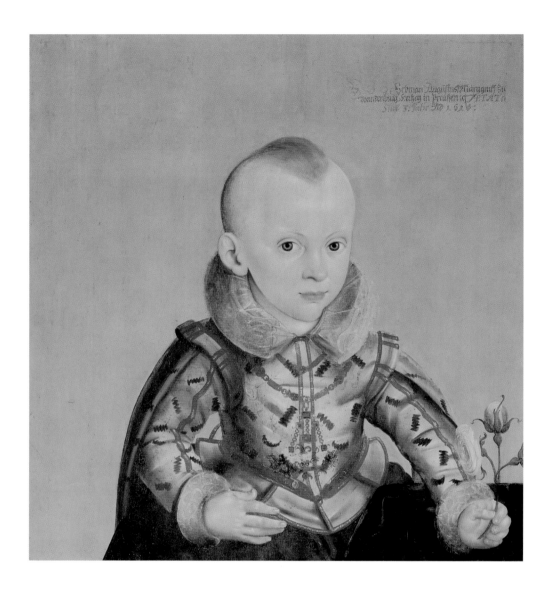

zard (426) is ascribed to Matthäus Merian the
Younger, a Frankfurt-born pupil of van Dyck who
was active throughout northern Europe. The Land-
grave came to the Hohenzollern court to teach fal-
conry in 1651. Among the Hohenzollern's many fine
Dutch and Flemish seventeenth-century paintings
is one showing two musicians by Jan Miense
Molenaer; a fine Hendrick TerBrugghen *Caesar* is
from a cycle of twelve, a common feature of palace
embellishment since the Renaissance.

Where eighteenth-century decorative arts from
Germany and Austria are striking for originality and
technical brilliance, the same is less true for much
of their painting. However, Johan Heinrich

Tischbein the Elder's Fragonard-like *Portrait of
the Artist and His Wife at the Spinet* (436) is brisk and
vivid, bespeaking the French-oriented spirit of the
German and Austrian Enlightenment.

A life-size image of Frederick's favorite hunting
hound — the *Ulmer Dogge* (427), by Johann Christof
Merck, also bears his master's monogram minia-
ture, attached to the "sitter's" collar. This canine
likeness recalls George Stubbs's animal canvases
— both presenting an individualized "who," not a
categorized "what." Along with many lesser images
at Grunewald, this image is central to the sport of
the chase, one so fervently pursued in the lodge's
surrounding woods.

Back at Court

Thomas Carlyle's monumental *History of Frederick II of Prussia, Called Frederick the Great* (1858–65) was to be Hitler's favorite book, read aloud by Goebbels in their fatal Berlin bunker:

> *Friedrich Wilhelm has not the shadow of a Constitutional Parliament, nor even a Privy-Council . . . his Ministers being in general mere Clerks to register and execute what he had otherwise resolved upon: but he had his* Tabaks Collegium, *Tobacco-College, Smoking Room,* Tabagie *which has made so much noise in the world, and which, in a rough, natural way, affords him the use of a Parliament, on most cheap terms, and without the formidable inconveniences attached to that kind of Institution. A Parliament reduced to its simplest expression, and instead of Parliamentary eloquence, provided with Dutch claypipes and tobacco. . . .*

Paul Carl Leygebe's *Tabakskollegium of Frederick I* (429) is a sketch for a tapestry series of that king's deeds. This canvas shows the extravagant yet isolated character of the court of Prussia's first king. Frederick's love of luxury led his nervous, militant, intelligent son Frederick William I (1688–1740), father of Frederick the Great, to react in anxiously puritanical fashion toward any aspiration to the Grand Manner — or even to the cosmopolitan — that was displayed by either his father or his own famous son.

Similarly small-time in feeling to Leygebe's canvases is a rare, far earlier example of German Baroque painting, *The Triumph of Venus* (430) of c. 1640–45, by Johann Heinrich Schönfeld. Gentle in spirit, this tender triumph is far from Rubens's contemporary, authoritatively Romanizing mode. Most of his life Schönfeld stayed in Augsburg, which had long been a wealthy center for sophisticated patronage, beginning with that for the Holbeins (106, 109).

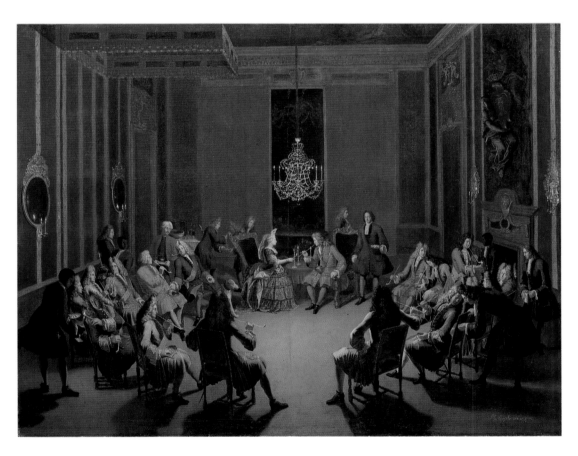

PAUL CARL LEYGEBE, Nuremberg, 1664–Berlin, after 1730, *Tabakskollegium of Frederick I*, 1709–10

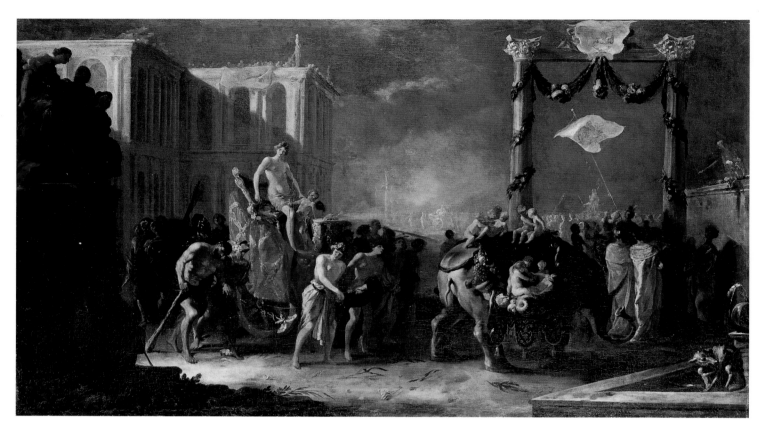

JOHANN HEINRICH SCHÖNFELD, Biberach, 1609–Augsburg, 1684, *The Triumph of Venus*, c. 1640–45

A proto–Magic Realist, Willem-Frederick van Royen, was called to Berlin from Haarlem in 1669 by Frederick William III, the Great Elector of Brandenburg (1620–1688). Under this ruler Prussia became a major power requiring its own academy, which was founded under van Royen's direction in 1698, as a suitable symbol of prestige. Reigning from 1640 until his death, Frederick William III assembled the scattered Hohenzollern properties after the Thirty Years' War (1618–48), paving the way to modern Prussia.

Well into the nineteenth century, Berlin was still among the most rustic of capitals, housing many farms within its confines, the city teeming with bird life that survives to this day. The Alexanderplatz was named for Czar Alexander I in 1805 by his close friend Frederick William III. Among Berlin's centers for civic events, it nonetheless nurtured a most peculiar carrot (431), which was immortalized by van Royen. Since Dürer's day, such nature studies had been important to German art and science, and were perpetuated in this clinical rendering of freakish growth.

In 1698 an Academy of Art was founded in Berlin as part of the cultural furniture so long essential to any government since the Medici first made that obvious in Michelangelo's Florence. Prussia assumed regal status under Frederick I in 1701. Court portraitist and *animalier* Johann Christof Merck, who painted *Ulmer Dogge* (427) in 1705, was summoned to Berlin in 1695 to portray the grenadiers of Frederick William I and continued working there until 1717.

Moving from the real to the ideal, from the documentary to flattery, is a portrait of 1739, the year when its sitter, the twenty-seven-year-old prince Frederick II, acceded to the throne. Antoine Pesne's polite unlikeness foreshortened the prince's great nose (432). For this portrait the new king of Prussia is suitably regal in velvet and ermine over armor, invested with the Order of the Black Eagle, which was founded by his grandfather Frederick I in 1701.

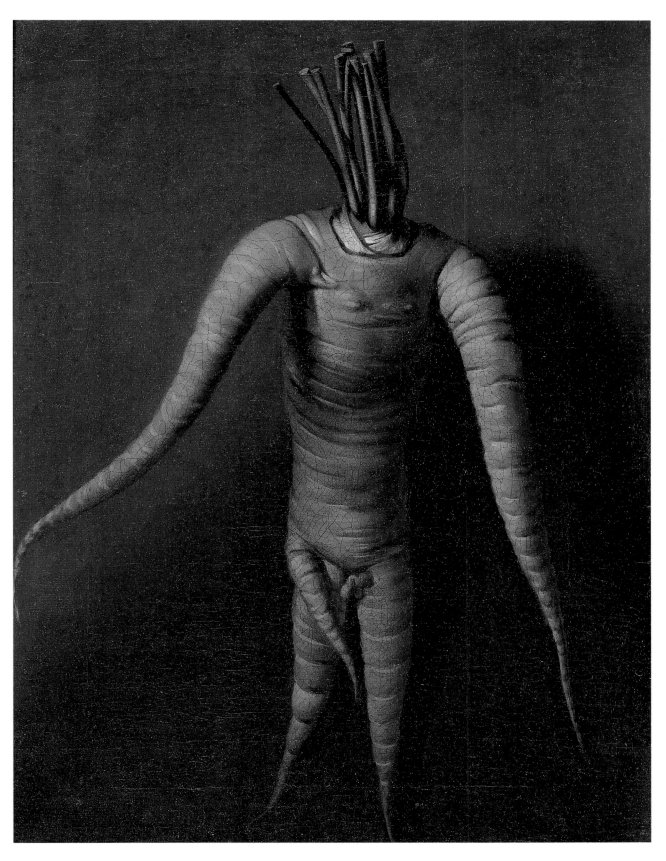

WILLEM-FREDERICK VAN ROYEN, Haarlem (?), 1645–Berlin (?), 1723, *The Carrot*, 1699

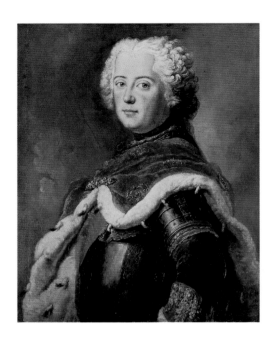

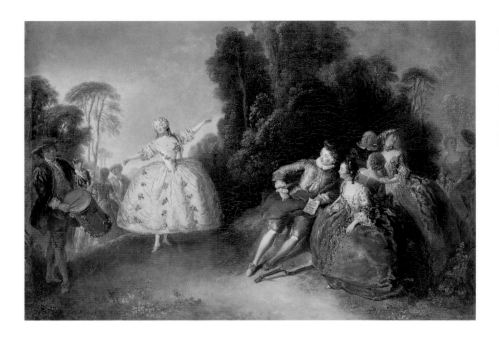

ANTOINE PESNE
Paris, 1683–Berlin, 1757
Frederick the Great as Crown Prince, 1739
(above)

ANTOINE PESNE
Marianne Cochois, c. 1750 (above, right)

ANTOINE PESNE
*The Artist at Work with His Two
Daughters*, 1754 (right)

Opposite:
ANTOINE PESNE
*The Dancer Barbara Campanini,
Called Barbarina*, c. 1745

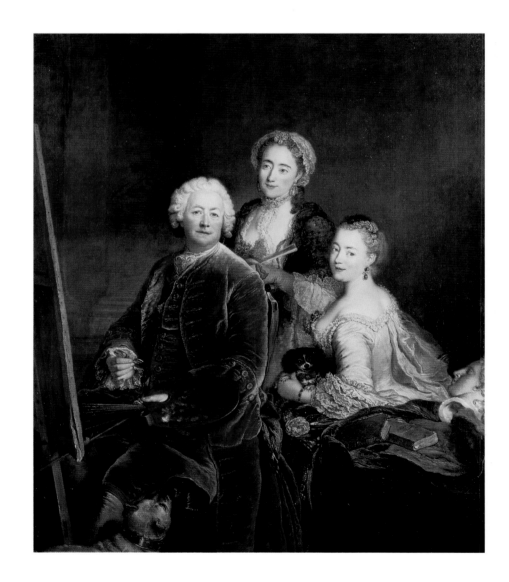

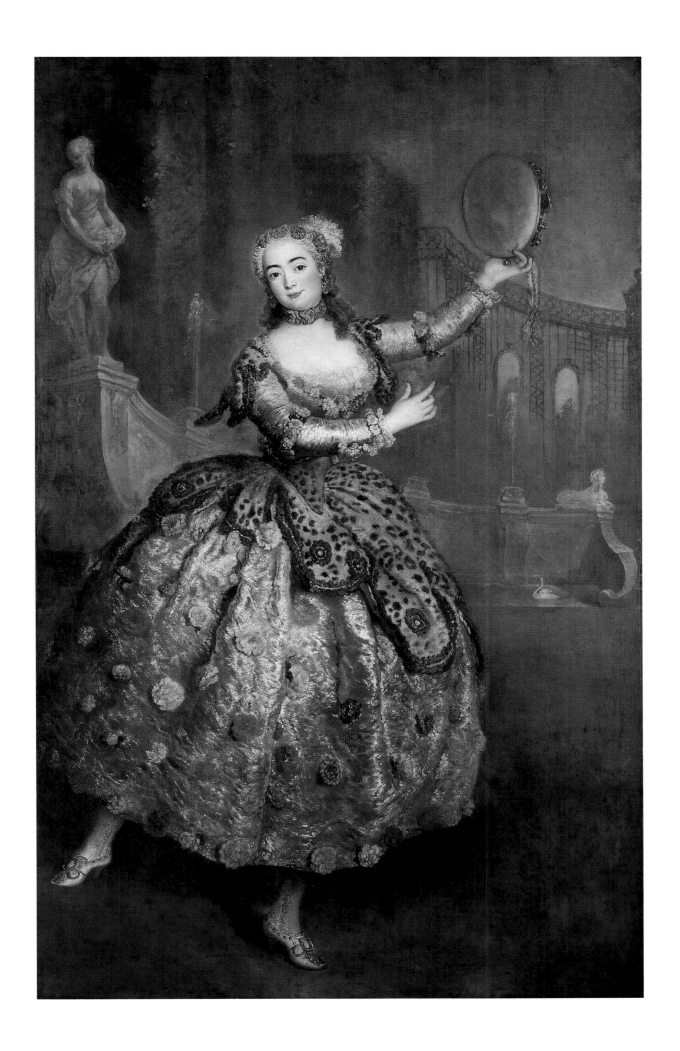

The aesthetic young king was sensitive to his own homeliness and made sure that no portrait of himself was ever in sight at any royal residence.

Though he was first trained by his father, Pesne learned more from a gifted and inventive uncle, Charles de la Fosse (1636–1716), and then from experiences during his Italian travels. Berlin called in 1711; here Pesne also taught art to Prince Frederick and his more talented younger brother. Pesne became Prussia's official painter and, as such, aspired to Largillièrre's monumentality (416). The expatriate Frenchman's self-portrait of 1754, *The Artist at Work with His Two Daughters* (432), shows the painter as stiff-faced from staring into a mirror. Placed behind Papa, the girls fare better, typifying the flattering talents that made their father such a well-loved, well-paid figure at Berlin's court for over forty-six years. No "Tribute to Art," this elaborately self-congratulatory pictorial epistle is a "Thank-me-very-much" commemorating Pesne's success and the many-creatured comforts he and his far-from-*jeune filles* so long enjoyed.

Frederick found Marianne Cochois (432), première danseuse at the Berlin Opera since 1742, equal to Terpsichore, muse of the Dance, concluding his French paean: *"Ses pas étudiés, ses airs luxurieux / Tout incite nos sens voluptieux."* Dance, so close to the spirit of the arts in the earlier eighteenth century, before Neoclassicism put a damper on animation, likewise enlivens a portrait by Pesne of the Italian ballerina Barbara Campanini (433), known as Barbarina. She left for Paris in 1739, and then went to London for a still more successful career. By 1744 she was a famous dancer in Venice, and Frederick the Great would invite her to dance at the opera from 1744 to 1748. This portrait dates from c. 1745 and was originally installed just behind Frederick's desk in his oval white and gold study at the Berlin Palace. The dancer's marriage to the son of the Prussian High Chancellor incurred the king's wrath. Upon her divorce, Barbarina was given the title of Countess of Campanini.

From the early eighteenth century is a Mozartean portrait, painted by Luigi Crespi in 1732, of a woman surmised to be Elisabetta Cellesi (434). A member of the famous family of Bolognese painters, son of Giuseppe Maria, Luigi's style is far

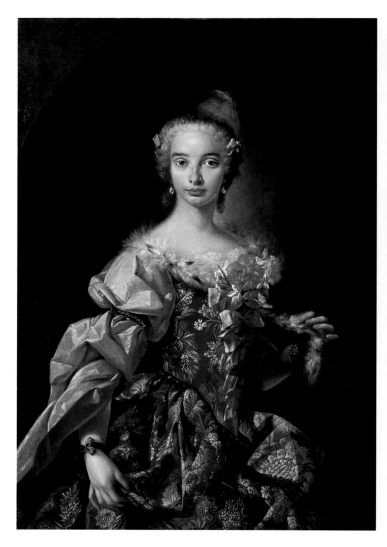

LUIGI CRESPI, Bologna, 1709–1779
Elisabetta Cellesi (?), 1732

crisper and more Rococo in concept, as seen in this balletic image, with its emphasis on a sudden glance and decorously agitated drapery, all in keeping with the light touch of that period.

German Rococo delicacy is seen in the Chinoiserie overdoor (435) for a Brandenburg interior, by Bernhard Rode, a Pesne pupil. Here the Empress of China picks the first mulberry leaves for silk cultivation. Plans were drawn up in 1755 for a Chinese tea-house in the gardens of Sanssouci, which would only be completed in 1764, after the end of the Seven Years' War. This festive, Eastern-inspired style also lent itself happily to exquisite German court porcelain, jewelry, and precious metalwork, and to

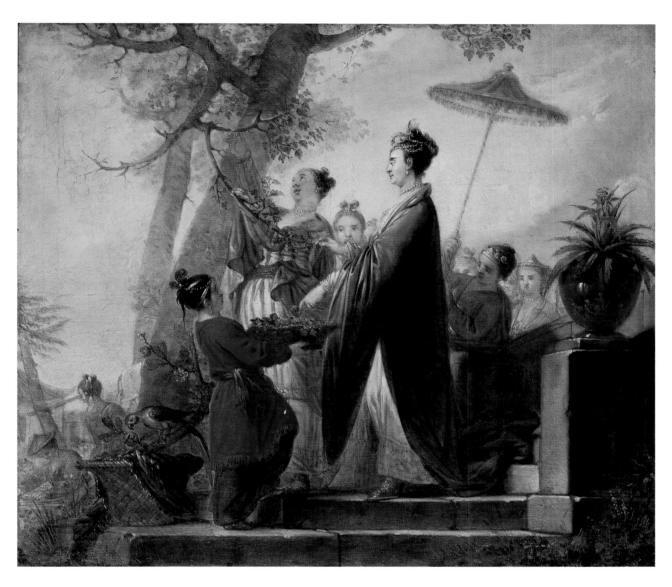

BERNHARD RODE, Berlin, 1725–1797, Chinoiserie overdoor: *The Empress of China Culling Mulberry Leaves*, c. 1773

the design of silver-gilt and polychromed furniture and scintillating mirror-lined walls in the same regions. A triumph of caprice, close to the neo-Gothic in its irrational, unorthodox gaiety, Rococo Chinoiserie was admirably suited to the virtuoso skills and exotic tastes of German and Austrian artists of the eighteenth century.

Where German-speaking lands often imported Venetian artists like Giovanni Battista Tiepolo (469–71, 473), Bernardo Bellotto, the Dalmatian Federico Bencovich, or Michele Marieschi (489) to decorate ceilings and walls, they also exported superb artisans to create the most complex curving — or ravishingly austere — furniture for France and

northern Italy. Europe's finest *ébénisterie* would have been impossible without German and Austrian technical accomplishments. These brilliant crafts provided scintillating settings for Berlin's eighteenth-century art collecting.

Close to the condition of music, Rococo and Baroque modes paralleled the art of Germany's and Austria's composers, long leaders in European music. German artists of the Rococo took on a somewhat French manner, as in the genial like-nesses of Joachim Ulrich Giese (1719–1780), founder of the Stralsund faience manufactury, and of his wife, née Schwerin (1733–1796) (436). These Greuze-like images, painted by Georg David Matthieu

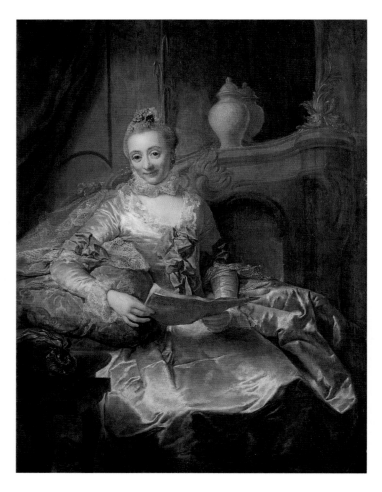

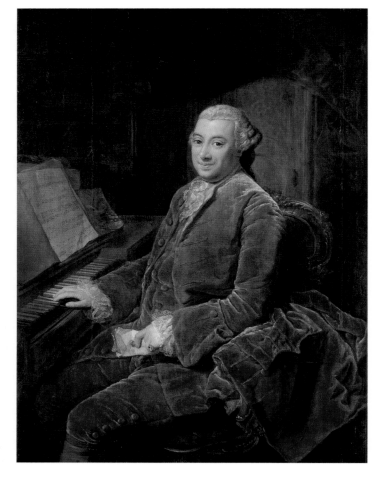

GEORG DAVID MATTHIEU
Berlin, 1737–Ludwigslust, 1778
The Wife of Joachim Ulrich Giese (née Schwerin), c. 1762–64
(above)

Joachim Ulrich Giese, c. 1762–64 (above, right)

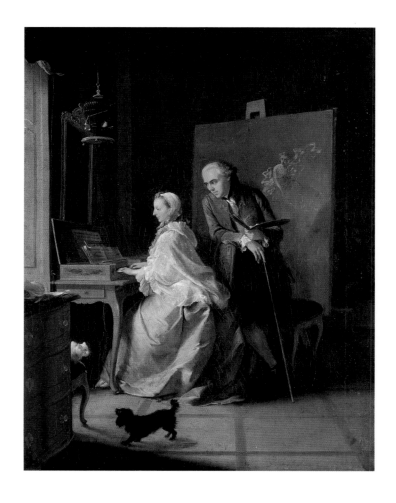

JOHAN HEINRICH TISCHBEIN THE ELDER
Haina, 1722–Cassel, 1789
Portrait of the Artist and His Wife at the Spinet, 1769

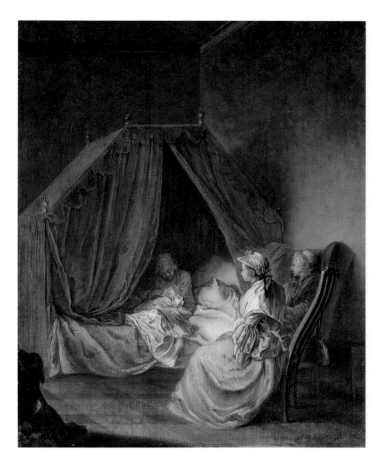

DANIEL NIKOLAUS CHODOWIECKI
Danzig, 1726–Berlin, 1801
The Lying-in Room, 1759

DANIEL NIKOLAUS CHODOWIECKI
The Lying-in Room, 1759

between 1762 and 1764, are pleasant, pleasurable portraits that convey the reasonable delights of an Enlightened Germany, with its new sense of amused urbanity.

Two intimate scenes by Berlin's Daniel Chodowiecki of a young mother in childbed (*437*), both dated 1759, show the light touch of one of Germany's most deft painters of the later-eighteenth-century domestic scene. In the first, the mother must receive visitors; in the second she may rejoice in their absence.

Some German painters developed a direct approach, far from that of Paris. Among Prussia's strongest portraitists was Anna Dorothea Therbusch, daughter and sister of skilled artists, painter to Frederick the Great, and member of many academies. Her canvases of arch, chubby, royal favorites such as Wilhelmine Encke, Countess Lichtenau (*438*), pretty — if porcine — in pink, suggest Fred-

erick's possible later propensity for Rubensian *Saftigkeit*, in life as well as art. Lest anyone miss the source of Billy's smile or use of her ample décolletage, lovebirds bill and coo overhead.

A self-portrait (*439*) by Therbusch of c. 1776–77 is her best work. Partly unfinished, it is a monument to the artist's self-scrutiny. She shows herself reading, not painting, and hides her right, "working," hand because this is hardest to paint. A pendant likeness of Herr Therbusch is lost.

Among the most skillful Austrian masters of the Rococo vocabulary was Franz Anton Maulbertsch, whose sketch for a ceiling painting — an *Apotheosis of a Hungarian Saint* of 1773 (*441*) — despite its obvious indebtedness to Tiepolo, presents an original approach to color. Also close to Venetian art is a brilliant, anonymous South German canvas of c. 1770, *Execution of a Woman* (*440*).

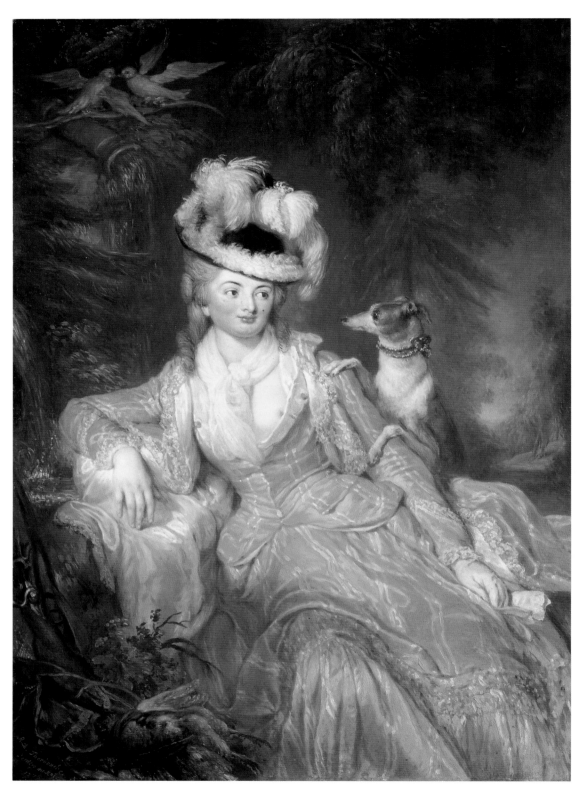

ANNA DOROTHEA THERBUSCH
Berlin, 1721–1782
Wilhelmine Encke, Countess Lichtenau, 1776

Opposite:
ANNA DOROTHEA THERBUSCH
Self-Portrait, c. 1776–77

ANONYMOUS
South German
Execution of a Woman, c. 1770

Opposite:
FRANZ ANTON MAULBERTSCH
Langenargen (Upper Austria), 1724–Vienna, 1796
Apotheosis of a Hungarian Saint, 1773

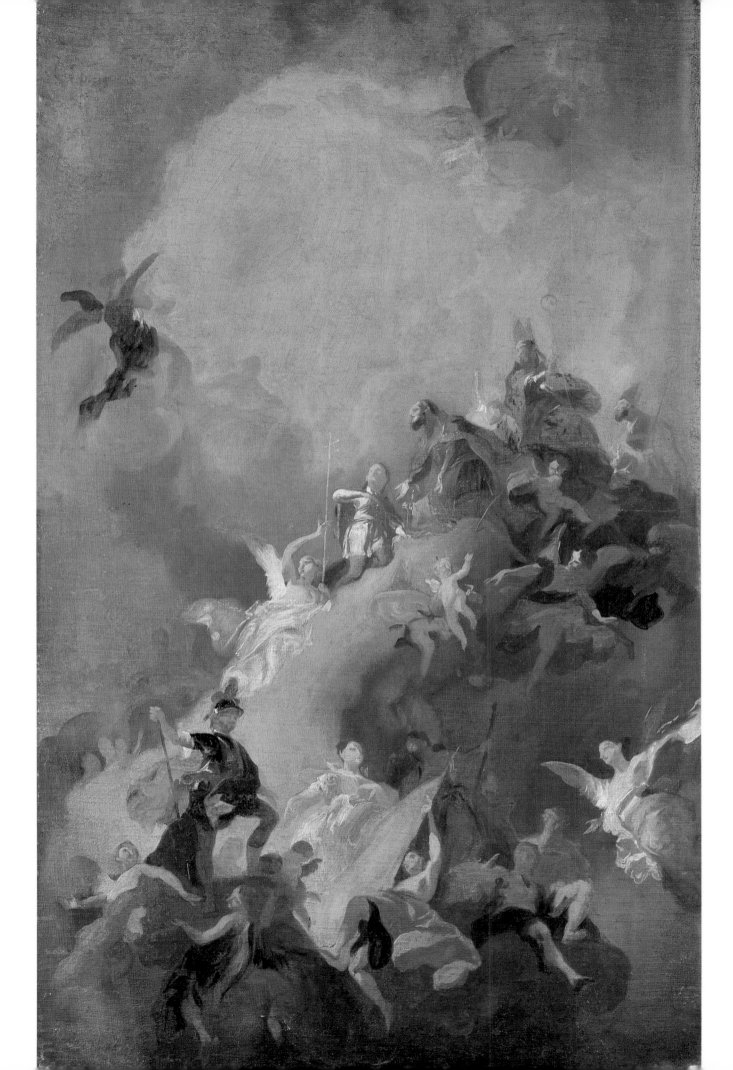

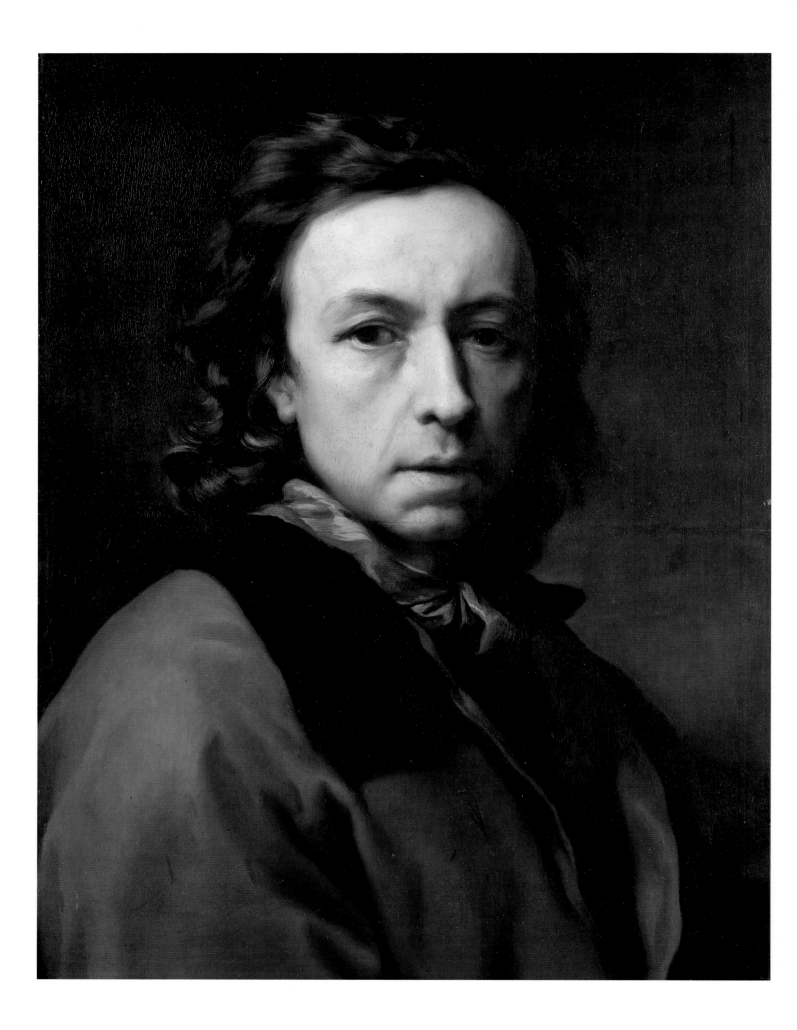

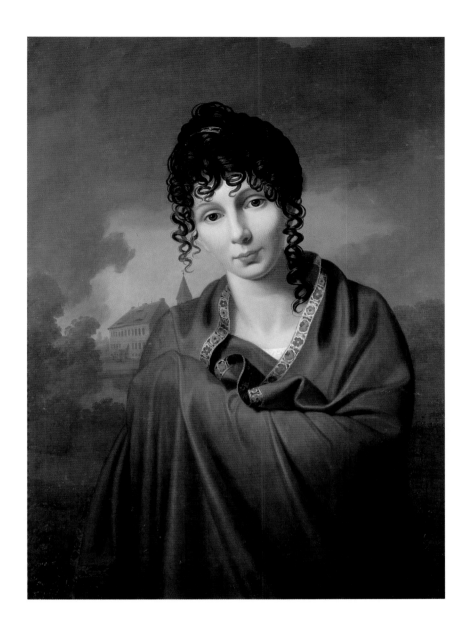

Opposite:

ANTON RAPHAEL MENGS
Aussig (Bohemia), 1728–Rome, 1779
Self-Portrait, 1779

FRIEDRICH BURY
Hanau, 1761–Aachen, 1823
Countess Luise von Voss, 1810

Cautious classicism was advocated by Anton Raphael Mengs, whose vigorous *Self-Portrait* (442) was painted in Rome in 1779, the year of his death. Mengs, the most famous German painter since Dürer, was the son of a Dresden court painter. Like Sir Thomas Lawrence (502) he was a child prodigy. He went on to receive key Vatican commissions and became court painter to Spain's King Charles III in Madrid. Mengs and the major theorist–art historian Johann Joachim Winckelmann (1717–1768) first met when they both came to Rome in 1755. The Neoclassicist scholar's influential position as librarian at the Villa Albani, with his soon-celebrated prescription

for "noble simplicity and calm grandeur," may have helped win Mengs his first major Roman fresco commission at the Villa.

On the borderline between the art of the eighteenth century and Biedermeier is a domestic Northern version of the Empire style (443), a portrait of 1810 by Friedrich Bury of winsome Countess Luise von Voss (1780–1832). Wrapped in a cashmere shawl, her manor glimpsed in the background, Voss's presentation in semi-grisaille recalls early Ingres. Once again, links between German and French art, so strong since the seventeenth century, continued in the nineteenth.

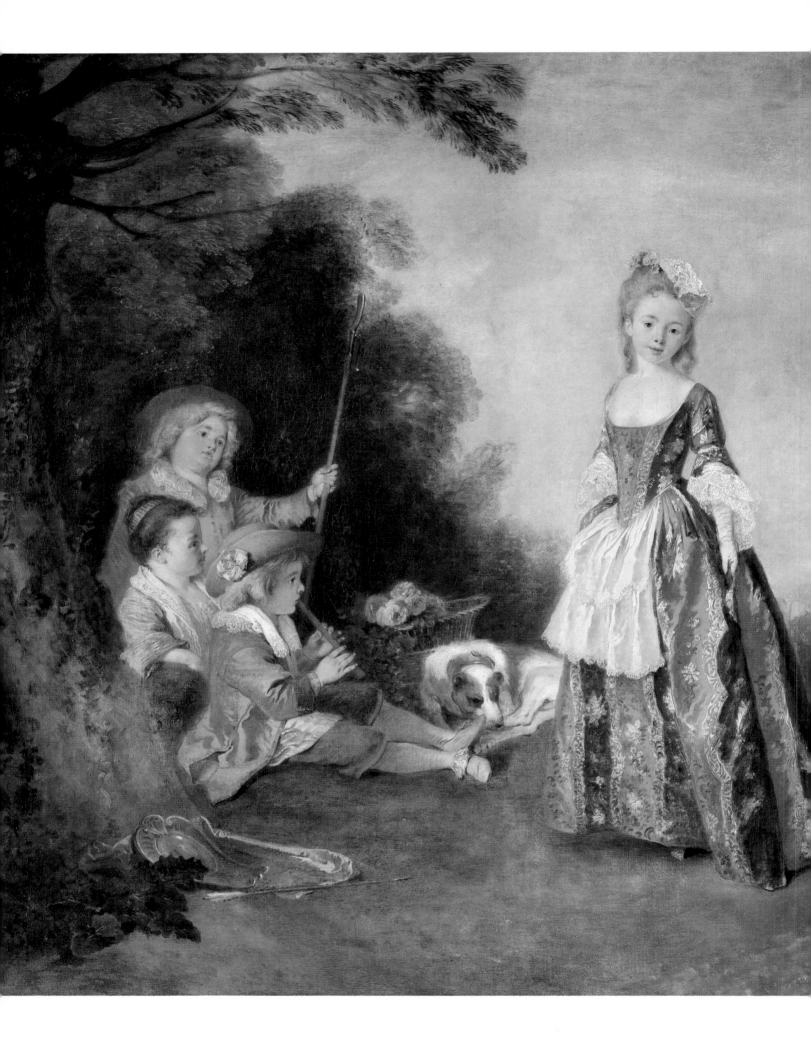

Witnessing Love's Passage:
Watteau et ses émules

Like many passions, that of Prussia for France was often a love/hate relationship, one in which Protestant Prussia adored yet resented France's often enlightened Roman Catholic culture, immense power, and absolute prestige. Much of the northern nation's new Rococo painting followed upon the young Frederick the Great's sympathetic response to the art of Jean-Antoine Watteau and his circle. One of its leading figures was Nicolas Lancret, a fellow student with Watteau in Claude Gillot's studio; the other — Jean-Baptiste-Joseph Pater, a painter of often slender, derivative skills — may have been a student of Watteau's.

It was Frederick the Great's high-living grandfather, Frederick I, who first bridged Berlin and Paris by hiring Antoine Pesne (432–33), one year Watteau's senior and a member of the same circle. Around 1718, Pesne sent a sketch from Berlin to Watteau's Parisian employer, Nicholas Vleughels, with the request that it be "shown also to Monsieur Watau, he has insights which I do not have, and does not flatter."

At fourteen poor little Frederick's father made him a captain of the Grenadier Guards in the regiment of Potsdam Life Guards, those giants recruited for high pay from all over Europe that were thrifty King Frederick William's pride and joy and major extravagance. Few young men, let alone heirs apparent, were so frequently and publicly abused by fathers mad with rage as was the young Crown Prince Frederick. He wrote his mother from Potsdam in December 1729,

> I am in the utmost despair. . . . The King has entirely forgotten that I am his son. . . . At the first sight of me he sprang forward, seized me by the collar, and struck me a shower of cruel blows with his cane. . . . He was in so terrible a rage, almost out of himself;

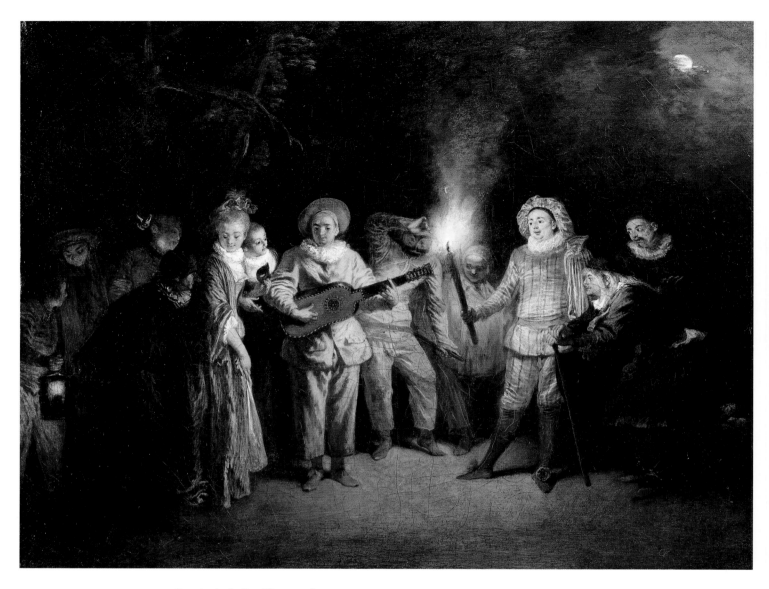

ANTOINE WATTEAU, *Love in the Italian Theater*, after 1716

it was only weariness, not my superior strength, that made him give up. I am driven to extremity. I have too much honour to endure such treatment; and I am resolved to put an end to it one way or another.

In 1730, Frederick sought surcease from Potsdam's paternal, military rigors. He planned to take off for a gentler, less-pressured life at the English court ruled by his mother's Hanoverian kinsmen — a flight to freedom if ever there was one. The attempt was foiled: his father cooled the errant son's ardor for such "disloyalty" by equating it with the high crime of military desertion. In an uncommon pedagogical exercise, Frederick was forced to

witness the fatal flogging of his potential flight companion. Oddly stirred by so extreme a display of paternal firmness, the prince thereupon proved almost all his progenitor could hope for. But the heir apparent maintained his ongoing, lamentable interests in literature, music, art, and other concerns of the French Enlightenment.

Like Renaissance *condottieri*, with their pretentious references to *ars et mars* — balancing passively contemplative with actively military lives — Frederick, with his passion for conspicuous learning and art coupled with the strident pleasures of martial life, followed in these far earlier military leaders' culturally ambitious footsteps. As soon as the royal

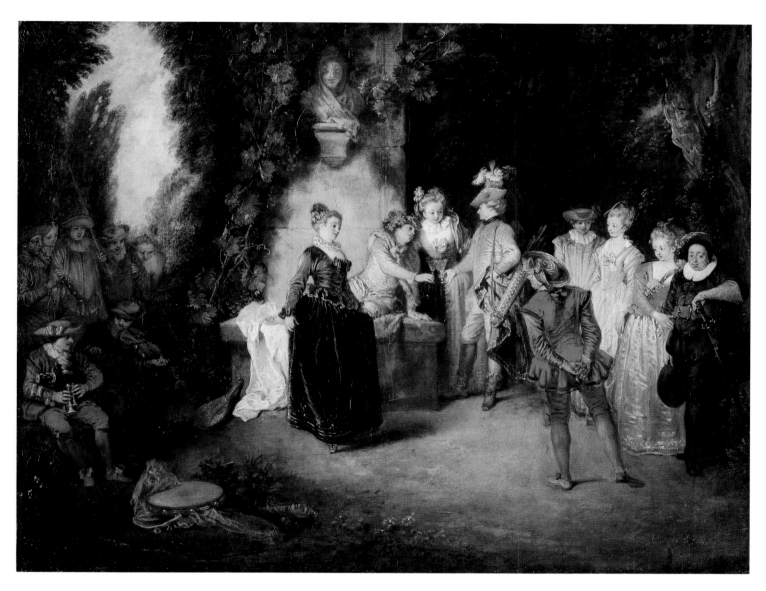

ANTOINE WATTEAU, *Love in the French Theater*, after 1716

succession and Prussia's treasury were his, the second Frederick bought the best of France for Berlin, including a visit of Voltaire's. More of a one-man invasion than a visit, Voltaire remained at Frederick's court for thirty-two months and sullied his stay with sharp financial speculations verging upon the criminal. German-born, Catherine the Great extended the *philosophe* similar hospitality. She was rumored to have been Frederick the Great's daughter, but that is highly implausible. She, like Prussia's new king, adored playing with soldiers. If sexual opposites did not attract, then aesthetic correspondences most certainly did, for Frederick's was a vital response to the gentlest arts. He was a skilled

flautist and composer and a major patron of music and of its closest visually related form, architecture. The king built the Frenchified pavilions, gardens, galleries, and *maison de plaisance* of Sanssouci at Potsdam, the royal center near Berlin, in a new, appropriately carefree, style.

Watteau and his exquisite arts provided a necessarily introspective Gallic Yin to an extrovertedly Prussian Yang. Emperor and artist, though they never met, represented a pictorial odd couple that possessed a strangely fraternal chemistry by image and desire. Obverse and reverse of the same coin, king and creator bespoke the extremes of the human condition. For this reason, art of Watteau's

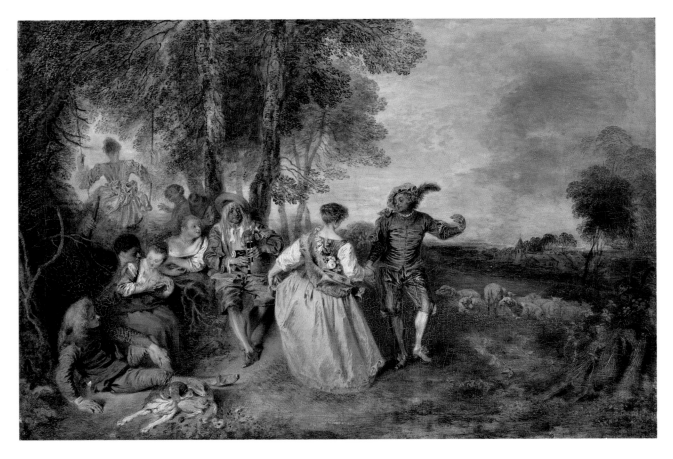

ANTOINE WATTEAU, *The Shepherds*, c. 1717–19

circle spoke so eloquently to the most dread Western militarist in the century of Napoleon's birth.

Subtle and psychologically adroit, Watteau's exploratory images were probably closer to the inner Frederick than we'll ever know. Many of his early subjects dealt with the agonizing tedium of military life's endless halts and regroupings. These conventional, small-scale scenes of army encampment were profitably close to the realistic genres of Dutch and Flemish seventeenth-century art and found a ready market. So Watteau, too, had his military training, as he was "drafted" to prepare these successful, all-too-topical, pictorial skirmishes and *longeurs*.

In terms of today's overly fashionable term "strategies," such images are quite literally concerned with scheming. A chancy element of win or lose, whether of military or sexual advance or retreat, attraction or repulsion, informs these and most other Watteau canvases. Sudden exchanges, guarded or vulnerable gestures and glances, fans

and muskets, prove equally potent weapons in games of war or love, where all is proverbially fair.

Campaign and consummation are at the core of Jean-Antoine's art; his is a pictorial theater of brief encounters in war or peace. Who but he could have dared so effectively to devote a canvas to *"le faux pas"*? — to the good and bad tempering and timing of sexual rise and fall, to unwise masculine insistence and impatience with feminine resistance? The artist learned a lot from Jan Steen (*316–18*) and Willem Pietersz. Buytewech (*313–14*), as well as from Rubens (*300*), in his study of sexuality's infinitely conflicting signals.

In 1702, the eighteen-year-old artist came to Paris from his native, long Flemish, Valenciennes. Playing the human tragicomedy on two chief arenas — the battlefield and the open-air stage — Watteau took special delight in the Parisian performances and stock characters of the French and the Italian comedy, the latter banned by Mme. de Maintenon in 1697 for its broad, bawdy farce. Only upon the old

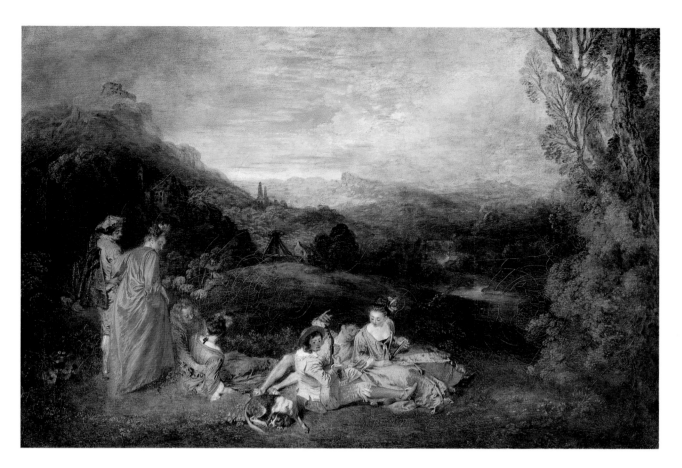

ANTOINE WATTEAU, *Peaceful Love*, c. 1718

king's death could the Regent restore the challenge of laughter. Seldom one for the simple gesture, Watteau combined the costumes of street and stage, blurring distinctions between artifice and reality. Like the Japanese *Ukioy-e* woodcuts, much of Watteau's oeuvre could also be called "Pictures of the Floating World" — scenes of daily, often raffish, events endowed with a subtly layered, frequently ironic, theatricality and elegance; his canvases often merging the demimonde and the officially fashionable.

Fortunately for the young painter (and for us) familiarity with what he did best never bred contempt. Watteau's many achievements in drawing as well as painting were most unusually, extensively reproduced, during or just after the young artist's all too brief life. They were preserved in hundreds of fine prints (some etched by Boucher) for the lavish, loving publication known as the *Recueil Julienne*. So we are unusually familiar with the matchless graphic aperçus provided by this prodigiously musi-

cal artist who died at thirty-seven — the same age as Raphael and Mozart.

Rudolf Frederick, Count Rothenburg, was one of Frederick the Great's major links to French purchases. Attached to the Prussian diplomatic mission to Versailles, the count was entrusted with art acquisition. Frederick wrote to him in 1744 of the need for three Watteaus that Helmut Börsch-Supan believes were for the decoration of the small gallery in Frederick's Potsdam City Castle. In the years 1740–47 the king was also expanding his mother's summer palace in Charlottenburg for his own use.

As many as thirty paintings ascribed to Watteau were in the royal palaces in and around Berlin by the 1770s. Nine were in Potsdam's City Castle, twelve at Sanssouci (where they looked best), and

Overleaf:
ANTOINE WATTEAU
The Embarcation for Cythera, c. 1718–19

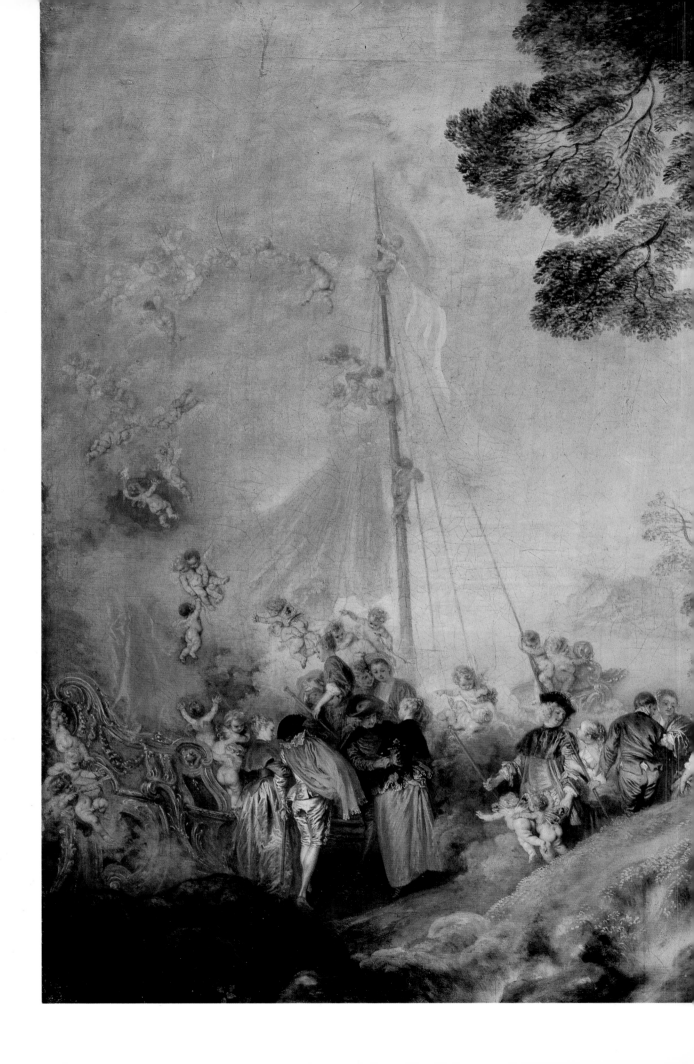

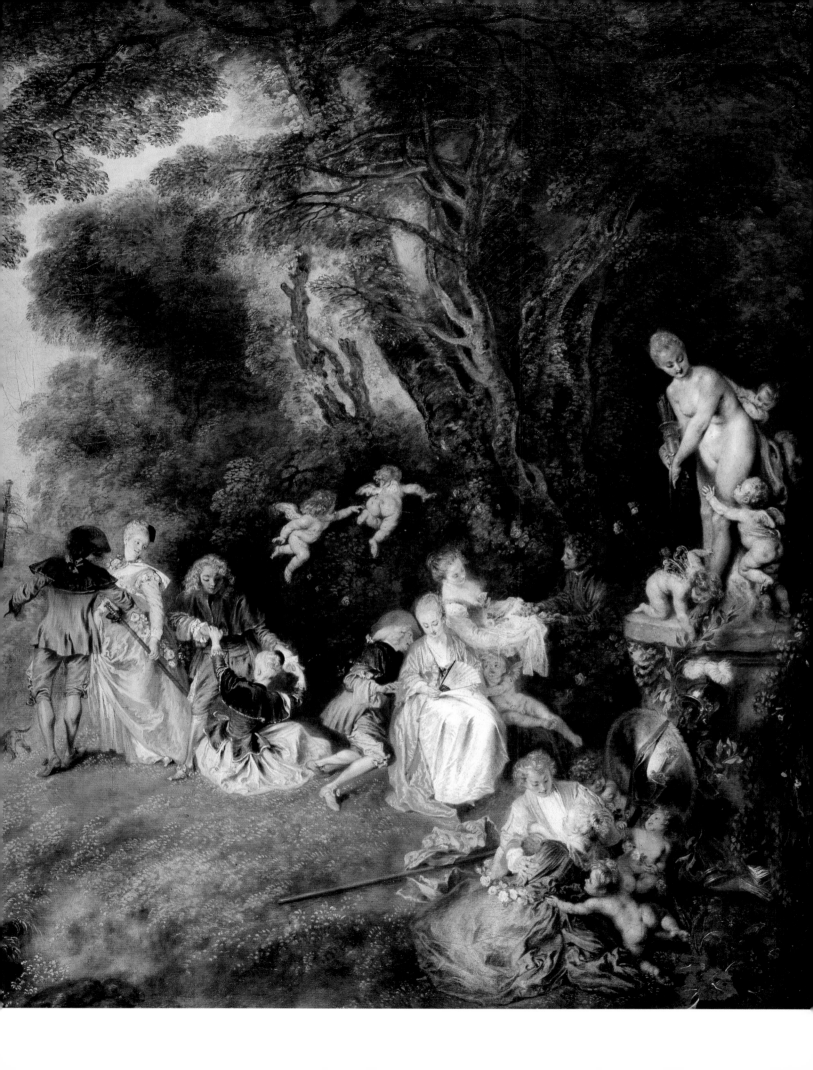

two remained at Charlottenburg. No more than two Watteaus were installed at Potsdam's bombastic Neues Palais, which was built from the swollen Prussian Treasury with proceeds gained from the Seven Years' War's successful conclusion in 1763. Börsch-Supan noted that in addition to this constellation there were thirty-two canvases ascribed to Lancret and thirty-one to Pater, making Prussia Europe's most massive conglomeration of *"Watteau et ses émules."*

Not all fourteen surviving works by Watteau (or those by Pater and Lancret), so long in Berlin, are still there. After World War I the Kaiser, who shared his progenitor's tastes, slipped into Dutch exile with many canvases, including *The French Comedians,* which was later sold to Jules Bache and now is in New York's Metropolitan Museum of Art. Another imperial Watteau — *The Love Lesson* — went to Stockholm; three more, including *The Dance* (444–45) and Berlin's *Embarcation for Cythera* (450–51), were restored to the Hohenzollerns after the Revolution of 1918 and repurchased by West Germany decades after World War II. *The Dance* had initially been bought by Frederick or his younger brother, Prince Henry, in 1766 from the Gerrit Braamcamp sale (Amsterdam). It was originally circular in format and is no longer in good condition. The *Embarcation* was acquired in 1984 for Schloss Charlottenburg, where, for about thirty years, it had been left on deposit by Prince Louis-Ferdinand of Prussia, sold by him for DM 15 million, a sneeze by today's gargantuan Getty standards.

Just as Berlin has two unusual Canaletto nocturnes (482–83), it has an equally uncharacteristic night-piece by Watteau, *Love in the Italian Theater* (446). Here the troupe's grand finale or vaudeville comprises the entire cast singing couplets, interrupted by choruses and dances. Pulcinello strums a guitar and is flanked by Arlecchino and Silvia. This canvas is often mistakenly bracketed with *Love in the French Theater* (447), partly because both came from the same Parisian collection in 1734. They were bought by Frederick and were at Sanssouci by 1769.

By artful mixing of modes and *moeurs,* whether of stage and court or peasantry and city folk, Watteau kept the cliché away, or at least at bay. Such spiced variety is seen in *The Shepherds* (448). These are rich people playing at peasantry, a practice that had been popular in France since at least the days of the early-fifteenth-century Burgundian ducal court at Germolles. Watteau's amorous ladies and gentlemen assume the purportedly readier eroticism of rustic life as they dance, push, or grab one another while a bagpiper provides the "food of love." Here the painter returns to Venetian Arcadian settings with their abundant reminders of the classical joys of sex. He also recalls Jan Steen (316–18), Holland's major master of social witticism and nuance, to help get his party off the ground. *Peaceful Love* (449) is a more elegant version of a similarly rustic theme. Now a guitarist provides musical parallels to amorous concord.

Among Watteau's grandest surviving paintings is the "other" version of the *Embarcation for Cythera* (450–51), the artist's restatement of his *morceau de réception* for the Académie Royale (Louvre). Ambiguous and innovative, the subject led to a new painterly classification — that of *peintre des fêtes galantes.* Berlin's canvas, which is slightly later in date than the Louvre's, is not a "replica," as it has many original features. Arguments as to which *Embarcation* is superior are insoluble; they are matters of taste, not fact. Though identical in size, each canvas has its distinct and distinctive qualities. Paris's has fewer participants — eighteen to Berlin's twenty-four. While the Louvre's has a bolder, more Titianesque landscape, Berlin's enjoys a splendid sky and is more richly Rubensian in figure style and autumnal coloring.

Purchased by 1765, this glorious canvas made a singularly suitable terminal Watteau acquisition, for Frederick's tastes had shifted to the Baroque. Nine years before, when the king was offered works by Lancret, an abundance of which he already owned, he declined, adding, "I am now happily buying Rubens and van Dyck, in a word, the paintings of the great masters, as much from the Flemish as the French School." Perhaps Frederick's newfound leaning toward Baroque art was, as Börsch-Supan has suggested, due to the taste (or lack of it) of Voltaire, who can be counted among those *philosophes* who, far too often, were surprisingly conventional in their view of the *beaux-arts.* Nevertheless, the *Embarcation* could still appeal to Frederick for its

overtly Rubensian references (Watteau himself was ever proud of his Flemish heritage). Despite Voltaire's low estimate of Watteau, Frederick could not forget the painter and bought this great *Embarcation* for installation at Potsdam's Neues Palais.

Each work of art is unique, but, to paraphrase George Orwell, some are more unique than others. This is exceptionally true for a large shop sign by Watteau (454–55), which he painted on two joined canvases in one of the very last weeks of his life. The *enseigne* was made for the artist's dealer Edmé-François Gersaint, whose gallery on Paris's medieval Pont Nôtre-Dame sold bric-a-brac, fine toilet articles, clocks, and mirrors as well as paintings and exotic wares.

The sign was originally curved at the top to fit within the arched format of Gersaint's shopfront, one of many on the bridge's arcade, like those still found on the Rialto in Venice, or on Florence's Ponte Vecchio.

Gersaint recalled,

[Watteau,] on his return to Paris [after unsuccessfully seeking a cure for tuberculosis in London in 1721], during the first years of my establishment, came to ask if I would . . . allow him to stretch his fingers, those were his words, if I were willing . . . to allow him to paint a sign which I was to exhibit outdoors. I had some reluctance to grant his wish, much preferring to occupy him with something more substantial, but seeing this would please him, I agreed. The success he had with this piece is well known. All was based on life; . . . the groups so well understood that [the sign] attracted . . . passersby. Even the most skilled painters came several times to admire it. The sign was completed in eight days, he could only work in the mornings, his delicate health . . . not permitting a longer day. It is the only painting that brought out a little conceit [in Watteau], — he made no bones about admitting this to me.

Exhibited *in situ* for only two weeks (the *enseigne* was sold to Claude Glucq, counselor of the Parlement, a friend of the artist's, and cousin to Jean de Jullienne, the print dealer who issued Watteau's drawings in unprecedentedly lavish form), this large painting shows Gersaint's clients, searching for some new/old bibelot, mirror, or canvas — purchases designed to shed luster on their homes and thus upon themselves. The *démodé* is packed away. Only the wistful young woman in pink casts a glance at an oval portrait of the once absolute ruler Louis XIV, source of the shop's name, *Au Grand Monarque*. Frederick the Great may well have chuckled at this humble fate for his old enemy, whose noble visage is here lowered and boxed, protected by straw emblematic of *merde*. Now the almighty *Roi Soleil* is less lively than the fleas so avidly pursued by a hound at the right, painted with the vitality of a Flemish Baroque master.

Ticking away near the dead king's image is a fine clock emblematic of Time, particularly poignant as the mortally ill artist was working so swiftly against its passage. A gilt-bronze Fame surmounts the timepiece. Its location before a mirror doubles the clock's symbolic impact, that of the triumph of Fame over Time.

Arguably the supreme author of a purely secular painting devoted to sight and insight, Watteau doesn't hesitate to employ sight gags. One of these is made by the presence of the elderly couple examining a *Diana and Her Nymphs Bathing*. While the lady peers through a lorgnette at some suitably innocuous detail, her companion, assisted by his cane, is cast in the unlikely role of Actaeon. Connoisseur and voyeur — often one and the same — he kneels to sneak a peek at the virgin huntress's naked bathing beauties. Long over the hill, he hides behind his companion's skirts to indulge his *joie de voie*.

Another classical reference to sight may be found to the right, where a young couple with a companion all stare entranced at their reflections in a looking glass. Could Watteau, by placing this self-absorbed threesome in an art gallery, be making a reference to the long-held belief that Narcissus invented painting by falling literally, and fatally, in love with his own image?

This mirror, with its enchanted trio and the hay and timepiece, all bespeak "Vanitas," preaching a witty pictorial sermon concerning blindness to verities and heedlessness of Time's passage when in headlong pursuit of earthly vanities. Youth's

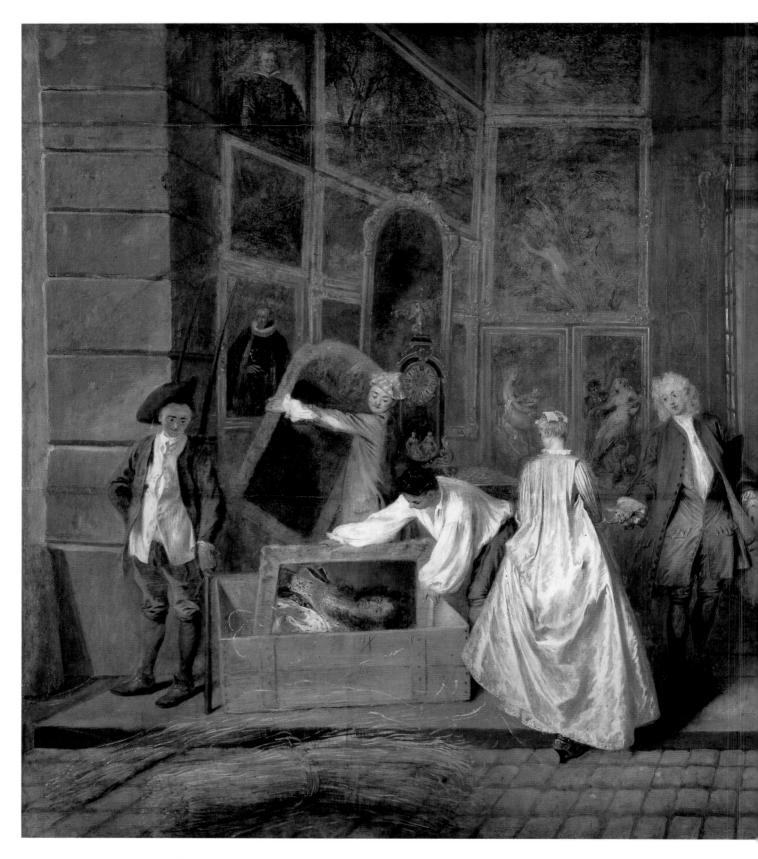

ANTOINE WATTEAU, *Enseigne de Gersaint*, 1721

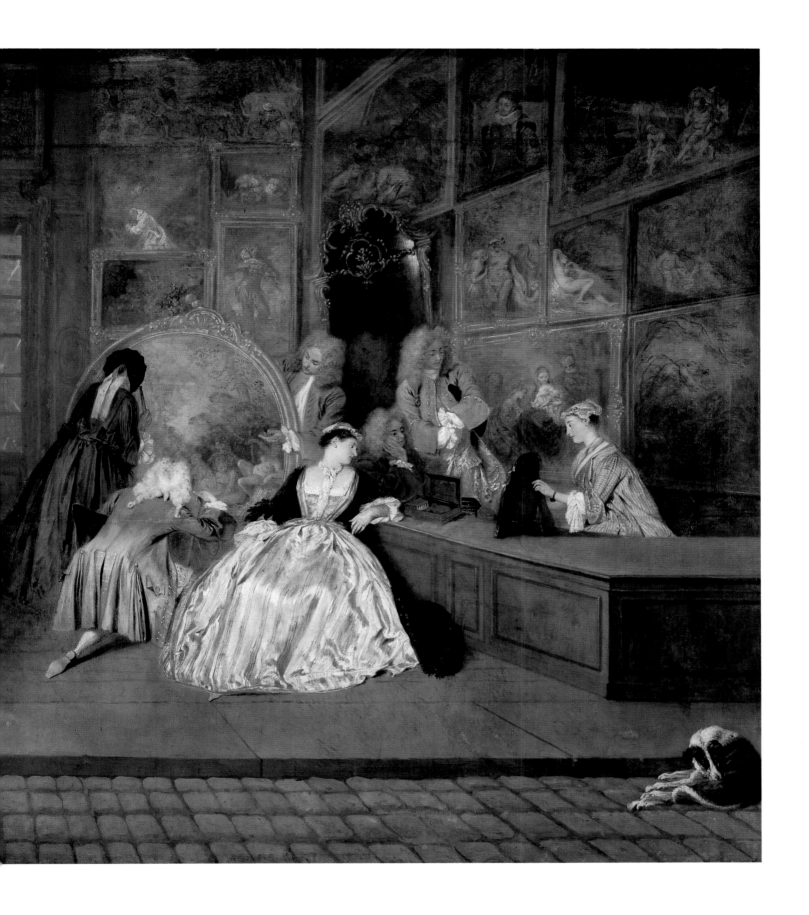

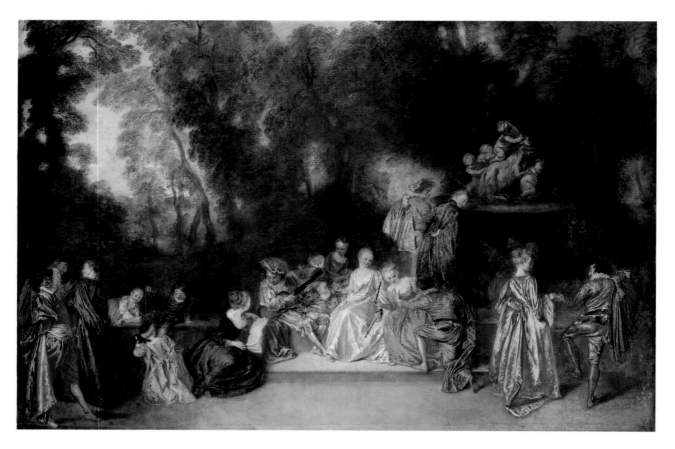

ANTOINE WATTEAU, *Party in the Open Air*, c. 1718–20

ignorant frivolity is stressed by the placement of the young people just before, but blind to, Gersaint's sole large religious painting. All but one of the remaining canvases are portraits, landscapes, or erotic mythologies — *Pan and Syrinx, Leda and the Swan*, a *Bacchanal*. Their display doubtless presents Gersaint's most saleable stock, and much of Watteau's own.

The encylopaedic shop sign is no less than an allegory of the nature and transience of art and life, as central to picturing the role of eighteenth-century painting as Velázquez's *Las Meninas* (Prado) was to the century before, or Courbet's *Real Allegory* (Louvre) would become for the one to follow. Unlike those earlier and later allegories, Watteau's is an ironic yet affectionate tribute to art's dealing. The powers of sight and salesmanship devoted to the twin vanities of acquisition and voyeurism — not the immediate creative consequences of inspiration — are the artist's concerns as he celebrates the successful commercial activities housed just below his *enseigne*. The profound ingenuity of Watteau's

canvas, with the virtuoso speed of its execution, may well have led to the artist's feelings of pride concerning this uncharacteristically intricate image.

The *enseigne* is art's own Last Judgment, an empathic self-portrait by one of its most perceptive painters, a witty tribute to passing passions and to fleeting values, whether for people or pictures. Gersaint's shop sign is a catalogue of the quality of time spent in and on pleasures of the eye, a reflection upon the nature of transience by, for, in, and with art. What better place for this wry pictorial reflection than a location immediately above the shop window through which similar transactions could be witnessed daily? Only such a setting could allow for so telling and sympathetic a dialogue between art and life.

Watteau was as musical a master as Titian, much of his oeuvre devoted to the sound of guitar, flute, bagpipe, harp, or harpsichord. His reference to stretching his fingers suggests a musician's exercise preparatory to the playing of an instrument. For his terminal canvas Watteau strikes almost every chord

toward this most complex, ambitious, and totally successful sign, a Mozartean *opéra comique* informed by the tragedy of finality, to be seen above the glass just before the curtain falls and art's shop is forever shuttered.

Latest of Berlin's many Watteaus may be another unusually large, unfinished canvas, a *Party in the Open Air* (456). Watteau's image of this theme returns to Titian as well as Rubens, whose *Garden of Love* (Prado) is close to it in thought and format. In this French canvas, lovers in various degrees of engagement are in a park whose Baroque statuary group — an elaborate marble showing putti clambering about a goat — symbolizes passion's exigency. While the dance of love animates this canvas, its completion was stayed by that of death.

Where the sexuality of American women has been celebrated by a Russian (Vladimir Nabokov's nymphet Lolita) or by a German (Florenz Ziegfeld's "glorifying the American Girl"), the French took care of their own. Nicolas Lancret's girl/woman ignites passion's fire in a nasty fusion of innocence and calculation that is entitled *The Burning Glass* (457). Its painter had shared a teacher with Watteau, but unlike the latter, Lancret was constantly reprimanded at the Académie for inattentiveness! This did not keep him from becoming *Peintre du roi* by 1717; his *morceau de réception* for the Académie, in 1719, was a *fête galante*. That new category was actually an Arcadian, necessarily rustic, yet most comfortable, amorous good-time-had-by-almost-all set in a Romantically inspecific, but still somewhat courtly, open-air setting.

Decorative vertical pendants, *Le Moulinet* (458) and the *Dance in a Pavilion* (459) are typical of Lancret's art, with women who are almost alarmingly unindividualized and men but a bit more identifiable. Lancret's people are little more than mannequins — Barbie dolls of the *dix-huitième*, their tiny, porcelain heads and hands emerging from costly clothes — caught in a perpetually affluent, overdressed divertissement. Unsurprisingly, it was during Lancret's time that very costly windup dolls first came on the scene.

Like the Merry Companies of the sixteenth and seventeenth centuries (313–15), many Lancrets, such as the *Repas Italien* (460), are feasts in the open air.

Of Pater's forty-two canvases originally in Berlin, fourteen are Hogarthian illustrations of a burlesque tale, *Ragotin*, by Paul Scarron (1610–1660), who was,

NICOLAS LANCRET
Paris, 1690–1743
The Burning Glass
("Woman igniting passion's fire")

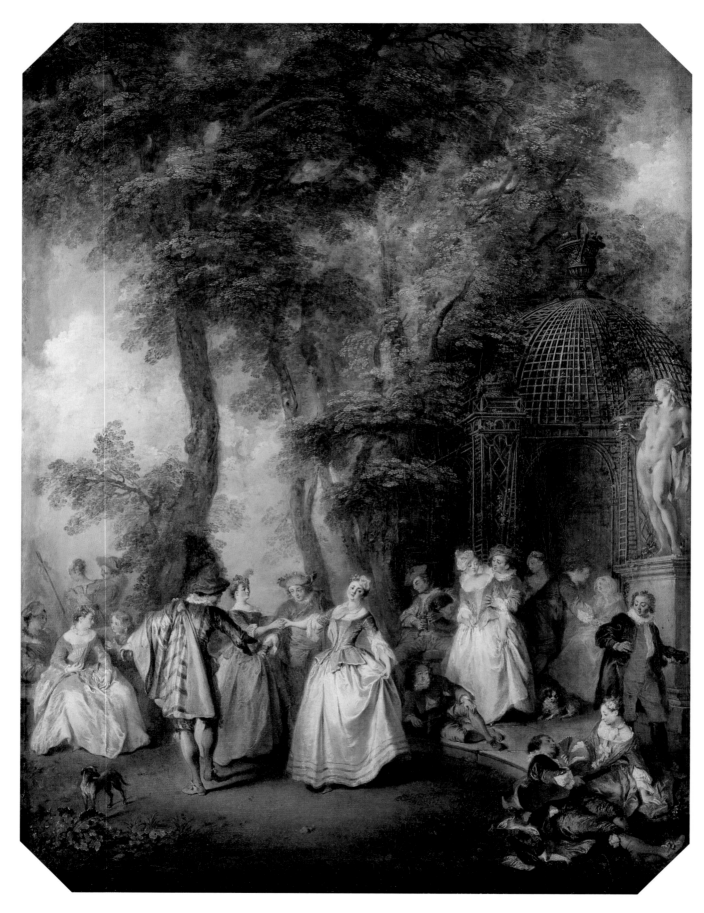

NICOLAS LANCRET, *Le Moulinet*

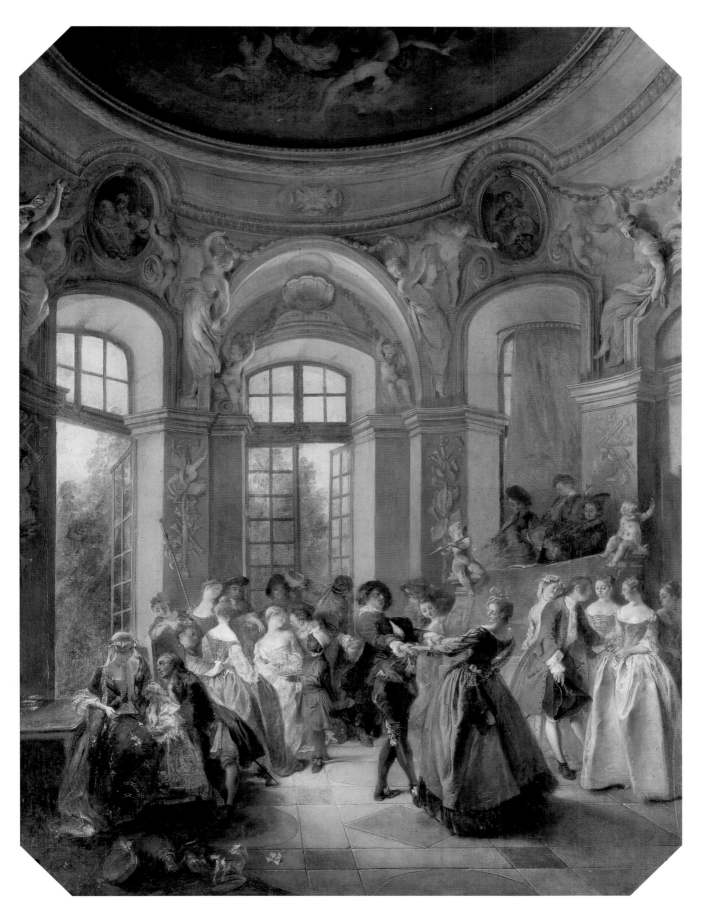

NICOLAS LANCRET, *Dance in a Pavilion*, c. 1730–35

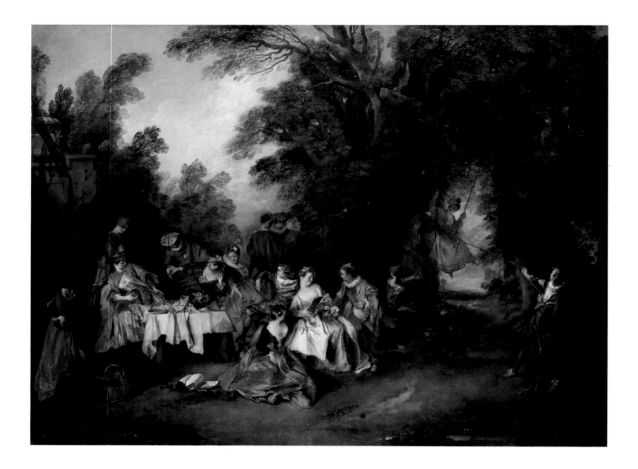

most surprisingly, husband to the censorious Mme. de Maintenon, future mistress and then wife of Louis XIV. Far from Pater's too frequently saccharine or formulaic approach, his Picaresque cycle is full of fun, telling of the amorous adventures and misadventures of its handsome hero, as in *Mme. de Bouvillon Tempts Fate by Asking Ragotin to Search for a Flea* (461) or *The Poet Roquebrune Breaks His Garter* (461).

More than twenty other Paters were in Berlin (two taken by the last Kaiser to Doorn), most of them much in Watteau's manner. Since the king was owner of fifty-five works by Pater, that artist must have been the favorite painter of Frederick the Great in his lighter-hearted youth, unless many of these French canvases came to him as "Watteaus."

Fewer works by François Boucher were sold to Berlin than might be expected, with three bought long after World War II. In *The Education of Cupid* of 1742 (462), Boucher presents a mythological nuclear family where mother Venus and father Mercury are captured in a moment of parental responsibility. As Messenger of the Arts, Mercury seems to be instructing his offspring in lessons of love, catching

Venus's eye in a moment of romantic encounter. His amorous curriculum is underscored by the love goddess's typically Boucheresque "bottoms-up" pose.

The adult Polish prince Heinrich Lubomirski (1777–1850) may well have squirmed before his boyhood likeness, for which he is shown as the Genius of Fame (463). By the adroit Elisabeth-Louise Vigée-LeBrun, his nude is a painted paraphrase of a famous Hellenistic *Crouching Venus*. The tireless French painter and diarist Vigée-LeBrun traveled throughout Europe and Russia in search of courtly commissions, especially after the French Revolution. Her villainous art-dealer husband robbed her of French patronage and dowry alike.

If never again to collect French pictures in the quantity of Frederick II, Germany and her painters loved that nation's later art, admiring innovational paintings by Courbet (568–70), Manet (591–93), Degas (594), Cézanne (612, 614), Renoir (602–3), Picasso, and Matisse. Each of these masters would stimulate and sustain radical developments in the Schools of Munich, Dresden, and Berlin.

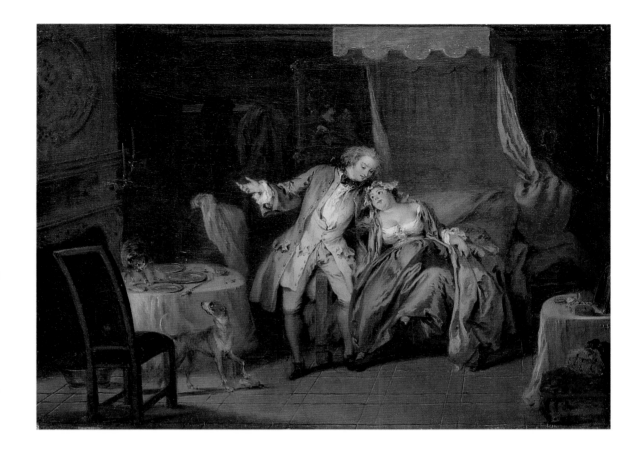

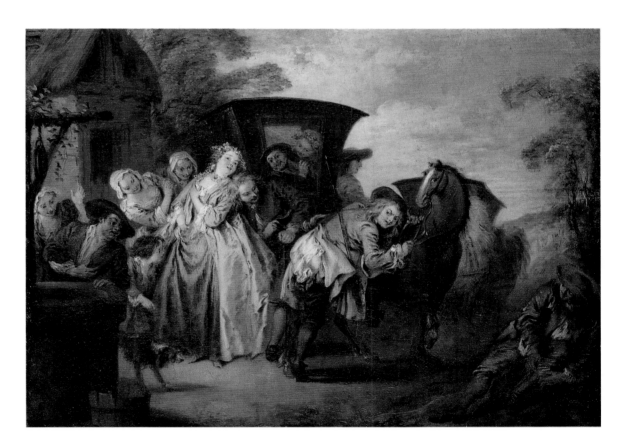

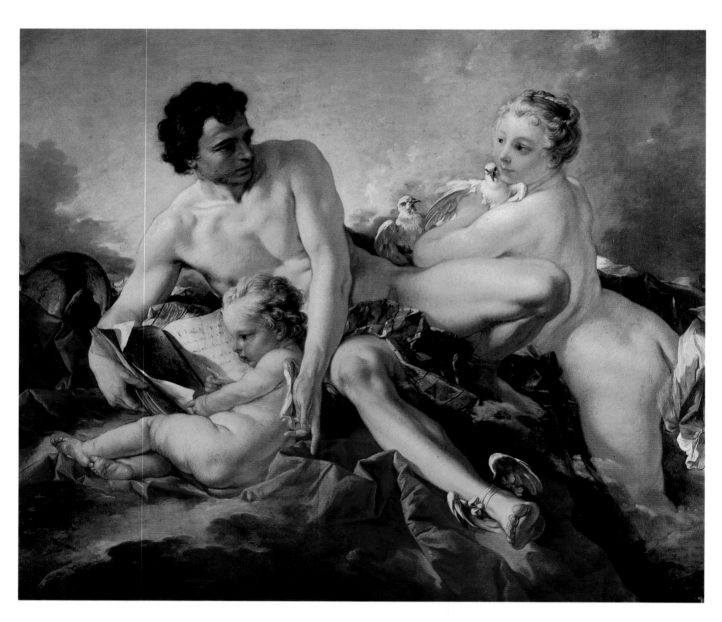

FRANÇOIS BOUCHER
Paris, 1703–1770
The Education of Cupid, 1742

ELISABETH-LOUISE VIGÉE-LEBRUN
Paris, 1755–1842
Prince Heinrich Lubomirski as the Genius of Fame, 1789

JEAN-BAPTISTE-SIMÉON CHARDIN, Paris, 1699–1779, *Sealing the Letter*, 1733

CHARDIN AND THE ARTS OF DOMESTICITY

JEAN-BAPTISTE-SIMÉON CHARDIN, son of a craftsman (a maker of gaming tables), was a slow but very steady success — first at the Academy of St. Luke and then with the Académie Royale. His scenes of cooks and other servants let Upstairs see what Downstairs was all about in the most tranquil, intimate, yet discreetly observed fashion. In keeping with his orderly, usually restrained, character was Chardin's obligation to the Académie — hanging pictures for the annual Salon.

But for a few still lifes in the Grand Manner and fewer figure pieces with relatively large-scale figures, the painter's exquisitely rendered, small canvases, with their often repeated images, were collected by many leading European royal houses and also proved popular in print form.

Frederick the Great bought Chardin's largest anecdotal figure piece for Potsdam (464). Dated 1733, *Sealing the Letter* had been exhibited (along with fifteen other of his canvases) at the Exposition de la Jeunesse the following year, where it was described as "a young woman impatiently waiting for a candle to be lit so that she can seal a letter" — presumably a *billet-doux*. In subject, if not size, the canvas goes back to Dutch seventeenth-century sources, as the artist's domestic scenes so often do. Only the great swoop of curtain and the hound reminiscent of Alexandre-François Desportes or Jean-Baptiste Oudry show the artist taking on a grander manner than usual.

One of Chardin's many versions of a kitchen maid — *La Ratisseuse* of c. 1738 — was bought by Frederick the Great in 1746 along with a *Servant Returning from the Market (La Pourvoyeuse)* of 1738 (465). Whether scraping vegetables or supplying the larder, servants like these attended to the household's healthy diet, a subject of special concern to Chardin, whose duties for the Académie included

JEAN-BAPTISTE-SIMÉON CHARDIN
Servant Returning from the Market (La Pourvoyeuse), 1738

visiting its sick members.

For all its rather dismal subject, a *Dead Pheasant and Game Bag* (466) of 1760 — pendant to a *Dead Hare with Flowers and Onions* (Detroit, Institute of Arts) — shows the painterly alchemy by which Chardin could convert death to life, largely by his exquisite control of light and color, which led him to tell Fragonard the way one learns to paint — "You search, you scumble, you glaze."

Children — playing with battledore and shuttlecock or cards, or blowing bubbles — provided the

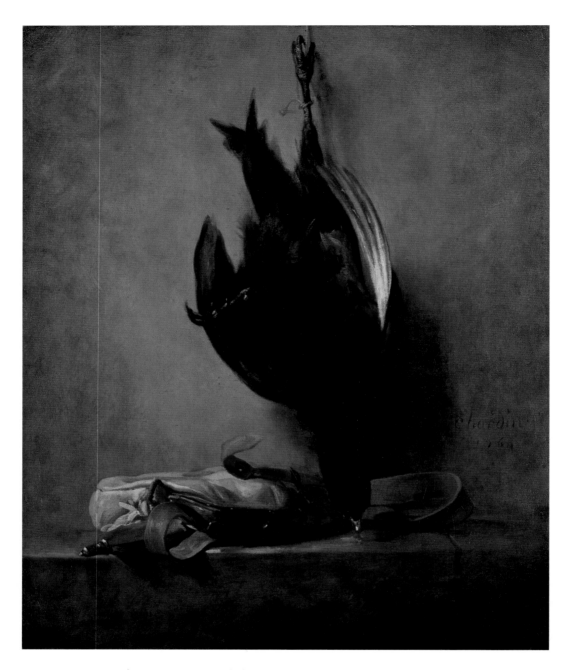

JEAN-BAPTISTE-SIMÉON CHARDIN, *Dead Pheasant and Game Bag*, 1760

painter's favorite large-scale subjects. Though Chardin was not known as a teacher, he was Fragonard's, who entered his studio in 1727 at fifteen and was soon assigned to copying prints so that he could learn to draw. The youth at work in *The Drawing Lesson* (467) of 1737 is a forerunner of young Fragonard. Like this student, Fragonard would also have sharpened his *porte-crayon* to complete a copy of an image of a grizzled elder after prints by Giovanni Battista Tiepolo (469–71, 473) or Gian Battista

Piazzetta (468). Fragonard's work, strange to say, is not included in the Berlin collections — his career post-dated the peak of Frederick the Great's interest in eighteenth-century art — nor is there any major painting by Fragonard's closest later follower, Eugène Delacroix.

Opposite:
JEAN-BAPTISTE-SIMÉON CHARDIN
The Drawing Lesson, 1737

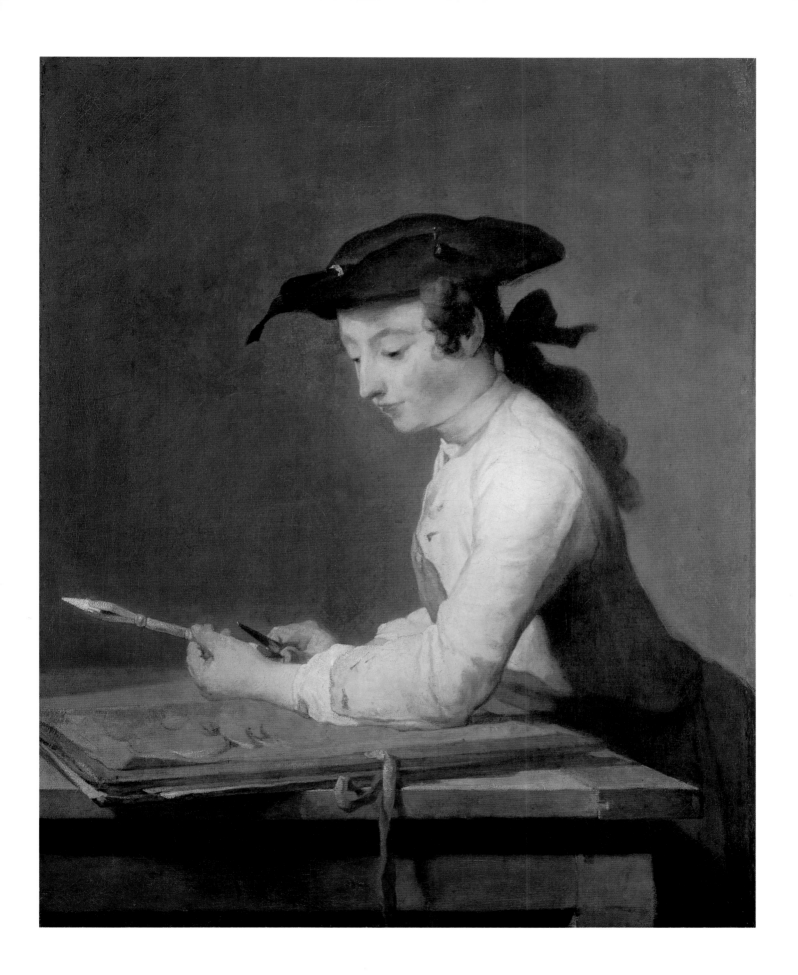

Italian Guides to Faith, Literature, and Life

Eighteenth-century Venetian art, usually seen as more profane than sacred, was surprisingly inventive in terms of religious subject matter, none more so than that of Giovanni Battista Tiepolo, in both his etchings and paintings. Berlin's *Bearing of the Cross* (469), panoramic in the great Venetian tradition, is a *bozzetto* for the central section of a Passion triptych for San Alvise in Venice, completed c. 1738. The antithesis to such a view, though equally cinematic in effect, is a close-up *St. John the Baptist* (468) of c. 1740–50, by Gian Battista Piazzetta, whose brilliant graphic style, as publicized by widely circulated reproductive prints, influenced much of Europe.

Tiepolo was also extremely well known not only by the diffusion of his prints, but because he was the fresco master par excellence, active in the palaces and churches of Spanish and German leaders of church and state. Blanketing the Royal Palace in Madrid, the Episcopal Palace in Würzburg, and many other courtly centers, Tiepolo proved to be a Veronese *redivivus*, whose genius for decoration and flattering allegory in no way diminished the intensity of his piety or gift for romance. This is seen to best advantage in two horizontal panels illustrating Tasso's Renaissance epic poem *Gerusalemme Liberata*. The lovers Rinaldo and Armida are first seen in Armida's ravishing Palladian magical garden (470), then at Rinaldo's reluctant departure (471). These Mozartian paintings are either *bozzetti* or replicas in small format of the painter's large scenes of 1753 for the Episcopal Palace at Würzburg.

Tiepolo's most compelling religious art is seen in his *Martyrdom of St. Agatha* (473) of c. 1750. Formerly on the high altar of the Church of St. Agatha in Lendinara, the canvas was originally arched and then cut down at top and bottom. In this decorous restatement of the violent art of the Counter Reformation, a Charon-like torturer looms to the right. Compositionally still close to the Venetian High Renaissance and the world of Veronese (272), Tiepolo returns to such classically effective formulae as the use of column and steps to set the stage for early Christian martyrdom.

GIAN BATTISTA PIAZZETTA
Venice, 1683–1754
St. John the Baptist, c. 1740–50

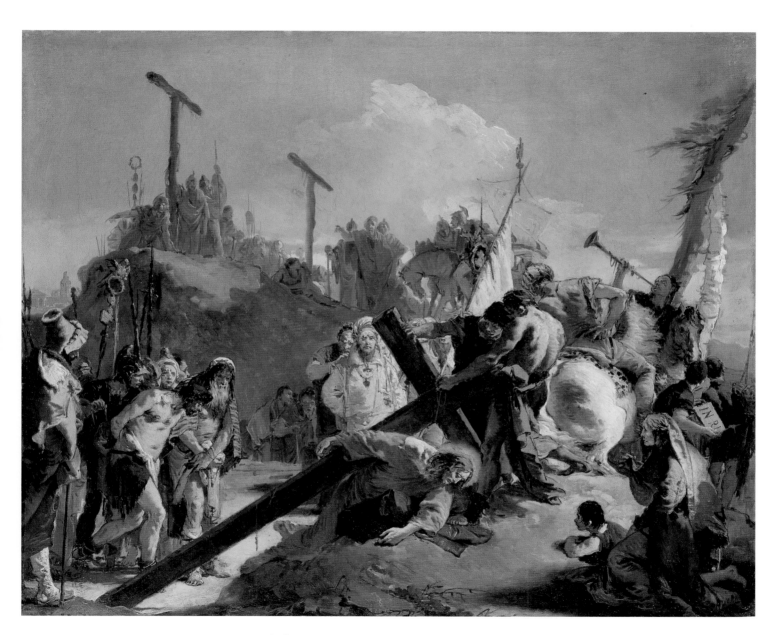

GIOVANNI BATTISTA TIEPOLO, Venice, 1696–Madrid, 1770
The Bearing of the Cross, c. 1738

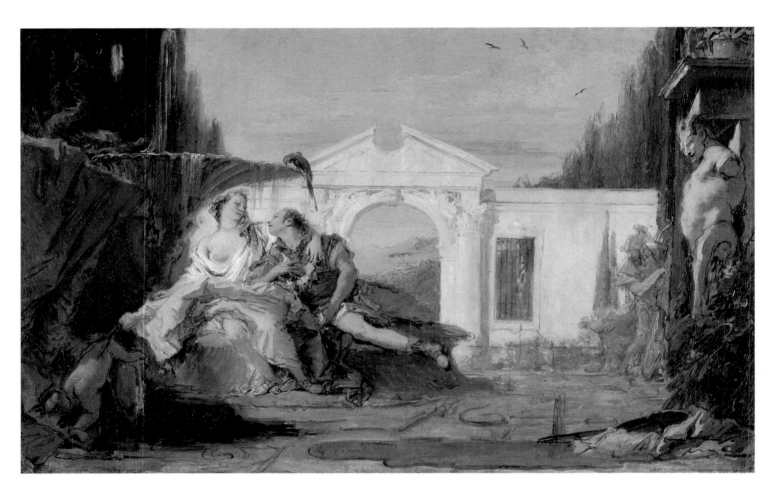

GIOVANNI BATTISTA TIEPOLO
Rinaldo and Armida Overheard by Carlo and Ubaldo in Armida's Magic Garden, c. 1755–60

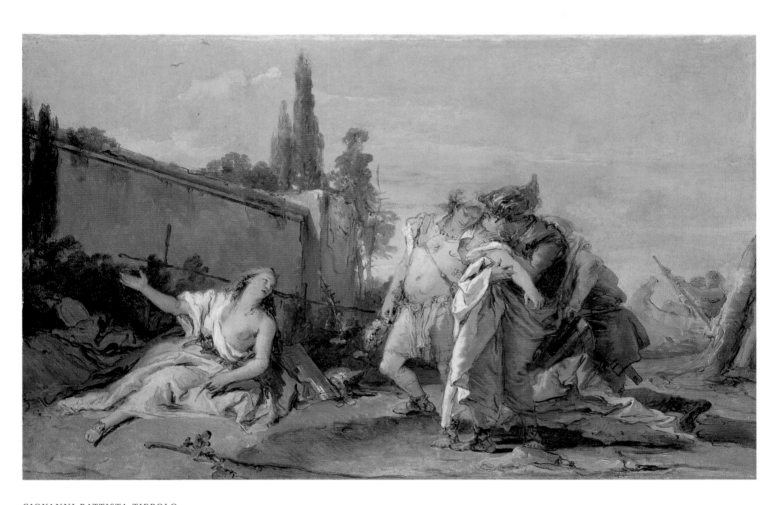

GIOVANNI BATTISTA TIEPOLO

Rinaldo's Departure from Armida, c. 1755–60

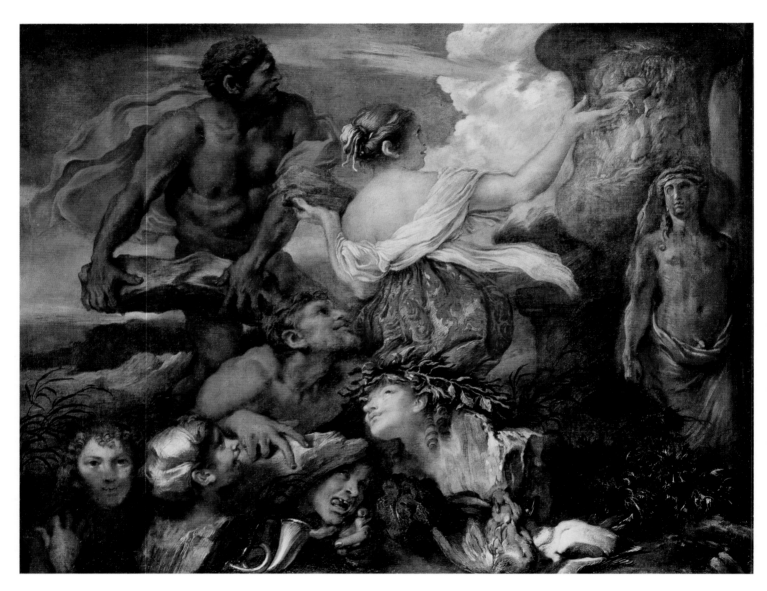

GIOVANNI BENEDETTO CASTIGLIONE, Genoa, 1610–Mantua, 1670, *Pyrrha and Deucalion*, 1655

Opposite:
GIOVANNI BATTISTA TIEPOLO
The Martyrdom of St. Agatha, c. 1750

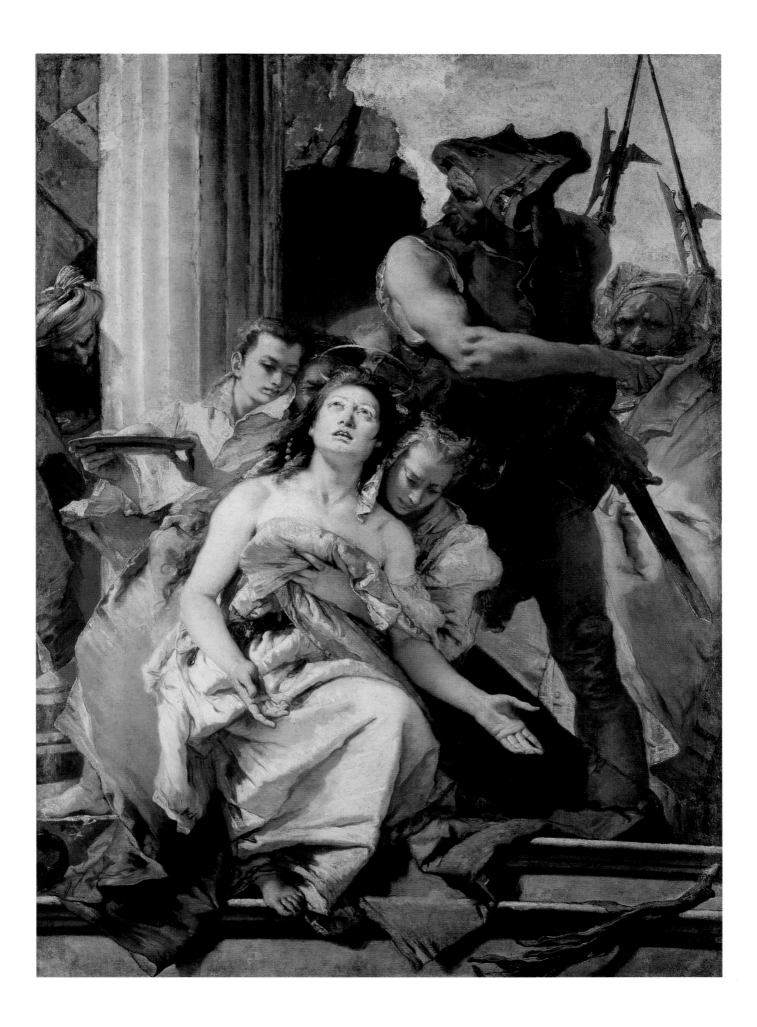

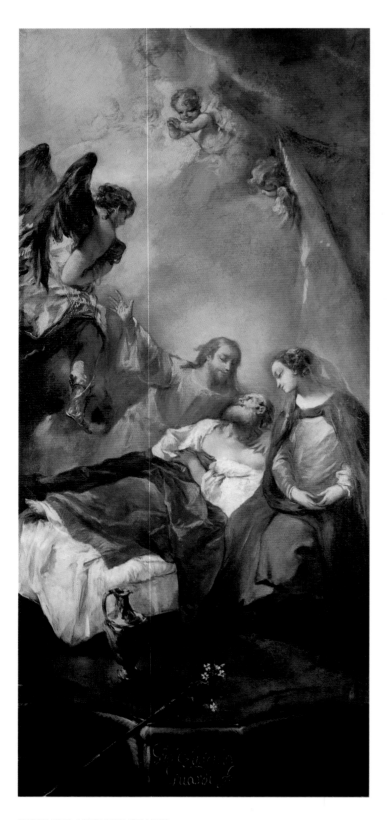

GIOVANNI BATTISTA PITTONI
Venice, 1687–1767
The Death of Joseph

New religious subjects were established or popu-
larized as a result of the Counter Reformation.
Joseph had long been a figure of fun, but no longer.
He was now cast as the father figure of the Terres-
trial Trinity completed by Mary and Jesus. Invested
with fresh dignity, Joseph's death became a newly
important subject for devotional art and thought,
and he was venerated as patron saint of a good
death. Berlin has two Venetian depictions of this
scene. Giovanni Antonio Guardi's (474) is a surpris-
ingly bourgeois view, while that by Giovanni Bat-
tista Pittoni (474), who succeeded Tiepolo as
president of the Serenissima's academy, is far more
dramatic as Jesus shows his earthly father radiance
from his Father in heaven.

GIOVANNI ANTONIO GUARDI
Venice, 1712–1793
The Death of Joseph

PIETRO LONGHI
Venice, 1702–1785
The Music Lesson, c. 1760–70

Venetian views of a very different genre are the witty Hogarthian interiors by Pietro Longhi and his contemporaries. These painters were no Protestant moralists; they chuckled at the mendacity, the greed, the folly of the human condition. Depicted with a minimum of brush waggling, such Goldoni-like vignettes pay cynical homage to the Serenissima's longstanding tradition of selling people in the most gentlemanly or ladylike ways. In rendering what is ostensibly a music lesson (475), Longhi depicts the harmonious transaction of desire. As a friar scrutinizes a young lady's budding charms, the painting of satyrs hanging on the wall gives the show away to those who need its telling.

Sebastiano Ricci's decorative *Bathsheba* (476) is a lighthearted reworking of earlier themes by Venetian and French painters, Veronese being particularly well remembered. This subject must have appealed to the artist as well as his patrons, since Ricci, a notorious Don Juan, was perpetually on the move to escape retribution. Sebastiano's nephew, Marco, also traveled widely and often worked in tandem with his uncle in England and Venice. His tender *Southern Landscape at Twilight* (477) suggests Marco's interest in the work of Northern contemporaries for the spatial dialogue established by the trees in the fore- and middle grounds.

Suitable to its maritime location, the art of Genoa is a rich mix of Venetian and northern European sources, a heady brew of Rembrandt and

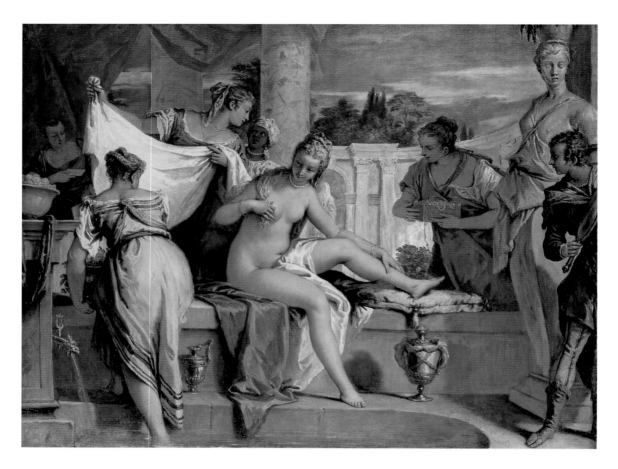

SEBASTIANO RICCI
Belluno, 1659–Venice, 1734
Bathsheba, c. 1725

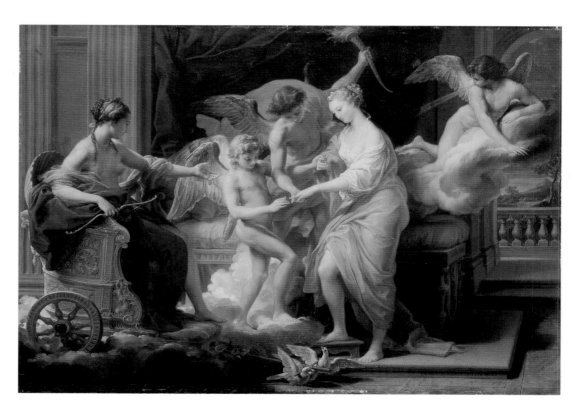

POMPEO GIROLAMO BATONI
Lucca, 1708–Rome, 1787
*The Marriage of Cupid and
Psyche*, 1756

MARCO RICCI, Belluno, 1676–Venice, 1730, *Southern Landscape at Twilight*

Titian. Giovanni Benedetto Castiglione, founder of the center's Baroque school, painted a vigorous *Pyrrha and Deucalion* in 1655 (472). The couple are a classical equivalent to Adam and Eve. Warned by Deucalion's father, Prometheus, of Zeus's intended flood, they were the sole mortals to survive. Following Prometheus's counsel, they built a box that floated them to Parnassus, where they thanked Zeus for their safe arrival and begat a new race by throwing rocks — the "bones of the earth" — over their shoulders.

Castiglione's spontaneity, activated surfaces, and use of ruddy, free coloring, along with his lively nature studies, colored sketches on paper, and work with monotypes, give his art an unusual immediacy.

Best-known and last of Rome's leading eighteenth-century painters was Pompeo Batoni. Curator of the papal collections, he was extensively patronized by Grand Tourists. An assured portraitist, Batoni proved equally at home with mythological and biblical subjects, giving them a porcelainlike finish. His *Marriage of Cupid and Psyche* (476), painted in 1756 — in which the torch-bearing Hymen, god of marriage, arranges for the exchange of rings in the presence of Venus and Zephyr — presents a sleek pictorial solution to mythological subject matter.

Artful Souvenirs: Venetian and Other *Vedute*

WHERE Florence could prove forbiddingly intellectual and chillily masculine, and Rome's Pontine marshes (*550*) teemed with disease, Venice was a tourist's heaven of perpetual revelry and constant carnival. Roman tummy and Florentine snobbery took time to forget; Venice was instantly worth remembering. Enduringly large-scale Venetian picture postcards — the *vedute* — were souvenir views on canvas by such masterful local painters of the picturesque as Bernardo Bellotto, Antonio Canaletto, and Francesco Guardi. *Vedute* show what you saw, sharing and stimulating memory, returning to you the eyes of the person you were when in Venice. Their subjects present the floating city's unique intersection of artifice and nature, where sky and water illuminate and animate an otherwise totally man-made stage. The vagaries of wind and light guarantee an ever-changing performance whose Acts can never be repeated.

At their best, these vistas take on a haunting, oddly intimate quality that is utterly alien to their blandly decorative, topographical genesis. Since they were often painted in suites, all four walls of dining or living rooms could be decorated, or the canvases could be hung one above another in halls or up the stairs. Scene — and seen — alike, Venetian views have none of the vicarious possessiveness, the materialism, of so much Northern art in related genres. The Serenissima's un-real estate almost

always has a visionary quality, as fantastic as the hanging gardens of Babylon. Yet *vedute* are necessarily impersonal, catering to a shared, anonymous nostalgia. Ready for any and all buyers, their pictorial neutrality was engendered from the start. *Vedute* were, in fact, often composed by looking through a *camera obscura,* a perspectival peep show used to guide an artist's preparatory design.

These radiant, pre-photographic images are pictorial transparencies projected on canvas to jog the memory. Their dwarfed figures suggest a human ant colony or supernumeraries in an operetta. So small is this scale that it dismisses or diminishes the possibility of our ever making a dent, none of us more than an extra in life's brief *commedia dell'arte.* Venice, city of masked carnivals, rejoices in anonymity's pleasures and privileges, that impersonal personality characterizing most of her *vedute.*

People — brushed quickly by Canaletto — were sketched on paper and then glued to panel. These figures (*491*) were prepared for staffage, designed to animate urban space, readied to give the viewer a sense for the actual size of the site, to provide a sense of proportion by their presence. Casts of little characters, such groups waited in the wings, ready for their artist-producer's application, designed to animate *vedute*'s yawning spaces.

One of the most splendidly varied series of eighteenth-century Venetian views has long been on permanent loan to the Berlin museum from the German trading company founded in Venice by Sigismund Streit (1687–1775). He commissioned four of these canvases from Canaletto and also turned to other topographical masters in patronage of truly inspired *Gründlichkeit.* All his orders were produced between 1758 and 1763. Streit bequeathed these paintings to his Berlin high school, the Gymnasium zum Grauen Kloster.

Forerunner to such splendid German patronage

Opposite:
FRANCESCO GUARDI, Venice, 1712–1793
Hot-Air Balloon Rising, 1784

Overleaf:
FRANCESCO GUARDI
View of the Giudecca Canal from the Northwest with the Zattere,
after 1760

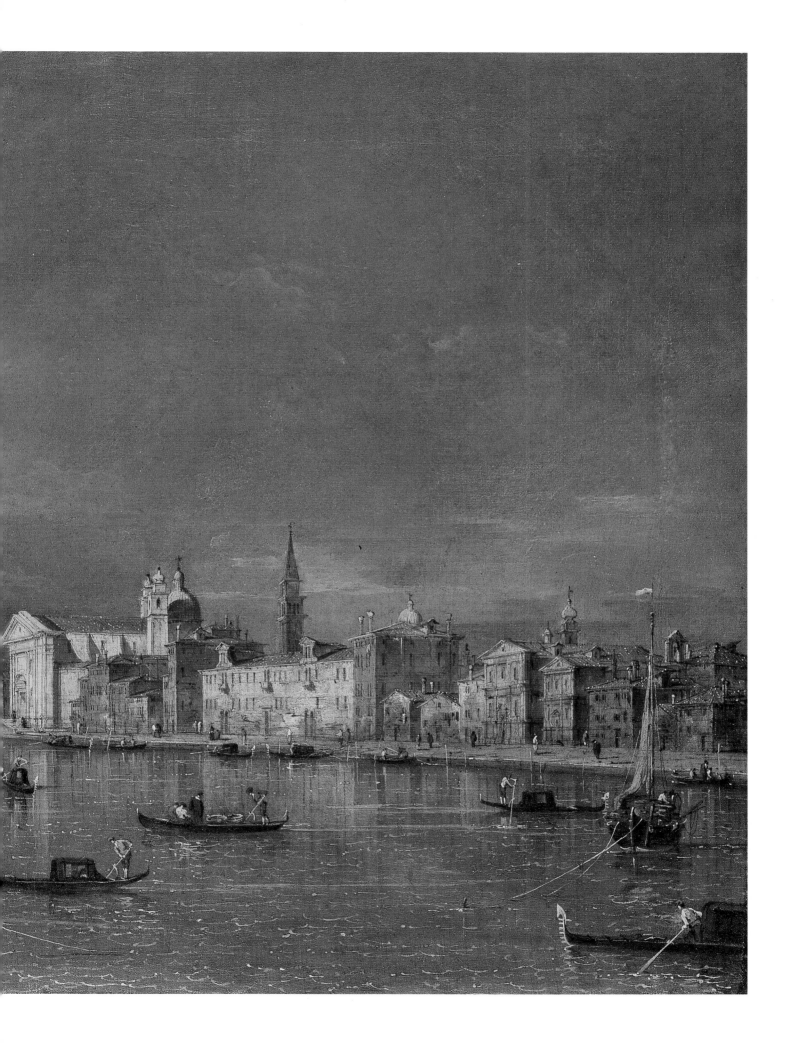

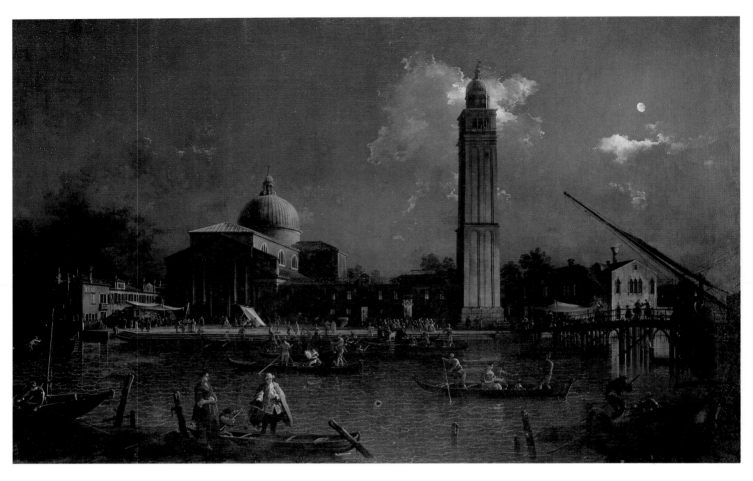

GIOVANNI ANTONIO CANAL, KNOWN AS CANALETTO, Venice, 1697–1768, *The Vigilia di S. Pietro*, after 1755–56

of *vedutisti* was Marshal Schulenberg, a military hero in Venetian service and major purchaser of Guardi's art between 1730 and 1746. That painter's scintillating *View of the Giudecca Canal from the Northwest with the Zattere* (480–81), signed on a fishing boat in the foreground, is pendant to a *View of San Giorgio Maggiore* that was sold at Christie's in 1982.

Canaletto's scenes for Streit include compelling pendant nocturnes of two of the city's four local, annual, evening church festivities — rare subjects for Venetian *vedutisti*. One records the Vigilia di S. Pietro (482) on June 28, the feast day of SS. Peter and Paul. S. Pietro di Castello, the church shown, was the residence of the Republic's Patriarch and of great local importance prior to his move to San Marco. Backlit by the moon, this romantic vista is among Canaletto's most arresting, painted after his return from England in 1755/56.

The other nocturne shows a similar festivity for the feast of St. Marta (483), a holiday for fishermen resident in the modest parish of San Niccolò dei Mendicoli, and its Augustinian convent of St. Marta. As literal as any patron of *vedute* could possibly (or impossibly) be, Streit faulted Canaletto for failing to include the boats of banqueting patricians, doubtless a deliberate omission on the artist's part.

The remaining Canaletto pendants are more conventional: *The Grand Canal Looking Down to the Rialto Bridge* (484) includes a view of Streit's residence, the Palazzo Foscari, the second house on the left. The canvas's austere, strikingly effective companion piece depicts the Campo di Rialto (485). To the left is the goldsmiths' center — the Ruga degli Orefici — and the Palazzo dei Dieci Savi, with the campanile of San Giovanni degli Elemosinario in the background. To the center and at the right is the

CANALETTO, *The Vigilia di S. Marta*, after 1755–56

Fabbriche Vecchie di Rialto. Another great Berlin Canaletto (not ordered by Streit) shows Santa Maria della Salute from the Grand Canal (486–87).

Among Streit's many other Venetian commissions is a cycle of six feasts and ceremonies painted by the less brilliant Antonio Diziani. These scenes stress the dramatic intersection of people and place, presenting the Serenissima as perpetual theater. One canvas, *The Sala del Maggior Consiglio, Doges' Palace* (488), depicts the Republic's seat of government; another, the great procession for the Feast of Corpus Christi traversing the Piazza di San Marco (488).

Even third-raters may have their inspired moments, found in two surprisingly fine *vedute* by Michele Marieschi, their staffage (the small figures animating the scenes) ascribed to Giovanni Antonio Guardi (1699–1760). These are *The Grand Canal with the Palazzo Labia and Entry to the Cannaregio* (489) and *The Grand Canal with the Ca' Rezzonico and the Campo San Samuele* (489). Like so many other later Venetian artists, Marieschi spent some of his working years in Germany.

Francesco Guardi viewed a hot-air balloon ascent in 1782, two years before he painted the subject (478). The balloon is artfully framed by the portico of the Dogana di Mare, as the viewer faces the Giudecca canal; two Palladian basilicas are visible in the distance. Such sky-rising was a popular sport initiated in the eighteenth century. Built for the Procurator Pesaro, this balloon was manned by Conte Zambeccari only a year after the Montgolfier brothers' ascent. Box-spring upholstery and ballooning were among the most Rococo of inventions, both true to a time hell-bent on creature comfort and heaven-bent on scientific adventure.

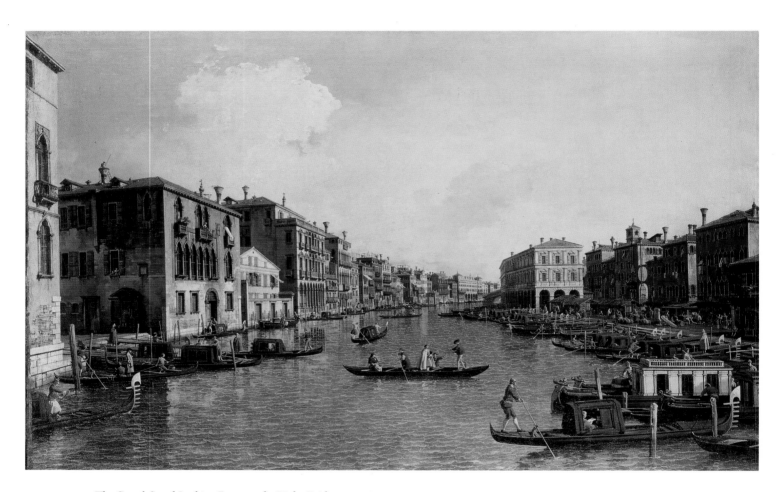

CANALETTO, *The Grand Canal Looking Down to the Rialto Bridge*, c. 1758–63

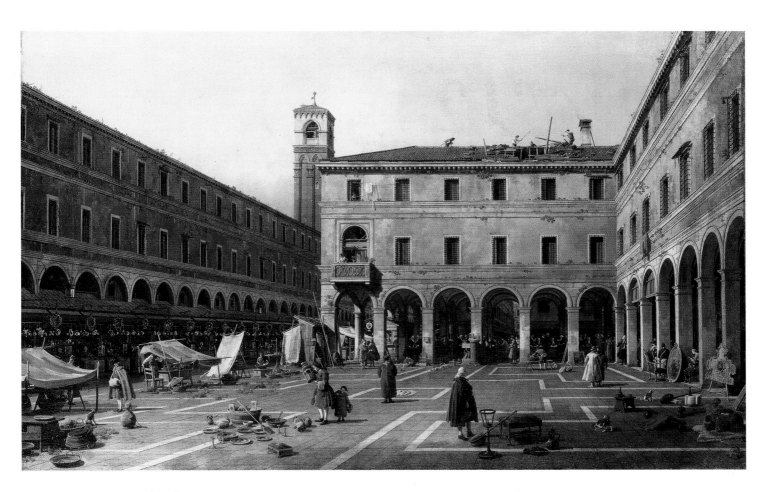

CANALETTO, *The Campo di Rialto*, c. 1758–63

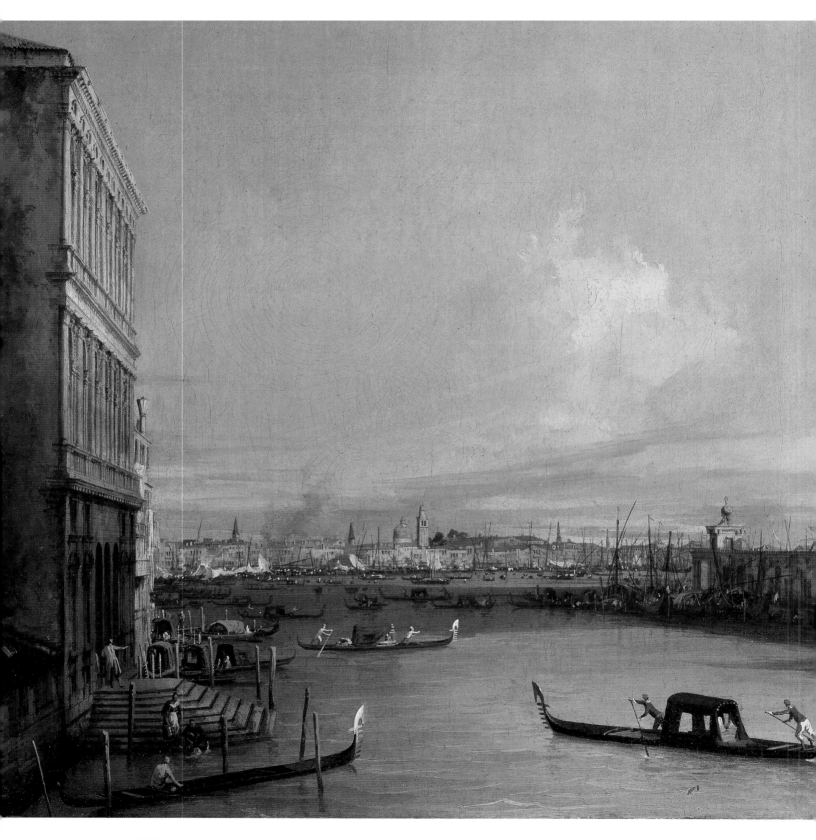

CANALETTO
Santa Maria della Salute Seen from the Grand Canal, shortly before 1730

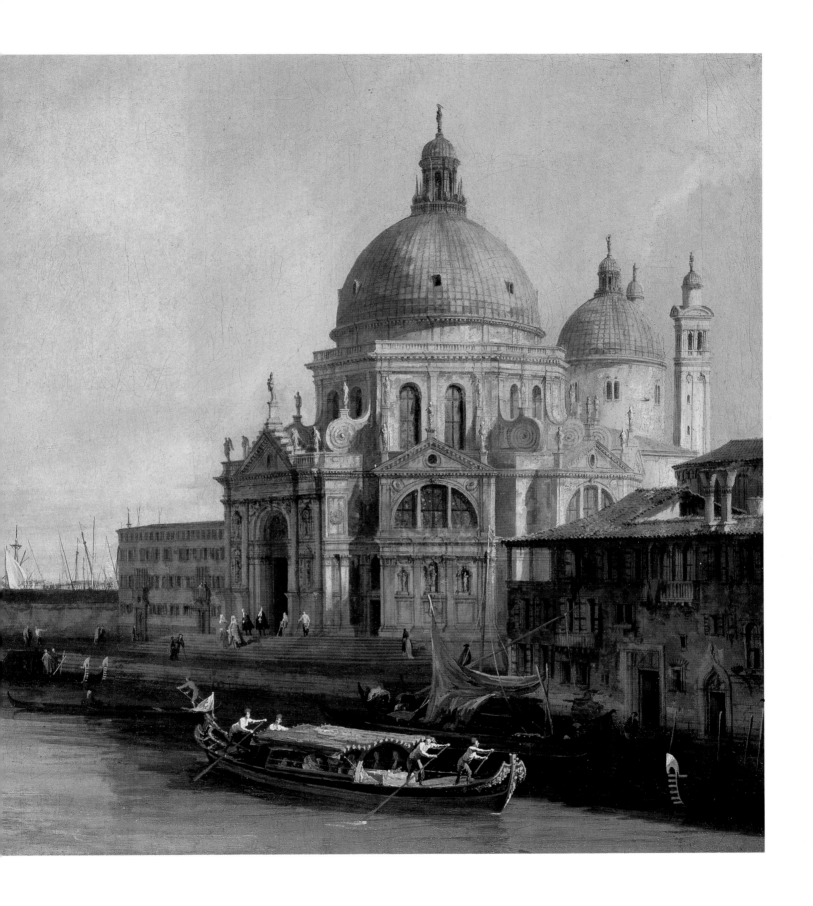

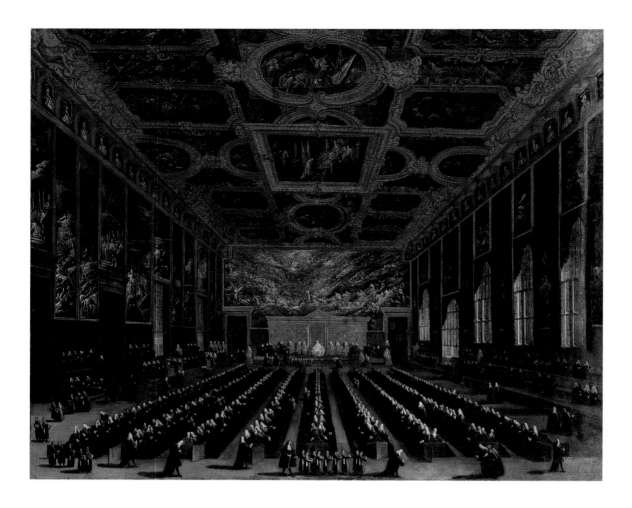

ANTONIO DIZIANI
Venice, 1737–1797
*The Sala del Maggior
Consiglio, Doges' Palace,*
c. 1758–63

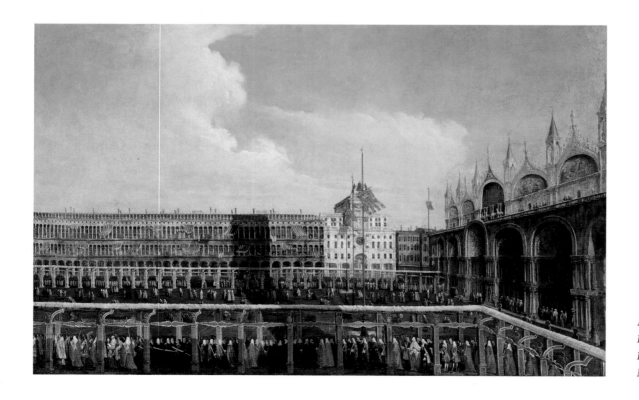

ANTONIO DIZIANI
*Feast of Corpus Christi
Procession, Piazza di San
Marco,* 1758–63

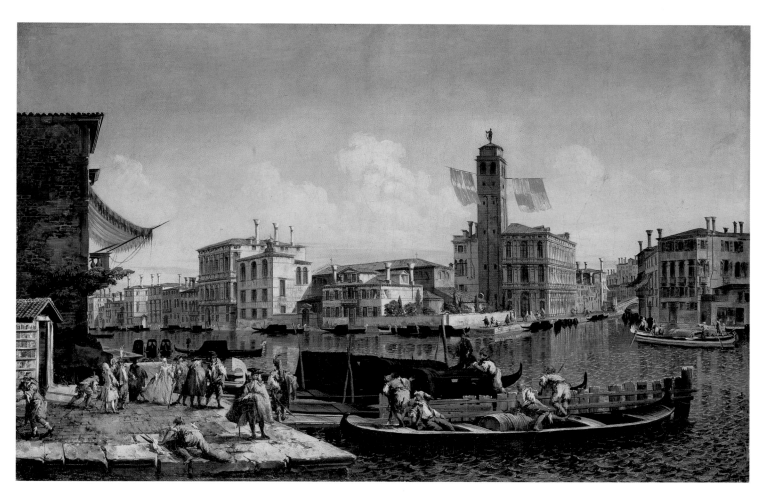

MICHELE MARIESCHI
Venice, 1710–1744
(staffage ascribed to Giovanni
Antonio Guardi)
*The Grand Canal with the
Palazzo Labia and Entry to the
Cannaregio,* c. 1742

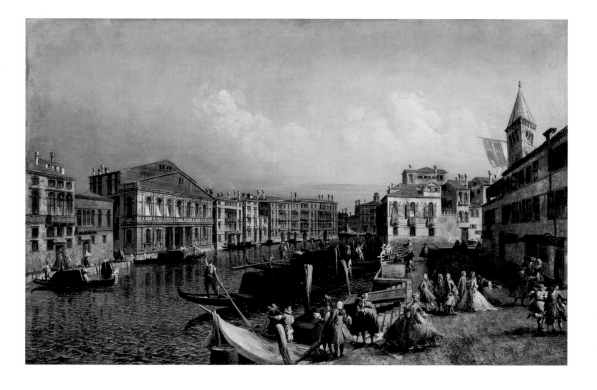

MICHELE MARIESCHI
(staffage ascribed to Giovanni
Antonio Guardi)
*The Grand Canal with the Ca'
Rezzonico and the Campo San
Samuele,* c. 1742

Vedutisti and their clients did not limit themselves to souvenirs of the seen; they also enjoyed frankly imaginary, deliberately impossible landscapes. Known as *capricci*, these were exercises in contrived inconsistency, an ingenious scramble of time, place, and style, of the real and the fantastic. First of these Venetian pictorial diversions may have been Giorgione's famous *Tempesta* (Venice, Accademia), whose magic may lie in meaning nothing at all. The same is certainly true for Canaletto's little scenes (490), studies in calculated pictorial absurdity. In one of these, a gondolier blithely boats past supposedly classical funerary monuments; others have toppled, as Gothic spires rise in the distance.

Berlin has among the very best works of Giovanni Paolo Panini, Rome's leading view painter, as seen in an early, unusually dazzling *Departure of the Duc de Choiseul from the Piazza di S. Pietro* (493), which was once owned by Hubert Robert along with twenty-nine other Paninis. The French painter was in Choiseul's retinue in Rome, where he studied with Panini. The four additional large canvases ordered by, and pertaining to, Choiseul in Rome include one similar in subject (Duke of Sutherland); an *Interior of St. Peter's with Choiseul and Retinue* (Boston, Athenaeum); an *Imaginary Gallery with Views of Modern Rome* (Boston, Museum of Fine

Arts); and an *Imaginary Gallery with Views of Ancient Rome* (Stuttgart, Staatsgalerie).

To paraphrase that old Scottish song, "I know where I'm going," Choiseul's cycle could be called *I know where I've been*. Painted at the end of his three-year Roman appointment, this massive series is an exercise in biography, fixing the duke's golden ambassadorial employ (secured through Mme de Pompadour) in time. The series' possession by Panini also suggests that Choiseul may have been a ducal deadbeat.

Bigger can well be better, and this painting, one of Panini's largest, is certainly among his very finest. Choiseul, French ambassador to the Holy See, has just had his initial papal audience with Benedict XIV. Leaving Bernini's Hemicycle, with the facade of St. Peter's in the background, the gilded ducal carriage leads a lengthy procession, tribute to the joint powers of Etienne-François de Choiseul, Comte de Stainville, Duc de Choiseul, and his king, Louis XV. This painting, among Panini's most laboriously documentary scenes, combines a bird's-eye view with others, providing a costly, yet obviously cost-effective, synoptic visual gospel of a major moment in eighteenth-century Franco-Roman piety and power.

Far less formal is a highly unusual view by Panini

of the far side of St. Peter's from the southeast, situating the Castel Sant' Angelo near the horizon's center (*492*). Two centuries before its present-day metropolitan sprawl, Rococo Rome was relatively concentrated in urban scope, allowing for deliciously sudden contrasts between city and country, a paradox fully appreciated by so keen a student of landscape as Panini.

Deservedly popular for his dramatically illuminated interiors, the English painter Joseph Wright of Derby seldom did quite as well by the light of day. His *Cloister of San Cosimato* of 1789 (*494*) comes close to the border of subjective, Romantic landscape but lacks the courage of its barely intimated convictions. Yet such picturesque inhibition has a certain fascination all its own.

An example of French eighteenth-century view-painting practice is an adroit scene by Claude-Joseph Vernet, who belonged to a highly successful family of topographical artists. His *Nogent-sur-Seine* (*494–95*) was executed in 1764. Often produced in decorative suites such as the popular *Harbors of France*, some of Vernet's vistas look almost like wallpaper, and in fact, were used as sources for the earliest such pictorial mural coverings. But that "by-the-yard" quality is far from true for this river view, with its surprisingly intimate, balletic charms.

The exhibition of this work — along with twenty-four other canvases by the same artist — in the Salon of 1765 aroused Denis Diderot to exclaim: "Twenty-five paintings, my friend! Twenty-five paintings! But what paintings!" The cycle made Claude-Joseph's great reputation; each picture described by Diderot in his habitually literal fashion as if it were a real, rather than a painted, view. Giving him the ultimate accolade, Diderot declared Vernet to be the equal of Claude!

Usually enchanted by ruins' romantic, suggestive spectacle, Hubert Robert could also respond to the reverse — to the miracle of the survival of antiquity's monuments intact (*495*). At Nîmes, in the Provence, the so-called Maison Carrée provides one of the best known of Roman buildings still to convey its original ancient state. Robert turned to this extraordinary site as the antithesis of his usual delight in decay.

Living in a keenly Neoclassical culture, eighteenth-century French collectors found Robert canvases such as this to convey the best of both worlds. It paid reliable tribute to the authority and splendor of ancient Rome, yet invested such topographical, architectural homage with the requisitely lighthearted, deftly romantic touch that Robert provided with uniquely decorative skill.

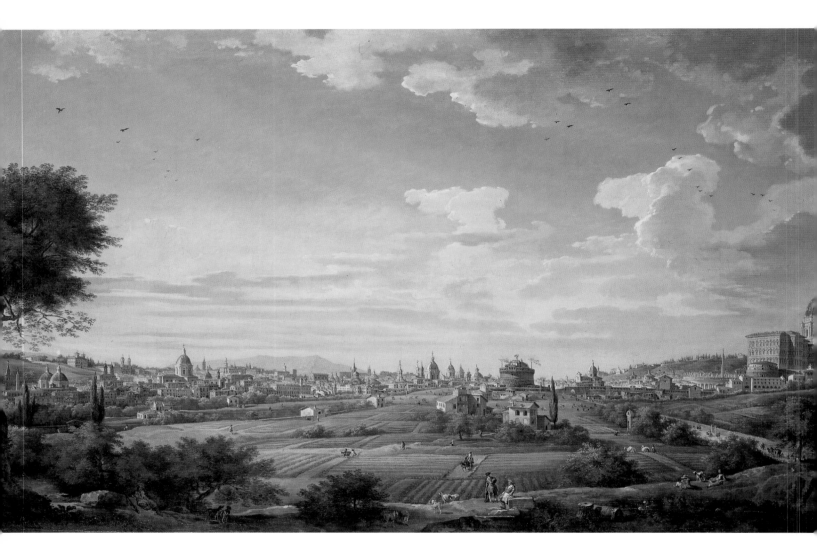

GIOVANNI PAOLO PANINI, Piacenza, 1691–Rome, 1765
View of Rome from Mt. Mario, in the Southeast, 1749

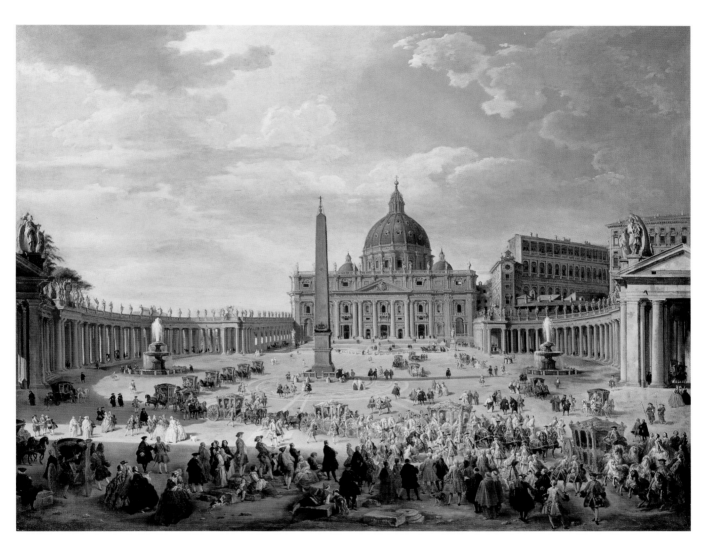

GIOVANNI PAOLO PANINI

Departure of the Duc de Choiseul from the Piazza di S. Pietro, 1754

JOSEPH WRIGHT, KNOWN AS WRIGHT OF DERBY
Derby, 1734–1797
The Cloister of San Cosimato, 1789

Opposite:
HUBERT ROBERT, Paris, 1733–1808
Ruins at Nîmes

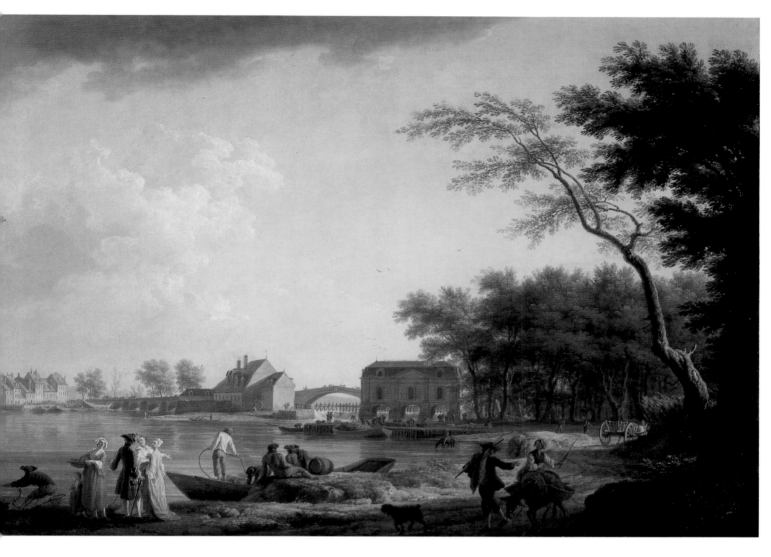

CLAUDE-JOSEPH VERNET
Avignon, 1714–Paris, 1789
Nogent-sur-Seine, 1764

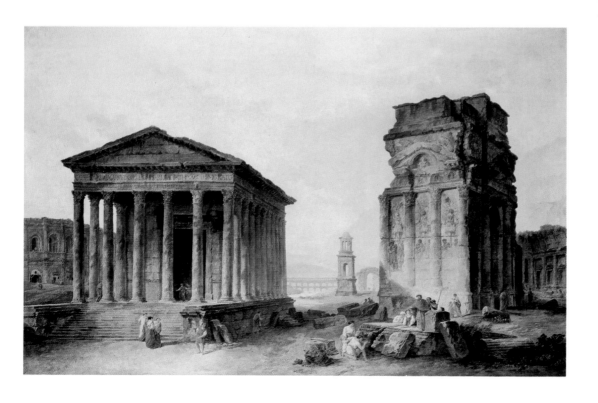

495

PORTRAYED POMP AND BRITISH CIRCUMSTANCE

UNDERSTATEMENT has long been among the hallmarks of British aristocrats; perhaps that's why they so often depended on foreigners to present their image, assuming that alien artists would be unafraid of making the authoritative likeness. Only Nicholas Hilliard, working in Shakespeare's day, created diminutive portraits of stunning power, miniatures on vellum or ivory that proclaim passion or other intimate revelations.

So Germans and Flemings were called upon to produce pictures of large size that projected the unique glamour of English privilege, conveying the authority and elegance of those born to command or desirous of that state. Beginning with Holbein (*106, 109*), followed by Daniel Mytens, John and Emmanuel de Critz, Rubens, and van Dyck (*309–11*) — the last two knighted for their glorious gifts in the realm of royal and aristocratic pictorial public relations — foreigners established new formulae for British portraiture. Imaginative attire, elongated physiques, a slight air of isolation and languorous melancholy, all led to a flattering likeness for those who could afford it. A column or landscape, a view of a distant country house or a recently purchased antiquity, along with the glint of armor or knightly plume and spur, added breeding or martial spirits. Wit, or any other acceptable sign of character (save intelligence), gave much-needed life to these soon-to-be ancestral ikons.

By the beginning of the nineteenth century, England and Scotland had suddenly begun to produce their own bevy of splendidly gifted por-

Opposite:
SIR THOMAS GAINSBOROUGH
Sudbury (Suffolk), 1727–London, 1788
The Artist's Wife, c. 1758

traitists. Many of these artists could paint whatever they wished but usually limited themselves to likeness because it paid so well. Thomas Gainsborough, John Hoppner, Thomas Lawrence, Henry Raeburn, Allan Ramsay, Joshua Reynolds, George Romney, and Martin Archer Shee are among the most successful, knowledgeable, and urbane portraitists, many of whom were knighted. These men often had more clients than they knew what to do with because Britannia was burgeoning at home and abroad, ruling foreign lands as well as waves.

Many of Berlin's grandest English paintings were bought long after World War II, in fitting if unwitting tribute to the city's great scholar Edgar Wind (1900–1971), a refugee to England and America, whose pioneering, profound studies of such portraits brought them renewed attention after long neglect. Germany and England, so close to one another in language and love of the military tradition — even in a certain distrust of the "artistic" (other than the musical) — were also particularly near one another through royal intermarriage in the eighteenth and nineteenth centuries. Academically, the ties came to be close too. In 1755, just when some of the British portraitists whose works now grace Berlin's collection were at their peak, the Prussian Academy's subject for a prize essay called for a philosophical examination of Alexander Pope's *Essay on Man.*

Dating from c. 1758 is a portrait, *The Artist's Wife* (*496*), by Sir Thomas Gainsborough. The former Margaret Burr (1728–1798), she may have been the illegitimate daughter of the duke of Bedford. Gainsborough's early portraits are fresh and delicate, often in the contemporary French manner with a touch of van Dyck, along with a Gallic awareness of *la belle poitrine*. This canvas, acquired in 1958, may have been cut down at an earlier date.

SIR THOMAS GAINSBOROUGH
Squire John Wilkinson, c. 1776

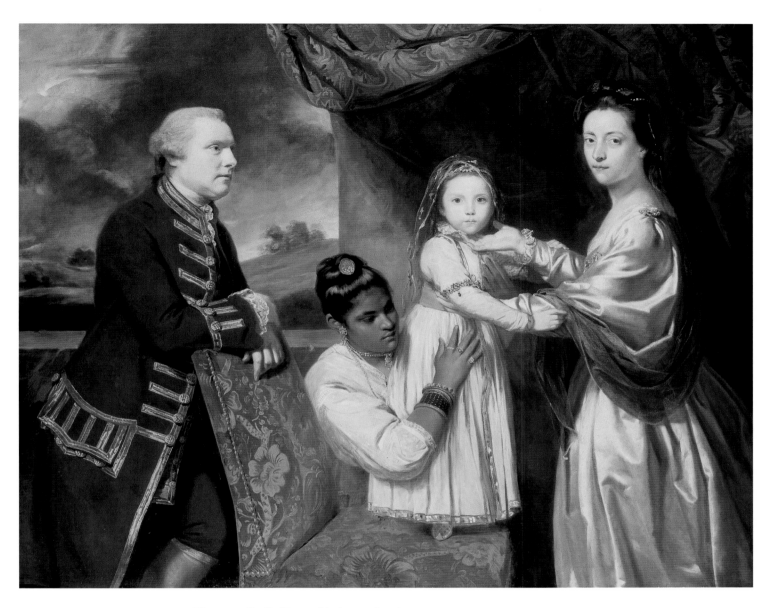

SIR JOSHUA REYNOLDS, Plympton-Earl's (Devonshire), 1723–London, 1792
Lord George Clive and His Family with an Indian Servant, c. 1765–66

Late Gainsborough at his best is seen in a large, surprisingly austere portrait of Squire John Wilkinson (*498*), which was given to the museum in 1904 by Alfred Beit, a Hamburg-born, British partner of Cecil Rhodes, the African diamond king. Doubtless due to the sitter's demands, this likeness is relatively restrained; even the setting is less glamorized than usual for the painter's late phase (after 1774). Wilkinson, a manufacturer of cannon and a founder of the British iron industry, was known as the "Great Staffordshire Ironmaster"; he was a self-proclaimed atheist and follower of Tom Paine.

Prosperity permeates Sir Joshua Reynolds's group portrait of c. 1765–66, *Lord George Clive and His Family with an Indian Servant* (*499*), from the collection of the earl of Ellesmere at Bridgwater House. The paterfamilias was cousin of Robert Clive (c. 1720–1779), founder of the empire of British India, and made his fortune in that land. Reynolds's special sympathy for Dutch and Flemish painting may have led to this group portrait's horizontal format, so popular in the Lowlands and found in Rembrandt's Anslo double-portrait (*310–11*), which was then in the famous Ashburnham

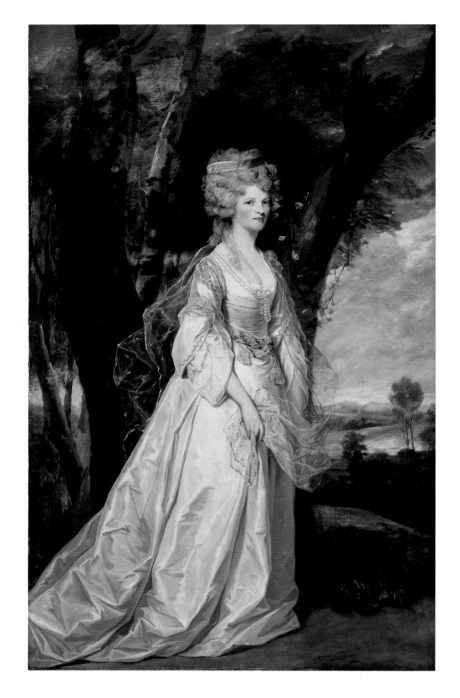

SIR JOSHUA REYNOLDS
Lady Sunderlin, 1786

collection and doubtless known to the English artist. Most beautifully painted by far is the centrally placed Indian nurse, who, kneeling, takes on the "Black Woman's Burden" as she supports the little girl in Indian courtly attire (the child was to die in infancy). Clearly the painter found the Indian's depiction his greatest pleasure. No eighteenth-century artist had a more encyclopaedic knowledge than Reynolds, who relished the opportunity to paint as great a variety of faces as possible, including native Hawaiians and Americans in London.

More stereotypical of assumed airs and graces is Sir Joshua's 1786 portrait of Lady Sunderlin (*500*), who stands larger than life and very, very tall, seen against a Rubensian landscape. This is the archetypal Grand Manner British portrait, the sort John Singer Sargent was to revive with such consummate skill, conferring just the right touch of to-the-castle-born to every chorus girl or barmaid who became a duchess. These British paintings can be surprisingly compelling and original in color when their artists' ingenious juxtaposition of brilliantly tinted, van

Dyck–like silks and satins are seen against a flamingly Rubensian background. Owned later by Baron Ferdinand de Rothschild and by Lord Burton, imperial images such as this formed ideal ancestor ikons for the moneylender and tailor to the masses.

Most surprising are Reynolds's little portrait sketches done for himself or to please a favorite. One of Kitty Fisher (501), the popular actress, seated like Danae, is shown in a small, almost Manetesque rendering. This picture came to Berlin in 1905 as the gift of Sir Charles Robinson, director of London's National Gallery, who presented many more "important" works to Berlin.

Berlin has two unusually fine and extremely large group portraits of children: Gainsborough's *Marsham Children* of 1787 (503) and Sir Thomas Lawrence's *Angerstein Children* (502) of 1807. Supposedly liberated of parental or other adult control, only their respective painters act as nanny. The four Angersteins were the grandchildren of a Russo-British banker, John Julius Angerstein (1735–1823), a cofounder of Lloyd's of London and financial adviser to William Pitt. Lawrence, a splendid collector in his own right, also advised Angerstein in the formation of his superb picture gallery, which was purchased by the British government in 1824 to form the nucleus of the National Gallery.

A frayed, red-velvet curtain makes it clear that the children are posing for a fancy *tableau vivant*. Like an infant Hercules, the littlest Angerstein,

guided by his sister, wields a spade. Picturesque in tattered velvets, holding a broom, the boy to the far right recalls those unsinkably poor children painted by Murillo (421), whose works were among the most popular pictures of the eighteenth and nineteenth centuries, once they had been brought to the rest of Europe during the Napoleonic Wars.

"Let's pretend we're poor" portraits, like those of the exceedingly rich little Angersteins, were first painted in the seventeenth century, when they were known as "fancy pictures," meaning fanciful images. The subjects of those canvases often were depicted in exotic garb or poetically impoverished settings that added a much-needed element of diversion to the conformity of privilege.

Gainsborough's Impressionist brushstrokes, with their feathery realization of form, hold a flickering fascination that makes them a triumph of technical ingenuity over routine demand. He was a keen admirer of Watteau (445–56) and worked by artificial light to control the quality of his movemented brushwork. Whether picking and holding fruit or embracing their pets, the Marsham kids seem more bored or conventional than the little Angersteins. Touches of Classicism and shrewd technique are not quite up to enlivening quite so large a canvas, nor is four a number that allows for picturesque grouping, so the artist used the two dogs at the far left to create a serpentine line. Master Marsham's pose at the far right is freely adapted from that of the Apollo Belvedere, which, at the time, was the most popular of the Vatican's antiquities.

Conversely, Sir Henry Raeburn's *Mrs. Anne Hart* (505) of c. 1810 is more than equal to her Antique pose — sufficiently beautiful (if the artist is to be trusted) to enliven so classical a stance. Possibly the portrait was cut down, as the way it stops just below the knee looks precipitous.

John Hoppner's bombastic image of Sir John Jeffreys Pratt (504) is over life-size, a full-length likeness invested with all the apparatus and grandeur of the Garter, Britain's premier knightly Order. Hoppner adapts a series of architectural devices invented by Titian and used with great skill by van Dyck for this setting. Roman statuary, such as the Prima Porta Augustus, buttress Jeffrey's Neoclassical stance.

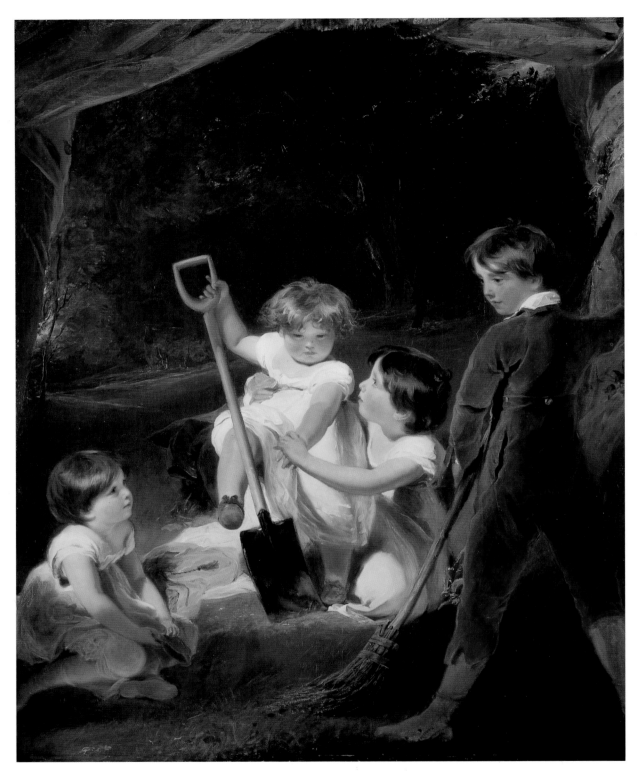

SIR THOMAS LAWRENCE, Brussels, 1769–London, 1830, *The Angerstein Children*, 1807

Opposite:

SIR THOMAS GAINSBOROUGH, *The Marsham Children*, 1787

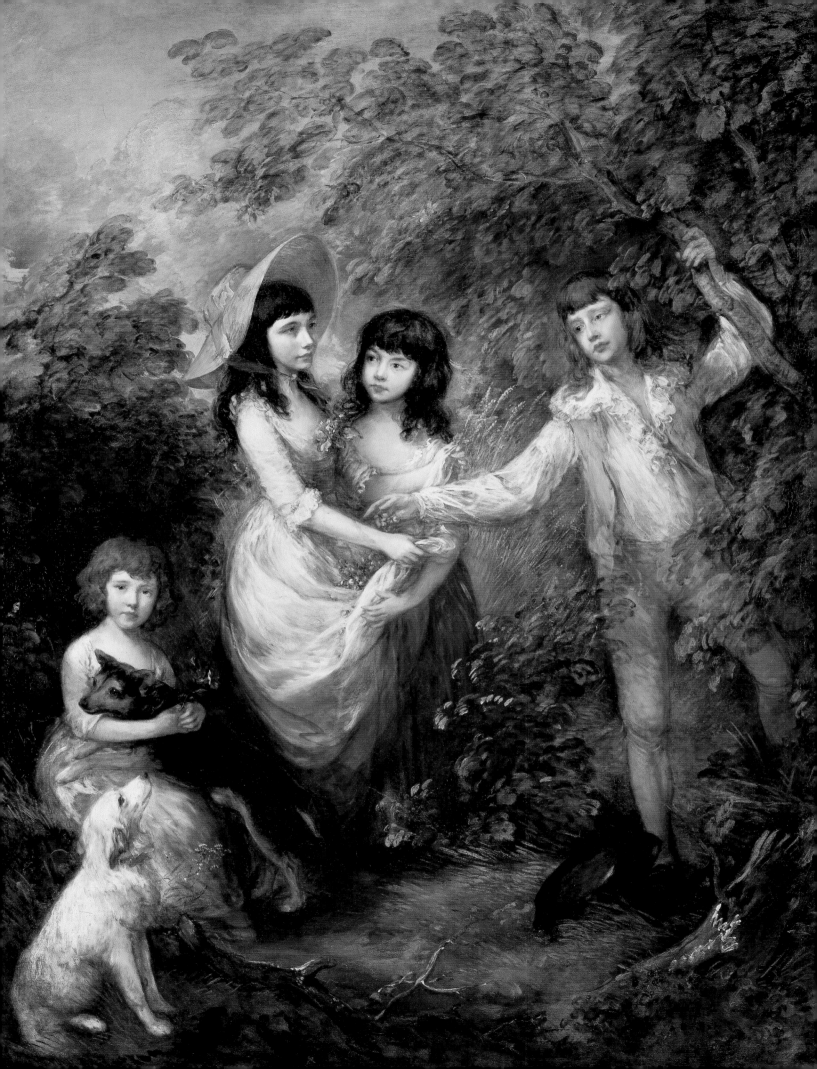

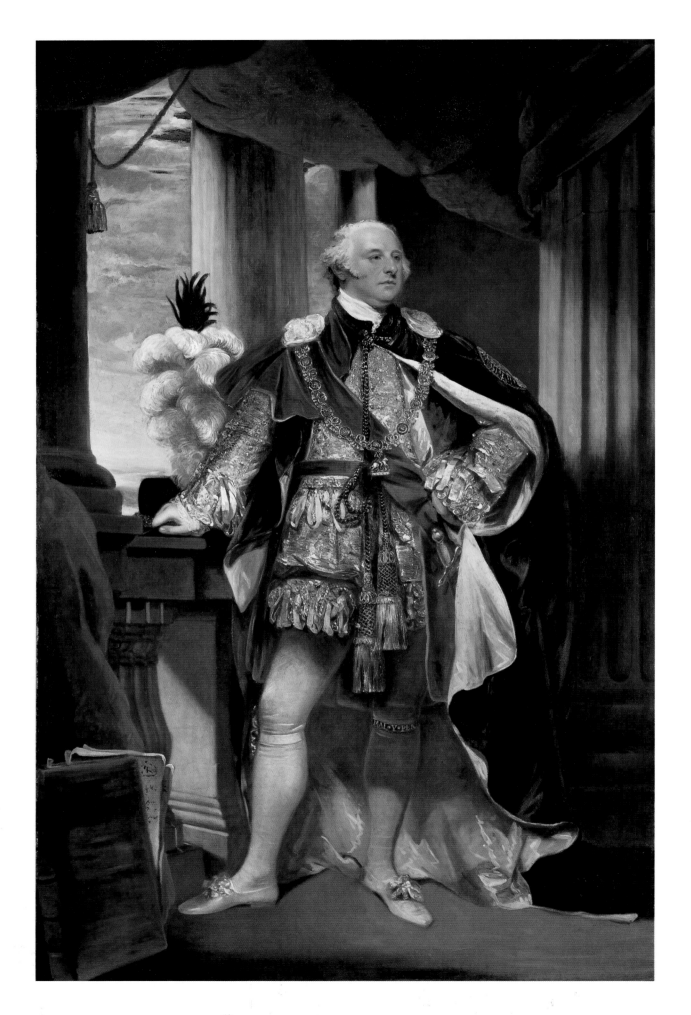

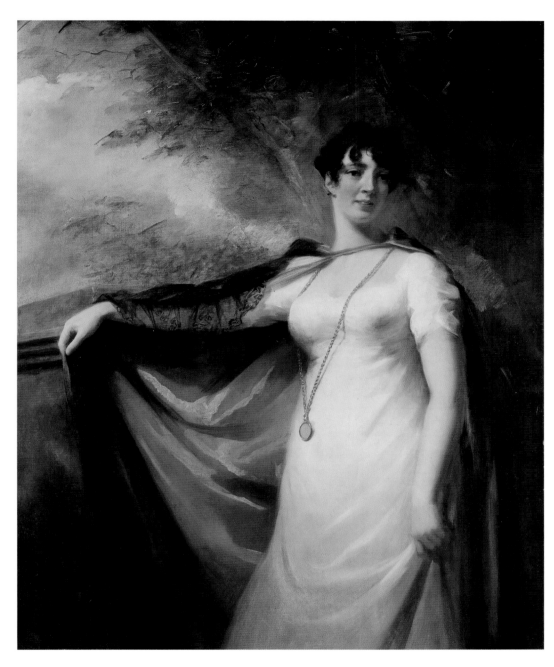

SIR HENRY RAEBURN, Stockbridge (Edinburgh), 1756–Edinburgh, 1823
Mrs. Anne Hart, c. 1810

Opposite:
JOHN HOPPNER, London, 1758–1810
Sir John Jeffreys Pratt, Second Earl and First Marquis of Camden, as Knight of the Order of the Garter

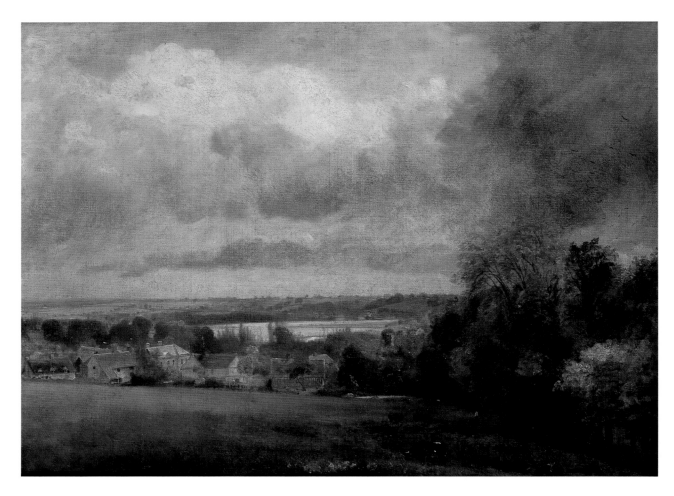

JOHN CONSTABLE, East Bergholt (Suffolk), 1776–London, 1837, *The Stour Valley from Higham*, c. 1804

English landscape painters seldom forgot Rubens's works, which were so uniquely well represented in that nation's great collections of Flemish art. One of his best renderings of the Lowlands (*306–7*) was probably admired by John Constable and came to Berlin from British ownership. The English painter's early response to the freedom of the Fleming's approach is found in *The Stour Valley from Higham* (*506*) of c. 1804. A mill in the nearby Dedham Vale, close to Constable's home, provided the painter with linseed oil. When he moved to Hampstead, then a village on London's outskirts, this oil was shipped to him by his brother on their vessel *The Balloon*.

The technique used for this valley view anticipates the free brushwork found in so much later-nineteenth-century German painting — that of the mature Max Liebermann (*578–79*), Max Slevogt (*626*), and Lovis Corinth (*627*). Far earlier, Adolf Menzel (*558–67*) was a close student of Constable's

art, which was exhibited in Berlin in 1839. In 1896 *The Stour Valley from Higham* was presented to the Kaiser Friedrich Museum by its Friends, doubtless the same men and women who, often at Liebermann's suggestion, started giving the Museum works by Manet (*591–93*), Cézanne (*612, 614*), and the Impressionists (*590–603*).

Many of Monet's Parisian views (*596*) were scenes painted from windows, as was Constable's *The Admiral's House (The Grove)* (*507*), which was seen from his own nearby Hampstead home in the 1820s. Married to an admiralty counselor's daughter, this artist was intrigued by the ship-shaped house, as are Hampstead visitors to this very day. Some earlier New England seaport houses resemble the admiral's, with widow's walks on their rooftops. Unlike those in America, the admiral's house was merely a souvenir of a maritime lifestyle — all he could see was Hampstead Heath and faraway views of Londontown.

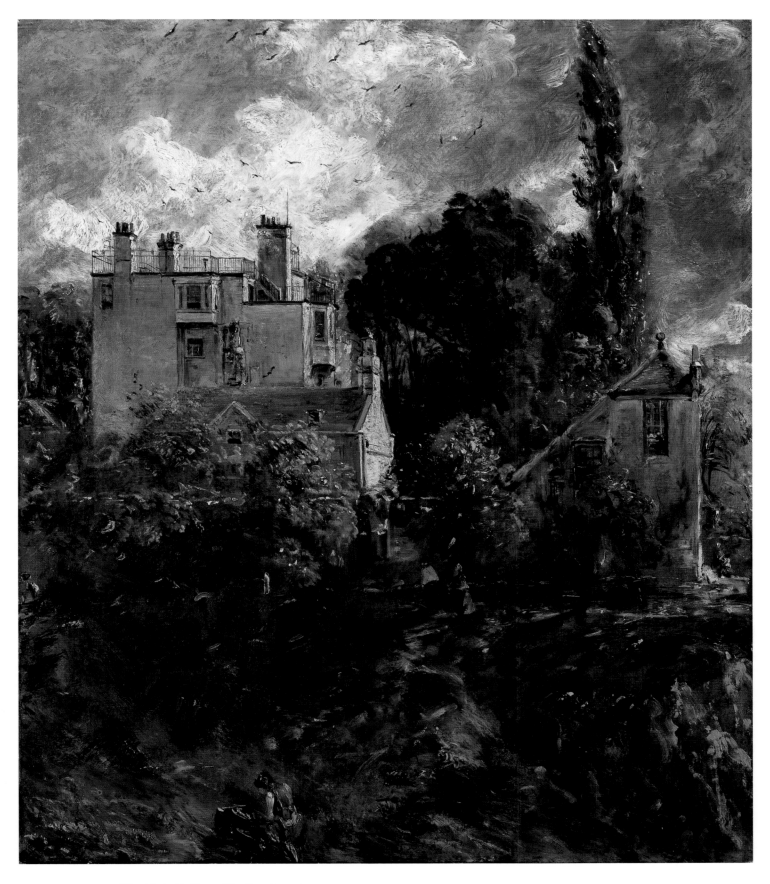

JOHN CONSTABLE, *The Admiral's House (The Grove)*, c. 1820–23

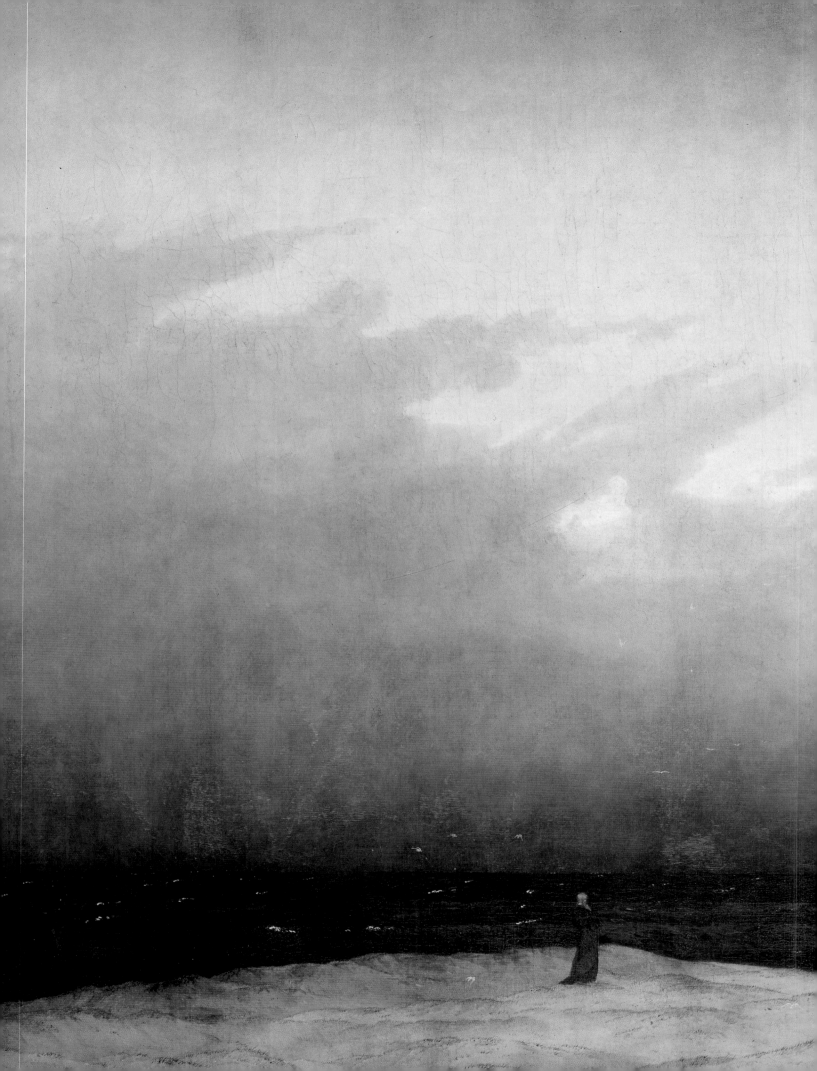

From Romanticism to Expressionism:

European Painting, 1800–1914

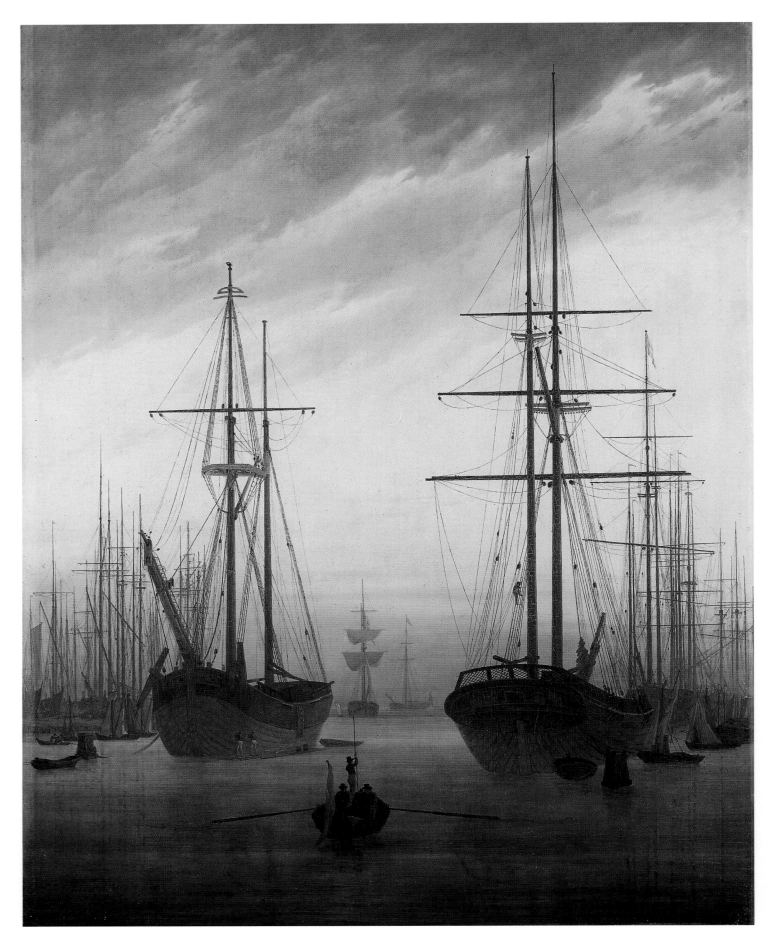

CASPAR DAVID FRIEDRICH, Greifswald, 1774–Dresden, 1840, *View of a Harbor*, 1816

GOTHIC ROMANTICS:

CASPAR DAVID FRIEDRICH AND HIS FOLLOWING

PROFOUNDLY yet sensitively Germanic, images by Caspar David Friedrich are those of a Wagner *in nucleo* — without the heavy orchestral breathing. Implicitly musical, the painter's tender art reaches back to Mozart and on to Richard Strauss, filled with death and transfiguration. A one-man, more benevolent Brothers Grimm, Friedrich, born in Swedish Pomerania, never terrorized his enchanted audience of overgrown Kindergartners.

Protestantism, conveyed by the vehicle of the visual arts, tended to see Nature more as pagan Mother than God's Work, too close to pantheism for comfort (or a free ride). Friedrich presents an exception. His anti-Classical emphasis upon experience, its reception and communication, stressed the personal, the "I in the eye," the mind, the heart, and the hand. Heinrich von Kleist wrote how a Friedrich landscape, one "with nothing but a frame as foreground," made him feel as if his "eyelids had been cut away." So radical a perception of the image shows Friedrich's art as a shocking breakthrough, bordering upon an expressionistic confrontation, facing infinity.

By illumination and artful scenic shifting, the painter brought to light an awesome interweaving of Nationalism and Protestantism seen as one and the same, revealed by and within a Teutonic Nature. Were you to send Burke's *Philosophical Enquiry into the Origins of Our Ideas of the Sublime and the Beautiful* (1757) to attend a liberal German Protestant Seminary of the next decades, the spiritual mix would come close to Friedrich's art.

The painter's love for medieval motifs was inspired by his friend Goethe, whose first book, *Von deutscher Baukunst* (1773), was given over to the architectural beauties of Strasbourg Cathedral, ascribed to an otherwise mythical "Meister Erwin," First German Builder.

Paradoxically, it was Napoleon, that New Caesar and Alexander — seen by Friedrich as the Antichrist incarnate — who helped northern Europe admire the spectrum of its medieval heritage, looting many early paintings from Germany and the Lowlands for exhibition in his museum at the Louvre. Both the Napoleonic presence and expulsion from German lands resulted in a fresh appreciation for, and even fabrication of, Teutonic and later Christian roots.

The devoutly Catholic brothers Boisserée, suitably named Melchior (1786–1851) and Sulpiz (1778–1854), also brought Germany new awareness of medieval Northern Christian art and a willingness to abandon some of the rigid Neoclassicism prescribed by Winckelman. Such academicism was now seen as contra Natura and Ecclesia, too concerned with the extremes of the rational and of the Body Beautiful, both equally alien to the true faith. Even in periods of official commitment to Antiquity's clarity, the picturesque anarchy of a Piranesi etching or a Rococo folly finally cracked Neoclassicism's ice. Britain's legendary eccentricity was accentuated by an ongoing love of the Gothic, and by its fervent if gimcrack revival at Horace Walpole's villa at Strawberry Hill (1764) — its medieval trimmings revealed to Horace in a dream.

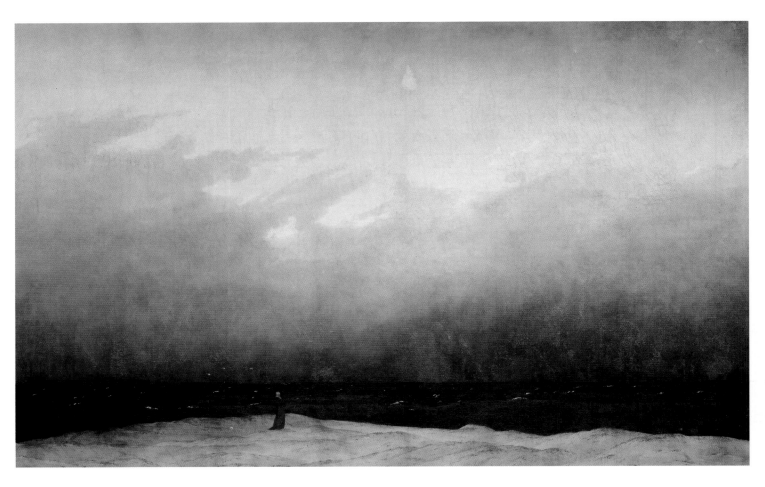

CASPAR DAVID FRIEDRICH, *Monk by the Sea*, 1809

Such evocative images as Jacob van Ruisdael's *Jewish Cemetery* (Dresden) came into their own once again when Goethe recognized their artist as a great poet. The Dutch painter's haunting canvas was much copied in the earlier nineteenth century, its symbolism in keeping with Friedrich's scenes of similarly neglected monuments to Faith fallen into Nature's keeping.

For all his Gothic references, often taken from the ruined Cistercian abbey near the artist's Pomeranian home, Friedrich's images emerge from a mystical Now, from a poetic communion with the divinity of God's works. Just as Rodin wrote *When the Cathedrals Were White*, so might Friedrich have written *When the Cathedrals Were Nature*.

Placed at the Dresden Academy in 1798, Caspar David was followed there by some of his best students from the Copenhagen Academy, such as Georg Friedrich Kersting (*516*). The artist was now well situated to sell his works to visiting Prussian

and Russian royalty so often stopping at that great art center for studio visits, many such purchases now in Berlin and The Hermitage. Other paintings were exhibited at the Berlin Academy. Both the *Abbey in the Oaks* and the *Monk by the Sea* (*512*), shown there in 1818, were bought by Frederick William III at the fifteen-year-old Crown Prince's request. Their innate romanticism, allowing for release and adventure, makes it easy to see why these canvases exerted such appeal upon an adolescent heir apparent.

Romantic images such as *Monk by the Sea* continued speaking to successive generations, a sense of high drama conveyed by a single figure open to the echoing sound of the seas, the water's motion mirrored by the sky's. The absolutes of radical, rocky foreground and tragic isolation come close to the dramatic agony of a Munch canvas (*622*) or to a massively moody theatrical project by Gordon Craig. The monk, according to Albert Boime, is

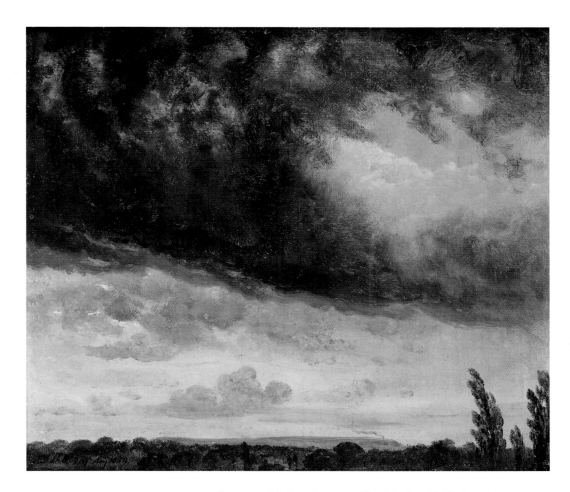

JOHAN CHRISTIAN CLAUSEN DAHL, Bergen, 1788–Dresden, 1857, *Cloud Study with Horizon*, 1832

Friedrich himself, in Capuchin garb, walking the cliffs at Rügen, high above the sea. That elevated site is near a poor fishermen's chapel, built by the Protestant mystic Kösegarten, so that those men, their calling the apostles', could profess their faith though far from home.

Least known of Friedrich's works are his small, surprisingly sunny views, conveyed with crystalline clarity. *Landscape with Windmills* (Schloss Charlottenburg) of 1822–23 shows how much the artist learned from Dutch painters of the seventeenth century (especially van de Velde), in terms of a bold mirroring of sky and water. Caspar David's canvases also convey his pursuit of cloud studies, his own, not those then advanced in England by Luke Howard and so closely followed by Goethe. Friedrich was repelled by such intrusive, reductive cataloguing of natural phenomena, rejecting the new science as one that would diminish his pictorial poetry and reduce his key role as Nature's interpreter.

Yet Friedrich's Norwegian follower Johan Christian Clausen Dahl adhered to Howard's categorizing text in the *Cloud Study with Horizon* (*513*) of 1832. Later hospitality of Berlin to Constable's art (*507*) and to Impressionism is less surprising in view of so many German painters' impassioned response to sky, light, and sea at the century's start.

Though snow was first popular in European landscapes with those of the sixteenth and seventeenth centuries from the Lowlands (*330, 331, 334–35*), Friedrich saw it in a new light, close to silent death or miraculous rebirth — never as a rococo confectioner's seasonal sugaring.

Fog in the Elbe Valley (*515*) has the delicacy of Chinese painting on silk in its silent capture of rolling mists. Antlerlike bare branches grouped in the foreground suggest a flock of deer.

Friedrich's people are often portrayed in a rapt, Brontëesque contemplation of the mysteries of their own passions as reflected by water's moon-

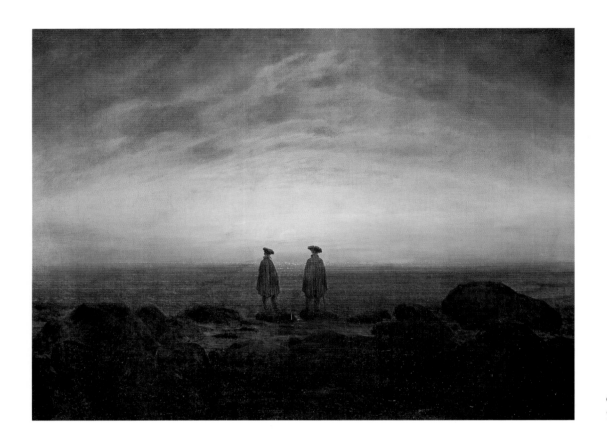

CASPAR DAVID FRIEDRICH
Two Men by the Sea, 1817

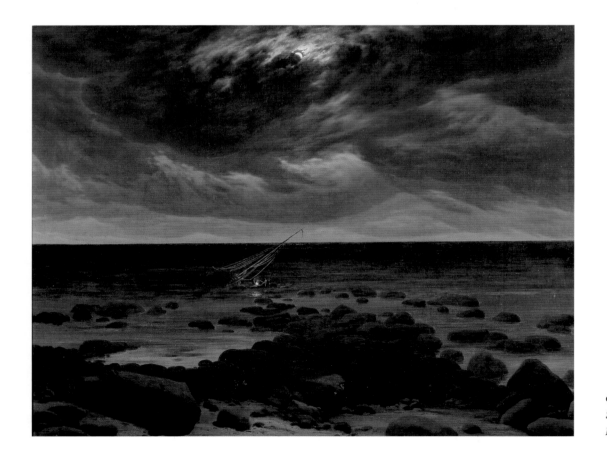

CASPAR DAVID FRIEDRICH
*Seashore with Shipwreck by
Moonlight*, c. 1825–30

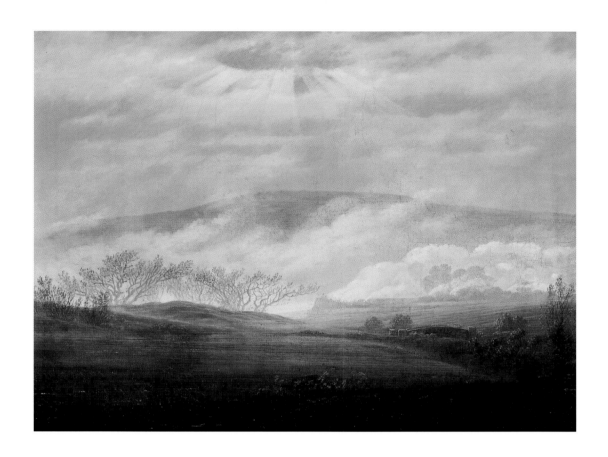

CASPAR DAVID FRIEDRICH
Fog in the Elbe Valley, 1821

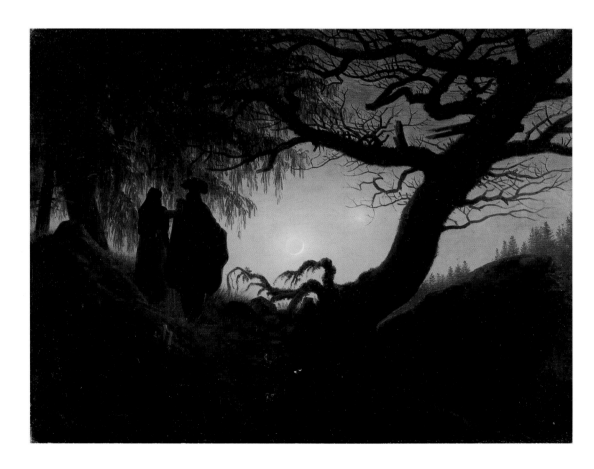

CASPAR DAVID FRIEDRICH
Couple Watching the Moon,
c. 1824

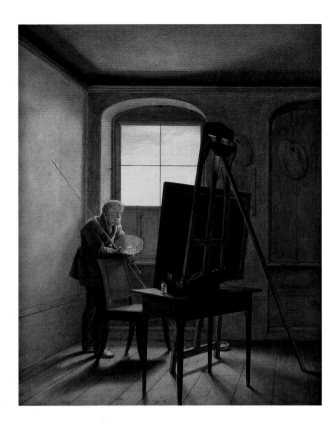

struck rise and fall, extended by the passage of time and tide. His seascapes combine intimacy and grandeur in unprecedented fashion, their contrast between the individual and the infinite seldom sogging into cliché. In the surreal *Two Men by the Sea* (*514*), each viewer is the other's clone, twinned in Burkean or Kantian confrontation of the Infinitely Sublime.

Trade and manufacturing now enabled Germany's nation-states to begin rivaling world powers' markets. Though Friedrich's *Greifswald Harbor* of c. 1818–20 (*520*) teems with sailboats, true too for his *View of a Harbor* (*510*), these have no such overt message of new German maritime success. To the marine genre, long popular among Dutch and Flemish masters (*336–37*), Friedrich adds a haunting sense of mystery, one not far from the worlds of Melville and Ryder, as seen in the German's *Seashore with Shipwreck by Moonlight* (*514*). His more optimistic seascapes anticipate those by the later New England Luminist, FitzHugh Lane.

Among the first of later artists to wring such res-

onance from a back view, Friedrich followed the Dutch Little Masters (*385*) who had used that pose long before, one found titillating or daunting for its challenging inscrutability. Seen from the rear, the subject of *The Woman at the Window* (*517*) is the artist's wife Christine Caroline (1793–1847), to whom he had been married for five years when she posed for this canvas. Is hers a yearning for escape aboard the boat whose masts rise behind her, a would-be stowaway from proto-Ibsenian domestic drudgery, seeking relief from a depressive, wildly jealous mate? Or is she contemplating supper? As Christine's are the canvas's only curves, all those rigidly enframing lines assume commanding interest, such as the cruciform intersection of the window panes overhead.

As shown by Georg Friedrich Kersting (*516*), Friedrich's looming easel and canvas, seen from the back, dwarf and corner him the way young Rembrandt's did in an early *Self-Portrait in His Studio* (Boston, Museum of Fine Arts). Canvas and easel, acting in concert, may dominate Kersting's vision and creation. Such potential conflict between the artist and his work is a powerful Romantic conceit.

His later years were unusually hard for Friedrich. Goethe loathed his ever more allegory-freighted canvases, telling Boisserée they were best suited to destruction. With the new fashion for the archaizing, Italianate neo-Catholic Nazarenes (*526, 528–30*), for the intricate anecdotage of Düsseldorf, for the arid Poussin *cum* Claude pretensions of a Joseph Anton Koch (*528*), Friedrich witnessed his increasing marginalization, never receiving the high Dresden post he had hoped for. Attacked by a stroke in 1835, the artist was unable to paint, dying five years later. Friedrich's students include Karl Blechen (*532–39*), and Karl Friedrich Schinkel (*522–25*), who, with Dahl (*513*), continued his personal yet cosmic musings.

One of the few landscape painters to see both forest *and* tree, Friedrich found no conflict between the separate splendors of the individual and the collective. That rare pictorial capacity makes his Nature so persuasive and original. Following Rembrandt (*356*) and Ruisdael (*350*), the German painter often used a single aged or lightning-struck tree to speak for existential hazard. Centrally placed, a tree provides a melodramatic silhouette filling most of

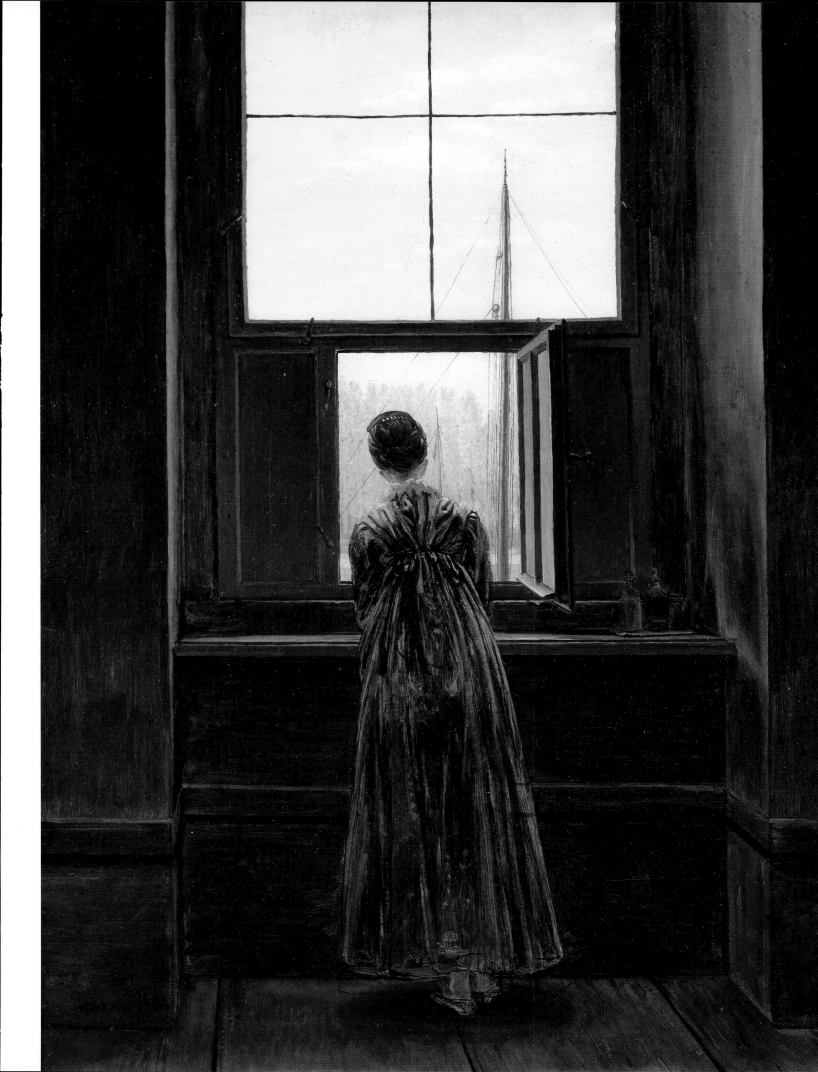

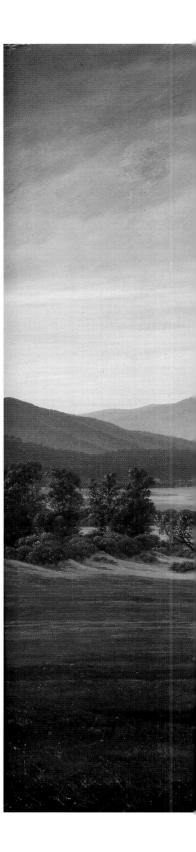

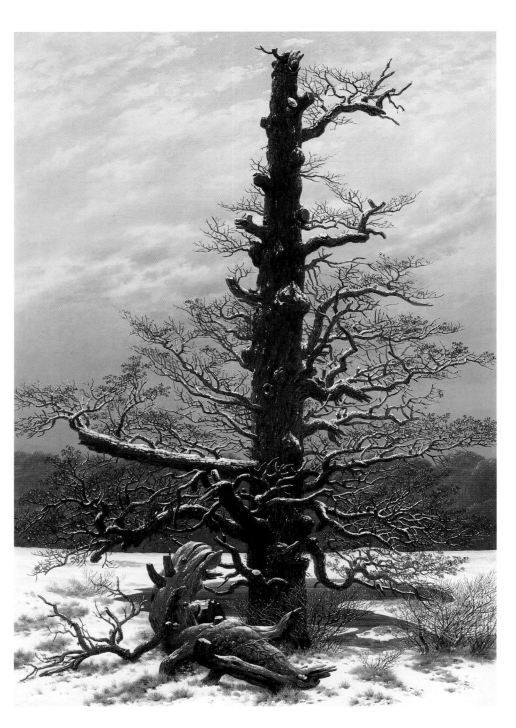

CASPAR DAVID FRIEDRICH
Oak Tree in the Snow, 1829

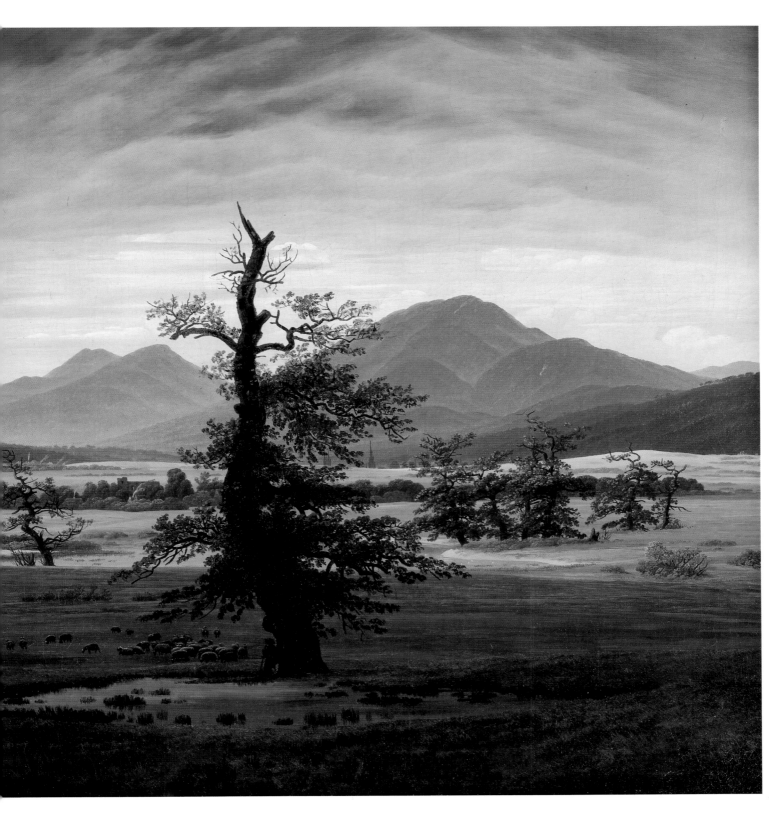

CASPAR DAVID FRIEDRICH
The Solitary Tree, c. 1822

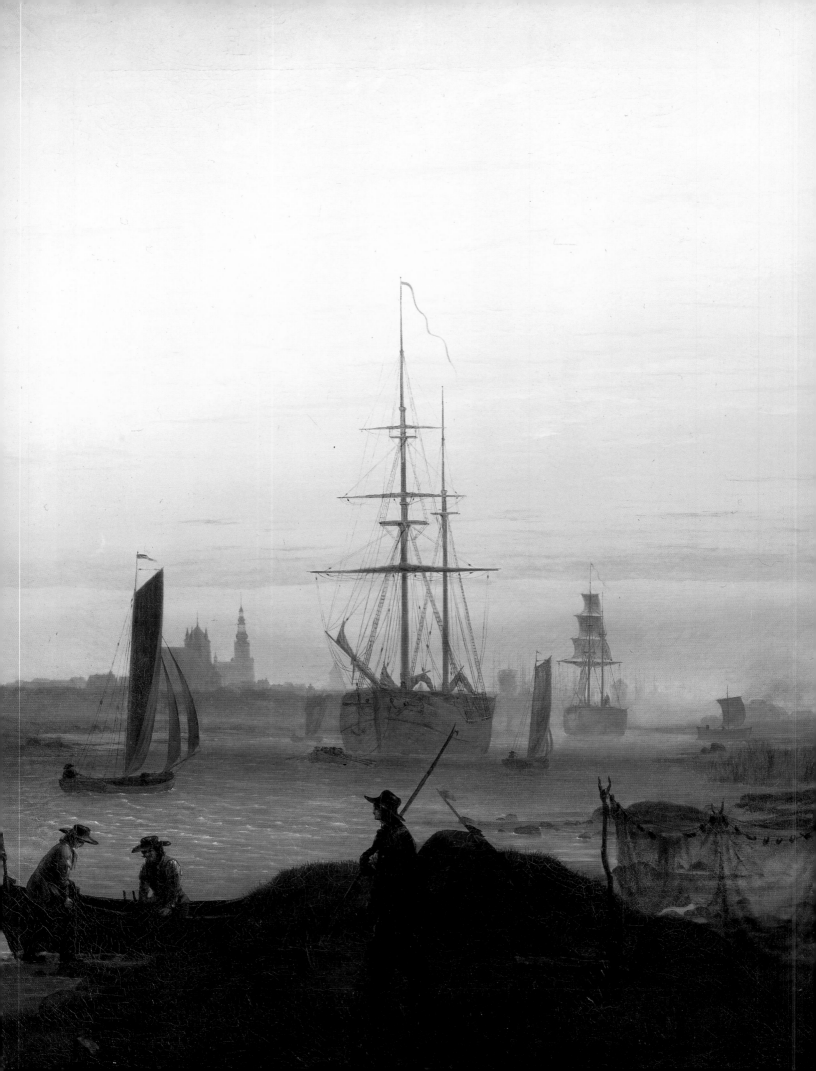

Opposite:
CASPAR DAVID
FRIEDRICH
Greifswald Harbor,
c. 1818–20

CARL GUSTAV CARUS
Leipzig, 1789–
Dresden, 1869
Morning Fog, c. 1825

the surface of *Couple Watching the Moon* (*515*). An oak tree in the snow (*518*) becomes an obelisk, another sturdy monument to death's denial, or — in Nazism's phrase — to the Triumph of the Will. Here the heritage of Nordic heroes of yore, living on as an aged trunk of the tree sacred to Wotan, sends out new branchlets despite its shattered state.

The disaster-blasted *Solitary Tree* of c. 1822 (*518–19*) — pendant to a *Moonrise by the Sea* — seems arrested in dance. With distant oaks as its *corps de ballet,* the central tree's solo is reflected by the trapezoidal pool below. Here a mixture of animation, mimesis, realism, and fantasy anticipate the dubious blessings of Disney.

Still rooted in the banks of the Rhine and those of Dresden's Elbe, the Hudson River School seldom forgot the biblical basis for so much German scenic art. In his *Letters on Landscape Painting* (1855), Asher B. Durand noted how "the external appearance of this our dwelling-place, apart from its wondrous structure and functions that minister to our well-being, is fraught with lessons of high and holy meaning only surpassed by the light of Revelation. . . . The Great Designer of these glorious pictures has placed them before us as types of the Divine attributes. . . . "

In other, later hands, with topography's increasing triumph over theology, Friedrich's visionary views were lost — all surface and no spirit. His false followers were deaf (or blind) to the German's message: "An artist should not just paint what he sees before him, but also what he sees within himself. And when he sees nothing within, then he should not paint what he sees without."

Carl Gustav Carus, though fifteen years Friedrich's junior, was a close friend, associate, and in some ways influence. Like Friedrich, he was a friend of Goethe's. He was also author of important literature for the Romantic movement and its ethos. Carus, with Friedrich, was keenly interested in Dutch art of the seventeenth century and took over some of its elements. Medicine was the center of Carus's career, with art an avocation. His *Foggy Landscape* (*521*) also known as *Morning Fog*, has much of the clear-eyed vision of Dutch Baroque art, but it shares the freshness of contemporary works by John Constable (*506*) and Joseph Mallord Turner. The watercolor medium of this view was ever more popular in the nineteenth century, especially among men and women like Carus who had other careers in addition to painting and needed speedy pictorial results.

Karl Friedrich Schinkel

STILL MORE significant as architect than painter, Schinkel's two contrasting yet not neccessarily conflicting imperatives of Neo-classic and neo-Gothic — known as Romantic Classicism to those who care — can be best seen in a juxtaposition of his *Medieval Town on a River* (*525*) and his *Vision of the Golden Age — Greece* (*522*), the latter re-created by Wilhelm Ahlborn in 1836 after a destroyed work of Schinkel's. Rooted in city planning and stage design, Schinkel turned to painting during the Napoleonic Wars, when building commissions were few and far between.

He found little conflict between the Medieval and the Antique, both essentially fantasies in his art. The first was sustained by an English visit of 1826, the second stimulated by the dramatic rigor of French revolutionary architecture. Two lengthy Italian journeys, the first in 1803–4, the second in 1824, gave "equal time" to classical and medieval currents. Conceptually, Schinkel's art, with much of Friedrich's, recalls Sherrie Levine's characterization

of her oeuvre as "membranes permeable from both sides," allowing for an easy flow between the present and two pasts, these, in Levine's terms, "between my history and yours." Even the medium for many works of Friedrich's period, painted flats and scrim for panoramas, often permeable by light, intensified the power of their illusionistic magic, losing the Now in a once and future Then.

Following the format of his Berlin panoramas, Schinkel's *Vision of the Golden Age* is more like Empire wallpaper, presenting an appealing if implausible building *in medias res*. A narrative frieze is being installed between a double arcade of Ionic columns by an unlikely labor force of nude ephebes seemingly better suited to leisurely pleasures in some nearby grove.

Vedute-influenced, an early example of Schinkel's theatrical arts is his *Banks of the Spree at Stralau* (*524*), signed and dated 1817. Berlin's spires rise on the horizon as a group of music makers punt along the river, an eel trap to the left. For all the scene's

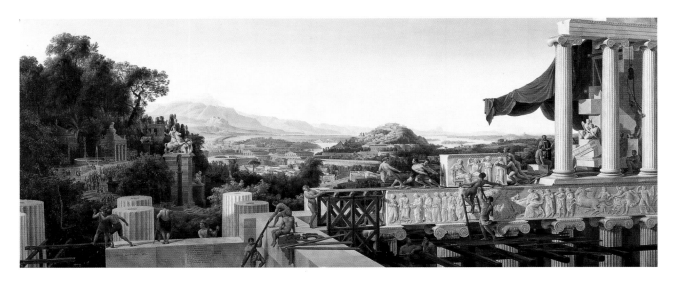

WILHELM AHLBORN (AFTER SCHINKEL), Hanover, 1796–Rome, 1857, *Vision of the Golden Age — Greece*, 1836

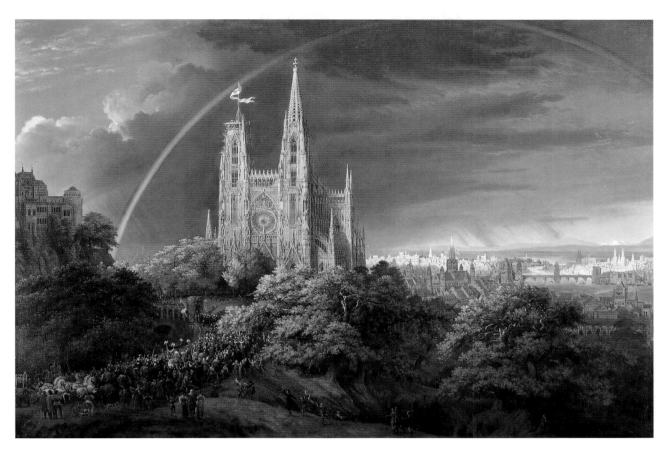

KARL FRIEDRICH SCHINKEL, Neuruppin, 1781–Berlin, 1841, *Gothic Cathedral with Imperial Palace*, 1815

unmistakably Northern setting, there is an Arcadian element to this vista, with its classically inspired, Claude-like architecture and trees.

Appropriately, Schinkel's first official exposure to the Gothic world came with a Rhine journey in 1816, during which he acted as Prussian agent for the Berlin Museum — designed by Schinkel — in the purchase of the Boisserée's collection at Heidelberg. One of the few occasions when Berlin lost out, the paintings went to wealthy, conservatively Catholic Munich instead. This journey, including Cologne and Belgium's Brabant, helped Schinkel, who was entrusted with its preservation in Berlin, study Gothic architecture. So the painter's *Gothic Cathedral with Imperial Palace* (*523*) suggests a nostalgic souvenir, intensified by the celestial arc's presence, a symbol of divine covenant, here that between God and his people, represented by an ideally situated Gothic building.

The neo-Gothic fruits of Schinkel's labors as an interior designer are found in the *Armor Room in the Palace of Prince Frederick of Prussia* (*524*), painted by his student, Carl Friedrich Zimmermann. Here the royal couple grapple with an intensely operatic life- (and death-) style of interior design, one more suited to *Lucia di Lamermoor* than to playing the palace, where Gothicke gloom is too slowly house-broken toward a new-old ominously national domesticity. Looming on the left wall is what must have been an actual-sized copy of Stephan Lochner's vast Cologne *Dombild*.

Returning to the past may prove progressive — or, as the French proverb goes, *"Reculer pour mieux sauter"* (Step back the better to leap forward). Just as Schinkel's neo-Gothicism contributed to Eiffel's revolutionary engineering, so would Wright's spiritual pilgrimages to Yucatán and Egypt, or Rodin's passionate vision of the medieval, illuminate the way to the future.

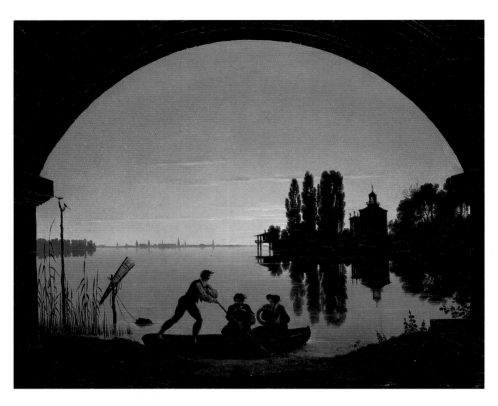

KARL FRIEDRICH SCHINKEL, *The Banks of the Spree at Stralau*, 1817

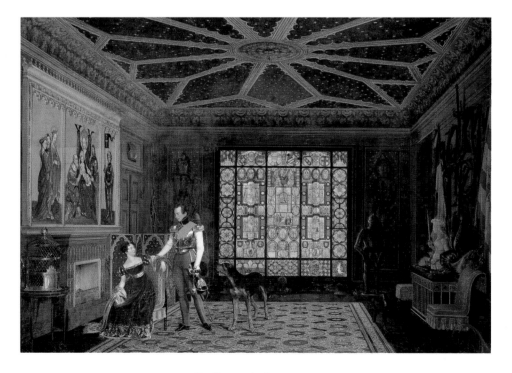

CARL FRIEDRICH ZIMMERMANN, Berlin, 1796–1820
Armor Room in the Palace of Prince Frederick of Prussia

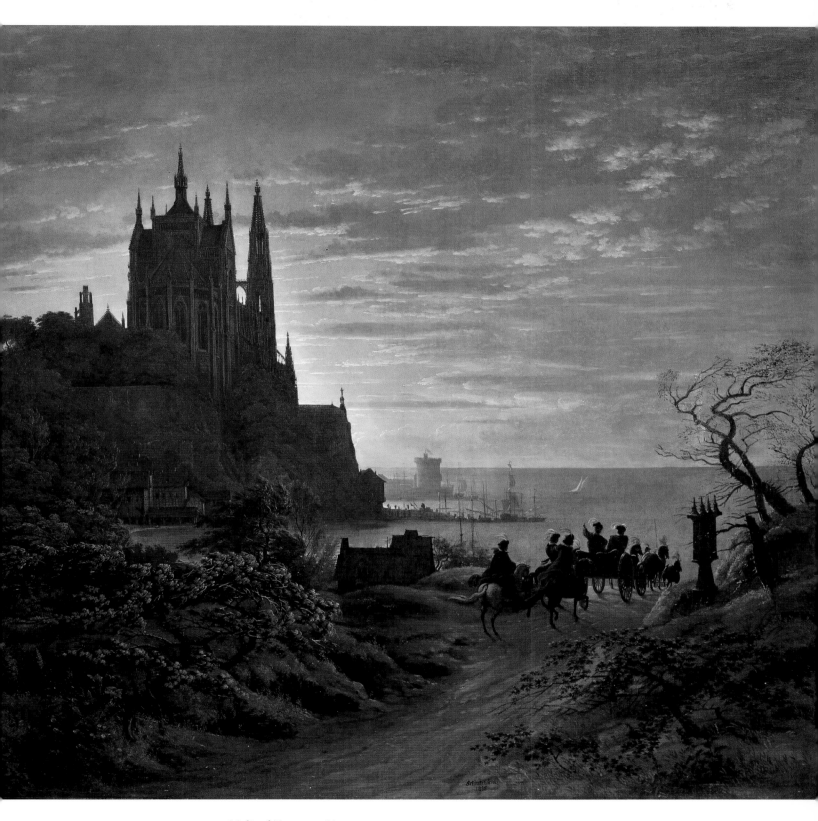

KARL FRIEDRICH SCHINKEL, *Medieval Town on a River*, 1813

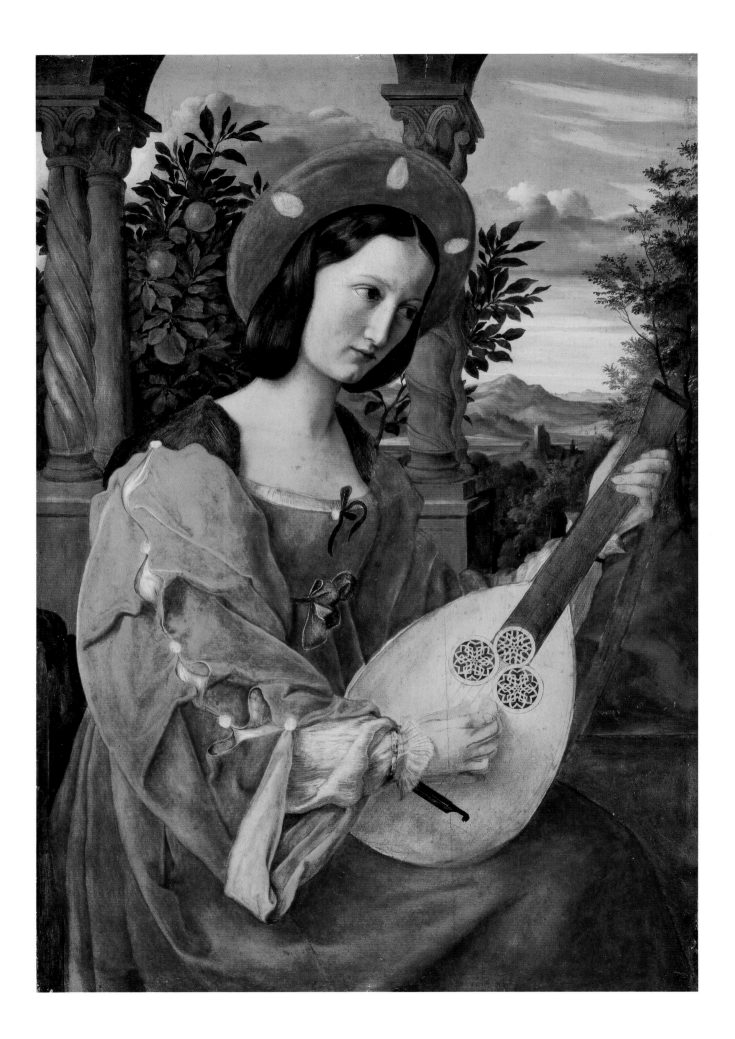

CREATIVE BROTHERS IN CHRIST: THE NAZARENES

NAMING their new brotherhood for St. Luke, patron saint of painters, a society of pious artists was founded in Vienna in 1809 by Johann Friedrich Overbeck and Franz Pforr. They, with most other group members, converted to Catholicism, their "holier than thou" manner leading to the unwanted designation as "Nazarenes," which stuck. Austrian academic training was far too classical for these devout young German painters, who yearned for the neo-medievalism then flourishing in a pan-European Gothic revival, most notably in Paris, Frankfurt, and Cologne, and inspired in German lands by the writings of Ludwig Tieck, Wilhelm Heinrich Wackenroder, and Friedrich von Schlegel.

John Flaxman (1755–1826), popular pioneer of a newly linear manner, helped artists achieve an austere, abstract approach, as did the similarly outlined and well-received reproductions after early Italian paintings by the brothers Johannes and Franz Riepenhausen. Collecting "Gothic" art from south of the Alps also changed Northern perspectives. Having ended in the violence of the Revolution, the Enlightenment was now viewed with suspicion, rendering neo-orthodoxy part and parcel of the Roman Catholic and national revivals. Contemporary with England's archaizing art movement — the Elders — and Ingres's Primitives, the Nazarenes were forerunners of the Pre-Raphaelites, that Anglo-Christian brotherhood founded in 1848.

Moving to the Roman fountainhead of their faith in 1810, the Brotherhood of St. Luke settled into an abandoned monastery. Love for the art of the late Middle Ages led to the revival of fresco painting — "to be reintroduced as it had existed . . . from the time of Giotto to the divine Raphael," in Peter von Cornelius's words. He joined the group in Rome in 1811 and soon became a major figure in their best-known commission there, the *Joseph Cycle*, which was painted in 1816–17 for the Casa Bartholdy, so named for its then resident Prussian consul. (Built by and for the painter Federico Zuccaro, it is now known as the Hertziana and is the Roman center for German art-historical research.) The frescoes were moved to Berlin in 1877. Seldom shown on such a large scale, scenes from Joseph's life may have been chosen since the German Count Stolberg, a convert to Catholicism, stressed it in his popular *History of Christian Religion* (1806).

Joseph Recognized by His Brothers (528) shows how Cornelius blended elements from Luca Signorelli (238–41) and Michelangelo, along with such earlier-fifteenth-century sources as Ghiberti's reliefs, Pinturicchio, and the beloved art of Perugino, who, as Raphael's teacher, was the ultimate Pre-Raphaelite.

Cornelius later established himself in Munich, which soon became a Northern Nazarene center. His *Last Judgment* for the Ludwigskirche was larger than Michelangelo's. Interest in Cornelius came to England when Sir Charles Eastlake — director of the National Gallery, librarian of the Royal Academy, and a prominent painter of Romantic historical subjects — consulted the Nazarene for revival of fresco techniques.

Schnorr von Carolsfeld's *Annunciation* (529), signed and dated 1818, is one of a series of Marian subjects ordered from the Nazarenes by the canon of Dresden's cathedral. Its Roman execution is attested to by St. Peter's dome, rising in the background. Stiff, precise, with a loving re-creation of Albertian perspective, this archaizing *Annunciation*

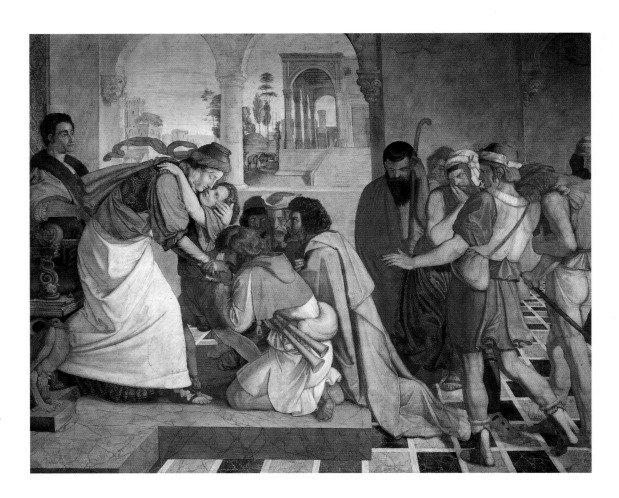

PETER VON CORNELIUS
Düsseldorf, 1783–Berlin, 1867
Joseph Recognized by His
Brothers, from the *Joseph*
Cycle, 1816

JOSEPH ANTON KOCH
Obergibeln (Tirol), 1768–
Rome, 1839
Waterfall Near Subiaco, 1813

528 *Masterworks in Berlin*

JULIUS SCHNORR VON CAROLSFELD
The Annunciation, 1818

FRIEDRICH OVERBECK, Lübeck, 1789–Rome, 1869
The Painter Franz Pforr, c. 1811

merges Northern European and Italian fifteenth-century motifs in an ingratiating pastiche. Schnorr von Carolsfeld found his canvas to have been a personal annunciation, revealing the true nature of sacred art and his own mission as Christian painter.

Equally archaizing, if less appealing, is Friedrich Overbeck's pictorial tribute to his friendship for Franz Pforr by means of a portrait (529) showing that Nazarene cofounder in quasi-fifteenth-century Northern attire framed by a Dutch seventeenth-century-style window setting, its vines and bird invested with Christian symbolism; the cross-crowned skull is Pforr's device. Though painted in Rome about a year after the Brotherhood arrived there in 1810, the artist is given a Gothic background and an ideal virgin/companion/wife. Chaste and very, very busy, she reads, knits, and kneels at a *prie-dieu,* rather like the woman in Erasmus Engert's *Viennese Domestic Garden* (540). Pforr's affectionate pussycat may refer to the Italian belief

in the *gatta del vergine* sometimes present in sixteenth-century depictions of the Annunciation.

How and why Joseph Anton Koch achieved such great success remains a major mystery, as he was possessed of no originality and slight distinction. Young Joseph must have had something going for him, as an English theologian staked him to a three-year Italian stipend. Fortunately for Koch, his uninspired rehash of the French Baroque art of Gaspard Dughet was found remarkable. In Rome during the 1820s, he joined the Nazarenes on their Casino Massimo frescoes. Berlin's *Waterfall Near Subiaco* (528), painted in 1813 in Vienna after sketches *in situ,* is a typical Koch. This one is enlivened by a peasant group, probably cribbed from a Flemish source. Though it suggests a Flight into Egypt, that's no baby, its a fruit basket. With a naive mixture of modesty and conceit, the artist described this work as "completely in the taste of Gaspard Poussin [Dughet] but more brightly colored."

Johann Anton Alban Ramboux, pupil of a self-styled "monk-painter," Friar Abraham zu Florenville (*nom de brosse* for Jean Henri Gilson), came to Rome in 1816. He joined the Nazarene circle there and made extensive, documentarily important watercolors after early Italian painting in addition to collecting works from that period. His *Rebecca and Eliezer at the Well* (*530*) of 1819 has some of the delicacy of a Persian miniature, and of Ingres's early Primitive style. Nazarene re-creations yield a fairy-tale version of biblical events, an Andersen-like narrator their fifth evangelist.

"It has now become the fashion to commission only paintings à la Raphael." So wrote Baroness Buntsen, English wife of the Prussian ambassador, from Rome in 1810. That practice is much in evidence in Julius Schnorr von Carolsfeld's *Clara Bianca von Quandt, 1820* (*526*). This panel, based on the Renaissance master's *Joanna of Aragon* (Louvre), includes a pinch of earlier Netherlandish precisionism for good Gothic measure. No mere prop, the sitter's lute was well played by Bianca, whose husband bought Gentile da Fabriano's *Altar* (216) for the Prussian court.

Christian Gottlieb Schick posed Heinrike Dannecker (*531*) in the authoritative attitude of some Michelangelesque sibyl. Her likeness of 1802 is startling for its brilliant coloring and decidedly anti-Classical, blonde, broad features. Heinrike's frank gaze is at odds with the artifice of her gestures and daintily pointed slippers. A certain elegance is reminiscent of Jacques-Louis David, one of Schick's teachers. The sitter's wardrobe, scarcely befitting a sibyl, is that of a very chic peasant's market-day or Sunday best and reflects the new German nationalism — the same concern for folkways that is found in Beethoven's rustic songs or the verses of Burns and Scott.

Artists from the United States came close to the Nazarenes, as so many of the new nation's painters trained in Germany. The movement's Christian focus also inspired the pious, medievalizing ideals of John Ruskin and William Morris, both of whom were even more popular in America than England. Soon the arts of the Rhine and Hudson River Schools merged in surprising ways, the latter often taking over German aesthetics and ethics alike. By the mid-nineteenth century, the president of the National Academy, Daniel Huntington, was an avowed Nazarene follower, as were the popular

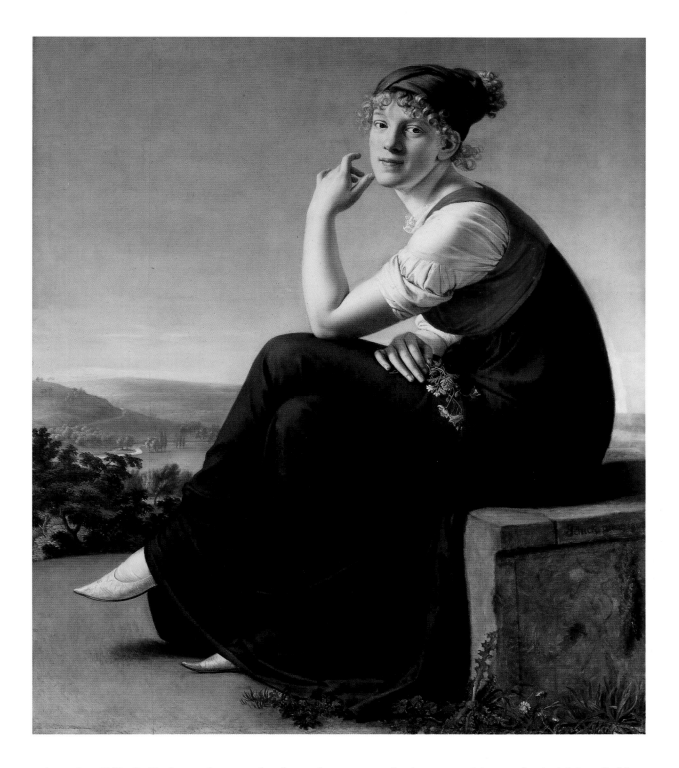

printmaker Felix O. Darley and, somewhat later, the leading American painter Elihu Vedder. So what may seem a quaint, long-extinct example of pious Germanic pictorial revivalism proved of transatlantic significance, ending with the Christian Communism of artists for *The Catholic Worker*. Such later-nineteenth-century French pictorial movements as the Nabis (Hebrew for "prophets"), with their joint emphasis on mysticism and primitivism (led by Maurice Denis, who at fourteen vowed to become a pious painter and so "celebrate all the miracles of Christianity"), and the bizarre Croix-Rouge movement might never have seen their devotional light of day without that momentous Austrian assembly of art students at the century's start.

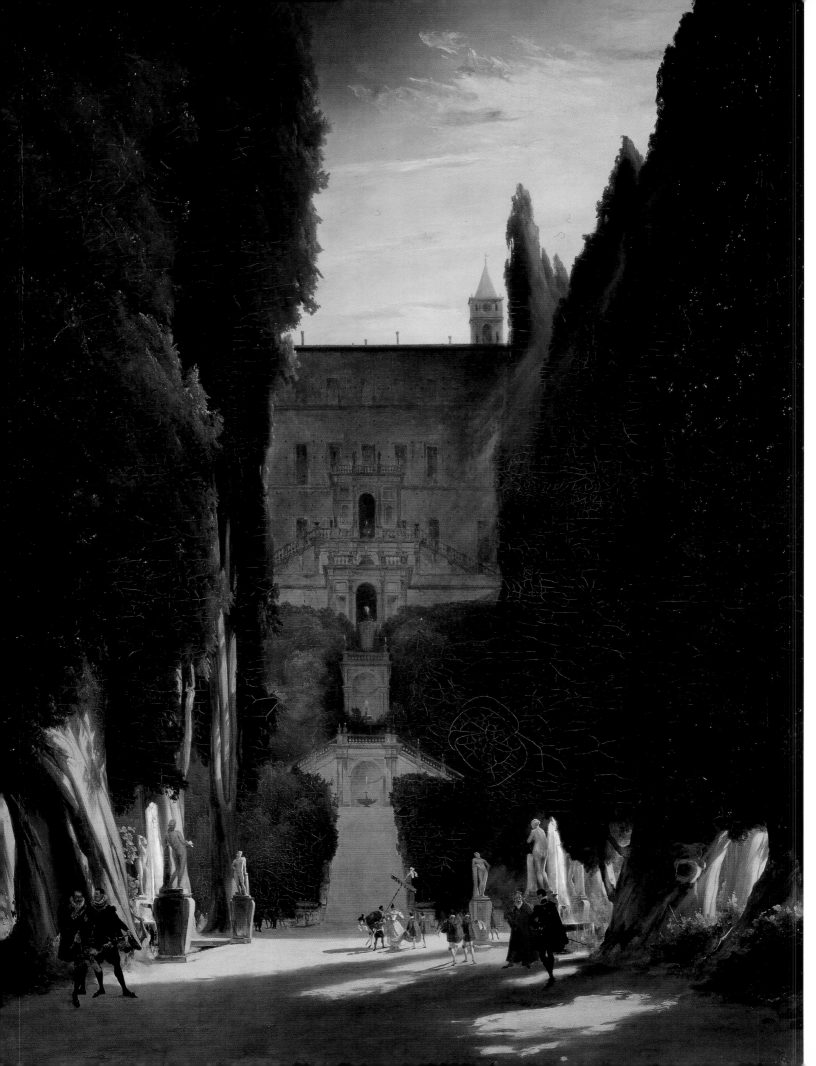

IMPROMPTU: THE ART OF KARL BLECHEN

BLECHEN'S PAINTINGS, ever musical in their spritely, fugitive fashion, suggest Frédéric Chopin's designation of some of his most sparkling — exactly contemporary — compositions as impromptus. These canvases also recall those by Richard Parkes Bonington, who was four years Blechen's junior and, like Chopin, lived in France. Both painters are essentially Little Masters and share the same sense of intimacy and informality, without a dominating eye (or I). Their delicate touch is still reminscent of French eighteenth-century painting, when the Rubensian sketch was first revived for small-scale oils.

The German's slashing strokes, like Bonington's, come close to those of Constable and Delacroix. Seldom commissioned, Blechen's oeuvre projects spontaneity; his original, almost casual pictorialism is often that of an impulsive *aperçu,* inspired by free engagement — the art of the impromptu.

The young artist's images sometimes suggest the irregular bordering of vignettes such as Turner's picturesque, shimmeringly Romantic Rhineland views that were so popular in print form. Blechen never strove for the Grand Manner or the dashing subject; rather, his records are often those of a happy visual diary, a serenely documentary "This I saw," without Goya's *terribilità,* or Romantic agony.

He came from a poor family and could not come to art until his mid-twenties. Beginning in the Berlin Academy, then directed by the distinguished Neoclassical sculptor Johann Gottfried Schadow, Blechen soon found a far more sympathetic ambience at the Dresden Academy, where he was

attracted by two professors — the gently mystical Caspar David Friedrich (*510, 512, 514–15, 517–20*) and the newly naturalistic Johan Christian Clausen Dahl (*513*). Gloomy topics, part of Friedrich's neo-Gothic passion, also captured Blechen's imagination, and he sometimes painted similarly medieval ruins. Dramatic works in that genre helped him find employment in 1824 painting sets for the recently founded Royal State Theatre under Karl Friedrich Schinkel (*522–25*).

In 1828 Blechen went to Italy for a journey that unleashed a flood of new images, including many beach scenes, some of which are strikingly close to Turner's — pictures of Neapolitan fisherfolk (*534*) by both artists seem dashed off with Byronic gaiety. Boldly, speedily sketched in oil on paper, Blechen's *Stormy Weather over the Roman Campagna* (*535*) of 1829 shows the ruins of an ancient aqueduct threading its way along the plain, the snowcapped Alban mountains in the background. Shattered, the elevated waterway suggests a Titanic battle between the forces of humanity and nature, with the latter, as usual, the winner. Elongated in format, this view recalls the vistas of Rembrandt (*364*), Seghers (*364*), and Ruisdael (*346–47*), Dutch masters some of whose works may well have been seen by Blechen, a Berliner, in the capital's museum, then known as the Royal Picture Gallery.

Corot was in Rome at the time of Blechen's Italian travels. Both painters working *en plein air,* and new freedom shaped their art. An inevitable view of the Tivoli Gardens at the Villa d'Este (*532*) escapes the clichéd aspects of that setting.

Blechen's deft, Impressionistic scenes led to his being characterized as a "Menzel before Menzel." Pioneering aspects of the earlier artist's oeuvre justify such a view: Blechen's *Rolling Mill* of c. 1834 (*538*) predates Menzel's (*567*) by more than forty years.

Opposite:
KARL BLECHEN
Cottbus, 1798–Berlin, 1840
The Tivoli Gardens at the Villa d'Este, 1831–32

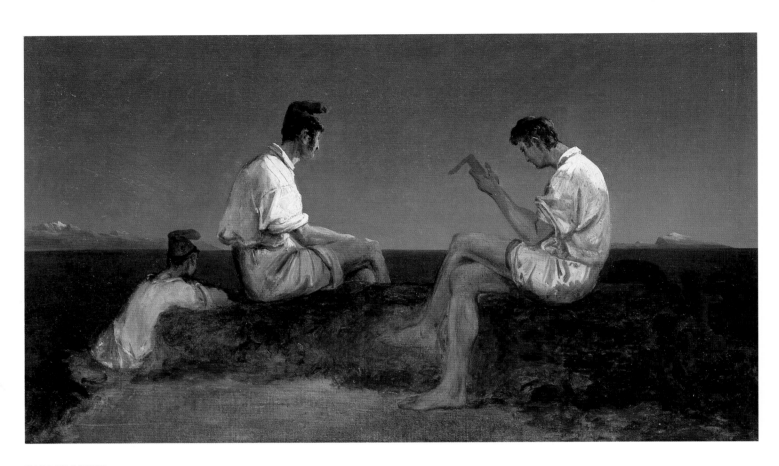

KARL BLECHEN
Fishermen at the Gulf of Naples, c. 1829–30

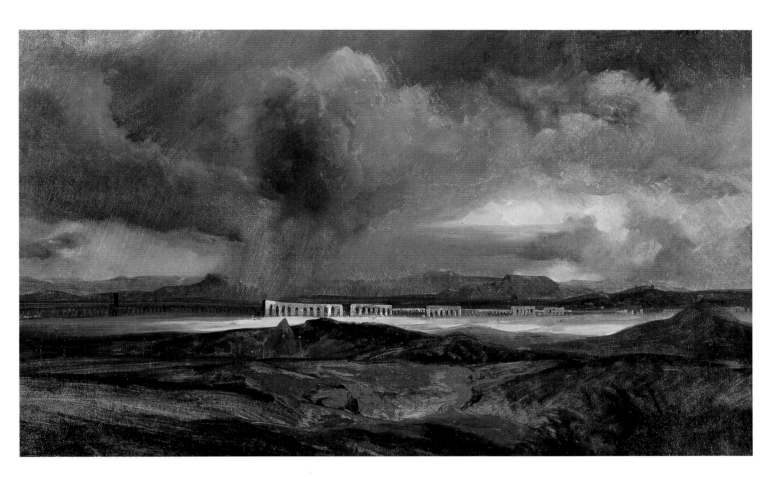

KARL BLECHEN
Stormy Weather over the Roman Campagna, 1829

Typical of the earlier-nineteenth-century concern with urban landscapes, also seen in Constable, is Blechen's *View of Rooftops and Gardens* (*538*) of c. 1835, sketched in Potsdam, so close to, yet far from, the palaces there. The splendors of one of those — Sanssouci — are evoked in an oil sketch of its uppermost terrace (*xvi*), with its two magnificent jets, the palace's garden facade seen in the background. Frederick the Great is credited with providing the initial sketches for this residence, indulging in the only art form suitable to a gentleman — architecture. This pleasure palace was built between 1745 and 1749, after plans by Georg Wenzeslaus von Knobelsdorff.

Far away from the Frenchified classical grandeur of Frederick the Great is the bourgeois apparatus of Frederick William III, seen in his "Gothic Moroccan" Palm Court on the Pfaueninsel (Peacock Isle). Designed in the opulent late Regency style, this building is a reminder of the many marital and cultural links between Prussia and England.

The Palm Court was unusually realistically recorded in Blechen's canvas (*539*) commissioned in 1832 by the arch-conservative king as a gift for his daughter, the Czarina Charlotte. Her collection of German nineteenth-century art, including many Friedrichs and Gärtners, is mostly in The Hermitage (St. Petersburg). One of Blechen's several Romantic studies of a funerary monument (*537*) suggests a Mozartean grandeur and pathos, worthy of a vengeful Commendatore rising from his sepulchre to finish off Don Giovanni. Schinkel had staged another famous opera by the same composer in Berlin, and the heritage of a Mozartean operatic *mise-en-scène* lingers on in the mists of this evocative minute oil sketch.

A youthful self-portrait (*537*) shows Blechen long before his life ended at forty-two, after seven years devastated by progressive disease of the nervous system. Haunted by the question "Is it optical fraud that I see the world as I do?" he died insane in 1840. Solace may have come from his friendship with the Romantic writer Bettina von Arnim. Close too to Goethe and Beethoven, she appreciated the painter's unique vision. As was true for works by Friedrich, many of Blechen's major paintings were destroyed in the disastrous fire at Munich's

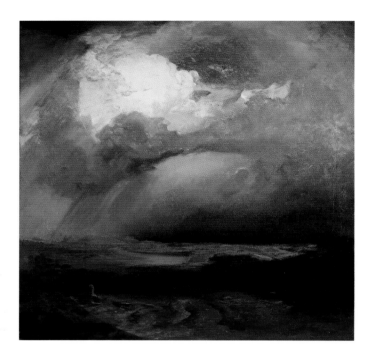

Crystal Palace exhibition of 1931 that devastated hundreds of major early-nineteenth-century pictures.

King Ludwig I of Bavaria sent the Bavarian painter Carl Rottmann to Italy and Greece to prepare records of magnificent ancient sites, which were then re-created on Munich's walls. Many of these images stressed the nobility of their legendary landscapes, causing Ludwig, by association, to be regarded as their worthy heir. While Holy Roman emperors fulfilled their destiny south of the Alps, King Ludwig realized his in reverse, by bringing back commissioned views and splendid classical antiquities.

Rottmann's Romantic canvas of the battlefield at Marathon (*536*) of c. 1849 is one of a series of oil sketches he prepared as Munich court painter for a projected fresco cycle of thirty-eight "Greek Landscapes" intended to supplement those of Italy. The first was planned for the north side of Ludwig's Court Garden Arcade, the second for the Neue Pinakothek. Greece meant as much to Ludwig I as Wagnerian mythology would to his son. Marathon was a site with a powerful political agenda. It was the battleground that represented the triumph of the West over the East, of the Greeks over the Persians, a drama that Germany, following Napoleon, was to replay, with equally disastrous results, in fighting Russia.

KARL BLECHEN
Self-Portrait, 1823

KARL BLECHEN
Study for a Funerary Monument, 1824–27

From Romanticism to Expressionism: European Painting, 1800–1914 537

Opposite:
KARL BLECHEN
Friedrich Wilhelm III's Palm Court, 1832

KARL BLECHEN
A View of Rooftops and Gardens,
c. 1835

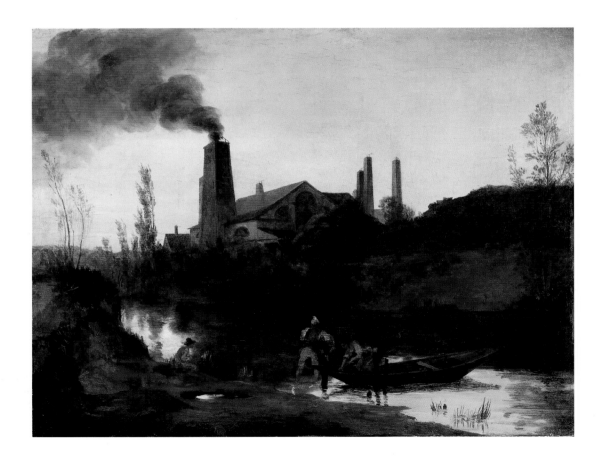

KARL BLECHEN
Rolling Mill, c. 1834

Biedermeier, the Calm before the Northern Storm

BIEDERMEIER, more a state of mind than a style, hovers between Neoclassical sanity and Victorian sentimentality, a secular paean to the comfort and joy of the ever-so-slightly upper middle class, mostly of the Protestant, transalpine cultures that prevailed between the Congress of Vienna (1815) — which initiated post-Napoleonic conservatism — and the European revolutions of 1848. This period's odd name is taken from that of a comic fictitious poet, Wilhelm Gottlieb Biedermeier, which was the pen name two writers shared to personify the Philistinism of the times, their joint poems published in the 1850s in a Munich satirical magazine.

This fraudulent lyric was nostalgic, conservative, simplistic, and it characterized a yearning for the Good Old Days before the squalor, the greed and grandeur, of capitalism's urban and industrial conquests. Only in the late nineteenth century did those persuasive pastiches come to be seen as characterizing the ethos of early-nineteenth-century German, Austrian, and Scandinavian conventional culture.

Biedermeier is domestic, an art of *calme*, with an occasional pinch of *luxe*, and no *volupté* whatever; a Biedermeier nude is quite simply unimaginable. Devoted to pleasant manners and entertainments, or to the rational delights of solitude, these canvases evoke well-decorated, warm interiors, sensibly pretty clothes, and an orderly society without need or extravagance. In 1818, when this movement was at its apogee, Karl Marx was still a prosperous young Jewish journalist in Trier, who had taken

Classical Materialism — the quintessence of Biedermeier! — as the subject for his dissertation.

Biedermeier recalls the housebound joys of much seventeenth-century Dutch imagery, but blipped out that forerunner's brothels and rowdies. Its closest American parallels in art and thought are the innumerable tinted, midcentury lithographs of Messrs. Currier and Ives, with their carefully censored self-portrait of the discreet charms and pleasures of a modest bourgeoisie. Predictably, many of those prints were designed by German-trained artists.

With the restoration of order that followed the defeat of Napoleon, bourgeois standards were exalted throughout Europe — even monarchies came to conform to them. The aristocracy began minding its p's and q's where offending middle-class morality was an issue, curtailing (or curtaining) wenching, gambling, and buggery.

Little did the Continent's new society realize the fugitive nature of its newly more sensible, if still pleasurable, way of life. Soon almost all that remained of the resonant calm before the new storms of Germany's revolutionary 1840s were the paintings grouped under that uncommonly common name of Biedermeier.

Sadly for us, Erasmus Engert's administrative skills allowed all too little time for his enchanting art. Elevated to the aristocracy, made director of Vienna's Belvedere art collections, this restorer was also a fine painter, evidenced by his *Viennese Domestic Garden* (*540*) of c. 1828–30. Under a grape arbor, dwarfed by sunflowers, a young woman manages to read the Bible while knitting a stocking. Just that combination of sacred and secular labors had already been assigned the ideal wife of Austrian art leader Franz Pforr (*529*). In this essay in middle-class beatitude, one awaits an annunciate angel to fly in at the right, so bringing a Biedermeier Bible to life. Almost square in format, the garden scene is a har-

Opposite:
ERASMUS ENGERT
Vienna, 1796–1871
Viennese Domestic Garden, c. 1828–30

PHILIPP OTTO RUNGE, Wolgast, 1777–Hamburg, 1810
The Artist's Wife and Son, 1807

binger of landscapes painted a century later by
another Viennese artist, Gustav Klimt.

A modest mix of antique pose and Northern
physiognomy is found in Philipp Otto Runge's por-
trait of his wife and son (542). The woman's sparse
hair is screwed up in a sad Psyche knot, her dress
classically uninspired; these harried, pathetic con-
cessions to the Antique do little for this forthright
woman in her husband's touchingly unaffected
rendering. Christian values, rather than those of
Winckelmann's Greece, come through in Runge's
Madonna-like grouping. The painter's infant son
holds fruit like that so often grasped by the baby
Jesus. This Hamburg artist, in some ways the Ger-
man William Blake, is among that nation's favorite
painters, beloved for his lyrical, devout Utopianism.

Runge first studied art in nearby Copenhagen

and then in Dresden, where he was devoted to his
teacher, Caspar David Friedrich. Like his friend
Goethe, Runge too was a student of the scientific
character of color. His art, with that of so many of
his contemporaries, first became widely known
when a large centennial exhibition of German
painting from 1775 to 1875 was organized by Berlin's
most progressive museum director, Hugo von
Tschudi, and installed in 1906.

A number of fine early-nineteenth-century views
of Berlin were lost in World War II, but one of the
best remaining is by Ludwig Deppe, a professional
secretary who is known from only two signed paint-
ings of 1820. His *Houses at a Millrace* (543), like so
many eighteenth-century *vedute*, with its prismatic
realism, suggests the use of a *camera obscura*.

Many of photography's founding fathers were
painters of the Biedermeier period who sought a
shortcut to portraiture and other tasks through
their optical research. Often these artists were
employed in the production of elaborately illusion-
istic topographical panoramas known as dioramas.
Among the finest of these is one still in Berlin, by
Eduard Gärtner, painted for Frederick William IV of
Prussia atop Schinkel's Friedrichswerderkirche in
1843, and including the artist and his family (544–45).
Similarly illusionistic in its theatrical sense of sud-
den confrontation is Gärtner's *Staircase in the Berlin
Palace* (546) of 1828. Guardsmen march in the dis-
tance while a servant and her little girl are seen in
the foreground of Andreas Schlüter's magnificently
designed Baroque palace, destroyed in World
War II.

Prismatic in its definition, the Neoclassical archi-
tectural vistas of Gärtner's *Workshop of the Gropius
Brothers* (543) show the influential workshop for the
city's theatrical and operatic scene painting, which
provided much-needed employment for so many of
the city's young artists. These included Gärtner,
who studied with Carl Gropius, attended the Berlin
Academy, and painted at the Berlin Porcelain Manu-
factory. Prussia's king had also sent him for special
landscape study in Paris under Ingres's friend
François Edouard Bertin.

The capital's new opulence is seen in Gärtner's
Königsbrücke and Königskolonnade (547), its theaterlike
pavilions still under construction, part of a new

LUDWIG DEPPE
active Berlin early nineteenth
century
Houses at a Millrace, 1820

EDUARD GÄRTNER
Berlin, 1801–1877
Workshop of the Gropius Brothers,
1830

EDUARD GÄRTNER, *Berlin Diorama from Friedrichswerder Church Looking South* (top); *Looking North*
(bottom), 1843

EDUARD GÄRTNER
Staircase in the Berlin Palace, 1828

EDUARD GÄRTNER
Klosterstrasse, 1830

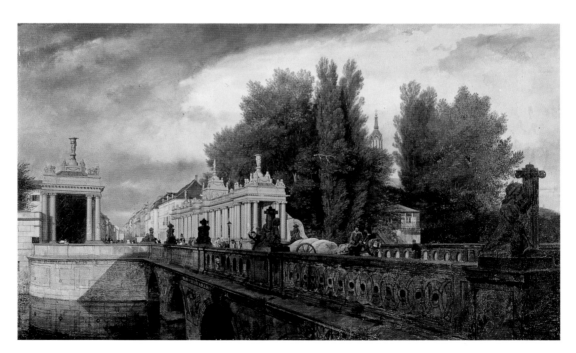

EDUARD GÄRTNER
*Königsbrücke and
Königskolonnade, 1853*

FRANZ KRÜGER, Dessau, 1797–Berlin, 1857, *Parade at the Opernplatz*, 1829

JOHANN ERDMANN
HUMMEL
Cassel, 1769–
Berlin, 1852
*The Granite Basin in
the Lustgarten*, c. 1831

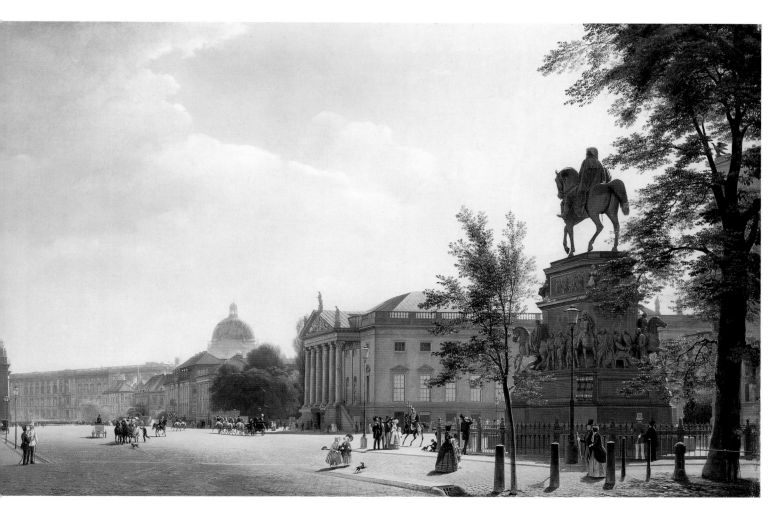

EDUARD GÄRTNER, *Unter den Linden*, 1853

urban drama in which Berlin would rival Paris or Rome. Though the capital of an ever more powerful Prussia, Berlin, like Paris or London, had not yet lost a certain intimacy and rusticity. A very old-fashioned view of a mostly old-fashioned Berlin quarter is found in the same painter's *Klosterstrasse* (*547*), with its eighteenth-century shops and winding streets, all painted in the Dutch mode.

Modern Berlin is shown in the painter's *Unter den Linden* (*548–49*) with Christian Daniel Rauch's 1851 equestrian statue of Frederick the Great, which is set before the west wing of the former Berlin palace of Prince Henry, next to the customs house. Another vista of the capital's new splendors, also on that same avenue of lindens, is Franz Krüger's *Parade at the Opernplatz* (*548*) of 1829. A replica of this, along with one of Gärtner's panoramas, was sent to the king's daughter, the Czarina Alexandra,

and her husband Nicholas I. They invited Gärtner to Russia, where he painted many views.

Another panorama, completed in 1848, is of the Pontine Marshes near Rome (*550*), by the painter-poet and writer on art August Kopisch. He was befriended in Capri by King Frederick William IV of Prussia, who granted him a number of royal commissions, which caused Kopisch to move to Berlin and Potsdam. The king bought this sweeping vista, whose realistic yet romantic transcription of light comes close to that of the Luminists. Exploring a spectacle so sublime as a Pontine sunset must have brought down many a Jamesian heroine (among other mortals) before Mussolini drained the malarial death traps lurking in the marshes below.

Artists of the Biedermeier period could, and did, deal with motion, yet the static was the state closest to their frame of mind, as seen in *Riders at the*

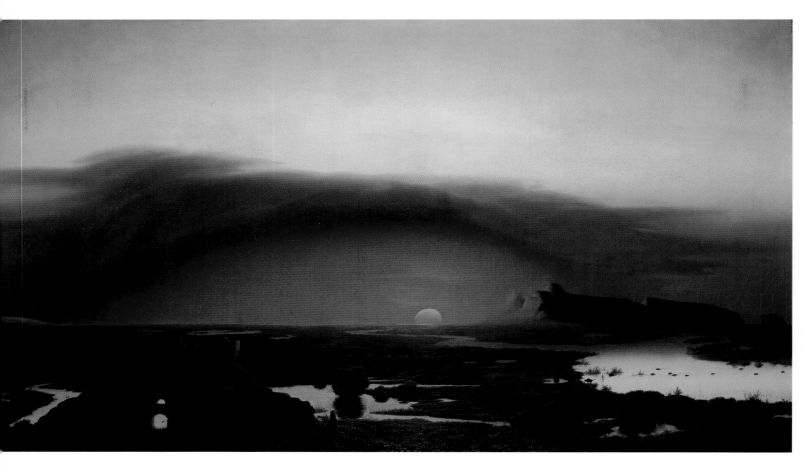

AUGUST KOPISCH, Breslau, 1799–Berlin, 1853, *The Pontine Marshes at Sunset*, 1848

Tegernsee (*551*) of 1832, by Wilhelm von Kobell. Despite rain at the far side of the lake, and peasants walking up and down the hill, the riders themselves seem petrified, their mounts as still as those carved for a merry-go-round, not so much holding a pose as unable to break it.

As accomplished as any equestrian group of the period is Krüger's *Two Cuirassiers from the Regiment of Czar Nicholas I* of 1839 (*552*). That valance of brooding skies brings this scene away from the Biedermeier toward the Romantic. Perish the thought that rain might dampen so ample a mustache as the one above the left rider's lip, or stain those gleaming cuirasses, or wet the helmets' black plumage or the rider's glittering standard embroidered in silver.

Johann Erdmann Hummel's almost compulsive focus upon the fabrication and installation of the great granite basin before the Lustgarten (*548*),

painted in 1831, typifies the orderly, ingratiatingly satisfied perspective of this period. As one might suspect, Hummel was a professor of optics and perspective. Why does such almost smug art please rather than repel? That's Biedermeier's saving grace, its complacency closer to innocence than anything else.

A group portrait of Paul, Maria, and Filomena von Putzer (*553*), by Friedrich Wasmann, is strikingly reminiscent of far earlier American portraits in which the clothes, poses, and settings were all prepainted by itinerant artists, made ready for the purchaser's selection, with only the heads needing "filling in." Surprisingly, such a modest *modus operandi* could result in searching and sophisticated images, close to those of the three little Putzers.

Friendship pictures, a tradition going back to Holbein (*106, 109*), were revived in the nineteenth

WILHELM VON
KOBELL
Mannheim, 1766–
Munich, 1853
Riders at the Tegernsee,
1832

century. One of these, by Julius Hübner, shows the painters Carl Friedrich Lessing, Carl Sohn, and Theodor Hildebrandt (*553*). Their *trompe l'oeil,* inscribed frame recalls those of Jan van Eyck; the pictorial format is close to that of the early-fifteenth-century *Founders of the Florentine Renaissance* ascribed to Uccello (Louvre).

Hübner's friends were students of a prominent Berlin academician, Wilhelm von Schadow, son of Germany's best-known Neoclassical sculptor. They followed their master to Berlin, then to Düsseldorf, and on to Rome. As if invisible to one another, they are united by Hübner's all-encompassing portrayal. These three friends are shown with a precision suit-

able to the year of their depiction: 1839, when Daguerre presented his invention to the French Academy, eliciting the famous response that henceforth painting was dead. As one of the founders of the Düsseldorf School, which was a center for German realism, Hübner attracted many students from America.

The Vienna-based painter Ferdinand Georg Waldmüller was a master of modest pleasures, a laureate of the status quo. But even he can surprise with the contrast between his skills for both hermetic still life and *plein air* narrative. The first may be witnessed in his glitteringly Ingres-like *Bouquet in an Attic Bell Crater* (*555*) of c. 1840. Seen against a

Opposite (top):
FRIEDRICH WASMANN
Hamburg, 1805–Meran, 1886
Paul, Maria, and Filomena von Putzer,
1870

Opposite (bottom):
JULIUS HÜBNER
Oels (Silesia), 1806–Loschwitz
(near Dresden), 1882
Carl Friedrich Lessing, Carl Sohn, and
Theodor Hildebrandt, 1839

FRANZ KRÜGER
Two Cuirassiers from the Regiment of Czar
Nicholas I, 1839

startlingly neutral, dark background, the flowers are surrounded by early Victorian silver, ribbon, and jewelry, where even nature seems designed to win a prize for overwrought artifice. All is painted with such compelling fidelity that the Greek vase can be identified as one from 370 B.C., now in Vienna's Kunsthistorisches Museum. Waldmüller's old-fashioned technique — oil on panel — is updated by an oddly magical quality suggesting *découpage.*

Early Spring in the Wienerwald (554) of 1864 will remind American viewers of the anecdotal ways in which Eastman Johnson (1824–1906) brought together young human nature and nature itself. Paradoxically, this spring scene was one that obsessed Waldmüller in the last months of his life. He painted four versions of the subject; Berlin's is the second.

Like all "Provincial" styles, Biedermeier lasted longest in less-sophisticated centers and was still in evidence in Scandinavia at the century's end in such views as Vilhelm Hammershøi's *Sunny Chamber* (556). Here the almost neo-Egyptian monumentality of the furniture is in striking contrast with the light pouring into the chamber, and with the abstract elegance of the four paintings on the wall.

Carl Spitzweg, at once master of the fairy tale or the bittersweet anecdote, became one of the most popular of all German painters. His *Poor Poet,* recently stolen from the Berlin museums, was as much beloved by the German populace as any work by Dürer. Occasionally Spitzweg could abandon his illustrational mode in favor of a more spontaneous manner. A major example is found in a small, vertical sketch, *Kite Flying* (557), that is close to Constable and the Impressionists in its fresh observation of light, time, and motion. Here the kites tell a tale of liberation, as if their freedom were shared by the artist.

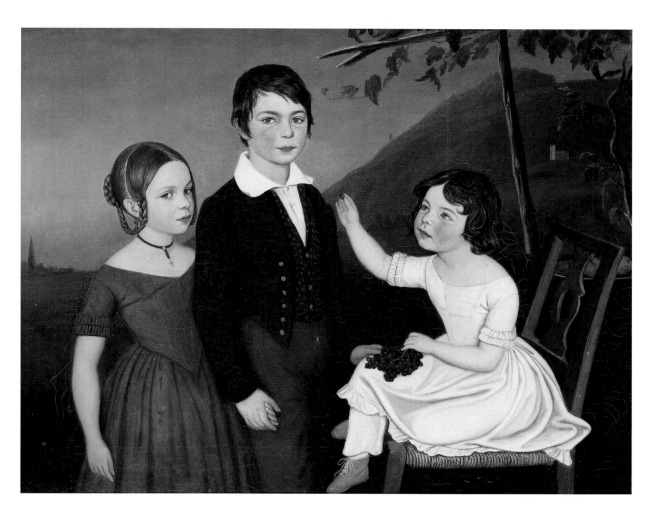

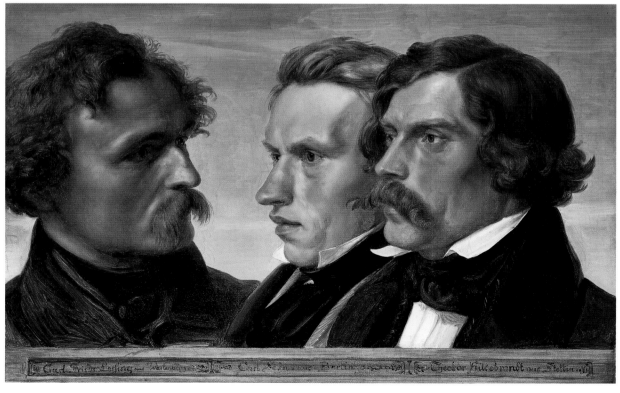

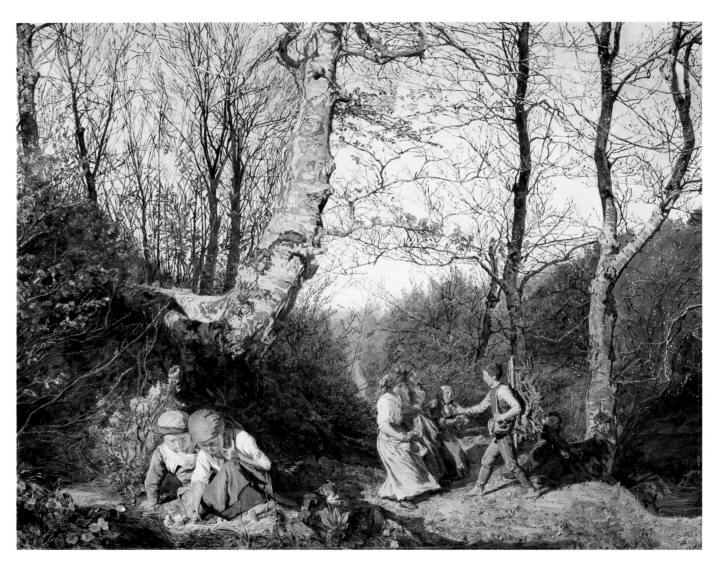

FERDINAND GEORG WALDMÜLLER, Vienna, 1793–Helmstreitmühle (near Baden), 1865
Early Spring in the Wienerwald, 1864

Opposite:
FERDINAND GEORG WALDMÜLLER
Bouquet in an Attic Bell Crater, c. 1840

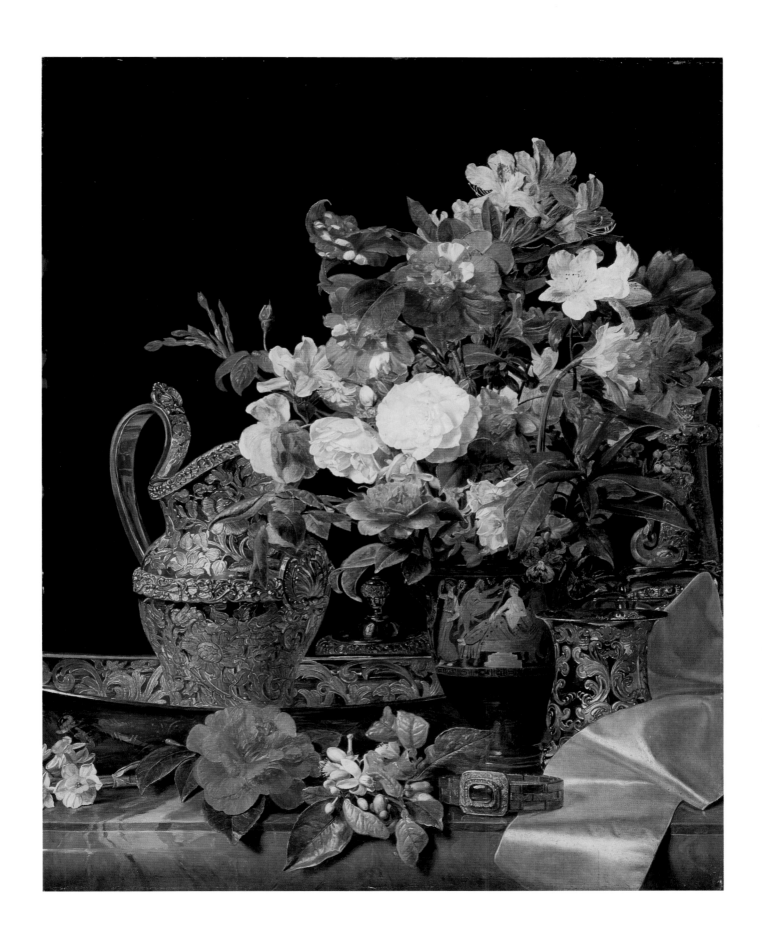

Opposite:
VILHELM HAMMERSHØI
Copenhagen, 1864–1916
Sunny Chamber

CARL SPITZWEG
Munich, 1808–1885
Kite Flying, c. 1880

Menzel, Modern Conservative

So great was Menzel's German popularity that few of his paintings are to be found elsewhere. Early on, his major pictures entered German museums — most often Berlin's — and many pertain to the city's role as Prussian capital or to its more intimate topography. Abundant examples of his virtuoso graphism are appreciated throughout the West, as Menzel's many drawings could be widely circulated and are still accessible to collectors.

Menzel had the rare knack of pleasing two different tastes; he met the needs of one searching for the too tried, and of the other striving for the newly true. Great fame in his lifetime rested upon the first gift; Menzel's posthumous celebrity stems from the second. The two-sided, if not two-faced, "public," professionally successful Menzel was acutely propagandistic, exalting the life of Frederick the Great as Germany's Manifest Destiny. This historical genre first came to the fore in 1834–36, with the young artist's series of lithographs, *Memorable Events in the History of Brandenburg-Prussia,* produced in his father's Berlin print shop. Far more important was a commission to illustrate the art historian Franz Kugler's biography of Frederick (1840–42). Menzel prepared drawings for this book that were printed as wood engravings. The artist went on to embellish *The Works of Frederick the Great* (1844–49) and *The Armies of Frederick the Great* (1845–51), finding himself in a profitable biographic rut.

Soon Menzel reveled in far larger-scale exercises in imperial hagiography, producing extremely highly finished, almost panoramic, pictorial cycles

of Frederick's life, proving a sentimental cult during years of tension and unrest. Frederick William IV (1795–1861) had done so much for Prussian cultural institutions, especially museums, yet his suppression of the Revolution of 1848 lost Germany much of its most enlightened populace. He was insane by the 1850s and the Regency was assumed by Prince William of Prussia (1797–1888) in 1858. He became King William I in 1861 and appointed the high-handed, dictatorial Otto von Bismarck (1815–1898) prime minister in 1862.

Prussia fought and defeated Denmark in 1864, forming a North German Confederacy, and won much other disputed territory in additional conflicts. Where the Seven Years' War had gained Frederick the Great the powers he sought, in 1864 a seven weeks' war did almost the same for the timid William I, who proved to be a most reluctant commander in chief. Ever the strategist for German unification under Prussian rule, Bismarck created his king's novel imperial status in 1871 and was rewarded with a First "Iron" Chancellorship. This took place after France's failed war against Prussia in 1871, when William I became titular head of the twenty-five German states, crowned by Bismarck at Versailles.

Menzel's oils of the 1850s and 1860s proved of political importance for Bismarck. They presented dazzling tableaux of a vastly wealthy, conspicuously refined Potsdam court under Frederick the Great, depicted as if on the same gargantuan plane as Versailles, in a Prussian palace more French than the one near Paris! These empire-chronicling images are exceedingly close to those by their painter's French contemporary, Ernest Meissonnier (1815–1891), whose art brings an equal propagandistic fervor to his re-creation of the Napoleonic campaigns.

Menzel's exaltation of Frederick the Great anticipated the "casts of thousands" later poured into Cecil B. De Mille's mercifully silent movies. Can-

ADOLF MENZEL
*A Flute Concert of Frederick the
Great at Sanssouci, 1852*

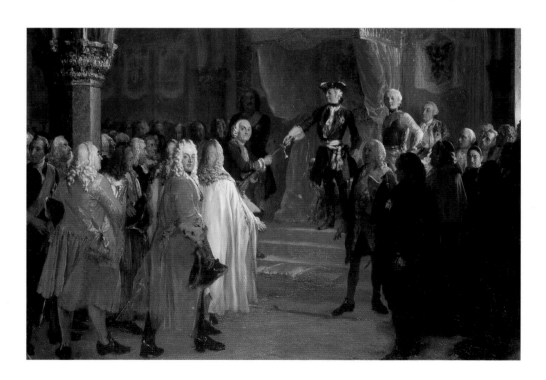

ADOLF MENZEL
*The Allegiance of the Silesian Diet
before Frederick II in Breslau, 1855*

ADOLF MENZEL, *William I Departs for the Front, July 31, 1870,* 1871

vases such as *A Flute Concert of Frederick the Great at Sanssouci* (*560*) of 1852 were images the monarch might have wished painted in his own day, yet none of his artists were up to so cinematic a task.

Menzel's *Allegiance of the Silesian Diet before Frederick II in Breslau* (*560*), signed and dated 1855, is another early, unusually fresh, exercise in Frederickiana. His habitually powerful re-creative imagination makes these canvases look as if he were working after a lost depiction of the subject by an eyewitness. Knowing his audience required a massively detailed approach, Menzel turned to a Dutch seventeenth-century precedent — the skilled reportage and engaged eye of Gerard TerBorch (*384–85, 387*), whose work was still very popular in the nineteenth century.

William I Departs for the Front, July 31, 1870 (*561*), is a key document in the new nation's propaganda, balanced between the gracious culture of the past and the bourgeois monarchy of the post–Industrial Revolution. In fact, William's departure was highly unwilling. Menzel's rendering is full of long-popular tale-telling devices, such as the newsboy in his "read all about it" pose and Queen Augusta weeping into her handkerchief. The combined flags of Prussia and Germany on the Unter den Linden housefronts testify to a great new nation — modern Germany — united by battle against the invading French. The picture's patron was Berlin businessman Magnus Herrmann, whose daughter and her painter-husband, Albert Hertel, are portrayed on the balcony. Innumerable devices of genre anticipate photojournalism's pseudo-documentation, made possible by cameras that "never lie." Menzel displays an approach that points to the most literal aspects of early Impressionism.

ADOLF MENZEL
*The Palace Garden of Prince
Albert*, 1846

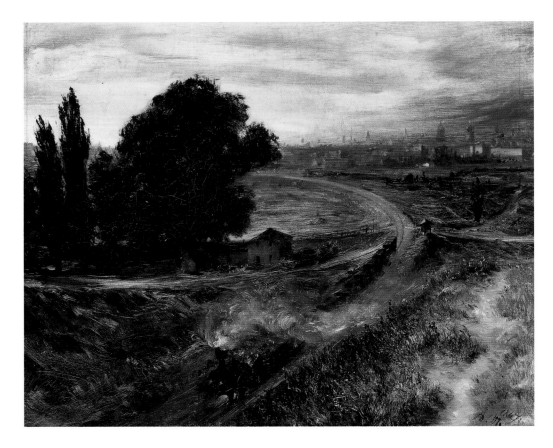

ADOLF MENZEL
The Berlin-Potsdam Railway,
1847

ADOLF MENZEL, *Rear of House and Backyard,* c. 1846

Predictably, Menzel and the skilled, if obsessive, portraitist Franz von Lenbach (a friend of Bismarck's) were the favorite painters of Kaiser William I. The new emperor opposed any aspect of French-influenced *plein air* elements in his nation, hating Manet's art (*591–93*).

Menzel was Germany's most successful painter. There are many striking correspondences between him and France's richest, most popular artist of the time, Ernest Meissonnier. Both were born in 1819, and each specialized in the same infinitely detailed re-creations, in print and on canvas, of scenes of earlier national glory. Such Lilliputian execution was made all the easier by each man's being a dwarf.

Surprisingly, both Menzel and Meissonnier, though arch-conservatives, had strong "subversive" streaks, each nurturing reluctant admiration for Manet's art. Though Menzel never confessed to

being impressed by the art of Constable (*506–7*), which he saw in a Berlin exhibition at the Hôtel de Russie in 1839, many of the Berliner's oil sketches suggest the contrary. Rapidly worked from, and in, nature, capturing the fleeting passages of light and shadow, his proto-Impressionist images of the 1840s differ radically from those painfully labored canvases painted in "imperial service" over the next two decades.

Menzel might have turned to a fellow Berliner, Karl Blechen, for some of his most freely rendered images. *Rear of House and Backyard* (*563*) recalls Blechen's art (*532–39*). Anglo-French currents could have stimulated others. Blechen was dead by 1840, and Menzel's most unorthodox scene — *The Berlin-Potsdam Railway* (*562*), in which the Prussian capital is visible at the upper right — was painted seven years later. Such subjects were far better known in

Opposite:
ADOLF MENZEL
*Moonlight on the
Friedrichskanal in Old
Berlin,* c. 1856

ADOLF MENZEL
Théâtre du Gymnase,
1856

England, including Turner's *Rain, Steam, and Speed* (1844, London, National Gallery). Blechen may have seen Turner's works in Italy, but there is no possibility of Menzel's having known them.

The French Window (558) and The Palace Garden of Prince Albert (562), of 1845 and 1846, respectively, both painted in Menzel's apartment on the Schöneberger Strasse, are among the most freely observed of mid-nineteenth-century images. Many painters of the time found Berlin's old waterfront and other antiquated commercial districts at least as arresting as the new city's magnetic monumentality and formality. Menzel caught the Friedrichskanal (565) by moonlight, c. 1856, which he shows with a flickering intensity close to later works by Vincent van Gogh (616).

If Menzel was predictably unstinting in his praise of Ernest Meissonnier, he had not a word for Manet (591–93), whose art is so close to the Berliner's Parisian canvases such as *Théâtre du Gymnase* (564), which is signed and dated 1856. Menzel painted the latter in Berlin, following sketches made on his initial visit to see the Paris World's Fair. Some of those Goya-like (422) heads of playgoers were added shortly before the painter's death.

Stressing the hairsbreadth separating illusion from reality, and the power of metamorphoses, Menzel's haunting *Studio Interior with Casts* (566) of 1852 endows the plasters with a sinister life of their own; the casts seem more real than the nearby skull or dissected hand at the center. In oil on paper, then mounted on wood, this sketch comes to grips with the painter's role, suspended between those of magician and artisan.

Menzel was understandably comfortable with the massive financial and political approval engendered by his historical scenes. His informal art was kept in the closet, never exhibited in his lifetime. Its exposure might have proven unwise, as the genre sketches share obvious English and French associations, aspects almost as politically incorrect in Wilhelmine Germany as the making and showing of Modernist art in Stalinist Russia.

Subjects such as Menzel's large *Iron Rolling Works* (566–67) of 1875 follow Blechen's lead in the industrial genre (538) and are also in keeping with the nineteenth-century manufacturing boom that gave rise to the vast iron- and steelworks in the Ruhr Valley. These factories soon put Germany in the forefront of the armaments industry and made possible the devastating defeat of the invading French troops

in the Franco-Prussian War. Unprecedented for the sheer size accorded its subject, *The Iron Rolling Works* was painted five years after that victory, a stunning example of an oxymoronic genre: "Contemporary History Painting."

Twentieth-century taste embraces Menzel's readily likable sketches, but his far more mechanical, aridly photographic re-creations of imperial life were the images that may have made, as well as reflected, history. They were used for German electoral posters of the 1930s, when a failed Austrian artist named Adolf Hitler shrewdly identified himself with the militant father of modern German national culture, Frederick the Great.

ADOLF MENZEL, *Studio Interior with Casts*, 1852

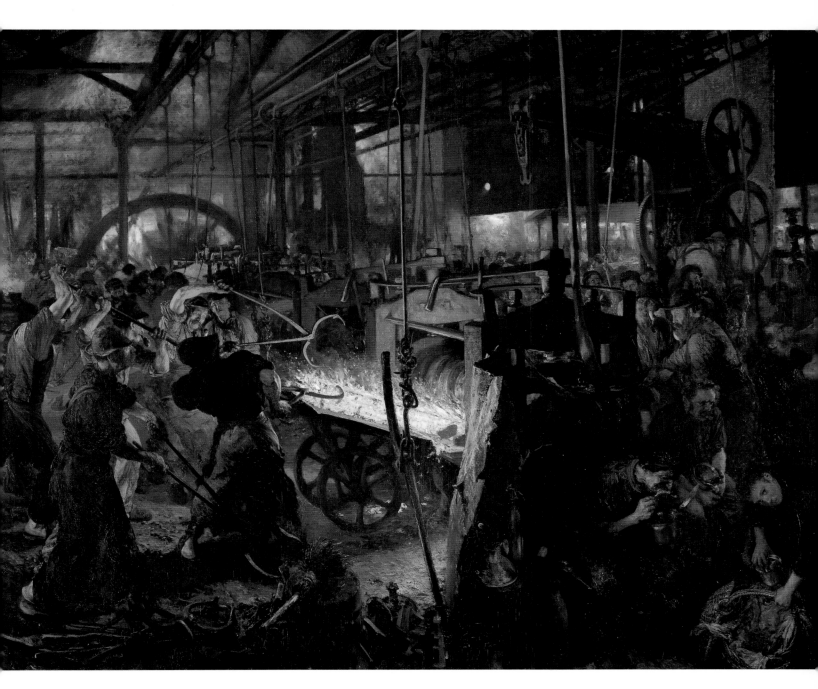

ADOLF MENZEL, *The Iron Rolling Works*, 1875

COURBET, CONSERVATIVE REBEL

GUSTAVE COURBET, the son of a landowner, was at once traditional and revolutionary. Great physical strength, along with his handsome, brooding profile and archaic cut of beard, contributed to the artist's sobriquet: "The Assyrian." He was largely self-taught, copying Spanish Baroque canvases and those of Caravaggio in Paris. Profoundly concerned with the integrity and ethics of his actions, Courbet perceived his life — like his symbolic depiction of his studio, now in the Louvre — as a "Real Allegory." Despite his commitments to Realism and Socialism, and to his friendships with Proudhon and Zola, Courbet's art remains close to Romanticism, to theatrical performance. His painting is an autobiographical narrative documenting the artist's developing sense of self in a seamless, panoramic *Bildungsroman.*

The French artist's immediate concerns were remarkably akin to those embodied by Teutonic self-discovery. They parallel Germany's many kingdoms' revolutions and their keen sibling rivalries between Realism and Romanticism. Courbet's macho persona and anticlerical stance proved as popular in Germany as his art. In the winter of 1858/59 he was in Frankfurt for a very popular exhibition of his work. There began such bravura pieces as *The Battle of the Stags* (Paris, Musée d'Orsay). Also from this time, his *Uhu Attacking a Fallen Deer* (destroyed) follows a genre long popular in Germany. Similar subjects filled the borders of Holy Roman Emperor Maximilian's *Prayer Book* and many of Cranach's canvases more than three centuries earlier.

A decade later, Courbet went to Munich, where his paintings enjoyed great success at that city's International Exhibition. During this sojourn, he made the acquaintance of many leading young German artists, including Wilhelm Leibl (*575*). A life-

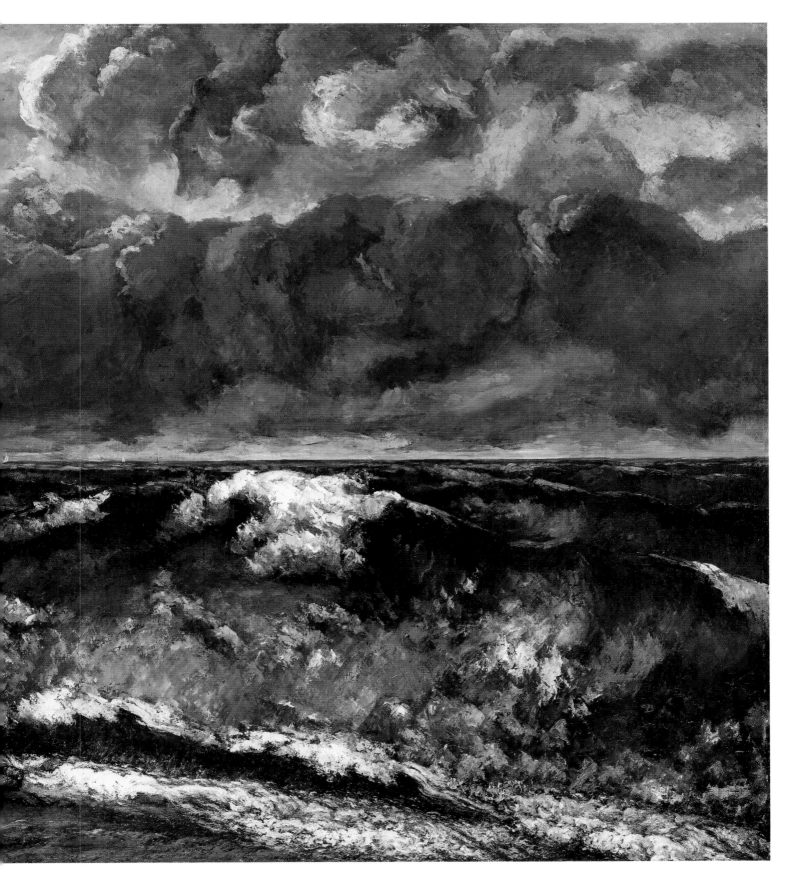

GUSTAVE COURBET, Ornans, 1819–La Tour-de-Peilz, near Vevey, 1877, *The Wave*, 1870

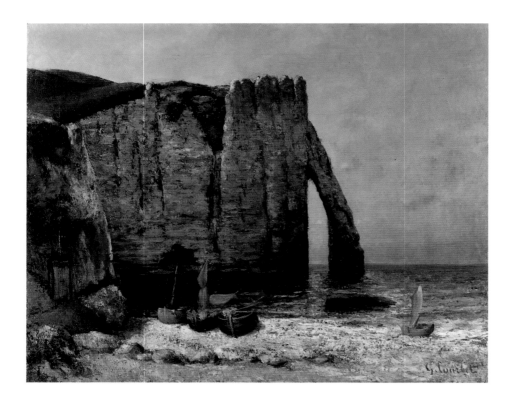

size canvas, *La Femme de Munich* (destroyed) was painted by Courbet in Wilhelm von Kaulbach's Munich studio. The work was completed in two hours, and his German colleagues were staggered by the French painter's facility. Courbet's art was soon well represented in many German museums and private collections.

Innumerable Northern artists found aspects of Courbet's forthright pictorial attack essential to their own. Anselm Feuerbach (585–86), Arnold Böcklin (582–84), Hans von Marées (587–89), Ferdinand Hodler (625), and Edvard Munch (621–23) all recognized the Frenchman's heroic, larger-than-, yet faithful-to-life images as providing a groundbreaking way beyond the limitations so long laid upon their art.

Vulgar and gorgeous, Courbet's art abounds in rhetorical, didactic, and dramatic elements, akin to contemporary innovations found in opera and novel alike. Paradoxically, for all his revolutionary stance, Courbet was always an Old Master, in much the same sense as his great forerunner Géricault. Both continued aspects of fashionable salon practices in comprehensiveness and sheer size, if not in subject.

Courbet's marine scenes were often painted at Étretat, a Norman fishing village popular among artists of his generation and, later, the Impressionists. Its great cliffs, rising so precipitously from the beach and from the waters, provided a striking contrast to sand-bound or storm-tossed boats below, and with the ever-changing sea and sky. Courbet painted many views of this site in the late 1860s and early 1870s; some, including Berlin's canvas (570), stress a rock formation known as *Aval* and *Aiouille,* where a natural flying buttress appears to support an equally natural, crenellated tower. This sense of implicit architecture suggests a great city lost in primeval times.

Like a surfer, Courbet seems always to have searched for the perfect wave, captured with brush rather than board. Athlete and artist celebrate their heroic conquest of the sea. Herman Melville and Courbet were born in the same year, 1819. Each, whether writing or painting, brought an almost Homeric recognition of the ocean's powers to his work, yet their encounter with the waters was enduringly primal, one where man counts for little and the Divine for less.

The Wave (568–69) was much admired by Guy de Maupassant during its painting in 1870. Friend of many photographers, Courbet studied the pioneering marine camera work of Gustave Le Gray, which

HONORÉ DAUMIER
Marseilles, 1808–
Valmondois, 1879
*Don Quixote and
Sancho Panza,*
c. 1866–68

allowed for the exploration of the seas within the safety of the studio. This photographic analysis of waves' "time and motion studies" led to Courbet's unprecedented, Columbus-like command of the waters. His canvas was presented to the Berlin Museum in 1906 by a shining knight of Germany's new stainless-steel nobility, Guido, Count Henckell von Donnersmarck.

The art of Spain might be described as among Europe's last great discoveries before that of psychoanalysis. Iberian literature and art, but for that of Diego Rodríguez Velázquez (423) and Bartolomé Esteban Murillo (421), had long languished in obscurity. Only with the Napoleonic invasions did it first make a major dent. Soon Spanish art was given a Parisian museum of its very own, and France a Spanish queen.

Predating this Spanish renaissance was the popularity of Miguel de Cervantes, whose novel *Don Quixote* became popular through numerous French translations between 1768 and 1773. Jean-Honoré Fragonard, who in so many ways was the key painter to shape Daumier's art, had planned to illustrate one of these editions of *Don Quichotte*. He characterized his freest, most Daumier-like images as "Spanish" or in "Spanish costume."

The art of Goya (422), who died in Bordeaux in 1828, was also rediscovered by the French and Germans in the mid-nineteenth century. This may have helped open their eyes to the genius of Honoré Daumier. Best known for his popular caricatures, the French artist was a powerful painter who also extended the subjects of his satire into sculpture. Supported by his successful friend J.-B. Camille Corot, Daumier could devote himself to painting in his old age. These works were soon bought by Degas (594), and much admired by Cézanne (612, 614) and van Gogh (616). They first emerged for public exhibition in 1879, the year of Daumier's death.

For Daumier, Cervantes's antihero Don Quixote personifies life's folly and grandeur. The skeletal old knight astride his nag Rocinante, followed by his faithful squire Sancho Panza (571), offers a trenchant image of antiquated values, maintained to the despair of a loving, realistic companion, as retraced along Cervantes's penetrating lines.

This canvas was presented to the museum by Sir Alfred Beit in 1906, doubtless at the museum's urging. Far from the conservative tastes of the German-born, empire-building partner of Cecil Rhodes, this stirring canvas comes close to the new German art of Max Slevogt (626) and Lovis Corinth (627).

FRANCO-GERMAN PICTORIAL ALLIANCES

LIKE ANDREW WYETH a century later, Wilhelm Leibl ascribed a certain innate superiority to his peasant subjects. All these supposedly "simple folk" prove capable of withstanding their artist's scrutiny with singular fortitude. Rightly or wrongly, there may be a whiff of racism in this exaltation of the peasant as a sort of noble savage, purer and stronger than decadent contemporary city folk. Such ikons of stoical rusticity, whether in Maine or in Bavaria's Black Forest, reassured and justified their respective industrial societies' aggressive ways.

Leibl belonged to an international movement that found the last bastion of integrity in peasant life. This group included Courbet (568–70), whom the German met in Munich in 1859. Later Leibl came to know many other French painters, mostly members of the Barbizon School, whom the artist encountered in Paris in 1870.

At his best, Leibl possessed an austere and impressive talent. His peasant subjects were often posed for by the artist's relatives. The head of a peasant woman (575) shows an almost Degas-like sharpness of focus and lack of sentimentality conveyed with an impressive combination of clear-eyed objectivity and innate elegance. This was the world to which Leibl returned, that of his peasant roots, after battles with the Munich art establishment. Clearly Leibl proves to be the victor.

Though painted earlier, flowerpieces were first popular in the seventeenth century (396). These decorative lessons in the fragility and passage of life addressed the moral of "Vanitas." Hans Thoma was a highly skilled practitioner of still life who brushed

at least twenty-two flowerpieces between 1862 and 1887. His mastery of this genre betrays traces of J.-B.-S. Chardin (464–67) and Henri Fantin-Latour (590), but he Teutonized such Parisian sources by selecting German wildflowers and thrusting them into a German stein; only a Frenchified demitasse points southward (572).

Hans Thoma painted the panoramic view of the Rhine near Säckingen (574) in 1873, during the time he was living in Frankfurt. This canvas marks a new period in his work, one in which he moved away from the allegorical and mythological themes that had previously taken up so much of his life. Thoma also moved to a much broader, freer form of expression than that dictated during his art school days in Düsseldorf. This new manner was inspired by a journey, in 1866, to Paris, where he also explored the achievements of the Barbizon School. This river view was one of the artist's favorites, and Thoma painted it at least seven times.

Like so many of his compatriots, Thoma was much impressed by Courbet, admiring his works in Paris before settling in Munich in 1870. There he became friends with Arnold Böcklin, whose most carefree art, as in his *Campagna Landscape* (582), is seen again in Thoma's *Summer* (574) of 1872. A cascading brook meanders through a field of wildflowers, music-making lovers at the lower left, all under the brightest of Mediterranean skies.

Wilhelm Trübner (1851–1917) was among the most sensitive yet strong artists of the later nineteenth century. Sadly, few of his works are found outside Germany. He, too, learned a great deal from French developments. Manet, whose paintings Trübner saw at Munich's International Exhibition of 1869, first liberated the German painter's art. This new freedom went along with the Hals (320, 326–29) revival, since both the Parisian and the Haarlem artists loosened brush

Opposite:
HANS THOMA, Bernau, 1839–Karlsruhe, 1924
Wildflowers with Porcelain Cup, 1872

HANS THOMA
Summer, 1872

HANS THOMA
The Rhine Near Säckingen, 1873

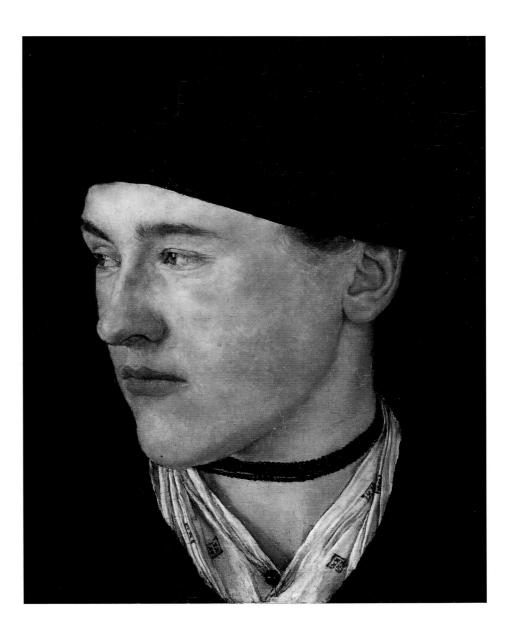

WILHELM LEIBL
Cologne, 1844–
Würzburg, 1900
A Peasant Woman, 1871

strokes as they opened minds and eyes.

With many Northern European painters, Trübner found Courbet, as well as Manet, to be unusually influential. He also knew the arts of the Netherlands and Italy, as he traveled in 1873 and 1874 to these lands with his friend the very talented yet less well known Carl Schuch.

On the Sofa (577) was painted when Trübner shared a studio with Thoma in 1872 and was bought by the Nationalgalerie from the artist in 1899. This domestic scene has a proto-Matisse-like quality in the way the painter revels in a wealth of scintillating pattern — the red checked tablecloth, the blue patterned wall, the beflowered sofa cover. Among Trübner's most successful canvases, it was painted

in Heidelberg when the artist was only twenty. *On the Sofa,* far more than decorative, shares a psychological penetration with works of other artists of Trübner's generation, including Edgar Degas (594), Henri Fantin-Latour (590), and James McNeill Whistler.

Though Trübner all too readily churned out John Singer Sargent–like pastiches for and of Old and New German Money before World War I, at his very best, he produced arresting, uncompromising likenesses such as *The Equestrienne — Ida Görz (576)*. In contrast to Trübner's flattering portrayals of riders, elevating them to ever loftier social status, Görz is shown with a penetrating, Toulouse-Lautrec–like sharpness of focus and animation.

As the nineteenth century advanced, equestri-
ennes were often depicted in close-up, given an
almost Strindbergian dimension of dominance as
their subtext. Images of women like Görz, wearing
the conventional riding habit — severe, long-
sleeved, and long-skirted black, with black top hat
— were often named after their attire, then known
as the "Amazon." That Greek name referred to the
powerful, man-hating warrior-women of Asia, their
name signifying the "one breasted," as they cut off
the other to allow for more bow room.

Tension between Görz's then obligatory side-
saddled seat and the potential power of her massive
steed, seemingly held in check as much by the
rider's willpower as by her reins, also suggests a
battle of the sexes, with the omnipresent question as
to who's on top. Speedily slapped on and scratched
through, the turbulent paint surface shares the
excitement of this power play, with Görz clearly the
winner, conveyed by her "Don't mess with me" vis-
age, and by her mount's sharply reined-in head.

Today it may be difficult to perceive the revolu-
tionary character of Max Liebermann's canvases.
When young, the artist tackled unpopular subjects

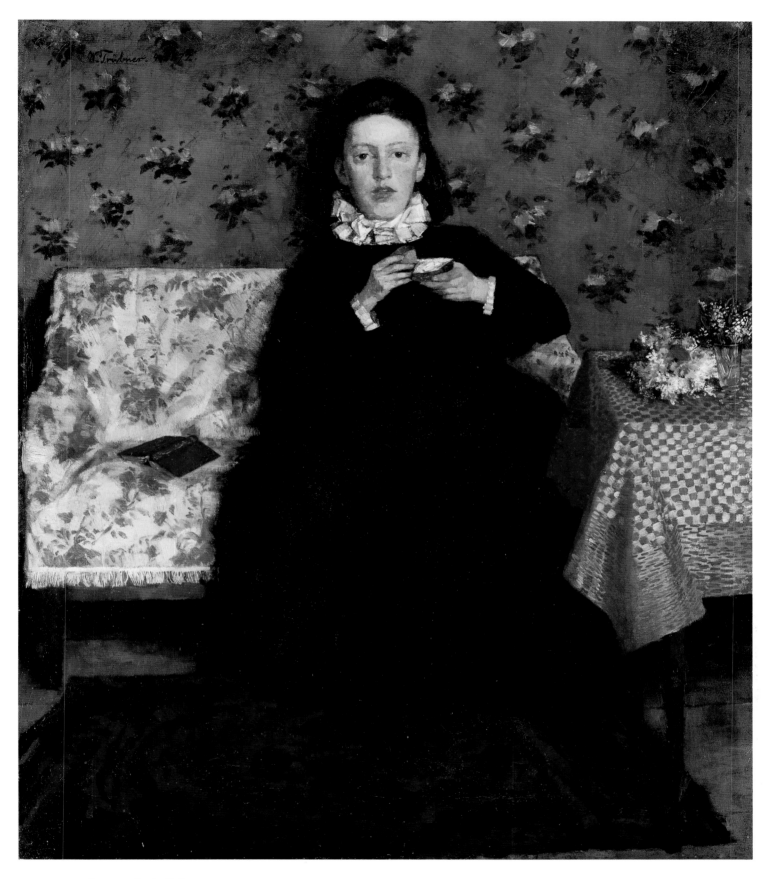

WILHELM TRÜBNER, *On the Sofa*, 1872

MAX LIEBERMANN
Berlin, 1847–1935
The Dunes at Noordwijk, 1906

MAX LIEBERMANN
Country House at Hilversum, 1901

MAX LIEBERMANN
The Flax Workers, 1898

including orphanages, old people's homes, and factories, usually painted with a sunny, matter-of-fact naturalism. Stoical in their making do, his models' resolutely "good face" is still light-years away from whatever social criticism their condition might imply. Now they may seem as bland as those old Norman Rockwell covers for *The Saturday Evening Post,* but in their day such subjects suggested an unseemly curiosity concerning subjects best left unseen.

Like Rembrandt (*371*), Liebermann also showed the young Christ as more Semitic than sentimental in appearance. A convinced Socialist, the painter was born into a long extremely wealthy and liberal Berlin Jewish family. Six years Vincent van Gogh's senior, he led the way to the Dutchman's radical topics and to those of Berlin's great Käthe Kollwitz.

Such subjects as Liebermann's *Dunes at Noordwijk* (*578*) shaped the pictorial photography of young Alfred Stieglitz, whose student years were spent in Berlin. That American's camera followed the German's art to the same Dutch fishing village just a few years later. The painter's canvas *Country House at Hilversum* (*578*) shows how close the Berliner had come to his Parisian ideal, Manet (*591–93*). In another vein is his *Flax Workers* (*579*), which communicates some of the tedium of factory labor. None of these sturdy blond lassies, however, convey a hint of the tuberculosis that was rife among women in such centers, which seldom were as sunlit as this happy interior.

Over the long haul, Liebermann the art collector may prove more important than Liebermann the successful painter. His art collection, mostly purchased from Berlin's great art dealer Paul Cassirer, included works by Cézanne, Degas, Manet, and Monet. A man of unusually genial temperament, Liebermann enjoyed the patronage of his own class, the wealthy Berlin intelligentsia, who then often followed their portraitist's buying policies. The artist may have influenced the assembly of Arnhold's splendid collection, and his passion for Manet certainly contributed to the purchase and presentation of several of the master's works to what was then the Nationalgalerie.

The courageous Liebermann could also be counted on to support socially concerned local artists like Käthe Kollwitz, who had to endure opposition from both court and academy. When the Berlin Academy closed an exhibition of works by Edvard Munch (*621–23*) over Liebermann's opposition, he helped found the Avant-Garde Group of Eleven with Leistikow (*611*). He also established the Berlin Sezession in 1899, following those of Munich (1892) and Vienna (1897), with Lovis Corinth (*627*) and Max Slevogt (*626*) among its members. But Fauvist painters of a later generation, such as Emil Nolde (*629*), along with the early works by Max Beckmann (*633*), proved to be more than even Liebermann could bear.

THE GERMAN ROMANISTS:
BÖCKLIN, FEUERBACH, AND VON MARÉES

THREE TEUTONIC MASTERS brought a new severity, grandeur, and sensuality to the later-nineteenth-century art of their nation. Drawn to monumentality, all lived for many years in Italy, where they were liberated and inspired by its classical, sensuous ambience.

Most popular and accessible of the three was the Basel-born Arnold Böcklin. His art is a passionate, theatrical celebration of self, sexuality, and death. Teeming with the infinite thrills of naked mythology, it revolted subsequent Purist generations and many of his Puritanical Swiss contemporaries. All shuddered at the obviousness and vulgarity of his "Philistine" canvases, whose often lurid and sensual images supposedly pandered to the triune evils of the Sentimental, the Literal, and the Bourgeois. These paintings provided a mother lode of golden erotic pictorialism soon profitably neutered by his innumerable followers, or developed to new psychological heights by Max Klinger.

Contrary to Modern dictates, Böcklin's subject matter *did* matter — enormously so. Bardic, cinematic, romantically realistic, operatic, the Swiss master's full-blooded depictions of well-known themes eventually proved of vast contemporary appeal, fetching unprecedented prices in Germany near the end of his life. The lavish sensibilities of Böcklin, who was fourteen years younger than Richard Wagner, come close to the all-consuming passion of the composer's *Liebestod*. His rich pictorialism approaches the contemporary, cosmic aesthetic ambitions of the time, leading to the concept of the *Gesamtkunstwerk* — that ideal unification of painting, sculpture, and architecture, with all the impact of its synergy.

Of the same slick generation as Léon Gérôme, Böcklin eschewed the barroom sensuality and "for real" finish of the Parisian's Salon art for a far more liberated and original experience. With radically differing styles at his command, the painter could render sensitive, almost Impressionistic views, such as his early *Campagna Landscape* of c. 1857–58 (*582*), as well as boldly primitivizing biblical and classical views whose generous slugs of sexuality soon kept buyers crying for more. Just as Matisse claimed "to paint for the tired businessman," so might Böcklin. Like all Realists, he left little to the viewers to conjure up for themselves, his pictorial fantasies theirs.

Böcklin's flair for archaization, one already employed by the Nazarenes (*526–31*), is seen in the Quattrocento coloring of *The Deposition,* painted c. 1871–74 (*582*). Its bold eclecticism brings together Fra Angelico (*182, 186–90*) and von Kulmbach (*121*). The complex ambitions of this canvas border upon the documentary goals of Ernest Renan's *Pursuit of the Historical Jesus* (1866) with the bold, almost Deco stylization of Diaghilev's *Ballets Russe* (1907–14). Part camp theatricality, part convinced and convincing Christianity, part prophecy, this canvas proved to be an Avant-Garde and unpopular work when first exhibited at the Vienna Exposition.

Böcklin married an Italian orphan named Angela. Their Catholic union created endless problems in the Protestant painter's hometown even though the couple lived mostly in Florence and Rome. Angela, who bore Böcklin eighteen children, resolutely opposed his working from any female model other than herself. Though the artist described this ban as the tragedy of his life, it may have proved quite the reverse. That hyperphysicality so peculiar to Böcklin's figures, who seem to live and breathe on can-

Opposite:
ARNOLD BÖCKLIN
Basel, 1827–San Domenico, near Florence, 1901
The Surf, 1883

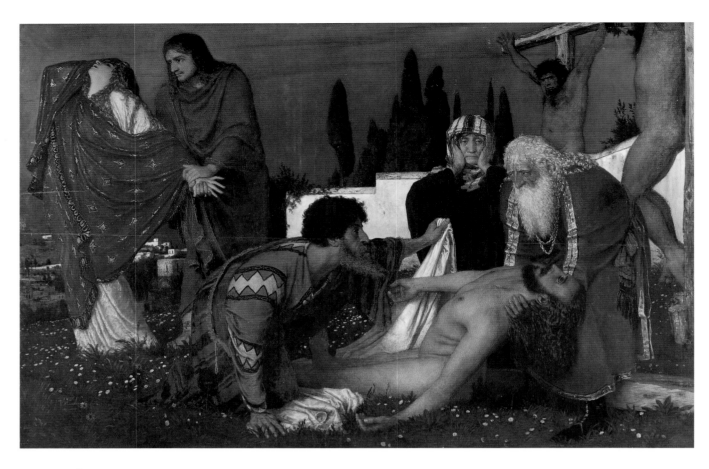

ARNOLD BÖCKLIN
The Deposition, c. 1871–74

ARNOLD BÖCKLIN
Campagna Landscape, c. 1857–58

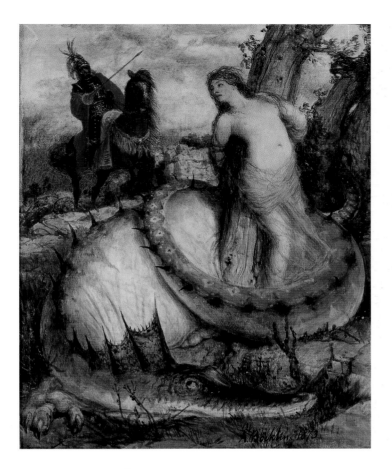

ARNOLD BÖCKLIN
Roger and Angelica, c. 1871–74

ARNOLD BÖCKLIN
Self-Portrait with Death as Fiddler, c. 1871–74

vas, as if even his least attainable models flew or floated to his studio, must be due to the artist's Herculean effort to draw such images from his mind alone, above and beyond Angela's ban.

The Surf (*581*) recalls Rubens's *Andromeda* (*300*), but this woman exposes herself to rocks and water of her own free will. Flesh, stone, and water were an elemental triad dear to Böcklin's art, each bringing out the others' qualities. More romantic is a rendering of a Renaissance tale, that of *Roger and Angelica* (*583*) from Ariosto's *Orlando Furioso* (*1532*). This canvas is close to the romantic mysticism of Gustave Moreau (1826–1898). Angelica, encircled by a wistful dragon, is approached by a far less appealing liberator.

Böcklin's unfinished *Self-Portrait with Death as Fiddler* (*583*), begun c. 1871 during the artist's Munich residence, returns to the Medieval motif of the Dance of Death, and to the sharp focus of German early-sixteenth-century likenesses. It is partly mod-

eled upon a supposed work by Holbein, who was famous for his dealing with the theme of the fatal dance and for his realistic portraiture (*106, 109*). In life, rather than art, Death proved relatively patient and left the painter alone for almost twenty more years.

Some scenes strike the popular imagination in singularly effective fashion, including *The Angelus* (1859) by Jean-François Millet and Whistler's painting of his mother (1872) (both in the Louvre), along with Böcklin's *Isle of the Dead* (*584*) of 1883. Dalí once combined the latter with *The Angelus,* noting how Millet could never equal Böcklin's graphism.

The canvas was first painted as a tranquil refuge for Marie Berna, a recently bereaved Florentine widow. Böcklin wrote to her, "You will be able to dream yourself into the the world of dark shadows until you believe you can feel the soft and gentle breeze that ripples the sea, so that you shy from interrupting the stillness with sound." Less reassur-

ARNOLD BÖCKLIN, *The Isle of the Dead,* 1883

ing was the artist's knowledge of the silence his picture could be counted upon to create: "It shall become so quiet you will be frightened by a knock at the door." Soul-satisfying, *The Isle of the Dead* — that romantic title a dealer's invention — meets our unspoken need for imaging a pacific afterlife.

Böcklin's rare gift for establishing a pictorial *déjà vu,* a mystical cliché, was cited by the metaphysical painter Giorgio di Chirico, who noted how "all of Böcklin's works unsettle us, creating the same shock felt upon encountering a stranger who makes us believe we've seen him before, but we can't remember where or when." This craggy funerary setting bespeaks the lyrical worlds of Gabriele D'Annunzio and Giacomo Puccini as Death's oars drip with operatic grandiloquence.

The Isle of the Dead inspired musical compositions by Sergei Rachmaninoff and Max Reger. Emil Nolde and August Strindberg both turned to this painting for their dramas on canvas or stage. Hitler

also cherished this picture, appropriating it for his own collection and taking comfort in its calculatedly exclusive, excluding message. Shrewdly drawing upon natural elements for the rugged enclosure of a singularly select, First-Class Afterlife, Böcklin makes it clear that if and when we've got to go, his is the ultimate in terminal passages. Important is the Swiss artist's subtle exploitation of his national industry — inn-keeping — arousing hope for a lakeside luxury hotel, one tactfully hidden on the isle's far side; a room with a fine view, forever reserved in our name. Böcklin knew perfectly well just how close this picture came to home. Counting on its popularity, he painted five versions.

Anselm Feuerbach's often ponderous, static, magnificent works come very close to the dazzling technical security and heroic classicism of his exact contemporary, Lord Frederic Leighton (1830–1896). Both artists perfected an Establishment Aesthetic

bespeaking the official beauties of authority, dignity, and antiquity in the grandest of manners, taking their weighty subjects from history and literature.

Potentially as great a success as Lord Leighton, Feuerbach, though close to the aggressive self-confidence of an expanding Wilhelmine Germany, kept himself from such rewards. Tiny — his mother said there was too little of him to contain so great an artist — Feuerbach was also narcissistic, infantile, manic-depressive, and fixated on his stepmother.

As the painter's father, also named Anselm, was a classical archaeologist, the young artist was brought up by the ideals of Antiquity, and he chose a suitably grand Parisian teacher, Thomas Couture. In Couture's Paris Feuerbach was a fellow student of Manet's, while earlier-nineteenth-century giants such as Géricault, Delacroix, and Courbet all played

ANSELM FEUERBACH, *Miriam,* 1862

ANSELM FEUERBACH, Speyer, 1829–Venice, 1880
Ricordo da Tivoli, 1867

their role in defining his grandiose dreams. So, though officially grouped with the German Romanists, Anselm, with many other artists from his homeland, has a strong, if less obvious, French "agenda." Months spent in Antwerp and Venice exposed him to the twin forces of Rubens and Titian and clarified the young painter's goals. Venice was the perfect place for Feuerbach's later life, as its culture hovered between North and South.

Both the German painter and Manet died at fifty-one from syphilis. Suitably, Feuerbach was buried in Nuremberg, near the grave of Albrecht Dürer (*120*), the first German painter to bring elements of Venetian art to his nation. Only posthumously did Anselm win massive popularity, and then less from his paintings than from his words. These were published in the form of artfully selected extracts from the hundreds of letters sent to his stepmother, their editor. Entitled *A Testament,* the book went into

ANSELM FEUERBACH, *Platonic Banquet, 1873*

forty-six printings, making Anselm's life by far the best-known of all German artists'.

Feuerbach's imposing Italian model, Anna "Nana" Risi, the wife of a Roman shoemaker, is found in many of his paintings. Her severe beauty suggests both a dominatrix and a nanny. In *Miriam* (585), Risi poses as Moses' sister, striking a tambourine to celebrate the safe crossing of the Red Sea.

Anselm was moderately successful, yet far from popular, because his arrogance and immaturity thwarted sales. He depended upon his stepmother to smooth his way. As evidenced by his *Ricordo da Tivoli* (585), Feuerbach's naked bambini sometimes point to the Sicilian silliness of Baron von Gloeden's photographs of totally stripped peasant lads or fisherboys.

Berlin has the second, far more ornate, version of the artist's *Platonic Banquet* (586) — the earlier canvas is in Karlsruhe. This is a major example of his monumental manner. The handsomely patterned, tapestrylike enclosure reinforces the powerful figure groupings within. Its design comes close to the goals of the many new German schools for applied design, founded at a time of burgeoning industrial manufacture.

Though officially considered a third member of the so-called "German Romanists," Hans von Marées (1837–1887), long resident in Italy, moved far from the dramatic narrative of Böcklin or the ponderous perspective of Feuerbach. Dying in early middle age, the Berlin-trained painter was Germany's major prophet of Modernism, filling a critical role as that nation's Puvis de Chavannes, the French master who was thirteen years his senior.

Just as there would have been no Blue or Pink Period Picasso without Puvis, so could no major modern breakthrough have been imaginable in Germany but for the critical rediscovery, c. 1900, of von Marées. In 1909 there were major von Marées exhibitions in the Berlin and Munich Sezessions and in Paris at the Salon d'Automne. His appreciation proved as important for liberating German art from a narrowly realistic approach as had Liebermann's

(578–79) previous discovery of Manet (591–93).

Von Marées's father came from the nobility, holding a high Prussian official appointment — and his mother was Jewish, such unorthodox parentage very much to the painter's advantage. His art was Germany's most inventive, receptive synthesis of Baroque past and recent French present. It offered a virile, lucid vision that freed painting from incident and sentiment, from opulent, too often derivative literary subjects and stale technical virtuosity. He brought theme and rendering back to basics.

Like Puvis de Chavannes, von Marées followed the Nazarene (526–31) and Pre-Raphaelite revival of wall painting, restoring a sense of the mural, of response to the special quality of surface. These goals were reinforced by the artist's close friendships with the distinguished art theorist Konrad Fiedler (1841–1895) and the sculptor and theorist Hans von Hildebrandt (1847–1921). The three lived together in Florence in the 1860s and 1870s, and

both Fiedler and von Hildebrandt contributed to von Marées's financial support. Fiedler's *Schriften über Kunst* (1876–87), opposing Hegel, stressed the concept of pure visibility, independent equally from the German philosopher's Absolute Spirit and from contemporary French sociologically centered art theory.

Friendship among these three men proved central to their defining one another's works and views, reinforcing a new clarity and simplicity of representation and of responsiveness to material, attitudes that would underlie advanced German figurative arts well into the twentieth century.

Von Marées traveled to France and Spain in 1869 at Fiedler's invitation, coming close to the art of Goya (422) and Manet (591–93). Von Hildebrandt provided him with funds when the painter broke with Baron Adolf Friedrich von Schack in 1868. That patron had commissioned von Marées's scintillating copies after Raphael, Titian and other Vene-

HANS VON MARÉES, Elberfeld, 1837–Rome, 1887, *The Oarsmen*, 1873

tian Renaissance masters, as well as Velázquez, now found in the Schack-Gallery, Munich, and essential, with Rubens, for the painter's formation.

From 1873 to his death the artist remained in Italy, first in Florence and then in Rome, dying there of a brain infection in 1887. Von Marées's major commission was the 1873 murals for the Library of the German Marine Zoological Station in Naples. Among the many canvases vying for the title of his most original is *The Oarsmen* (*587*), a powerful study for one of the largest Library frescoes. Located on the North Wall, it is bordered and divided by architectural elements devised by von Hildebrandt. The far right end of the oarsmen's boat, not shown in the canvas, has passengers and another oarsman, seen to the right of the Library's pilaster, with the larger group, identical to Berlin's vigorous canvas, to the left.

The *Youth Picking Oranges* (*588*) is a life-size oil sketch preparatory to the fresco on the Library's South Wall. Though this work is strikingly reminiscent of Cézanne (*612, 614*), two years von Marées's junior, the French painter was almost certainly ignorant of the German's art. Like so much of von Marées's oeuvre, this scene refers to a Golden Age long before a Judeo-Christian sense of sinful self-knowledge muddied the crystalline pagan waters. It is as if the artist rewrote Genesis, so Adam does the picking with impunity. Since women played a distinctly secondary role in von Marées's art and life, there was no Fall at all.

A rare sense of self-confidence without self-righteousness pervades von Marées's *Orangenbild* (*589*) — the title he and its recipient, Fiedler, gave this painting, the latter's long overdue wedding present. Only thirty years after its completion in 1878 was it entitled *The Four Ages of Man*. On panel, using the old-fashioned tempera medium, the scene is set in the Garden of the Hesperides — a pagan Paradise — where nymphs guard trees bearing the golden apples, wedding gifts to Hera. Echoes of Poussin (*411–14*), with free quotations from the Quattrocento — especially Signorelli (*238–41*) — are found in this splendid canvas, whose archaism may also have been stimulated by the popular art of Sir Edward Coley Burne-Jones (1833–1898). Von Marées's panel was bought for Berlin from Fiedler's estate in 1902.

HANS VON MARÉES, *Youth Picking Oranges*, 1873–78

With the Swiss Ferdinand Hodler (*625*) and the Norwegian Edvard Munch (*621–23*), von Marées's almost relentlessly masculine genre assumed an ever greater European role. Yet these followers lacked his luminous touch, or sacrificed it for the all too meaningful requirements of Symbolism.

HANS VON MARÉES, *Das Orangenbild (The Four Ages of Man)*, 1877–78

589

"PAINTERS OF MODERN LIFE": IMPRESSIONISTS AND JUST BEFORE

Best-known of Berlin's art collections are those conventionally "Old Master" assemblages bequeathed to the city's museum *en bloc* by Richard von Kaufmann and James von Simon. Eduard Arnhold's gift was the equivalent to these in terms of later-nineteenth-century holdings. Arnhold was a businessman whose pictures by Manet, Degas, and many others were almost as important as — if far less daring than — those by Cézanne, Matisse, and Picasso that S. I. Shchukin and I. A. Morosov brought to Russia. Arnhold's greatest canvas may have been Monet's *La Grenouillière* (1869), which was destroyed during World War II. Many of his other pictures were sold before that time, having been "contaminated" by their Jewish ownership.

Paul Cassirer, followed by Matthiessen and Fritz Gurlitt, were Berlin's major twentieth-century commercial links to the Parisian art market. All three specialized in works by Manet and the Impressionists and were doubtless well connected to the premier Parisian Impressionist dealer Durand-Ruel.

Fantin-Latour, Manet, and Degas

Painters' self-portraits often take on the character of painting accounting for itself; the artist eyes spectator and self, scrutinizing a mirror image in order to take on new sights and insights, to establish where the creator is in terms of time and genesis. All this is felt in the reflective likeness by Nicholas Poussin (*414*), or the one in which Arnold Böcklin and Death (*583*) may be arriving at an uneasy truce.

No artist had a greater sense for the selection and depiction of the key writers, artists, and musicians of his own day than Henri Fantin-Latour, who created group portraits in the manner of the seventeenth-century Netherlands. His selective assemblages of the key figures of Romanticism and Impressionism remain the major visual monuments to the founders of those movements. Individual likenesses of Manet, Berlioz, and Whistler, along with a group tribute paid to Delacroix, are among Fantin's many acts of pictorial piety, fraternity, and remembrance.

His *Self-Portrait* (*590*), painted in 1858, when he was twenty-two, shows Fantin in unkempt garb, his hair ungroomed, a character straight out of Henri Murger's *Scènes de la Vie Bohème* (1847); a similar lack

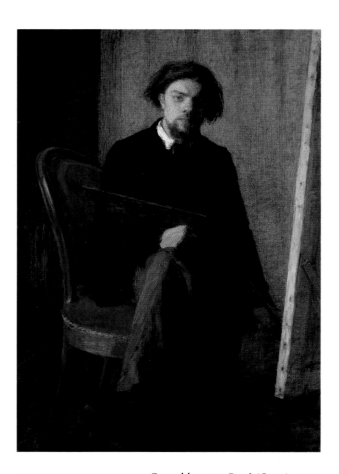

HENRI FANTIN-LATOUR, Grenoble, 1836–Buré (Orne), 1904
Self-Portrait, 1858

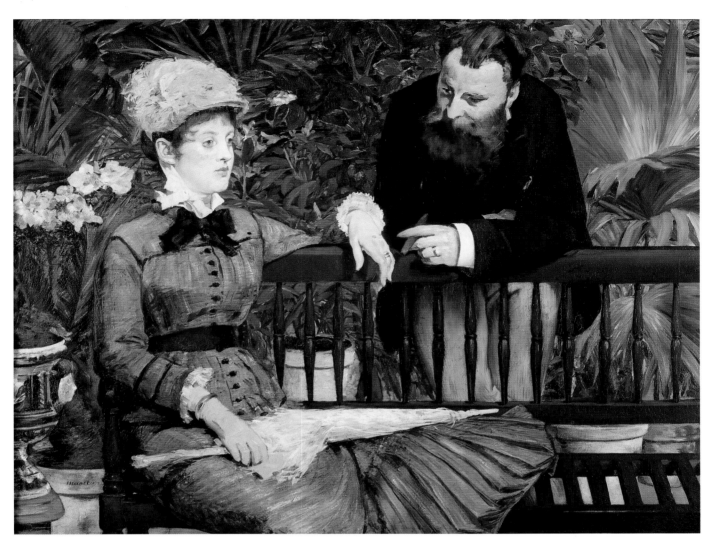

EDOUARD MANET, Paris, 1832–1883, *In the Wintergarden*, 1879

of decorum reveals the sole of his shoe. As he won prosperity, Fantin turned to a sleeker, smoother manner with which he won countless commissions from wealthy English and French patrons for his exquisite still lifes and for increasingly boring portraiture.

Edouard Manet, though a Thomas Couture student, invented his own style by way of Velázquez (*423*). Affluent, aristocratic, intelligent, and widely traveled, he possessed the assured simplicity that only comes with sophistication. Frédéric Bazille, Claude Monet (*596, 598–601*), Pierre Renoir (*602–3*), and Alfred Sisley all found this authoritative, independent figure a source for their art, though Manet

was not, narrowly speaking, an Impressionist, his virtuoso technique — *peinture claire* — not shared by them but imitated by others.

In the Wintergarden (*591*) of 1879 is the quintessence of Manet's art. Dashing but without superficiality, fashionable yet perceptive, the scene's bravura intimacy permits the viewer to witness a personal encounter narrowly escaping theatricality. Using friends and relatives as models, Manet, like Degas, often painted his own class, so lending his work unusual panache. The sitters' wedding-ringed hands approach one another in Halsian fashion. Beyond self-consciousness, this handsome, Proustian couple, the Guillemets, friends of Manet, pre-

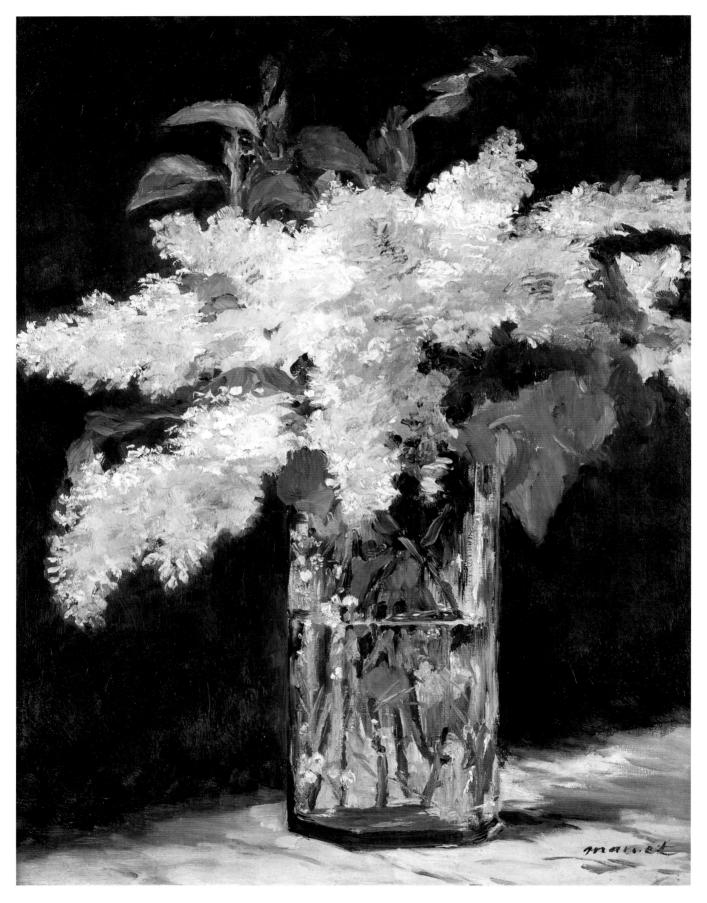

EDOUARD MANET, *Lilac in a Glass*, c. 1882

592

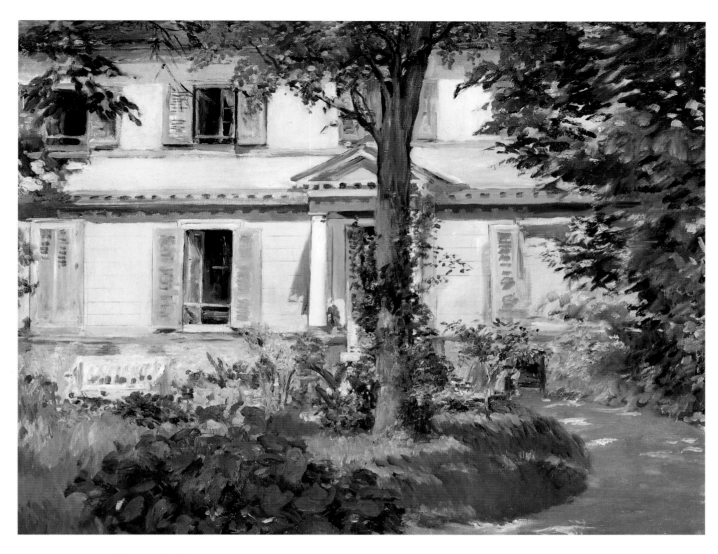

EDOUARD MANET, *House at Rueil*, 1882

sent a study in social self-assurance, one of almost voluptuous propriety. That sense is reinforced by the lady's white parasol, which forms a secure rectangle with the garden bench and her back.

In the Wintergarden spoke of and to the richest of Berlin's collectors of nineteenth-century art — to Ruhr industrialists like Guido, Count Henckell von Donnersmarck, and to such Jewish aristocrats as Eduard Arnhold, Ernst and Robert von Mendelsohn, and H. Oppenheim — all of whom clubbed together in 1896 to make Manet's masterpiece Berlin's.

The same donor circle gave Manet's *Lilac in a Glass* (592), which was painted c. 1882. Just thrust in a tumbler, this sprig is no victim of *ikebana* or other agonizingly "artistic" arrangement. Another paint-

ing from 1882 shows the house at Rueil (593) that was rented by Manet in the last year of his life. Here he stood to sketch in the shade of the acacia seen in its garden. This canvas, close to the art of such German painters as Wilhelm Trübner (576–77), was exhibited in the Berlin Sezession of 1903, and given to the city's museum by Karl Hagen in 1906.

Rich or aristocratic artists tend to aestheticize or dramatize middle- and lower-class concerns, often seeing them from afar, choreographed to alien sound. Yet such distance can allow for fresh insights and novel perspectives, as in the oeuvre of Hilaire-Germain-Edgar Degas, seen in his characteristically original focus and oblique placement for *Conversation chez la modiste* (594) of c. 1884, where three women at a hat shop are looked both at and down upon.

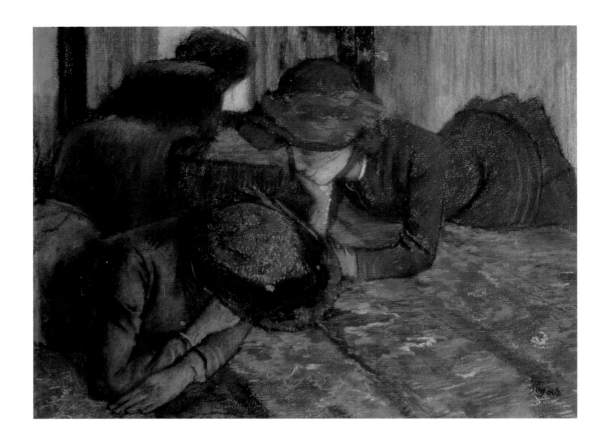

GERMAINE-HILLAIRE-EDGAR
DEGAS
Paris, 1834–1917
Conversation chez la modiste,
c. 1884

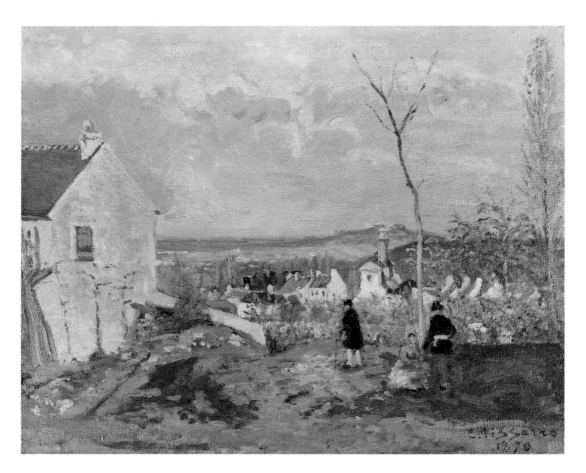

CAMILLE PISSARRO
St. Thomas, 1830–Paris, 1903
Louvéciennes with Mont Valérien,
1879

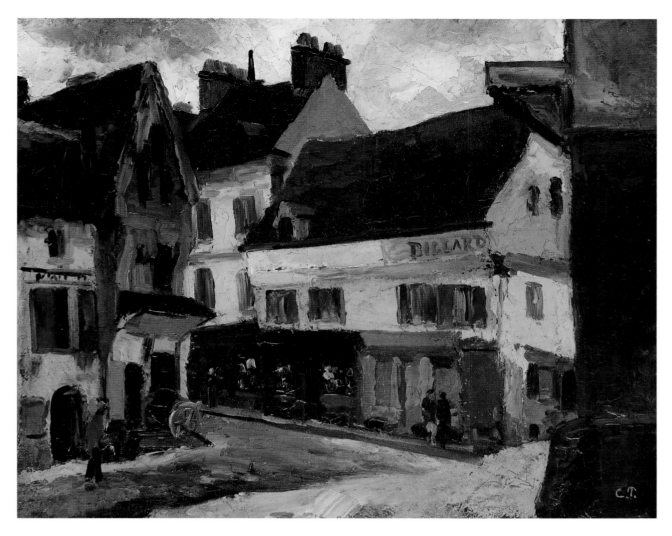

CAMILLE PISSARRO, *A Square at La Roche-Guyon*, c. 1867

The most confirmed of bachelors, Degas may have stayed further from, and come closer to the depiction of, women than any other artist. That unique dichotomy makes Degas the scourge and sphinx of Feminist studies, perceptible equally as a master of misogyny or as a witness of unparalleled objectivity.

All the jockeys, the musicians, the male portraits that appear in Degas's art are just a drop in the bucket compared with the preponderance of his female subjects, including thousands of bathers, prostitutes, and ballerinas. Balanchine's famous pronouncement "Ballet is woman" may very well follow the selfsame unspoken sentiment evidenced throughout so very much of the art of Degas.

In Italian and French, "conversation" has a very different sense from its English equivalent, closer to "dialogue" or to "mystical collectivity." Both these meanings may apply to Degas's pastel, where all three women, though they appear to be reading — like a literary Three Graces — seem to share a mutual, unknown, and unknowable concern, a truly feminine mystique.

Pissarro, Daubigny, Monet, and Renoir

Camille Pissarro, despite the fact that he exhibited in all eight Impressionist shows between 1874 and 1886, remained very much his own man. Though in later works he seems insecure and too often sentimental, there is an implicit sense of structure to his earlier canvases that led him to play a key role in the formation of the work of Cézanne and Gau-

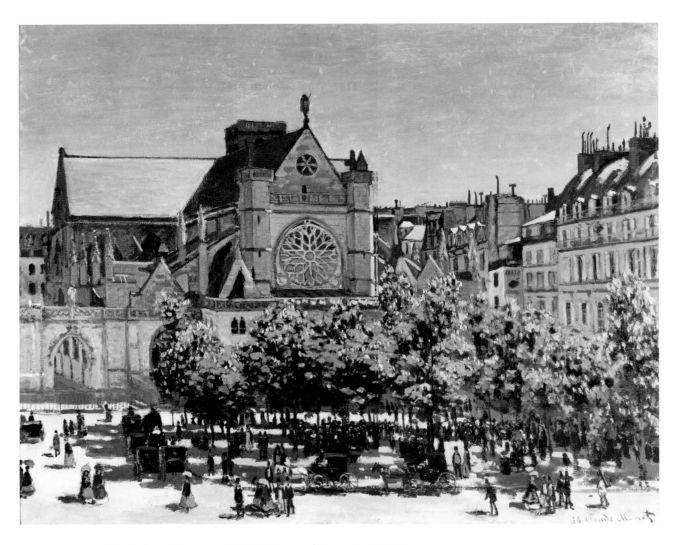

CLAUDE MONET, Paris, 1840–Giverny, 1926, *Saint-Germain l'Auxerrois,* 1866–67

guin. Nine years Pissarro's junior, Cézanne viewed the patriarchal Jewish painter as a father. They were especially close in the 1870s and 1880s. Berlin has two Pissarros: the early *Square at La Roche-Guyon* of c. 1867 (*595*) and *Louvéciennes with Mont Valérien* (*594*) of 1879. Mysterious, introspective, asking and answering the most rigorous, demanding questions, these paintings represent the artist at his best.

Claude Monet lived nearly ninety years, and during his long career he worked with or under a remarkably varied group of leading figures. As a very young man he began with Eugène Boudin at Le Havre on the Normandy coast and then became a fellow student of Pissarro's in 1859 in Paris. There he met Renoir, Sisley, and Bazille in Charles Gleyre's studio. Monet then went on to work with Courbet (*568–70*) at Trouville, another Normandy beach. He

came to know Manet in 1866, learning later of Turner's works and renewing acquaintance with Pissarro in England, where, in 1870–71, they escaped the Franco-Prussian War and the horrors of the Paris Commune.

Like Atget, but working with pigments, so able to arrest motion in color, Monet and Renoir "photographed" the quality of Parisian life in the 1860s and 1870s. Their documentary canvases are an affectionate repicturing of the city as it had never been shown before. This is the modern Paris realized by Baron Haussmann's urban renewal. Great boulevards were described by Pissarro as "so luminous and so vital," "so completely modern," when he, too, turned to urban portraits in the 1890s.

Berlin is rich in Monets, but its major picture is his *Saint-Germain l'Auxerrois* (*596*). He signed it in

1866 but continued working on the canvas in the spring of the following year. This view belongs with at least three other paintings showing the Louvre's immediate environs; all share a vantage point taken from the shelter of the palace's colonnade.

Saint-Germain l'Auxerrois has an unusually distinguished history of provenance and display. Shown by Durand-Ruel in London in 1872, and in the Monet-Rodin exhibition of 1889, it was owned by the artist's friend Zacharie Astruc, and then by Monet's major patron Ernest Hoschedé. Bought for Berlin in 1906 with funds from Karl Hagen, the canvas is very much in keeping with later paintings of the German capital by Lesser Ury (*609*), Lovis Corinth, and Max Slevogt.

To the west of Argenteuil, near Paris, where Monet lived between 1872 and 1878, he painted the *Fields of Bezons* (*598*), c. 1873. This unusually light-hearted canvas of a woman with a parasol seated in the grass was also included in the Monet-Rodin exhibition of 1889. It first appeared in the major Impressionist exhibition of 1876 at Durand-Ruel's gallery, and was bought for Berlin in 1907.

About 1881 Monet painted Vétheuil-sur-Seine (*600–601*), his residence from 1878 to 1883, as seen from a barge on the river. The village is partially hidden by the wooded isle of Musart. Berlin bought the picture from Durand-Ruel in 1896. Monet's 1891 canvas of the little houses on modest lots at the summer resort of Argenteuil (*599*) shows the town where the artist lived. Monet depicted Manet painting in this garden when the older artist visited him at Argenteuil in 1874, in a canvas that was Manet's property before purchase by Max Liebermann by 1904. Exhibited in Dresden in 1897, and in Vienna the following year, this canvas was donated to Berlin by Henriette Mankiewicz in 1899.

Dated German slang for "Super" or "First Rate," *prima* describes Berlin's superlative Renoirs. Too well known for those late, spun-sugary scenes of sun-dappled flesh or forest, Pierre-Auguste Renoir at his best was one of Impressionism's giants. He started, at the age of thirteen, as a porcelain decorator, painting ceramics with posies and cupids before going on to study with Charles Gleyre. The young artist came to know Bazille, Monet, and Sisley in 1862.

Works of Renoir's first maturity show great delicacy and strength, their shimmering surfaces sensitive to feature, light, and texture. The memory of Renoir's first artistic training as a porcelain painter survives in his feathery brushwork. His art is a passionate, yet essentially polite, response to the most accessible aspects of Titian, Rubens, and Delacroix. Renoir also recalled those painters frequenting Fontainebleau in the Renaissance and the nineteenth century alike. He bestowed an ever more generous affirmation upon the past as his work became increasingly classical with age. His canvases often mirrored the painter's warm, voluptuous muse, first nurse to his children, then of his own old age. That Renoir, with his devout reaction to the miracles of light and color, should have contributed his son Jean to the ranks of France's premier filmmakers is especially appropriate.

Berlin has two canvases dating from Renoir's strongest period — from the 1860s through the 1880s: *In the Summer* (*602*) of 1868 and *Children's Afternoon at Wargemont* (*603*) of 1884.

In the Summer is not that far from Salon painting of the period. Only the free rendering of sunstruck leaves in the background and the unprettified, forthright girl indicate a new direction.

Renoir had numerous patrons from the newly prosperous professional class of later-nineteenth-century Paris. This led to his keen sense for the harmony of ideal bourgeois domestic happiness, in the *Children's Afternoon*. A servant's presence — or its suggestion — in sufficient proximity for parents' comfort, communicates upper-middle-class well-being without too overt an indication of those Downstairs to disturb Upstairs's peace of mind.

Long before the aged, bedridden Matisse triumphed over time by turning to studio-assisted découpage, old Renoir had found similar fulfillment in sculpture, his arthritic hand guiding those of an assistant in the execution of his *pensées* in clay. Many decades before this final flickering, his very finest work was long done. It bears witness to the stout affirmation of sociable security, of confidence in a bourgeois world destined to destruction almost as soon as its lifestyle was perpetuated by Renoir's art.

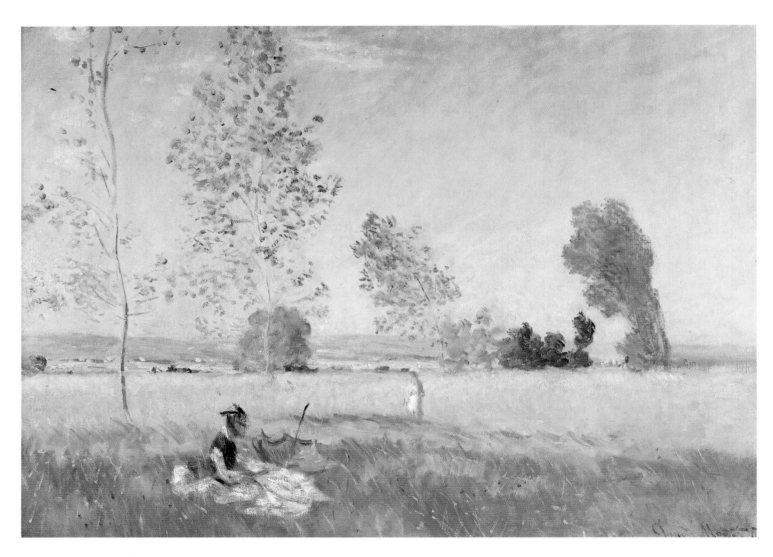

CLAUDE MONET, *Fields of Bezons*, c. 1873

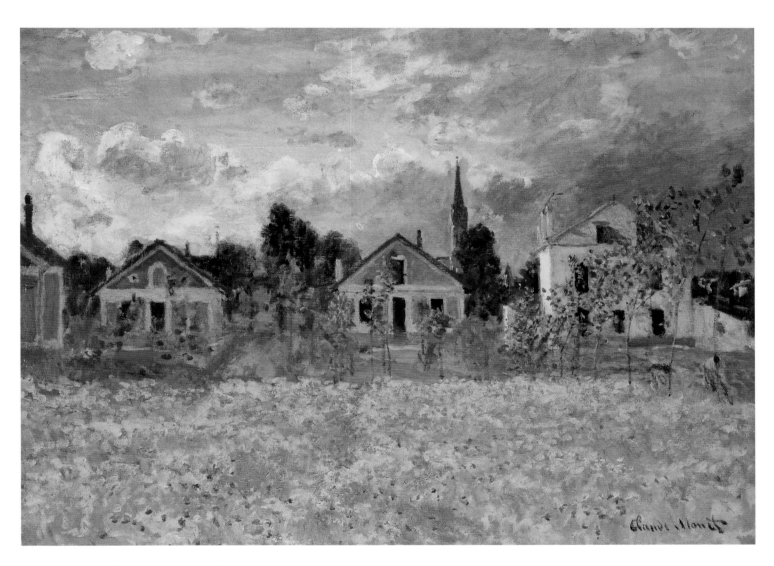

CLAUDE MONET, *Houses at Argenteuil*, 1891

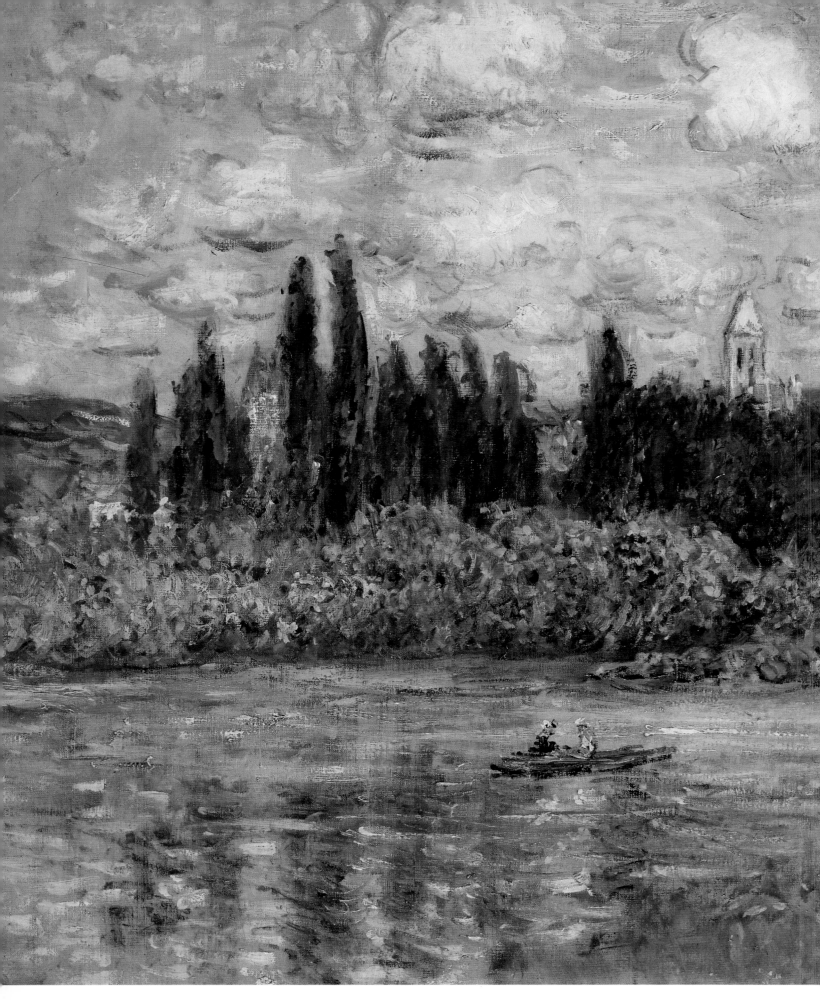

CLAUDE MONET, *Vétheuil-sur-Seine*, 1881

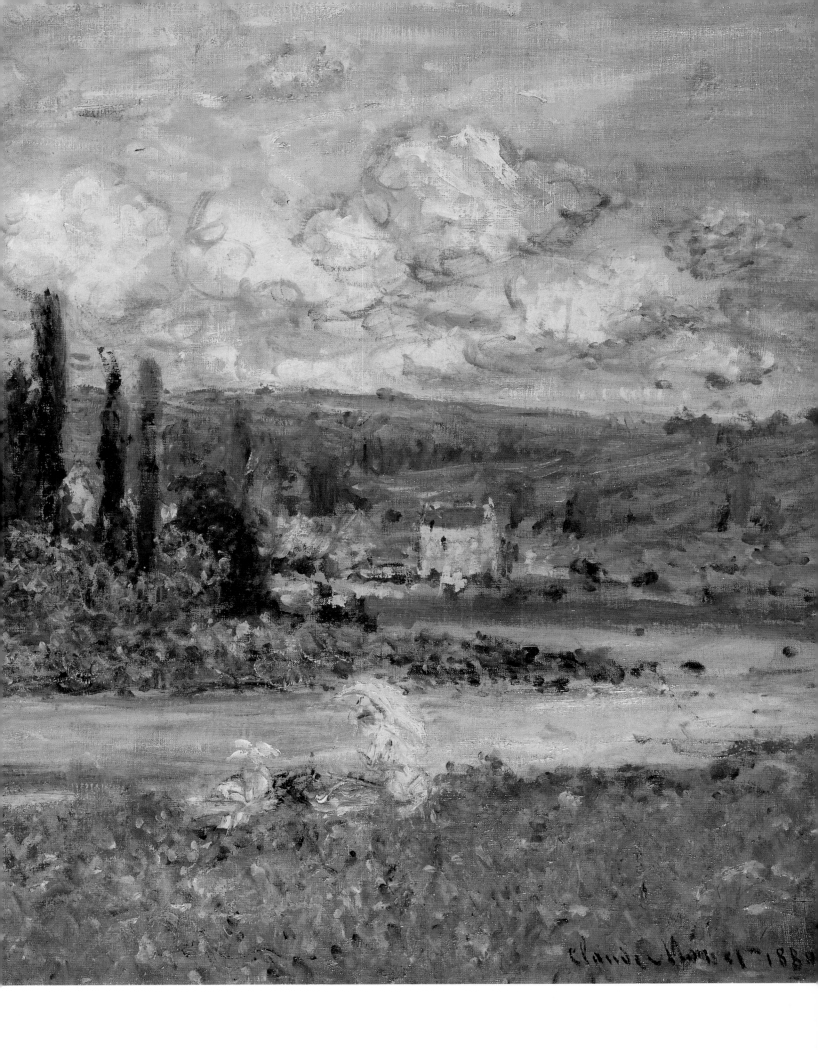
Claude Monet 1880

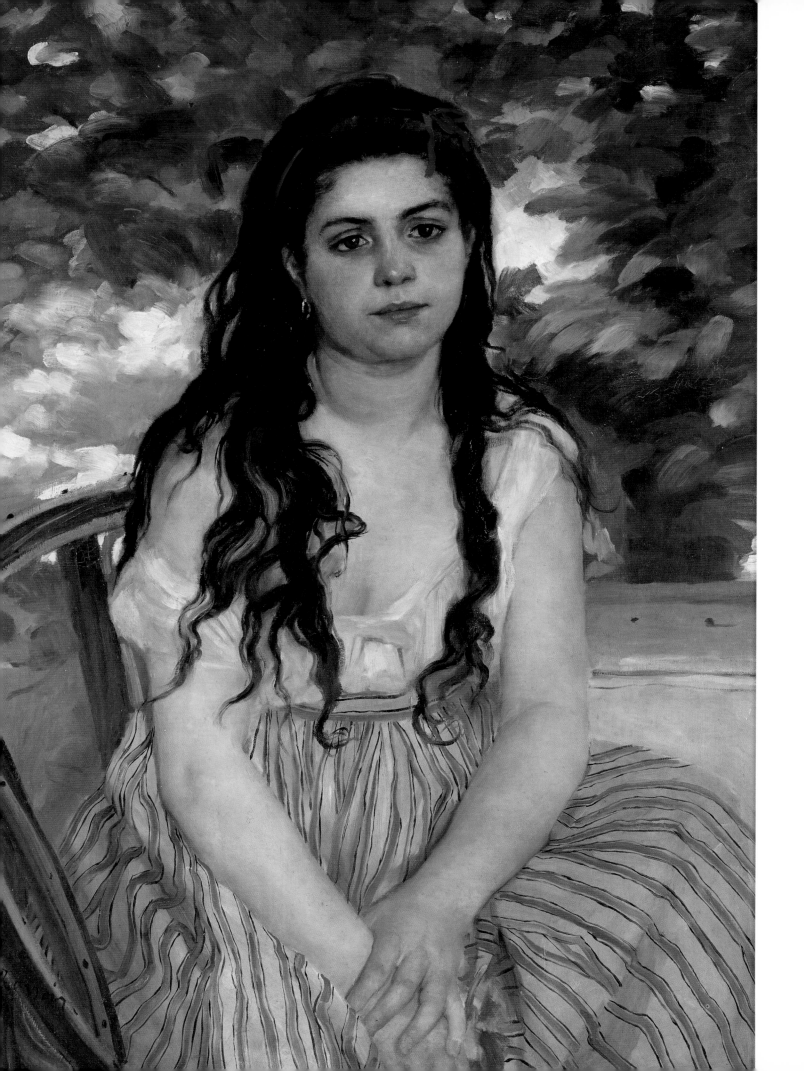

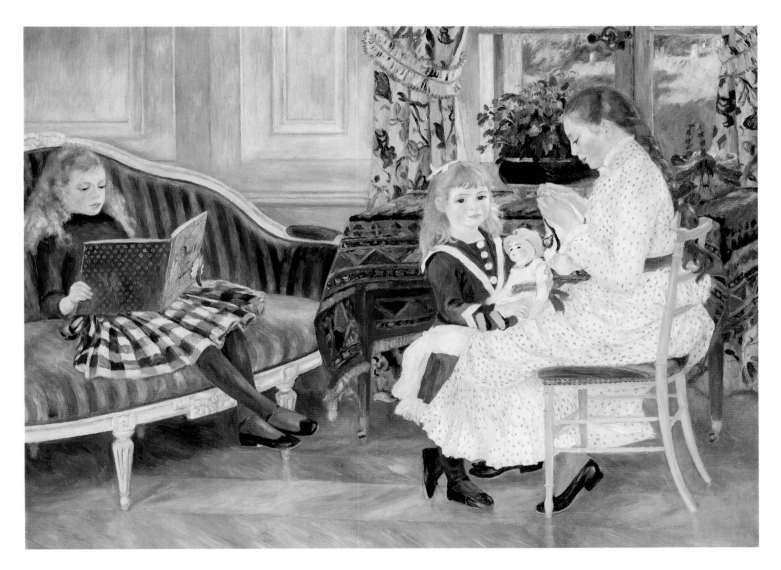

PIERRE-AUGUSTE RENOIR, Limoges, 1841–Cagnes-sur-Mer, 1919

Children's Afternoon at Wargemont, 1884

Opposite:

PIERRE-AUGUST RENOIR, *In the Summer, 1868*

FIN-DE-SIÈCLE BERLIN

AMONG BERLIN's most enigmatic, surprising paintings must be Max Klinger's *The Attack* (606–7), also entitled *Against the Wall.* This panoramic panel shows four roughly dressed bandits attacking a centrally placed figure in bourgeois attire. Journalistic in feeling, this scene was realized in 1879, when Klinger was only twenty-one and a Socialist. It is light-years away in subject and treatment from the peekaboo eroticism of his later oeuvre.

In addition to being among the most popular German painters of his day, Klinger was also an immensely accomplished illustrator, printmaker, and sculptor. He specialized in Maxfield Parrish–like fantasies and in complex juxtapositions of painting and sculpture known as *Gesamtkunstwerke,* or collective art works. An ever welcome contributor to the Sezessions founded in Vienna in 1897 and in Berlin in 1898, Klinger's images by then were usually campy, close to calendar art. Yet they were studied by leading artists for the force of their surreal illusionism and for their intense eroticism.

The quasi-documentary approach taken in painting *The Attack* seems decades ahead of its day, close to the photography and compositions of Ben Shahn. The awful sense of calm and acceptance that pervades Klinger's early panel presages the hideous events of the following century.

Berlin's native son Franz Skarbina was both elegist and pop lyricist to the capital's fin-de-siècle prosperity. Like so many Prussian painters, he took much of his training in Paris. The successful artist soon received extensive patronage as well as membership in two advanced groups, the Eleven and the Berlin Sezession. Skarbina's two themes — the pleasures of the rich, and the changing face of Berlin — were usually in complete contrast to one another.

The first category is exemplified by *The Girl on the Boardwalk* (605), painted in 1883 at a chic Belgian seaside resort. Background details bear an uncanny resemblance to Seurat's *Sunday Afternoon on the Island of La Grande Jatte* (Chicago Art Institute), which was painted two years later. A life preserver of crisp observation and witty eroticism saves this bathing beauty from drowning in a sea of kitsch.

Painted in shades of gray, Adolf von Meckel's grisaille rendering of Berlin's British Gas Works on the River Spree (610) shows how a new industrial beauty replaced the Prussian capital's rustic, riverside setting, one that has a spectral, lunar quality of its own. Much of von Meckel's oeuvre deals with the profitable theme of Near Eastern views, and he even endowed the British Gas Works with the quality of a mirage. Though this artist is not narrowly dependent upon James McNeill Whistler or the Impressionists, both devoted to a new appreciation of the urban landscape, those precursors may have contributed to his sensitive depiction of a tough topic.

Like Renoir, Paul Baum began his career as a painter of flowers on china, but he soon went on to study painting at the Dresden Academy before traveling to Paris and the Lowlands. There he absorbed the new technique of the Divisionists, coming close to Paul Signac and Theo van Rysselberghe. Berlin's unusually austere *Landscape* (610), painted by Baum in 1896, is close to the Pointillism of Georges Seurat.

Another Berlin artist, Lesser Ury, based nearly his entire oeuvre on views of that city, flashing its traditionally lively nightlife on canvas two decades before the Weimar days immortalized in Christopher Isherwood's *I Am a Camera.* Ury's

Opposite:
FRANZ SKARBINA, Berlin, 1849–1910
The Girl on the Boardwalk, 1883

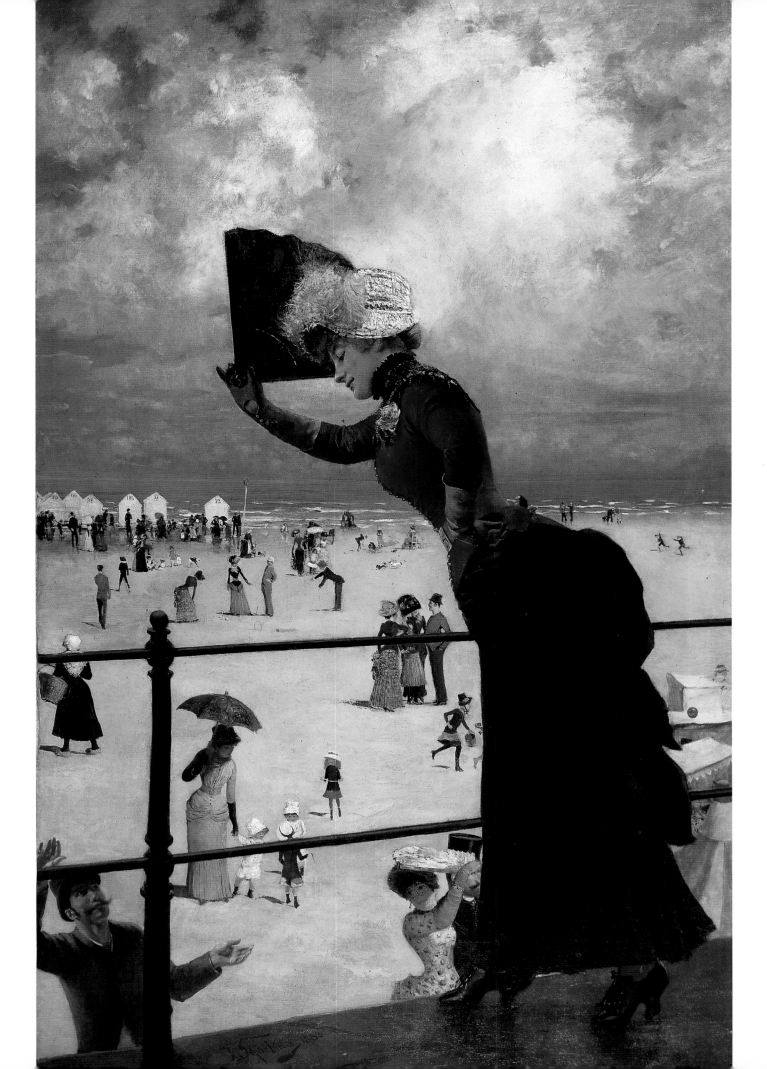

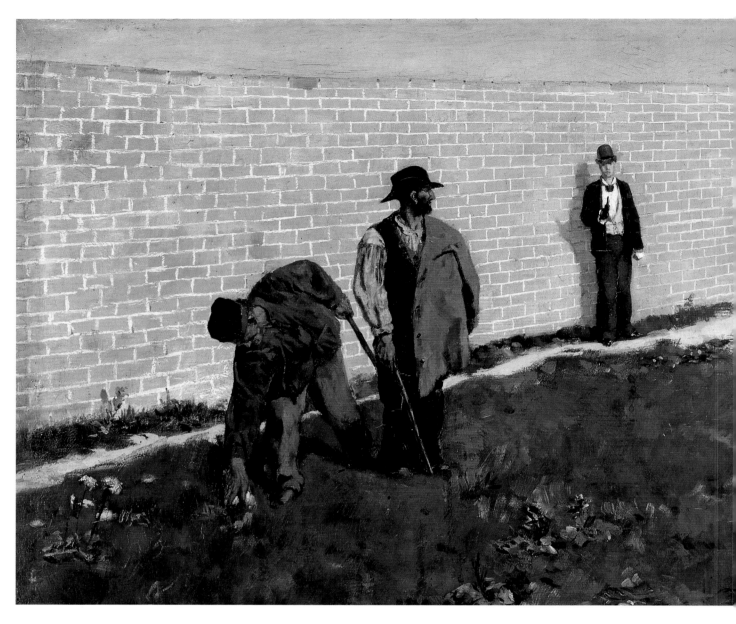

MAX KLINGER, Leipzig, 1857–Grossjena, 1920, *The Attack,* 1879

Bonnard-like *Berlin Street Scene (Leipzigerstrasse)* of 1889 (609) not only points to German painters' proximity to Paris, but to their new interest in the rediscovered arts of Baroque Spain and Goya (422), both so striking for their eloquent blacks and dramatically reduced palettes.

Scorned for much of this century, Frans von Stuck was guilty of combining originality with enormous popularity. Often working in a powerful proto-Deco aesthetic, in a style associated with the Modernist Sezessions, von Stuck's oeuvre has a strong sense of plasticity. This brings him close to

such contemporaries as Antoine Bourdelle, Aristide Maillol, or the American George Grey Barnard, all of whom, like the German painter, were born in the early 1860s. His work is modified by a certain Wagnerian relish for the erotic, which is close to another artist of his own generation, the Austrian Gustav Klimt (1862–1917), and the Belgian Symbolist Fernand Khnopff (1858–1924). Egon Schiele was a passionate admirer of von Stuck's art. He wrote beseechingly for an autograph in 1908, which he revered as a relic!

The artist's more overtly *avant-garde* contempo-

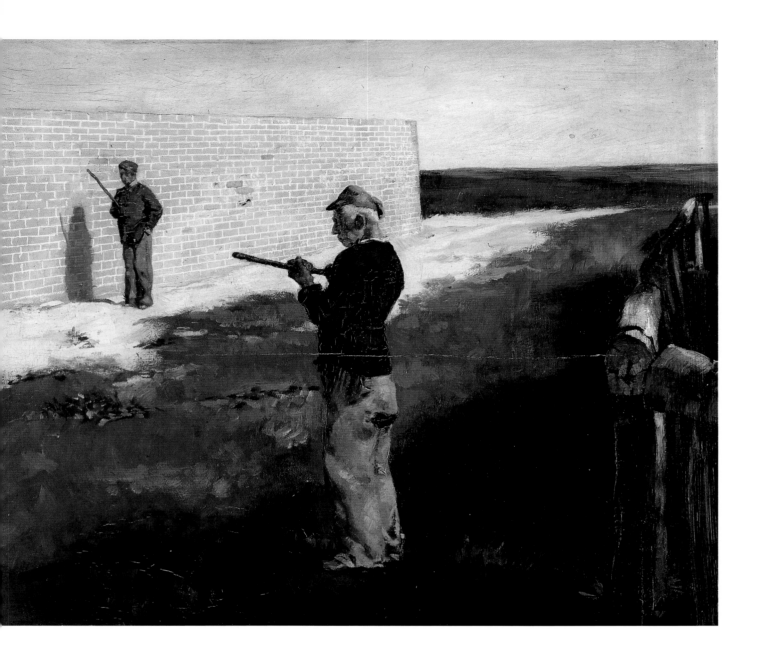

raries must have been astounded by von Stuck's ability to convey his own advanced, often explicitly sexual, imagery in such singularly unthreatening fashion. Doubtless von Stuck had learned much from the art of Böcklin (581–84) as to just how far one could go. Miraculously, so sensual a canvas as von Stuck's *Sin* (608) was embraced as a model of stout morality, an ikon of middle-class conformism just a few years after it was painted in 1893. Sin, sister to Eve — or Eve herself — flashes her torso, a suitably phallic serpent slung over the Original Sinner's shoulder like a fox stole.

Von Stuck devoted many canvases to Sin, which was among his favorite and most profitable themes, and he often provided them with lovingly designed frames. By 1897, sexual associations with this image were made more overt by having the serpent writhe between Sin's legs. Elements of the Arts and Crafts tradition prevail in the painter's approach, his frames intensifying the images' cultlike character.

A great teacher, von Stuck was revered by Wassily Kandinsky, Paul Klee, and Hans Purrmann (620). A *Self-Portrait* (609) shows him in his grand studio, its walls inscribed with the names of Phidias (visible in

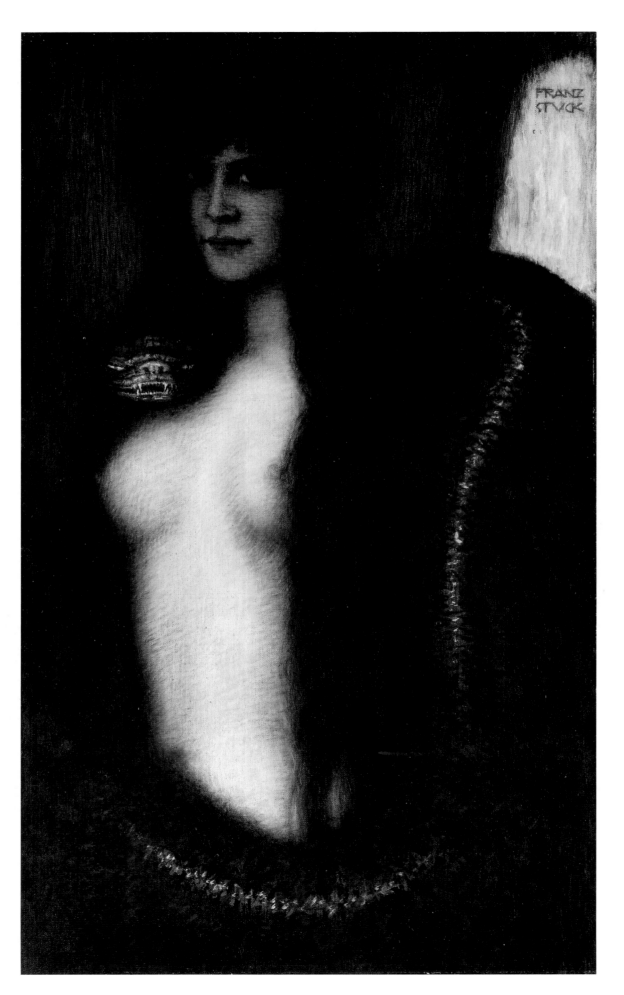

FRANS VON STUCK
Tettenweis, Bavaria,
1863–Tetschen, 1928
Sin, 1893

FRANS VON STUCK, *Self-Portrait in the Studio*

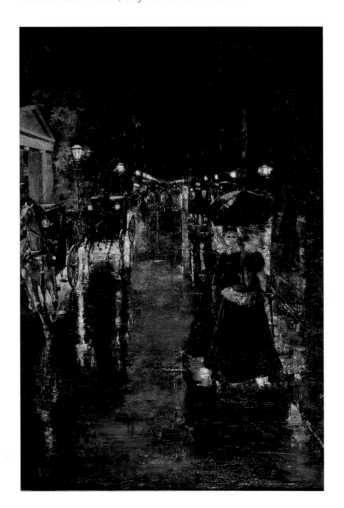

LESSER URY, Birnbaum, 1861–Berlin, 1931
Berlin Street Scene (Leipzigerstrasse), 1889

the painting) along with those of Michelangelo, Titian, Rubens, and Velázquez. Here is an artist who knew his own worth and could persuade the most significant others to that effect, doubtless the key to von Stuck's success. This self-image stresses the artist's gentlemanly role: he paints in formal attire, wearing a wing collar, as he gazes in awe at a completed nude of his own creation (whereabouts unknown). Von Stuck had much to be pleased about. Living in one of Munich's most magnificent new villas on Prince Regent Street, he was knighted in 1906. This image is once again in a Grecian frame of the artist's devising.

As industrialization consumed more and more of Europe's landscape and labor force, painters took an ever closer look at the ties between the earth and its workers. Changing links between the two came to symbolize the altered state of continental life, as seen in a major canvas by Giovanni Segantini, variously titled *The Last Journey* and *Return to Native Soil* (611). He had perfected a Divisionist technique named the "Segantini stitch," based upon his reading of Leonardo's *Notebooks,* which the young artist encountered as a student in Milan, where the Renaissance master had long resided.

This scene typifies an elegiac, melancholic aspect of European art of the fin-de-siècle. Here the Tyrolean painter shows a farm laborer's journey to burial, returned to the earth he had long worked, the cart bearing his coffin and a mourner now drawn by the same horse that had pulled his plow. Immutable mountains rising in the background, in what becomes akin to a frieze, contrast with the pathetic mortality of the foreground cortège.

This canvas was completed in 1895 and won the First International Prize given by the Italian government in the Venetian Biennale of that year, from which it was purchased by a Berlin dealer. The German capital's lavish Sezession art magazine *Pan,* founded in 1895, devoted its third issue to Segantini. His canvas was bought by the museum in 1901.

Reflecting the world of Wilde and *Jugendstil*

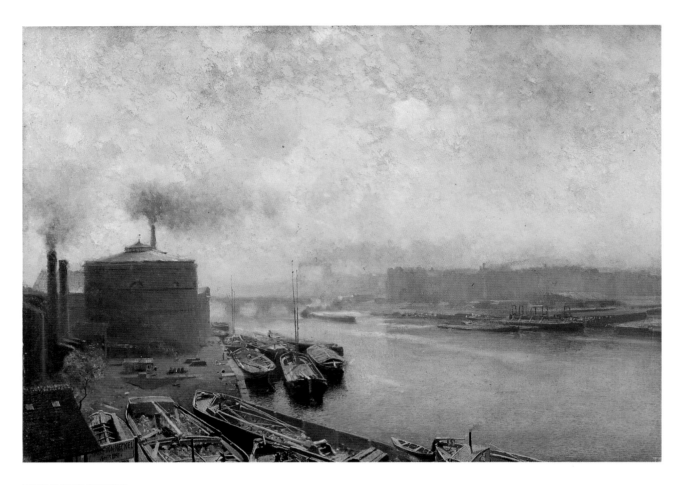

ADOLF VON MECKEL
Berlin, 1856–1893
*British Gas Works on
the River Spree*

PAUL BAUM
Meissen, 1859–
San Gimignano, 1932
Landscape, 1896

alike, the ominous, yet almost Orientally decorative treatment of the *Grunwaldsee* (611) by Walter Leistikow shows the new trend toward the abstract as the nineteenth century comes to a close. Flat, patterned, close to lacquer screen or brocade in its restraint, this approach to the experience of nature anticipates Modernism in its restraint and respect for the two-dimensional. Leistikow was concerned with the decorative arts, writing extensively on wallpaper and other media for the *Kunstgewerbeblatt*.

This large painting of the lake near the Hohenzollern's hunting lodge outside Berlin was presented to the Nationalgalerie in 1898, having been exhibited at the Gross Berliner Kunst-Austellung in the same year. Unsurprisingly, its artist was a founder of the Berlin Eleven in 1892 and a leader of the Berlin Sezession, ever open to new currents.

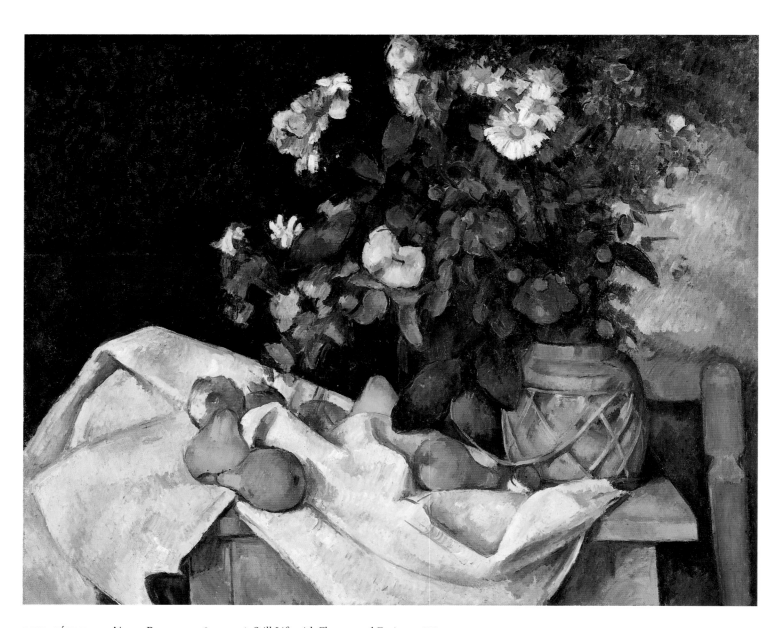

PAUL CÉZANNE, Aix-en-Provence, 1839–1906, *Still Life with Flowers and Fruit*, c. 1888–90

New Ways to Light, Form, and Color

For all its revolutionary impact, Cézanne's uncompromising art is profoundly conservative. Like his idol Poussin (411–14), the definitive French classicist active two centuries before, Cézanne sought the simplest and strongest solutions.

His contemporaries Wilhelm Trübner (576–77) and Hans von Marées (587–89) were close to Cézanne's sources, open to the oeuvre of such friends as Courbet (568–70) and Manet (591–93), whose works were exhibited and sold in Munich, Hamburg, and Berlin. Soon Cézanne's canvases were also sold in Berlin and bought by Max Liebermann (578–79). They also entered many German museums and private collections.

Grouped objects (along with the splendors of Provençal landscape) provided Cézanne with his grandest, most successful affirmation of heroic vision, as pertinent to future Modernism as it was to the continued awareness of French Classicism. Of the city's four paintings by Cézanne, the earliest, an austere *Still Life* of 1871 (614), is in many ways prophetic of Fauvism and Cubism as well as of the late Braque. This canvas comes from Eduard Arnhold's great collection and, like the work of many major Impressionists in Germany, was bought from Paul Cassirer's Berlin gallery. It provides a vivid demonstration of the nineteenth-century Old Master's passion for clarification without loss of vibrance.

A magnificent *Still Life with Flowers and Fruit* (612) shows Cézanne at his most fulfilled and fulfilling. Here the ginger jar, pears, and flowers, all placed on a turbulent swirl of tablecloth, bespeak a world of both fixity and change, where the ceramic's immutability stands in dramatic contrast to the passionate, organic vulnerability of the fruit and the frail, short-lived flags of waving flowers. Like Matisse, Cézanne returned to the most abundant, extravagant Dutch and Flemish Baroque still lifes (396, 398, 400–407) as a point of departure for his own. As he was terrified by the flesh, only a few of Cezanne's many *Bathers* transcend inhibition, so, when it comes to the sensuous, his pears prove far more so than his nudes.

When Vincent van Gogh and his faithful brother, Theo, first lived in Paris, they made their home near the end of a little street in the Buttes of Montmartre where the rent was as low as the region high. Windmills in that still rustic quarter must have reminded both brothers of their Dutch homeland. Already visited by some chic Parisians by the 1870s, some of these windmills had nearby open-air dance floors — cabarets — for their still largely working-class patrons, rural nightspots that were forerunners of the Moulin Rouge, where washerwomen's cancans were staged to entertain prosperous slummers.

Renoir and his artist friends went to dance at the Moulin de la Galette, so shown in one of his grandest canvases (Paris, Musée d'Orsay). In contrast to that happy scene of romantic nightlife, Vincent painted the same mill by day (616), all dancers gone, at least seven times. In these silent, often gloomy canvases the only playing may have been that of cold winds about the trees' bared limbs.

Beginning as a pastor, van Gogh never felt a divide between word and image. In Paris he admired works by Paul Signac, whose *Still Life with a Book* (615) is close in color and content to those by the Dutch painter, so many of whose still lifes included a Bible or other text. In the French picture, the book is Guy de Maupassant's *Au Soleil,* a collection of travel sketches published in 1881. Its title, *To the Sun,* suits the radiant, almost pantheistic suggestion of solar worship in the later colors of the Dutch artist as well as in those used by Signac.

After van Gogh's death, German collectors of

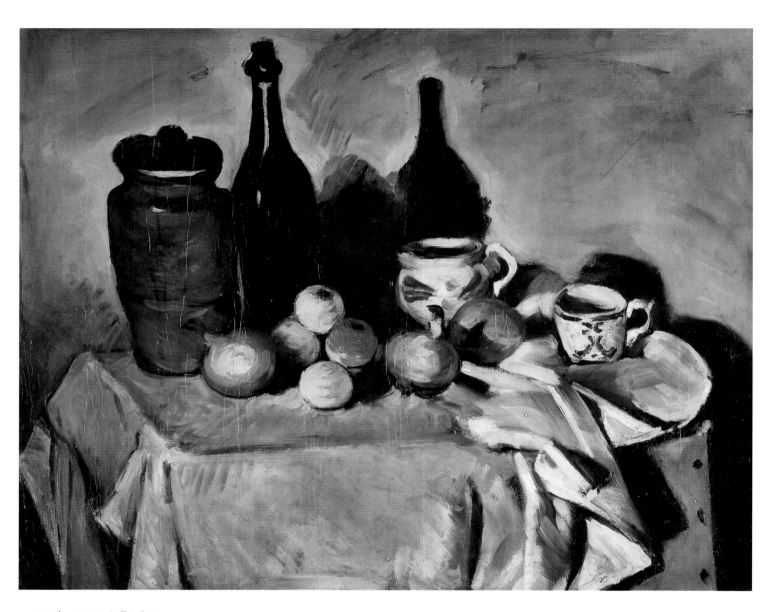

PAUL CÉZANNE, *Still Life,* 1871

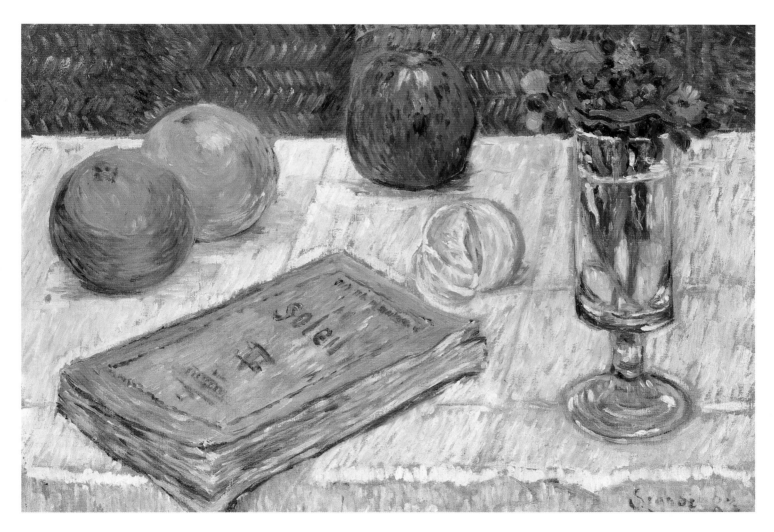

PAUL SIGNAC, Paris, 1863–1935, *Still Life with a Book*, 1883

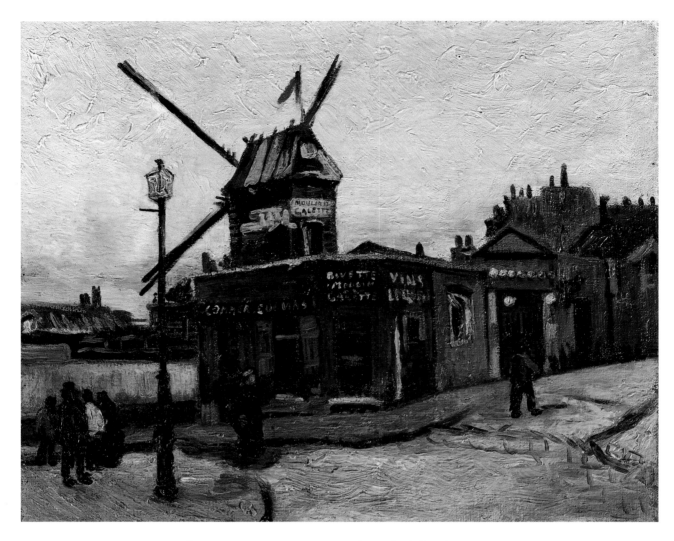

VINCENT VAN GOGH, Groot-Zudert, 1853–Auvers-sur-Oise, 1890, *The Moulin de la Galette, 1886*

contemporary art, especially that of Munch (*621–23*) and Käthe Kollwitz, were among the first to purchase the Dutchman's works. These buyers were prepared for Vincent's subjects because happier versions of many of the same themes had already been painted by their own Max Liebermann (*578–79*). Always interested in artists' letters, Germans pored over the recent, lavishly published translation of Vincent's beautiful, heartrending correspondence.

In spite of Berlin's canvas, van Gogh has brought sunshine into hundreds of thousands of German homes for almost a century. His radiant *Sunflowers* (National Gallery, London) may have been that nation's most popular image, its reproductions possibly outnumbering even those of Dürer's beloved *Hare* (Albertina, Vienna).

Where Munch's authoritative, almost brutally

sexual imagery made him *the* Modern Master for the rich and famous, for the intelligentsia, Vincent's feverish Protestant compassion and brilliant color spoke to one and all. His own art, in flamboyant canvases, far from the Moulin's sobriety, opened the way to more challenging, often primitivistic images of the German Expressionists (*618–41*) — of the Blue Rider and other movements active before World War I.

Maria Slavona (pseudonym of Maria Schorer) attended the women's art schools of Munich and Berlin. A student of Käthe Kollwitz's, she joined the Berlin Sezession. Though Slavona painted in the same Parisian areas as van Gogh, who was eleven years her senior, her own approach, as seen in *Houses at Montmartre* (*617*), was closer to Pissarro's, a close friend during the German painter's long Parisian residence.

Opposite:

MARIA SLAVONA, Lübeck, 1865–Berlin, 1931, *Houses at Montmartre, 1898*

INTERNATIONAL EXPRESSIONISM

TOO OFTEN PREFIXED by "German," Expressionism was an international movement, its seeds planted throughout the later nineteenth century in Belgium, England, France, Italy, and Norway. Painters like Jean-François Millet, Théodore Rousseau, Eugéne Carrière, Frans von Stuck, and, above all, the sculpture and drawings of Rodin were Expressionism's key sources. Symbolists, the Nabis, and the Fauves also used more outspoken color and line in their striving toward a personal way of communicating feeling. By means of landscape, physiognomy, or the corporeal, all conveyed by brushstroke, or from the abstract designs of the movement variously known as Art Nouveau, *Jugendstil,* or Stile Liberty, there was a keen sense of the personal in modeling, line, and color, which stressed the emotional in ever more compelling fashion.

The obsessively decorative, often erotic aspects of Art Nouveau and the popular art of Max Klinger (606–7) also led to a new sympathy for overt feeling. The Arts and Crafts and Pont Aven movements, with their own primitivism and their love of bold outline and strong statement, of peasant culture and folklore, contributed to ever stronger and more immediate ways to the art of communicating radical reaction: Expressionism.

All media — clay, plaster, silver, enamel, or oil — became animated by a quivering, sensate quality as if sympathetic magic were exercised to generate form. Works often retained a quality of flux rather than fixity, each proclaiming a state of becoming, not finality. Now the spectator, too, was personally involved, as in the art of the late Titian (268), of Hals (326), or of Rembrandt (366, 370–72), all demanding a new dynamic of vision. Far more than mere witness, such empathic regard constituted and completed the work of art.

The magisterial oeuvre of Auguste Rodin (1840–1917) — a Promethean model of creativity — accompanied the rediscovery of El Greco and Goya (422) and the revelation of Daumier's canvases (571) to ready a younger generation of painters for an increasingly direct, personal approach. Works by Manet (591–93) and Cézanne (612, 614) were also sought after by the German market at an early date. All of these loosened and liberated many artists of that nation from a conventional approach. Though Cézanne is often seen in neo-Poussinesque terms, that was certainly not what attracted his northern buyers. The seemingly raw power of his emotions, his magisterial directness of vision and immediacy of execution, drew young German artists' attention. Working in nearby Antwerp, James Ensor (1860–1949) also anticipated German and Austrian Expressionism, as did the Norwegian Edvard Munch (1863–1944). A rise in the revival of interest in the etching and the woodcut, both long popular in Berlin — especially those of Paul Gauguin and Edvard Munch — led artists back to a hands-on clarification of purpose. Many young painters asked themselves the same basic questions as those giving title to Gauguin's great canvas *Where Do We Come From? What Are We? Where Are We Going?* of 1897 (Boston, Museum of Fine Arts).

Van Gogh (616) and Picasso were also among the founding fathers of German Expressionism's vital, youthful line and brilliant color. The Dutchman was given a very large one-man show in Cologne in 1905. Matisse and Cézanne were much on view at Cassirer's Berlin gallery and at Thannhauser's in Munich. Gauguin was the recipient of a huge Cologne exhibition in 1910, and Munch a substantial one in Dresden in 1906. He, too, was often shown in Berlin. Picasso was very well known to German art critics, essays about him and reproductions of his works appearing in many *avant-garde* publications. So any and all young German artists interested in

PAUL GAUGUIN, Paris, 1848–Atuona Hiva-Oa (South Seas), 1903, *The Fisherwomen of Tahiti,* 1891

the *avant-garde* never had to leave their land to explore the key facets of Modernism's cornerstone.

In many ways, Northern and Central Europe — Germany, with Austria, Czechoslovakia, Holland, and the Scandinavian countries — developed the world's most innovational design culture just before and after the First World War. This achievement was distinguished by a fresh, newly clean-lined, radically no-nonsense approach. So stripped down and austere an ambience provided the perfect setting for the challenge of Expressionist art.

Though Gauguin may have left Paris for Tahiti to discover an unspoiled island Paradise, his mental baggage included vivid memories of Greek and Egyptian sculpture, along with copies after Egyptian paintings, all closely studied at the Musée Trocadero. So *The Fisherwomen of Tahiti* (619), painted in 1891, Gauguin's first year on the Pacific island,

retains much of the sense of profile so strongly felt in ancient or tribal cultures.

Degas, such a potent influence on many late-nineteenth-century members of the Avant-Garde, is also in evidence in the quality of arrested motion found in Gauguin's Tahitian figures. Gauguin was sent by his Parisian dealer to the Pacific in the hope that works painted in such an "exotic" setting might sell. The beautiful Tahitian models and landscapes did indeed prove a source of forceful, ultimately profitable inspiration. Yet the artist's isolated way of abandoned life led to alcoholism and syphilis that killed him at an early age. He yearned for return to the only somewhat safer joys of Paris, whose recent art Gauguin so skillfully merged with ethnic elements found in *The Fisherwomen of Tahiti.*

Significant for the genesis of German Expressionism, this canvas was exhibited in the International

Exhibition held in Cologne in 1912, and came to the museum in 1928 from Munich's Thannhauser Gallery, one so important for introducing *avant-garde* French painting to that city's collectors and curators. Expelled as a Jew, Thannhauser came to New York, where his gallery continued the same role. He left a collection now filling a wing of the Guggenheim Museum in memory of his son, an American soldier who fell in World War II.

Active near the twentieth century's start, the Fauves, led by Henri Matisse, were impatient with academic restraint and intellectualization alike. Breaking with conservative practices, Matisse attracted several German and Scandinavian students to his Parisian atelier before World War I. Matisse's very few writings were published in German translation as early as 1909, his *Notes* studied by Expressionist leaders who also showed a new interest in Goethe's color theory. They were drawn to the former lawyer by the reasoned audacity of his new approach, one only called "wild" — *fauve* — by those who failed to perceive its strong classical roots. Hans Purrmann was among this group of early disciples, most of whom returned to their northern homes to spread the Fauve gospel. His *Still Life* (620) of 1908 shows the young German's ready command of the new Parisian style.

Artists such as Max Liebermann (578–79), Lovis Corinth, Max Slevogt, Vincent van Gogh, Lesser Ury, and Edvard Munch, many of whom were active or exhibited in Berlin, moved away from the tedious aesthetic of the glossy flat surface of the "Photo-Finish" toward a far more personal impress, with a heavy impasto and a quality of work-in-process rather than perfected completion. Though often predating the official Expressionist fold (if such there was), many of these painters share its strongest features.

Berlin, Europe's most modern city, became a lodestar for foreign painters and their works. It was a center for the exhibition of Gauguin's woodcuts; van Gogh was to make his greatest impact there. Here, too, resided the major figure for Expressionism, the Norwegian painter and printmaker Edvard Munch.

Munch was the bridge between Max Slevogt and successive Expressionist generations; more than fifty of his paintings were exhibited in Berlin's Künstlerverein in 1892. His frank approach to life and direct, impulsive technique shocked Wilhelmine Prussia and the show was closed by the state. Yet such leading Berlin artists as Max Liebermann, already a major local collector of modern Parisian art, recognized the Norwegian's strengths and joined with fellow admirers of Munch's art to found the Berlin Sezession in 1898. A second Berlin exhibition in 1907, largely devoted to Munch's monumental *Frieze of Life* (622), brought a further infusion of symbolist power to art in Germany, initiating or at least contributing to an emotional breadth and intensity that proved critical to developing Expressionism.

Significantly, Munch was close to the old/new Nordic propensity for worshipping Mother Nature, heroic nudity, and sunshine, a pagan faith long shared by Germans. That nation's new ethnographic collections at Dresden, along with Essen's great Folkwang Museum, guided by the scholar-collector Wilhelm Osthaus, provided ready resources for an accessible reappraisal of tribal arts, as did Berlin's splendid meso-American archaeological collections that were established under the influence of the Humboldt brothers.

From 1893 to 1897 Munch spent his winters in Berlin, where he also lived in 1904 and joined the city's Sezession movement. In 1904/5 the Norwegian painter had banker patrons in Hamburg — Warburgs and others — and made two extended visits to that city. There he painted uncharacteristically cheerful landscapes of the nearby medieval Hanseatic port, such as *Lübeck Harbor with the Holstentor* (621), which shows that medieval twin-towered fortification at the far left. Munch was very happy in Lübeck and later wrote how much he missed the seaport.

Paul Cassirer, who, with Fritz Gurlitt, had brought so many Impressionist works to Berlin, took on Munch as a client and the Norwegian soon became one of the leading artists active in Germany. He lived in Berlin until 1908, where he painted many of his strongest works and made his

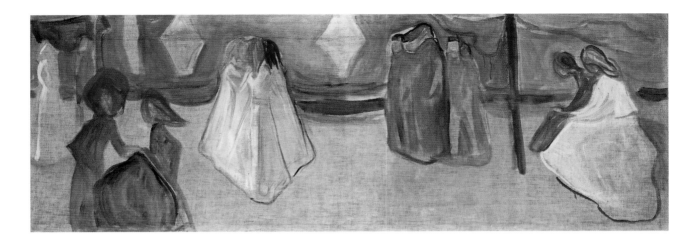

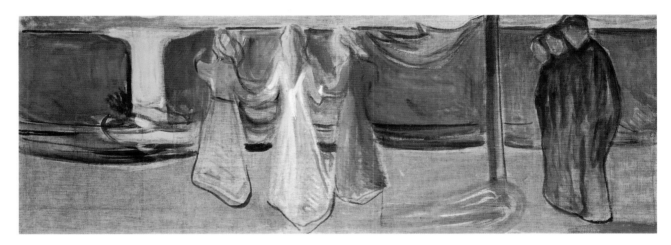

EDVARD MUNCH, *Frieze of Life: Summer Night* (top); *Longing* (bottom), 1907

finest woodcuts. His magnificent graphics, with Gauguin's, stimulated German painters to follow suit, enriching and defining Expressionist currents by adopting that medium. Similarly, his canvases were to prove seminal for American painting — for Milton Avery, David Park, Richard Diebenkorn, and Willem de Kooning, and for the gestural brushstrokes of the Abstract Expressionists.

Munch took on the commission to paint a multipaneled *Frieze of Life* (622) for Max Reinhardt's Berlin theater, a project that was begun by 1905. The cycle, with much of Munch's art, is haunted by a personal pessimism, leaving plenty of *Lebensraum* for Death in the decor. Munch and his friend the Swedish playwright August Strindberg, a distinguished pair, were described as "partners in passion for wine, women and neuroses." Following Caspar David Friedrich's contrast between humanity and

the absolute (*512, 515*), Munch also grappled with so daunting a comparison, conveying the tragic futility of individual endeavor when confronted by eternity in one of the sections of Reinhardt's frieze.

The artist portrayed many of Germany's most artistically inclined and less conventional rich or famous people, men like Walther Rathenau (623), who was all of the above, inspiring the central character in Robert Musil's unfinished novel *The Man Without Qualities* (1930–43). Singularly brilliant, this imposing man was a major economist, social theorist, government official, art patron, and heir to Berlin's great electric company, the AEG, for which his father had purchased Edison's patent. Telefunken, electric railways, radiotelegraphy, turbodynamos, and the use of aluminum were all established in Germany by Emil Rathenau. So Munch's portrait of 1907 presents the heir apparent

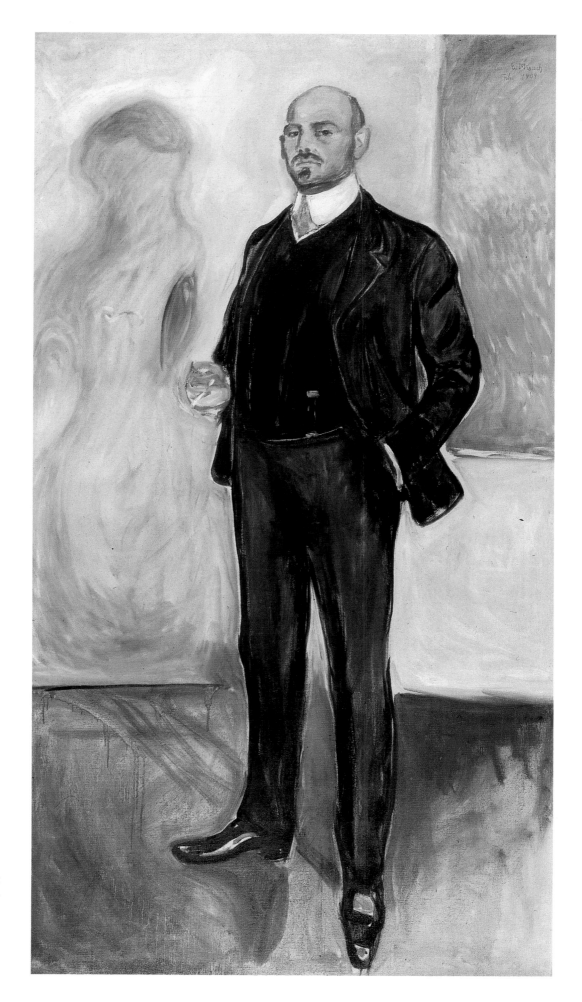

EDVARD MUNCH
Walter Rathenau, 1907

to the New Germany, that nation now a world leader in academe, the sciences, manufacture, and research.

The younger Rathenau was to turn his father's industrial might into an effective organization for Germany's military preparedness for World War I. Later, as Foreign Minister, he became a leading figure in the nation's recently Socialist Weimar Republic, representing it at European peace conferences. A liberal, Rathenau nonetheless long nursed romantically imperialistic leanings, craving admission to the Kaiser's richly uniformed Horseguards, from which he was barred due to his Jewish birth.

Munch's full-length portrait of Rathenau (another of the same date is in the collection of Rasmus Meyer, Bergen) shows the sitter in 1907, at the age of forty. Consumed by, and attracted to, intense sexuality, Munch found the latter, albeit in repressed form, in his remarkable sitter. Though his subjects are shown in formal attire, many of Munch's full-length portraits of bankers, professors, and esthetes suggest the predatory. Seething with desire, his bearded wor-

thies seem ever on the prowl, ready for game of all sorts. Portraits such as Rathenau's established new ikons of authority. Broadly, boldly brushed, impatient with detail, such likenesses provide a novel reduction to basics in their presentation. As much ultimatums as portraits, these overt and uncompromising images bespeak: "This is *it*. Ignore me at your peril. Take me or I'll leave you." Theirs is a new, threatening note in the history of portraiture and culture alike.

Though Rathenau had yearned to be a Horseguard in his youth, he turned down any protection for himself when the President of the Weimar Republic heard that his Minister was the target of assassins. Fifteen years after the portrait's completion its subject was gunned down by three young, well-born veterans of the Freikorps. Right-wing anti-Semites, they disapproved of Rathenau's policies as Germany's Foreign Minister, seeing him as a Bolshevik subscriber to the Protocols of Zion, one who betrayed the Fatherland to the Allies.

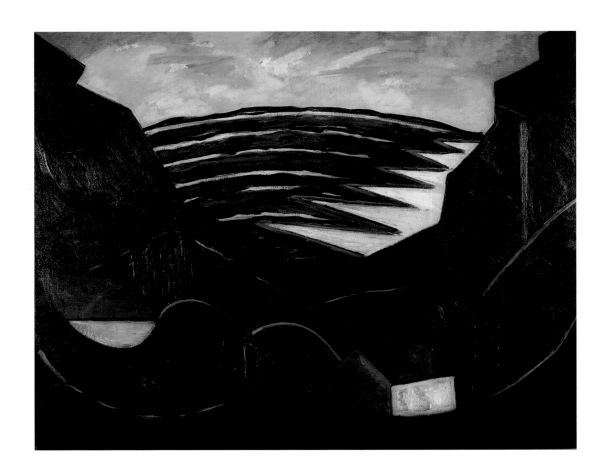

JACOBA VAN
HEEMSKERCK
The Hague, 1876–
Domburg, 1923
Landscape, c. 1914

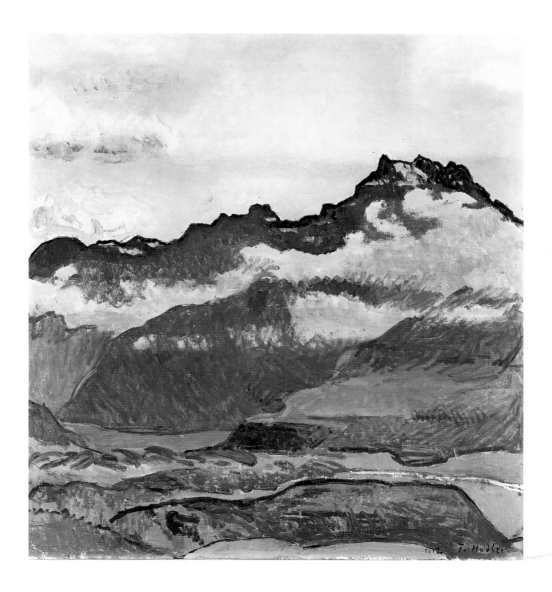

FERDINAND HODLER
Berne, 1853–
Geneva, 1918
Dents-du-Midi, 1912

Distressed by her son's having accepted the vulnerable ministerial post, Frau Rathenau uttered a tragic variant of the Jewish Mother line, asking "Walter, why have you done this to me?" — to which her son replied with Christ-like humility, "I really had to, Mama, because they couldn't find anyone else."

Child of two artists, the Dutch-born Jacoba van Heemskerck (1876–1923) proved to be a very powerful painter, though she had a short working life. Her cosmopolitan career began as a student at the conservative Hague School. She then entered Eugène Carrière's Parisian studio. Van Heemskerck went on to a much more hard-edged, design-oriented approach, working with Jan Toorop, the pioneer Dutch Modernist, designing mosaics and active as a

printmaker. These linear qualities are seen in her forceful, ominous *Landscape* (624), which is surprisingly close to Maine views by the American Marsden Hartley. One year older than the Dutch painter, he spent his formative artistic years in Berlin before World War I. Close to Herwarth Walden, van Heemskerck may have exhibited her canvas at his influential Berlin gallery, Der Sturm.

A "poor Swiss" sounds oxymoronic, but Ferdinand Hodler (1853–1918) was just that. He survived dire straits, including the death of his parents and nine siblings during his childhood. Unsurprisingly, his art swings between images of extreme force — rugged mountains and Nietzschean men and women — and just a few of vulnerability and death. Hodler's native Alpine landscape is ideally suited to a search for enduring strength. Berlin's *Dents-du-*

Midi (625) shows the Alps near Berne, their sharp formation suggesting their name — Teeth of the South. Such views are characteristic of the Swiss painter's clarified, prismatic vision, which, with a bold, challenging use of the nude, made him an artist of international importance by the late 1890s.

Hodler's monumental canvases of Swiss history have a proto-Deco aspect, one whose influence is seen in the equally propagandistic historical frescoes by the Mexican Diego Rivera.

Amazingly enough, Lovis Corinth (1858–1925), known for his highly emotional, often fiercely innovative images, got his start in Paris studying under Adolphe-William Bouguereau, that quintessentially sleek, later-nineteenth-century painter at the Académie Julian. The son of a tanner, Corinth, like Wilhelm Leibl (575), broke Germany's strict class barriers to become a highly successful painter, proving himself to be a surprisingly popular portraitist. An apopleptic stroke in 1911 changed the artist's life and work. After a period of enforced inactivity, he moved to a new, free style, matching it with suitable subjects for the remaining fourteen years of his life.

Where Munich, a conservative Catholic center, had found Corinth's blood-and-guts approach more than it could bear, the far more Protestant and cosmopolitan Berlin recognized the painter's challenging gifts. His art, with that of Max Slevogt (626), proved central to building the shaky foundations of German Expressionism. Carnal knowledge is Corinth's first and final concern, achieved on canvas by way of a devil-may-care, slash-and-burn brushstroke soon followed by many a master, including Francis Bacon and Willem de Kooning.

The subject of *Samson Blinded* (627) is ideally suited to Corinth's profound pictorial involvement with passion and its price. That Old Testament strongman was long popular in Northern European art, abounding in the worlds of Cranach and Rembrandt (358), his the paradox of strength and weakness in the same human envelope. Corinth's canvas shows how Samson, too long blind to Delilah's evil nature, is now literally blinded by her Philistine henchmen. Baroque insights from Rembrandt's graphism and Hals's brushwork inform this horrendous image, one that coincides with Germany's rediscovery of Goya (422) and Daumier (571).

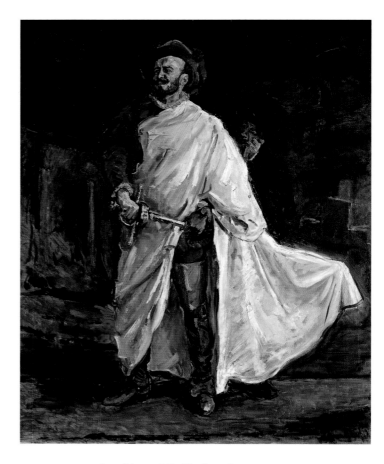

MAX SLEVOGT, Landshut, 1868–Neukastel, 1932
The Singer Francisco d'Andrade as Don Giovanni, c. 1901–2

Painted two years before the Great War, this image of tortured flesh seems to anticipate that conflict's horrors.

Ten years Corinth's junior, Max Slevogt was, quite literally, the most musical of the German proto-Expressionists. His dashing, theatrical canvases have a neo-Delacroixian sense of personal, turbulent drama, of romantic sentiment restated in a more freewheeling technique. Responsive to the great musical heritage of Austria and Germany, Slevogt illustrated an edition of Mozart's *Magic Flute* and portrayed Francisco d'Andrade in the title role of another of the composer's great operas, *Don Giovanni* (626).

Both Max Pechstein (628) and Emil Nolde (629), following Gauguin's precedent, sailed away to their respective neo-Noa-Noas. Chaperoned by their wives, each painter was thus preserved from the

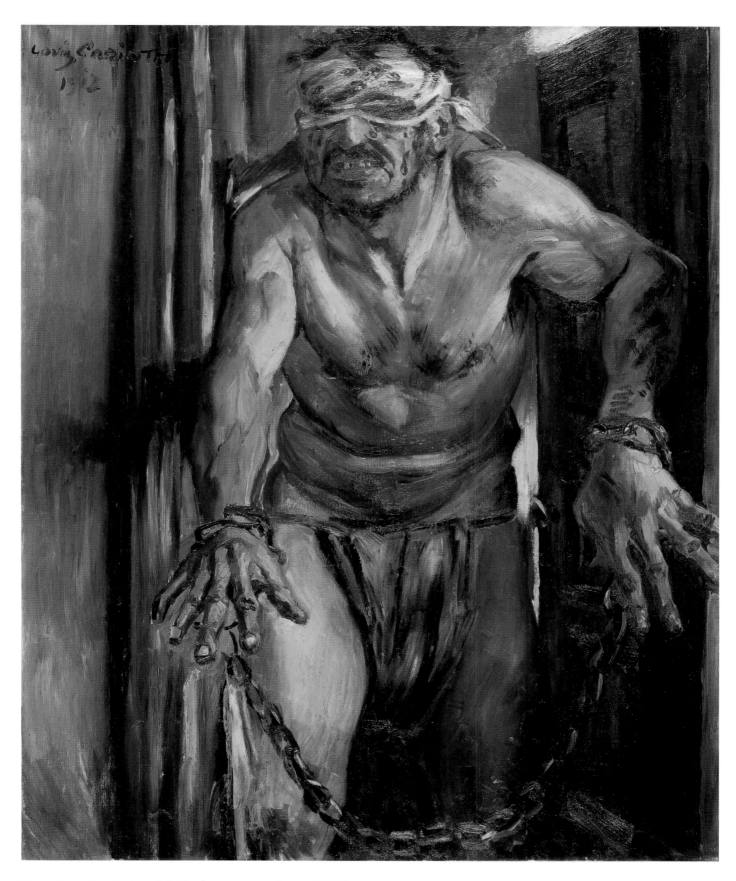

LOVIS CORINTH, Tapiau, 1858–Zandervoort, 1925, *Samson Blinded,* 1912

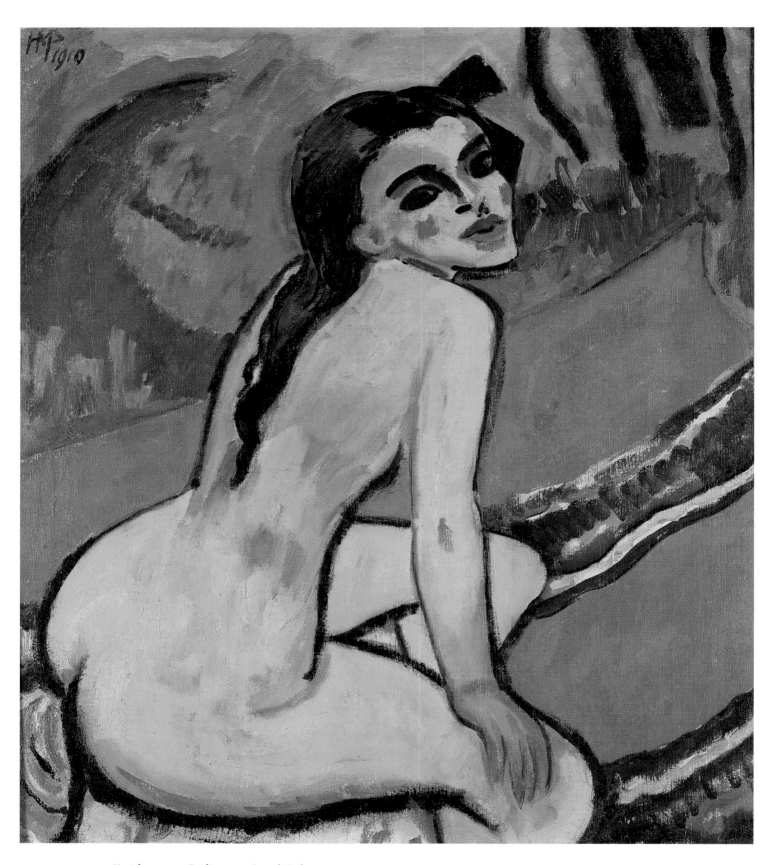

MAX PECHSTEIN, Zwickau, 1881–Berlin, 1955, *Seated Nude*, 1910

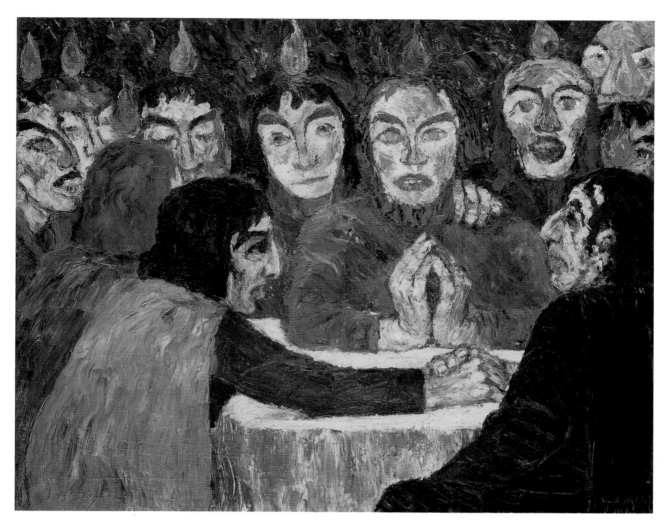

EMIL NOLDE
Nolde, 1867–
Seebüll (Nordschleswig
Holstein), 1956
Pentecost, 1909

EMIL NOLDE
Hunting Lodge at Alsem, 1909

629

Frenchman's disastrously libidinous foray in Tahiti, one that proved all too much this side of Paradise. While the Pechsteins were off to German New Guinea in 1913, the Noldes went to the Palau Islands a year later. Like Gauguin's, each of these costly journeys was financed by art dealers. The *avant-garde* Berliner Fritz Gurlitt sponsored Pechstein's sojourn. Correctly, these merchants of art calculated that "exotic" nudity, "savagery" on canvas or in polychromed sculpture, might help move their unconventional merchandise from sales room to living room. Often belligerent in color and line, Pechstein's and Nolde's art is unlike Gauguin's, two decades their senior, or even that of such contemporaries as Matisse or Munch.

Nolde's brushwork and color scale are both daringly and overtly ugly. They break with the traditional emphasis upon *matière,* upon the facile, slick ways of rendering form with smooth, harmonious virtuosity. His hues are far from those of even the most unconventional artists of the period, favoring odd purples, mustards, violets, and crimsons, along with harshly acidic greens. All these are used with boldness, scrubbed and dabbed upon the canvas with an aggressive, zealous independence, one that is harshly dismissive of the expected.

Nolde's "in your face" way of painting makes the contemporary Fauves seem positively Neoclassical by comparison. Though his canvases were featured in the Degenerate Art show of 1937, Nolde was himself stoutly sympathetic to the Nazi cause, forced to paint in secret in his lavish country house.

Fauvism is much in evidence in Max Pechstein's *Seated Nude* of 1910 (628), with its reminiscence of classical corporeality. The strong and clear coloring is designed to stress the effect of light on the body, one that is heightened by the brilliantly contrasting background.

Self-taught, Maurice Vlaminck (1876–1958) received the strengths and weaknesses of such ignorant instruction. When he first saw van Gogh's art at the Bernheim-Jeune exhibition of 1901, Vlaminck proclaimed how the Dutch artist "means more to me than my father and mother." As long as he followed van Gogh's brisk brushstrokes and vibrant color, Vlaminck did well, as in *Bridge at Chatou* (631). Later, when the painter abandoned brush for palette

ERICH HECKEL
Döbeln (Saxony), 1883–Radolfzell on the Bodensee, 1970
Seated Child, 1906

knife, this resulted in works with a squishy, icinglike surface far better suited to cake than canvas.

Too often with his brush in his mouth, the older, less wise Max Beckmann allowed a tendency to self-conscious narration and ham-handed symbolism to come between art's two leading assets — its capacity for direct communication and its ability to sneak up on you. Though the painter's traditionally Teutonic nature has been blamed for his downfall by Hans Belting, present-day Germany's leading art scholar, it was Beckmann's compulsion to tell rather than show that caused all the trouble. No painter since Anton Mengs (442) may have painted as many self-portraits as Beckmann.

A true conservative and a pacifist in World War I, in 1933 his early anti-Nazi sentiments cost the artist his teaching job in Frankfurt. Beckmann left Germany for Holland in 1937 — one day after the opening in Munich of the Degenerate Art exhibition, which featured his work. The painter's use of rich blacks and stained-glass-like coloring are often superior to the similar coloristic approach of Georges Rouault. A Rubensian relish for bold characteriza-

MAURICE VLAMINCK
Paris, 1876–Reuil-la-Gadelière
(Eure-et-Loire), 1958
Bridge at Chatou, c. 1900

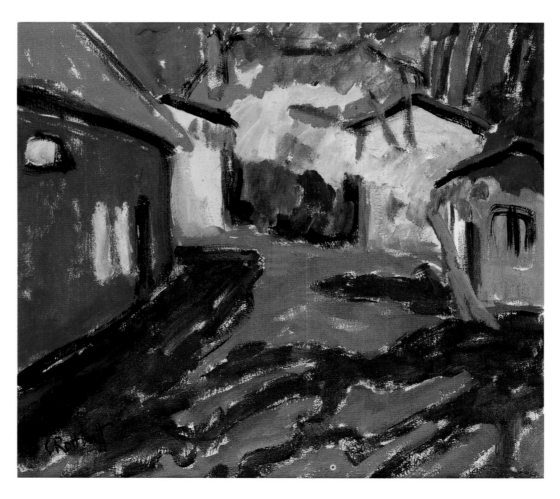

KARL SCHMIDT-ROTTLUFF
Rottluff bei Chemnitz (Saxony)
1884–Berlin, 1976
Gutshof in Dangast, 1910

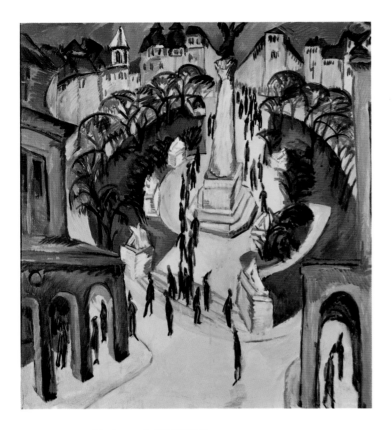

ERNST LUDWIG KIRCHNER
Aschaffenburg, 1880–Davos, 1938
Belle-Alliance Platz, Berlin, 1914

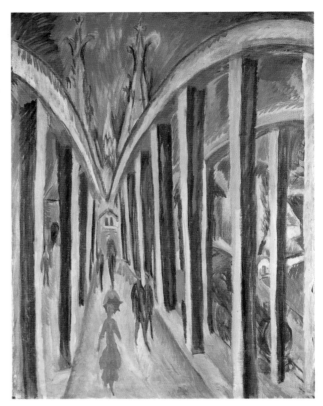

ERNST LUDWIG KIRCHNER
The Rhine Bridge, 1914

tion, corporeality, and texture enhances the German artist's work.

Berlin owns Beckmann's early, most challenging pictures, with their difficult coloring. His *Small Deathbed Scene (633)* was painted there in 1906, along with a larger version of the same subject (Munich, Bayerische Staatsgemäldesammlung). Both canvases are responses to the death of the artist's mother that summer, but expiration had long proved a source of Northern artistic inspiration, from the *Death of the Virgin* to Schubert's settings of *Death and the Maiden.* Berlin's image is far superior to Beckmann's more theatrical version in Munich with its overambitious, pretentious use of the nude.

A major donation by Erich Heckel of his own works and some of his fellow founding members of the Dresden group Die Brücke (The Bridge) has made Berlin an important place to see the donor's achievements, along with those of Ernst Ludwig Kirchner and Karl Schmidt-Rottluff *(631).* Heckel's early studies as an architect in Dresden may have helped him rise to the challenge of taking on some

of the lessons in color and line that were presented by the early Fauve art of Henri Matisse as well as in paintings by Gauguin, exhibited in Dresden and in Berlin by Alfred Flechtheim. Heckel's work is seen at its early, brief best in the *Seated Child (630).* Clearly the young painter has his daunting sources under control in this Expressionist canvas.

A member of *Die Brücke,* the Dresden-centered artists' movement established in 1905, Ernst Ludwig Kirchner's works were shown in Berlin by Fritz Gurlitt in 1910, '12, and '13. The painter is best known for his vivid, elegantly satirical renderings of city slickers in an anxious, threatening urban world. Kirchner's landscapes are also often surprisingly successful, stimulated by the challenge of topographical specificity.

The Rhine Bridge (632) of 1914 contrasts two forms of technical ingenuity — that of the building of Cologne's Gothic cathedral and the new world of bridge construction. Here one achievement quite literally leads to the other. Contemporary with Italian Futurism, the canvas shares that movement's

Opposite: MAX BECKMANN, Leipzig, 1894–New York, 1950, *Small Deathbed Scene,* 1906

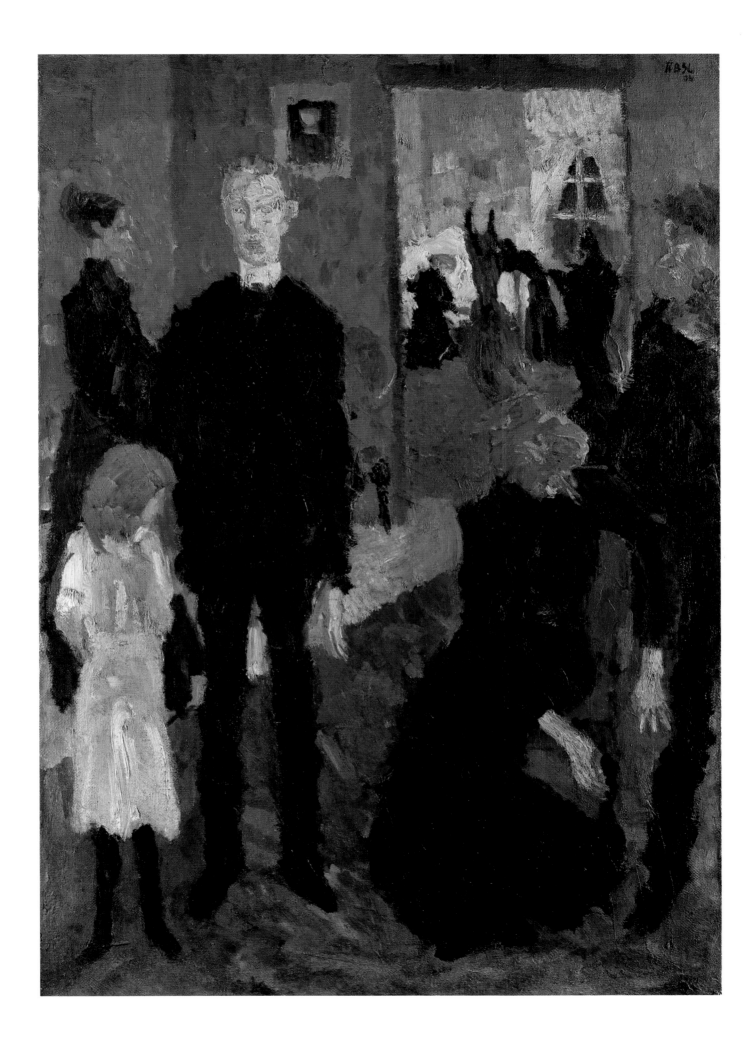

LYONEL FEININGER, New York, 1871–1956, *Carnival*, 1908

OSKAR KOKOSCHKA
Pöchlarn on the Danube
(Austria), 1886–Villaneuve,
Switzerland, 1980
The Austrian Architect,
Adolf Loos, 1909

delight in motion, in the way the locomotive's steam-driven progress outstrips the fashionably languid strollers' pace as they walk obliviously alongside. This canvas was a commission, ordered to decorate the wall of a Cologne manufacturer's — Feinhals — tobacco collection.

Another urban view of the same year shows Berlin's Belle-Alliance Platz (*632*), which commemorated a victory over Napoleon. One of Kirchner's several Berlin scenes, done in the spirit, but far from the style, of Monet's Paris (*596*). Kirchner continued the French painter's practice of sketching from windows for such cityscapes. With its brisk, festive sense of observation, this scene is imbued with a quality of theater and artifice — the essence of metropolitan life, first felt so keenly in Venetian *vedute* (*478–90*).

As was true for most Expressionists, Kirchner's peak years were brief, from 1904 to c. 1920. Like many of his colleagues, he too was torpedoed by Picasso's virtuosity, imitating the Catalan's art of the 1920s in naïve, disastrous fashion. Kirchner fled Nazism to Switzerland, where his works had long been popular. There he received much-needed med-

ical care. After preparing a great potlatch of his drawings, prints, and sculpture, their maker destroyed these along with himself in 1938.

The best portraits can commemorate a special bond between sitter and painter; this is true for the Austrian painter Oskar Kokoschka's canvas of Adolf Loos (*635*), the Viennese pioneer in modern design and architecture (1870–1933). Loos was among the first to recognize the young painter's skills, and their friendship began one year before the execution of this canvas, which was first exhibited at Paul Cassirer's Berlin gallery in 1910. It dates within the three best years of Kokoschka's career as portraitist, between 1909 and 1912, a brief, radiant period during which he depicted a pantheon of predominantly Austrian intelligentsia. Though indebted to Vincent van Gogh (*616*), Lovis Corinth (*627*), and Max Slevogt (*626*), the artist realized his own incisive style, one characterized by contrasting areas of broad brushstrokes, with others where color is laid down extremely thinly, the artist often scratching through the oil to reveal the canvas beneath, as seen here in Loos's hair.

A master of the humorous, Lyonel Feininger

drew comics as his first profession. Of American birth, to a German-born father, the young painter went to Germany, where he studied art in Berlin and soon published witty pages for *Lustige Blätter* (which was published by the grand-uncle of the author of this book) before sending his soon to be popular comic strip, the "Kinderkids," from Germany to the *Chicago Tribune.*

Berlin's *Carnival* (*634*), showing the Paris suburb's elevated railway bridge crossing the background, has much the same eerie, oblique quality as Feininger's comic strips. Here human caprice is shared by that of architecture. Feininger went on to an ever more distinguished German career, becoming an important figure in its leading art school, the Bauhaus.

A far cry from Engert's pious, industrious figure seated in a Viennese domestic garden (*540*), suggesting a potential Annunciate Lily, Oskar Zwintscher's *Portrait in Flowers: The Artist's Wife* (*636*) is beyond Biedermeier industry and sentimentality. Painted in 1904, her Good Work is now self-understanding and self-fulfillment, and her garden, though with a phantasmic, Paradisiacal dimension, is not without reality, possibly including a spray of Baudelairian *Fleurs du Mal* tucked away on a *Jugendstil* espalier. The sitter's demeanor and environment are in keeping with the contemporary age of psychoanalytic discovery — that of Freud and Jung. Klimt-like, her garden grows out of the German Romantic obsession with botany that was so close to Goethe and Runge (*542*).

Poet as well as painter, Zwintscher (1870–1916) was a friend of Rilke and the Worpswede community. Bench and garden are close to the new design world of the Wiener Werkstätte.

Among the strongest young German artists to respond to Munch's achievements was Paula Modersohn-Becker (1876–1907). Brought up in Bremen, she studied at Berlin's School of Art for Women and then joined the artist's colony at Worp-

swede in the countryside near Bremen. A Barbizon School follower, Otto Modersohn, was the major figure at Worpswede and Paula Becker married him in 1901. Like van Gogh, whose work was exhibited in Berlin that year, Modersohn-Becker first painted in a muddy palette, one that brightened for her, as it had for van Gogh, once she gained an acquaintance with Impressionist art. In 1900 Modersohn-Becker left for Paris, where the Fauves and Cézanne wrought powerful changes in her work. The young German's closest friends, including her suitor Rainer Maria Rilke, had already joined the Rodin circle, where the poet became the sculptor's secretary.

Working with clear conviction and authority, whether from the figure or in still life, Modersohn-Becker soon achieved images of urgent clarity and touching, enduring strength. Without sentimentality or brutalism, her oeuvre is informed by an acute appreciation for life that is still so evident in the portraits of America's Alice Neel.

Renoir-like in its warm luminosity, a still life of 1903 by Modersohn-Becker (*638*) shows her early turn toward late Impressionism, one given fluidity without loss of structure due to the young artist's consultation of Cézanne's forceful yet fugitive watercolors. Yet this glowing canvas is a far cry from what she would achieve within the next four years.

Nursing Mother (*639*) of 1906–7 is very possibly this painter's most powerful statement; an extraordinary fusion of nurture and sacrifice, it presents the essence of motherhood. The artist has turned to African wooden sculpture, probably to Bangwa (Cameroon) wooden statuary that was already so well represented in the museums of Berlin, Munich, and Stuttgart, Modersohn-Becker having studied art in the first two of these centers. Such quotations from tribal culture recall those found in Picasso's *Demoiselles d'Avignon* (New York, Museum of Modern Art), which is exactly contemporary with Modersohn-Becker's canvas. Describing her time in Paris, the artist wrote: "My whole week has consisted of nothing but work and inspiration. I work with such passion that it shuts out everything else." Painting at a furious rate, making unbelievable strides, Modersohn-Becker wrote her increasingly

Opposite:
OSKAR ZWINTSCHER
Leipzig, 1870–Dresden-Loschwitz, 1916
Portrait in Flowers: The Artist's Wife, 1904

PAULA MODERSOHN-BECKER, Dresden, 1876–Worpswede, 1907, *Still Life with Apples,* 1903

impatient husband, who was waiting for her at Worpswede: "I *can't* come to you, I *can't*. Presently I don't want any child of yours." But Becker came for her, in 1907, just when Berlin's great canvas was completed. She returned with him, pregnant.

Though in 1900 she had written "If I've painted three good pictures, then I shall leave [life] gladly, with flowers in my hand," a letter of Modersohn-Becker's from a few days after her baby's birth noted, "I'm not afraid of anything, all will be well — except death: that is the only ghost I am afraid of, that is the only true misfortune." Two months later the artist was dead, of a pulmonary embolism.

Revolutionary, Berlin, though the capital of Prussia, consistently had a left-wing voting majority, an urban constituency ever alien to totalitarian "ideals," though often cursed by their consequences. The capital's core of political and artistic extremes — Rosa Luxembourg and Karl Sternheim were killed here — and The Sezession opened Berlin to new thought and new art, making it a potent center for new politics and new arts. Waves of immigration from the East, especially from Russia, contributed to a sense of change, a dynamic of urgency, resulting in a cosmopolitan, skeptical yet creative climate.

Opposite:
PAULA MODERSOHN-BECKER, *Nursing Mother,* c. 1906–7

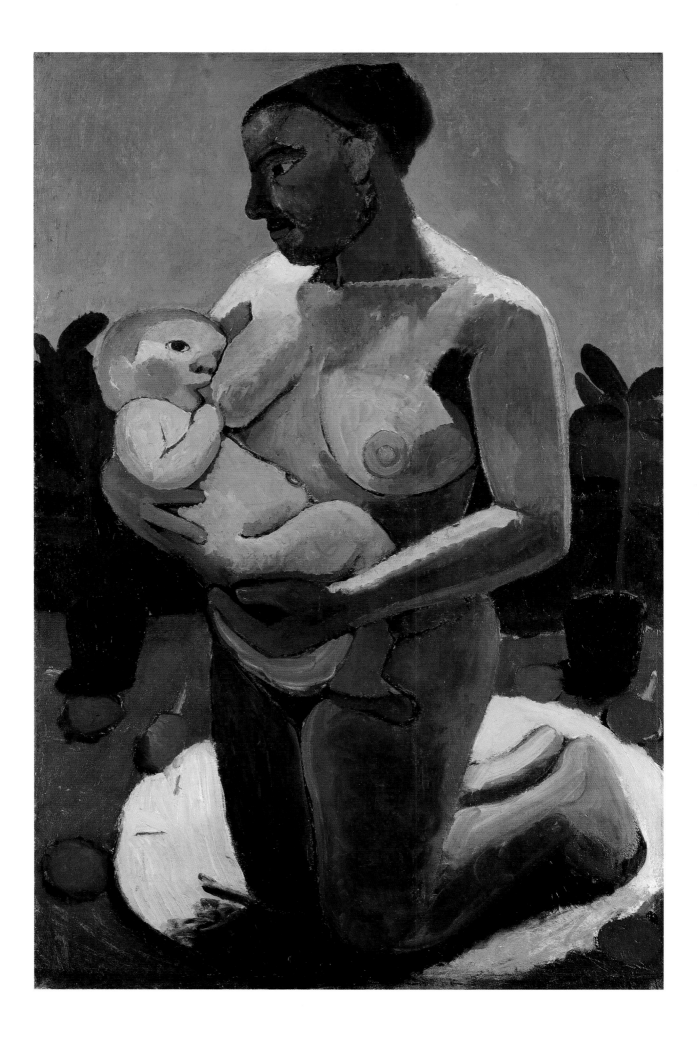

Open-minded, witty, cynical, thriving on the unorthodox, Berlin before and after World War I was in many ways Europe's intellectual center — adventurous, experimental, far less materialistic than Paris's too long professionally Bohemian heritage. Neither committed to a Protestant majority, as was true for Hamburg, nor, like Munich, with a conservative Catholic regime, Berlin remained a surprisingly liberal, artistically and politically adventurous metropolis.

Berlin-born, in 1888, Hans Richter represents that capital as Germany's Modernist center. Herwarth Walden of Der Sturm had young Hans distribute the Futurist Manifesto at the Potsdamer Platz, present site for the city's new Gemäldegalerie as well as the recently built Museum for Decorative Arts, the Library and Print Room, and the Philharmonic Hall — the city's first postwar monument to American Modernism.

Wounded in World War I, Richter was released and his new arts were soon the subject of a special issue of *Action*. Exposed to the Dada movement in Zürich in 1916, he also embraced the abstract, and had his first one-man show in Berlin. Richter was also close to music and film, combining these in experimental works and in his writings entitled *Enemy of Today's Films, Friend of Tomorrow's* (1929). Berlin was Germany's film capital; UFA, the state-subsidized company, was centered there. Richter fled Nazism for France in 1931, and yet again in 1941, when he came to the United States.

Though Richter was too little known as a painter, that medium was perhaps this singularly versatile artist's greatest strength. Richter's cataclysmic image of *Revolution* (641) of 1914 seems a singularly apt prophecy of incipient debacle from right and left alike, a rain of blood all too readily legible as anticipating the one that would ultimately destroy the rich culture that Berlin was to represent until the advent of Nazism a decade and a half after this gripping image's realization.

Radical political and social currents before and after World War I that were deeply concerned with the inequities and corruption of Western society and with a fight for individuality also brought about a pictorial *cri de coeur* against the injustices of a military society and the extremes of capitalism. These powerful feelings proved far stronger after German defeat in 1918, with its terrrible losses in human life, the Inflation, and Depression. Antimilitarism was all the stronger for the earlier honeymoon that army service had enjoyed: Corinth and Slevogt were well known for their fervor for World War I; Otto Dix, Oskar Kokoschka, and Frans Marc were all volunteers, the last being among the many talented artists who were lost in combat. Where Germany had triumphed in the Franco-Prussian War, the tables were turned after the First World War. The Hall of Mirrors at Versailles, where Germany had demanded massive reparations from their French invaders, now was the site at which the Allies exacted crippling reparations from the former victors.

As artists, Expressionists seldom aged well, soon softening with success. Some, like Max Beckmann (633), Oskar Kokoschka (635), or Emil Nolde (629), deteriorated into garrulous Old Masters, depending upon a neo-Venetian haze or pretentious symbolism to disguise lack of rigor and diminishing skills, substituting size and "Meaning" for intrinsic significance. A Fauve spark initiated their art, which often dwindled into a somewhat mindless, shapeless Primitivism. As long as they stayed close to the restraint of graphism, these painters flourished, but, by the time Nazism drove them from Germany, with the *Entarte Kunst* (Degenerate Art) exhibitions in Berlin and Munich of 1937, the movement was long played out.

Opposite:
HANS RICHTER, Berlin, 1888–1976, *Revolution,* 1914

LIST OF ILLUSTRATIONS

Aert Anthonisz.
Battle at Sea, 1604
Oak, 8¹⁵⁄₁₆ in. (23 cm) diameter
Ex coll. Suermondt
Gemäldegalerie, cat. no. 740A

Antonello da Messina
A Young Man, 1474
Poplar, 12½ x 10⅛ in. (32 x 26 cm)
Gemäldegalerie, cat. no. 18A

A Young Man, 1478
Walnut, 8 x 5¹¹⁄₁₆ in. (20.4 x 14.5 cm)
Ex coll. Solly
Gemäldegalerie, cat. no. 18

Antonio Veneziano
The Apostle James the Greater, c. 1384
Poplar, 20¹⁄₁₆ x 12⅞ in. (51.4 x 33 cm)
Ex coll. Solly
Gemäldegalerie, cat. no. 1104

Balthasar van der Ast
Still Life with Apple Blossoms, 1635
Oak, 8⁹⁄₁₆ x 15 in. (22 x 38.5 cm)
Gemäldegalerie, cat. no. 934B

Still Life with Fruit Basket, c. 1625
Oak, 5⁹⁄₁₆ x 7¹³⁄₁₆ in. (14.3 x 20 cm)
Gemäldegalerie, cat. no. 1786

Barent Avercamp
Landscape with Frozen River, c. 1655
Oak, 7⁷⁄₁₆ x 12¹⁄₁₆ in. (19 x 31 cm)
Ex coll. Solly
Gemäldegalerie, cat. no. 760

Dirck van Baburen
Christ Washing the Apostles' Feet, c. 1616
Canvas, 77⅝ x 115¹³⁄₁₆ in. (199 x 297 cm)
Ex coll. Giustiniani
Gemäldegalerie, cat. no. 462

Bacchiacca
Woman with a Cat
Poplar, 10⅛ x 7³⁄₁₆ in. (26 x 18.5 cm)
Gemäldegalerie, cat. no. 267A

Giovanni Baglione
The Triumph of Heavenly over Earthly Love,
c. 1602–03
Poplar, 10⅛ x 7³⁄₁₆ in. (26 x 18.5 cm)
Gemäldegalerie, cat. no. 381

Alessio Baldovinetti, *see* Antonio Pollaiuolo

Hans Baldung
The Crucifixion, 1512
Linden, 58⅞ x 40⁹⁄₁₆ in. (151 x 104 cm)
Gemäldegalerie, cat. no. 603

The Lamentation, c. 1515
Linden, 54³⁄₁₆ x 36¼ in. (139 x 93 cm)
Gemäldegalerie, cat. no. 603B

Ludwig, Count von Löwenstein (1463–1524), 1513
Linden, 17¹⁵⁄₁₆ x 12⅞ in. (46 x 33 cm)
Gemäldegalerie, cat. no. 1842

Pyramus and Thisbe, c. 1530
Linden, 36¼ x 26⅛ in.
(93 x 67 cm)
Gemäldegalerie, cat. no. 1875

The Three Kings Altarpiece, 1507:
Central panel and interior wings:
*The Adoration of the Magi; SS. George and
Maurice*
Exterior wings: *SS. Catherine of Alexandria
and Agnes*
Linden, central panel 47³⁄₁₆ x 27⁵⁄₁₆ in.
(121 x 70 cm); each wing 47³⁄₁₆ x 10¹⁵⁄₁₆ in.
(121 x 28 cm)
Ex coll. Wilke, Halle
Gemäldegalerie, cat. no. 603A

Virgin and Child, c. 1539–40
Linden, 35½ x 24¹⁵⁄₁₆ in. (91 x 64 cm)
Gemäldegalerie, cat. no. 552B

Lazzaro Bastiani (?)
Madonna and Child in Painted Frame
Poplar, 30¹³⁄₁₆ x 26⅛ in. (79 x 67 cm),
including painted frame; inner painted
surface 21¼ x 16⁹⁄₁₆ in.
(54.5 x 42.5 cm)
Gemäldegalerie, cat. no. 27

Pompeo Girolamo Batoni
The Marriage of Cupid and Psyche, 1756
Canvas, 32⅜ x 46 in. (83 x 118 cm)
Gemäldegalerie, cat. no. 504

Paul Baum
Landscape, 1896
Canvas, 26¹⁵⁄₁₆ x 34⁵⁄₁₆ in. (69 x 88 cm)
Berlinische Galerie, cat. no. BG-M 3826/86

Francesco Beccaruzzi
A Ballplayer and His Page
Canvas, 40³⁄₁₆ x 45⅝ in. (103 x 117 cm)
Gemäldegalerie, cat. no. 158

Max Beckmann
Small Deathbed Scene, 1906
Canvas, 42⅞ x 27¹¹⁄₁₆ in. (110 x 71 cm)
Nationalgalerie, cat. no. B 53/25

Osias Beert
*Still Life with Cherries and Strawberries in
Porcelain Bowls*, 1608
Copper, 19½ x 25½ in. (50 x 65.5 cm)
Gemäldegalerie, cat. no. 2/60

Cornelis Bega
Lutanist, 1662
Canvas, 13⅝ x 12½ in. (35 x 32 cm)
Ex Prussian Royal Collection
Gemäldegalerie, cat. no. 871

Jean Bellegambe
The Last Judgment, c. 1525
Oak, central panel 86⁹⁄₁₆ x 69⁷⁄₁₆ in.
(222 x 178 cm); each wing 86⁹⁄₁₆ x 31¹⁵⁄₁₆ in.
(222 x 82 cm)
Gemäldegalerie, cat. no. 641

Gentile Bellini
Madonna and Child with Donors, c. 1460
Linden, 28¹¹⁄₁₆ x 17¾ in. (73.5 x 45.5 cm)
Ex coll. Solly
Gemäldegalerie, cat. no. 1180

Giovanni Bellini
Dead Christ Supported by Two Angels,
c. 1480–85
Poplar, 32⅛ x 26⁵⁄₁₆ in. (83 x 67.5 cm)
Ex coll. Solly
Gemäldegalerie, cat. no. 28

Madonna and Child
Poplar, 29⁷⁄₁₆ x 20¹¹⁄₁₆ in. (75.5 x 53 cm)
Gemäldegalerie, cat. no. 10A

Madonna, with Child Standing on a Parapet
Poplar, 26⅛ x 19⅛ in. (67 x 49 cm)
Ex coll. Solly
Gemäldegalerie, cat. no. 1177

The Resurrection, 1475–79
Canvas, transferred from poplar panel,
57¾ x 49¹⁵⁄₁₆ in. (148 x 128 cm)
Gemäldegalerie, cat. no. 1177A

Jacopo Bellini
Two panels from an altarpiece, c. 1430–35:
St. John the Evangelist
The Apostle Peter
Poplar, each panel 33⅛ x 9⁵⁄₁₆ in.
(85 x 24 cm)
Ex coll. Solly
Gemäldegalerie, cat. no. 1161

Nicolaes Pietersz. Berchem
Return from the Falcon Hunt, c. 1670
Oak, 29¼ x 41⁵⁄₁₆ in. (75 x 106 cm)
Gemäldegalerie, cat. no. KFMV 253

Bartolomé Bermejo
The Death of the Virgin, c. 1460–62
Oak, 24⁹⁄₁₆ x 16 in. (63 x 41 cm)
Ex coll. Solly
Gemäldegalerie, cat. no. 552

Karl Blechen
Fishermen at the Gulf of Naples, c. 1829–30
Canvas, 7¹³⁄₁₆ x 13¼ in. (20 x 34 cm)
Nationalgalerie, cat. no. F 561

Friedrich Wilhelm III's Palm Court, 1832
Paper over canvas, 25 x 21¹³⁄₁₆ in.
(64 x 56 cm)
Nationalgalerie, cat. no. AI 617

Rolling Mill, c. 1834
Canvas, 10 x 12⅞ in. (25.5 x 33 cm)
Nationalgalerie, cat. no. F561

Sanssouci Palace, 1830–32
Paper, 16 x 12⅞ in. (41 x 33 cm)
Nationalgalerie, cat. no. AI 319

Self-Portrait, 1823
Canvas mounted on board, 10⅛ x 7¹³⁄₁₆ in.
(26 x 20 cm)
Nationalgalerie, cat. no. AI 1002

Stormy Weather over the Roman Campagna,
1829
Board, 10¾ x 17⅜ in. (27.5 x 44.5 cm)
Nationalgalerie, cat. no. FV 40

Study for a Funerary Monument, 1824–27
Board over wood, 5¼ x 9 in. (13.5 x 23 cm)
Nationalgalerie, cat. no. F 561

The Tivoli Gardens at the Villa d'Este, 1831–32
Canvas, 49¾ x 36¹¹⁄₁₆ in. (127.5 x 94 cm)
Nationalgalerie, cat. no. AIII 463

A View of Rooftops and Gardens, c. 1835
Canvas, 7¹³⁄₁₆ x 10⅛ in. (20 x 26 cm)
Nationalgalerie, cat. no. AI 319

Abraham Bloemaert
Charikleia and Theagenes, 1625
Canvas, 37¹⁄₁₆ x 45¹³⁄₁₆ in. (95 x 117.5 cm)
Schloss Sanssouci, cat. no. 2531

Arnold Böcklin
Campagna Landscape, c. 1857–58
Canvas, 34⁵⁄₁₆ x 41 in. (88 x 105 cm)
Nationalgalerie, cat. no. AI 1112

The Deposition, c. 1871–74
Tempera and colored varnish on panel,
62⅜ x 97½ in. (160 x 250 cm)
Nationalgalerie, cat. no. AI 827

The Isle of the Dead, 1883
Panel, 31³⁄₁₆ x 58½ in. (80 x 150 cm)
Nationalgalerie, cat. no. NG 2/80

Roger and Angelica, c. 1871–74
Tempera on panel, 17³⁄₁₆ x 14¹⁄₁₆ in.
(44 x 36 cm)
Nationalgalerie, cat. no. AI 753

Self-Portrait with Death as Fiddler, c. 1871–74
Canvas, 29¼ x 23¹³⁄₁₆ in. (75 x 61 cm)
Nationalgalerie, cat. no. AI 633

The Surf, 1883
Panel, 47³⁄₁₆ x 32 in. (121 x 82 cm)
Nationalgalerie, cat. no. AI 611

Heinrich Bollandt
*Erdmann August, Crown Prince of
Brandenburg-Bayreuth*
Linden, 23¹⁵⁄₁₆ x 21³⁄₁₆ in.
(61.5 x 54.3 cm)
Jagdschloss Grunewald, cat. no. GKI 2107

Paris Bordone
*Madonna and Child with SS. Roche, Sebastian,
Catherine of Alexandria, and Fabianus,* c. 1535
Poplar, 115⁷⁄₁₆ x 69¹³⁄₁₆ in. (296 x 179 cm)
Gemäldegalerie, cat. no. 191

Hieronymus Bosch
St. John on Patmos, and *Scenes from the
Passion of Christ,* c. 1485–90
Oak, 24⁹⁄₁₆ x 16⅞ in. (63 x 43.3 cm)
Ex coll. Fuller Maitland, London
Gemäldegalerie, cat. no. 1647A

Botticelli
Madonna and Child with Singing Angels,
c. 1477
Poplar, 52⅝ in. (135 cm) diameter
Ex coll. Raczynski
Gemäldegalerie, cat. no. 102A

*Madonna and Child Enthroned with SS. John
the Baptist and John the Evangelist,* 1484
Poplar, 72⅛ x 70³⁄₁₆ in. (185 x 180 cm)
Gemäldegalerie, cat. no. 106

St. Sebastian, 1474
Poplar, 76¹⁄₁₆ x 29¼ in. (195 x 75 cm)
Ex coll. Solly
Gemäldegalerie, cat. no. 1128

Botticelli (studio of)
Profile Portrait of a Young Woman, after 1480
Poplar, 18½ x 13⅝ in. (47.5 x 35 cm)
Gemäldegalerie, cat. no. 106A

Venus
Poplar, 61⅝ x 26¹¹⁄₁₆ in. (158 x 68.5 cm)
Ex coll. Solly
Gemäldegalerie, cat. no. 1124

François Boucher
The Education of Cupid, 1742
Canvas, 46 x 52¼ in. (118 x 134 cm)
Schloss Charlottenburg, cat. no. GKI 4509

Louis de Boullogne the Younger
Earth, 1698
Copper, 20⁵⁄₁₆ x 17½ in. (52 x 45 cm)
Schloss Sanssouci, cat. no. 9998

Sébastien Bourdon
The Adoration of the Magi, c. 1642–45
Copper, 17¹⁵⁄₁₆ x 14¹⁄₁₆ in. (46 x 36 cm)
Schloss Sanssouci, cat. no. 5132

Esaias Boursse
Dutch Interior with Woman Sewing, c. 1660
Canvas, 20¼ x 23 in. (52 x 59 cm)
Gemäldegalerie, cat. no. 2036

Agnolo Bronzino
Ugolino Martelli (1519–1592), c. 1535–38
Poplar, 39¾ x 33⅛ in. (102 x 85 cm)
Gemäldegalerie, cat. no. 338A

Adriaen Brouwer
Dune Landscape by Moonlight, c. 1635–37
Oak, 9¾ x 13¼ in. (25 x 34 cm)
Ex coll. Suermondt
Gemäldegalerie, cat. no. 853B

Pieter Bruegel
Netherlandish Proverbs, 1559
Oak, 45⅝ x 63⁹/₁₆ in. (117 x 163 cm)
Gemäldegalerie, cat. no. 1720

Two Chained Monkeys, 1562
Oak, 7¹³/₁₆ x 9 in. (20 x 23 cm)
Gemäldegalerie, cat. no. 2077

Jan Brueghel the Elder
Bouquet of Flowers, c. 1609–15
Oak, 25 x 23 in. (64 x 59 cm)
Gemäldegalerie, cat. no. 688A

Jan Brueghel the Younger
Paradise, c. 1620
Oak, 23 x 16⅜ in. (59 x 42 cm)
Ex Prussian Royal Collection
Gemäldegalerie, cat. no. 742

**Giuliano di Piero di Simone Bugiardini
(ascribed to)**
Spalliere with Scenes from the
Story of Tobias
Poplar, 23½ x 62 in. (60.3 x 159 cm),
23³/₁₆ x 61⅝ in. (59.5 x 158 cm)
Gemäldegalerie, cat. nos. 142, 149

Hendrick van der Burch (attributed to)
Dutch Interior, c. 1660
Canvas, 17 x 14¼ in. (43.5 x 36.5 cm)
Ex coll. Thiem
Gemäldegalerie, cat. no. 912D

Friedrich Bury
Countess Luise von Voss, 1810
Canvas, 29½ x 21¾ in. (75.6 x 55.8 cm)
Gemäldegalerie, cat. no. 4/55

Willem Pietersz. Buytewech
Merry Company, c. 1622–24
Canvas, 25⅜ x 31⁹/₁₆ in. (65 x 81 cm)
Gemäldegalerie, cat. no. 1983

Merry Company on a Garden Terrace,
c. 1616–17
Canvas, 27¹¹/₁₆ x 36¹¹/₁₆ in. (71 x 94 cm)
Gemäldegalerie (on loan)

Robert Campin
Madonna by a Grassy Bank, c. 1425
Oak, 15⁵/₁₆ x 10½ in. (39.2 x 27 cm)
Ex coll. von Kaufmann
Gemäldegalerie, cat. no. 1835

Robert de Masmines, c. 1425
Oak, 11⅛ x 6⅞ in. (28.5 x 17.7 cm)
Ex coll. Sir Hope Edwards
Gemäldegalerie, cat. no. 537A

Canaletto
The Campo di Rialto, c. 1758–63
Canvas, 46⁷/₁₆ x 72½ in. (119 x 186 cm)
Gemäldegalerie, Streit No. 5

Capriccio
Canvas, 10¹⁵/₁₆ x 15¹⁵/₁₆ in. (28 x 41 cm)
Gemäldegalerie, cat. no. 1990

Figure Studies
Paper on pasteboard, 15¹⁵/₁₆ x 22¹³/₁₆ in.
(41 x 58.5 cm)
Gemäldegalerie, cat. no. KFMV 249

*The Grand Canal Looking Down to the Rialto
Bridge,* c. 1758–63
Canvas, 46 x 73⅝ in. (118 x 188 cm)
Gemäldegalerie, Streit No. 3

*Santa Maria della Salute Seen from the Grand
Canal,* shortly before 1730
Canvas, 17³/₁₆ x 34¹¹/₁₆ in. (44 x 89 cm)
Gemäldegalerie, cat. no. 1653

The Vigilia di S. Marta, after 1755–56
Canvas, 46⁷/₁₆ x 72¹⁵/₁₆ in. (119 x 187 cm)
Gemäldegalerie, Streit No. 6

The Vigilia di S. Pietro, after 1755–56
Canvas, 46⁷/₁₆ x 72¹⁵/₁₆ in. (119 x 187 cm)
Gemäldegalerie, Streit No. 4

Caravaggio
Amor Victorious, c. 1602
Canvas, 60¹³/₁₆ x 44¹/₁₆ in. (156 x 113 cm)
Ex coll. Giustiniani
Gemäldegalerie, cat. no. 369

The Doubting Thomas, c. 1595–1600
Canvas, 41¾ x 56¹⁵/₁₆ in. (107 x 146 cm)
Schloss Sanssouci, cat. no. 5438

Vittore Carpaccio
The Entombment, c. 1505
Canvas, 56½ x 72⅛ in. (145 x 185 cm)
Gemäldegalerie, cat. no. 23A

The Ordination of St. Stephen as Deacon, 1511
Canvas, 57¾ x 90¹/₁₆ in. (148 x 231 cm)
Ex coll. Solly
Gemäldegalerie, cat. no. 23

Annibale Carracci
*Roman River Landscape with Castle and
Bridge,* c. 1600
Canvas, 28½ x 55¾ in. (73 x 143 cm)
Ex coll. Giustiniani
Gemäldegalerie, cat. no. 372

Ludovico Carracci
Christ Served by Angels in the Wilderness,
c. 1608–10
Canvas, 61¹⁵/₁₆ x 87⅞ in. (157.2 x 225.3 cm)
Gemäldegalerie, cat. no. 2/85

Carl Gustav Carus
Morning Fog, c. 1825
Paper mounted on board, 7⅝ x 10⅛ in.
(19.5 x 26 cm)
Nationalgalerie, cat. no. AII 425

Andrea Castagno
*The Assumption of the Virgin with SS. Julian
and Miniato,* c. 1450
Poplar, 51¹/₁₆ x 58¹¹/₁₆ in. (131 x 150.5 cm)
Ex coll. Solly
Gemäldegalerie, cat. no. 47A

Giovanni Benedetto Castiglione
Pyrrha and Deucalion, 1655
Canvas, 32½ x 41¾ in. (83.3 x 107 cm)
Gemäldegalerie, cat. no. 2078

Paul Cézanne
Still Life, 1871
Canvas, 23⅜ x 31¹³/₁₆ in. (65 x 81.5 cm)
Nationalgalerie, cat. no. AI 964

Still Life with Flowers and Fruit, c. 1888–90
Canvas, 26 x 32⅛ in. (66 x 81.5 cm)
Nationalgalerie, cat. no. AI 965

Jean-Baptiste-Siméon Chardin
Dead Pheasant and Game Bag, 1760
Canvas, 28¹/₁₆ x 22⅝ in. (72 x 58 cm)
Gemäldegalerie, cat. no. 1944

The Drawing Lesson, 1737
Canvas, 31⁹/₁₆ x 26⅛ in. (81 x 67 cm)
Gemäldegalerie, cat. no. 2076

*Servant Returning from the Market
(La Pourvoyeuse),* 1738
Canvas, 17¹⁵/₁₆ x 14⁷/₁₆ in. (46 x 37 cm)
Schloss Charlottenburg, cat. no. GKI 2330

Sealing the Letter, 1733
Canvas, 56¹⁵/₁₆ x 57⁵/₁₆ in. (146 x 147 cm)
Schloss Charlottenburg, GKI 4507

Daniel Nikolaus Chodowiecki
The Lying-in Room, 1759
Pine, 11¹¹⁄₁₆ x 9⅜ in. (30 x 24 cm)
Gemäldegalerie, cat. no. 2006

The Lying-in Room, 1759
Pine, 11¹¹⁄₁₆ x 9⅜ in. (30 x 24 cm)
Gemäldegalerie, cat. no. 2008

Petrus Christus
Madonna and Child with St. Barbara and a Carthusian Monk (Exeter Madonna), c. 1450
Oak, 7⁷⁄₁₆ x 5⁷⁄₁₆ in. (19 x 14 cm)
Ex coll. Marquis of Exeter, Burleigh House
Gemäldegalerie, cat. no. 523B

Two wings from a triptych, 1452:
Left wing: *The Annunciation and The Nativity*
Right wing: *The Last Judgment*
Oak, each 52¼ x 21¹³⁄₁₆ in. (134 x 56 cm)
Gemäldegalerie, cat. nos. 529A, 529B

A Young Lady, c. 1470
Oak, 11⁵⁄₁₆ x 8¾ in. (29 x 22.5 cm)
Ex coll. Solly
Gemäldegalerie, cat. no. 532

Cima da Conegliano
The Healing of Anianus
Poplar, 67¹⁄₁₆ x 52⅝ in. (172 x 135 cm)
Gemäldegalerie, cat. no. 15

Madonna and Child Enthroned with SS. Peter, Romuald, Benedict, and Paul, c. 1495–97
Poplar, 80⁵⁄₁₆ x 52⅝ in. (206 x 135 cm)
Ex coll. Solly
Gemäldegalerie, cat. no. 2

Pieter Codde
Actors' Changing Room, c. 1630s
Oak, 12⅞ x 20¼ in. (33 x 52 cm)
Ex coll. Suermondt
Gemäldegalerie, cat. no. 800A

Cologne Master
Diptych, c. 1320–30:
Left panel: *Madonna and Child Enthroned*
Right panel: *Crucifixion*
Oak, 19⁵⁄₁₆ x 26½ in. (49.5 x 68 cm)
Gemäldegalerie, cat. no. 1627

Cologne Master of the Life of the Virgin
Madonna and Child, c. 1470
Oak, 22⁷⁄₁₆ x 19¹¹⁄₁₆ in. (57.5 x 50.5 cm)
Gemäldegalerie, cat. no. 1235B

Cologne Master of the Life of the Virgin (Circle of)
Madonna and Child with Three Saints, c. 1470
Oak, 38¼ x 33¹⁵⁄₁₆ in. (98 x 87 cm)
Ex coll. Solly
Gemäldegalerie, cat. no. 1235

Cologne School
The Life of Christ: (altar in thirty-five scenes), c. 1410–20
Oak, 32 x 43⁵⁄₁₆ in. (82 x 111 cm)
Gemäldegalerie, cat. no. 1224

Woman of the Apocalypse (Madonna and Child atop the Sun and Moon), c. 1390–1400
Oak, 12⁵⁄₁₆ x 7⅝ in. (31.5 x 19.5 cm)
Ex coll. Suermondt
Gemäldegalerie, cat. no. 1205A

John Constable
The Admiral's House (The Grove), c. 1820–23
Canvas, 23⅜ x 19½ in. (60 x 50 cm)
Nationalgalerie, cat. no. AI 850

The Stour Valley from Higham, c. 1804
Canvas, 17¹⁵⁄₁₆ x 23¹³⁄₁₆ in. (46 x 61 cm)
Nationalgalerie, cat. no. AI 555

Lovis Corinth
Samson Blinded, 1912
Canvas, 50¹¹⁄₁₆ x 41 in. (130 x 105 cm)
Nationalgalerie, cat. no. AIII 668

Corneille de Lyon
A Young Lady
Oak, 6⅞ x 5¾ in. (17.7 x 14.8 cm)
Gemäldegalerie, cat. no. 2165

Cornelis Cornelisz. van Haarlem
Bathsheba
Canvas, 39¾ x 50¹¹⁄₁₆ in. (102 x 130 cm)
Gemäldegalerie, cat. no. 734

Temperance
Canvas, 37¹⁄₁₆ x 55⅜ in. (95 x 142 cm)
Schloss Sanssouci, cat. no. 2658

Peter von Cornelius
Joseph Recognized by His Brothers, from the *Joseph Cycle,* 1816
Fresco with tempera overpainting, 92¹⁄₁₆ x 113⅛ in. (236 x 290 cm)
From the Casa Bartholdy, Rome
Nationalgalerie, cat. no. AI 419

Correggio
Leda and the Swan, c. 1532
Canvas, 59¼ x 74½ in. (152 x 191 cm)
Ex Prussian Royal Collection
Gemäldegalerie, cat. no. 218

Cossa, Francesco del, *see* **Anonymous, Ferrarese**

Gustave Courbet
Cliffs at Étretat, 1870
Canvas, 25¾ x 32 in. (66 x 82 cm)
Nationalgalerie, cat. no. NG 44/76

The Wave, 1870
Canvas, 43¹¹⁄₁₆ x 56³⁄₁₆ in. (112 x 144 cm)
Nationalgalerie, cat. no. AI 967

Lucas Cranach the Elder
David and Bathsheba, 1526
Red beechwood, 15⅛ x 10 in. (38.8 x 25.7 cm)
Ex coll. Knaus
Gemäldegalerie, cat. no. 567B

Fountain of Youth, 1546
Linden, 47¾ x 72¾ in. (122.5 x 186.5 cm)
Ex Prussian Royal Collection
Gemäldegalerie, cat. no. 593

Johannes Carion, c. 1530
Beech, 20¼ x 14½ in. (52 x 37.3 cm)
Gemäldegalerie (on loan)

Judith Victorious, c. 1530
Beech, 29¼ x 21¹³⁄₁₆ in. (75 x 56 cm)
Jagdschloss Grunewald, cat. no. GKI 1182

Katharina von Bora, c. 1525
Panel, 4⁵⁄₁₆ in. (11 cm) diameter
Gemäldegalerie, cat. no. 637

A Lady (The Wife of Law Professor Johannes Reuss), 1503
Spruce, 20½ x 14⅛ in. (52.5 x 36.2 cm)
Ex coll. Fürst Schwarzburg-Rudolstadt
Gemäldegalerie, cat. no. 1907

Lucretia, 1533
Red beechwood, 14½ x 9⁵⁄₁₆ in. (37.3 x 23.9 cm)
Ex coll. Knaus
Gemäldegalerie, cat. no. 1832

The Rest on the Flight into Egypt, 1504
Linden, 27⁹/₁₆ x 20¹¹/₁₆ in. (70.7 x 53 cm)
Ex coll. Fiedler, Munich
Gemäldegalerie, cat. no. 564A

Venus and Cupid, c. 1530
Linden, 65⅛ x 24³/₁₆ in. (167 x 62 cm)
Ex Prussian Royal Collection
Gemäldegalerie, cat. no. 594

Luigi Crespi
Elisabetta Cellesi (?), 1732
Canvas, 47⁹/₁₆ x 32⁵/₁₆ in. (122 x 82.8 cm)
Gemäldegalerie, cat. no. 5/55

Carlo Crivelli
*Madonna and Child Enthroned with
Presentation of Keys to St. Peter, with SS. John
of Capistrano, Emidius, Francis, Louis of
Toulouse, James of the Marches, and an
Unidentified Bishop,* 1488
Poplar, 74½ x 76⁷/₁₆ in. (191 x 196 cm)
Gemäldegalerie, cat. no. 1156A

Bernardo Daddi
The Temptation of St. Thomas Aquinas, 1338
Poplar, 14¹³/₁₆ x 13¹/₁₆ in. (38 x 33.5 cm)
Gemäldegalerie, cat. no. 1094

Triptych, c. 1338–1340
Left wing: *The Nativity*
Middle panel: *The Coronation of the Virgin*
Right wing: *The Crucifixion*
Poplar, including frames 22¼ x 22⅝ in.
(57 x 58 cm); middle painted surface
16⁷/₁₆ x 8⅜ in. (42.2 x 21.5 cm); wings each
14⅝ x 5¹¹/₁₆ in. (37.5 x 14.5 cm)
Ex coll. Solly
Gemäldegalerie, cat. no. 1064

Johan Christian Clausen Dahl
Cloud Study with Horizon, 1832
Board, 9¾ x 10¹⁵/₁₆ in. (25 x 28 cm)
Nationalgalerie, cat. no. AII 91

Jacques Daret
Two wings from the *St. Vaast Altar,* 1434–35
The Visitation
The Adoration of the Magi
Oak, each 22¼ x 20¼ in. (57 x 52 cm)
Ex coll. Solly
Gemäldegalerie, cat. nos. 542, 527

Honoré Daumier
Don Quixote and Sancho Panza, c. 1866–88
Canvas, 30⁷/₁₆ x 46¹³/₁₆ in. (78 x 120 cm)
Nationalgalerie, cat. no. AI 976

Gerard David
The Crucifixion, c. 1515
Oak, 55 x 39 in. (141 x 100 cm)
Ex coll. Solly
Gemäldegalerie, cat. no. 573

Edgar Degas
Conversation chez la modiste, c. 1884
Pastel on board, 25⅜ x 33½ in. (65 x 86 cm)
Nationalgalerie, cat. no. AI 552

Ludwig Deppe
Houses at a Millrace, 1820
Canvas, 17¾ x 21¹³/₁₆ in. (45.5 x 56 cm)
Schloss Charlottenburg, GKI 4369

Antonio Diziani
*Feast of Corpus Christi Procession, Piazza di
San Marco,* 1758–63
Canvas, 46⁷/₁₆ x 72¹⁵/₁₆ in. (119 x 187 cm)
Gemäldegalerie, Streit No. 10

The Sala del Maggior Consiglio, Doges' Palace,
c. 1758–63
Canvas, 60¼ x 72¾ in. (154.5 x 186.5 cm)
Gemäldegalerie, Streit No. 7

Domenico Veneziano
The Adoration of the Magi, c. 1439–41
Poplar, 32¾ in. (84 cm) diameter
Gemäldegalerie, cat. no. 95A

The Martyrdom of St. Lucy, c. 1445–48
Poplar, 10⁵/₁₆ x 11½ in. (26.5 x 29.5 cm)
Gemäldegalerie, cat. no. 64

Gerard Dou
The Young Mother, c. 1655–60
Oak, 19⅛ x 14¼ in. (49.1 x 36.5 cm)
Ex coll. Duke of Westminster
Gemäldegalerie, cat no. KFMV 269

Albrecht Dürer
*Duke Frederick III (the Wise), Elector of
Saxony,* c. 1496
Watercolor on canvas, 29⅝ x 22¼ in.
(76 x 57 cm)
Ex coll. Duke of Hamilton
Gemäldegalerie, cat. no. 557C

Hieronymus Holzschuher, 1526
Linden, 19⅞ x 14⁷/₁₆ in. (51 x 37 cm)
Ex coll. Holzschuher
Gemäldegalerie, cat. no. 557E

Protective cover for Holzschuher portrait,
1526
Linden, 19⅞ x 14⁷/₁₆ in. (51 x 37 cm)
Ex coll. Holzschuher
Gemäldegalerie, cat. no. 557E

Madonna with a Siskin, 1506
Poplar, 35½ x 29⅝ in. (91 x 76 cm)
Ex coll. Marquis of Lothian, Edinburgh
Gemäldegalerie, cat. no. 557F

Jakob Muffel, 1526
Canvas, transferred from panel,
18¾ x 14⅛ in. (48 x 36 cm)
Ex coll. Narischkine
Gemäldegalerie, cat. no. 557D

A Young Venetian Woman, c. 1506
Poplar, 11⅛ x 8⅜ in. (28.5 x 21.5 cm)
Gemäldegalerie, cat. no. 557G

Willem Cornelisz. Duyster
Carnival Clowns, c. 1620
Oak, 10¹⁵/₁₆ x 14¹¹/₁₆ in. (28 x 37.7 cm)
Ex coll. Schubart, Munich
Gemäldegalerie, cat. no. 1735

A Music-Making Couple
Oak, 16¹⁵/₁₆ x 14 in. (43.4 x 35.9 cm)
Jagdschloss Grunewald, cat. no. GKI 5196

Anthony van Dyck
An Apostle, c. 1618
Oak, 23¾ x 19⅛ in. (61 x 49 cm)
Ex coll. Suermondt
Gemäldegalerie, cat. no. 790 F

An Apostle with Folded Hands, c. 1618–20
Paper on oak panel, 22¼ x 17½ in.
(57 x 45 cm)
Gemäldegalerie, cat. no. 798F

An Aristocratic Genoese Couple, c. 1622–26
Canvas, each 78 x 45¼ in. (200 x 116 cm)
Gemäldegalerie, cat. nos. 782B, 782C

The Descent of the Holy Spirit (Pentecost),
c. 1618–20
Canvas, 103⅜ x 85¹³/₁₆ in. (265 x 220.5 cm)
Schloss Sanssouci, cat. no. 10623

Marchesa Geronima Spinola, c. 1624–26
Canvas, 88⅛ x 58⅞ in. (226 x 151 cm)
Gemäldegalerie, cat. no. 787A

Adam Elsheimer
Holy Family with Angels, c. 1598–1600
Copper, 14⅝ x 9½ in. (37.5 x 24.3 cm)
Gemäldegalerie, cat. no. 2039

Nymph Fleeing Satyrs
Copper, 5⁷⁄₁₆ x 7¹³⁄₁₆ in. (14 x 20 cm)
Gemäldegalerie, cat. no. 664A

Cornelis Engebrechtsz
Virgin and Child with St. Anne, c. 1500
Oak, 9⁹⁄₁₆ in. (23.5 cm) diameter
Gemäldegalerie, cat. no. 609

Erasmus Engert
Viennese Domestic Garden, c. 1828–30
Canvas, 12½ x 10³⁄₁₆ in. (32 x 26.1 cm)
Nationalgalerie, cat. no. AI 852

Jan van Eyck
Baudoin de Lannoy, c. 1431–35
Oak, 10⅛ x 7⅝ in. (26 x 19.5 cm)
Gemäldegalerie, cat. no. 525G

Giovanni Arnolfini, 1434
Oak, 11⁵⁄₁₆ x 7¹³⁄₁₆ in. (29 x 20 cm)
Ex coll. Earl of Shrewsbury, Alton Towers
Gemäldegalerie, cat. no. 523A

The Madonna in the Church, c. 1425–27
Oak, 12¹⁄₆ x 5⁷⁄₁₆ in. (31 x 14 cm)
Ex coll. Suermondt
Gemäldegalerie, cat. no. 525C

Barent Pietersz. Fabritius
The Slaughtered Pig, 1656
Canvas, 31 x 25⁷⁄₁₆ in. (79.5 x 65.3 cm)
Gemäldegalerie, cat. no. 819B

Henri Fantin-Latour
Self-Portrait, 1858
Canvas, 40 x 27⅞ in. (102.5 x 71.5 cm)
Nationalgalerie, cat. no. AI 971

Lyonel Feininger
Carnival, 1908
Canvas, 26¹⁵⁄₁₆ x 21⁷⁄₁₆ in. (69 x 54 cm)
Nationalgalerie, cat. no. AIV 500

Anselm Feuerbach
Miriam, 1862
Canvas, 39¾ x 31⁹⁄₁₆ in. (102 x 81 cm)
Nationalgalerie, cat. no. AI 1101

Platonic Banquet, 1873
Canvas, 156 x 292½ in. (400 x 750 cm)
Nationalgalerie, cat. no. AI 279

Ricordo da Tivoli, 1867
Canvas, 75¹¹⁄₁₆ x 51¹⁄₁₆ in. (194 x 131 cm)
Nationalgalerie, cat. no. AI 732

Frans Floris de Vriendt
Venus at Vulcan's Forge, c. 1560–64
Oak, 58½ x 77¼ in. (150 x 198 cm)
Gemäldegalerie, cat. no. 698

Vincenzo Foppa
Madonna and Child, c. 1460–70
Poplar, 22¼ x 16 in. (57 x 41 cm)
Ex coll. Solly
Gemäldegalerie, cat. no. 1368

Jean Fouquet
Estienne Chevalier with St. Stephen, c. 1450
Oak, 36¼ x 33½ in. (93 x 86 cm)
Ex coll. Brentano, Frankfort
Gemäldegalerie, cat. no. 1617

Francesco di Giorgio Martini (attributed to)
Architectural View, c. 1477
Poplar, 48⅜ x 91¼ in. (124 x 234 cm)
Gemäldegalerie, cat. no. 1615

Francesco di Vannuccio
Crucifixion with Donor, 1380
Poplar, 9⅜ x 7 in. (24 x 18 cm),
framed 15³⁄₁₆ x 8¾ in. (39 x 22.5 cm)
Ex coll. James Simon
Gemäldegalerie, cat. no. 1062B

Franciabigio
A Young Man (Matteo Sofferoni?), 1522
Poplar, 30⁷⁄₁₆ x 23¾ in. (78 x 61 cm)
Ex coll. Nerli, Siena and Florence
Gemäldegalerie, cat. no. 245

Caspar David Friedrich
Couple Watching the Moon, c. 1824
Canvas, 13⅜ x 17⅜ in. (34 x 44 cm)
Nationalgalerie, cat. no. AII 887

Fog in the Elbe Valley, 1821
Canvas, 12⅞ x 16⁹⁄₁₆ in. (33 x 42.5 cm)
Nationalgalerie, cat. no. NG 11/85

Greifswald Harbor, c. 1818–20
Canvas, 35⅛ x 27⁵⁄₁₆ in. (90 x 70 cm)
Nationalgalerie, cat. no. AII 356

Monk by the Sea, 1809
Canvas, 42⅞ x 66⅞ in. (110 x 171.5 cm)
Nationalgalerie, cat. no. NG 9/85

Oak Tree in the Snow, 1829
Canvas, 27¹¹⁄₁₆ x 18¾ in. (71 x 48 cm)
Nationalgalerie, cat. no. AII 338

Seashore with Shipwreck by Moonlight,
c. 1825–30
Canvas, 30 x 37¹³⁄₁₆ in. (77 x 97 cm)
Nationalgalerie, cat. no. AI 749

The Solitary Tree, c. 1822
Canvas, 21⁷⁄₁₆ x 27¹¹⁄₁₆ in. (55 x 71 cm)
Ex coll. Wagener
Nationalgalerie, cat. no. SW 52

Two Men by the Sea, 1817
Canvas, 19⅞ x 25¾ in. (51 x 66 cm)
Nationalgalerie, cat. no. AII 884

View of a Harbor, 1816
Canvas, 35⅛ x 27¹¹⁄₁₆ in. (90 x 71 cm)
Schloss Sanssouci, cat. no. GKI 6180

The Woman at the Window, 1822
Canvas, 17³⁄₁₆ x 14⁷⁄₁₆ in. (44 x 37 cm)
Nationalgalerie, cat. no. AI 918

Taddeo Gaddi
Pentecost, c. 1335–40
Walnut, 13⁷⁄₁₆ x 10⅝ in. (34.5 x 27.3 cm)
Gemäldegalerie, cat. no. 1073

St. Francis Restoring a Boy to Life, c. 1335–40
Walnut, 13⅝ x 11⅞ in. (35 x 30.5 cm)
Gemäldegalerie, cat. no. 1074

Triptych, 1333:
Exterior of wings:
Left side: *Christ Entrusts the Care of Mary to
John;* (above) *St. Margaret*
Right side: *St. Christopher;* (above)
St. Catherine of Alexandria
Interior:
Left panel: *The Nativity;* (above) *St. Nicholas
Freeing Adeodatus from Slavery*
Middle panel: *Madonna and Child Enthroned
with Apostles and Prophets*
Right panel: *The Crucifixion;* (above) *St.
Nicholas Restoring Adeodatus to His Parents*
Poplar, exterior of wings each
24⁵⁄₁₆ x 8⁹⁄₁₆ in. (62.4 x 22 cm); central panel
24⅜ x 16 in. (62.5 x 41.1 cm);
interior of wings each 24⁵⁄₁₆ x 8¹⁄₁₆ in.
(62.3 x 20.7 cm)
Wings ex coll. Solly
Gemäldegalerie, cat. nos. 1079, 1080

Sir Thomas Gainsborough
The Artist's Wife, c. 1758
Canvas, 29⅝ x 24¾ in. (76 x 63.5 cm)
Gemäldegalerie, cat. no. 2200

The Marsham Children, 1787
Canvas, 94¾ x 70¹⁵⁄₁₆ in. (242.9 x 181.9 cm)
Gemäldegalerie, cat. no. 4/82

Squire John Wilkinson, c. 1776
Canvas, 91¼ x 56½ in. (234 x 145 cm)
Gemäldegalerie, cat. no. 1638

Eduard Gärtner
Berlin Diorama from Friedrichswerder Church,
1843
Canvas, two central panels 35⅞ x 36⅝ in.
(91 x 93 cm); four side panels
35⅞ x 43¼ in. (91 x 110 cm)
Schloss Charlottenburg, cat. no. GKI 6179

Klosterstrasse, 1830
Canvas, 12½ x 17³⁄₁₆ in. (32 x 44 cm)
Nationalgalerie, cat. no. AII 736

Königsbrücke and Königskolonnade, 1853
Canvas, 20⅞ x 33¹⁵⁄₁₆ in. (53.5 x 87 cm)
Märkisches Museum, cat. no. VII 59/747x

Staircase in the Berlin Palace, 1828
Canvas, 18½ x 23 in. (47.5 x 59 cm)
Schloss Charlottenburg, cat. no. GKI 4369

Unter den Linden, 1853
Canvas, 29¼ x 60⁷⁄₁₆ in. (75 x 155 cm)
Nationalgalerie, cat. no. AII 880

Workshop of the Gropius Brothers, 1830
Canvas, 9¾ x 13⅞ in. (25 x 35.5 cm)
Nationalgalerie, cat. no. AII 19

Paul Gauguin
The Fisherwomen of Tahiti, 1891
Canvas, 27¹¹⁄₁₆ x 35⅛ in. (71 x 90 cm)
Nationalgalerie, cat. no. FV 180

Geertgen tot Sint Jans
Madonna and Child
Oak, 31⁹⁄₁₆ x 20¼ in. (81 x 52 cm)
Ex coll. Hollitscher
Gemäldegalerie, cat. no. 1853

St. John the Baptist in the Wilderness
Oak, 16⅜ x 10¹⁵⁄₁₆ in. (42 x 28 cm)
Ex coll. Macquoid, London
Gemäldegalerie, cat. no. 1631

Gentile da Fabriano
*Virgin and Child Enthroned with
SS. Nicholas of Bari and Catherine of
Alexandria and a Donor*, c. 1395–1400
Poplar, 51¹⁄₁₆ x 44¹⁄₁₆ in. (131 x 113 cm)
Ex coll. Friedrich Wilhelm III
Gemäldegalerie, cat. no. 1130

Artemisia Gentileschi
Bathsheba
Canvas, 100⅝ x 85 in. (258 x 218 cm)
Neues Palais, Potsdam, cat. no. GKI 5392

Orazio Gentileschi
David with the Head of Goliath, c. 1610
Copper, 14⁵⁄₁₆ x 11¹³⁄₁₆ in. (36.7 x 28.7 cm)
Gemäldegalerie, cat. no. 1723

Landscape with St. Christopher, c. 1605–10
Copper, 8³⁄₁₆ x 10¹⁵⁄₁₆ in. (21 x 28 cm)
Gemäldegalerie, cat. no. 1707

Lot and His Daughters, c. 1622–23
Canvas, 64 x 75¼ in. (164 x 193 cm)
Gemäldegalerie, cat. no. 2/70

Luca Giordano
St. Michael, c. 1663
Canvas, 77¼ x 57⁵⁄₁₆ in. (198 x 147 cm)
Gemäldegalerie, cat. no. KFMV 261

Giorgione
A Young Man, c. 1505–6
Canvas, 22⅝ x 18 in. (58 x 46 cm)
Ex coll. Giustiniani
Gemäldegalerie, cat. no. 12A

Giotto di Bondone
The Death of the Virgin, c. 1310
Poplar, width 69¹³⁄₁₆ in. (179 cm); height in
middle 29¼ in (75 cm); height at sides
20 in (51 cm)
Gemäldegalerie, cat. no. 1884

Giovanni di Paolo
St. Clare Rescuing the Shipwrecked, c. 1455–60
Poplar, 8 x 11½ in. (20.5 x 29.5 cm)
Ex coll. Kaufmann
Gemäldegalerie, cat. no. 2171

St. Jerome Appearing to St. Augustine, c. 1465
Poplar, 14⁷⁄₁₆ x 15⅜ in. (37 x 39.5 cm)
Gemäldegalerie, cat. no. 2142

Hugo van der Goes
The Adoration of the Shepherds, c. 1480
Oak, 37¹³⁄₁₆ x 95½ in. (97 x 245 cm)
Ex coll. Infanta Cristina de Borbón, Madrid
Gemäldegalerie, cat. no. 1622A

*The Lamentation (The Three Marys and John
the Evangelist)*, c. 1480
Linen, 20⅞ x 15 in. (53.5 x 38.5 cm)
Ex coll. Huldschinsky
Gemäldegalerie, cat. no. 1622

Monforte Altar (The Adoration of the Magi),
c. 1470
Oak, 57⁵⁄₁₆ x 94⅜ in. (147 x 242 cm); height at
center 60¹³⁄₁₆ in. (156 cm)
Ex coll. Monastery of Monforte de Lemos
Gemäldegalerie, cat. no. 1718

Vincent van Gogh
The Moulin de la Galette, 1886
Canvas, 14¹³⁄₁₆ x 18⅛ in. (38 x 46.5 cm)
Nationalgalerie, cat. no. AII 687

Jan Gossaert
Adam and Eve in Paradise, c. 1525
Oak, 66⁵⁄₁₆ x 44⁷⁄₁₆ in. (170 x 114 cm)
Gemäldegalerie, cat. no. 661

The Agony in the Garden, c. 1510
Oak, 33⅛ x 24⁹⁄₁₆ in. (85 x 63 cm)
Ex coll. Winckler, Leipzig
Gemäldegalerie, cat. no. 551A

Madonna and Child, c. 1530
Oak, 18⅝ x 14⅞ in. (47.7 x 38.2 cm)
Ex coll. Solly
Gemäldegalerie, cat. no. 650

Neptune and Amphitrite, 1516
Oak, 73⁵⁄₁₆ x 48⅜ in. (188 x 124 cm)
Gemäldegalerie, cat. no. 648

A Nobleman (Adolphe of Burgundy?),
c. 1525–28
Oak, 21¹³⁄₁₆ x 16⁹⁄₁₆ in. (56 x 42.5 cm)
Ex coll. Suermondt
Gemäldegalerie, cat. no. 586A

Francisco José Goya y Lucientes
The Philippine Junta, 1815
Canvas, 21¹⁄₁₆ x 27⁵⁄₁₆ in. (54 x 70 cm)
Gemäldegalerie, cat. no. 1619

Jan van Goyen
Landscape with Skaters, 1643
Oak, 9 x 12½ in. (23 x 32 cm)
Ex coll. A. Thiem
Gemäldegalerie, cat. no. 865 F

Summer
Oak, 3¹⁵⁄₁₆ in. (10 cm) diameter
Gemäldegalerie, cat. no. 865A

View of Nijmegen, 1649
Oak, 26³⁄₈ x 38¹⁄₈ in. (67.7 x 97.8 cm)
Ex coll. Suermondt
Gemäldegalerie, cat. no. 865E

Winter
Oak, 3¹⁵⁄₁₆ in. (10 cm) diameter
Gemäldegalerie, 865B

Benozzo Gozzoli
St. Zenobius Resurrecting a Dead Boy, c. 1461
Poplar, 9³⁄₈ x 13¼ in. (24 x 34 cm)
Gemäldegalerie, cat. no. 60C

Francesco Guardi
Hot-Air Balloon Rising, 1784
Canvas, 25³⁄₄ x 19⁷⁄₈ in. (66 x 51 cm)
Gemäldegalerie, cat. no. 501F

*View of the Giudecca Canal from the
Northwest with the Zattere,* after 1760
Canvas, 20¹¹⁄₁₆ x 32³⁄₄ in. (53 x 84 cm)
Gemäldegalerie, cat. no. 501E

Giovanni Antonio Guardi
The Death of Joseph
Canvas, 65¹⁵⁄₁₆ x 29⁷⁄₁₆ in. (169 x 75.5 cm)
Gemäldegalerie, cat. no. 1715

Guercino
*The Mystical Marriage of St. Catherine of
Alexandria,* 1620
Canvas, 34⁵⁄₁₆ x 27⁵⁄₁₆ in. (88 x 70 cm)
Ex coll. D. Mahon, London
Gemäldegalerie, cat. no. 1/70

Dirck Hals
Merry Company at Table, late 1620s
Oak, 10³⁄₄ x 16¹¹⁄₁₆ in. (27.6 x 43.5 cm)
Gemäldegalerie, cat. no. 816B

Frans Hals
Boy with a Flute, c. 1623–25
Canvas, 24³⁄₁₆ x 21¼ in. (62 x 54.5 cm)
Ex coll. Suermondt
Gemäldegalerie, cat. no. 801A

*The Infant Catharina Hooft (1618–1691) with
Her Nurse,* c. 1619–20
Canvas, 33½ x 25³⁄₈ in. (86 x 65 cm)
Ex coll. Suermondt
Gemäldegalerie, cat. no. 801G

"Malle Babbe," c. 1629–30
Canvas, 28⁷⁄₈ x 25 in. (74 x 64 cm)
Ex coll. Suermondt
Gemäldegalerie, cat. no. 801C

Portrait of a Man, c. 1627
Canvas, 7³⁄₄ x 5½ in. (19.9 x 14.1 cm)
Ex coll. Reimer
Gemäldegalerie, cat. no. 766

Portrait of a Man, c. 1630–33
Canvas, 29¼ x 22⁵⁄₈ in. (75 x 58 cm)
Gemäldegalerie, cat. no. 800

Portrait of a Woman, c. 1630–33
Canvas, 29¼ x 22⁵⁄₈ in. (75 x 58 cm)
Gemäldegalerie, cat. no. 801

Tyman Oosdorp, 1656
Canvas, 34¹¹⁄₁₆ x 27⁵⁄₁₆ in. (89 x 70 cm)
Ex coll. Liphart zu Ratshoff
Gemäldegalerie, cat. no. 801H

Vilhelm Hammershøi
Sunny Chamber
Canvas, 19³⁄₈ x 15⁵⁄₈ in. (49.7 x 40 cm)
Nationalgalerie, cat. no. AI 977

Erich Heckel
Seated Child, 1906
Canvas, 27⁵⁄₁₆ x 25 in. (70 x 64 cm)
Brücke Museum, cat. no. 2/66

Jan Davidsz. de Heem
Still Life with Fruit and Lobster, c. 1648–49
Canvas, 37¹⁄₁₆ x 46¹³⁄₁₆ in. (95 x 120 cm)
Gemäldegalerie, cat. no. 3/75

Jacoba van Heemskerck
Landscape, c. 1914
Canvas, 31⁹⁄₁₆ x 39 in. (81 x 100 cm)
Berlinische Galerie, cat. no. BG-M 3014/82

Maerten van Heemskerck
Momus Criticizes the Gods' Creations, 1561
Oak, 46¹³⁄₁₆ x 67⁷⁄₈ in. (120 x 174 cm)
Gemäldegalerie, cat. no. 655

Jan Sanders van Hemessen (attributed to)
The Prodigal Son, c. 1540
Oak, 11⁵⁄₁₆ x 17½ in. (29 x 45 cm)
Gemäldegalerie, cat. no. 4/59

Jan van der Heyden
Amsterdam: Street Before Harlem Tower
Oak, 13¼ x 16 in. (34 x 41 cm)
Gemäldegalerie, cat. no. 1623

Johann Heinrich Hintze
Altes Museum, 1832
Canvas, 12¹⁄₁₆ x 18¹⁵⁄₁₆ in. (30.9 x 47 cm)
Berlin Museum, cat. no. GEM 86/15

Meindert Hobbema
Village Street under Trees, c. 1665
Canvas, 37¹³⁄₁₆ x 50¹⁄₈ in. (97 x 128.5 cm)
Gemäldegalerie, cat. no. 1984

Ferdinand Hodler
Dents-du-Midi, 1912
Canvas, 29¹³⁄₁₆ x 27½ in. (76.5 x 70.5 cm)
Nationalgalerie, cat. no. FV 166

Hans Holbein the Younger
Duke Anton the Good of Lorraine (?), c. 1543
Oak, 19⁷⁄₈ x 14⁷⁄₁₆ in. (51 x 37 cm)
Ex coll. Millais, London
Gemäldegalerie, cat. no. 586D

The Merchant Georg Gisze, 1532
Oak, 37⁹⁄₁₆ x 33⁷⁄₁₆ in. (96.3 x 85.7 cm)
Ex coll. Solly
Gemäldegalerie, cat. no. 586

Gerrit van Honthorst
The Liberation of St. Peter
Canvas, 50⁵⁄₁₆ x 69¹³⁄₁₆ in. (129 x 179 cm)
Gemäldegalerie, cat. no. 431

Pieter de Hooch
The Gold Weigher, c. 1664
Canvas, 23¹³⁄₁₆ x 20¹¹⁄₁₆ in. (61 x 53 cm)
Gemäldegalerie, cat. no. 1401B

The Mother, c. 1659–60
Canvas, 35⁷⁄₈ x 39 in. (92 x 100 cm)
Gemäldegalerie, cat. no. 820B

John Hoppner
*Sir John Jeffreys Pratt, Second Earl and
First Marquis of Camden, as Knight of the
Order of the Garter*
Canvas, 97¹⁄₈ x 58 in. (249 x 148.7 cm)
Gemäldegalerie, cat. no. 3/81

Wolf Huber
The Flight into Egypt, c. 1525–30
Linden, 21^{15}/$_{16}$ x 22^1/$_{16}$ in. (56.2 x 56.6 cm)
Ex coll. Lipperheide
Gemäldegalerie (on loan from
Kunstbibliothek, SMPK)

Julius Hübner
*Carl Friedrich Lessing, Carl Sohn, and Theodor
Hildebrandt,* 1839
Canvas, 15 x 22^{13}/$_{16}$ in. (28.5 x 58.5 cm)
Nationalgalerie, cat. no. AI 929

Johann Erdmann Hummel
The Granite Basin in the Lustgarten, c. 1831
Canvas, 25^3/$_4$ x 34^{11}/$_{16}$ in. (66 x 89 cm)
Nationalgalerie, cat. no. AI 843

Jacob Jordaens
The Return of the Holy Family from Egypt,
c. 1616
Oak, 24^9/$_{16}$ x 19^1/$_2$ in. (63 x 50 cm)
Gemäldegalerie, cat. no. 2/57

Juan de Flandes
Christ Appearing to His Mother, c. 1500–1504
Oak, 8^7/$_{16}$ x 6^1/$_4$ in. (21.6 x 16 cm)
Gemäldegalerie, cat. no. 2064

Willem Kalf
Still Life with Chinese Porcelain Bowl, 1662
Canvas, 24^{15}/$_{16}$ x 20^{11}/$_{16}$ in. (64 x 53 cm)
Gemäldegalerie, cat. no. 948F

Still Life with Glass Goblet and Fruit, c. 1655
Canvas, 25^3/$_8$ x 21^{13}/$_{16}$ in. (65 x 56 cm)
Gemäldegalerie, cat. no. 948D

Georg Friedrich Kersting
Caspar David Friedrich in His Studio, c. 1812
Canvas, 20^7/$_8$ x 16 in. (53.5 x 41 cm)
Nationalgalerie, cat. no. AI 931

Thomas de Keyser
A Lady, 1632
Oak, 30^7/$_8$ x 20^7/$_{16}$ in. (79.1 x 52.4 cm)
Gemäldegalerie, cat. no. 1/82

Ernst Ludwig Kirchner
Belle-Alliance Platz, Berlin, 1914
Tempera on canvas, 37^7/$_{16}$ x 33^1/$_8$ in.
(96 x 85 cm)
Nationalgalerie, cat. no. B 129

The Rhine Bridge, 1914
Canvas, 47 x 35^1/$_2$ in. (120.5 x 91 cm)
Nationalgalerie, cat. no. AII 319

Max Klinger
The Attack, 1879
Panel, 14^7/$_{16}$ x 33^1/$_2$ in. (37 x 86 cm)
Nationalgalerie, cat. no. AII 818

Wilhelm von Kobell
Riders at the Tegernsee, 1832
Panel, 11 x 10^1/$_4$ in. (28.2 x 26.3 cm)
Nationalgalerie, cat. no. AII 609

Joseph Anton Koch
Waterfall Near Subiaco, 1813
Canvas, 22^5/$_8$ x 26^1/$_2$ in. (58 x 68 cm)
Nationalgalerie, cat. no. AI 407

Oskar Kokoschka
The Austrian Architect, Adolf Loos, 1909
Canvas, 28^7/$_8$ x 35^1/$_2$ in. (74 x 91 cm)
Nationalgalerie, cat. no. AII 448

August Kopisch
The Pontine Marshes at Sunset, 1848
Canvas, 24^3/$_{16}$ x 43^5/$_{16}$ in. (62 x 111 cm)
Nationalgalerie, cat. no. WS 118

Franz Krüger
Parade at the Opernplatz, 1829
Canvas, 98 x 147^1/$_4$ in. (249 x 374 cm)
Schloss Charlottenburg, GKI 505

*Two Cuirassiers from the Regiment of
Czar Nicholas I,* 1839
Canvas, 26^{15}/$_{16}$ x 21^7/$_{16}$ in. (69 x 55 cm)
Schloss Charlottenburg, GKI 30302

Hans von Kulmbach
The Adoration of the Magi, 1511
Linden, 59^{11}/$_{16}$ x 42^7/$_8$ in. (153 x 110 cm)
Ex coll. Lippmann, Vienna
Gemäldegalerie, cat. no. 596A

Georges de La Tour (attributed to)
Peasant Couple Eating, c. 1620
Canvas, 28^7/$_8$ x 33^{15}/$_{16}$ in. (74 x 87 cm)
Gemäldegalerie, cat. no. 1/76

Nicolas Lancret
*The Burning Glass
("Woman igniting passion's fire")*
Canvas, 14^7/$_{16}$ x 19^1/$_8$ in. (37 x 49 cm)
Schloss Charlottenburg, cat. no. GKI 4032

Dance in a Pavilion, c. 1730–35
Canvas, 50^{11}/$_{16}$ x 37^{13}/$_{16}$ in. (130 x 97 cm)
Schloss Charlottenburg, cat. no. GKI 4186

Le Moulinet
Canvas, 50^5/$_{16}$ x 37^1/$_{16}$ in. (129 x 95 cm)
Schloss Charlottenburg, cat. no. GKI 4188

Le Repas Italien (La fin du repas), before 1738
Canvas, 35^1/$_8$ x 27^{11}/$_{16}$ in. (90 x 91 cm)
Schloss Sanssouci, cat. no. GKI 6180

Nicolas de Largillièrre
The Sculptor Nicolas Coustou in His Atelier,
c. 1710–12
Canvas, 52^7/$_8$ x 42^9/$_{16}$ in. (135.5 x 109.2 cm)
Gemäldegalerie, cat. no. 1/80

Pieter Lastman
Susanna and the Elders, 1614
Oak, 16^3/$_8$ x 22^{11}/$_{16}$ in. (42 x 58 cm)
Gemäldegalerie, cat. no. 1719

Sir Thomas Lawrence
The Angerstein Children, 1807
Canvas, 71^3/$_4$ x 58^1/$_8$ in. (184 x 149 cm)
Gemäldegalerie, cat. no. 2/79

Wilhelm Leibl
A Peasant Woman, 1871
Panel, 7^{13}/$_{16}$ x 6^1/$_4$ in. (20 x 16 cm)
Nationalgalerie, cat. no. AI 953

The Brothers Le Nain (Circle of)
The Adoration of the Shepherds
Canvas, 62 x 43^1/$_2$ in. (159 x 111.5 cm)
Gemäldegalerie, cat. no. 4/67

Walter Leistikow
Lake Grunewald, 1898
Canvas, 65^1/$_8$ x 98^1/$_4$ in. (167 x 252 cm)
Nationalgalerie, cat. no. AI 622

Eustache LeSueur
Christ Healing the Blind Man
Panel, 19^1/$_8$ x 25^3/$_{16}$ in. (49 x 64.5 cm)
Schloss Sanssouci, cat. no. 7669

Paul Carl Leygebe
Tabakskollegium of Frederick I, 1709–10
Canvas, 50^{11}/$_{16}$ x 64^3/$_4$ in. (130 x 166 cm)
Neues Palais, Potsdam, cat. no. 1556

Max Liebermann
Country House at Hilversum, 1901
Canvas, 25^3/$_8$ x 31^3/$_{16}$ in. (65 x 80 cm)
Nationalgalerie, cat. no. AOO 158

The Dunes at Noordwijk, 1906
Panel, 24^9/$_{16}$ x 26^{15}/$_{16}$ in. (63 x 69 cm)
Nationalgalerie, cat. no. AI 966

The Flax Workers, 1898
Canvas, 52⁷⁄₁₆ x 90¹⁄₁₆ in. (134.5 x 231 cm)
Nationalgalerie, cat. no. AI 431

Jan Lievens
Old Man in Oriental Garb, c. 1628–30
Canvas, 52⁵⁄₈ x 39³⁄₁₆ in. (135 x 100.5 cm)
Schloss Sanssouci, cat. no. 884

Filippino Lippi
Allegory of Music (The Muse Erato), c. 1500
Poplar, 23¹³⁄₁₆ x 19⁷⁄₈ in. (61 x 51 cm)
Gemäldegalerie, cat. no. 78A

Fra Filippo Lippi
*The Adoration, with the Infant Baptist and
St. Bernard,* c. 1459
Poplar, 49¹⁄₂ x 45¹⁄₄ in. (127 x 116 cm)
Ex coll. Solly
Gemäldegalerie, cat. no. 69

Johann Liss
The Ecstasy of St. Paul, c. 1628–29
Canvas, 31⁹⁄₁₆ x 22¹³⁄₁₆ in. (80 x 58.5 cm)
Gemäldegalerie, cat. no. 1858

Lombard School
The Resurrection
Poplar, cut down from arched format,
89¹¹⁄₁₆ x 71³⁄₈ in. (230 x 183 cm)
Gemäldegalerie, cat. no. 90B

Pietro Longhi
The Music Lesson, c. 1760–70
Canvas, 24¹⁄₈ x 19¹⁄₈ in. (61.9 x 49 cm)
Gemäldegalerie, cat. no. 2/73

Pietro Lorenzetti
Two panels from the *Beata Humilitas Altar,*
c. 1341:
Blessed Humilitas Heals a Sick Nun
Poplar, 17¹¹⁄₁₆ x 21⁵⁄₁₆ in. (45.4 x 54.7 cm)
Ex coll. Solly
Gemäldegalerie, cat. no. 1077

The Miracle of the Ice
Poplar, 16³⁄₈ x 12⁵⁄₁₆ in. (42 x 31.6 cm)
Gemäldegalerie, cat. nos. 1077, 1077A

Lorenzo Monaco
The Nativity, c. 1390
Poplar, 10¹⁄₄ x 23¹¹⁄₁₆ in. (26.3 x 60.7 cm)
Ex coll. Solly
Gemäldegalerie, cat. no. 1113

Two predella panels, c. 1394–95:
The Last Supper (A)
Poplar, 18³⁄₁₆ x 55¹⁄₂ in. (46.6 x 142.4 cm)
*The Beheading of St. Catherine of
Alexandria* (B)
Poplar, 16⁷⁄₁₆ x 22¹⁄₄ in. (42.2 x 57 cm)
Ex coll. Solly (B)
Gemäldegalerie, cat. nos. 1108, 1063

Lorenzo Veneziano
Predella panels, c. 1370, with scenes from
the lives of SS. Peter and Paul:
The Conversion of Paul (A)
*The Calling of the Apostles Peter and
Andrew* (B)
Christ Rescuing Peter from Drowning (C)
The Apostle Peter Preaching (D)
The Crucifixion of Peter (E)
Poplar, (A and E): 10¹⁄₈ x 12⁷⁄₈ in. (26 x
33 cm); (C): 9³⁄₄ x 24³⁄₈ in. (25 x 62.5 cm);
(B and D): 9¹⁄₄ x 12¹¹⁄₁₆ in. (23.7 x 32.5 cm)
Ex coll. Solly (A, B, and C)
Gemäldegalerie, cat. nos. 1140 (A and E),
1140A (C), III.80 (B and D)

Johann Carl Loth
Apollo, Pan, and Marsyas
Canvas, 37¹³⁄₁₆ x 45⁵⁄₈ in. (97 x 117 cm)
Gemäldegalerie, cat. no. 1962

Lorenzo Lotto
An Architect, c. 1525–30
Canvas, 42⁵⁄₁₆ x 33¹⁄₂ in. (108.5 x 86 cm)
Ex coll. Giustiniani
Gemäldegalerie, cat. no. 153

Christ Taking Leave of His Mother, 1521
Canvas, 49¹⁄₈ x 38⁵⁄₈ in. (126 x 99 cm)
Ex coll. Solly
Gemäldegalerie, cat. no. 325

Wings of a triptych, 1531:
St. Sebastian
St. Christopher
Canvas, each 63³⁄₁₆ x 22¹⁄₈ in. (162 x 56.7 cm)
Ex coll. Solly
Gemäldegalerie, cat. no. 325

A Young Man, 1526
Canvas, 18⁷⁄₁₆ x 14⁵⁄₈ in. (47 x 37.5 cm)
Ex coll. Giustiniani
Gemäldegalerie, cat. no. 320

Lower Rhenish School
Holy Family with Angels, c. 1425
Oak, 9³⁄₄ x 7⁷⁄₁₆ in. (25 x 19 cm)
Ex coll. Figdor
Gemäldegalerie, cat. no. 2116

Lucas van Leyden
The Game of Chess, c. 1508
Oak, 10¹⁄₂ x 13⁵⁄₈ in. (27 x 35 cm)
Ex coll. Suermondt
Gemäldegalerie, cat. no. 574A

St. Jerome Penitent, c. 1515–16
Oak, 10¹⁄₂ x 12¹⁄₆ in. (27 x 31 cm)
Gemäldegalerie, cat. no. 548A

Virgin and Child with Angels, c. 1520
Oak, 28⁷⁄₈ x 17³⁄₁₆ in. (74 x 44 cm)
Ex coll. Posonyi, Vienna
Gemäldegalerie, cat. no. 584B

Mabuse, *see* **Jan Gossaert**

Macagnini, Angelo, *see* **Anonymous,
Ferrarese**

Nicolaes Maes
Old Woman Peeling Apples, c. 1655
Canvas, 21⁷⁄₁₆ x 19¹⁄₂ in. (55 x 50 cm)
Ex coll. Lord Francis Pelham-Clinton-
Hope, Deepdene
Gemäldegalerie, cat. no. 819C

The Magdalen Master
*Madonna and Child Enthroned with Two
Angels,* 1260s or 1270s
Poplar, 61¹⁄₄ x 34¹¹⁄₁₆ in. (157 x 89 cm)
Gemäldegalerie, cat. no. 1663

Jean Malouel
Virgin and Child with Angels, c. 1410
Linen, 41³⁄₄ x 31⁹⁄₁₆ in. (107 x 81 cm)
Gemäldegalerie, cat. no. 1/87

Edouard Manet
House at Rueil, 1882
Canvas, 26¹⁵⁄₁₆ x 35¹⁄₈ in. (69 x 90 cm)
Nationalgalerie, cat. no. AI 970

In the Wintergarden, 1879
Canvas, 44⁷⁄₈ x 58¹⁄₂ in. (115 x 150 cm)
Nationalgalerie, cat. no. AII 550

Lilac in a Glass, c. 1882
Canvas, 21¹⁄₁₆ x 16³⁄₈ in. (54 x 42 cm)
Nationalgalerie, cat. no. AII 379

Andrea Mantegna

Cardinal Lodovico Trevisan, c. 1459–60
Poplar, 17³/₁₆ x 12⁷/₈ x in. (44 x 33 cm)
Gemäldegalerie, cat. no. 9

Madonna with Sleeping Child, c. 1465–70
Canvas, 16³/₄ x 12¹/₂ in. (43 x 32 cm)
Ex coll. James Simon
Gemäldegalerie, cat. no. S.5

The Presentation in the Temple, c. 1465–66
Canvas, 26¹⁵/₁₆ x 33¹¹/₁₆ in. (69 x 86.3 cm)
Ex coll. Solly
Gemäldegalerie, cat. no. 29

Carlo Maratta (attributed to)

A Young Man, 1663
Canvas, 24⁵/₁₆ x 20¹/₄ in. (63 x 52 cm)
Ex coll. Suermondt
Gemäldegalerie, cat. no. 426A

Hans von Marées

Das Orangenbild (The Four Ages of Man),
1877–78
Panel, 38¹/₄ x 30⁷/₁₆ in. (98 x 78 cm)
Nationalgalerie, cat. no. AI 768

The Oarsmen, 1873
Canvas, 53¹/₁₆ x 65¹/₈ in. (136 x 167 cm)
Nationalgalerie, cat. no. AI 1024

Youth Picking Oranges, 1873–78
Canvas, 77¹/₄ x 38¹/₄ in. (198 x 98 cm)
Nationalgalerie, cat. no. AI 768

Michele Marieschi (staffage ascribed to Giovanni Antonio Guardi)

The Grand Canal with the Ca' Rezzonico and the Campo San Samuele, c. 1742
Canvas, 21⁷/₁₆ x 32³/₄ in. (55 x 84 cm)
Ex Prussian Royal Collection
Gemäldegalerie, cat. no. 5689

The Grand Canal with the Palazzo Labia and the Entry to the Cannaregio, c. 1742
Canvas, 21⁷/₁₆ x 32³/₄ in. (55 x 84 cm)
Ex Prussian Royal Collection
Schloss Sanssouci, cat. no. 5680

Simon Marmion

Wings from the Altar of the Abbey of
St. Bertin at St. Omer, c. 1459
Oak, each 21¹³/₁₆ x 57⁵/₁₆ in. (56 x 147 cm)
Ex coll. Prince of Wied
Gemäldegalerie, cat. nos. 1645, 1645A

Masaccio

Birth Salver, c. 1420
Poplar, 21¹³/₁₆ in. (56 cm) diameter
Gemäldegalerie, cat. no. 58C

Three predella panels from the *Pisa Altar,*
1426:
*The Crucifixion of St. Peter — The Beheading
of St. John the Baptist* (A)
The Adoration of the Magi (B)
*St. Julian Slaying His Parents — St. Nicholas
Saving Three Sisters from Prostitution* (C)
Poplar, each 8³/₁₆ x 23¹³/₁₆ in. (21 x 61 cm)
Ex coll. Marchese Gino Capponi, Florence
(A and B)
Gemäldegalerie, cat. nos. 58A, 58B, and 58E

Two panels from the *Pisa Altar,* 1426:
Two Carmelite Saints
SS. Jerome and Augustine
Poplar, each 14¹³/₁₆ x 4⁷/₈ in. (38 x 12.5 cm)
Gemäldegalerie, cat. no. 58D

Maso di Banco

*The Descent of Mary's Girdle to the Apostle
Thomas,* late 1330s
Poplar, 20³/₈ x 9 in. (52.2 x 23 cm)
Ex coll. Tiele-Winckler
Gemäldegalerie, cat. no. 1141B

Madonna and Child, c.1335
Poplar, 31¹³/₁₆ x 19³/₁₆ in. (81.5 x 49.2 cm)
Ex coll. Solly
Gemäldegalerie, cat. no. 1040

Cornelis Massys

The Arrival of the Holy Family in Bethlehem,
1543
Oak, 10¹/₂ x 14¹³/₁₆ in. (27 x 38 cm)
Ex coll. Solly
Gemäldegalerie, cat. no. 675

Master Lcz

Christ before Pilate, c. 1500
Pine, 30¹/₄ x 23³/₈ in. (77.5 x 60 cm)
Gemäldegalerie, cat. no. 1847

Master LS

A Knight of the Rehlinger Family, 1540
Linden, 18³/₄ x 17¹⁵/₁₆ in. (48 x 46 cm)
Ex coll. Solly
Gemäldegalerie, cat. no. 629

Master of the Aachen Altar

Epiphany, c. 1510
Oak, 31⁹/₁₆ x 52⁵/₈ in. (81 x 135 cm)
Gemäldegalerie, cat. no. 1829

Master of the Argonaut Panels

Two *cassone* panels with the Legend of
Cupid and Psyche, c. 1448
Poplar, each 15⁵/₈ x 50¹¹/₁₆ in. (40 x 130 cm)
Gemäldegalerie, cat. nos. 1823, 1824

Master of the Darmstadt Passion

Panels from the *Darmstadt Altarpiece,*
1440–50:
The Virgin and Child Enthroned
The Throne of Grace
Adoration of the Magi
*Constantine and His Mother Helena Venerating
the True Cross*
Pine, each 80³/₄ x 42¹/₂ in. (207 x 109 cm)
Ex coll. Solly
Gemäldegalerie, cat. nos. 1205, 1206

Master of the Deichsler Altar

Two panels from the *Deichsler Altar,*
c. 1415–20:
Madonna and Child
St. Peter Martyr
Pine, 62³/₁₆ x 15³/₈ in. (159.5 x 39.5 cm)
Gemäldegalerie, cat. nos. 1208, 1209

Master of 1456

*Madonna on a Crescent Moon in Hortus
Conclusus*
Oak, 37¹/₁₆ x 24³/₁₆ in. (95 x 62 cm)
Ex coll. Solly
Gemäldegalerie, cat. no. 1230

Master of 1499

The Annunciation
Oak, 7 x 5¹/₁₆ in. (18 x 13 cm)
Gemäldegalerie, cat. no. 528A

Master of 1548

A Lady, c. 1550
Linen, 27¹¹/₁₆ x 19¹/₈ in. (71 x 49 cm)
Gemäldegalerie, cat. no. 628

Master of the Gardner Annunciation

Madonna and Child, 1481
Poplar, 56³/₁₆ x 25³/₄ in. (144 x 66 cm)
Gemäldegalerie, cat. no. 129

Master of the Housebook

Panel from *Passion Altar,* c. 1475–80:
The Last Supper
Oak, 51¹/₁₆ x 29¹/₂ in. (131 x 75.6 cm)
Gemäldegalerie, cat. no. 2073

Master of the Joseph Roundels
Joseph and Asenath, c. 1500
Oak, 59¹¹⁄₁₆ in. (153 cm) diameter
Ex coll. Wernher
Gemäldegalerie, cat. no. 539

Master of the Legend of St. Barbara
Epitaph for the Nun Janne Colijns, c. 1491
Oak, 21¹³⁄₁₆ x 21¹⁄₁₆ in. (56 x 54 cm)
Ex coll. Fürstlich-Hohenzollernschen Slg.
Sigmaringen
Gemäldegalerie, cat. no. 2129

Master of the Older Holy Kinship Altar
Triptych: *Madonna and Child with Saints,*
c. 1410–20
Oak, 13⅞ x 15⅝ in. (35.5 x 40 cm)
Ex coll. Solly
Gemäldegalerie, cat. no. 1238

Master of the Osservanza Triptych
St. Anthony at Mass Dedicates His Life to God,
c. 1435
Poplar, 18¼ x 13 in. (46.8 x 33.4 cm)
Gemäldegalerie, cat. no. 63D

Master of the Presentation
Christ as Man of Sorrows below the Cross
Fir, 9¾ x 13¼ in. (25 x 34 cm)
Gemäldegalerie, cat. no. 1837

Master of St. Gilles
St. Jerome Penitent, c. 1500
Oak, 23¹³⁄₁₆ x 19⅞ in. (61 x 51 cm)
Gemäldegalerie, cat. no. 1704

Master of the Sebastian Diptych
The Martyrdom of St. Sebastian
Linden, 11¹¹⁄₁₆ x 8⁹⁄₁₆ in. (30 x 22 cm)
Ex coll. Hauses Lepke
Gemäldegalerie, cat. no. 1689

Master of the Virgo inter Virgines
The Adoration of the Magi, c. 1485
Oak, 24⁹⁄₁₆ x 18¾ in. (63 x 48 cm)
Ex coll. Seligmann, Paris
Gemäldegalerie, cat. no. 1672

Georg David Matthieu
Joachim Ulrich Giese, c. 1762–64
Canvas, 55⅜ x 41⁵⁄₁₆ in. (142 x 106 cm)
Gemäldegalerie, cat. no. 2042

The Wife of Joachim Ulrich Giese
(née Schwerin), c. 1762–64
Canvas, 55⅜ x 41⁵⁄₁₆ in. (142 x 106 cm)
Gemäldegalerie, cat. no. 2043

Franz Anton Maulbertsch
Apotheosis of a Hungarian Saint, 1773
Canvas, 28½ x 17¹⁵⁄₁₆ in. (73 x 46 cm)
Gemäldegalerie, cat. no. 1712

Adolf von Meckel
British Gas Works on the River Spree
Cardboard, 30 x 38⅝ in. (70 x 99 cm)
Berlin Museum, cat. no. GEM 76/31

Charles Mellin (attributed to)
The Tuscan General Alessandro del Borro (?),
c. 1645
Canvas, 79³⁄₁₆ x 47³⁄₁₆ in. (203 x 121 cm)
Gemäldegalerie, cat. no. 413A

Francesco Melzi
Vertumnus and Pomona
Poplar, 72⅛ x 52¼ in. (185 x 134 cm)
Gemäldegalerie, cat. no. 222

Hans Memling
Madonna and Child, 1487
Oak, 21¼ x 16¾ x in. (54.5 x 43 cm)
Gemäldegalerie, cat. no. 528B

Madonna and Child Enthroned, c. 1480–90
Oak, 31⁹⁄₁₆ x 21⁷⁄₁₆ in. (81 x 55 cm)
Ex coll. Crown Prince Friedrich Wilhelm
Gemäldegalerie, cat. no. 529

Lippo Memmi (Circle of)
Madonna and Child, c. 1340s
Poplar panel with original frame,
12⅝ x 9⅛ in. (32.3 x 23.4 cm)
Ex coll. Solly
Gemäldegalerie, cat. no. 1072

Anton Raphael Mengs
Self-Portrait, 1779
Panel, 22¹⁄₁₆ x 16¾ (56.5 x 43 cm)
Gemäldegalerie, cat. no. 1986

Adolf Menzel
The Allegiance of the Silesian Diet before
Frederick II in Breslau, 1855
Canvas, 38 x 53³⁄₁₆ in. (97.5 x 136.4 cm)
Nationalgalerie, cat. no. FV 21

The Berlin-Potsdam Railway, 1847
Canvas, 16¾ x 20¼ in. (43 x 52 cm)
Nationalgalerie, cat. no. AI 643

A Flute Concert of Frederick the Great at
Sanssouci, 1852
Canvas, 55⅜ x 80 in. (142 x 205 cm)
Nationalgalerie, cat. no. AI 206

The French Window, 1845
Canvas, 22⅝ x 18⁵⁄₁₆ in. (58 x 47 cm)
Nationalgalerie, cat. no. AI 744

The Iron Rolling Works, 1875
Canvas, 61⅝ x 99¹⁄₁₆ in. (158 x 254 cm)
Nationalgalerie, cat. no. AI 201

Moonlight on the Friedrichskanal in Old Berlin,
c. 1856
Canvas, 15⁷⁄₁₆ x 12⅞ in. (39.5 x 33 cm)
Nationalgalerie, cat. no. AI 150

The Palace Garden of Prince Albert, 1846
Canvas, 26½ x 33½ in. (68 x 86 cm)
Nationalgalerie, cat. no. AI 988

Rear of House and Backyard, c. 1846
Canvas, 16¾ x 23¹³⁄₁₆ in. (43 x 61 cm)
Nationalgalerie, cat. no. AI 957

Studio Interior with Casts, 1852
Paper mounted on board, 23¹³⁄₁₆ x 17³⁄₁₆ in.
(61 x 44 cm)
Nationalgalerie, cat. no. AI 904

Théâtre du Gymnase, 1856
Canvas, 24³⁄₁₆ x 17¹⁵⁄₁₆ in. (62 x 46 cm)
Nationalgalerie, cat. no. AI 901

William I Departs for the Front,
July 31, 1870, 1871
Canvas, 24⁹⁄₁₆ x 30⁷⁄₁₆ in. (63 x 78 cm)
Nationalgalerie, cat. no. AI 323

Johann Christof Merck
Ulmer Dogge, 1705
Canvas, 49½ x 61¼ in. (127 x 157 cm)
Jagdschloss Grunewald, cat. no. GKI 7174

Matthäus Merian the Younger (attributed to)
Landgrave Friedrich of Hessen-Eschwege
Canvas, 74⅛ x 32¾ in. (190 x 84 cm)
Jagdschloss Grunewald, cat. no. GKI 5546

Gabriel Metsu
Burgomaster Gillis Valckenier and His Family,
c. 1675
Canvas, 28¹⁄₁₆ x 30¹³⁄₁₆ in. (72 x 79 cm)
Ex coll. Tschiffeli, Bern
Gemäldegalerie, cat. no. 792

The Sick Girl, c. 1658–59
Oak, 11½ x 10⅛ in. (29.5 x 26 cm)
Gemäldegalerie, cat. no. 792C

Paula Modersohn-Becker
Nursing Mother, c. 1906–7
Tempera on canvas, 44¹/₁₆ x 28⁷/₈ in.
(113 x 74 cm)
Nationalgalerie, cat. no. NG 7/85

Still Life with Apples, 1903
Panel, 24⁹/₁₆ x 28½ in. (63 x 73 cm)
Nationalgalerie, cat. no. NG 5/57

Jan Miense Molenaer
The Artist's Studio
Canvas, 35½ x 49½ in. (91 x 127 cm)
Gemäldegalerie, cat. no. 873

Claude Monet
Fields of Bezons, c. 1873
Canvas, 22¼ x 31³/₁₆ in. (57 x 80 cm)
Nationalgalerie, cat. no. AI 1013

Houses at Argenteuil, c. 1891
Canvas, 21¹/₁₆ x 28½ in. (54 x 73 cm)
Nationalgalerie, cat. no. AI 637

Saint-Germain l'Auxerrois, 1866–67
Canvas, 30¹³/₁₆ x 38¼ in. (79 x 98 cm)
Nationalgalerie, cat. no. AI 984

Vétheuil-sur-Seine, 1881
Canvas, 23³/₈ x 39 in. (60 x 100 cm)
Nationalgalerie, cat. no. AI 551

Anthonis Mor
Margaret, Duchess of Parma, 1562
Canvas, 41⁵/₁₆ x 29⁷/₁₆ in. (106 x 75.5 cm)
Gemäldegalerie, cat. no. 585B

Luis de Morales
Madonna and Child with a Spindle, late 1560s
Oak, 18¹⁵/₁₆ x 13 in. (48.5 x 33.3 cm)
Gemäldegalerie, cat. no. 412

Giovanni Battista Moroni
Don Gabriel de la Cueva, Count of Albuquerque, 1560
Canvas, 44⁵/₈ x 35⁷/₁₆ in. (114.5 x 90.8 cm)
Gemäldegalerie, cat. no. 1/79

Hans Multscher
Landsberger Altar, 1437:
Annunciation to the Shepherds and Nativity
The Adoration of the Magi
The Agony in the Garden
Christ before Pilate
The Way to Calvary
The Resurrection
The Pentecost
The Death of the Virgin
Fir, each 58½ x 54⁵/₈ in. (150 x 140 cm)
Ex coll. Wernher, London
Gemäldegalerie, cat. nos. 1621, 1621A–G

Edvard Munch
Lübeck Harbor with the Holstentor, 1907
Canvas, 32³/₄ x 39 in. (84 x 100 cm)
Nationalgalerie, cat. no. NG 3/61

Walther Rathenau, 1907
Canvas, 80 x 41 in. (205 x 105 cm)
Märkisches Museum, cat. no. VII 93/53

Frieze of Life, 1907:
Summer Night
Longing
Tempera on canvas, 35½ x 98¼ in.
(91 x 252 cm); 35½ x 97½ in. (91 x 250 cm)
Nationalgalerie, cat. nos. NG 19/66, 22/66

Bartolomé Esteban Murillo
The Baptism of Christ, c. 1655
Canvas, 90⁷/₈ x 62³/₈ in. (233 x 160 cm)
Gemäldegalerie, cat. no. 2/68

Emil Nolde
Hunting Lodge at Alsem, 1909
Canvas, 28½ x 35½ in. (73 x 91 cm)
Brücke Museum

Pentecost, 1909
Canvas, 33¹⁵/₁₆ x 41¼ in. (87 x 107 cm)
Nationalgalerie, cat. no. NG 7/74

Jacob Ochtervelt
Itinerant Musicians, c. 1660–65
Oak, 21¹³/₁₆ x 18¹/₈ in. (56 x 46.5 cm)
Gemäldegalerie, cat. no. 1972

Isack van Ostade
Barn Interior, 1645
Oak, 22¹/₁₆ x 29¹/₁₆ in. (56.5 x 74.5 cm)
Gemäldegalerie, cat. no. 4/58

Aelbert van Ouwater
The Raising of Lazarus, c. 1450–60
Oak, 47⁹/₁₆ x 35⁷/₈ in. (122 x 92 cm)
Ex coll. Marchese Mamelli, Genoa
Gemäldegalerie, cat. no. 532A

Friedrich Overbeck
The Painter Franz Pforr, c. 1811
Canvas, 24³/₁₆ x 18⁵/₁₆ in. (62 x 47 cm)
Nationalgalerie, cat. no. AII 381

Giovanni Paolo Panini
Departure of the Duc de Choiseul from the Piazza di S. Pietro, 1754
Canvas, 59¼ x 76¹/₁₆ in. (152 x 195 cm)
Gemäldegalerie, cat. no. 2/80

View of Rome from Mt. Mario, in the Southeast, 1749
Canvas, 39⁹/₁₆ x 65½ in. (101.5 x 168 cm)
Ex Prussian Royal Collection
Gemäldegalerie, cat no. GK 5671

Jean-Baptiste-Joseph Pater
Mme. de Bouvillon Tempts Fate by Asking Ragotin to Search for a Flea
Canvas, 11 x 14³/₄ in. (28.2 x 37.9 cm)
Schloss Sanssouci, cat. no. GKI 5073

The Poet Roquebrune Breaks His Garter
Canvas, 11 x 14¹³/₁₆ in. (28.2 x 38 cm)
Schloss Sanssouci, cat. no. GKI 5067

Max Pechstein
Seated Nude, 1910
Canvas, 31³/₁₆ x 27⁵/₁₆ in. (80 x 70 cm)
Nationalgalerie, cat. no. AII 1068

Antoine Pesne
The Artist at Work with His Two Daughters, 1754
Canvas, 65¹/₈ x 58½ in. (167 x 150 cm)
Gemäldegalerie, cat. no. 496B

The Dancer Barbara Campanini, Called Barbarina, c. 1745
Canvas, 86³/₁₆ x 54⁵/₈ in. (221 x 140 cm)
Schloss Charlottenburg, cat. no. GKI 2638

Frederick the Great as Crown Prince, 1739
Canvas, 30⁷/₁₆ x 24⁹/₁₆ in. (78 x 63 cm)
Gemäldegalerie, cat. no. 489

Marianne Cochois, c. 1750
Canvas, 30⁷/₁₆ x 41³/₄ in. (78.5 x 107 cm)
Schloss Charlottenburg, cat. no. GKI 4192

Gian Battista Piazzetta
St. John the Baptist, c. 1740–50
Canvas, 18¾ x 15³⁄₁₆ in. (48 x 39 cm)
Gemäldegalerie, cat. no. 926

Piero di Cosimo
Venus, Mars, and Cupid, c. 1505
Poplar, 7 x 28¹⁄₁₆ in. (182 x 72 cm)
Gemäldegalerie, cat. no. 107

Pieter Pietersz.
*Laurens Jacobszoon with His Wife and Three
Sons*, 1598
Panel, 28½ x 64¾ in. (73 x 166 cm)
Gemäldegalerie, cat. no. II 241

Pietro di Giovanni Ambrogio
St. Augustine's Departure (?) before 1430 (?)
Poplar, 10⅛ x 12½ in. (26 x 32 cm)
Gemäldegalerie, cat. no. 1097

Camille Pissarro
Louvéciennes with Mont Valérien, 1879
Canvas, 17½ x 20¹¹⁄₁₆ in. (45 x 53 cm)
Nationalgalerie, cat. no. NG 23/61

A Square at La Roche-Guyon, c. 1867
Canvas, 19½ x 23¹³⁄₁₆ in. (50 x 61 cm)
Nationalgalerie, cat. no. NG 75/61

Giovanni Battista Pittoni
The Death of Joseph
Canvas, 37¹⁵⁄₁₆ x 30¹⁵⁄₁₆ in. (97.3 x 79.3 cm)
Schloss Charlottenburg, cat. no. GKI 30193

Cornelis van Poelenburgh
Amaryllis Giving Myrtill the Prize, c. 1635
Canvas, 44⅞ x 56¹⁵⁄₁₆ in. (115 x 146 cm)
Gemäldegalerie, cat. no. 956

Antonio Pollaiuolo
David Victorious, c. 1472
Poplar, 18 x 13⅝ in. (46.2 x 35 cm)
Gemäldegalerie, cat. no. 73A

Antonio Pollaiuolo (or Alessio Baldovinetti)
A Young Woman in Left Profile, c. 1465
Poplar, 20½ x 14¼ in. (52.5 x 36.5 cm)
Gemäldegalerie, cat. no. 1614

Jan Porcellis
*Single-Masted Damlooper and Rowboat on a
Breezy Day*
Oak, 9¹⁄₁₆ x 8⅛ in. (23.2 x 20.8 cm)
Gemäldegalerie, cat. no. 832A

Paulus Potter
The Bull, 1649
Oak, 9 x 11⁵⁄₁₆ in. (23 x 29 cm)
Gemäldegalerie, cat. no. 872B

The Start of the Hunt, 1652
Canvas, 23⅜ x 29⅝ in. (60 x 76 cm)
Ex coll. Suermondt
Gemäldegalerie, cat. no. 872A

Nicolas Poussin
*Helios and Phaeton with Saturn and the Four
Seasons*, c. 1629–30
Canvas, 47⁹⁄₁₆ x 59¹¹⁄₁₆ in. (122 x 153 cm)
Ex Prussian Royal Collection
Gemäldegalerie, cat. no. 478

*The Infant Jupiter Nurtured by the Goat
Amalthea*, c. 1638
Canvas, 37¹³⁄₁₆ x 51⅞ in. (97 x 133 cm)
Ex Prussian Royal Collection
Gemäldegalerie, cat. no. 467

St. Matthew Writing His Gospel, 1640
Canvas, 38⅝ x 52⅝ in. (99 x 135 cm)
Gemäldegalerie, cat. no. 478A

Self-Portrait, 1649
Canvas, 30⁷⁄₁₆ x 25⅜ in. (78 x 65 cm)
Gemäldegalerie, cat. no. 1488

Hans Purrmann
Still Life, 1908
Canvas, 31³⁄₁₆ x 38¹³⁄₁₆ in. (85 x 59 cm)
Nationalgalerie, cat. no. AII 262

Sir Henry Raeburn
Mrs. Anne Hart, c. 1810
Canvas, 52½ x 42⁹⁄₁₆ in. (134.7 x 109.2 cm)
Gemäldegalerie, cat. no. 3/82

Johann Anton Alban Ramboux
Rebecca and Eliezer at the Well, 1819
Panel, 20¼ x 34⁵⁄₁₆ in. (52 x 88 cm)
Nationalgalerie, cat. no. AII 726

Raphael
Colonna Madonna, c. 1508
Poplar, 30 x 21¹³⁄₁₆ in. (77 x 56 cm)
Ex coll. Duchess Maria Colonna Lante della
Rovere, Rome
Gemäldegalerie, cat. no. 248

Diotalevi Madonna, c. 1503
Poplar, 26¹⁵⁄₁₆ x 19½ in. (69 x 50 cm)
Ex coll. Marchese Diotalevi, Rimini
Gemäldegalerie, cat. no. 147

*Madonna with the Christ Child Blessing and
SS. Jerome and Francis (Von der Ropp
Madonna)*, c. 1502
Poplar, 13¼ x 11⁵⁄₁₆ in. (34 x 29 cm)
Ex coll. von der Ropp, Mitau
Gemäldegalerie, cat. no. 145

Solly Madonna, c. 1502
Poplar, 20¼ x 14¹³⁄₁₆ in. (52 x 38 cm)
Ex coll. Solly
Gemäldegalerie, cat. no. 141

Terranuova Madonna, c. 1505
Poplar, 33½ in. (86 cm) diameter
Ex coll. duke of Terranuova, Genoa,
and Naples
Gemäldegalerie, cat. no. 247A

Rembrandt Harmensz. van Rijn
The Artist's Wife, Saskia, 1643
Mahogany, 29⁵⁄₁₆ x 23⅜ in. (75.2 x 60 cm)
Ex Prussian Royal Collection
Gemäldegalerie, cat. no. 812

Christ and the Woman of Samaria, 1659
Oak, 18¾ x 15¹³⁄₁₆ in. (48 x 40.5 cm)
Ex coll. R. Kann, Paris
Gemäldegalerie, cat. no. 811B

Head of Christ, c. 1655
Oak, 9¾ x 8⅜ in. (25 x 21.5 cm)
Gemäldegalerie, cat. no. 811C

Hendrickje Stoffels, c. 1659
Canvas, 34½ x 26⅛ in. (88.5 x 67 cm)
Ex coll. John Wardele, London
Gemäldegalerie, cat. no. 828B

Joseph's Dream, 1645
Mahogany, 7¹³⁄₁₆ x 10½ in. (20 x 27 cm)
Ex Prussian Royal Collection
Gemäldegalerie, cat. no. 806

Landscape with a Long Arched Bridge,
late 1630s
Oak, 11⅛ x 15⅜ in. (28.5 x 39.5 cm)
Gemäldegalerie, cat. no. 1932

*The Mennonite Preacher Cornelis Claesz. Anslo
and His Wife Aeltje Gerritse Schouten*, 1641
Canvas, 68⅝ x 81⅞ in. (176 x 210 cm)
Ex coll. Lord Ashburnham, London
Gemäldegalerie, cat. no. 828L

Minerva, 1635
Oak, 23⅝ x 19⅛ in. (60.5 x 49 cm)
Ex Prussian Royal Collection
Gemäldegalerie, cat. no. 828C

Moses Smashing the Tablets of the Law, 1659
Canvas, 65¹¹⁄₁₆ x 53¼ in. (168.5 x 136.5 cm)
Ex Prussian Royal Collection
Gemäldegalerie, cat. no. 811

Parable of the Rich Man, 1627
Oak, 12⅜ x 16⁹⁄₁₆ in. (31.7 x 42.5 cm)
Ex coll. Sir Charles Robinson, London
Gemäldegalerie, cat. no. 828D

The Rape of Proserpina, c. 1631–32
Oak, 33 x 31 in. (84.5 x 79.5 cm)
Ex Prussian Royal Collection
Gemäldegalerie, cat. no. 823

St. John the Baptist Preaching, c. 1634–36
Canvas on oak panel, 24³⁄₁₆ x 31³⁄₁₆ in.
(62 x 80 cm)
Ex coll. Estate of Jan Six, Amsterdam
Gemäldegalerie, cat. no. 828K

Samson Accusing His Father-in-Law, 1635
Canvas, 61¹³⁄₁₆ x 50⅞ in. (158.5 x 130.5 cm)
Ex Prussian Royal Collection
Gemäldegalerie, cat. no. 802

Samson and Delilah, 1628
Oak, 23¹⁵⁄₁₆ x 19½ in. (61.4 x 50 cm)
Gemäldegalerie, cat. no. 812A

Self-Portrait with Velvet Beret and Furred Mantel, 1634
Oak, 22¾ x 18½ in. (58.3 x 47.5 cm)
Ex Prussian Royal Collection
Gemäldegalerie, cat. no. 810

Susanna and the Elders, 1647
Mahogany, 29⅞ x 36⅛ in. (76.6 x 92.7 cm)
Gemäldegalerie, cat. no. 828E

Tobit's Wife with the Goat, 1645
Mahogany, 7¹³⁄₁₆ x 10½ in. (20 x 27 cm)
Ex Prussian Royal Collection
Gemäldegalerie, cat. no. 805

Rembrandt Harmensz. van Rijn (Circle of)
The Man in a Golden Helmet, c. 1650–55
Canvas, 26⁵⁄₁₆ x 19¾ in. (67.5 x 50.7 cm)
Gemäldegalerie, cat. no. 811A

Guido Reni
The Death of Cleopatra, c. 1625–30
Canvas, 48⅜ x 36¹¹⁄₁₆ in. (124 x 94 cm)
Neues Palais, Potsdam, cat. no. 5054

Pierre-Auguste Renoir
Children's Afternoon at Wargemont, 1884
Canvas, 49½ x 67½ in. (127 x 173 cm)
Nationalgalerie, cat. no. AI 969

In the Summer, 1868
Canvas, 33⅛ x 23 in. (85 x 59 cm)
Nationalgalerie, cat. no. AI 1019

Sir Joshua Reynolds
The Actress Kitty Fischer
Canvas, 17¹⁵⁄₁₆ x 21⁷⁄₁₆ in. (46 x 55 cm)
Gemäldegalerie, cat. no. 1637A

Lady Sunderlin, 1786
Canvas, 92¹⁄₁₆ x 56½ in. (236 x 145 cm)
Gemäldegalerie, cat. no. 4/83

Lord George Clive and His Family with an Indian Servant, c. 1765–66
Canvas, 54⅝ x 66¹¹⁄₁₆ in. (140 x 171 cm)
Gemäldegalerie, cat. no. 1/78

Marco Ricci
Southern Landscape at Twilight
Canvas, 36¾ x 42⅛ in. (94.3 x 108 cm)
Gemäldegalerie, cat. no. 4/75

Sebastiano Ricci
Bathsheba, c. 1725
Canvas, 42½ x 55⅜ in. (109 x 142 cm)
Ex Prussian Royal Collection
Gemäldegalerie, cat. no. 454

Hans Richter
Revolution, 1914
Board, 24¾ x 18¾ in. (63.5 x 48 cm)
Berlinische Galerie, cat. no. BG-M 3074/82

Hubert Robert
Ruins at Nîmes
Canvas, 45⅝ x 67⅞ in. (117 x 174 cm)
Gemäldegalerie, cat. no. B131

Ercole de' Roberti
St. John the Baptist, c. 1480
Poplar, 21¹⁄₁₆ x 12¹⁄₁₆ in. (54 x 31 cm)
Gemäldegalerie, cat. no. 112C

Bernhard Rode
Chinoiserie overdoor: *The Empress of China Culling Mulberry Leaves*, c. 1773
Canvas, 35½ x 40³⁄₁₆ in. (91 x 103 cm)
Gemäldegalerie, cat. no. 2151

Pieter Gerritsz. van Roestraten
Still Life with Chinese Teabowls
Canvas, 13⅝ x 18½ in. (35 x 47.5 cm)
Gemäldegalerie, cat. no. 2010

Salvator Rosa
Pythagoras and the Fisherman, 1662
Canvas, 51⁵⁄₁₆ x 73⁵⁄₁₆ in. (131.5 x 188 cm)
Gemäldegalerie, cat. no. 1/59

Rosso Fiorentino
A Young Man, c. 1517–18
Poplar, 32⅛ x 23⅜ in. (82.4 x 59.9 cm)
Ex coll. Marchese Patrizi, Rome
Gemäldegalerie, cat. no. 245A

Johann Rottenhammer
Allegory of the Arts
Copper, 10¹⁵⁄₁₆ x 8³⁄₁₆ in. (28 x 21 cm)
Ex Prussian Royal Collection
Gemäldegalerie, cat. no. 690

Carl Rottmann
The Battlefield at Marathon, c. 1849
Canvas, 35½ x 35⁵⁄₁₆ in. (91 x 90.5 cm)
Nationalgalerie, cat. no. AI 209

Willem-Frederick van Royen
The Carrot, 1699
Canvas, 13⅝ x 9¹⁵⁄₁₆ in. (35 x 25.5 cm)
Märkisches Museum, cat. no. VII 60/209x

Peter Paul Rubens
Andromeda, c. 1638
Oak, 73¹¹⁄₁₆ x 36¹¹⁄₁₆ in. (189 x 94 cm)
Ex coll. Duke of Marlborough
Gemäldegalerie, cat. no. 776C

The Four Evangelists, c. 1614
Canvas, 87⅜ x 105⁵⁄₁₆ in. (224 x 270 cm)
Schloss Sanssouci, cat. no. 7580

Infant with a Bird, c. 1624–25
Oak, 19¹³⁄₁₆ x 15¹³⁄₁₆ in. (50.8 x 40.5 cm)
Ex Prussian Royal Collection
Gemäldegalerie, cat. no. 762A

Isabella Brant (?), c. 1626
Oak, 38 x 27⅞ in. (97.5 x 71.5 cm)
Ex coll. Empress Friedrich, Friedrichshof
(Kronberg im Taunus)
Gemäldegalerie, cat. no. 762A

The Lamentation, c. 1609–11
Oak, 13¼ x 10½ in. (34 x 27 cm)
Ex coll. Demidoff, Florence
Gemäldegalerie, cat. no. 798K

Landscape with Cows and Duck Hunters,
c. 1635–38
Oak, 44¹/₁₆ x 68⅝ in. (113 x 176 cm)
Ex coll. Duke of Devonshire, Hoeker Hall
Gemäldegalerie, cat. no. 2013

Landscape with the Shipwreck of St. Paul,
c. 1620
Canvas, 23¹³/₁₆ x 38¼ in. (61 x 98 cm)
Ex coll. Duke de Richelieu
Gemäldegalerie, cat. no. 776E

Madonna and Child, c. 1624–25
Canvas, 58⅞ x 42⅛ in. (151 x 108 cm)
Ex Prussian Royal Collection
Gemäldegalerie, cat. no. 917

Madonna and Child Enthroned with Saints,
c. 1627–28
Oak, 30¹³/₁₆ x 21⁷/₁₆ in. (79 x 55 cm)
Ex Prussian Royal Collection
Gemäldegalerie, cat. no. 780

Music-Making Angels, c. 1628
Panel, 25³/₁₆ x 32³/₁₆ in. (64.6 x 82.5 cm): left
half 25³/₁₆ x 15⅝/15⅞ in. (64.6 x 40/40.7 cm),
right half 25³/₁₆ x 16³/₁₆/16⁷/₁₆ in.
(64.6 x 41.5/42.1 cm)
Schloss Sanssouci, cat. no. 7745

Perseus Liberating Andromeda, 1622
Oak, 39 x 54 in. (100 x 138.5 cm)
Ex Prussian Royal Collection
Gemäldegalerie, cat. no. 785

St. Cecilia, 1639–40
Oak, 69 x 54³/₁₆ x 69 in. (177 x 139 cm)
Ex Prussian Royal Collection
Gemäldegalerie, cat. no. 781

St. Jerome in His Hermitage, 1608–9
Panel, 72⁵/₁₆ x 52¹³/₁₆ in. (185.5 x 135.5 cm)
Schloss Sanssouci, cat. no. 7578

St. Sebastian, c. 1618
Canvas, 78 x 49¹⁵/₁₆ in. (200 x 128 cm)
Ex coll. H. A. J. Munro of Novar, London
Gemäldegalerie, cat. no. 798H

SS. Gregory, Maurus, Papianus, and Domitilla,
1606
Canvas, 57⅛ x 46¹³/₁₆ in. (146.5 x 120 cm)
Gemäldegalerie (on loan)

Jacob Isaacsz. van Ruisdael
Haarlem Seen from the Dunes to the Northwest,
c. 1670
Canvas, 12½ x 15⅝ in. (32 x 40 cm)
Ex coll. Mestern, Hamburg
Gemäldegalerie, cat. no. 885C

Oaks by a Lake with Waterlilies, c. 1665–69
Canvas, 45⁷/₁₆ x 55⁷/₁₆ in. (116.6 cm x 142.2 cm)
Gemäldegalerie, cat. no. 885G

A View of the Dam with the Weigh House at
Amsterdam, c. 1670
Canvas, 20¼ x 25⅜ in. (52 x 65 cm)
Ex coll. Suermondt
Gemäldegalerie, cat. no. 885D

Village at the Woods' Edge, c. 1651
Canvas, 20¼ x 25¾ in. (52 x 66 cm)
Ex coll. Habbich, Kassel
Gemäldegalerie, cat. no. 885F

Woodland Scene with Lake, c. 1657
Oak, 5¼ x 6¹¹/₁₆ in. (13.5 x 17 cm)
Ex coll. A. Thiem
Gemäldegalerie, cat. no. 884D

Philipp Otto Runge
The Artist's Wife and Son, 1807
Canvas, 37¹³/₁₆ x 28½ in. (97 x 73 cm)
Nationalgalerie, cat. no. AII 755

Salomon Jacobsz. van Ruysdael
Dutch Landscape with Highwaymen, 1656
Canvas, 41⁵/₁₆ x 57¾ in. (106 x 148 cm)
Ex coll. Baron von Mecklenburg
Gemäldegalerie, cat. no. 901B

River Landscape at Arnheim, 1642
Canvas, 44⅞ x 64⅜ in. (115 x 165 cm)
Ex coll. Solly
Gemäldegalerie, cat. no. 957

Sailboats on the Wijkermeer, c. 1648
Oak, 15⅝ x 23⅜ in. (40 x 60 cm)
Gemäldegalerie, cat. no. 901F

Pieter Jansz. Saenredam
Choir of St. Bavo, Haarlem, 1635
Oak, 18¹³/₁₆ x 14½ in. (48.2 x 37.1 cm)
Ex coll. Suermondt
Gemäldegalerie, cat. no. 898B

Sassetta
The Blessed Raniero of Borgo San Sepolcro
Appearing to a Cardinal in a Dream, 1444
Poplar, 17 x 23⁵/₁₆ in. (43.5 x 59.8 cm)
Gemäldegalerie, cat. no. 1945

Madonna of Humility, c. 1432–36
Poplar, 18¼ x 9⅞ in. (46.8 x 25.3 cm)
Ex coll. Solly
Gemäldegalerie, cat. no. 63B

Giorgio Schiavone
Madonna and Child Enthroned, c. 1456–60
Canvas, transferred from poplar panel,
31⁹/₁₆ x 22¼ in. (81 x 57 cm)
Ex coll. Solly
Gemäldegalerie, cat. no. 1162

Christian Gottlieb Schick
Heinrike Dannecker, 1802
Canvas, 46⁷/₁₆ x 39 in. (119 x 100 cm)
Nationalgalerie, cat. no. AII 840

Karl Friedrich Schinkel
The Banks of the Spree at Stralau, 1817
Canvas, 14¹/₁₆ x 17³/₁₆ in. (36 x 44 cm)
Nationalgalerie, cat. no. NG 5/91

Gothic Cathedral with Imperial Palace, 1815
Canvas, 36¹¹/₁₆ x 54⅝ in. (94 x 140 cm)
Nationalgalerie, cat. no. Schinkel-Mus. A 2

Medieval Town on a River, 1813
Canvas, 28¹/₁₆ x 38¼ in. (72 x 98 cm)
Nationalgalerie, cat. no. SW 200

Karl Schmidt-Rottluff
Gutshof in Dangast, 1910
Canvas, 33¾ x 36⅞ in. (86.5 x 94.5 cm)
Nationalgalerie, cat. no. B 86a

Julius Schnorr von Carolsfeld
The Annunciation, 1818
Canvas, 46¹³/₁₆ x 35⅞ in. (120 x 92 cm)
Nationalgalerie, cat. no. AI 895

Clara Bianca von Quandt, 1820
Panel, 14⁷/₁₆ x 10⅛ in. (37 x 26 cm)
Nationalgalerie, cat. no. AAII 361

Johann Heinrich Schönfeld
The Triumph of Venus, c. 1640–45
Canvas, 27⁵⁄₁₆ x 48 in. (70 x 123 cm)
Gemäldegalerie, cat. no. 1947

Martin Schongauer
The Nativity, c. 1480
Oak, 14⁵⁄₈ x 10¹⁵⁄₁₆ in. (37.5 x 28 cm)
Gemäldegalerie, cat. no. 1629

Jan van Scorel
Lucretia, c. 1535
Oak, 25³⁄₈ x 17³⁄₁₆ in. (65 x 44 cm)
Gemäldegalerie, cat. no. 644B

Portrait of a Man, c. 1535
Oak, 25³⁄₈ x 17³⁄₁₆ in. (65 x 44 cm)
Gemäldegalerie, cat. no. 644B

Sebastiano del Piombo
A Young Roman Woman, c. 1512–13
Poplar, 30⁷⁄₁₆ x 23¹³⁄₁₆ in. (78 x 61 cm)
Ex coll. Duke of Marlborough,
Blenheim Castle
Gemäldegalerie, cat. no. 259

Giovanni Segantini
The Last Journey (Return to Native Soil), 1895
Canvas, 63 x 116⁵⁄₈ in. (161.5 x 299 cm)
Nationalgalerie, cat. no. AI 699

Daniel Seghers
*Floral Wreath Surrounding Relief after
Quellinus*
Canvas, 50⁵⁄₁₆ x 37¹¹⁄₁₆ in. (129 x 95 cm)
Gemäldegalerie, cat. no. 978

Hercules Pietersz. Seghers
Landscape with City on a River, late 1620s
Oak, 10⁵⁄₈ x 14¹⁄₈ in. (27.2 x 36.2 cm)
Ex coll. Suermondt
Gemäldegalerie, cat. no. 806B

View of Rhenen, c. 1625–30
Oak, 16⁵⁄₈ x 25¹⁵⁄₁₆ in. (42.6 x 66.5 cm)
Ex coll. Suermondt
Gemäldegalerie, cat. no. 808A

Jan Siberechts
The Ford, 1670
Canvas, 24³⁄₄ x 20⁷⁄₈ in. (63.5 x 53.5 cm)
Gemäldegalerie, cat. no. 1744

Paul Signac
Still Life with a Book, 1883
Canvas, 12¹¹⁄₁₆ x 18¹⁄₈ in. (32.5 x 46.5 cm)
Nationalgalerie, cat. no. NG 19/57

Luca Signorelli
*The Holy Family with Zachariah, Elizabeth,
and the Infant Baptist,* after 1512
Poplar, 27⁵⁄₁₆ in. (70 cm) diameter
Gemäldegalerie, cat. no. 79B

Portrait of an Elderly Man, c. 1492
Poplar, 19¹⁄₂ x 12¹⁄₂ in. (50 x 32 cm)
Ex coll. Torrigiani, Florence
Gemäldegalerie, cat. no. 79C

Two wings from the *St. Agostino Altarpiece,*
1498:
Left wing: *SS. Catherine of Siena, Mary
Magdalen, and Jerome*
Right wing: *SS. Augustine, Catherine of
Alexandria, and Anthony of Padua*
Poplar, left 57¹⁄₈ x 29⁷⁄₁₆ in. (146.5 x 75.5 cm);
right 56³⁄₄ x 29⁵⁄₈ in. (145.5 x 76 cm)
Ex coll. Solly
Gemäldegalerie, cat. no. 79

Simone Martini
The Entombment, c. 1335–44
Poplar, 9¹⁄₄ x 6¹⁄₂ in. (23.7 x 16.7 cm)
Gemäldegalerie, cat. no. 1070A

Michiel Sittow
Madonna and Child, c. 1515
Panel, 12¹⁄₂ x 9¹⁄₂ in. (32 x 24.5 cm)
Gemäldegalerie, cat. no. 1722

Franz Skarbina
The Girl on the Boardwalk, 1883
Canvas, 53¹⁄₁₆ x 33³⁄₈ in. (136 x 85.5 cm)
Berlinische Galerie, cat. no. BG-M 2637/82

Maria Slavona
Houses at Montmartre, 1898
Canvas, 45⁷⁄₁₆ x 31⁹⁄₁₆ in. (116.5 x 81 cm)
Nationalgalerie, cat. no. AII 657

Max Slevogt
*The Singer Francisco d'Andrade as Don
Giovanni,* c. 1901–2
Canvas, 81⁷⁄₈ x 66⁵⁄₁₆ in. (210 x 170 cm)
Nationalgalerie, cat. no. AII 36

Frans Snyders
*Hungry Cat with Poultry, Lobster, Game, and
Fruit,* c. 1615–20
Canvas, 33¹⁵⁄₁₆ x 46 in. (87 x 118 cm)
Gemäldegalerie, cat. no. 774C

Still Life with Fruit Basket and Game, c. 1620
Canvas, 35⁷⁄₈ x 53¹⁄₁₆ in. (92 x 136 cm)
Gemäldegalerie, cat. no. 4/65

Carl Spitzweg
Kite Flying, c. 1880
Board, 14¹³⁄₁₆ x 4¹¹⁄₁₆ in. (38 x 12 cm)
Nationalgalerie, cat. no. AI 1033

Francesco Squarcione
Madonna and Child, c. 1460
Poplar, 31³⁄₈ x 25¹⁄₂ in. (80.5 x 65.5 cm)
Gemäldegalerie, cat. no. 27A

Jan Steen
Argument over a Card Game
Canvas, 35¹⁄₈ x 46⁷⁄₁₆ in. (90 x 119 cm)
Ex coll. Suermondt
Gemäldegalerie, cat. no. 795B

"So de oude songen, so pypen de jongen"
Canvas, 32³⁄₈ x 38⁵⁄₈ in. (83 x 99 cm)
Ex coll. Lord Francis Pelham Clinton
Hope, Deepdene
Gemäldegalerie, cat. no. 795D

Tavern Garden, c. 1660
Canvas, 26¹⁄₂ x 22⁵⁄₈ in. (68 x 58 cm)
Ex Prussian Royal Collection
Gemäldegalerie, cat. no. 795

Matthias Stomer
Sarah Leading Hagar to Abraham
Canvas, 43⁷⁄₈ x 65¹⁄₂ in. (112.5 x 168 cm)
Gemäldegalerie, cat. no. 2146

Bernhard Strigel
Christ Taking Leave of His Mother, c. 1520
Pine, 33³⁄₄ x 27⁷⁄₈ in. (86.5 x 71.5 cm)
Ex coll. Hirscher, Freiburg
Gemäldegalerie, cat. no. 1197A

The Disrobing of Christ, c. 1520
Pine, 33¹⁵⁄₁₆ x 28¹⁄₁₆ in. (87 x 72 cm)
Ex coll. Hirscher, Freiburg
Gemäldegalerie, cat. no. 1197B

Franz von Stuck
Self-Portrait in the Studio
Panel, 28¹⁄₄ x 29⁵⁄₈ in. (72.5 x 76 cm)
Nationalgalerie, cat. no. FV 50

Sin, 1893
Canvas, 34⁵⁄₁₆ x 20¹⁄₄ in. (88 x 52 cm)
Nationalgalerie, cat. no. FV 72

David Teniers the Younger

The Painter and His Family, c. 1645–46
Oak, 14¹³⁄₁₆ x 22⁵⁄₈ in. (38 x 58 cm)
Ex Prussian Royal Collection
Gemäldegalerie, cat. no. 857

Gerard TerBorch

The Concert, c. 1675
Oak, 21¹³⁄₁₆ x 17³⁄₁₆ in. (56 x 44 cm)
Gemäldegalerie, cat. no. 791G

"The Fatherly Admonition," c. 1654–55
Canvas, 12⁷⁄₈ x 10½ in. (33 x 27 cm)
Gemäldegalerie, cat. no. 791

The Knifegrinder's Family
Canvas, 28¹¹⁄₁₆ x 23⁵⁄₈ in. (73.5 x 60.5 cm)
Gemäldegalerie, cat. no. 793

Hendrick TerBrugghen

Esau Selling His Birthright, c. 1625
Canvas, 36¹⁵⁄₁₆ x 45³⁄₈ in. (94.8 x 116.3 cm)
Gemäldegalerie, cat. no. 1982

The Supper at Emmaus, c. 1621
Canvas, 42½ x 54¹⁵⁄₁₆ in. (109 x 141 cm)
Schloss Sanssouci, cat. no. 5425

Anna Dorothea Therbusch

Self-Portrait, c. 1776–77
Canvas, 58⁷⁄₈ x 44⁷⁄₈ in. (151 x 115 cm)
Gemäldegalerie, cat. no. 1925

Wilhelmine Encke, Countess Lichtenau, 1776
Canvas, 55³⁄₄ x 40³⁄₁₆ in. (143 x 103 cm)
Neues Palais, Potsdam, cat. no. GKI 2584

Hans Thoma

The Rhine near Säckingen, 1873
Canvas, 24³⁄₄ x 43⁷⁄₈ in. (63.5 x 112.5 cm)
Nationalgalerie, cat. no. AI 851

Summer, 1872
Canvas, 29⁵⁄₈ x 40⁹⁄₁₆ in. (76 x 104 cm)
Nationalgalerie, cat. no. AII 510

Wildflowers with Porcelain Cup, 1872
Canvas, 30 x 21⁷⁄₁₆ in. (77 x 55 cm)
Nationalgalerie, cat. no. AII 146

Giovanni Battista Tiepolo

The Bearing of the Cross, c. 1738
Canvas, 20¼ x 24⁹⁄₁₆ in. (52 x 63 cm)
Gemäldegalerie, cat. no. 459C

The Martyrdom of St. Agatha, c. 1750
Canvas, 71³⁄₄ x 51¹⁄₁₆ in. (184 x 131 cm)
Gemäldegalerie, cat. no. 459B

*Rinaldo and Armida Overheard by Carlo and
Ubaldo in Armida's Magic Garden,* c. 1755–60
Canvas, 15³⁄₁₆ x 24³⁄₁₆ in. (39 x 62 cm)
Gemäldegalerie, cat. no. 459D

Rinaldo's Departure from Armida, c. 1755–60
Canvas, 15³⁄₁₆ x 24³⁄₁₆ in. (39 x 62 cm)
Gemäldegalerie, cat. no. 3/79

Johan Heinrich Tischbein the Elder

*Portrait of the Artist and His Wife at the
Spinet,* 1769
Canvas, 18½ x 13¹⁄₁₆ in. (47.5 x 33.5 cm)
Gemäldegalerie, cat. no. 1697

Titian

A Bearded Young Man, c. 1525
Canvas, 36¹¹⁄₁₆ x 28¹⁄₁₆ in. (94 x 72 cm)
Ex Prussian Royal Collection
Gemäldegalerie, cat. no. 301

Clarissa Strozzi, 1542
Canvas, 44⁷⁄₈ x 38¼ in. (115 x 98 cm)
Ex coll. Strozzi, Florence
Gemäldegalerie, cat. no. 160A

Self-Portrait, c. 1572
Canvas, 37⁷⁄₁₆ x 29¼ in. (96 x 75 cm)
Ex coll. Solly
Gemäldegalerie, cat. no. 163

Venus and the Organ Player, c. 1550–52
Canvas, 44⁷⁄₈ x 81⁷⁄₈ in. (115 x 210 cm)
Gemäldegalerie, cat. no. 1849

Woman with a Fruit Bowl, c. 1555
Canvas, 39³⁄₄ x 32 in. (102 x 82 cm)
Ex coll. Abate Celotti, Florence
Gemäldegalerie, cat. no. 166

Jean-François de Troy

Bacchus and Ariadne, c. 1717
Canvas, 54⁵⁄₈ x 64³⁄₈ in. (140 x 165 cm)
Gemäldegalerie, cat. no. KFMV 241

Wilhelm Trübner

The Equestrienne — Ida Görz, 1901
Canvas, 65³⁄₄ x 50¹¹⁄₁₆ in. (168.5 x 130 cm)
Nationalgalerie, cat. no. NG 1370

On the Sofa, 1872
Canvas, 20¼ x 17½ in. (52 x 45 cm)
Nationalgalerie, cat. no. AI 645

Cosimo Tura

St. Christopher, c. 1484
Poplar, 29¼ x 12½ in. (75 x 32 cm)
Ex coll. Solly
Gemäldegalerie, cat. no. 1170C

St. Sebastian, c. 1484
Poplar, 28½ x 11¹¹⁄₁₆ in. (73 x 30 cm)
Ex coll. Solly
Gemäldegalerie, cat. no. 1170B

Francesco Ubertini, *see* **Bacchiacca**

Ugolino di Nerio

Five panels from the *Santa Croce Altar,*
c. 1325–30
The Flagellation (A)
The Entombment (B)
St. Peter; (above) *SS. James the Greater and
Philip* (C)
St. John the Baptist; (above) *SS. Matthias and
Elizabeth of Hungary* (?) (D)
St. Paul; (above) *SS. Matthew and James the
Less* (E)
Poplar, (A) 15¹³⁄₁₆ x 22³⁄₄ in. (40.6 x 58.4 cm);
(B) 15¹⁵⁄₁₆ x 38½ in. (40.8 x 58 cm);
(C) 25¹¹⁄₁₆ x 21³⁄₄ in. (65.8 x 55.7 cm);
(D) 21¹⁵⁄₁₆ x 22³⁄₁₆ in. (56.2 x 56.9 cm);
(E) 21¹³⁄₁₆ x 22³⁄₁₆ in. (56 x 56.9 cm)
Gemäldegalerie, cat. nos. 1635 A–E

Lesser Ury

Berlin Street Scene (Leipzigerstrasse), 1889
Canvas, 41³⁄₄ x 26½ in. (107 x 68 cm)
Berlinische Galerie, cat. no. BG-M 1340/78

Werner van den Valckert

Five Regents of the Groot-Kramergild, 1622
Oak, 50¹¹⁄₁₆ x 72¹⁄₈ in. (130 x 185 cm)
Gemäldegalerie, cat. no. 1909

Diego Rodríguez de Silva y Velázquez

Portrait of a Lady, c. 1630–33
Canvas, 48 x 38⁵⁄₈ in. (123 x 99 cm)
Ex coll. Lord Ward, Earl of Dudley
Gemäldegalerie, cat. no. 413E

Adriaen van de Velde

Cows on a Meadow, 1658
Oak, 10½ x 8⁹⁄₁₆ in. (27 x 22 cm)
Gemäldegalerie, cat. no. 903A

The Farm, 1666
Canvas over panel, 24⁹/₁₆ x 30⁷/₁₆ in.
(63 x 78 cm)
Ex coll. Lord Francis Pelham Clinton
Hope, Deepdene
Gemäldegalerie, cat. no. 922C

River Landscape with Horses and Cows, c. 1660
Canvas, 16 x 25³/₄ in. (41 x 66 cm)
Ex coll. Suermondt
Gemäldegalerie, cat. no. 922B

Esaias van de Velde

Merry Company Banqueting on a Terrace,
c. 1615
Canvas, 16³/₄ x 30 in. (43 x 77 cm)
Gemäldegalerie, cat. no. 1838

View of the Zierikzee, 1618
Canvas, 10¹/₂ x 15⁵/₈ in. (27 x 40 cm)
Gemäldegalerie, cat. no. 1952

Adriaen Pietersz. van der Venne

Summer, 1614
Oak, 16³/₄ x 26¹/₂ in. (43 x 68 cm)
Ex coll. Suermondt
Gemäldegalerie, cat. no. 741A

Winter, 1614
Oak, 16³/₄ x 26¹/₂ in. (43 x 68 cm)
Ex coll. Suermondt
Gemäldegalerie, cat. no. 741B

Jan Vermeer van Delft

The Glass of Wine, c. 1660
Canvas, 25⁷/₈ x 29¹³/₁₆ in. (66.3 x 76.5 cm)
Ex coll. Lord Francis Pelham Clinton
Hope, Deepdene
Gemäldegalerie, cat. no. 912C

Young Woman with a Pearl Necklace,
c. 1660–65
Canvas, 21⁷/₁₆ x 17¹/₂ in. (55 x 45 cm)
Ex coll. Suermondt
Gemäldegalerie, cat. no. 912B

Claude-Joseph Vernet

Nogent-sur-Seine, 1764
Canvas, 29¹/₄ x 52⁵/₈ in. (75 x 135 cm)
Ex coll. Cailleux, Paris
Gemäldegalerie, cat. no. 2/75

Paolo Veronese

*The Dead Christ Supported by Two Mourning
Angels*, late 1580s
Canvas, 42⁷/₈ x 36¹¹/₁₆ in. (110 x 94 cm)
Ex coll. Giustiniani
Gemäldegalerie, cat. no. 295

Andrea Verrocchio

Madonna and Child, c. 1470
Poplar, 29⁷/₁₆ x 21³/₈ in. (75.5 x 54.8 cm)
Gemäldegalerie, cat. no. 104A

Elisabeth-Louise Vigée-LeBrun

*Prince Heinrich Lubomirski as the Genius of
Fame*, 1789
Oak, 41¹/₈ x 32³/₈ in. (105.5 x 83 cm)
Ex coll. Prince Georg Lubomirski
Gemäldegalerie, cat. no. 4/74

Antonio Vivarini

The Adoration of the Magi, c. 1445–47
Poplar, 43⁵/₁₆ x 68⁵/₈ in. (111 x 176 cm)
Ex coll. Craglietti, Venice
Gemäldegalerie, cat. no. 5

Maurice Vlaminck

Bridge at Chatou, c. 1900
Canvas, 26¹/₂ x 37⁷/₁₆ in. (68 x 96 cm)
Nationalgalerie, cat. no. NG 17/62

Jacob-Ferdinand Voet (attributed to)

Maria Mancini as Cleopatra, c. 1663–72
Canvas, 29¹/₄ x 24³/₁₆ in. (75 x 62 cm)
Ex Prussian Royal Collection
Gemäldegalerie, cat. no. 465

Cornelis de Vos

Magdalena and Jan-Baptist de Vos, c. 1622
Canvas, 30⁷/₁₆ x 35⁷/₈ in. (78 x 92 cm)
Gemäldegalerie, cat. no. 832

Ferdinand Georg Waldmüller

Bouquet in an Attic Bell Crater, c. 1840
Panel, 22⁵/₈ x 17¹⁵/₁₆ in. (58 x 46 cm)
Nationalgalerie, cat. no. AI 1107

Early Spring in the Wienerwald, 1864
Canvas, 16³/₄ x 21¹/₁₆ in. (43 x 54 cm)
Nationalgalerie, cat. no. AI 866

Friedrich Wasmann

Paul, Maria, and Filomena von Putzer, 1870
Canvas, 14¹³/₁₆ x 19¹/₈ in. (38 x 49 cm)
Nationalgalerie, cat. no. AII 478

Antoine Watteau

The Dance, c. 1719
Canvas, 37¹³/₁₆ x 64³/₄ in. (97 x 166 cm)
Gemäldegalerie (on loan)

The Embarcation for Cythera, c. 1718–19
Canvas, 50⁵/₁₆ x 75¹¹/₁₆ in. (129 x 194 cm)
Schloss Charlottenburg, cat. no. GKI 1198

Enseigne de Gersaint, 1721
Canvas, 64³/₄ x 119⁵/₁₆ in. (166 x 306 cm)
Schloss Charlottenburg, cat. no. GKI 1200,
1201

Love in the French Theater, after 1716
Canvas, 14⁷/₁₆ x 18³/₄ in. (37 x 48 cm)
Ex Prussian Royal Collection
Gemäldegalerie, cat. no. 468

Love in the Italian Theater, after 1716
Canvas, 14⁷/₁₆ x 18³/₄ in. (37 x 48 cm)
Ex Prussian Royal Collection
Gemäldegalerie, cat. no. 470

Party in the Open Air, c. 1718–20
Canvas, 43⁵/₁₆ x 63⁹/₁₆ in. (111 x 163 cm)
Gemäldegalerie, cat. no. 474B

Peaceful Love, c. 1718
Canvas, 21¹³/₁₆ x 31⁹/₁₆ in. (56 x 81 cm)
Schloss Charlottenburg, cat. no. GKI 5337

The Shepherds, c. 1717–19
Canvas, 21¹³/₁₆ x 31⁹/₁₆ in. (56 x 81 cm)
Schloss Charlottenburg, cat. no. GKI 5303

Adriaen van der Werff

Amorous Shepherds, c. 1690
Canvas, 17¹⁵/₁₆ x 14¹³/₁₆ in. (46 x 38 cm)
Ex Prussian Royal Collection
Gemäldegalerie, cat. no. 492

Rogier van der Weyden

Lady Wearing a Gauze Headdress, c. 1435
Oak, 18⁵/₁₆ x 12¹/₂ in. (47 x 32 cm)
Gemäldegalerie, cat. no. 545D

Middelburg Altar, c. 1452:
Left wing: *Madonna and Child Appearing to
Caesar Augustus and the Tiburtine Sibyl*
Middle panel: *The Nativity*
Right wing: *The Star of Bethlehem Appears to
the Magi*
Oak, each wing 35¹/₂ x 15⁵/₈ in. (91 x 40 cm);
middle panel 35¹/₂ x 34¹¹/₁₆ in. (91 x 89 cm)
Gemäldegalerie, cat. no. 535

Miraflores Altar, c. 1438–45
Left wing: *The Adoration*
Middle panel: *Pietà*
Right wing: *Christ Appearing to His Mother*
Oak, each 27¹¹/₁₆ x 16¾ in. (71 x 43 cm)
Ex coll. King William II of Holland
Gemäldegalerie, cat. no. 534A

St. John the Baptist Altar, after c. 1455:
Left wing: *The Birth of John the Baptist*
Middle panel: *The Baptism of Christ*
Right wing: *The Martyrdom of John the Baptist*
Oak, each 30 x 18¾ in. (77 x 48 cm)
Ex coll. King William II of Holland
Gemäldegalerie, cat. no. 534

Rogier van der Weyden with Workshop

Charles the Bold, Duke of Burgundy, c. 1460
Oak, 19⅛ x 12½ in. (49 x 32 cm)
Ex coll. Solly
Gemäldegalerie, cat. no. 545

Emanuel de Witte

Interior of a Baroque Church, c. 1660
Canvas, 18¹⁵/₁₆ x 22¹/₁₆ in. (48.5 x 56.5 cm)
Gemäldegalerie, cat. no. 898C

Konrad Witz

The Queen of Sheba before Solomon,
before 1437
Oak, 33 x 30¹³/₁₆ in. (84.5 x 79 cm)
Gemäldegalerie, cat. no. 1701

Philips Wouwerman

Path Through the Dunes
Oak, 13⅝ x 16¾ in. (35 x 43 cm)
Gemäldegalerie, cat. no. 900E

Winter Landscape with Wooden Bridge
Oak, 11⅛ x 14¼ in. (28.5 x 36.5 cm)
Gemäldegalerie, cat. no. 900F

Joseph Wright (known as Wright of Derby)

The Cloister of San Cosimato, 1789
Mahogany, 23¾ x 31¹¹/₁₆ in. (60.9 x 81.3 cm)
Gemäldegalerie, cat. no. 3/74

Carl Friedrich Zimmermann

Armor Room in the Palace of Prince Frederick of Prussia
Canvas, 28½ x 37⅝ in. (73 x 96.5 cm)
Schloss Charlottenburg, cat. no. GKI 30228

Marco Zoppo

Madonna and Child Enthroned with Saints, 1471
Poplar, 102³/₁₆ x 99¹/₁₆ in. (262 x 254 cm)
Gemäldegalerie, cat. no. 1170

Francisco de Zurbarán

Don Alonso Verdugo de Albornoz, c. 1635
Canvas, 72⅛ x 40³/₁₆ in. (185 x 103 cm)
Ex coll. Alfred Morrison, London
Gemäldegalerie, cat. no. 404C

Oskar Zwintscher

Portrait in Flowers: The Artist's Wife, 1904
Canvas, 70⅜ x 54¹³/₁₆ in. (180.5 x 140.5 cm)
Nationalgalerie, cat. no. AI 1074

Selected Bibliography

For general information concerning paintings collections in Berlin discussed in this book, excluding monographs and articles on individual artists

Arndt, Karl. *Altniederländische Malerei.* Bilderhefte der Staatlichen Museen Berlin. Heft 5/6. 1968.

Barron, Stephanie (ed.). *Degenerate Art: The Fate of the Avante-Garde in Nazi Germany.* New York, 1991. Includes a reprint, in translation, of the German exhibition's original catalogue.

Bartoschek, Gerd. *Die Gemälde im Neuen Palais.* Potsdam-Sanssouci, 1991.

Bernhard, Marianne, Kurt Martin, and Klaus P. Progner. *Verlorene Werke der Malerei in Deutschland in der Zeit von 1939 bis 1945 Zerstörte und verschollende Gemälde aus Museen und Galerien.* Munich, 1965.

Bock, Henning, Hans-Joachim Eberhart, Wilhem H. Köhler, Rainald Grosshans, Erich Schleier, Ina Keller, Jan Kelch, and Wolfgang Schulz. *Katalog der ausgestellten: Gemälde des 13.–18. Jahrhunderts.* Staatliche Museen Preussischer Kulturbesitz. Berlin-Dahlem, 1975. English edition translated by Linda B. Parshall, Berlin, 1978.

Bock, Henning, Wilhem H. Köhler, Rainald Grosshans, Jan Kelch, and Erich Schleier. *Gemäldegalerie Berlin, Geschichte der Sammlung und ausgewählte Meisterwerke.* Staatliche Museen Preussischer Kulturbesitz, Berlin, 1985.

Bock, Henning, Rainald Grosshans, Jan Kelch, Wilhelm H. Köhler, and Erich Schleier. *Gemäldegalerie Berlin, Gesamtverzeichnis der Gemälde.* Staatliche Museen Preussischer Kulturbesitz, Berlin, 1986. English edition, New York, 1986.

Bode, Wilhelm von. *Mein Leben,* I–II. Berlin, 1930.

Börsch-Supan, Eva and Helmut, Günther Kühne, and Hella Reelfs. *Berlin — Kunstdenkmäler und Museen.* Reclams Kunstführer, Deutschland, VIII, Stuttgart, 1977.

Börsch-Supan, Helmut. *Antoine Watteaus Embarquement im Schloss Charlottenburg. Aus Berliner Schlössern.* Kleine Schriften VIII. 1983.

———. *Charlottenburg Palace.* 5th ed. Translated by Margarethe Kühn. Schloss Charlottenburg, Berlin.

———. *Die Gemälde im Jagdschloss Grunewald.* Berlin, 1964.

———. *450 Jahre Jagdschloss Grunewald — 1542–1992.* Berlin, 1992.

———. *Friedrich der Grosse, Ausstellung des Geheimer Staatsarchivs Preussischer Kulturbesitz.* Schloss Charlottenburg, 1986.

———. *Watteau 1684–1721, Führer zur Ausstellung im Schloss Charlottenburg 23. Februar–27. Mai 1985.* Berlin, 1985.

Boskovits, Miklos. *Frühe italienische Malerei: Staatliche Museen Preussischer Kulturbesitz, Gemäldegalerie Berlin.* Berlin, 1988.

Eckardt, Götz. *Die Gemälde in der Bildergalerie von Sanssouci.* 4th ed. Potsdam-Sanssouci, 1990.

Gaethgens, Thomas W. *Die Berliner Museumsinsel im Deutschen Kaiserreich.* Munich, 1992.

Geismeier, Irene. *Europäischer Malerei 14.–18. Jahrundert im Bode-Museum.* Berlin, 1970, 1972 (with Hannelore Nützmann), 1978.

———. *Holländisch und flämische Gemälde des siebzehnten Jahrhunderts im Bode-Museum.* 2nd ed. Staatliche Museen zu Berlin. Berlin, 1972.

Geismeier, Irene, Hannelore Nützmann, Rainer Michaelis. *Gemäldegalerie, Malerei 13.–18. Jahrhundert im Bodemuseum.* 4th ed. Staatliche Museen zu Berlin. Berlin, 1990.

Honisch, Dieter, Peter Krieger. *Deutsche Malerei des 19. Jahrhunderts–60 Meisterwerke aus der Nationalgalerie Berlin, Kunsthalle Düsseldorf, July 20–September 14, 1980.*

Klessmann, Rüdiger. *The Berlin Museum — Paintings in the Picture Gallery, Dahlem, West Berlin.* Translated by D. J. S. Thomson. New York, 1971.

——— (ed.). *Holländische Malerei des 17. Jahrhunderts in der Gemäldegalerie, Berlin.* Bilderhefte der Staatlichen Museen Preussischer Kulturbesitz. Heft 11/12. Berlin, 1969.

Krieger, Peter. *Maler des Impressionismus aus der Nationalgalerie Berlin.* Bilderhefte der Staatlichen Museen Berlin. Heft 3. 1967.

Reidemeister, Leopold, and Stephan Waetzoldt. *Verzeichnis der Gemälde und Bildwerke der Nationalgalerie Berlin in der Orangerie des Schlosses Charlottenburg.* Berlin, 1966.

Warnke, Martin. *Flämische Malerei des 17. Jahrhundert.* Bilderhefte der Staatlichen Museen Berlin. Heft 1. 1967.

Wilhelm von Bode als Zeitgenosse der Kunstl — Zum 150. Geburtstag. Nationalgalerie, Staatliche Museen zu Berlin. Berlin, 1995–96.

Index

Numbers in *italics* refer to pages on which pictures will be found.

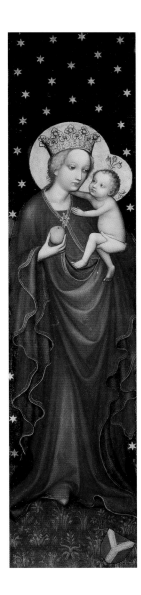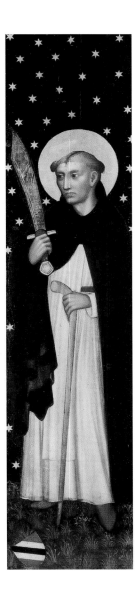

DESIGNED BY SUSAN MARSH

COMPOSITION IN POSTSCRIPT MONOTYPE DANTE BY DIX, SYRACUSE, NEW YORK

PRINTED AND BOUND BY AMILCARE PIZZI, MILAN, ITALY